WOMEN ARTISTS
An Historical, Contemporary and Feminist Bibliography
second edition

by
SHERRY PILAND

The Scarecrow Press, Inc.
Metuchen, N.J., & London
1994

First edition: *Women Artists: An Historical, Contemporary and Feminist Bibliography,* by Donna G. Bachmann and Sherry Piland (Scarecrow Press, 1978).

British Library Cataloguing-in-Publication data available

Library of Congress Cataloging-in-Publication Data

Piland, Sherry.
　　Women artists : an historical, contemporary and feminist bibliography
／ by Sherry Piland. — 2nd ed.
　　　　p.　cm.
　　Rev. ed. of: Women artists / by Donna G. Bachmann and Sherry
Piland.　1978.
　　Includes bibliographical references.
　　ISBN 0-8108-2559-7 (acid-free paper)
　　1. Women artists—Bibliography.　2. Feminism and art—
Bibliography.　I. Bachmann, Donna G., 1948–　　Women artists.　II.
Title.
Z7963.A75B32　　1994
[N8354]
016.7′092′2—dc20　　　　　　　　　　　　　　93-27248

CONTENTS

CONTENTS

LIST OF ILLUSTRATIONS

All illustrations are grouped within separation photo signature. Bracketed numbers correspond to order of photo's appearance within signature.

Foundation in memory of Josephine Bay Paul and Ambassador Charles Ulrick Paul.

[10.] Mary Cassatt. *The Bath.* ca. 1891. Oil on canvas. 39″ × 26″. The Art Institute of Chicago, Robert A. Waller Fund. (Top.)

[10.] Mary Hallock Foote. *Old Lady.* Oil on canvas, before 1913. 91.5 cm × 63.6 cm, Friends of American Art, 1913.520, © 1990 The Art Institute of Chicago, all rights reserved. (Bottom.)

[11.] Berthe Morisot. *In the Dining Room.* 1963.10.185. Canvas; 24-1/8″ × 19-3/4″. National Gallery of Art, Washington, D.C., Chester Dale Collection.

[12.] Sarah Miriam Peale. *Slice of Watermelon.* 1825. Oil on canvas; 17″ × 21-13/16″. Wadsworth Atheneum, Hartford, Connecticut. Ella Gallup Sumner and Mary Catlin Sumner Collection.

[13.] Mary Ann Willson. *The Prodigal Son Wasted His Substance with Riotous Living.* ca. 1815. B-25138. Watercolor. National Gallery of Art, Washington, D.C., gift of Edgar William and Bernice Chrysler Garbisch. (Top.)

[13.] Isabel Bishop. *Girl Reading Newspaper.* Oil on pressed wood. 62.9 cm × 38.4 cm. Nelson-Atkins Museum of Art, Kansas City, Missouri. Bequest of Marie P. McCune, 68-8/2. (Bottom.)

[14.] Romaine Brooks. *Self Portrait.* 1923. Oil on canvas; 46-3/4″ × 26-7/8″. National Museum of American Art, Smithsonian Institution, Washington, D.C. Gift of the artist. 1966.49.1.

[15.] Emily Carr. *Western Forest.* ca. 1931. Oil on canvas; 128.3 cm × 91.8 cm. Art Gallery of Ontario, Toronto, Canada.

[16.] Caroline Durieux. *Nice Men.* 1936. Lithograph, printed in black composition; 11″ × 14-7/16″. Collection, The Museum of Modern Art, New York. Purchase.

[17.] Grace Hartigan. *Broadway Restaurant.* 1957. Oil on canvas. 79″ × 62-3/4″. Nelson-Atkins Museum of Art, Kansas City, Missouri, gift of Mr. William T. Kemper.

[18.] Lilian Wescott Hale, *L'Edition de Luxe.* Oil on canvas; 23″-1/4 × 15″. Gift of Miss Mary C. Wheelwright; courtesy, Museum of Fine Arts, Boston. (Top.)

[18.] Frida Kahlo. *Self Portrait with Cropped Hair.* 1940. Oil on canvas; 15-3/4″ × 11″. Collection, The Museum

PREFACE

In the fourteen years since this bibliography was first published, the interest in historical women artists has mushroomed. Today, not only is there a recognized field of women's art history, but feminist criticism and feminist theory are viable entities as well. Yet, in some ways, it seems that the more things change the more they remain the same. Some of the issues so hotly debated during the women artist's movement of the 1970's—such as the appropriateness of women-only exhibitions, the identification of images thought to be specific to women, and the usefulness of women's studies programs—still find their supporters and detractors.

The enormously important *Women Artists, 1500-1950* exhibition in 1976 and its catalog written by Ann Sutherland Harris and Linda Nochlin have to be credited with bringing the study of historical women artists to wider public awareness. Their excellent scholarship served also as an example of the kind of serious study that women artists deserve. Overall, the study of women artists has evolved from the discovery phase to an analytical phase. The first step, that of simply recovering the names of women artists and the locations of their works, resurrecting them from dusty and forgotten tomes, was a labor of continual surprise. The discovery that women, for the most part, had been written out of the history of art produced substantial righteous anger. This outrage was often eloquently expressed in the pages of the *Feminist Art Journal,* which was published between 1972 and 1977 and contained articles on historical and contemporary women artists and also examined the problem women still faced in obtaining exhibitions. The strident tone that often characterized this periodical, a reflection of the activism of the times, has been replaced by the more reflective and scholarly approach of the *Women's Art Journal,* which began publication in 1980 and which seems to improve with each issue.

As the work of the discovery phase continues, there is now more analysis of the lives, careers, and works of women artists. There were very few catalogs devoted to women artists when this bibliography was first published. Happily, that situation is gradually changing, as evidenced by the catalog on Vigée-LeBrun by Joseph Baillio published in 1982, Maria Maria Cantaro's *catalogue raisonné* on Lavinia Fontana published in 1989, and Mary Garrard's monumental study of Artemisia Gentileschi, also published in 1989. Garrard's prodigious work is the kind of scholarship and feminist analysis that can serve as an inspiration and model for others working in the field.

In the 1980's a dichotomy of styles and philosophy was apparent in the controversies surrounding two widely different organizations. The opening of the National Museum of Women in the Arts in Washington, D.C., in 1987 was hailed by many and was also obviously the recipient of substantial financial revenue. It was criticized by others as simply perpetuating the separation of women artists from the mainstream of art history. The detractors would have preferred to find women fully represented in the museums that already exist. This seems a fairly remote possibility, since currently 95 to 98 percent of the art in U.S. art museums is by men. Selecting a more radical and confrontational approach is the anonymous group based in New York City, called the Guerrilla Girls. The members of this organization have shown up at panel discussions in their trademark guerrilla masks. They have also staged events, published posters, and purchased space in magazines to raise consciousness and to call attention to the lack of representation of women in museum shows. Activism still lives in the 1990's, knowledge about women artists is rapidly expanding, women artists are still emerging from the murky past, and it seems that the proliferation of information about women artists needs to be incorporated into the bibliography.

Several changes will be noted in this revised edition of the bibliography. A few names have been changed in keeping with their more common usage (Susannah Hourbout is now listed as Horenbout; Sarah Goodrich is now listed as Goodridge). Sabina Von Steinbach has been removed from the bibliography. She is now believed to have perhaps been a donor of sculpture at Strasbourg Cathedral rather than the carver. The few women architects included in the original publication have also been

removed. Research on women architects is also a blossoming field, and much more information is available now than a decade ago. It seemed impossible to include women architects within the scope of this work. Twenty-nine artists have been added to the bibliography. They represent a wide diversity, from the seventeenth-century Portuguese artist Josefa de Ayala, to the eighteenth-century U.S. wax sculptor Patience Lovell Wright, to the nineteenth-century illustrators Maria Martin and Mary Hallock Foote, to Miriam Schapiro, a feminist artist and teacher working today.

Because of prohibitive costs, some previously published reproductions have been eliminated in favor of those by the newly added artists whose works are usually less familiar. The reproduction of *A Vase of Flowers* by Rachel Ruysch from the collection of the North Carolina Museum of Art in Raleigh has been deleted. That work has since been reattributed to Willem van Aelst.

One can never hope to thank all the people who make such a publication possible. The encouragement of family and friends is, of course, the sustenance that makes monumental tasks possible. The staffs of the State Library of South Carolina and the libraries of the University of South Carolina and Florida State University answered innumerable questions and pointed the way out of frustrating dead ends. You have to love libraries even to think of undertaking a project such as this! Sincere thanks also are expressed to Dr. Patricia Rose, chairman of the Art History Department at Florida State University, who helped me find the time to complete this project. Donna Bachmann, my co-author of the original publication, is absent from this revision. This is testimony to steady but slow improvements in the status of women artists. Her responsibilities as head of the Art Department at Park College in Parkville, Missouri, did not leave her time to be fully involved in this revision, although her early enthusiasm got the project off the ground.

Sherry Piland
Tallahassee, FL

A NOTE ON FORM

Complete citations in standard form are provided throughout this bibliography; however, there are some entries for which this has not been possible. For example, sometimes the publisher or the page numbers are not available. Rather than delete such entries, they are included in the belief that they are useful even though incomplete.

References to exhibition catalogs present a special problem to the bibliographer. The following form has been arbitrarily chosen:

City. Institution [i.e., gallery or museum]. *Title.* Dates.

When a catalog contains an important essay, it may be listed in the catalog section under the author's name, as though it were a book.

SECTION I

GENERAL WORKS

This section is composed of a large variety of works, all relating to the general subject of women artists. Surveys, biographical dictionaries, criticism, theory, catalogs, bibliographies, microfilm collections, slide sets, and dissertations are included. In addition there are a few works supplying cultural and social background, and thus, the attitudes toward women and their work. While historical women artists are emphasized in this bibliography, works about the contemporary women's art movement are also included. A range of points of view are represented, from misogyny to feminism.

This section is divided into three groups: books, periodicals, and catalogs. Microfilm collections, slide sets, and dissertations are included with the books. Papers delivered before societies are grouped with the periodicals. Full citations are given here for works that are listed several times in Section II in shortened form.

BOOKS

Adair, Virginia, and Lee Adair. *Eighteenth Century Pastel Portraits.* London: Gifford, 1971.

Afro-American Women in Art: Their Achievements in Sculpture and Painting. Greensboro, North Carolina: Alpha Kappa Alpha Society, 1969.

Alcott, Abigail May [Mme. Nieriker]. *Studying Art Abroad and How to Do It Cheaply.* Boston: Roberts Brothers, 1879.
　　Louisa May Alcott's sister was considered, prior to her early death, to have had a quite promising art career ahead of her. She was one of the many adventurous U.S. women who journeyed to Paris to study. In this volume she offers practical advice concerning such things as the most fatherly ship captains and which ateliers had life classes segregated by sex so that one might properly study the nude. Its usefulness today is its ability to convey the problems and options of women art students in nineteenth-century Paris. (*See* Jeanne Stump in the periodical section for more information about Alcott.)

Alesson, Jean. *Les femmes artistes au salon de 1878 et l'exposition universelle.* Paris: Au bureau de la gazette des femmes, 1878.
　　The success of women artists at this world's fair and their special pavillion had much to do with the inclusion of a Woman's Building at the Chicago World's Columbian Exposition in 1893.

Anton, Ferdinand. *Women in Pre-Columbian America.* New York: Abner Schram Enterprises, 1976.

Armstrong, Tom, et al. *Two Hundred Years of American Sculpture.* New York: Whitney Museum of American Art, 1976.
　　Contains excellent section of short "Artists' Biographies and Bibliographies" compiled by Libby Seaberg and Cherene Holland, which includes a number of women. Photographs of most of the sculptors are included.

Azar, Amie. *Femmes peintres d'Egypte.* Cairo, 1953.
This book discusses nine Egyptian women artists.

Barnard College Women's Center. *Women's Work and Women's Studies, 1972.* Pittsburgh: Know, 1972.

————. *Women's Work and Women's Studies, 1973–74: A Bibliography.* Old Westbury, New York: The Feminist Press, 1975.
A 370-page bibliography.

Beaton, Cecil, and Gail Buckland Nicolson. *The Magic Image: The Genius of Photography from 1839 to the Present Day.* London: Weidenfeld, 1975.
Several women photographers are discussed.

Behr, Shulamith. *Women Expressionists.* Oxford: Phaidon, 1988.
The introductory essay presents a concise picture of the role women played in the development of Expressionism, their training, and the obstacles they encountered. The well-known artists Kollwitz, Modersohn-Becker, and Münter are discussed in addition to less-familiar women Expressionists from Russia, Sweden, Yugoslavia, and Holland. Color plates and discussions of thirty-two paintings provide the bulk of this work.

Bell, Susan G., ed. *Women: From the Greeks to the French Revolution.* Belmont, California: Wadsworth Publishing Company, 1973.

Bellier de la Chavignerie, Emile, and Louis Auvray. *Dictionnaire général des arts du dessin jusqu'à nos jours.* 2 vols. Paris, 1882–1885.

Bénézit, Emmanuel Charles. *Dictionnaire des peintres, sculpteurs, dessinatures et graveurs.* 10 vols. Paris: Librairie Grund, 1976 edition.
Bénézit includes many women in his dictionary. Though entries are often short, they can provide a starting place for research.

Benjamin, S. G. W. *Contemporary Art in Europe.* New York: Harper and Brothers, 1877.
Mentions a few women artists very briefly.

Benoust, Madeleine. *Quelques femmes peintres.* Paris: Librairie Stock, 1936.
Photographs, reproductions, and biographies are included.

Benton, Suzanne. *The Art of Welded Sculpture.* New York: Van Nostrand Reinhold, 1975.

A truly feminist book that covers not only technique in a field often considered "masculine," but personal commentary on the problems of women in the art world and how those problems encroach on one's personal life. Benton includes an extremely beneficial section on the presentation and promotion of one's work. Her book is also distinguished by the use of female pronouns throughout.

Boccaccio, Giovanni. *Concerning Famous Women (De Claris mulieribus,* ca. 1370). Trans. and ed. G. A. Guarino. New Brunswick, 1973.

Boccaccio elaborates Pliny's short paragraph on women artists.

Bowlt, John E., ed. and trans. *Russian Art of the Avant-Garde: Theory and Criticism, 1902–1936.* New York: Viking Press, 1976.

A number of women were in the forefront of the Russian avant-garde, particularly Alexandra Exter, Liubov Popova, and Olga Rozanova.

Bradley, John. *A Dictionary of Miniaturists, Illuminators, Calligraphers and Copyists.* 3 vols. London, 1887–1889; reprint, New York: Macmillan Company, 1903.

Broude, Norma, and Mary D. Garrard, eds. *Feminism and Art History: Questioning the Litany.* New York: Harper and Row, 1982.

A collection of essays that bring a feminist corrective view to the assumptions of traditional male-dominated art history.

Bryan, Michael. *Dictionary of Painters and Engravers.* 5 vols. Ed. George Williams. New York: Macmillan Company, 1903.

Many women are discussed in this work.

Bulliet, C. J. *The Courtezan Olympia: An Intimate Survey of Artists and Their Mistress Models.* New York: Covici, Friede Publishers, 1930.

Chapter 12 is of particular interest: "How the Model Olympia Stepped Down from the Dais and Picked Up a Paint Brush."

Burke, Janine. *Australian Women Artists, 1840–1940.* Richmond, Victoria: Greenhouse Publications, 1980.

Callen, Anthea. *Women Artists of the Arts and Crafts Movement, 1870–1914.* New York: Pantheon Books, 1979.

A strong feminist, socialist perspective underlies this comprehensive discussion of the social and economic factors in the United States

and England that impacted the craftswomen of the period. This well-documented study includes a discussion of ceramics, needle-crafts, jewelry, illustration, and furniture design. Many excellent photographs are incorporated into the text. A short bibliography is also provided.

Castiglione, Baldassare. *The Book of the Courtier (Il cortegiano,* 1528). Trans. C. S. Singleton. New York, 1959.

Ann Sutherland Harris cites the original edition and the approxi-mately thirty that followed throughout Europe as popularizing and legitimizing education for upper-class women, including art educa-tion. This idea had an important impact on the development of women artists.

Cederholm, Theresa D., ed. and comp. *Afro-American Artists: A Bio-bibliographical Dictionary.* Boston: Trustees of the Boston Public Library, 1973.

This work covers the period from the eighteenth century to the present. Each alphabetical entry includes exhibition information.

Chadwick, Whitney. *Women Artists and the Surrealist Movement.* London: Thames and Hudson, 1985.

A discussion of women whose works show the clear influence of Surrealist ideas about art and the creative process. Chadwick concen-trates on the years between 1924 and 1947.

Champlin, John D., Jr., ed. 4 vols. *Cyclopedia of Painters and Paintings.* New York: Charles Scribner's Sons, 1913.

An illustrated biographical dictionary that includes descriptive articles on specific paintings and themes.

Chicago, Judy. *Through the Flower: My Struggle as a Woman Artist.* New York: Doubleday and Company, 1975.

A personal and passionate autobiography in which a "successful" woman artist acknowledges, and shares with her sisters, the price she paid. This is unusual in that many women in her position have chosen not to identify with other women.

Chicago World's Columbian Exposition, Official Catalogue, Part XIV, Woman's Building. Chicago: W. B. Conkey Company, 1893.

The catalog of the historic Woman's Building merely lists each display by country, the artist (all of whom are women), title of the work, and catalog number. It also contains a floor plan of the building. All this conveys a sense of the magnitude of the entire project. The

exhibits are staggering in their number and variety and in the degree to which all nationalities are included.

Clark, Alice. *The Working Life of Women in the Seventeenth Century.* London: G. Routledge and Sons, 1919; reprint, New York: A. M. Kelley, 1968.

Clayton, Ellen C. *English Female Artists.* 2 vols. London: Tinsley Brothers, 1876.
 Volume 1 concerns historical women artists. Volume 2 deals with then contemporary women, most of whom are obscure or unknown today. Clayton gives only a vague general list of her sources.

Clement, Clara Erskine. *Women in the Fine Arts: From the Seventh Century B.C. to the Twentieth Century A.D.* Cambridge, Massachusetts: Houghton Mifflin and Company, The Riverside Press, 1904: reprint, New York: Hacker Art Books, 1974.
 This small biographical dictionary provides a rich source on historical women artists. The approximately five hundred entries consist of short biographies and descriptions of major works, ranging in length from a few lines to several pages. Particular emphasis is placed on nineteenth-century women. Thirty-three black-and-white reproductions of inferior quality are included. The book suffers a flaw common to most of its era—sources are quoted only in a general way.

————, and Laurence Hutton. *Artists of the Nineteenth Century.* Boston: Ticknor and Company, 1884.
 A number of women are included.

Colding, Torben Holch. *Aspects of Miniature Painting: Its Origins and Development.* Copenhagen: Ejnar Munksgaard, 1953.
 Many women have worked in this format.

Collins, J. L. *Women Artists in America: Eighteenth Century to the Present.* Chattanooga: University of Tennessee, Art Department, vol. 1, 1973; vol. 2, 1975.
 This reference index has been reviewed by the *ARLIS Newsletter* as needing an index and a major reediting, and thus being of negligible value.

Collins, Jim, and Glenn B. Opitz, eds. *Women Artists in America, Eighteenth Century to the Present.* Revised ed. Poughkeepsie, New York: Apollo, 1980.

Craven, Wayne. *Sculpture in America*. New York: Thomas Y. Crowell Company, 1968.
 A narrative history of American sculpture with biographical sketches of more than 130 sculptors (many of them women) and descriptions and evaluations of their work.

Crespi, Luigi. *Vite de'Pittori Bolognesi*. Rome, 1769.
 Records twenty-three women painters as active in Bologna in the sixteenth and seventeenth centuries.

Daniels, Arlene Kaplan. *A Survey of Research Concerns on Women's Issues*. Washington, D.C.: The Project on the Status and Education of Women of the Association of American Colleges, 1976.
 An overview and bibliography.

Daubié, J. V. *La femme pauvre au XIXe siècle*. Paris, 1866.

Dawson, Bonnie, comp. *Women's Films in Print: An Annotated Guide to Eight Hundred Films by Women*. San Francisco: Booklegger Press, 1975.

Dewhurst, C. Kurt; Betty MacDowell; and Marsha MacDowell. *Artists in Aprons: Folk Art by American Women*. New York: E. P. Dutton, 1979.

Dodd, Loring Holmes. *Golden Moments in American Sculpture*. Cambridge, Massachusetts: Dressler, Chapman and Grimes, 1967.
 Essays on twenty-three different sculptors, including four women.

Dorival, Bernard. *The School of Paris in the Musée d'Art Moderne*. New York: Harry N. Abrams, 1962.

————. *Twentieth Century Painters*. Trans. Arnold Rosin, New York: Universe Books, 1958.

Doty, Robert. *Human Concern/Personal Torment: The Grotesque in American Art*. New York: Whitney Museum, 1969.
 Includes few contemporary female artists, including May Wilson, Gladys Nilsson, Nancy Grossman.

Duhet, P.-M., ed. *Les femmes et la révolution, 1789–1794*. Paris, 1971.

Earle, Helen, comp. *Biographical Sketches of American Artists*. Lansing: Michigan State Library, 1924.
 Includes numerous short accounts of women artists.

Eckenstein, Lina. *Women Under Monasticism.* Cambridge: University Press, 1896.

Edwards, Lee R.; Mary Heath; and Lisa Baskin, eds. *Women: An Issue.* Boston: Little, Brown and Company, 1972.
The chapter entitled "Art's Looking Glass" is cited for a number of women in Section II. "A brilliantly diverse exploration into just what it means to be a woman and a human being." Self-portraits of fifteen women artists are included.

Ellet, Elizabeth Fries Lummia. *Women Artists in All Ages and Countries.* New York: Harper and Brothers, 1859.
This book has unfortunately not yet been reprinted. It served as a principal source for Clement's *Women in the Fine Arts,* which she acknowledged. This one is the more readable of the two. It is organized by century and geographic area. A substantial amount of the text was translated from Ernst Guhl's *Die Frauen in die Kunstgeschichte,* cited below.

Elliot, Maude Howe, ed. *Art and Handicraft in the Woman's Building of the World's Columbian Exposition of 1893.*
Elliot's is the best contemporary source about the Woman's Building, razed after the fair. The only reproductions of the specially commissioned murals are to be found there, the most important one being *Modern Woman* by Mary Cassatt. Elliot was a member of the Board of Lady Managers, and thus this is in some respects an "official" version.

Encyclopedia of World Art. 15 vols. New York: McGraw-Hill Book Co., 1959.
Only rarely is a substantiative account given of a woman artist. Usually a woman listed in the index is mentioned in a sentence that begins something like, "Also painting in this time period were . . ."

Fidiere, Octave. *Les femmes artistes a l'Académie Royale.* Paris: Charavey Frères, 1885.

Fielding, Mantel. *Dictionary of American Painters, Sculptors and Engravers.* Philadelphia, 1926.

Films by Women. Toronto: Canadian Film Maker's Distribution Center, 1976.
Lists feature-length and short films by Canadian women.

Fine, Elsa Honig. *Women and Art.* Montclair, New Jersey: Allanheld and Schram, 1978.

The history of almost a hundred women painters and sculptors from the Renaissance to the twentieth century. Each chapter begins by detailing the social and philosophical context of the society in which the artists were working. Many reproductions, most in black and white.

Foskett, Daphne. *A Dictionary of British Miniature Painters.* 2 vols. London: Faber and Faber, 1972.

Provides brief biographical information, characterizes each artist's work, and illustrates his or her signature. Includes artists from ca. 1520 to 1910.

Foster, J. J. *A Dictionary of Painters of Miniatures (1525–1850).* London: Philip Allan and Company, 1926.

Fowler, Carol. *Contributions of Women: Art.* Minneapolis: Dillon Press, 1976.

This work, part of a series, consists of six brief biographies written for young people. An appendix includes thirteen sketches of artists and one patron/collector.

Furniss, Harry. *Some Victorian Women, Good, Bad and Indifferent.* London, 1923.

Furniss was a raconteur and caricaturist. His book contains a chapter on women artists. Also included are stories about models, whom he thought to be a curious and simple breed. "Period sexism."

Garb, Tamar. *Women Impressionists.* New York: Rizzoli, 1986.

Good synopsis of the work of four major women Impressionists: Cassatt, Morisot, Bracquemond, and Gonzalès. Discusses the social milieu, the obstacles to their artistic education, and their relationships to the male Impressionists. Many color reproductions, but the book unfortunately lacks footnotes.

Garrard, Mary. *Slides of Works by Women Artists: A Source Book.* Women's Caucus for Art, 1974.

Syllabi for women's studies in studio and art history have long decried the difficulty of obtaining slides of works by women, whether contemporary or historical. This source lists 666 women artists and directs the reader to over 1600 specific slides of their works.

Gautier, Xavière. *Surréalisme et sexualité.* Paris, 1971.
Many women artists have been and continue to be active in Surrealism.

Gerdts, William H. *American Neo-Classic Sculpture: The Marble Resurrection.* New York: The Viking Press, 1973.
An excellent and profusely illustrated volume. Major women sculptors are included, and Gerdts presents an enormous amount of bibliographic information on each artist. The book does suffer from not being better indexed—it is quite difficult to find all the illustrations and information on individual artists.

Gernsheim, Helmut, and Alison Gernsheim. *History of Photography from the Camera Obscura to the Beginning of the Modern Era.* New York: McGraw-Hill, 1969.

The Gerritsen Collection of Women's History. Glen Rock, New Jersey: Microfilming Corporation of America, 1975.
Over 4,000 volumes of books, periodicals, and pamphlets, covering the social, political, and intellectual history of women on microfilm.

Graham, Mayo. *Some Canadian Women Artists.* Ottawa: National Gallery of Canada, 1975.

Gray, Camilla. *The Great Experiment: Russian Art, 1863–1922.* New York: Harry N. Abrams, 1962.

Greer, Germaine. *The Obstacle Race: The Fortunes of Women Painters and Their Work.* New York: Farrar, Straus and Giroux, 1979.
An uneven thematic organization, with some artists discussed in more than one chapter. Examines the obstacles that have impeded artistic production and how women artists have coped with these difficulties.

Guhl, Ernst von. *Die Frauen in die Kunstgeschichte.* Berlin: Guttentag, 1858.
Ellet, cited above, took much (with acknowledgment) from this book. See also "Women Artists," a review cited in the periodical section.

Guicciardini, Ludovico. *Descrittione die Paesi Bassi.* Antwerp, 1567.
Ann Sutherland Harris cites from Guicciardini's *Account of the Ancient Flemish School of Painting* (London, 1795). She says that he records seven women as active artists in 1567.

Halle, F. W. *Women in Soviet Russia.* New York, 1933.

Hanaford, Phebe A. *Daughters of America.* Augusta, Maine: True and Company, 1883.
 Chapter 10 (pp. 271–304) is entitled "Women Artists." Much of the material is derived from Ellet's book.

Harksen, Sibylle. *Women in the Middle Ages.* New York: Abner Schram Enterprises, 1976.

Harris, Ann Sutherland, and Linda Nochlin. *Women Artists, 1550–1950.* New York: Alfred A. Knopf, 1976.
 The landmark catalog accompanying the exhibit of historical women artists that opened in January 1977. In contains definitive essays, bibliographies, and numerous reproductions, some of them in color. It is without doubt the most thorough and scholarly work on women artists available.

Hart, Charles H. *Some Lessons of Encouragement from the Lives of American Women Artists.* Philadelphia, 1906.
 This was an address delivered before the Philadelphia School of Design for Women at an annual commencement on May 31, 1906. In the address, Hart mentioned sculptors Patience Wright and Harriet Hosmer.

Hartley, Marsden. *Adventures in the Arts.* New York: Boni and Liveright, 1921.
 See chapter entitled "Some Women Artists," pp. 112ff.

Hayes, Danielle B. *Women Photograph Men.* New York: William Morrow, 1977.
 A humanistic collection of images of men as seen by women, and lacking reverse sexism. The introduction is by Molly Haskell; see the periodical section for a reprinted adaption of that essay.

Hedges, Elaine, and Ingrid Wendt. *In Her Own Image: Women Working in the Arts.* New York: McGraw-Hill, 1980.

Heller, Nancy. *Women Artists: An Illustrated History.* New York: Abbeville Press, 1987.
 A chronological overview of painters and sculptors from the Renaissance to the twentieth century, intended for the general reader. It includes many excellent color reproductions and a selected bibliography.

Hess, Thomas B., and Elizabeth C. Baker. *Art and Sexual Politics: Women's Liberation, Women Artists, and Art History.* New York: Art News Service, Collier Books, 1973.
 Essentially a reprint of the special issue of *Art News* devoted to the issue of women in art (vol. 69, January 1971). Most of the important articles from that issue are cited individually below.

————, and Linda Nochlin, eds. *Women as Sex Object: Studies in Erotic Art, 1730–1970 (Art News Annual,* vol. 38). Newsweek, 1972.
 A lavish, scholarly, entertaining, and occasionally feminist treatment.

Hildebrandt, Hans. *Die Frau als Kunsterin.* Berlin, 1928.

Hirsch, Anton. *Die Frauen in der bildenden Kunst.* Stuttgart, 1905.

History of Women. Woodbridge, Connecticut: Research Publications, 1975–1979 (microfilm).
 Described as comprehensive and interdisciplinary. "The world's most important holdings of women's history resources have been brought together."

Howitt, Anna Mary. *An Art Student in Munich.* Boston: Ticknor, Reed, and Fields, 1854.

Hsu, Chung-p'ei. *The Position of Women in Free China: Chinese Women Show Their Mettle in the Arts.* Taipei: Culture Publishing Foundation, 1953.

Interviews with Women in the Arts, Part 2. New York: Tower Press, 1976.
 The project of a class taught by Janet Kozloff at the School for Visual Arts in 1973 and 1974. Each student interviewed a woman artist; a reproduction of each artist's work is included.

James, Edward, et al. *Notable American Women, 1607–1950.* 3 vols. Cambridge: Belknap Press of Harvard University Press, 1971.

Jean, Marcel. *The History of Surrealist Painting.* Trans. Simon W. Taylor. New York: Grove Press, 1960.
 Mentions the work of several women working in the Surrealist style.

Johnson, J., and A. Greutzner. *The Dictionary of British Artists, 1880–1940.* Woodbridge, Suffolk: Antique Collectors Club, 1980.

Kampen, Natalie. *Images and Status of Roman Working Women: Second and Third Century Sculpture from Ostia.* Ph.D. dissertation, Brown University, 1976.

Karas, Maria. *The Woman's Building, Chicago 1893; The Woman's Building, Los Angeles 1973–.* Los Angeles: Woman's Graphic Center, May 1975.

Kelso, Ruth. *Doctrine for the Lady of the Renaissance.* Urbana, Illinois, 1956.

Kirkland, Winifred, and Frances Kirkland. *Girls Who Became Artists.* New York, 1934; reprinted, Freeport, New York: Books for Libraries Press, 1967.
Biographical sketches of eleven women artists, intended for juvenile readers.

Kowalski, Rosemary Ribich. *Women and Film: A Bibliography.* Metuchen, New Jersey: Scarecrow Press, 1976.

Krull, Edith. *Women in Art.* Trans. T. Lux Feininger. London: Studio Vista, 1986.
A cultural, historical, and socioeconomic study of women working in the plastic arts. Rather than offer biographical presentations, Krull takes a broader approach. She examines the training, exhibition opportunities, working conditions, and choices of media and subject matter. She profiles typical careers and presents a study that is full of interesting detail and anecdotal material. Many excellent illustrations are included, some in color. There is also a selected bibliography, primarily of German sources. Unfortunately, there are no footnotes.

Lauter, Estella. *Women as Mythmakers: Poetry and Visual Art by Twentieth-Century Women.* Bloomington: Indiana University Press, 1984.
A fascinating study of cultural mythology and its transformations as seen in creative works by women.

Lexikon der Frau. 2 vols. Zurich, 1953.

Lippard, Lucy. *From the Center: Feminist Essays on Women's Art.* New
 York: E. P. Dutton and Company, 1976.
 Essays written by Lippard since 1971, plus a section of fiction.

Long, Basil S. *British Miniaturists.* London: G. Bles, 1929.

Loth, Heinrich. *Woman in Ancient Africa.* Westport, Connecticut, 1987.
 This illustrated survey includes information about the craft work of
 African women.

Lucie-Smith, Edward. *Impressionist Women.* London: Weidenfeld and
 Nicolson, 1989.
 Discussion of women and their activities as subject matter in
 Impressionist art. Includes brief biographical sketches of several
 women painters.

Macksey, Joan, and Kenneth Macksey. *The Book of Women's Achieve-
 ments.* New York: Stein and Day, 1976. Pp. 194–209.
 Contains a chapter entitled "As Artists" that provides a biographi-
 cal survey of seventy-two women artists.

Malvasia, Carlo Cesare. *Felsina Pittrice vite de pittori bolognesi.* 2 vols.
 Bologna, 1678.
 These are two beautifully set and bound volumes (if you have the
 good fortune to see the first editions). Information is provided on
 Lavinia Fontana and Elisabetta Sirani. Both entries are faced with
 engraved portraits of the artists. Citing from an 1841 edition, Harris
 and Nochlin also note mentions of Anguissola, Fontana, and
 Galizia.

Mann, Marjory, and Ann Noggle. *Women in Photography: An Historical
 Survey.* San Francisco: Museum of Art, 1975.
 The introduction is by John Humphrey.

Marrow, Deborah. *The Art Patronage of Maria de Medici.* Ann Arbor:
 UMI Research Press, 1982.
 This is a revision of Marrow's 1978 Ph.D. dissertation for the
 University of Pennsylvania.

Marsh, Jan. *The Pre-Raphaelite Sisterhood.* New York: St. Martin's
 Press, 1985.
 A biographical study of the women who moved in the Pre-

Raphaelite circle, as models, mistresses, wives, and as painters in their own right.

Marsh, Jan, and Pamela Gerrish Nunn. *Women Artists and the Pre-Raphaelite Movement*. London: Virago Press, 1989.
 Presents three generations of women artists working in the Pre-Raphaelite circle from 1848 to 1914. Includes biographical summaries and numerous reproductions, several in color.

Mathey, François. *Six femmes peintres*. Paris: Editions du Chene, 1951.
 Mathey discusses Morisot, Gonzalès, Seraphine Louis, Valadon, Blanchard, and Laurencin. In her excellent bibliography Karsilovsky (*see* the periodical section) praises the color reproductions but condemns Mathey's text as "incredibly sexist."

Mazerod, L. *Les femmes célèbres*. 2 vols. Paris, 1960–61.

Miller, Lynn F., and Sally S. Swenson. *Lives and Works: Talks with Women Artists*. Metuchen, New Jersey: Scarecrow Press, 1981.
 Interviews with fifteen women artists.

Miner, Dorothy. *Anastaise and Her Sisters: Women Artists of the Middle Ages*. Baltimore: Walters Art Gallery, 1974.
 This pamphlet is a transcript of a lecture given by Miner in connection with the Walters Art Gallery's 1972 exhibition, "Old Mistresses—Women Artists of the Past." Miner summarizes information available on medieval women illuminators and quotes Christine de Pisan, writing in her *Cité des dames,* ca. 1405,: "With regard to painting at the present time I know of a woman called Anastaise who is so skillful and experienced in painting the borders of manuscripts and the backgrounds of stories that no one can cite a craftsman in the city of Paris, the center of the best illuminators on earth, who in these endeavors surpasses her in any way."

Mitchell, Peter. *Great Flower Painters: Four Centuries of Floral Art*. Woodstock, New York: Overlook Press, 1973.

Moore, Julia Gordon. *History of the Detroit Society of Women Painters and Sculptors, 1903–1953*. Detroit, 1953.

Moutoussamy-Ashe, Jeanne. *Viewfinders: Black Women Photographers*. New York: Dodd, Mead and Company, 1986.
 A fascinating history of a long-neglected area. The author includes

biographies of thirty-four photographers from 1839 to the present and includes numerous reproductions of their work.

Munro, Eleanor. *Originals: American Women Artists.* New York: Simon and Schuster, 1979.

This book grew out of a PBS television series of the same name. It combines biographies and interviews of forty twentieth-century artists and includes a background essay on Mary Cassatt.

Munsterberg, Hugo. *A History of Women Artists.* New York: Clarkson N. Potter, 1975.

This is a survey covering pottery, weaving, paintings, graphics, sculpture, and photography from the prehistoric era to the present day. Although the book has 110 adequate illustrations, it is sorely lacking in footnotes and a bibliography. Munsterberg takes a patronizing, condescending attitude in his treatment of women artists and is frequently contradictory in his assessment of their historical status.

National Cyclopaedia of American Biography. New York: James T. White and Company, 1892–1984. Vol.1–63.

Neilson, Winthrop, and Frances Neilson. *Seven Women: Great Painters.* Philadelphia: Chilton Book Company, 1969.

The Neilsons provide chapters and reproductions on Angelica Kauffman, Vigée-LeBrun, Morisot, Cassatt, Beaux, Laurencin, and O'Keeffe. A valuable feature of the book is an extensive list of the works of each woman on public display and their locations. Otherwise, the book is quite weak. While the information provided is correct, the authors often lapse into the maudlin and into apologies which none of these artists needs. The bibliography is also inferior.

Nemser, Cindy. *Art Talk.* New York: Charles Scribner's Sons, 1975.

Nemser was the editor of the New York-based *Feminist Art Journal.* Here she publishes interviews with several contemporary women artists. Good black-and-white reproductions and a selected bibliography are included for each artist. Nemser's interviews are out of the ordinary in that she explores the lives and attitudes of her subjects as women, in addition to the usual information yielded in this format. Crucial insight is provided into how successful women artists have coped with the problems of a society that considered them housewives with hobbies, into problems of child rearing, and into basic economic survival. Much of Nemser's bibliography has been incorporated into Section II below.

Newhall, Beaumont. *The History of Photography from 1839 to the Present Day.* New York: Museum of Modern Art, 1964.

Nochlin, Linda. *Women, Art and Power.* New York: Harper and Row, 1988.

Nunn, Pamela Garrish, ed. *Canvassing: Recollections by Six Victorian Women Artists.* London: Camden Press, 1986.
Reprints excerpts from books written by six women artists of the Victorian period. The introduction by Nunn explores the problems faced by nineteenth-century women artists.

————. *Victorian Women Artists.* London: The Women's Press, 1987.
A general treatment of women artists in the nineteenth century, the environment in which they worked, and their exhibition opportunities. Nunn includes biographies of several artists, interspersed with critical observations of the period. Color and black-and-white reproductions are included.

Opitz, Glenn B., ed. *Dictionary of American Sculptors.* Poughkeepsie, New York: Apollo, 1984.

————. *Mantel Fielding's Dictionary of American Painters, Sculptors and Engravers.* Poughkeepsie, New York: Apollo, 1986.
Fielding's Dictionary was originally published in 1926. This is one of several revisions, addendums, and expansions published since 1965.

Oulmont, Pierre. *Les femmes peintres du dix-huitième siècle.* Paris, 1928.

Parada y Santin, José. *Las Pintaras Españolas: boceto histórico-biográfico y artístico.* Madrid: Imprint de Asilo de Huerfanos des S. C. de Jesus, 1902.

Parker, Rozsika, and Griselda Pollock, eds. *Framing Feminism: Art and the Women's Movement, 1970–85.* London: Pandora, 1987.
These authors document the transformation of art and artists by feminism in Great Britain. The book consists of a collection of writings drawn from diverse sources in which women artists air their aspirations and construct their theories. The articles are reproduced in fascimile form in order to give a concrete representation of the times, but unfortunately this results in poor-quality reproductions.

————. *Old Mistresses: Women, Art and Ideology.* New York: Pantheon
Books, 1981.
 Parker and Pollock are convinced that art history is made up of
inherited and prejudiced nineteenth-century ideas. This book soundly
documents the truth of that conviction.

Parton, James, et al. *Eminent Women of the Age.* Hartford, Connecticut:
S. M. Betts, 1868.

Pavière, Sydney Herbert. *A Dictionary of Flower, Fruit and Still life
Painters.* 3 vols. Leigh-on-Sea, Essex, 1962–64.

Pearson, Ralph M. *The Modern Renaissance in American Art.* New
York: Harper and Row, 1954.
 Brief sketches of modern U.S. artists, arranged by stylistic category.
Eight of the fifty-four artists profiled are women.

Petersen, Karen, and J. J. Wilson. *Women Artists: Recognition and
Reappraisal, from the Early Middle Ages to the Twentieth Century.*
New York: Harper and Row (Colophon paperback), 1976.
 This work discusses over 250 women and includes many reproduc-
tions. Rather than a strictly scholarly work, it is conceived as a badly
needed supplement to traditional art survey textbooks. The authors
also produce four sorely needed sets of slides: *Women Artists: An
Historical Survey* (early Middle Ages to 1900), 120 slides with notes;
*Women Artists: The Twentieth Century; Women Artists: The Third
World;* and *Women Artists: Images—Themes and Dreams.* The last
three sets each contain eighty slides and include notes. The text and
the four slide sets form a unique educational "first-aid kit"—
invaluable alike to those launching women's studies programs and to
traditionally trained art historians attempting to redress the old
imbalances.

Petteys, Chris. *Dictionary of Women Artists: An International Diction-
ary of Women Artists Born Before 1900.* Boston: G. K. Hall, 1985.

Pevsner, Nikolaus. *Academies of Art, Past and Present.* Cambridge,
1940.

Pilkington, Matthew. *A General Dictionary of Painters.* 2 vols. London:
Thomas McLean, 1824.
 Brief biographical entries that include a number of women artists.

Pliny the Elder. *The Elder Pliny's Chapters on the History of Art.* Chicago: Argonaut Publishers, 1968.
 The translation is by K. Jex-Blacke. Commentary and introduction are by E. Sellers. The preface and bibliography are by Raymond V. Schoder. Guhl, Clement, and Ellet all offer rehashings of the slim data regarding women artists of classical times. Their common source is Pliny, who begins the brief paragraphs allotted to them (pp. 105 and 171) with, "Women too have been painters." He mentions Timarete, Eirene, Kalypso, Aristarete, Iaia, and Olympias.

Poesch, Jessie. *Newcomb Pottery: An Enterprise for Southern Women, 1895–1940.* Exton, Pennsylvania: Schiffer Publishing Co., 1984.
 Fascinating account of pottery produced at Newcomb College in New Orleans. Includes excellent photographs, an explanation of basic marks and dating, an exhibition catalog, and a bibliography.

Poisson, Georges. *La femme dans la peinture française moderne.* Paris: Plon.
 Black-and-white reproductions of Lydia, Laurencin, Valadon, Morisot, Luks, Fini, Cassatt, and Abbema.

Pomeroy, S. B. *Goddesses, Whores, Wives and Slaves: Women in Classical Antiquity.* New York: Schocken, 1975.

Porter, James. *Modern Negro Art.* New York: Arno Press and the New York Times, 1967.

Post, Chandler R. *A History of European and American Sculpture.* New York: Cooper Square, 1969.

Power, Elleen. *Medieval Women.* Cambridge, 1975.
 Edited by M. M. Postan. See especially Chapter 3, "The Working Woman in Town and Country."

Press, Jacques Cattell, ed. *Who's Who in American Art, 1976.* New York: R. R. Bowker Company, 1976.

Proske, Beatrice Gilman. *Brookgreen Gardens Sculpture.* Brookgreen Gardens, South Carolina, 1968.
 A catalog of the sculpture garden founded by Anna Hyatt Huntington. It includes biographies of a number of women sculptors.

Pyke, E. J. *A Biographic Dictionary of Wax Modelers.* Oxford: Clarendon Press, 1973.

Ragg, Laura M. *The Women Artists of Bologna*. London: Methuen and Company, 1907.

Raven, Arlene; Cassandra Langer; and Joanna Frueh, eds. *Feminist Art Criticism: An Anthology*. Ann Arbor: UMI Research Press, 1988.
 A collection of essays written between 1973 and 1989, arranged chronologically to demonstrate a continuous feminist discourse. Most of the essays have been previously published. They include accounts of different female artists and of efforts to formulate a feminist art criticism.

Raynal, Maurice. *Modern French Painters*. Trans. Ralph Roeder. New York: Tudor Publishing Company, 1934.

Redgrave, Richard, and Samuel Redgrave. *A Century of Painters of the English School*. London: Sampson Low, Marston, 1890.

Redgrave, Samuel. *A Dictionary of Artists of the English School from the Middle Ages to the Nineteenth Century*. 1878; reprint, Amsterdam: G. W. Hissink, 1970.

Rodriquez-Prampolini, Ida. *El surrealismo y el arte fantástico de Mexico*. Mexico City: Universidad Nacional Autonoma de Mexico, 1969.

Rogers, Katherine. *The Troublesome Helpmate: A History of Misogyny in Literature*. Seattle: University of Washington Press, 1966.
 Rogers' work is indirectly related to the topic at hand. It provides an engrossingly readable and impeccably documented survey of the attitudes toward women and their abilities, as reflected in English and U.S. literature and in its biblical and classical forebears.

Rosenberg, Jan. *Women's Reflections: The Feminist Film Movement*. Ann Arbor, Michigan: UMI Research Press, 1983.

Rubinstein, Charlotte S. *American Women Artists*. Boston: G. K. Hall and Company, 1982.
 A chronological discussion beginning with Native American artists and concluding with the impact of the Feminist Art Movement in the 1970's and 1980's. It includes a list of women exhibitors at the Chicago World's Fair of 1933 and the New York World's Fair of 1939 and other helpful lists of exhibitions of women's art. An extensive bibliography is also provided.

Ruddick, Sarah, and Pamela Daniels, eds. *Working It Out: Twenty-three Women Writers, Artists, Scientists and Scholars Talk About Their Lives and Work.* New York: Pantheon, 1977.

Foreword by Adrienne Rich. See especially Miriam Schapiro's "Notes from a Conversation on Art, Feminism and Work."

Russo, Alexander, *Profiles on Women Artists.* Frederick, Maryland: University Publications of America, 1985.

A series of fifteen interviews with contemporary artists, inspired by the author's experience of teaching at a women's college. Accompanying each interview is a biographical fact sheet, list of selected exhibitions and collections, and a bibliography.

Sachs, Hannelore, *The Renaissance Woman.* New York: McGraw-Hill Book Company, 1971.

This book was translated from the German by Marianne Herzfeld and revised by D. Talbot Rice. It is an excellent cultural and sociological survey of the status of women in Renaissance society. The chapter entitled "The Practice of Art" (pp. 36–40) discusses the situation of women involved in the arts, including literature. The phenomenon of women artists learning from their fathers is noted. The book is beautifully illustrated, and large reproductions by Sofonisba Anguissola, Caterina van Hemessen, and Properzia de'Rossi are included.

Schapiro, Miriam, ed. *Anonymous Was a Woman: Documentation of the Women's Art Festival and a Collection of Letters to Young Women Artists.* Valencia, California: Feminist Art Program, California Institute of the Arts, 1974.

The title is derived from Virginia Woolf's famous line in *A Room of One's Own,* cited in this section. This is a product of the Feminist Art Program, now functioning independently as the Feminist Studio Workshop. More can be learned about it in Chicago's *Through the Flower* and Spear's *Women's Studies,* also cited in this section. A basic premise is the necessity of separatism from male teachers and students because feminine experience is devalued rather than affirmed in traditional settings. In this it is similar to consciousness-raising. The section of letters to young women artists (by older women artists) is inspired by a general lack of role models for female art students.

———, ed. *Art: A Woman's Sensibility.* La Jolla, California: Lawrence McGilbery, 1975.

At the request of the Feminist Art Program, California Institute of the Arts, seventy-six contemporary women artists each submitted one

photograph of her work, one photograph of herself, and a statement
about the intentions of her art.

Seibert, Ilse. *Women in the Ancient Near East.* New York: Abner Schram
Enterprises, 1976.

*Sex Differentials in Art Exhibition Reviews: A Statistical Study and
Selected Press Reaction.* Los Angeles: Tamarind Lithography Work-
shop, March 1972.
 This landmark study, prepared by Betty Fiske, Rosalie Braeutigam,
and June Wayne, documented the vast discrimination against women
artists in the reviews of their shows by the art press and other media.

Sherman, Claire Richter, and Adele M. Holcomb, eds. *Women as
Interpreters of the Visual Arts, 1820–1979.* Westport, Connecticut:
Greenwood Press, 1981.
 This is a collection of biographical essays on women critics, art
historians, educators, curators, and museum administrators. An essay
by the editors provides a historical context.

Short, Ernest. *The Painter in History.* London: Hollis and Carter, 1948.
 In this lengthy review of painting history, two brief pages summa-
rize the entire contribution of women. The women mentioned by Short
tend to be minor, forgotten English artists.

Sicherman, Barbara; Carol Hurd Green; et al., eds. *Notable American
Women: The Modern Period.* Cambridge, Massachusetts: Belknap
Press of Harvard University Press, 1980.
 A biographical dictionary that demonstrates women's achieve-
ments in various areas, including the arts. This volume includes
women who died between 1951 and 1975.

Singer, C., et al., eds. *A History of Technology.* Oxford, 1957.
 Ann Sutherland Harris cites plate 16, which depicts a woman
painting decoration on a Grecian vase in a pottery workshop, as
probably being the oldest image of a woman artist at work.

Skiles, Jacqueline. *The Women Artists Movement.* Pittsburgh, Pennsyl-
vania: Know.
 This was originally delivered as a paper before the American
Sociological Association Annual Meeting on August 18, 1972.

————, and Janet McDevitt, eds. *A Documentary Herstory of Women
Artists in Revolution.* Pittsburgh, Pennsylvania: Know, 1973.

The early 1970's saw increasing activism on the part of women artists. A focal point for that activity was the W.A.R. (Women Artists in Revolution) confrontation with New York galleries and museums. This publication is a fascinating compilation of position papers, posters, correspondence, and magazine and newspaper articles that graphically outline that struggle.

Slatkin, Wendy. *Women Artists in History.* Englewood Cliffs, New Jersey: Prentice-Hall, 1985.

This overview of women artists throughout recorded history was envisioned primarily as a supplemental text for college art history survey courses in which the standard texts fail to incorporate the contributions of women artists.

Snyder-Ott, Joelynn. *Women and Creativity.* Millbrae, California: Les Femmes Publishing, 1978.

Interesting discussion of female imagery, drawing on the author's experiences as an artist and teacher.

Sonnenfeld, Amanda. *Deutsche Frauengestalten: Zehn Leben-beschreibungen nervorrangender Frauen für die Mädchenwelt.* Stuttgart, 1910.

Sparrow, Walter Shaw. *Women Painters of the World, from the Time of Caterina Vigri, 1413–1463, to Rosa Bonheur and the Present Day.* London: Hodder and Stoughton, 1905; New York 1909; reprint, New York: Hacker Art Books, 1976.

This book presents much important and obscure information about historical women artists. The entire index is reprinted in the Women's History Research Center's publication, *Female Artists Past and Present (see* below). However, Sparrow damns women from the onset with a "nursery nature." Schwartz (*see* the periodical section) cites Sparrow's book as one of a species that arose after 1850 in which women artists were revived in order to be attacked and "listed as second rate, unimportant and amateurs who should be directed and advised." Included in the book are essays by Sparrow on women painters in Italy, England, and the United States. Other essays are "Modern British Women Painters," by Ralpha Peacock; "Women Painters in Belgium and Holland," by N. Jany; "Women Painters in Germany, Austria, Russia, Switzerland and Spain," by Wilhelm Scholerman; and "Some Finnish Women Painters," by Helena Westermarck.

Stein, Judith E. *The Iconography of Sappho: 1775–1875.* Ph.D. dissertation, University of Pennsylvania, 1981.

Stephen, Leslie, and Sidney Lee, eds. *The Dictionary of National Biography.* London: Oxford University Press, 1908.

Sterling, Charles, *Still Life Painting from Antiquity to the Present Time.* New York: Universe Books, 1959.

Strutt, Joseph. *A Biographical Dictionary, Containing an Historical Account of All the Engravers.* 2 vols. London: J. Davis, 1785–1786; reprint, Geneva: Minkoff Reprint, 1972.

Sullerot, Evelyne. *Histoire et sociologie du travail féminin.* Paris, 1968.

Taft, Lorado. *The History of American Sculpture.* New York: Macmillan Company, 1930.
 Includes a chapter on women sculptors.

Thieme, Ulric, and Felix Becker, eds. *Allgemeines Lexikon der bildenden Künstler von der Antike bis zur Gegenwart.* 37 vols. 1907–1950.
 The short biographical entries often include some bibliographic data. A surprising number of women artists are included. Six supplementary volumes on twentieth-century artists are by Vollmer.

Thorp, Margaret Farrand. *The Literary Sculptors.* Durham, North Carolina: Duke University Press, 1965.
 Includes a chapter on the "white, marmorean flock," American women sculptors working in Rome in the nineteenth century.

Tinling, Marion. *Women Remembered: A Guide to Landmarks on Women's History in the United States.* Westport, Connecticut: Greenwood Press, 1986.
 Organized by state, the focus of this work is on women who have been commemorated by the preservation of their homes; through the erection of monuments, the naming of parks, streets, and schools; or recognized by historical markers. An appendix categorizes women by fields of endeavor with women artists, architects, sculptors, collectors, and patrons liberally included.

Torelli, Vieri. *Pitricci e scultrici Italiane d'Oggi.* Rome: Flammenghi, 1953.
 Karsilovsky (*see* periodical section below) says, regarding the

selections on Italian women painters and sculptors, that this is a tasteful publishing product but essentially useless.

Trapp, Kenneth R. *The Cincinnati Ceramic Movement and Rockwood Pottery, 1876–1916.* Ph.D. dissertation, University of Illinois, Urbana.
　　See also Macht, *The Ladies, God Bless 'Em,* in the catalog section below.

Tucker, Anne, ed. *The Woman's Eye.* New York: Knopf, 1973.
　　A survey of important women photographers, including Kasebier, Arbus, Johnston, Bourke-White, Lange, Abbott, Morgan, Wells, Dater, and Neetles. Provides large black-and-white reproductions.

Tuckerman, Henry T. *Book of the Artists.* 1867; facsimile edition, New York: James F. Carr Publisher, 1966.
　　Mentions several women sculptors.

Tufts, Eleanor. *American Women Artists, Past and Present: A Selected Bibliographic Guide.* New York: Garland Publishing, 1984.

―――. *Our Hidden Heritage: Five Centuries of Women Artists.* New York: Paddington Press, Two Continents Publishing Group, 1974.
　　This is a beautiful, scholarly, and useful book on women artists. Each chapter discusses a woman artist and includes a portrait, several good black-and-white reproductions, and an extensive bibliography, helpful in the early stages of this volume.

Urquidi, José Macedonio. *Bolivianas ilustres: heroínas escritoras, artistas, estudios, biográficos y críticos.* La Paz: Escuela Tipográfica Salesiana, 1918.

Vachon, Marius. *La femme dans l'art: les protectrices des arts, les femmes artistes.* 2 vols. Paris, 1893.

Vasari, Georgio. *Lives of Italian Painters.* Edited and prefaced by Havelock Ellis. Vol. 4. London: Walter Scott.

―――. *Lives of the Most Eminent Painters, Sculptors and Architects.* Translated by Guston Devere. Vol. 10. London: Phillip Lee Warm, 1912–1915.

Vequaud, Yves. *The Women Painters of Mithila.* New York: Thames and Hudson and W. W. Norton and Co., 1977.

Mithila is a province in northern India in which all the women are painters. Vequaud "discovered" them in 1970, and this book provides over eighty illustrations of their work, most in color.

Viallet, Bice. *Gil autoritratti femminili delle R. R. Galleria degli Uffizi.* Rome, ca. 1924.

Vicinus, Martha, ed. *Suffer and Be Still: Women in the Victorian Age.* Bloomington: Indiana University Press, 1972.
Chapter 4, "Marriage, Redundancy or Sin: The Painter's View of Women in the First Twenty-Five Years of Victoria's Reign" (pp. 45–76), is of particular interest. Other chapters outline the status of women in other areas of Victorian society.

Wald, Carol. *Myth America: Picturing Women, 1865–1945.* New York: Pantheon Books, 1975.

Walpole, Horace. *Anecdotes of Painting in England.* Vol. 3. London: Henry G. Bohn, 1849.
Several women who worked in England are discussed in this chronological examination which emphasizes royal patronage.

Watson-Jones, Virginia. *Contemporary American Women Sculptors.* Phoenix: Oryx Press, 1986.
Brief summaries include education, training, exhibitions, awards, a selected bibliography, and a statement by the artist.

Weese, Maria, and Doris Wild. *Die schweizer Frau in Kunstgewerbe und bildender Kunst.* Zurich, 1928.

Wehle, Harry B. *American Miniatures, 1730–1850.* Garden City, New York: Doubleday, Page and Company, 1927.
Includes brief accounts of several women miniaturists.

Weimann, Jeanne Madeline. *The Fair Women.* Chicago: Academy Press, 1981.
Detailed account of the Woman's Building at the 1893 World's Columbian Exposition at Chicago. Profusely illustrated.

Wiesenfeld, Cheryl, et al., eds. *Women See Women.* New York: Thomas Y. Crowell Company, 1975.
Photographic anthology and short biographies of several women photographers. The introductory essay is by Annie Gottlieb.

Wilding, Faith. *By Our Hands.* Santa Monica, California: Double X, 1977.
A documentation of the women artist's movement in southern California from 1970 to 1976.

Willard, Frances, and Mary A. Livermore, eds. *American Women.* New York: Mast, Crowell and Kirkpatrick, 1897; reprint, Detroit: Gale Publishing Company, 1973.
This was originally published under the title *A Woman of the Century.* It contains 1500 biographies and 1400 portraits in two volumes. An index classifies entries by occupation or interest. Several women artists are included.

Williams, Ora. *American Black Women in the Arts and Social Sciences: A Bibliographic Survey.* Metuchen, New Jersey: Scarecrow Press, 1973.

Williams, Val. *Women Photographers: The Other Observers, 1900 to the Present.* London: Virago Press, 1986.
A history of women in photography in Great Britain. It includes a discussion of portrait and documentary photographers. A selected bibliography and many black-and-white reproductions are included.

Wolff-Arndt, Phillippine. *Wir frauen von einst: Erinnerungen einer Malerin.* Munich, 1929.

Women and Film: A Resource Handbook. Washington, D.C.: Project on the Status and Education of Women, Association of American Colleges (1818 R Street NW, 20009).

Women as Artists and Women in the Arts: A Bibliography of Art Exhibition Catalogues. Boston: World Wide Books, 1978.
An extraordinary bibliography of exhibition catalogs featuring women, both contemporary and historical. Offerings are genuinely "world wide." World Wide Books (37–39 Antwerp Street, Boston 02135) also has a quarterly bulletin in which catalogs are described and reviewed.

Women's Films in Print. San Francisco: Booklegger Press, 1976.
Annotated guide to 800 16mm films by women.

Women's Work: American Art, 1974. Stamford, Connecticut: Sandak, 1974.
A set of seventy-six glass-mounted slides from the exhibition of the

same name held at the Philadelphia Civic Center Museum, Spring, 1974. The show was organized by ''Philadelphia Focuses on Women in the Visual Arts.'' Judith Stein provides the commentary that accompanies the set. From the listing it appears to be a fairly good cross-section of contemporary women artists of both painting and sculpture.

Wood, Christopher. *The Dictionary of Victorian Painters,* 2nd edition. Woodbridge, Suffolk: Antique Collectors Club, 1978.

Woolf, Virginia. *A Room of One's Own.* New York: Harcourt, Brace and World, 1929.
 This is actually a long essay in which is found the famous line, ''Indeed, I would venture to guess that anon, who wrote so many poems without signing them, was often a woman.'' Woolf explores the nature of the creative process and the peculiar historical position of women in relation to it. Though she uses literature as her example of creativity, her analysis applies equally well to other creative fields.

Yeldham, Charlotte. *Women Artists in Nineteenth-Century France and England.* 2 vols. New York: Garland Publishing, 1984.
 A comprehensive discussion of the art education, exhibition opportunities, and favored subject manner. Included are membership lists of academies and societies, statistical analysis of exhibitions, lists of works classified by themes, and almost two hundred black-and-white illustrations. It is a major compendium of useful information about nineteenth-century women artists. Confusingly, what the author arranged as a four-volume work is listed and bound as two volumes, and this makes it difficult to use. An index would add greatly to the usefulness of this rich lode of material.

Zinserling, Verena. *Women in Greece and Rome.* New York: Schram, 1973.
 The limited and circumscribed sphere of ancient women is described.

PERIODICALS

Alf, Martha. "My Interest in Women Artists of the Past." *Womanspace Journal.* 1(April–May):15–16.

Alf is interested in the life-styles and conditions of historical women artists. She observes the prevalence of daughters of artists and their variety of marital experience.

Alloway, Lawrence. "Women's Art in the Seventies." *Art in America.* 64(May–June 1976):64–72.

An examination of the history, results, and problems of the women artists' movement.

Art Education (November 1975).

Issue edited by Bette Acuff. Scholarly articles on women in art and art education, and sexual stereotyping. Available from the National Art Education Association, 1916 Association Drive, Reston, Virginia.

Art Journal. 35(Summer 1976).

Entire issue deals with women in art. Most of the articles are cited individually below. The cover is especially delightful, featuring a sepia reproduction of an old photograph of Neoclassical sculptor Harriet Hosmer, surrounded by some twenty-four of her male assistants, circa 1860.

Art Magazine. 5(Fall 1973).

Published in Toronto, this is a special issue devoted to women in art. Several of the articles are cited below.

Art News. 69(January 1971).

The majority of this issue is devoted to women in the arts. Several of the articles are cited below. Good color plates and other reproductions are included. A number of contemporary women artists contribute their response to Nochlin's question, "Why Have There Been No Great Women Artists?" Most of the text is reprinted in Hess and

Baker's *Art and Sexual Politics: Women's Liberation, Women Artists and Art History* (cited in book section above).

Artes Visuales (January–March 1976).

This issue of the periodical, published by the Museo de Art Moderno in Mexico City, has articles on women, art, and femininity by contemporary Mexican women artists. Also included are articles by Charlotte Moser, Lippard, Chicago, and Raven.

Baker, Elizabeth C. "Sexual Art-Politics." *Art News.* 69(January 1971):47–48, 60–62.

Baker deals with the discrimination against women artists, both as students and as faculty in the university setting. The article is reprinted in Hess and Baker's *Art and Sexual Politics.*

Baldwin, Carl. "The Predestined Delicate Hand: Some Second Empire Definitions of Women's Role in Art and Indusrtry." *Feminist Art Journal.* 2(Winter 1973–1974):14–15.

Baldwin considers French society between the years 1860 and 1863. He states that women were considered to possess talents only of patience and dexterity. He speaks of women being "gently persuaded or violently hounded" out of the profession of art. He cites sources that praise women only in terms of their skill at reproduction, visually or biologically.

Beatts, Anne, and Lowena Hymovitch. "Paintings You Never Studied in Art 101." *Ms.* 4(October 1975):80.

An eloquest reply to those who do not understand why some women today are less than happy with the ways women, especially the female nude, have been treated by Western painters. Their reply is in the form of a color reproduction of what at first glance appears to be Manet's *Le déjeuner sur l'herbe* captioned with a brief commentary on its significance to modern art. The second glance reveals it as a superb parody—the sexes have been reversed. Two fasionably clad young women hold a conversation in the company of two quite unidealized male nudes. The commentary continues the parody.

Berliner, David. "Women Artists Today." *Cosmopolitan.* 175(October 1973):46–53.

Berman, Avis. "A Decade of Progress, but Could a Female Chardin Make a Living?" *Art News.* 79(October 1980):73–93.

Interviews with several women artists with the consensus that the

position of women in the art world has improved although barriers remain.

Boyers, Robert, and Maxine Bernstein. "Women, the Arts, and the Politics of Culture: An Interview with Susan Sontag." *Salmagundi.* Nos. 31–32(Fall 1975–Winter 1976):29–48.

Braden, S. "Politics in Art." *Studio.* 187(June 1974):272–274.

Braderman, Joan. "Report: The First Festival of Women's Films." *Artforum* (September 1972).

Bretteville, Sheila Levrant de. "A Reexamination of Some Aspects of the Design Arts from the Perspective of a Woman Designer." *Arts in Society.* 11 (Spring–Summer 1974):115–123.
 The author describes common depictions of women and men in advertising art as a continuation of their stereotyped roles and behaviors and shows how this is capitalized upon. Discusses ways to develop images of alternative values, drawing on her own experiences as a designer for examples. She speculates on the possibilities of design in disseminating feminism.

Broderick, Herbert. "Solomon and Sheba Revisited." *Gesta.* 16(1977):45–48.

Brodsky, Judith K. "Some Notes on Women Printmakers." *Art Journal.* 35(Summer 1976):374–377.
 Excellent historical survey of women printmakers.

———. "The Women's Caucus for Art." *Women's Studies Newsletter.* 5(Winter–Spring 1977):13–15.

Brooks, Valerie. "The Wives of the Artists." *Print.* 29(March–April 1975):44–49, 86.
 Three women painters and illustrators discuss the difficulties in defining their own professional identities while being overshadowed by their husbands' careers.

Broude, Norma. "Degas' 'Misogyny.'" *Art Bulletin.* 59(March 1977):95–107.

———, and Mary D. Garrard. "Discussion: An Exchange on the Feminist Critique of Art History." *Art Bulletin.* 71(March 1989):124–126.

A response to the Gouma-Peterson and Mathews "State of Research" presentation in the *Art Bulletin* of September 1987. Gouma-Peterson and Mathews respond to Broude and Garrard's comments in the same issue, pp. 126–127. These two excellent articles and the response demonstrate the ongoing dialogue in constructing an art history that treats fairly the role of women artists.

Brumer, Miriam. "Organic Image = Women's Image?" *Feminist Art Journal.* 2(Spring 1973):12–13.
 An interesting argument against curved organic shapes being seen as "inner-core imagery" of women related to the womb and sexuality.

Buckley, Cheryl. "Women Designers in the English Pottery Industry, 1919–1939." *Woman's Art Journal.* 5(Fall 1984–Winter 1985):11–15.
 Buckley explains the reasons for acceptance of women as designers in the pottery industry. She also provides a brief discussion of several individual designers.

Buettner, Stewart. "Images of Modern Motherhood in the Art of Morisot, Cassatt, Modersohn-Becker and Kollwitz." *Woman's Art Journal.* 7(Fall 1986–Winter 1987):14–21.
 Buettner shows how these artists reflect the social mores of their particular worlds.

Bumpus, Judy. "What a Pity They Aren't Men." *Art and Artists.* 201(June 1983):8–10.
 The title is a quote by Manet referring to the Morisot sisters' painting. The article is a brief summary of the work of women Impressionists.

Burnham, Jack. "Patriarchal Tendencies Within the Feminist Art Movement." *The New Art Examiner.* 4(Summer 1977):1, 8–9, 11.

Bye, Arthur E. "Women and the World of Art." *Arts and Decoration.* 10(1918):86–87.

Callen, Anthea. "Sexual Division of Labor in the Arts and Crafts Movement." *Woman's Art Journal.* 5(Fall 1984–Winter 1985):1–6.
 A Marxist-feminist analysis of the Arts and Crafts movement. The bourgeois idea of domesticity was encouraged among poor women through craft revival schemes.

Carpenter, Edward. "Statement: Designing Women." *Industrial Design.* 11(June 1964):72–74.

An informal survey on women in design which begins by referring to "girls" who graduate from industrial design courses. Discusses the lack of awareness of the field among students and the fear of women students about technical aspects. Mentions the large number of women working for General Motors, but stresses their main concern is car interiors, where they feel "more comfortable."

Carr, Annmarie Weyl. "Women Artists in the Middle Ages." *Feminist Art Journal.* 5(Spring 1976):5–9.

Excellent summary of the state of research on women artists who worked from around A.D. 800 to the fifteenth century. An extensive bibliography and several reproductions are included.

Chadwick, Whitney. "Eros or Thanatos—The Surrealist Cult of Love Reexamined." *Artforum.* 14(November 1975):45–56.

———. "The Muse as Artist: Women in the Surrealist Movement." *Art in America.* 73(July 1985):120–129.

Excellent discussion of the role of women artists in the International Surrealist exhibitions of the 1930's and 1940's and their diminished presence in recent exhibitions and histories of the period. Discusses imagery used by female Surrealists—such as disguises, masquerades, and images of maternal experience. Sees the imagery as often defining women in terms of man's desire.

Chauda, Jagdish J. "The Narrative Paintings of India's Jitwarpuri Women." *Woman's Art Journal.* 11(Spring–Summer 1990):26–28.

Chicago, Judy, and Miriam Schapiro. "A Feminist Art Program." *Art Journal.* 31(Fall 1971):48–49.

A brief explanation of the California Institute of Arts feminist program. Includes quotations by both authors from *Everywoman* magazine.

Comini, Alessandra. "Art History, Revisionism, and Some Holy Cows." *Arts.* 54(June 1980):96–100.

This was originally presented as the convocation address at the College Art Association's annual meeting in New Orleans in February 1980. Comini ponders the problems of overcompensation for previous neglect in the study of women artists, sensing that separatism rather than true revisionism could be the result. Comini's thoughts are well

documented with numerous small, thought-provoking, black-and-white illustrations.

———. "State of the Field, 1980: The Women Artists of German Expressionism." *Arts*. 55(November 1980):147–153.
Discusses the puzzling omission of German women Expressionists in current Expressionist exhibitions.

Corning, Leonard J. "Women Artists of the Olden Times." *The Manhattan Magazine*. 4(1884):215.

Dijkstra, Bram. "The Androgyne in Nineteenth-Century Art and Literature." *Comparative Literature*. 26(Winter 1974):62–73.

Duncan, Carol. "Virility and Domination in Early Twentieth Century Vanguard Painting." *Artforum*. 12(Deember 1973):30–39.
This is a good example of how a feminist analysis can offer valuable new insights and interpretations of art. Illustrations and bibliography are included. The degree to which "gentlemen wilt protest too much" is seen in a reply (and a rejoinder) in the letter column of the following issue (March 1974, p. 9). Duncan explores primarily the aggressive male sexuality, in both imagery and style, of the Fauves and the Brucke artists. She briefly discusses how this imagery of women was an especially pernicious obstacle for women artists.

Duro, Paul. "The 'Desmoiselles à Copier' in the Second Empire." *Woman's Art Journal*. 7(Spring–Summer 1986):1–7.
Discussion of the French government's commissioning of copies of art works between 1851 and 1870 and the nineteenth-century perception of copying as an activity dominated by women.

Edgerton, Giles. "Is There a Sex Distinction in Art? The Attitude of the Critic Toward Women's Exhibits." *Craftsman*. 14(1908):238–251.

Elderkin, Kate McK. "The Contribution of Women to Ornament in Antiquity." *Classical Studies Presented to Edward Capps*. Princeton, 1936.

Eva. "Women Artists: What History Has Done with Them." *Liberation News Service* (December 2, 1972).

Everywoman (May 7, 1971).
A special issue devoted to feminist art, edited by Judy Chicago.

Farnsworth, Paul."The Effects of Role-Taking on Artistic Achievement." *Journal of Aesthetics and Art Criticism.* 18(March 1960):345–349.

Results of a 1957 study seeking data on sex roles in the arts, which shows the general thinking that creativity is a masculine trait and passive artistic activities are feminine in nature. Women who consider creativity a masculine role therefore find it difficult to sustain creative effort.

Feminist Art Journal.

A quarterly begun in the spring of 1972 that ceased publication with Volume 6 in the summer of 1977. This high-quality, pioneer journal consistently combined controversy with scholarship.

Film Library Quarterly (Winter 1971–1972).

A special issue on women and film.

Fleisher, Pat. "Love or Art." *Art Magazine* (Fall 1973).

A discussion of the conflict that most women artists face: unresolvable claims upon their energies and time by their art and their loved ones. This is a dilemma which society does not generally impose upon male artists.

Frankenstein, Alfred. "Toward a Complete History of Art: Women Artists, 1550–1950." *Art in America.* 65(March–April 1977):66–69.

A review of the Harris and Nochlin show. Three glorious color reproductions are included.

"French Women Painters: Exhibition." *Cahiers d'art.* 7(January 1926):18.

Friedman, Joan. "Every Lady Her Own Drawing Master." *Apollo.* 105(April 1977):262–267.

Gabhart, Ann, and Broun, Elizabeth. "Old Mistresses: Women Artists of the Past." *Walters Art Gallery Bulletin.* 24(April 1972):1–8.

This article discusses an exhibition of women artists presented by the Walters Art Gallery in April 1972. It is an excellent introduction to the entire topic of historical women artists and their problems. Even the title touches on the sexism of our culture as expressed in language. The authors demonstrate that however great the social obstacles and the personal price, numbers of women have successfully persevered to produce "works of real merit." They also touch upon the irony of

misattributions and the profound conflicts involved in assuming the male role of artist.

Gallichan, Mrs. C. G. (Hartley). "The Paris Club of International Women Artists." *Art Journal* (1900):282–284.

Garb, Tamar. "L'art feminin: The Formation of a Critical Category in Late Nineteenth-Century France." *Art History.* 12(March 1989):39–65.
 Discussion of the concept of "feminine art."

————. "Revising the Revisionists: The Formulation of the Union des Femmes Peintres et Sculpteurs." *Art Journal.* 48(Spring 1989):63–70.
 Garb relates the formation of this important group to the economic and social changes in the Paris art world.

Gardner, Albert Ten Eyck. "A Century of Women." *Metropolitan Museum of Art Bulletin.* 7(December 1948):110–118.
 Gardner writes on the centennial anniversary of the Seneca Falls Convention of 1848, which marked the beginning of organized feminism in the United States. He provides an excellent survey of the struggle of women artists to compete in the mainstream of U.S. art and discusses the mural projects for the Chicago World's Fair Woman's Building of 1893. But even he ends on a note of sexism in asserting that a woman's greatest contribution to the world of art is to be the mother of a genius (presumably male).

Garrard, Mary. " 'Of Men, Women and Art': Some Historical Reflections." *Art Journal.* 35(Summer 1976):324–329.
 An analysis of the art world as suffering from the same stereotypical feminity that women have been subjected to.

Gates, Eugene. "The Female Voice: Sexual Aesthetics Revisited." *Journal of Aesthetic Education.* 22(Winter 1988):59–68.
 Gates reviews the myth of woman's inferior creative ability. He then explores the idea of a specific female creative manifestation, or "female voice," concluding there is no evidence to support this concept.

Glueck, Grace. "Making Cultural Institutions More Responsive to Social Needs." *Arts in Society.* 11(Spring–Summer 1974):49–54.
 One of several articles in a special issue called "Women and the Arts." Glueck summarizes the innovations being tried by museums

(often under pressure) to make their programs more relevant to the community through outreach branches and ethnic and women's exhibitions. She discusses the possibilities of alternative institutions and change coming from within existing institutions through pressure from employees.

Goldin, Amy. "American Art History Has Been Called Elitist, Racist, and Sexist. The Charges Stick." *Art News*. 74(April 1975):48–51.

Goldin launches wholesale and across-the-board charges against U.S. art history in a short editorial-style essay that is unfortunately more witty than soundly substantiated. The timely heresy she speaks deserves more documentation.

Goldman, Shifra M. "Six Women Artists of Mexico." *Woman's Art Journal*. 3(Fall 1982–Winter 1983):1–9.

Excellent summary of the status of women artists in twentieth-century Mexico. Lists activities that resulted from the First World Conference for International Women's Year. Goldman summarizes the careers of six contemporary artists, based on interviews.

Goodman, Helen. "The Plastic Club." *Arts*. 59(March 1985):100–103.

An account of the oldest art club for women in continuous existence in the United States. The Plastic Club was founded in Philadelphia in 1897.

———. "Women Illustrators of the Golden Age of American Illustration." *Woman's Art Journal*. 8(Spring–Summer 1987):13–22.

Discussion of women illustrators working between 1880 and 1914. Biographies of six women, out of the estimated eighty actively working during this period, are summarized. Black-and-white reproductions are included.

Goulinat, J. G. "Les femmes peintres au XVIIIe siècle." *L'art et les artistes*. 13(June 1926):289–294.

A review of an important exhibit which features several French women painters.

Gouma-Peterson, Thalia, and Patricia Mathews. "The Feminist Critique of Art History." *Art Bulletin*. 69(September 1987):326–357.

This article contains an excellent review of the past fifteen years of writing about women in art and the history of the women artists movement. The authors lament what they see as the uncritical acceptance of traditional male historical structures, especially by U.S.

art historians. They argue for a new historical construct, free from traditional male historical and value structures.

Graham, Julie. "American Women Artists' Groups, 1867–1930." *Woman's Art Journal.* 1(Spring–Summer 1980):7–12.
 Graham discusses historical organizations of women artists and compares them with their modern counterparts that grew out of the women's movement.

Greene, Alice. "The Girl-Student in Paris." *Magazine of Art.* 6(1883):286–287.

Grier, Barbara, and Coletta Reid, eds. *The Lavender Herring: Lesbian Essays from the Ladder.* Baltimore: Diana Press, 1976. Pp. 284–357.
 This includes a section entitled "The Lesbian Image in Art," consisting of eight essays written by Sarah Whitworth.

Hackney, L. W. "Chinese Women Painters." *International Studio.* 78(1923):74–77.

Hagen, Luise. "Lady Artists in Germany." *International Studio.* 4(1898):91–99.
 Hagen discusses the work of two women, Bertha Wegmann and Jeanna Bauck, with good black-and-white accompanying reproductions. Unfortunately, this quite complimentary discussion of their work begins with a great load of vituperation for the work of other, unnamed, German women artists.

Hardenburgh, Linn, and Susan Duchon. "In Retrospect—The Midwest Women's Artists' Conference." *Art Journal.* 35(Summer 1976):386–388.

Harper, Paula. "Suffrage Posters." *Spare Rib.* No. 41(November 1975):9–13.
 The English suffrage movement was far more militant and flamboyant generally than its U.S. counterpart.

Harris, Anne Sutherland. "The Second Sex in Academe (Fine Arts Division)." *Art in America.* 60(May 1972):18–19.
 A review, with statistics, of the status of women in studio and art history departments in four-year colleges, universities, and museums.

———. "Women in College Art Departments and Museums." *Art Journal.* 32(Summer 1973):417–419.
 This contains a bibliography and statistics.

Harrison, Margaret. "Notes on Feminist Art in Britain, 1970–77." *Studio International.* 193(May–June 1977).

Haskell, Molly. "As the Lens Turns: Women Photograph Men." *Ms.* 6(September 1977):31–34.
 An adaptation of the introduction Haskell wrote for Danielle Hayes' book, *Women Photograph Men,* listed in the book section above. She discusses the fundamentally different views the sexes have taken of one another.

Havice, Christine. "The Artist in Her Own Words." *Woman's Art Journal.* 2(Fall–Winter 1982):107.
 A brief examination of the published letters of eight women artists.

————. "In a Class by Herself: Nineteenth-Century Images of the Woman Artist as Student." *Woman's Art Journal.* 2(Spring–Summer 1981):35–40.
 Havice discusses images of the woman art student in the atelier.

Helson, Ravenna. "Inner Reality of Women." *Arts in Society.* 11(Spring–Summer 1974):25–36.

Henrotin, Ellen. "An Outsider's View of the Woman's Exhibit." *Cosmopolitan.* 15(September 1893):560–566.
 Inventories the art contained in the Woman's Building of the Columbian Exposition with several reproductions. Also mentions other aspects of the building, such as the scientific department, nursing section, and model kitchen.

Henshaw, Richard. "Women Directors: 160 Filmographies." *Film Comment.* (November–December 1972).

Heresies: A Feminist Publication on Art and Politics. 1(January 1977).
 This first issue included the following articles: Eva Cockcroft, "Women in the Community Mural Movement"; Harmony Hannond, "Feminist Abstract Art—A Political Viewpoint"; and Lucy Lippard, "The Pink Glass Swan: Upward and Downward Mobility in the Art World." A selected bibliography on feminism, art, and politics closes the issue.

Hess, Thomas B. "Editorial: Is Women's Lib Medieval?" *Art News.* 69(January 1971):49; reprinted in Hess and Baker, *Art and Sexual Politics: Women's Liberation, Women Artists and Art History,* under the title, "Great Women Artists."

Here Hess chivalrously declares in rebuttal to Linda Nochlin that there have been great women artists.

Hillman, James. "First Adam, Then Eve: Fantasies of Female Inferiority in Changing Consciousness." *Art International.* 14(September 1970):30–43.

Hillman deals with one of the most difficult and crucial issues relating to the status of women, that of their "unreal" status as reflected in myth, literature, the imagination, and even science. This may seem rather far afield for this bibliography, but unconscious attitudes about the nature of women, held by both sexes, have a profound effect on the images a society produces. More simply, it is very hard to take yourself seriously when nobody else does.

Holder, Maryse. "Another Cuntree: At Last, A Mainstream Female Art Movement." *Off Our Backs.* 11(September 1973):11–17.

A good survey article focusing on female imagery and erotic content.

Holland, Clife. "Lady Art Student's Life in Paris." *International Studio.* 21(1904):225–233.

Holland covers much the same ground as Alcott's *Study Art Abroad,* cited in the book section above.

Holmes, C. J. "Women as Painters." *The Dome.* 3(April–June–July 1899).

The Dome, a London periodical, lists twenty-six historical women artists but observes that while women may be observant, tasteful, and teachable, they are not creative.

Hoppin, Martha J. "Women Artists in Boston, 1870–1900: The Pupils of William Morris Hunt." *American Art Journal.* 13(Winter 1981):17–46.

Hoppin identifies twenty women artists who studied with Hunt, beginning ca. 1870. Illustrated with black-and-white reproductions.

Ingelman, Ingrid. "Women Artists in Sweden: A Two-Front Struggle." *Woman's Art Journal.* 5(Spring–Summer 1984):1–7.

Discussion of the internal and external resistance Swedish women artists have confronted. Accompanied by several black-and-white reproductions.

Iskin, Ruth. "Sexual Imagery in Art—Male and Female." *Womanspace Journal.* 1(Summer 1973).

Janeway, Elizabeth. "Images of Women." *Arts in Society.* 11(Spring–Summer 1974):9–18.

John, Augustus. "The Woman Artist." *Vogue.* 72(October 27, 1928):76–77, 112, 116.

This is a truly classic example of the standard slander regarding women artists. John begins typically enough by asserting his position as an ally. Angelica Kauffman and Rosa Bonheur he calls "energetic but empty," blaming this on their painting like men and rejecting their "natural feminine grace." He does allow that when a woman paints avowedly as a woman the case is different, but of the several women he cites as examples, the only one known today is Marie Laurencin, whom he does not consider successful. The delicious irony of Augustus John's position is that he was then a very successful artist and president of the Royal Academy while his own sister, Gwendolyn John—with at least equal talent, the same parents, and a shared and equal education—lived in obscurity in a shack on the outskirts of Paris with a large collection of cats. He makes no connection between the lot of his sister and what he calls the "realm of art, which is free to every comer."

Jouin, Henry. "L'exposition des artistes femmes." *Journal des beaux-arts et de la littérature* (Brussels). 24(1882):66.

Kahr, Madlyn Millner. "Women as Artists and 'Women's Art.' " *Woman's Art Journal.* 3(Fall 1982–Winter 1983):28–31.

An examination of women artists' exhibitions of the late nineteenth and early twentieth centuries and the critical responses they evoked.

Kamerick, Maureen. "The Woman Artist and the Art Academy: A Case Study in Institutional Prejudice." *New Research on Women at the University of Michigan* (1974):249–260.

Kampen, Marjorie. "Women's Art: Beginning of a Methodology." *Feminist Art Journal.* 1(Fall 1972):10, 19.

Kampen, Natalie. "Hellenistic Artists: Female." *Archeologia Classica.* 27, fasc. 1(1975):9–17.

Karsilovsky, Alexis Rafael. "Feminism in the Arts: An Interim Bibliography." *Artform* (June 1972):72–76.

An excellent annotated bibliography that touches upon historical women artists as well as the contemporary feminist art movement. It has been one of my principal sources.

Katz, M. Barry. "The Women of Futurism." *Woman's Art Journal.* 7(Fall 1986–Winter 1987):1–13.

Discussion of eight serious, professional women artists who were involved in Futurism. This discussion provides a revision of the traditional view of this phase of Italian art. Includes black-and-white reproductions.

Kershaw, J. D. "Philadelphia School of Design for Women." *Sketch Book.* 4, no. 6(April 1905).

Kozloff, Joyce, and Barbara Zucker. "The Women's Movement: Still a 'Source of Strength' or 'One Big Bore'?" *Art News.* 75(April 1976):48–50.

Kraft, Selma. "Cognitive Function and Women's Art." *Woman's Art Journal.* 4(Fall 1983–Winter 1984):5–9.

Kraft argues that there is a particularly female way of processing information and that this reveals itself in art which emphasizes intervals and arrangements of repeated motifs. She believes that females process information by responding to a number of stimuli simultaneously, that they are likely to merge stimuli with their settings, and that they rely on peripheral vision to search the environment with a broader field of less depth.

Kuzmany, K. "Die Kunst der Frau." *Die Kunste für Alle.* 26(1910): 193ff.

Laduke, Betty. "Traditional Women Artists in Borneo, Indonesia and India." *Woman's Art Journal.* 2(Spring–Summer 1981):17–20.

Laduke traces the communal heritage and its relationship to contemporary art produced by women. Beadwork, embroidery, and painting are included in the discussion.

————. "Women and Art in Cuba: Feminism Is Not Our Issue." *Woman's Art Journal.* 5(Fall 1984–Winter 1985):34–40.

An overview of postrevolutionary Cuban women artists. Laduke presents the historical background, a discussion of art training, and brief summaries of the careers of six artists. Includes black-and-white reproductions.

LeGrange, Leon. "De rang des femmes dans les arts." *Gazette des beaux-arts.* (October 1, 1960):30–43; reprinted in English a few months later in *The Crayon,* a New York art magazine.

LeGrange begins, deceptively enough, by praising important

women artists of the past—Margaretha van Eyck and Rachel Ruysch in particular. But he quickly lapses into the most shocking condescension toward contemporary women artists, whose proper sphere he kindly outlines. They are good for decorating vases, for coloring prints, and for reproducing engravings of paintings by men, "and those painstaking arts which correspond so well to the role of abnegation and devotion which the honest woman happily fills here on earth and which is her religion."

Leris, G. de. "Les femmes à l'Académie de Peinture." *L'art.* 45(1888):122–133.

Likos, Patt. "The Ladies of the Red Rose." *Feminist Art Journal.* 5(Fall 1976):11–15, 43.
 Good discussion of the state of education for women artists in Philadelphia at the turn of the century. Focuses on the fascinating cooperative lives and careers of three women artists: Violet Oakley, Elizabeth Shippen Green, and Jessie Willcox Smith.

Lippard, Lucy. "Household Images in Art." *Ms.* 1(March 1973):22–25.
 A look at the use of domestic imagery by contemporary women artists. Well illustrated.

———. "The Pains and Pleasures of Rebirth: Women's Body Art." *Art in America.* 64(May–June 1976):73–81.
 Discussion of art in which the primary image or medium is the artist's own body. Examines male and female differences in this genre.

———. "Projecting a Feminist Criticism." *Art Journal.* 35(Summer 1976):337–339.

———. "Sexual Politics, Arts Style." *Art in America.* 59(September 1971):19–20.
 Short, but concise, summary of the state of discrimination against women artists by dealers, educators, and journalists.

———. "Sweeping Exchanges: The Contribution of Feminism to the Art of the 1970s." *Art Journal.* 40(Fall–Winter 1980):362–365.
 Lippard discusses the attempts of feminists in the 1970's to change the character of art. Rather than evolving new forms, feminism is seen as involving an altered concept of reality and morality.

————. "Why Separate Women's Art?" *Art and Artists.* 8(October 1973):8–9.

This short essay is an adaptation from the catalog of an exhibition, *Ten Artists (Who Also Happen to Be Women),* at the Kenan Art Center in Lockport, New York, and at the Michael C. Rockefeller Arts Center in Fredonia, New York, during January 1973. It is an excellent summary of why women's art should, on occasion, be separated.

Lorber, Richard. "Women Artists on Women in Art." *Portfolio.* (February–March 1980):68–73.

Interviews with several contemporary artists on their feelings about the progress toward artistic equality.

Loughery, John. "Mrs. Holladay and the Guerrilla Girls." *Arts.* 62(October 1987):61–65.

This interesting article contrasts the anonymous activist group Guerrilla Girls with the goals and conventionalism of the newly opened National Museum of Women in the Arts. The Guerrilla Girls attempt to publicize museum policies and politics that exclude women from gallery walls. Mrs. Holladay, on the other hand, was responsible for creating museum walls for women artists. Loughery sees problems in each of these divergent approaches.

Lyons, Lisa. "Sugar and Vice: Images of Women in Late Medieval Art." *Feminist Art Journal* (Winter 1974–1975):8–10.

Mainardi, Pat. "A Feminine Sensibility? Two Views." *Feminist Art Journal.* 1(April 1972):4, 25.

An argument against the "female aesthetic," stating that the only artistic freedom women should pursue is the same freedom that men have—the freedom to make every kind of art that is known.

Maison, Margaret. "Insignificant Objects of Desire." *Listener* (July 22, 1971):105–107.

Brief summary of the first women's movement that includes an account of the status of women artists.

Marcadé, Jean-Claude. "Femmes d'avant-garde sur fond Russe." *L'oeil.* 334(May 1983):38–45.

An analysis of the contributions of three avant-garde Russian women artists: Rozanova, Popova, and Exter. Includes several black-and-white reproductions.

Marcou, P. F. "Une exposition rétrospective d'art féminin." *Gazette des beaux-arts* (1908):297ff.

Marling, Daral Ann. "A New Deal for Women: Edris Eckhardt and the Federal Art Project." Abstract of a paper delivered to the College Art Association, January 1975.
A look at the effect of the WPA's Federal Art Project on opportunities for women and the image of women as professional artists.

Marmer, Nancy. "Womanspace: A Creative Battle for Equality in the Art World." *Art News.* 72(Summer 1973):38–39.

Marter, Joan M. "Interaction or Compromise: The Creative Production of Three Women Married to Early Modernists: Sonia Delaunay-Tery, Marguerite Thompson Zorach, Sophie Taeuber-Arp." Abstract of a paper delivered to the College Art Association, January 1975.

Merritt, A. L. "A Letter to Artists, Especially Women Artists." *Lippincott's Magazine.* 65(1900):463–469.

Meyer, Annie Nathan. "The Women's Section at the World's Fair." *International Studio.* 59(August 1916):XXIX–XXXII.
There was no woman's building at the World's Fair in 1916, only a room where, among others, Morisot and Cassatt were shown. Meyer describes the tenor of the room's display as "masculine," meaning "clear, capable, vigourous." This unfortunately leaves one with the impression that to be feminine must mean to be unclear, incompetent, and weak.

"More on Women's Art: An Exchange." *Art in America.* 64(November–December 1976):11–22.
Responses to Lawrence Alloway's article, "Women's Art in the Seventies."

Muto, Laverne. "A Feminist Art—The American Memorial Picture." *Art Journal.* 35(Summer 1976):352–358.
Discussion of a form of folk art widely practiced in the eighteenth and nineteenth centuries.

National Carvers Museum Review. Vol. 4, no. 3.
An issue devoted to women wood carvers.

Nemser, Cindy. "Art Criticism and the Gender Prejudice." *Arts.* 46(March 1972):44–46.

Nemser deals with the question of whether there are recognizable feminine characterisitics in art created by women. She also confronts the critical vocabulary that is rife with sexual connotations.

————. "Stereotypes and Women Artists." *Feminist Art Journal.* 1(April 1972):1, 22–23.

An excellent article which explores the characteristics of "phallic criticism" from the ninteenth century to the present day in reviews of women artists. One of the best points is that one may be fairly sure that some discrimination is afoot when the word "feminine" appears in art criticism.

————. "Towards a Feminist Sensibility: Contemporary Trends in Women's Art." *Feminist Art Journal.* 5(Summer 1976):19–23.

Discussion of the wide diversity of women's art as well as some of the commonalities, such as frequent autobiographical content, documentation of the immediate experiences of a woman, art with political statements, and art with sexual imagery.

————. "The Women's Conference at the Corcoran." *Art in America.* 61(January–February 1973):86–90.

Nochlin, Linda. "By a Woman Painted: Eight Who Made Art in the Nineteenth Century." *Ms.* 3(July 1974):68–75, 103.

Nochlin briefly discusses Rosa Bonheur, Sophie Anderson, Margaretta and Sarah Peale, Berthe Morisot, Elizabeth Siddal, Emily Mary Osborn, and Mary Cassatt. Several good color reproductions are included.

————. "Eroticism and Female Imagery in Nineteenth Century Art." *Woman as Sex Object: Studies in Erotic Art, 1730–1970.* Edited by Thomas B. Hess and Linda Nochlin. New York: Art News Annual 38, Newsweek. Pp. 8–15.

A hilarious and eloquent commentary on the ludicrousness and inhumanity of a standard "woman as sex object" motif, that of "breasts as fruit." Two photographs are placed side by side. The first is French, from the nineteenth century: a nude, vacuous damsel, clad only in black stockings, holds a fruit laden tray beneath her breasts. Next to it is a nude, equally vacuous young fellow, sporting knee socks, and holding a tray of bananas somewhat lower, beneath his penis.

————. "How Feminism in the Arts Can Implement Cultural Change." *Arts in Society.* 11(Spring–Summer 1974):81–89.

————. "Les femmes, l'art et le pouvoir." *Les cahiers du Musée National d'Art Moderne.* 24(Summer 1988):44–61.

————. "Some Women Realists." *Arts.* 48(Fall 1974):46–51.
Discussion of art of Sylvia Mangold, Yvonne Jacquette, and Janet Fish, with a valuable aside about an artistic foremother, Emily Mary Osborn. Some reproductions are included.

————. "Some Women Realists: Painters of the Figure." *Arts.* 48(May 1974):29–33.
Alice Neel and Sylvia Sleigh are among the artists discussed.

————. "Why Have There Been No Great Women Artists?" *Art News.* 69(January 1971):22–39, 67–71; reprinted in Hess and Baker, *Art and Sexual Politics;* and in Vivian Gornick and Barbara K. Moran, *Women in Sexist Society: Studies in Power and Powerlessness* (New York: Basic Books, 1971, chap. 3, pp. 344–366). This last version is without the very important illustrations.
Nochlin begins her long essay by pointing out the prejudice and assumptions of the question posed in her title. Unfortunately, she ends by concluding that there have been no great women artists, for which she is severely taken to task by Pat Mainardi in a book review in the *Feminist Art Journal,* 2(Winter 1973–1974):18. This judgment takes at face value accumulated art history regarding women without considering the centuries of bias against women both in art history and in Western civilization in general. Far more valuable is the main body of her essay in which she discusses the "golden nugget theory of art history," the denial of art education to women (especially study of the nude), and the importance of beginning to ask "where artists come from."

————. "Women Artists in the Twentieth Century: Issues, Problems and Controversies." *Studio International.* 193(May–June 1977):165–174.

Nunn, Pamela. "Ruskin's Patronage of Women Artists." *Woman's Art Journal.* 2(February 1981–Winter 1982):8–13.

Orenstein, Gloria F. "Art History." *Signs: A Journal of Women in Culture and Society.* 1(Winter 1975):505–525.
An analysis of the neglect of women artists in traditional art history.

————. "Art History and the Case for the Women of Surrealism." *Journal of General Education.* 27(Spring 1975):31–54.

———. "Women of Surrealism." *Feminist Art Journal.* 2(Spring 1973):1, 15–21.
 This is a shorter version of the article in the *Journal of General Education.* Several artists are discussed, including Remedios Varo, Toyen, and Elena Garro. Several black-and-white reproductions accompany the article, along with a bibliography.

Pacchioni, A. "Mostra nazionale d'arte femminile Torino." *Emporium.* 105(June 1947):271–272.

Pagels, Elaine H. "Whatever Became of God the Mother? Conflicting Images of God in Early Christianity." *Signs: Journal of Women in Culture and Society.* 2(Winter 1976):293–303.

Paine, Judith. "The Women's Pavilion of 1876." *Feminist Art Journal.* 4(Winter 1975–1976):5–12.
 An account of the organization, contents of, and reactions to the Women's Pavilion at the Centennial Exposition in Philadelphia.

Payne, Frank Owen. "The Work of Some American Women in Plastic Art." *Art and Archaeology.* 6(December 1917):311–322.
 Well-illustrated survey of women sculptors working in the early 1900's.

Peterson, Susan. "Matriarchs of Pueblo Pottery." *Portfolio.* 2(November–December 1980):50–55.
 Discussion of four Pueblo women potters who revitalized the pottery culture of their ancestors: Maria Martinez, Fanni Nampeyo, Margaret Tafoya, and Lucy Lewis. Includes photographs of all four women and good illustratiions of their work, some in color.

Postlethwaite, H. L. "More Noted Women Painters." *Magazine of Art.* 22(1898):480–484.

———. "Some Noted Women Painters." *Magazine of Art.* 18(1895): 17–22.

Print. 10(September 1955):16–67.
 An all-women's issue.

Proctor, Ida. "Some Early Women Painters." *Country Life.* 107(April 14, 1950):1040–1042.

Proske, Beatrice. "Part I: American Women Sculptors." *National Sculpture Review.* 24(Summer–Fall 1975):8–15, 28.

Excellent summary of the position of American women sculptors from 1725 to contemporary times. Beautifully illustrated with black-and-white reproductions.

Radycki, J. Diane. "The Life of Lady Art Students: Changing Art Education at the Turn of the Century." *Art Journal.* 42(Spring 1982):9–13.

Discusses the events that changed art education for women, which ironically were related to the efforts of men trying to liberalize the Ecole des Beaux-Arts.

Reiss, Margot. "Self Portraits of Women." *Der Kunstwanderer.* 9(April 1927):321–323.

Roberts, Helene. "The Inside, the Surface, the Mass: Some Recurring Images of Women." *Women's Studies.* 2, no. 3(1974):289–307.

Rorem, Ned. "Women: Artist or Artist-ess." *Vogue.* 155(April 1, 1971):172–173.

Russell, H. Diane. "Art History." *Signs: A Journal of Women in Culture and Society.* 5(Spring 1980):468–481.

Russell discusses and reflects on the important publications concerning women artists printed during the previous decade. This is an update of Orenstein's earlier article by the same title.

Russell, Margarita. "The Women Painters in Houbraken's Groote Schouburgh." *Woman's Art Journal.* 2(Spring–Summer 1981):7–11.

Discussion of this principal source for biographies of seventeenth-century Dutch painters. Russell briefly summarizes the biographies of women included by Houbraken. This was originally a paper delivered before the College Art Association.

Saunier, Charles. "Exposition rétrospective feminine au Lyceum-France." *Les arts.* 7(April 1908):1–7.

Sauzeau-Boetti, Anne-Marie. "Negative Capability as Practiced in Women's Art." *Studio International.* 19(January–February 1976):24–30.

Schapiro, Miriam. "The Education of Women as Artists: Project Womanhouse." *Art Journal.* 31(Spring 1972):268–270.

See the catalog to this exhibition under "Valencia, California," in the next section. Discusses the methods of teaching, the conception, and creation of Womanhouse.

Schlossman, Betty, and Hildreth York. "Women in Ancient Art." *Art Journal.* 35(Summer 1976):345–351.

Schulze, Franz. "Women's Art: Beyond Chauvinism." *Art News.* 74(March 1975):70–72.
 A highly favorable review of the success of two feminist galleries in Chicago, Artemisia and ARC.

Schwartz, Therese. "If De Kooning Is an Old Master, What Is Georgia O'Keeffe?" *Feminist Art Journal.* 1(Fall 1972):12–13, 20.
 A review of the "Old Mistresses" show in Baltimore at the Walters Art Gallery in the spring of 1972 (*see also* Gabhart and Broun cited above in this section). Fair black-and-white reproductions are included.

————. "They Built Women a Bad Art History." *Feminist Art Journal.* 2(Fall 1973):10–11, 22.
 Several late-nineteenth-century writers are examined for their extreme misogyny toward women artists. Their role in the near eradication of women from art history is discussed. Corning, Holmes, LaGrange (listed in this section), and Sparrow (listed in the book section) are included in the discussion.

Semmel, Joan, and April Kingsley. "Sexual Imagery in Women's Art." *Woman's Art Journal.* 1(Spring–Summer 1980):1–6.
 Discusses the ranges in styles and attitudes of sexual art produced by women.

Siblik, E. "Exposition de peinture feminine française à Prague." *Beaux-arts* (June 4, 1937):8.

Sims, Lowery S. "Black Americans in the Visual Arts: A Survey of Bibliographic Materials and Research Sources." *Artforum.* 11(April 1973):66–70.

Sloan, Patricia. "Statement on the Status of Women in the Arts." *Art Journal.* 31(Summer 1972):425–427.
 Scathing analysis by an artist on the good and bad effects of the women's movement on the art world.

Smith, Barbara Herrnstein. "Women Artists: Some Muted Notes." *Journal of Communication.* 24(Spring 1974):146–149.

Smith, David Loeffler. "Observations on a Few Celebrated Women Artists." *American Artist.* 26(January 1962):52–55, 78–81.
 Sympathetic survey of a number of historical women artists from Vigée-LeBrun to Cassatt. Includes several good illustrations.

Smith, Sharon. "Women Who Make Movies." *Women and Film.* 1, nos. 3, 4:77–92.
 An international filmmakers list arranged by country. This is a triannual magazine.

Snyder-Ott, Joelyn. "Woman's Place Is in the Home (That She Built)." *Feminist Art Journal.* 3(Fall 1974):7–8, 18.
 This is a survey article about the Woman's Building of the Chicago World's Columbian Exposition of 1893. It touches upon the political climate that helped bring it about but does not mention Susan B. Anthony as the originator of the idea. *See* "Letters," *Feminist Art Journal,* 4(Spring 1975):46–47, for additional comments on the article.

Somerville, E. "An 'Atelier des Dames.' " *Magazine of Art.* 9(1886):152–157.
 Humorous account of women art students in Paris.

Stump, Jeanne. "May Alcott: Problems of the Woman Artist in the Nineteenth Century." Abstract of a paper delivered before the College Art Association, January 1975.
 This paper discusses Louisa May Alcott's sister, an artist, whose book is listed in the book section of this bibliography.

Sutton, D. "A Londres: exposition de femmes peintres." *Arts.* (November 1946):3.

Symmes, Marilyn. "Important Photographs by Women." *Bulletin of the Detroit Institute of Art.* 56, no. 2(1978):149–151.

Take One. 3(February 1972).
 A special issue on women and film.

Taylor, Hilary. " 'If a Young Painter Be Not Fierce and Arrogant, God . . . Help Him': Some Women Art Students at the Slade, c. 1895–1899." *Art History.* 9(June 1986):232–244.

Examines the role of women art students at the Slade in the late nineteenth century and the limitations placed on them.

Thompson, Jane. "World of the Double Win: Male and Female Principles in Design." *Feminist Art Journal.* 5(Fall 1976):16–20.

Tourneux, M. "Une exposition rétrospective d'art féminin." *Gazette des beaux-arts.* 39(1908):290–300.

Tufts, Eleanor. "Beyond Gardner, Gombrich, and Janson: Towards a Total History of Art." *Arts.* 55(April 1981):150–154.
 Tufts calls attention to recent sexist language in writings about women artists. She urges the integration of women artists into standard art history texts, rather than an occasional token inclusion.

Velvet Light Trap (Fall 1972).
 Issue devoted to women and film.

Visual Dialog. 1(Winter 1975–1976); 2(Winter 1976–1977).
 Two issues devoted to women in the visual arts.

Vogel, Lise. "Erotica, the Academy, and Art Publishing: A Review of *Woman as Sex Object: Studies in Erotic Art, 1730–1970.*" *Art Journal.* 35(Summer 1976):378–385.

Wayne, Jane. "The Male Artist as a Stereotypical Female; or, Picasso as Scarlet O'Hara to Hirshhorn's Rhett Butler." *Art News.* 72(December 1973):41–42; reprinted in *Arts and Society,* 11(Spring–Summer 1974):107–113.
 Wayne relates the powerless position of artists to the stereotypical view of them as inept, unable to cope, and needing help—a view that is almost identical to the stereotypical concepts of women. She calls for the organization of artists into a power bloc to seize control of the art world from dealers, curators, and others and thus to look out for their own interests.

Weeks, Charlotte J. "Lady Art-Students in Munich." *Magazine of Art.* 4(1881):343–347.

———. "Women at Work: The Slade Girls." *Magazine of Art.* 6(1883):324–329.
 Description of women art students at the Slade School in England.

Wein, Jo Ann. "The Parisian Training of American Women Artists." *Women's Art Journal.* 2(Spring–Summer 1981):41–44.

Since the Ecole des Beaux-Arts did not admit women students, during the last third of the nineteenth century American women students studied in private ateliers of the French academic masters.

Weitenkampt, Frank. "Some Women Etchers." *Scribner's.* 46(December 1909):731–739.

"What Is Female Imagery?" *Ms.* 3(May 1975):62–65, 80–83.

Conversations exploring the controversial question of whether the art of women is, in some intrinsic way, different from that of men. In Chicago the participants were Johnnie Johnson, Celia Marriott, Joy Poe, and Royanne Rosenberg; in Los Angeles, Eleanor Antin, Sheila de Bretteville, Judy Chicago, Ruth Iskin, and Arlene Raven; in New York, Susan Hall, Lucy Lippard, Linda Nochlin, Joan Snyder, and Susan Torre.

Whelan, Richard. "Are Women Better Photographers Than Men?" *Art News.* 79(October 1980):80–88.

Discussion of the discrimination women artists have faced and their treatment by galleries. Includes brief summaries of the careers of several women photographers.

White, Barbara Ehrlich. "A 1974 Perspective: Why Women's Studies in Art and Art History?" *Art Journal.* 32(Summer 1973):420–421.

Statistical analysis of the results of a questionnaire sponsored by the College Art Association committee on the status of women.

Whitesel, Lita. "Women as Art Students, Teachers and Artists." *Art Education Journal of the National Art Education Association.* 28(March 1975):22–26.

A statistical review of the extent to which women, as compared to men, undertake training in art and participate at professional levels as teachers and artists.

Withers, Josephine. "Artistic Women and Women Artists." *Art Journal.* 35(Summer 1976):330–336.

A look at the nineteenth-century view of women as "naturally artistic" and the artistic training provided for young women of the period.

Womanart Magazine. 1, no. 1(1976); no. 2(Fall 1976); no. 3(Winter–Spring 1977).

The first issue of this quarterly had articles on Edmonia Lewis and on sexism at the Museum of Modern Art. Articles on Gertrude Stein, Laura Knight, and Artemisia Gentileschi were included in the second issue. The third issue reviewed *Women Artists, 1550–1950* and discussed the *Sister Chapel* at length.

"Woman as Photographer." *Camera.* 46(September 1967):3–46.

Womansphere.
This publication of the Washington Women's Art Center began in 1975.

Women and Art.
This was the predecessor of the *Feminist Art Journal.* It was edited by Pat Mainardi, Marjorie Kramer, and Irene Peslikis.

Women Artists News.
This was originally titled the *Women Artists Newsletter.* The name was changed in 1978. It has been published since 1975. The address is P.O. Box 3304, Grand Central Station, New York, New York, 10017.

"Women Artists." *Southern Review.* 5(April 1869):299–322.
A classical sexual put-down of women artists. Points out that as women increase their power, their morals decline. States that the only true function of women is to bring happiness to the world and that it is "only the disappointed woman who turns to Art."

"Women Artists." *Westminster Review.* 70(July 1858):91–104.
This is an anonymous review of Ernst Guhl's book, *Die Frauen in der Kunstgeschichte,* which is listed in the book section of this bibliography. This lengthy article summarizes large segments of Guhl's book, providing a useful synopsis of a work difficult to locate today.

"Women Painters Exhibition." *Chicago Art Institute Scrapbook.* 14(March–December 1901):22, 24, 27.

Women's Caucus for Art Newsletter.
This is the newsletter for a national organization of feminist artists, art historians, and museum and gallery women. It grew out of the College Art Association. The newsletter contains synopses of programs and panels relating to women in the arts, updates on affirmative action, regional reports, and an excellent ongoing bibliography. Subscription is by membership in the WCA. The address is WCA,

Moore College of Art and Design, 20th and the Parkway, Philadelphia, Pennsylvania 19103.

''The Women's Movement in Art, 1986.'' *Arts.* 61(September 1986):54+.
A panel of ten women discuss the impact of the women's movement on the arts. Lively discussion of the advantages and disadvantages of women-only exhibitions is included.

''X Salon Femenino de Arte Actual.'' *Goya.* 105(November 1971):197.

CATALOGS

Amsterdam. *Exposition les dessins exécutés par les femmes.* 1884.

Brooklyn Museum. *Works on Paper—Women Artists.* September 24–November 9, 1975.

Brussels. Bibliothèque Royale. *Femmes graveuses belges, 1870–1970.* January 30–February 28, 1971.

Chadds Ford, Pennsylvania. Brandywine River Museum. *Women Artists in the Howard Pyle Tradition.* September 6–November 23, 1975.
An illustrated catalog introduced by Anne E. Mayer. Howard Pyle was an important teacher and sponsor of women artists.

Dublin. National Gallery of Ireland and the Douglas Hyde Gallery. *Irish Women Artists from the Eighteenth Century to the Present Day.* July–August 1987.
Numerous scholars contributed essays to this impressive catalog which chronicles the training of women artists in Ireland and the diversity of activity that involved these artists. A dictionary of Irish women artists and a bibliography are included. There are also copious reproductions, some in color.

Gaud, Roger. *Les femmes peintres au XVIIIe siécle.* Castres: Musée Goya, 1973.

Gerdts, William H. *The White Marmorean Flock: Nineteenth Century American Women Neoclassical Sculptors.* Poughkeepsie, New York: Vassar College Art Gallery. April 4–April 30, 1972.
Gerdts is probably the foremost scholar on American Neoclassical sculpture. His long introduction discusses the phenomenon of the relatively large number of U.S. women who studied in Rome, the basis of the exhibition. A bibliography and good black-and-white reproductions are included.

Hill, M. Brawley. *Women: A Historical Survey of Works by Women Artists.* Winston-Salem and Raleigh, North Carolina: Salem Fine Arts Center and the North Carolina Museum of Art. February 27–April 20, 1972.

Hill presents a thorough and coherent listing of women artists, from the Middle Ages to the present day. The catalog consists of eight-five sharp black-and-white reproductions accompanied by thorough captions that in many instances include references to other reproductions and bibliographic information.

Huber, Christine Jones. *The Pennsylvania Academy and Its Women, 1850–1920.* Philadelphia: Peale House Galleries. May 3–June 16, 1973.

Huber's long essay is excellent and includes a discussion of the art training available to women of the nineteenth century. Black-and-white reproductions are included as well as a wealth of bibliographic sources. The catalog's entry on each woman is augmented with a short biographical paragraph. Artists included (in addition to the ones individually discussed in Section II below) are Ann Sophia Towne Darrah, Anna Sellers, Rosa M. Towne, Virginia Granbery, Juliet Lavinia Tanner, Fidelia Bridges, Ida Waugh, Emily Sartain, Mary Smith, Mrs. E. V. Duffey, Anna Lea Merritt, Mary Franklin, Anna Klumpke, Margaret Lesley Bush-Brown, Elisabeth Fearn Bonsall, Alice Schille, Anna Mary Richards, Nancy Maybin Ferguson, Marianna Sloan, Martha Walter, Margaret Foster Richardson, Helen Kiner McCarthy, Annie Traquair Lang, Alice Kent Stoddard, Edith Emerson, and Catherine Morris Wright.

Huntington, New York. Heckscher Museum. *Artists of Suffolk County, Part IX. Twenty Women Artists.* July 20–August 31, 1975.

This catalog includes a short introduction by Ruth Solomon indicating that the emphasis of the exhibition is on young, emerging artists. Artists included are Arneli Arms, Sandra Benney, Nicole Bigar, Priscilla Bowden, Margery Caggiano, Janet Culbertson, Natalie Edgar, Coco Gordon, Zena Kaplan, Li-Lan, Susanne Yardley Mason, Joyce Stillman Myers, Pat Ralph, Dorothy Ruddick, Patricia Stevens, Mary Stubelek, Jeanette Styborski, Sylvia Pauloo-Taylor, E. Sterina Velardi, and Graziella Zebilsky. Accompanied by black-and-white illustrations.

Indianapolis. Museum of Art. *Views from the Jade Terrace: Chinese Women Artists, 1300–1912.* September 3–November 6, 1988.

This beautiful catalog accompanied the first exhibition ever de-

voted to painting by Chinese women. The text attempts to place the contributions of women artists into the proper historical context. Essays by Marsha Weidner, Ellen Johnston Laing, and Irving Yuch-eng Lo are included. The catalog is illustrated with wonderful color plates. A selected bibliography and an index of extant and reproduced paintings is included.

Kansas City, Missouri. Women's Caucus for Art. *Women Artists '77: Kansas City Regional Juried Art Exhibition.* April 1977.
An illustrated catalog of the show juried by Miriam Schapiro, held in the University of Missouri–Kansas City Fine Arts Gallery. It contains an essay by Jeanne Stump, "In the Tradition of Women Artists."

Kohlmeyer, Ida. *American Women: Twentieth Century.* Peoria, Illinois: Lakeview Center for the Arts and Sciences. September 15–October 29, 1972.
Kohlmeyer's introduction discusses the premise of an all-women show.

Kovinick, Phil. *The Woman Artist in the American West, 1860–1960.* Fullerton, California: Muckenthaler Cultural Center. April 2–May 31, 1976.
The *WCA Newsletter* commented that this exhibition of a "pallid selection of works by 56 artists" would probably not "bring about the complete dissipation of the long-held view that the virile West can be effectively portrayed only by male delineators."

Los Angeles. *The American Personality: The Artist-Illustrator of Life in the United States, 1860–1930.*
Prepared by the Grunwald Center for the Graphic Arts, UCLA, by graduate students under the direction of E. Maurice Block. It has a section entitled "American Women and the Woman Illustrator."

Los Angeles. Los Angeles County Museum of Art. *Two Centuries of Black American Art.* September 30–November 21, 1976.
David Driskell provides excellent essays on black artists and craft workers and on the evolution of a black aesthetic. The catalog notes are by Leonard Simon and include discussions of some black women artists. Many excellent color and black-and-white reproductions are included.

Los Angeles. Los Angeles County Museum of Art. *Women Artists, 1550–1950.* December 21, 1976–March 13, 1977.

This immense exhibit traveled to the University Art Museum in Austin, Texas; the Museum of Art, Carnegie Institute in Pittsburgh; and the Brooklyn Museum, through the balance of 1977. *See* the book section above under "Harris and Nochlin," the co-curators of the exhibit, for additional annotation.

Los Angeles. The Women's Caucus for Art and the Woman's Building. *Contemporary Issues: Works on Paper by Women.* February 3–March 1, 1977.

Nearly two hundred artists from thirty states were chosen by thirty-seven curators, each of whom selected fewer than six artists.

Macht, Carol. *The Ladies, God Bless 'Em: The Woman's Art Movement in Cincinnati in the Nineteenth Century.* Cincinnati Art Museum. February 19–April 18, 1976.

An unfortunate title. Macht's introduction includes a bibliography. This show emphasized ceramics and furniture.

Mann, Margery, and Anne Noggle. *Women of Photography: An Historical Survey.* San Francisco Museum of Modern Art, Civic Center. April 18–June 15, 1975.

The catalog, a chronological survey of a large number of women photographers, includes a bibliography.

Minault, D. Denise. *Woman as Heroine.* Worcester, Massachusetts: Worcester Art Museum. September 15–October 22, 1973.

"The first exhibition to examine the role of women in seventeenth century Italian baroque painting."

National Museum of Women in the Arts. New York: Harry N. Abrams, 1987.

This is a catalog of selections from the permanent collection of the National Museum of Women in the Arts in Washington, D.C. The introduction by Alessandra Comini is titled "Why a National Museum of Women in the Arts?" Illustrated with superb color reproductions.

Newark, New Jersey. Newark Museum. *Women Artists of America, 1707–1964.* April 2–May 16, 1965.

One of the first museum shows devoted to a historical survey of the work of American women artists. The introduction is by William H. Gerdts. Several black-and-white illustrations are included in this catalog.

New York. Finch College Museum of Art. *Galaxy of Ladies—American Paintings from the Paul Magriel Collection.* 1966.
The exhibition catalog was prepared by Elayne H. Varian, the text by Barbara Novak O'Doherty.

New York. Grolier Club. *Catalogue of a Collection of Engravings, Etchings and Lithographs by Women.* April 12–April 27, 1901.
Includes an essay by Frank Weitenkampt.

New York. Museum of Modern Art. *Extraordinary Women—Drawings.* July 22–September 29, 1977.
Includes works by Sonia Gechtoff, Natalia Gontcharova, Hannah Höch, Lee Krasner, Sophie Taeuber-Arp, and Suzanne Valadon.

New York. Whitney Museum of American Art, Downtown Branch. *Nineteenth Century American Women Artists.* January 14–February 25, 1976.

New York Cultural Center. *Women Choose Women.* January 12–February 18, 1973.
The catalog lists 109 contemporary women.

Paris. Galerie J. Charpentier. *Exposition des femmes peintres du XVIIIe siècle.* 1926.

Paris. Grand Palais. *La femme peintre et sculpteur du XVIIe siècle.* 1975.

Paris. Grand Palais. *French Painting, 1774–1830: The Age of Revolution.* 1974–1975.
This exhibition traveled to the Detroit Institute of Art and to the New York Metropolitan Museum of Art. Among the contributors to the comprehensive catalog were Frederick J. Cummings, Pierre Rosenberg, Antoine Schnapper, and Robert Rosenblum.

Paris. Hôtel de Lyceum-France. *Exposition des femmes peintres.* 1908.
Exhibition organized by Mme. A. Besnard. For reviews, *see* C. Saunier and M. Tourneux in the periodical section above.

Paris. Hôtel de Lyceum-France. *Exposition des femmes peintres.* 1913.

Paris. Hôtel des Négociants en Objets d'Art. *Explication des peintres, graveurs, miniatures et autres ouvrages des femmes peintres du XVIIIe siècle.* 1926.

Paris. Musée des Ecoles Etrangères Contemporaines, du Jeu de Paume des Tuileries. *Les femmes artistes d'Europe exposent au Musée de Paume.* February 1937.

Paris. Petit Palais. *Women Painters Exhibition.* May 1937.
Artists included in this exhibition were Suzanne Valadon, Elisabeth Vigée-LeBrun, Berthe Morisot, Seraphine Louis, Marie Laurencin, Marie Blanchard, Eva Gonzalès, and Sonia Delaunay.

Philadelphia. *FOCUS: A Document of Philadelphia Focuses on Women in the Visual Arts.* April–May 1974.
This outlines the development of several exhibits and events coordinated for the spring of 1974 to honor women in the visual arts.

Philadelphia. Historical Society of Pennsylvania and Library Company of Philadelphia. *Women, 1500–1900.* April 25–July 5, 1974.
This is one of the events of FOCUS (*see above*).

Philadelphia. Samuel S. Fleisher Art Memorial. *In Her Own Image.* April 1974.
This is another of the FOCUS events, an exhibition organized by Cindy Nemser.

Philadelphia. Temple University. *The Tyler School: Working Women Artists from Tyler School of Art.* April 1974.
Another FOCUS event. Twenty-five selected artists are illustrated with short biographies and statements by each artist. The introductory essay is by Burrows Dunham.

Poughkeepsie, New York. Vassar College Art Gallery. *Seven American Women: The Depression Decade.* January 19–March 5, 1976.
This exhibition was sponsored by AIR, a women's cooperative gallery in New York City. Guest curators were Karal Ann Marling and Helen A. Harrison. The catalog is illustrated.

Saint Louis. City Art Museum. *Collection of Paintings by Women Artists of Boston.* December 7, 1913.

Saint Louis. City Art Museum. *Special Exhibit Catalogue—Paintings by Six American Women.* April 5, 1918.

San Antonio. Marion Koogler McNay Art Institute. *American Artists '76: A Celebration.* 1976.
An exhibition of living U.S. women artists.

South Hadley, Mass. Mount Holyoke College of Art Museum. *Fourteen American Women Printmakers of the Thirties and Forties.* April 5–10, 1973.

While there are no reproductions, there is a short paragraph on each woman and a selected bibliography. Included are Peggy Bacon, Isabel Bishop, Mable Dwight, Anga Enters, Wanda Gag, Marion Greenwood, Doris Lee, Clare Leighton, Ethel Myers, Andree Ruelian, Margery Ryerson, Helen Farr Sloan, Beulah Stevenson, and Agnes Tait.

Stony Brook, Long Island. Suffolk Museum. *Unmanly Art.* October 14–November 24, 1972.

The short introduction is by June Blum. Some of the artists represented in the show were Rosalyn Drexler, Alice Neel, Marisot, Lee Bontecou, Marjorie Strider, Linda Benglis, Elaine de Kooning, Louise Nevelson, Miriam Schapiro, Lee Krasner, Louise Bourgeois, Janet Fish, Sylvia Sleigh, Pat Mainardi, May Stevens, Judy Chicago, and Ellen Lanyon.

Stryker, Catherine Connell. Wilmington, Delaware. Delaware Art Museum. *Studios at Cogslea.* February 20–March 28, 1976.

An illustrated catalog of seventy-three pages of works by Violet Oakley, Elizabeth Shippen Green, and Jessie Willcox Smith.

Valencia, California. Feminist Art Program of the California Institute of the Arts. *Womanhouse.* February 1972.

An all-women environment created by twenty-six women. The co-directors of the Feminist Art Program were Judy Chicago and Miriam Schapiro. Some of the rooms were a Dollhouse, a Bridal Staircase, a Garden Jungle, a Menstruation Bathroom, a Nightmare Bathroom, Leah's room from Colette's *Chéri,* and a breast-to-eggs kitchen.

Washington, D.C. National Museum of Women in the Arts. *Women Artists of the New Deal Era: A Selection of Prints and Drawings.* October 18, 1988–January 8, 1989.

Catalog essays are by Helen Harrison and Lucy Lippard.

Washington, D.C. Washington Gallery. *Paper Works: A Juried Exhibition of Works by Women on, of, or about Paper.* May 3–May 26, 1974.

The catalog lists sixty women plus a chronology of the exhibit's development.

Zurich. Kunsthaus. *Die Frau als Künstlerin.* 1958.

SECTION II

INDIVIDUAL ARTISTS

This section is divided into centuries, with each artist's bibliography listed alphabetically under her respective century. Each artist is introduced by a short biographical paragraph. References to books, periodicals, and catalogs are grouped together in alphabetical order. Many citations are in shortened form; full citations for these references are found in Section I.

Due to ·the far greater numbers of women artists in the twentieth century, and to the even grater amount of literature available on all contemporary artists, this portion of the bibliography makes even less pretense toward completeness than do those covering earlier centuries. Also, a cutoff birth year of 1930 was selected to impose some limitation upon the scope of the twentieth-century section.

For many of the individual artists, a short, but by no means complete, collections list has been included at the end of their respective bibliographies. This should be helpful to those seeking to experience these artists firsthand.

FIFTEENTH CENTURY AND EARLIER

ENDE. Ca. 975. Spanish.

Little is known about the life of this manuscript illuminator, who may have been a nun. She is believed to be responsible for a 975 copy of a commentary on the Apocalypse, composed originally by Beatus, an eighth-century Spanish monk. Miner has called the *Beatus Apocalypse* (also known as the Gerona Beatus of 975), "one of the most splendid examples of Mozarabic book ornamentation and illustration known."

Apocalypse of Gerona. Commentary by J. M. Casanovas, Cesar Dubles, and Wilheim Neuss. Fascimile edition, Olten-Lausanne-Freiburg: Urs Graf, n.d.

Carr, Annemarie Weyl. "Women Artists in the Middle Ages." P. 6.
Discusses Ende's participation in the Gerona *Apocalypse*.

Harris and Nochlin. *Women Artists, 1550–1950.* P. 17.
These authors translate the signature of the *Beatus Apocalypse,* located in the Cathedral Treasury in Gerona, as "En (Ende) paintress and helper of God and Brother Emeterius Presbiter." They believe it is significant that her name precedes his. Another manuscript, signed by Emeterius alone, has made it possible to isolate their individual contributions, giving the majority to Ende.

Hirmer, Max, and Pedro de Palol. *Early Medieval Art in Spain.* London: Thames and Hudson, 1967. P. 56.
The Gerona manuscript was based on the commentary by Beatus of Liebana of 786. These authors believe the Visigothic script was by a senior priest and the illustrations by Ende.

Miner, Dorothy. *Anastaise and Her Sisters.* Pp. 9–11.

Munsterberg. *History of Women Artists.* Pp. 12, 14.

Petersen and Wilson. *Women Artists.* Pp. 13–14.

Williams, John. *Early Spanish Manuscript Illumination.* New York: George Braziller, 1977. Pp. 16, 92–99.
Includes three color illustrations of the Gerona Beatus of 975.

Collection:

Gerona (Spain), Gerona Cathedral Treasury.

MARGARETHA VAN EYCK. Ca. 1406–ca. 1430. Flemish.
Margaretha van Eyck was the sister of Jan and Hubert. The extent to which she was involved in their work has yet to be determined. She worked as a miniaturist and manuscript illuminator and was honored as an artist in her own lifetime.

Aulanier, Christiane. "Marguerite van Eyck et l'Homme au turban rouge." *Gazette des beaux-arts.* 16(July-August 1936):57–58.
This disucssion of the similarities in a portrait of Margaretha and *The Man with a Red Turban* includes some mention of Margaretha's dates.

Bénézit. *Dictionnaire.* Vol. 4, p. 228.

Bryan. *Dictionary of Painters.* Vol. 1, p. 473.

Champlin. *Cyclopedia of Painters and Paintings.* Vol. 2, p. 34.

Clement. *Women in the Fine Arts.* Pp. 119–120.

Crowe, J. A., and G. B. Cavalcaselle. *The Early Flemish Painters: Notices of Their Lives and Works.* 2nd edition. London: John Murray, 1872, Pp. 129–132.
This work includes a lengthy description of the missal of the Duke of Bedford which the authors attribute to Margaretha van Eyck.

Ellet. *Women Artists in All Ages.* P. 34.

Fine. *Women and Art.* P. 136.

Greer. *The Obstacle Race.* P. 29.

Mander, Carel van. *Dutch and Flemish Masters.* Trans. from the *Schilderboeck* by Constant van de Wall. New York, 1936. P. 4.

''Their sister, Margriete van Eyck, became famous for her painting, too. Like Minerva, Margriete shunned Hymen and Lucina and remained in maiden state to the end of her life.''

Petersen and Wilson. *Women Artists.* Pp. 35–36.

Schwartz. ''They Built Women a Bad Art History.''

Sparrow. *Women Painters of the World.* P. 253.

Thieme and Becker. *Allgemeines Lexikon.* Vol. 11, p. 134.

Wilenski, Reginald. *Flemish Painters, 1430–1830.* New York: Viking Press, 1960, Vol. 1, p. 552.
 A dictionary entry that gives a brief listing of recorded accounts of van Eyck and a listing of works that have been attributed to her or exhibited as her works.

Collections:

Lille, Musée de Beaux-Arts.
Paris, Bibliothèque Nationale.

HILDEGARDE VON BINGEN. 1098–1179. German.
 Although she was never canonized, this artist is known as Saint Hildegarde. From an early age she claimed the ability to foresee the future and to have unusual spiritual experiences. She also had an excitable personality and poor health. Reports of her formal education are conflicting, some claiming that all her knowledge was obtained through visions. Hildegarde von Bingen entered a Benedictine convent and in 1136 became the prioress of the monastery at Diessenberg. In 1147 she moved her community to Rupertsberg, near Bingen on the Rhine, and built a large convent. She was one of the most influential women of the Middle Ages, acting as an advisor to rulers of both church and state. Starting around 1141 she composed numerous manuscripts, dictating to monks who translated them into Latin. The information for these manuscripts was drawn from her visions and the subject matter encompassed science, music, medicine, and morality. Her chief work, *Liber Scivias,* ca. 1165, describes and illustrates thirty-five of her visions regarding the future history of the world. The earliest manuscript of *Liber Scivias,* perhaps not the original, has been lost from the Stadtsbibliothek in Wiesbaden since World War II. While Hildegarde von Bingen

probably did not illuminate the original manuscript herself, she surely worked closely with the artist, and the imagery must be credited to her imagination. The manuscripts attributed to her are dominated by circular forms and imaginative symbolism.

Attwater, Donald. *The Penguin Dictionary of Saints.* Harmondsworth, Middlesex: Penguin Books, 1965. Pp. 170–171.
 Good biographical summary.

Baillet, Dom L. "Les miniatures du Scivias de Sainte Hildegarde conservé à la Bibliothèque de Wiesbaden." *Foundation E. Piot: Monuments et mémoires.* 19(1911):49–149.

Carr, Annemarie Weyl. "Women Artists in the Middle Ages." *Feminist Art Journal.* 5(Spring 1976):7.
 While Saint Hildegarde may not have personally illustrated her manuscripts, the unique images should be credited to her imagination.

Greer. *The Obstacle Race.* Pp. 157–158.

Harris and Nochlin. *Women Artists, 1550–1950.* P. 18.

Heer, F. *The Medieval World.* London: Mentor paperback edition, 1961. Pp. 183, 320ff.

Hildegarde von Bingen. *A Feather on the Breath of God.* Gothic Voices, Hyperion C–66039.
 This recording draws on Hildegarde von Bingen's large collection of music and poetry and is digitally recorded.

———. *Music for the Mass by Nun Composers.* Leonarda 115.
 This recording features works by Hildegarde von Bingen and Isabella Leonarda, also a nun. An insert contains an article about music in Italian convents.

———. *Wisse die Wege (Scivias).* Salzburg: Otto Muller, 1954.

Hill. *Women: A Historical Survey . . . Catalogue,* P. viii.

Holweck, Rev. F. G. *A Biographical Dictionary of the Saints.* St. Louis: B. Herdes Book Co., 1924; reprint, Detroit: Gale Research Company, 1969. P. 485.

Kessler, Clemencia H. "A Problematic Illumination of the Heidelberg
Liber Scivias." Marsyas. 8(1957–1959):7–21.
Compares two manuscripts of *Liber Scivias,* a book of relevations
by Hildegarde von Bingen and discusses the different illuminations of
the same text. Although questioning her degree of involvement,
Kessler does believe Hildegarde von Bingen helped in the preparation
of the manuscripts since she was interested in every phase of cloister
life. Several illustrations are included.

McGuire, Therese B. "Monastic Artists and Educators of the Middle
Ages." *Woman's Art Journal.* 9(Fall 1988-Winter 1989):4–6.
Notes that Hildegarde von Bingen was also a playwright, a medical
doctor, and a philosopher. Provides an excellent biographical sum-
mary.

Pernoud, Régine. "Ce que vit Hildegarde." *Connaissance des arts.*
420(February 1987):66–73.
Excellent summary of the artist's life, including an account of her
preaching. Includes beautiful color reproductions of her work.

Petersen and Wilson. *Women Artists.* Pp. 14–15.
These authors report that von Bingen invented a secret language of
920 words.

Theodoric and Goafried. *Vie de Saint Hildegarde.* Paris, 1907.

Collection

Biblioteca Governativa de Lecques.

HERRADE VON LANDSBERG. 1125–1195. German
This well-educated artist was the abbess of Hohenbourg in Alsace
from 1167 until her death in 1195. In order to improve the education of
her nuns, she produced an encyclopedia, the *Hortus deliciarum* ("garden
of delights"), a compendium of medieval learning. She worked on this
manuscript from 1159 until 1175. The original manuscript was de-
stroyed by fire during the Franco-German war of 1870. It can be studied
today only through the line drawings traced by scholars prior to its
destruction. That manuscript is thought by some to be from a generation
after Herrade's death and to have been produced in Strasbourg. The
earliest manuscript was probably produced in her own convent by the
nuns.

Bénézit. *Dictionnaire.* Vol. 5, p. 511.

Bradley. *A Dictionary of Miniaturists.* Vol. 2, pp. 98–100.

Cames, G. *Allegories et symboles dans l'Hortus Deliciarum.* Leyden, 1971.

Carr. "Women Artists in the Middle Ages."
"The greatest of the medieval pictorial encyclopedias."

Greer. *The Obstacle Race.* Pp. 156–157.

Harris and Nochlin. *Women Artists, 1550–1950.* P. 18.

Katzenellenbogen, A. *Allegories of the Virtues and Vices in Medieval Art.* London, 1939.

McGuire, Therese B. "Monastic Artists and Educators of the Middle Ages." *Woman's Art Journal.* 9(Fall-Winter 1989):3–9.
Excellent summary of the role of artistic women in the monastic life. Includes concise biography of Herrade von Landsberg.

Munsterberg. *History of Women Artists.* Pp. 12, 15.

Petersen and Wilson. *Women Artists.* Pp. 15–19.

Straub, A., and G. Keller. *Herrade de Landsberg, Hortus Deliciarum.* Strasbourg, 1879–99; reprint, New Rochelle, New York: Caratzas Brothers, 1977.
This limited reprinted edition of 750 copies was edited and translated by Aristade D. Caratzas. It includes 113 illustrations.

SAINTE CATERINA DEI VIGRI. 1413–1463. Italian.
This artist-nun was born to a noble family in Bologna. As a Franciscan nun, she became the superior of the Convent of Corpus Domini in Bologna. Harris describes her work as "naive, provincial and archaic," which would seem to demonstrate the limitations a cloistered life could impose upon an artist's development. Some of her works, such as small religious works and decorated missals with miniatures and illumination, are preserved at the Convent of Corpus Domini. As the only artist to be canonized (1712), she is considered a special patron of the fine arts.

Bénézit. *Dictionnaire.* Vol. 10, pp. 507–508.

Bryan. *Dictionary of Painters.* Vol. 5, p. 301.

Clement. *Women in the Fine Arts.* Pp. 350–352.

Delaney, John J., and James T. Tobin. *Dictionary of Catholic Biography.* Garden City, New York: Doubleday and Company, 1961. Pp. 226-227.
 These authors say that at the age of eleven, dei Vigri became a maid of honor to Margaret d'Este. They note that she kept a diary of her religious difficulties and supernatural experiences and that she drew a number of pictures.

Ellet. *Women Artists in All Ages.* P. 35.

Fine. *Women and Art.* Pp. 6–7.
 Notes that her biographer was Sister Illuminato Bembo.

Greer. *The Obstacle Race.* Pp. 174–176.
 Greer discusses the questionable attributions to this artist.

Guhl. *Die Frauen . . .*

Harris and Nochlin. *Women Artists, 1550–1950.* P. 20.

Howeck, Rt. Rev. F. G. *A Biographical Dictionary of the Saints.* St. Louis: B. Herder Book Company, 1924. P. 197.
 Dei Vigri is listed here as Catherine of Bologna, but there is no mention of her artistic endeavors.

Ragg. *Women Artists of Bologna.* Pp. 11–164.

Sparrow. *Women Painters of the World.* P. 23.

Tufts. *Our Hidden Heritage.* P. 244.

''Women Artists'' (review of Guhl).

Collections:

 Bologna, Convent of Corpus Domini.
 Bologna, Museo Civico.

SIXTEENTH CENTURY

SOFONISBA ANGUISSOLA. 1532/35–1625. Italian.

Anguissola is unusual in that she was not the daughter of an artist. She was born in Cremona, the eldest of six talented daughters of a minor nobleman. Her sisters also painted and were gifted in music and literature. Anguissola studied painting under Bernardino Campi in Cremona, and later with Bernardino Gatti. She was primarily a portraitist but also did small historical subjects. She did a great many self-portraits, perhaps reflecting a demand for images of the phenomena she presented—a woman artist. From 1559 to 1580 she resided in Spain where she was a court painter and a lady-in-waiting at the court of Philip II. Anguissola was twice married, the second time for love. She was known by Vasari, Michelangelo, and in her old age, Van Dyck. Over fifty paintings are attributed to her today, but only one is currently known from her mature and productive Spanish years.

Adriani, Gert. *Anton Van Dyck italienisches Skizzenbuch.* Vienna, 1940. Pp. 72–73.
 This describes Van Dyck's visit to Anguissola in Palermo in 1624, shortly before her death.

Alf. "My Interest in Women Artists of the Past."

Baldinucci, Filippo. *Notizie de'professori del disegno da Cimabue in qua.* Florence, 1681.
 Harris cites *Opere di Filippo Baldinucci, Milan, 1808–12.* She describes his as the best early biography of Anguissola since it utilizes sixteenth–century sources.

Berenson, Bernard. *Italian Painters of the Renaissance: Central Italian and Northern Italian Schools.* London: Phaidon; revised edition, 1968, Vol. 1, pp. 13–14.
 Berenson provides a list of Anguissola's work.

Bonetti, C. *Sofonisba Anguissola.* Cremona, 1932

Borea, Evalina. "Caravaggio e La Spagna: osservazioni su una mostra a Siviglia." *Bollettino d'Arte.* 59(January-June 1974): 47–48.
Illustrated with *Ritratto di Vecchio.*

Bénézit. *Dictionnaire.* Vol. 1, p. 200.
Good summary of her biography. Includes a brief account of her five sisters and lists her works.

Campi, Antonio. *Cremona fedelissima città et nobilissima colonia di Romani* Cremona, 1585

Caroli, Flavio. "Antologia di artist, per Lucia Anguissola." *Paragone.* 277 (1973):69–73.
This is a discussion of one of Sofonisba's younger sisters, Lucia, whose dates are quite tentative (ca. 1540–ca. 1565).

Clement. *Women in the Fine Arts.* Pp. 11–16.

Cook, Herbert. "More Portraits by Sofonisba Anguissola." *Burlington Magazine.* 25(1915):288–236.
Cook attempts to clear up confusion over Anguissola's birth and death dates. The article is accompanied by five good illustrations of her portrait work.

Edwards. *Women: An issue.*

Ellet. *Women Artists in All Ages.* Pp. 48–55.

Fine. *Women and Art.* Pp. 9–10.
Fine believes many of Anguissola's self-portraits were used by her father to promote her work.

Fournier-Soclovèze, M. "Sofonisba Anguissola et ses soeurs." *Revue de l'art ancien et moderne.* 5, no. 25 (1899): Part I, pp. 313–324; 5, no. 26 (1899): Part II, pp. 379–392.

Frizzoni, G. "La pietra tombale di Sofonisba Anguissola." *Rassegna bibliografica dell'arte.* 12(1909):53–55.

Gabhart and Broun. "Old Mistresses."

Greer. *The Obstacle Race.* Pp. 180–185.

Haraszti-Takacs, Marianne. "Nouvelles données relatives à la vie et à l'oeuvre de Sofonisba Anguissola." *Bulletin du Musée Hongris des Beaux-Arts.* 31(1968):53–67.

Harris and Nochlin. *Women Artists, 1550–1950.* Pp. 13, 23–24, 27–31, 106–110, 340–341.

Heller. *Women Artists.* Pp. 15–19.
Notes that most of the works from her Spanish period were destroyed in a seventeenth-century fire.

Holmes, C. J. "S. Anguissola and Philip II." *Burlington Magazine.* 26(1915): 181–187.
Discussion of the reasoning for a new attribution.

Krull. *Women in Art.* Pp. 11–12, 17–19.

Kuhnel-Kunze, Irene. "Zur Bildniskunst der Sofonisba und Lucis Anguissola." *Pantheon.* 20(1962):83–96.

Longhi, R. "Indicazioni per Sofonisba Anguissola." *Paragone.* 157(1963):50–52.

Munsterberg. *History of Women Artists.* P. 19.

Nicodemi, G. "Commemorazione di artisti minor: Sofonisba Anguissola." *Emporium.* (1927):222–223.

Perlingieri, Ilya Sandra. "Lady in Waiting." *Arts and Antiques* (April 1988):66–71, 116–119.
Summarizes Anguissola's biography. Several beautiful color reproductions are included.

———. "Sofonisba Anguissola's Early Sketches." *Woman's Art Journal.* 9(Fall/Winter 1989):10–14.
Perlingieri calls Anguissola a pioneer in the field of genre and notes her importance in disseminating northern Italian Mannerism to Spain. She provides a good summary of her artistic education, discusses three of her early sketches, and suggests their importance in understanding her later work.

Pilkington. *A General Dictionary of Painters.* Vol. 1, pp. 21–22.

Prinz, W. *Die Sammlung der Selstbildnisse in den Uffizien I, Geschichte der Sammlung.* Berlin, 1971

Sacchi, Rossana. "Documenti per Sofonisba Anguissola." *Paragone.* 39(March 1988):73–89.

Sachs. *The Renaissance Woman.* Pp. 39, 88.
 Illustrations of Anguissola's work are provided.

"The Samuel H. Kress Study Collection—Sofonisba Anguissola." *Oberlin College Bulletin.* 19(Fall 1961):34.

Schwartz. "If De Kooning . . ."

Soprani, Raffaele. *Le vite de'pittori, scultori, et architetti genovesi* . . . Genoa, 1674.
 Harris cites from the 1768–69 edition with notes by G. Ratti, pp. 411–16. She describes it as the first published biography of this artist.

Sparrow. *Women Painters of the World.* Pp. 24–28.

Tolnay, Charles de. "Sofonisba Anguissola and Her Relations with Michelangelo." *Journal of the Walters Art Gallery.* 4(1941):116–117.
 An account of letters sent by Anguissola's father to Michelangelo, indicating the strong possibility that Michangelo gave her general advice and criticism of her work.

Tufts. *Our Hidden Heritage.* Pp. 21–29.

Vasari. *Lives of the Most Eminent Painters.*

Wallace, William Edward. "Un Retrato por Sofonisba Anguissola en el Museo Lazuro Galdiano." *Goya.* 207(November-December 1988):138–141.
 Attributes a female portrait in a museum in Madrid to Anguissola that had previously been assigned to Agnolo Bronzino and to Alonso Sanchez Coello.

Zaist, Giovanni Battista. *Notizie istoriche de' pittori, scultori et architetti cremonesi, opera postuma di Giambattista Zaist data in Luce da Anton Maria Panni.* 2 vols. Cremona, 1774.

Collections:

Baltimore, Walters Art Gallery.
Boston Museum of Fine Arts.
Madrid, Prado.
Naples, Museo e Gallerie Nazionali di Capodimonte.
Rome, Galleria Doria Pamphili.
Siena, Pinacotheca Nazionale.
Southampton Art Gallery.
Vienna, Kunsthistorisches Museum.

LAVINIA FONTANA. 1552-1614. Italian.

Fontana's father, Prospero (1512–1597), a Bolognese artist, was her teacher. She is said to have been influenced by Ludovico Carracci, who also was her father's student. In 1577 she married another of her father's students, Giovanni Zappi. Theirs was a liberated relationship in that he supported her career, perhaps even painting the drapery in her paintings. They had eleven children, only three of whom survived their mother. Under the patronage of the popes, Fontana worked in Rome from 1600 to 1614 and was elected to the Roman Academy. Her portraits of the Roman nobility were done in a conservative ''maniera'' style. She also did group portraits, religious scenes and altar pieces, and allegorical works. Of her 135 documented works, fewer than 60 are known today. In 1611 a portrait medal was cast in her honor.

Alf. ''My Interest in Women Artists of the Past.''

Baglione, Giovanni Battista. *Le Vite di Pittori, Scultori et Architetti dal pontificato di Georgio XII del 1572, in fino a'tempi di Papa Urbano VIII nel 1642.* Rome, 1642. P. 143, Facsimile edition with marginal notes by Bellori, edited by V. Mariani, Rome, 1935.

Bénézit. *Dictionnaire.* Vol. 4, p. 424.
Lists her paintings.

Borenius, Tancred. ''A Portrait by Lavinia Fontana.'' *Burlington Magazine.* 41(July 1922):41–42.
Mentions seventeenth-century Italian manuscripts concerning her life.

Bryan. *Dictionary of Painters.* Vol. 2, p. 177.
Lists twenty-two of her most important paintings and recounts the facts of her life.

Cantaro, Maria Tetesa. *Lavinia Fontana bolognese*. Milan: Jandi Sapi Editori, 1989.
 This sumptuous monograph, in Italian, provides a comprehensive essay on Fontana's life and career, a catalogue of her works, and an extensive bibliography. Many of the reproductions are full-page color plates.

Champlin. *Cyclopedia of Painters and Paintings*. Vol. 2, pp. 69–70.

Cheney, Liana. "Lavinia Fontana, *Boston Holy Family*." *Woman's Art Journal*. 5(Spring-Summer 1984):12–15.
 Discussion of a newly discovered painting in a private collection. Cheney compares the iconography with other paintings by Fontana of the same subject.

Clement. *Women in the Fine Arts*. Pp. 128–130.

Edwards. *Women: An Issue*.

Ellet. *Women Artists in All Ages*. Pp. 61–64.

Fine. *Women and Art*. Pp. 10–13.

Freedberg, Sydney. *Painting in Italy, 1500–1600*. Harmondsworth, Middlesex, and Baltimore: Penguin, 1971. P. 394.
 Harris says Freedberg "dismisses her without interest."

Galli, Romeo. *Lavinia Fontana, pittrice, 1552–1614*. Imola: Tip. P. Galeati, 1940.

Greer. *The Obstacle Race*. Pp. 208–214.
 Discusses her artistic relationship with her father and her husband. Says Fontana signed her husband's name to her own work.

Guhl. *Die Frauen* . . .

Harris and Nochlin. *Women Artists, 1550–1950*. Pp. 29–31, 69, 111–115, 341.

Heller. *Women Artists*. P. 19.

"Lavinia Fontana: A Further Contribution." *Burlington Magazine*. 85(October 1944): 258.
 Lists her works in England.

Malvasia, Carlo Cesare. *Felsina pittrice.* Bologna, 1678. Vol. 1, pp. 219–224.
 The chapter on Fontana is faced with a portrait engraving of her.

Mancini, Giulio. *Considerazioni sulla pittura.* 2 vols. Rome: Accademia Nazionale di S. Luca, 1956–57.
 Edited by A. Marucchi and L. Salerno.

Munsterberg. *History of Women Artists.* P. 22.

National Museum of Women in the Arts. Pp. 16–17

Pachero, Francisco. *Arte de la pintura.* 1956. Vol. 1, p. 148.

Parker and Pollock. *Old Mistresses.* Pp. 18–20, 25.

Petersen and Wilson. *Women Artists.* Pp. 26–27.

Ragg. *The Women Artists of Bologna.* Pp. 137–148.

Sachs. *The Renaissance Woman.* P. 39.

Santos, F. Francisco de los. *Descripción de San Lorenzo del Escorial.* 1657 and 1698; as quoted in F. J. Sanchex Canton, *Fuentes literarias para la Historia del Arte Español.* Madrid, 1933. Vol. 2, p. 249.

Schaefer, Jean O. "A Note on the Iconography of a Medal of Lavinia Fontana." *Journal of the Warburg and Courtauld Institutes.* 47(1984):232–234.
 Brief discussion of a portrait medal honoring Fontana, which was struck in 1611.

Schwartz. "If De Kooning . . ."

———. "They Built Women a Bad Art History."

Sparrow. *Women Painters of the World.* Pp. 28–29.

Thieme and Becker. *Allgemeines Lexikon.* Vol. 12, pp. 182–183.

Trevor-Roper, Hugh. *The Plunder of the Arts.* London, 1970. P. 32.

Tufts, Eleanor. "Ms. Lavinia Fontana from Bologna: A Successful Sixteenth Century Portraitist." *Art News.* 73(February 1974): 60–64.

———. *Our Hidden Heritage.* Pp. 31–43.

Collections:

Baltimore, Walters Art Gallery.
Bologna, Pinacoteca Nazionale.
Bordeaux, Musée des Beaux-Arts.
Dublin, National Gallery of Ireland.
Florence, Uffizi.
Imola, Pinacoteca Civica.
Naples, Museo e Gallerie Nazionale di Capodimonte.
Rome, Gallerie Nazionale d'Art Antica.
Washington (D.C.), National Museum of Women in the Arts.

CATERINA VAN HEMESSEN. 1528–after 1587. Flemish.

This Flemish painter, born in Antwerp, was the daughter of artist Jan Sanders van Hemessen. She is thought to have perhaps worked on the backgrounds of some of her father's paintings. She painted half-length portraits and small religious works in a style far simpler and more subdued than her father's lively mannerism. Van Hemessen and her husband, a musician, spent some years in Spain at the court of the abdicated Queen Mary of Hungary. Ten signed and dated works survive today, all painted prior to her marriage. This suggests that she either stopped painting or that her later production has yet to be found.

Bénézit. *Dictionnaire.* Vol. 5, p. 481.
Notes that she married in 1554.

Bergmans, Simone. "Note complémentaire à l'étude des De Hemessen, de van Amstel et du monogrammiste de Brunswick." *Revue belge d'archéologie et d'histoire de l'art.* 27(1958):77–83.

———. "Le problème du Monogrammiste de Brunswick." *Bulletine, Musées Royaux des Beaux-Arts de Belgique.* 14(1965):143–162.
Bergmans believes that Caterina van Hemessen might have been the Brunswick Monogrammist.

———. "Le problème de Jan van Hemessen, monogrammiste de Brunswick." *Revue belge d'archéologie et d'histoire de l'art.* 23(1955):133–157.

Bradley. *Dictionary of Miniaturists.* Vol. 3, p. 197.
Here she is listed as "Catherine Sanders."

Bryan. *Dictionary of Painters.* Vol. 5, p. 15.
 Bryan also lists her under ''Sanders.'' He says she went to Spain in 1556.

Edwards. *Women: An Issue.*

Ellet. *Women Artists. p. 57.*

Fine. *Women and Art.* Pp. 28–29.

Greer. *The Obstacle Race.* Pp. 109–110, 253.
 Describes her technique as that of a miniaturist.

Guicciardini. *Descrittione dei Paesi Bassi.*
 This work, dated 1567, lists Hemessen as a working artist.

Harris and Nochlin. *Women Artists, 1550–1950.* Pp. 12–13, 104–105, 340.

Heller. *Women Artists.* Pp. 24–26.

Munsterberg. *A History of Women Artists.* P. 22.

Sachs. *The Renaissance Woman.* Pp. 38–39.

Sparrow. *Women Painters of the World.* Pp. 24, 253–254.

Thieme and Becker. *Allgemeines Lexikon.* Vol. 16 p. 367.

Tufts. *Our Hidden Heritage.* Pp. 51–57.

Vasari. *Lives of the Most Eminent Painters.* Trans. Devere. Vol. 9, pp. 268–269.
 Mentions van Hemessen in his discussion of miniaturists.

Wilenski, Reginald H. *Flemish Painters, 1430–1830.* 2 vols. London: Faber and Faber, 1960. Vol. 1, p. 573.
 Says she married Christian de Morien, a musician, in 1554.

Collections:

 Amsterdam, Rijksmuseum
 Basel, Öffentliche Kunstsammlung-Kunstmuseum.

Brussels, Musées Royaux des Beaux-Arts de Belgique.
Cambridge, Fitzwilliam Museum.
Cologne, Wallraf-Richartz-Museum.
London, National Gallery.
Paris, Louvre.
Providence, Rhode Island School of Design, Museum of Art.

SUSANNAH HORENBOUT. 1503–after 1550. Flemish.
Only one scrap of documentation survives about this artist, re-
corded by Dürer. At the end of May 1521, while in Antwerp, Dürer made
the following entry in his diary: "Master Gerhard, the illuminator, has a
daughter about eighteen years old named Susannah. She has illuminated
a 'Salvator' on a little sheet, for which I gave her one florin. It is
wonderful that a woman can do so much." Gerhard, with his entire
family, departed for England around 1522 to enter the service of Henry
VIII and to satisfy the court's demand for miniatures. There Susannah
Horenbout married one of the king's archers. After his death she married
a sculptor named Whorstley. She died with honors in her adopted
country. There are numerous variations on the spelling of her name
("Hourbout," "Hornebolt," "Horneband," "Horenebolt," and "Hore-
bout").

Auerbach, Erna. *Tudor Artists*. London: University of London, Athlone
Press, 1954, Pp. 67, 172.

Bénézit. *Dictionnaire*. Vol. 5, p. 618.
Gives her death date as 1545.

Clayton. *English Female Artists*. Vol. 1, pp. 5–7.

Conway, William Martin, ed. and trans. *The Writings of Albrecht Dürer*.
New York: Philosophical Library, 1958. P. 120.

Ellet. *Women Artists*. P. 57.
Here Dürer is reported to have bought a little illuminated book from
Horenbout.

Fine. *Women and Art*. P. 36.

Guicciardini. *Descrittione dei Paesi Bassi*.
"Susan Horenbout" is cited as one of seven Flemish women artists
active in 1567.

Harris and Nochlin. *Women Artists, 1550–1950.* Pp. 25–26, 102.

Long. *British Miniaturists.* P. 222.

Munsterberg. *A History of Women Artists.* P. 22.

Paget, H. "Gerard and Lucas Hornebolt in England." *Burlington Magazine.* 101 (November 1959):396–402.
 An article about her father and brother. Susannah is representative of the many women artists who worked in family workshops and whose name and production are lost to us today.

Redgrave. *Dictionary of Artists of the English School.* P. 228.
 She is mentioned under the listing for her father, which Redgrave spells "Horneband."

Sachs. *The Renaissance Woman.* P. 38.

Sparrow. *Women Painters of the World.* P. 253.

Stephen and Lee. *Dictionary of National Biography.* Vol. 9, p. 1260.

Tufts. *Our Hidden Heritage.* Pp. 43, 243.

Vasari. *Lives of The Most Eminent Painters.* Trans. Devere. Vol. 9, pp. 268–269.
 Says she was the sister of Lucas, an artist, and was from Ghent. Mentions that she was invited into the service of Henry VIII.

Wilenski, Reginald H. *Flemish Painters, 1430–1830.* 2 vols. London: Faber and Faber, 1960. Vol. 1, p. 577.
 Identifies her first husband as John Parker.

BARBARA LONGHI. 1552–1638. Italian.
 Born in Ravenna, Longhi was the daughter and student of Luca Longhi, a Mannerist painter whose style she followed but simplified. She painted portraits and small-scale religious works during a thirty-year period.

Bénézit. *Dictionnaire.* Vol. 6, p. 725.

Bryan. *Dictionary of Painters.* Vol. 3, p. 243.
 Provides a list of her paintings.

Cheney, Liana DeGirolami. "Barbara Longhi of Ravenna." *Woman's Art Journal.* 9(Spring-Summer 1988):16–20.
 Excellent description of Longhi's style and its development. Cheney says that fifteen of her works have been identified, but she suspects that a close study of the works by her father and brother would reveal that some should be reattributed to her.

Clement. *Women in the Fine Arts.* P. 215.

Ellet. *Women Artists in All Ages.* P. 47.

Fine. *Women and Art.* Pp. 21–22.

Greer. *The Obstacle Race.* Pp. 127–128.
 Greer says Longhi probably often assisted her father and that she must have copied many of his works.

Harris and Nochlin. *Women Artists, 1550–1950.* Pp. 28, 106.
 They reproduce Longhi's *Madonna and Child with St. John the Baptist.*

Heller. *Women Artists.* Pp. 22–23.

Sparrow. *Women Painters of the World.* P. 24.

Thieme and Becker. *Allgemeines Lexikon.* Vol. 23, p. 356.

Vasari. *Lives of the Most Eminent Painters.* Trans. Devere. Vol. 9, p. 155.
 Mentions Longhi as "a little girl, draws well and has begun to do some work in color."

Collections:

 Baltimore, Walters Art Gallery.
 Dresden, Staatliche Kunstsammlungen.
 Milan, Pinacoteca di Brera.
 Paris, Louvre.
 Ravenna, Pincoteca dell'Accademia di Belle Arti.

MARIETTA ROBUSTI. 1560–1590. Italian.
 Robusti was the eldest daughter of Tintoretto, with whom she studied. A highly acclaimed portraitist, she was also an accomplished

musician. She was invited to paint for the courts of the Emperor Maximilian of Germany and Philip II of Spain. Whether she remained in Venice because of her father's insistence or because of his poor health is not clear. Robusti was married to a wealthy German jeweler; she died in childbirth. The bulk of her oeuvre has probably been misattributed to her father. One of the remarkable oversights of art history is that, although there has long been an awareness of Robusti as an artist, little interest in discovering her works has surfaced.

Alf. "My Interest in Women Artists of the Past."

Bénézit. *Dictionnaire.* Vol. 10, p. 190.
 Listed as "Maria Tintoretta."

Bryan. *Dictionary of Painters.* Vol. 4, p. 262.

"Buried in False Signatures: Women in Art." *Ladder* (April-May 1972).

Clement. *Women in the Fine Arts.* Pp. 290–292.

Edwards. *Women: An Issue.*

Ellet. *Women Artists.* Pp. 45–47.

Eva. "Women Artists . . ."

Fine. *Women and Art.* Pp. 13–14.
 Says her marriage was arranged under the condition that she remain under the "paternal roof."

Greer. *The Obstacle Race.* Pp. 14–15.

Guhl. *Die Frauen . . .*

Harris and Nochlin. *Women Artists, 1550–1950.* P. 28.
 These authors believe that only the self-portrait in the Uffizi can be securely attributed to Robusti.

Hess. "Is Women's Lib Medieval?"
 Hess relates that in 1920 Venturi changed the attribution of the portrait of Marco del Vescovi in the Vienna Museum from Tintoretto to his daughter.

Newton, Eric. *Tintoretto.* Westport, Connecticut: Greenwood Press, 1952, P. 62.

Osler, W. Roscoe. *Tintoretto.* New York: Scribner and Welford, 1879, Pp. 33–34.
 Anecdotal account of Tintoretto's relationship to his daughter. Until the age of fifteen she assisted him, dressed as a boy, with strangers not realizing her identity.

Petersen and Wilson. *Women Artists.* P. 28.

Rossi, P. *Iacopo Tintoretto, I Ritratti.* Venice, 1974. Pp. 138–139.

Schwartz. "They Built Women a Bad Art History."

Thieme and Becker. *Allgemeines Lexikon.* Vol. 33, pp. 198–199.

Tietze-Conrat, E. "Marietta, fille du Tintoret: peintre de portraits." *Gazette des beaux-arts.* 12(December 1934): 258–262.
 Discussion of the reattribution of a work from her father to her, based on the discovery of her signature. Illustrates two of her works and her portrait painted by her father.

"Women Artists" (review of Guhl).

Collections:

 Florence, Museo Nazionale.
 Florence, Uffizi.
 Vienna, Kunsthistorisches Museum.

PROPERZIA DE'ROSSI. 1490–1530. Italian.
 De'Rossi is the only women sculptor to emerge from the Italian Renaissance. Born in Bologna, she was a pupil of Marcantonio Raimondi and was influenced by Tribolo. De'Rossi also did engravings and etchings, was an accomplished musician, and was educated in the sciences. Her first work was reportedly a crucifixion scene carved on a peach stone. In 1534 she was commissioned to decorate the canopy of the high altar of the Bolognese church of S. Maria del Barracano. When she received a commission for part of the facade decorations of S. Petronio, another Bologna church, her male competitors became jealous and waged a campaign to discredit her. As a result, her bas-relief of

Joseph and Potiphar's Wife (a work that had earned praise from Vasari) was interpreted as revealing her unrequited love for a young nobleman. The church elected not to put the relief in place. Through grief and mortification at this discrimination, de'Rossi died at age forty.

Bénézit. *Dictionnaire.* Vol. 9, p.107
 Here de'Rossi is described as a sculptor in wood and stone, a carver of cameos, and an engraver.

Clement. *Women in the Fine Arts.* Pp. 229–301.

Ellet. *Women Artists.* Pp. 39–42.
 Spells her name "di Rossi."

Fine. *Women and Art.* Pp. 8–9.

Greer. *The Obstacle Race.* Pp. 209–210.

Guhl. *Die Frauen . . .*

Harris and Nochlin. *Women Artists, 1550–1950.* Pp. 25, 27, 30

Heller. *Women Artists.* Pp. 23–24.

Munsterberg. *A History of Women Artists.* P. 85

Parker and Pollock. *Old Mistresses.* Pp. 3, 9, 17–18, 86.

Petersen and Wilson. *Women Artists.* P. 27

Ragg. *Women Artists of Bologna.* Pp. 167–189.

Sachs. *The Renaissance Woman.* Pp. 39, 82.
 A reproduction of a bas-relief by de'Rossi is provided.

Thieme and Becker. *Allgemeines Lexikon.* Vol. 29, pp. 71-72.

Tufts. *Our Hidden Heritage.* Pp. xvi, 244.

Vasari. *Lives of Italian Painters.* Edited and prefaced by Havelock Ellis. London: Walter Scott, Vol. 4, pp. 181–186.

"Women Artists." (review of Guhl).

Collections:

Bologna, Museo Civico.
Bologna, Museo di San Petronio.

DIANA GHISI SCULTORI. 1530–1590. Italian.
This artist is known by a variety of names. She was born in Mantua and was the student of her father, who has been identified as Giovanni Battista Scultori and as Giovanni Battista Ghisi. Her name is sometimes found as "Diana Ghisi," as "Diana Scultori," or "Diana Sculptore," as "Mantuana," and as "Mantovana." There also seems to be confusion about the name of her husband. Various sources identify him as the architect-sculptor Francesco Ricciarelli, as the architect Francesco Capriani, or as the architect Francesco da Volterra. She apparently married around 1578. Diana Ghisi Scultori painted and engraved religious, genre, and history subjects. Forty-six engravings have been cataloged as hers.

Albricci, Giocanda. "Prints by Diana Scultori." *Print Collector.* 12(March-April 1975):17–23, 51–57.

Bartsch, Adam Ritter von. *Le peintre graveur italian.* Milan: U. Hoepli, 1906.
This author has cataloged her prints.

Bellini, Paolo. "Alcuni dati sull'attivita Romana di Diana Scultori." *Paragone.* 38(November 1987):53–60.
Discusses the artist's activities in Rome. No illustrations are provided.

Bénézit. *Dictionnaire.* Vol. 4, p. 704.

Brodsky, Judith. "Some Notes on Women Printmakers." *Art Journal.* 35(Summer 1976):28–30.

Bryan. *Dictionary of Painters.* Vol. 5, p. 60.

Ellet. *Women Artists in All Ages.* Pp. 43–44.

Feinberg, Alice M. "Diana Ghisi—Italian Printmaker, 1530–1590." *Feminist Art Journal.* 4(Fall 1975):28–30
Feinberg's article has supplied much of the above bibliography.

Good black-and-white reproductions of several of Ghisi's prints are included.

Harris and Nochlin. *Women Artists, 1550–1950.* P. 29.

Munsterberg. *A History of Women Artists.* Pp. 105–106.
 Cites different birth and death dates.

New York. Grolier Club. *Catalogue of a Collection of Engravings, Etchings and Lithographs by Women.* P. 38.

Sparrow. *Women Painters of the World.* P. 39.

Strutt. *Biographical Dictionary.* Vol. 1, p. 334.

Vasari. *Lives of the Most Eminent Painters.* Trans. Devere. Vol. 8, P. 42.

Collection:

Cambridge, Harvard University, Fogg Art Museum.

IRENE DI SPILIMBERG. 1540–1560. Italian.
 This artist was born in Udina, Italy, to a noble family that originated in Germany. She was educated in Venice, where for two years she was the student of Titian. She was not only skilled in painting, but was also proficient in letters, music, and design. She died at the age of twenty, her early promise unrealized. No work is attributed to her today.

Bénézit. *Dictionnaire.* Vol. 9, p. 748.
 Gives her death date as 1559.

Bryan. *Dictionary of Painters.* Vol. 5, p. 109.
 Bryan spells her name ''Spilembergo'' and says she painted for her amusement only.

Clement. *Women in the Fine Arts.* Pp. 320–321.

Ellet. *Women Artists in All Ages.* Pp. 44–45.

Fine. *Women and Art.* Pp. 21–22.

Greer. *The Obstacle Race.* Pp. 182–183.

Describes the Academy's public mourning of her death. Also gives her death date as 1559.

Guhl. *Die Frauen . . .*

Harris and Nochlin. *Women Artists, 1550–1950.* P. 28.
These authors note that Spilimberg was inspired to try painting after seeing a self-portrait of Sofonisba Anguissola. This incident points out the crucial necessity for role models, both historical and contemporary, for young women artists.

Minghetti, Marco. "Le donne italiane nelle belle arti al secolo xv et xvi." *Nuova antologia.* 35(1877):308–330.
Mention of Spilimberg, pp. 319ff.

Sachs, Hannelore. *Renaissance Woman.* P. 39.

Sparrow. *Women Painters of the World.* P. 285.

Vasari. *Lives of the Most Eminent Painters.* Trans. Devere. Vol. 9, p. 175.

LEVINA TEERLINC. ca. 1520–1576. Flemish.
Teerlinc was the daughter and student of Flemish miniaturist Simon Benninck. She too became a miniaturist. She was invited to England by Henry VIII, who paid her a higher salary than he did Holbein. In 1566, with her husband and son, she became an English subject and continued to serve under Edward VI, Mary, and Elizabeth I. While Teerlinc's life and career are quite well documented from contemporary records—enabling Harris and Nochlin to describe has as "the most important miniaturist active in England between Holbein and Hilliard"—the complete lack of signed works by her and the lack of a dedicated scholar to reassemble her oeuvre leave her with only a few tentative attributions. Her name is alternately spelled "Teerling."

Auerbach, Erna. *Tudor Artists.* London: University of London, Athlone Press, 1954. Pp. 103–106, 187–188.

Bénézit. *Dictionnaire.* Vol. 1, p. 624.
Gives her father's name as "Simon Bening."

Bergmans, Simone. "The Miniatures of Levina Teerlinc." *Burlington Magazine.* 64(1934):232–236.

This illustrated article attempts to attribute several minatures to Teerlinc, based on the previous attribution of a work in the Victoria and Albert Museum.

Clayton. *English Female Artists.* Pp. 7-12.

Durrieu, Paul. *Alexandre Bening et les peintres du Bréviare Grimani.* Paris, 1891.

Ellet. *Women Artists in All Ages. Pp. 57-58.*

Fine. *Women and Art.* Pp. 21–22.

Gucciardini. *Descrittione dei Paesi Bassi.* 1567.
 Harris and Nochlin cite this brief mention as the only one in print prior to the nineteenth century.

Harris and Nochlin. *Women Artists, 1550–1950.* Pp. 26, 102–104, 340.
 These authors question most of the attributions given in Tuft's chapter (below).

Heller. *Women Artists.* Pp. 26-27.

Long, Basil. *British Miniaturists.* London: Holland Press, 1929, Pp. 432–433.

Nichols, John Gough. ''Notices of the Contemporaries and Successors of Holbein.'' *Archaeologia.* 30(1863):39–40.

Petersen and Wilson. *Women Artists.* P. 27.

Reynolds, G. *The Connoisseur Period Guides: The Tudor Period, 1500–1603.* London, 1956.
 See ''Portrait Miniatures,'' p. 131.

Sachs. *The Renaissance Woman.* Pp. 38, 83.
 Reproduces a full-page, black-and-white self-portrait.

Strong, Roy C. *The English Icon: Elizabethan and Jacobean Portraiture.* London, 1969.

―――. *The English Renaissance Miniature.* London: Thames and Hudson, 1983. Pp. 54–64.
 In a chapter entitled ''Gentlewoman to the Queen,'' Strong re-

counts Teerlinc's career and her relationships with Queen Elizabeth I
and Queen Mary. Includes several black-and-white reproductions of
her work.

Tufts. *Our Hidden Heritage.* Pp. 43–49.

Vasari. *Lives of the Most Eminent Painters.* Trans. Devere. Vol. 9, pp.
268–269.
 Teerlinc is only mentioned in the discussion of miniaturists.

Walpole. *Anecdotes of Painting.* Vol. 1, p. 108.

Collections:

 Amsterdam, Rijksmuseum.
 London, Victoria and Albert Museum.
 Windsor Castle, Royal Art Collection.

MAYKEN VERHULST. ca. 1520–ca.1600. Flemish.
 Verhulst (also known as Marie Bessemers) was born in Malines. In
1537 she married the artist Pieter Coeck van Aelst. She was Pieter
Brueghel's mother-in-law and the grandmother and first teacher of Jan
"Velvet" Brueghel. There are no works currently attributed to her,
although she is known to have done watercolors and minatures.

Bénézit. *Dictionnaire.* Vol. 1, p. 713.
 Listed under "Marie Bessemers."

Bergmans, Simone. "Le problèm de Jan van Hemessen, monogramma-
 tiste de Brunswick." *Revue belge d'archéologie et d'histoire de l'art.*
 23(1955):133–157.
 Bergmans considers the possibility that Mayken Verhulst may have
 been the Brunswick Monogrammist.

Fine. *Women and Art.* Pp. 36, 38.
 Notes that Verhulst's father, Herman, was also a painter.

Foote, Timothy. *The World of Bruegel, c. 1525–1569.* New York:
 Time-Life Books, 1968. Pp. 70–71, 170.

Greer. *The Obstacle Race.* P. 26.

Harris and Nochlin. *Women Artists, 1550–1950.* P. 105.

Sachs. *The Renaissance Woman.* P. 38.

Thieme and Becker. *Allgemeines Lexikon.* Vol. 3, p. 534.
 Listed under "Bessemers."

Tufts. *Our Hidden Heritage.* Pp. 52, 243.

Wilenski, Reginald H. *Flemish Painters, 1430–1830.* 2 vols. London:
 Faber and Faber, 1960. Vol. 1, p. 494.
 Listed under "Bessemers."

SEVENTEENTH CENTURY

JOSEFA DE AYALA. Ca.1630–1684. Spanish/Portuguese.
De Ayala was born in Seville. Her mother was Spanish. Her father, a portrait painter, was Portuguese. By 1636 the family had moved to Obidos, Portugal, where de Ayala lived for most of her life. Her artistic output included prints, still lifes, portraits, and religious and allegorical works. De Ayala was elected to membership in the Lisbon Academy. She is also known as Josefa de Obidos.

Bénézit. *Dictionnaire.* Vol. 1, p. 339.
Says she was the student of landscape painter Balthazar Gómez Figueira.

Greer. *The Obstacle Race.* Pp. 235–236.

Heller. *Women Artists.* Pp. 48–49.

Mitchell. *Great Flower Painters.* P. 190.
Listed as "Obidos."

Smith, Robert C. *The Art of Portugal, 1500–1800.* New York: Meredith Press, 1968. P. 203.
Describes her works as displaying "obsessive piety." Although most of her work is religious, at the end of her life she did still lifes in the style of Zurbarán.

Sobral, Lujis de Moura. "Un nuevo cuadro de Josefa de Ayala (O de Obidos)." *Archivo Español de Arte.* 57(October–December 1984):386–387.
Description of one of her works. Includes a detail of her signature.

Sullivan, Edward J. "Josefa de Ayala—A Woman Painter of the Portuguese Baroque." *Journal of the Walters Art Gallery.* 37(1978):22–35.

This is the first study in English of de Ayala's life and work. Sullivan traces the influence of Zurbarán and northern painting on her oeuvre. Includes several black-and-white illustrations.

———. "Obras de Josefa de Ayala, Pintora Ibérica." *Archivo Español de Arte.* 54(January–March 1981):87–93.
Includes black-and-white reproductions.

Collections:

Baltimore, Walters Art Gallery.
Coimbra, Museu Nacional de "Machado de Castro."
Lisbon, Museu Nacional de Arte Antiga.

MARY BEALE. 1632–1699. English.
Beale is considered by some authorities to be the first English woman to make her living by painting. She was primarily a portraitist. Her father, a clergyman, was an amateur artist. Although she married an artist—Charles Beale, in 1651—he took over the roles of managing the household, grinding her colors, and preparing her canvas, while she became the breadwinner. Sir Peter Lely was her friend and mentor, and she probably studied with Thomas Flatman. Beale had two sons, one of whom, Charles, became a miniaturist and portrait painter and assisted his mother with her practice in London.

Bénézit. *Dictionnaire.* Vol. 1, pp. 543.

Bryan. *Dictionary of Painters.* Vol. 1, p. 100.

Champlin. *Cyclopedia of Painters and Paintings.* Vol. 1, p. 114.
Notes that she was also a reputed poet. Gives her death date as 1697.

Clayton. *English Female Artists.* Vol. 1, pp. 40–53.

Clement. *Women in the Fine Arts.* Pp. 34–35.

Cullum, George. *Mary Beale.* Ipswich: W. S. Harrison, 1918.

Daniels, Jeffery. "The Excellent Ms. Mary Beale." *Art News.* 74(October 1975):100–101.
Good summary of her life and work. Illustrated with a black-and-white self-portrait.

Ellet. *Women Artists in All Ages.* Pp. 123–124.

Fine. *Women and Art.* Pp. 68–69.
 Fine believes the portraitist Robert Walker may have been Beale's
first teacher.

Flower, Sibylla J. "The Excellent Mrs. Mary Beale." *Connoisseur.*
190(December 1975):302.

Foskett. *A Dictionary of British Miniature Painters.* Vol. 1, p. 157.

Foster. *Dictionary of Painters of Miniatures.* P. 15.

Greer. *The Obstacle Race.* Pp. 255–257.

Harris and Nochlin. *Women Artists, 1550–1950.* P. 363.

Heller. *Women Artists.* Pp. 46–47.
 Heller notes that Beale's art is often confused with that of Sir Peter
Lely, as she was commissioned to make copies of his works after his
death.

John. "The Woman Artist."

London. Geffrye Museum. *The Excellent Mrs. Mary Beale.* 1975.
 This catalog is by Elizabeth Walsh and Richard Jeffree. It is the
principal source of information on Beale's life.

Long. *British Ministurists.* Pp. 21–22.

Petersen and Wilson. *Women Artists.* Pp. 34–35.

Pilkington. *A General Dictionary of Painters.* Vol. 1, p. 58.
 "She was amiable in her conduct, assiduous in her profession, and
had the happiness to live in universal esteem, and to receive every
encouragement."

Redgrave. *Dictionary of Artists of the English School.* P. 33.
 Mentions Beale's skill as a poet.

Reitlinger, Henry S. "The Beale Drawings in the British Museum."
Burlington Magazine. 41(September 1922):143–147.
 Reitlinger provides a general description of the 176 drawings, 165
of which are attributed to Mary Beale. He discusses early documents
related to the drawings and proposes that the bulk of the collection

might instead be by Beale's son, Charles. Several good black-and-white illustrations are included.

Sparrow. *Women Painters of the World.* Pp. 57–58.

Stephen and Lee. *Dictionary of National Biography.* Vol. 2, pp. 2-3.
Here Beale is described as "one of the best female portrait painters of the seventeenth century."

Thieme and Becker. *Allgemeines Lexikon.* Vol. 3, p. 110.

Tufts. *Our Hidden Heritage.* Pp. xv, 101.

Vertue, George. *The Note-Books of G. Vertue Relating to Artists and Collections in England.* 6 vols. Oxford, 1930–42. Prepared by Katherine Esdaile, S. H. F. Strangways, and Sir Henry Hake.

Walpole. *Anecdotes of Painting.* Vol. 2, pp. 537–544.
Quotes at length from the pocketbook journals kept by Beale's husband, the most valuable source of information on this artist. According to Walpole, most of the thirty-odd volumes were lost, but one is located at Oxford University's Bodleian Library and one is in the possession of the National Portrait Gallery. Walpole's quotes are taken from Vertue's extractions of the journals.

Walsh, Elizabeth. "Mrs. Mary Beale, Paintress." *Connoisseur.* 131(April 1953):3–8.
Discusses the heavy influence of Lely on Beale's work between 1672 and 1681. Notes that her reputation as a portraitist was first established in ecclesiastical circles. Draws from contemporary letters and diaries to record details of her life. Establishes her death date as 1699 (not 1697, as Walpole notes).

Collections:

London, British Museum.
London, National Portrait Gallery.
Oxford, Bodleian Library.

JOAN CARLILE. Ca. 1606–1679. English.
Carlile is the earliest known professional English woman portrait painter. In virtually every source she is mistakenly listed as "Anne

Carlile.'' She was the daughter of a civil servant and received her training in London. In 1629 she married Lodwick Carlile. In 1654 she and her husband moved from their country home to the artists' quarter of London, Covent Garden. Carlile was a favorite painter of King Charles I. Most of her portraits were full-length.

Bryan. *Dictionary of Painters.* Vol. 1, p. 251.
 Bryan, who lists her as ''Anne Carlile,'' notes that she was admired for her copies of the works of Italian masters. He identifies her husband as a dramatist.

Clayton. *Women in the Fine Arts.* Vol. 1, pp. 19–21.
 Listed as ''Anne.''

Ellet. *Women Artists.* P. 122.

Fine. *Women and Art.* Pp. 67–68.

Foster. *Dictionary of Painters of Miniatures.* P. 48.

Greer. *The Obstacle Race.* P. 255.

Stephen and Lee. *Dictionary of National Biography.* Vol. 3, p. 1008.
 Carlile is listed as ''Anne.'' The entry notes that she copied Italian masters and reproduced them in miniature.

Redgrave. *Dictionary of Artists of the English School.* P. 70.

Toynbee, Margaret. ''Joan Carlile: Some Further Attributions.'' *Connoisseur.* 178(November 1971):186–188.
 Illustrates four works and defends their attribution to Carlile.

———, and Gyles Isham. ''Joan Carlile (1606?–1679): An Identification.'' *Burlington Magazine.* 96(September 1954):275–277.
 This article notes the frequent misidentification of the first name of the artist, but offers no explanation. These authors say her husband was the keeper of Richmond Park until their move to London in 1663. Sources of information about the artist are reviewed, and eight of her works are described. Five black-and-white reproductions are included.

Collection:

London, National Portrait Gallery.

ELISABETH SOPHIE CHÉRON. 1648–1711. French.

Chéron was born in Paris, the daughter of the painter Henri Chéron, from whom she learned miniature and enamel painting. When her father died, she became the sole support of the family. Originally a Protestant, she converted to Catholicism. Chéron was admitted to the French Academy in 1672 and was later pensioned by Louis XIV. In 1699 she became a member of the Padua Academy. She married in 1692, at the age of sixty. Her husband, Jacques Le Hay, was an engineer for the king. Chéron was known primarily for allegorical portraits and history paintings, but was also accomplished as a printmaker, musician, and poet. She painted several self-portraits.

Bénézit. *Dictionnaire.* Vol. 2, p. 714.

Brodsky, Judith. "Rediscovering Women Printmakers, 1550–1850." *Counterproof.* 1(Summer 1979):7.

Bryan. *Dictionary of Painters.* Vol. 1, p. 288.

Clement. *Women in the Fine Arts.* Pp. 81–83.

Ellet. *Women Artists in All Ages.* Pp. 90–92.

Fine. *Women and Art.* P. 44.

Greer. *The Obstacle Race.* Pp. 72–74, 259.

Greer says that Chéron had to support the family after the father abandoned them. She also notes that her religious conversion was a means of retaining royal patronage.

Guhl. *Die Frauen . . .*

Harris and Nochlin. *Women Artists. 1550–1950.* Pp. 29, 36.

Krull. *Women in Art.* Pp. 33, 76.

Krull notes that a folio of Chéron's engravings, *Livre des principes à dessiner,* was published in Paris, in 1706.

Mirimonde, A. P. de. "Portraits de musiciens et concerts de l'Ecole Française." *Revue du Louvre.* 15(1965):217–219.

Discusses Chéron's use of self-portraits to point out her talents as a musician. Includes two illustrations.

New York. Grolier Club. *Catalogue of a Collection of Engravings, Etchings and Lithographs by Women.* 1901. Pp. 18–19.

Paris. Grand Palais. *Le femme peintre et sculpteur du XVIIe siècle.* 1975.

Petersen and Wilson. *Women Artists.* P. 34.
 Illustrated with self-portrait.

Sparrow. *Women Painters of the World.* Pp. 173–174.

Strutt. *Biographical Dictionary.* Vol. 1, p. 197.

Thieme and Becker. *Allgemeines Lexikon.* Vol. 6, pp. 30–31.

"Women Artists" (review of Guhl).

Collection:

 Paris, Louvre.

SUZANNE DE COURT. Active ca. 1600. French.
 Suzanne de Court was the daughter of Jean de Court, from whom she learned the art of enameling, and the wife of Jehan de Court. She did elaborate Limoges enamels in colors rather than grisaille.

Bénézit. *Dictionnaire.* Vol. 3, p. 225.

Gabhart and Broun. "Old Mistresses."

Harris and Nochlin. *Women Artists, 1550–1950.* P. 20.

Krull. *Women in Art.* Pp. 22–23.
 Illustrates an enamel of *The Last Supper* by de Court.

Petersen and Wilson. *Women Artists.* P. 33.

Thieme and Becker. *Allgemeines Lexikon.* Vol. 7, p. 585.

Collections:

 Baltimore, Walters Art Gallery.
 Dijon, Musée des Beaux-Arts.

Lyon, Musée des Beaux-Arts.
New York, Metropolitan Museum of Art.
Paris, Louvre.

FEDE GALIZIA. 1578–1630. Italian.
Galizia was the daughter of the Milianese miniaturist Annunzio Galizia. A child prodigy, her talents were noted in print by the time she was twelve years old, and she had established a portrait career by the age of sixteen. Harris and Nochlin say the still lifes are her most important works, calling them among the earliest true still lifes. She also did religious and history paintings.

Bénézit. *Dictionnaire.* Vol. 4, p. 590.

Bottari, Stefan. "Fede Galizia." *Arte antica e moderna.* 24(1963):309–360.
Attributes a corpus of about twenty still lifes to Galizia.

———. *Fede Galizia pittrice (1578–1630).* Trento: Collana Artisti Trentini, 1965.
This catalog of Galizia's works is an enlarged version of the 1963 article. It contains more illustrations.

Bradley. *A Dictionary of Miniaturists.* Vol. 2, p. 7.

Bryan. *Dictionary of Painters.* Vol. 2, p. 209.
Says she excelled in small portraits.

Ellet. *Women Artists.* P. 60.

Fine. *Women and Art.* Pp. 21–22.

Greer. *The Obstacle Race.* Pp. 228–231.

Harris and Nochlin., *Women Artists, 1550–1950.* Pp. 28, 31–33, 41–43, 106, 115–117, 341.
I am indebted to this source for most of the above bibliography.

Heller. *Women Artists.* Pp. 20, 22.

Lomazzo, G. P. *Idea del tempio della pittura.* Milan, 1690. P. 163.

Parker and Pollock. *Old Mistresses.* Pp. 20, 51–52.

Spike, John T. *Italian Still-Life Paintings from Three Centuries.*
Florence: Centro Di, 1983. Pp. 30–32.

Thieme and Becker. *Allgemeines Lexikon.* Vol. 13, p. 99.

Collections:

Milan, Pinacoteca Ambrosiana.
Milan, Pinacoteca di Brera.
Sarasota (Florida), John and Mable Ringling Museum of Art.

GIOVANNA GARZONI. 1600–1670. Italian.
 Giovanna Garzoni did small studies of plants and animals in
tempera and watercolor on vellum, using a delicate and characteristic
stipple technique. Her simple and elegant compositions are among the
finest botanical studies made in the seventeenth century. She also did
portraits and religious works. Garzoni is thought to have been born in
Ascoli Piceno. She lived and worked in Florence, Rome, Naples, Turin,
and Venice. Nothing is known of her training. Her patrons included the
Medici and the Spanish viceroy of Naples. Garzoni was a member of the
Academy of St. Luke in Rome.

Bénézit. *Dictionnaire.* Vol. 4, p. 625.
 Notes that she also did miniatures.

Blunt, W. *The Art of Botanical Illustration.* New York, 1951. P. 81.

Bottari, Giovanni Gaetano. *Raccolta di lettere sulla pittura, scultore, ed
 architettura.* Milan, 1754; Milan, 1822–1825 ed., Vol. 1, pp. 238–
 242.
 Later edition enlarged by Stefan Ticozzi.

Bradley. *Dictionary of Miniaturists.* Vol. 2, p. 11.
 Says that she did copies, in miniature, of celebrated paintings.
Gives 1673 as her death date.

Bryan. *Dictionary of Painters.* Vol. 2, p. 217.
 Bryan notes that Garzoni bequeathed all her property to the
Academy of St. Luke in Rome.

Carboni, Giacinto. Cantalamessa. *Memorie intorno i letterati i gli artisti
 della citta di Ascoli nel Piceno.* Ascoli Piceno, 1830.

Colding, Torben Holch. *Aspects of Miniature Painting: Its Origins and Development.* Copenhagen, 1953.

Ellet. *Women Artists.* P. 82.

Fine. *Women and Art.* Pp. 21–22.

Greer. *The Obstacle Race.* P. 232.

Harris and Nochlin. *Women Artists, 1550–1950.* Pp. 27, 73, 134–136, 342.
 Harris and Nochlin cite many mentions of Garzoni in the archives of the Academy of St. Luke, of which she was a member.

Heller. *Women Artists.* Pp. 35–36.

Meloni, Silvia. "The Gentle Genre." *FMR.* 11(May 1985):105–124.
 Excellent biographical summary, accompanied by beautiful color reproductions. Notes that letters and documents relating to her life and travels are in the archives of the Academy of St. Luke.

Mitchell, Peter. *Great Flower Painters: Four Centuries of Floral Art.* P. 119.

Mongan, Agnes. "A Fête of Flowers: Women Artists' Contribution to Botanical Illustration." *Apollo.* 119(April 1984):264–267.

Naples. Palazzo Reale. *La natura morta italiana.* 1964.
 An exhibit organized by Stefan Bottari, with catalog by Raffaelo Causa, Italo Faldi, Mina Gregori, Anna Ottani, et al. Harris and Nochlin credit Mina Gregori with the reconstruction of Garzoni's artistic personality.

Pascoli, Lione. *Vite de' pittori, scultori, ed architetti moderni.* 2 vols. Rome, 1730–1736.

Petersen and Wilson. *Women Artists.* P. 131.
 A reproduction of her work is provided.

Spike, John T. *Italian Still-life Paintings from Three Centuries.* Florence: Centro Di, 1983. Pp. 65-70.
 Excellent biographical summary and description of her style. Spike notes that her works are often misattributed to Jacopo Ligozzi, a Veronese artist working at the Midici court in Florence and that she

may have studied with him. Excellent color reproductions are included.

Thieme and Becker. *Allgemeines Lexikon.* Vol. 13, pp. 223–224.

Collections:

Cleveland Museum of Art.
Florence, Palazzo Pitti.
Florence, Uffizi.
The Hague, Mauritshuis.
Madrid, Biblioteca Nacional.
Rome, Galleria dell'Accademia di San Luca.

ARTEMISIA GENTILESCHI. 1593–ca.1652. Italian.
 Gentileschi was born in Rome and grew up in Bologna. She was the daughter and student of Orazio Gentileschi (1563–1639), whose name she kept rather than take that of her husband. In 1612 her father charged Agostini Tassi, who had been hired to teach her perspective, with raping her. After a trial, Gentileschi was married off to a respectable Florentine and had at least one daughter. In 1615 she left her husband and moved to Rome. She became a member of the Florence Academy the following year. Gentileschi was working in Naples between 1626 and 1630 and by 1635 was working with her father in England. She was one of the major contributors to the development of the Baroque style and can be classified as a follower of Caravaggio. Gentileschi was one of the first women artists to choose women as subject matter, depicting strong, powerful heroines, as in her several paintings of Judith decapitating Holofernes.

Baldinucci, Filippo. *Notizie dei professori del disegno da Cimabue in qua.* Vol. 3. Florence, 1681.
 Harris and Nochlin cite the original edition as 1681–1728 and refer to *Opere di Filippo Baldinucci.* Milan, 1808–1812. They say Baldinucci merely added a short biography of her to the one on her father.

Bénézit. *Dictionnaire.* Vol. 4, p. 672.

Bissell, R. Ward. "Artemisia Gentileschi—A New Documented Chronology." *Art Bulletin.* 50(June 1968):153–168.
 This article discusses the records of the rape trial which her father initiated against Tassi. Gentileschi was reportedly tortured for evidence in the trial, which reveals the slow improvement in jurispru-

dence for rape victims. The assumption is often made that her work reflects a hostility to men—in fact, it could well be a reflection of empathy with women. She consistently chose strong female personalities as subjects—such as Queen Esther and Bathsheba. This article includes a number of good black-and-white reproductions.

Borea, Evelina. *Caravaggio e Caravaggeschi nelle Galleria di Firenze.* Florence: Palazzo Pitti, 1970.

Bryan. *Dictionary of Painters.* Vol. 2, p. 229.

Campos, R. Redig de. "Una giuditta opera sconosciuta del Gentileschi Nella Pinocoteca Vaticana." *Rivista d'Arte.* 11(July 1939):311–323.

Cavaliere, Barbara. "Artemisia Gentileschi: Her Life in Art." *Womanart.* 1(Fall 1976).

Clayton. *English Female Artists.* Pp. 21–30.

Clement. *Women in the Fine Arts.* Pp. 140–141.

Crino, Anna Maria. "More Letters from Orazio and Artemisia Gentileschi." *Burlington Magazine.* 102(July 1960):264–265.
 Reprints four letters from Gentileschi to her patron, Andrea Cioli. Mentions that she taught her daughter to paint.

Ellet. *Women Artists.* Pp. 66–67.

Farina, Ruth E. *Artemisia Gentileschi: Italian Artist of the Seicento.* M.A. thesis, California State University, Los Angeles, 1976.

Fine. *Women and Art.* Pp. 14–17.

Fowle, Geraldine E. "The Lady Who Got Tassi Thrown into Prison." *Helicon Nine.* 2(Summer 1980):54–63.
 Summarizes Gentileschi's career and rape trial.

Frohlich-Bume, L. "Rediscovered Picture by Artemisia Gentileschi: Fame." *Burlington Magazine.* 77(November 1940):169.

Gabhart and Broun. "Old Mistresses."

Garrard, Mary D. "Artemisia and Susanna." *Feminisim and Art History.* Broude and Garrard, eds. Pp. 146–167.

————. *Artemisia Gentileschi: The Image of the Female Hero in Italian Baroque Art.* Princeton, New Jersey: Princeton University Press, 1989.

The definitive work on Gentileschi and a marvelous example of feminist scholarship. Gentileschi's biography is thoroughly presented, her works are evaluated and placed in the context of the times, and superb reproductions, many in color, are provided.

————. "Artemisia Gentileschi's Self-Portrait as the Allegory of Painting." *Art Bulletin.* 62(March 1980):97–112.

Discussion of a work by Gentileschi in which she directly joins her own image with an allegorical representation of painting.

Greer. *The Obstacle Race.* Pp. 134, 191–207.

Recounts Gentileschi's relationship with Tassi. Provides a brief analysis of her work.

Guhl. *Die Frauen . . .*

Harris and Nochlin. *Women Artists, 1550–1950.* Pp. 15, 27, 32, 70–71, 118–124, 341–342.

Heller. *Women Artists.* Pp. 29–32.

Hofrichter, Frima Fox. "Artemisia Gentileschi: *Judith* and a Lost Rubens." *Rutgers Art Review.* 1(January 1980):9–15.

Krull. *Women in Art.* P. 113.

Levey, Michael. "Notes on the Royal Collection II: Artemisia Gentileschi's 'Self Portrait' at Hampton Court." *Burlington Magazine.* 104(February 1962):79–80.

Compares this work to other portraits by Gentileschi.

Longhi, Roberto. "Gentileschi padre e figlia." *L'arte.* 19(1916):245–314; reprinted in *Scritti Giovenili, 1912–1922* (Florence, 1961), Vol. 1, pp. 219–283.

Moir, Alfred. *The Italian Followers of Caravaggio.* Cambridge, Massachusetts: Harvard University Press, 1967.

Munsterberg. *A History of Women Artists.* Pp. 23–26.

Richardson, E. P. "Masterpiece of Baroque Drama: Gentileschi's *Judith and Holofernes." Art Quarterly.* 16(Summer 1953):90–92.
Contends that the servant depicted in this work is a self-portrait.

Ruffo, Vicenzo. "Galleria Ruffo nel secolo XVII in Messina con lettere di pittori ed altri documenti inediti." *Bollettino d'arte* (1916):21ff.

Sandrart, Joachim von. *Academie der Bau-, Bild- und Mahlery-Künste von 1675.* Munich, 1925.

Schwartz. "They Built Women a Bad Art History."

———. "If De Kooning . . ."

Sparrow. *Women Painters of the World.* Pp. 28, 31, 42, 45.

Spear, Richard. *Caravaggio and His Followers.* Cleveland: Cleveland Museum of Art, 1971. Pp. 96–99.

———. "Caravaggisti at the Palazzo Pitti." *Art Quarterly.* 34(1971):108–110.
A couple of attributions to Gentileschi are briefly mentioned.

Thieme and Becker. *Allgemeines Lexikon.* Vol. 13, pp. 408–409.

Toesca, Maria. "Versi in lode di Artemisia Gentileschi." *Paragone.* 251(1971):89–92.

Tufts. *Our Hidden Heritage.* Pp. 59–69.

Voss, Hermann. *Die Malerei des Barock in Rom.* Berlin, 1924. P. 463.

Walpole. *Anecdotes of Painting.* Vol. 2, p. 361.
"As famous for her loves as for her painting, but not inferior to her father."

Wittkower, Rudolf. *Art and Architecture in Italy, 1600–1750.* Baltimore: Penguin Books, 1969. Pp. 231.

———, and Margot Wittkower. *Born Under Saturn.* London: Weidenfeld and Nicolson, 1963, Pp. 162–164.
A section of chapter 7, entitled "Agostino Tassi—The Seducer of Artemisia Gentileschi," recounts the highlights of the rape trial, but in a rather flippant, anecdotal manner.

"Women's Art" (review of Guhl).

Young, Mahonri Sharp. "Three Baroque Masterpieces for Columbus."
Apollo. 86(July 1967):78–81.
 Briefly describes and illustrates in color her *David and Bathsheba.*

Collections:

Baltimore, Walters Art Gallery.
Bologna, Collezioni Communali d'Art.
Cambridge (Massachusetts), Harvard University, Fogg Art Museum.
Columbus (Ohio), Gallery of Fine Arts.
Detroit Institute of Arts.
Florence, Palazzo Pitti.
Florence, Uffizi.
London, Hampton Court, Royal Collection.
Madrid, Prado.
New York, Metropolitian Museum of Art.
Sarasota (Florida), John and Mable Ringling Museum of Art.
Vienna, Kunsthistorisches Museum.

JUDITH LEYSTER. 1609–1660. Dutch.
 Leyster, born in Haarlem, was the daughter of a brewer, not an
artist. At the age of nineteen she moved with her family to Vreeland, near
Utrecht. Her work of this period shows the influence of Terbrugghen and
the Utrecht Caravaggisti. Around 1629 she probably became the pupil of
Frans Hals, although their relationship is unclear. She witnessed the
baptism of one of his children, but later sued him when he lured one of
her students into his studio without compensating her. Leyster won the
case. She has long been dismissed as an imitator of Hals, and some of her
work has been misattributed to him. Her compositions are more com-
plex, however, and she places a greater emphasis on the play of light, and
her brush stroke is more controlled. Leyster entered the Haarlem Guild
of St. Luke in 1633. By 1635 she had three male students. In 1636 she
married a genre painter who had probably also studied with Hals, Jan
Molenaer (1610–1668). The couple moved to Amsterdam the following
year. They had three children. Unfortunately, Leyster's output seems to
have declined after her marriage, although she may have collaborated
with her husband. Leyster was primarily a genre painter, but she also did
portraits, still lifes, and flower painting. Her magnificent self-portrait in
the act of painting can be seen today at the National Gallery, Washing-
ton, D.C.

Ampzing, Samuel. *Beschrijvinge ende lof der stadt Haarlem.* Haarlem, 1628.
 The first mention of her name in print.

Bénézit. *Dictionnaire.* Vol. 6, pp. 641–642.

Bernt, Walther. *The Netherlandish Painters of the Seventeenth Century.* 3 vols. London: Phaidon, 1970. Vol. 2, pp. 71–72.
 Notes that many of Leyster's works have been ascribed to Frans Hals or Molenaer.

Bredius, A. "Een conflect tusschen Frans Hals en Judith Leyster." *Oud-Holland.* 35(1917):71–77.

Clement. *Women in the Fine Arts.* Pp. 382–383.

Crimm, Von Claus. "Frans Hals und seine 'Schule.' " *Müchner Jahrbuch der Bildenden Kunst.* 22(1971):146–150.

Fine. *Women and Art.* Pp. 31–34.

Greer. *The Obstacle Race.* Pp. 136–141.
 Discusses the problems that have been encountered in rediscovering Leyster's oeuvre.

Harms, Juliane. "Judith Leyster, ihr Leben und ihr Werk." *Oud-Holland.* 44(1927):88–96, 112–126, 145–154, 221–242, 275–279.
 No book or monograph has yet been done on Leyster. This is the principal source. It summarizes the known biographical data, stylistically reviews her oeuvre, gives a detailed chronology, and makes a number of attributions. Harms also points out the similarities Leyster's work has to that of Hals and Honthorst, and discusses her collaboration with Molenaer.

Harris and Nochlin. *Women Artists, 1550–1950.* Pp. 29, 35, 74, 137–140, 342–343.

Hess. "Is Women's Lib Medieval?"
 Hess relates how *The Jolly Topper* in Amsterdam's Rijksmuseum, long considered a work by Hals, revealed Leyster's characteristic "J*" upon being cleaned. The uncovered date, 1629, established the painting as the earliest attributed to her, done at the age of nineteen.

Hofrichter, Frima Fox. *Judith Leyster, 1609–1660.* Ph.D. dissertation, Rutgers University, 1979.

————. "Judith Leyster's *Proposition*—Between Virtue and Vice." *Feminist Art Journal.* 4(Fall 1975):22–26.
This was originally offered as a paper before the College Art Association, January 1975. Includes good black-and-white reproductions and footnotes.

————. "Judith Leyster's 'Self-Portrait': 'Ut Pictura Poesis.' " *Essays in Northern European Art Presented to Egbert Haverkamp-Begemann on His Sixtieth Birthday.* Doornspijk, Holland: Davaco, 1983. Pp. 106–109.
Description of Leyster's self-portrait in the National Gallery, Washington, D.C., which displays Leyster's expertise as both a portrait and a genre painter. The painting also reveals her knowledge of the intellectual relationship between painting and poetry.

Hofstede de Groot, Cornelis. "Judith Leyster." *Jahrbuch der Koniglich Preussischen Kunstsammlungen.* 14(1893):190–198, 232.
Discusses a "Hals" purchased by the Louvre that revealed Leyster's characteristic signature upon cleaning.

————. "Schilderijen door Judith Leyster." *Oud-Holland.* 26(1929): 25–26.
Presents arguments against a number of attributions made by Juliane Harms.

Iskin, Ruth. "Sexual and Self Imagery in Art: Male and Female." *Womanspace Journal.* 1(Summer 1973).

Krull. *Women in Art.* Pp. 113–114.

Mirimonde, A. P. de. "La musique dans les oeuvres hollandaises du Louvre." *Revue de Louvre.* 12(1962):126.

Neurdenburg, Elisabeth. "Judith Leyster." *Oud-Holland.* 46(1929):27– 30.
Recounts known biographical facts and attempts to clarify date of birth.

Petersen and Wilson. *Women Artists.* P. 38.

Rosenberg, Jakob; Seymour Slive; and E. H. Ter Kuile. *Dutch Art and Architecture, 1600–1800.* Baltimore: Penguin Books, 1966. Pp. 107–108.

Schneider, A. von. "Gerard Honthorst und Judith Leyster." *Oud-Holland.* 40(1922):173.

Slatkes, Leonard. "The Age of Rembrandt." *Art Quarterly.* 31(Spring 1968): 88.
 Briefly discusses the effect of Honthorst and Terbrugghen on Leyster's work. Includes a reproduction of her *Boy with a Skull.*

Sparrow. *Women Painters of the World.* P. 260.
 Says that Guillaume Wauters was her student in 1635 and that he later studied with Hals.

Thieme and Becker. *Allgemeines Lexikon.* Vol. 23, pp. 176–177.

Tufts. *Our Hidden Heritage.* Pp. 71–79.

Wilenski, R. H. *Introduction to Dutch Art.* London: Faber and Gwyer, 1929. Pp. 93–98.
 Lists several works attributed to Leyster and includes several reproductions. Sexual bias raises its ugly head: "Women painters, as everyone knows, always imitate the work of some man." Wilenski sees Leyster as the imitator of her husband and of Hals. He recounts the fantastic theory of Robert Dangers (*Die Rembrandt-Falschungen* [Hanover: Goedel, 1928]) that Molenaer was frequently unfaithful and that Leyster sought and found consolation with Rembrandt. Dangers also believed that Leyster helped Rembrandt with his pictures and was the mother of his child. He includes a list of works he attributes to Leyster in collaboration with Vermeer, Hals, and Rembrandt. No evidence is offered to substantiate this farfetched theory.

Willigen, A. van der. *Les artistes de Harlem.* Haarlem, 1927. P. 140.

Winjnman, H. F. "Het Geboortejaar van Judith Leyster." *Oud-Holland.* 49(1932):62–65.
 Documents Leyster's baptism and summarizes her early life. Winjnman speculates that she was probably an apprentice of Hendrik Terbrugghen in Utrecht in 1628. He discounts the theory that she died in childbirth.

Collections:

Amsterdam, Rijksmuseum.
Dublin, National Gallery of Ireland.
Haarlem, Frans Halsmuseum.
The Hague, Mauritshuis.
London, National Gallery.
Karlsruhe, Staatliche Kunsthalle.
Stockholm, National Museum.
Washington (D.C.), National Gallery of Art.
Worcester (Massachusetts), Worcester Art Museum.

MARIA SIBYLLA MERIAN. 1647–1717. German.
Merian was born into a German family of engravers and publishers. She received her art education from her stepfather, Jacob Marell, a flower painter. She became a scientist-artist who illustrated her own entomological, zoological, and botanical works. She usually painted in watercolor on vellum. Her first set of engravings was published when she was twenty-two. In 1665 she married Johann Graff, a flower painter. Two daughters were born during this reportedly unhappy marriage, which was dissolved in 1685. With her two daughters, Merian joined a religious sect, the Labadists. She settled in Amsterdam in 1690. In 1699, at the age of fifty-five and accompanied by one daughter, she departed for Surinam, South America, to do fieldwork, sponsored by the Dutch government. Merian returned to Hamburg in 1701 and presented the city with her collection of specimens. She spent the remainder of her life in Amsterdam.

Bénézit. *Dictionnaire.* Vol. 7, p. 343.
Lists her published works.

Blunt, Wilfred. *The Art of Botanical Illustration.* London, 1950; New York: Scribner, 1951. Pp. 127–129.

Bryan. *Dictionary of Painters.* Vol. 3, p. 324.

Champlin. *Cyclopedia of Painters and Paintings.* Vol. 3, p. 248.

Clement. *Women in the Fine Arts.* Pp. 238–240.
Clement says her teacher was Abraham Mignon and her husband was an architect. Mentions that she knew and admired Rachael Ruysch.

Duncan, James. *The Naturalist's Library.* Edinburgh, 1843. Vol. 40, pp. 39–40.

Ellet. *Women Artists.* Pp. 116–120.

Fine. *Women and Art.* Pp. 34–35.

Flower, Sibylla. "Prints by Maria Sibylla Merian." *Connoisseur.* 176(March 1971):227.
Review of an exhibition, accompanied by an illustration.

Gelder, Jan Gerrit van. *Dutch Drawings and Prints.* New York, 1959.

Harris and Nochlin. *Women Artists, 1550–1950.* Pp. 32, 43, 153–155, 344.

Heller. *Women Artists.* Pp. 36–37.

Krull. *Women in Art.* Pp. 114–115.

Lendorff, Gertrude. *Maria Sibylla Merian, 1647–1717: ihr Leben und ihr Werk.* Basel, 1955.

Merian, Maria Sibylla. *Erucarum ortus alimentum et paradoxa metamorphosis, in qua origo, pabulum, transformatio, nec non tempus, locus et proprietater erucarum vermium, papilionum, phaelaenarum, muscarum, aliorumque, hujusmodi exsanguinium animal—culorum exibentur . . .* Amsterdam, 1717.

————. *Der raupen wunderbare Verwandelung und sonderbare Blumennahrung. 1679.*
Second and third volumes on European insects were published in 1683 and 1717, respectively.

————. *Leningrad Watercolors.* New York: Harcourt, Brace, Jovanovich, 1975.
This two-volume set is a limited edition. The first volume contains fifty facsimiles with captions and descriptions in German, English, French, and Russian. The second volume contains the text and an illustrated catalog with seventeen foldout sheets. Altogether there are 196 reproductions of her paintings.

————. *Metamorphosis Insectorum Surinamensium.* Amsterdam, 1705.
The text is in both Latin and Dutch. Includes sixty plates.

———. *Neues Blumenbuch.* 3 vols. Nuremberg, 1680.
 Extremely rare. The first volume was issued in 1675 as *Florum fasciculi tres:* a second volume appeared in 1677; both were reissued with the third volume in 1680.

Mitchell. *Great Flower Painters.* Pp. 169–170.
 Includes a black-and-white reproduction of her work.

Mongan, Agnes. "A Fête of Flowers: Women Artists' Contribution to Botanical Illustration." *Apollo.* 119(April 1984):265.

Munsterberg. *A History of Women Artists.* P. 30.

National Museum of Women in the Arts. Pp. 24–25.

Petersen and Wilson. *Women Artists.* P. 30.
 Mentions Merian's acquaintance with the artist Anna van Schurman, also a Labadist. In discussing her marital problems, the authors note that she declared herself a widow somewhat prematurely.

Pfeiffer, M. A. *Die Werke der Maria Sibylla Merian.* Meissen, 1931.

Quednau, Werner. *Maria Sibylla Merian: der Lebensweg einer grossen Kunstlerin und Forcherin.* Gutersloh, 1966.

Rucker, Elizabeth. *Maria Sibylla Merian, 1647–1717.* Nuremberg: Germanisches Nationalmuseum, 1967.
 A catalog.

Russell. "The Women Painters in Houbraken's Groote Schouburgh." Pp. 8–9.
 Russell says that Merian studied with the German flower painter Abraham Mignon. She also mentions that Czar Peter the Great commissioned 196 watercolors on parchment from her.

Sandrart, Joachim von. *Deutsche Akademie der Edlen Bau-, Bild- und Mahlerey-Kunste.* Nuremberg, 1675–1679. 2 vols.
 Harris and Nochlin cite an edition by A. Pelzer, Munich, 1925, p. 339.

Schnack, Frederich. *Das kleine Bach der Tropenwunder: kolorierte Stiche . . .* Leipzig, 1954.

Strutt. *Biographical Dictionary.* Vol. 2, pp. 146–147.

Stuldreher-Nienhuis, J. *Verborgen paradijzen, het leven en de werken van Maria Sibylla Merian, 1647–1717.* Arnheim, 1944; 2nd edition, 1945.

"A Surinam Portfolio." *Natural History.* 71(December 1962):30–41.
An excellent account of Merian's years in Surinam. Includes several black-and-white reproductions of her work and a few color plates.

Thieme and Becker. *Allgemeines Lexikon.* Vol. 24, p. 413.

Tufts. *Our Hidden Heritage.* Pp. 89–97.

Collections:

Basel, Offentliche Kunstsammlung-Kunstmuseum.
Berlin, Kupferstichkabinett.
Darmstadt, Hessisches Landesmuseum.
London, British Museum.
Minneapolis Institute of Arts.
New Haven (Connecticut), Yale University, Beinecke Rare Book and Manuscript Library.
New York, Metropolitan Museum of Art.
New York, Pierpont Morgan Library.
Nuremberg, Germanisches Nationalmuseum.
Vienna, Albertina.
Washington (D.C.), National Museum of Women in the Arts.
Windsor Castle, Royal Library.

LOUISE MOILLON. 1610–1696. French.
Moillon was born in Paris, the daughter of landscape and portrait painter Nicolas Moillon. Her brothers also painted. She served an apprenticeship in the studio of her stepfather, François Garnier. On the strength of the talent she had exhibited by age ten or eleven, a contract was signed with Garnier regarding her future production. This contract specified his share in the profits from her work. Still life painting which included figures was her primary interest. Her style was based on Dutch and Flemish prototypes. Twenty-five paints from 1629 to 1682 are extant. In 1640 Moillon married Etienne Girardot, and they had at least three children. Because of the Protestant beliefs of the family, they were persecuted when the Edict of Nantes was revoked in 1685.

Bénézit. *Dictionnaire*. Vol. 7, pp. 455–456.

Brookner, Anita. "France, Country of a Thousand Museums, and the Age of Louis XIV." *Connoisseur*. 141 (March 1958):38.
Notes Moillon's dependence on Zurbarán, from whom she borrows her austerities of color and composition and her religious quality.

Douen, O. "Les Girardot à l'époque de la Révocation." *Bulletin historique et littéraire de la Société de l'Histoire du Protestantisme Française*. 3rd series, ix, Vol. 39(1890):449–464.

Faré, Michel. *La nature morte en France: son histoire et son évolution du XVIIIe au XXe siècle*. 2 vols. Geneva, 1962. Pp. 41–43, 98–100.

————. *Le grand siècle de la nature morte en France, le XVIIe siècle*. Paris, 1974. Pp. 48–69.

————, and Fabrice Faré. "Louise Moillon les Girardot, marchands de bois parisiens et une oeuvre inédite de Louise Moillon." *Gazette des beaux-arts*. 108(September 1986):49–65.
The authors relate a previously unpublished work by Moillon to the history of the times and to Moillon's persecution because of her religious beliefs.

————. "Trois peintures de fruits du temps de Louis XIII." *Connaissance des arts*. 272(October 1974): 88–95.
Good color reproductions of Moillon's work are included.

Fine. *Women and Art*. Pp. 43–44.
Notes that most of her works were done before the birth of her first child.

Greer. *The Obstacle Race*. Pp. 233–234.

Harris and Nochlin. *Women Artists, 1550–1950*. Pp. 75, 141–143, 343.

Heller. *Women Artists*. Pp. 37–39.

Munsterberg. *A History of Women Artists*. P. 31.

Petersen and Wilson. *Women Artists*. Pp. 33–34.

Thieme and Becker. *Allgemeines Lexikon*. Vol. 25, p. 22.

Wilhelm, Jacques. "Louise Moillon." *L'oeil.* 21(September 6–12, 1956):6–13.
This article includes several black-and-white and color reproductions as well as a short bibliography.

Wright, Christoper. *French Painters of the Seventeenth Century.* Boston: Little, Brown, 1985. P. 232–234.

Collections:

Chicago Art Institute.
Paris, Louvre.
Pasadena (California), Norton Simon Museum of Art.

MARIA VAN OOSTERWYCK. 1630–1693. Dutch.
Oosterwyck was a flower painter who worked in Delft and Amsterdam. She was born near Delft, the daughter of a Protestant clergyman. She is said to have studied with Jan Davidsz de Heem, a still-life painter, in Utrecht. Oosterwyck was reportedly courted by painter Willem van Aelst, but turned him down in order to devote herself to her career. Only about two dozen works are known today, their scarcity undoubtedly related to her slow and meticulous technique. Oosterwyck was patronized by the King of Poland, William III of England, Louis XIV, and the Emperor Leopold.

Bénézit. *Dictionnaire.* Vol. 8, p. 21.

Bernt, Walther. *The Netherlandish Painters of the Seventeenth Century.* 3 vols. London: Phaidon, 1970. Vol. 2, p. 89.

Bredius, A. "Archiefsprokkelingen: een en ander over Marie von Oosterwyck varmaert Konstschilderesse." *Oud-Holland.* 52(1935):180–182.

Bryan. *Dictionary of Painters.* Vol. 4, p. 41.

Bury, A. "Say It with Flowers." *Connoisseur.* 151(December 1962):254.

Champlin. *Cyclopedia of Painters and Paintings.* Vol. 3, p. 366.

Clement. *Women in the Fine Arts.* Pp. 260–261.

Ellet. *Women Artists.* Pp. 104–106.

Fine. *Women and Art.* P. 34.

Greer. *The Obstacle Race.* P. 239.

Harris and Nochlin. *Women Artists, 1550–1950.* Pp. 76, 145–146, 343.

Heller. *Women Artists.* Pp. 41, 43–44.

Houbraken, Arnold. *De groote schouburgh der Nederlantsche Konst-schilders en Schilderessen.* 3 vols. Amsterdam, 1718–1720; reprint, Maastricht: Leiter-Nypels, 1943–1953.
 Harris and Nochlin note this as the first compilation of artists' biographies to mention women artists ("Schilderessen") in its title. (*See also* "Russell" in the periodical section.)

Lewis, Frank. *Dictionary of Dutch and Flemish Flower, Fruit and Still-Life Painters: Fifteenth to Nineteenth Century.* Leigh-on-Sea, Essex: F. Lewis Publishers, 1973. Pp. 55 and fig. 36.

Mitchell. *Great Flower Painters.* Pp. 190.

Petersen and Wilson. *Women Artists.* P. 41.
 Notes that in keeping with her reputation for nonconformity, Oosterwyck gave painting lessons to her servants.

Russell. "The Women Painters in Houbraken's Groote Schouburgh." P. 7.

Thieme and Becker. *Allgemeines Lexikon.* Vol. 26, p. 25.

Collections:

Augsburg, Stadtische Kunstsammlungen.
Cambridge, Fitzwilliam Museum.
Copenhagen, Royal Museum.
Dresden, Staatliche Kunstsammlungen.
Florence, Uffizi.
The Hague, Mauritshuis.
Vienna, Kunsthistorisches Museum.

CLARA PEETERS. 1594–after 1657? Flemish.

Peeters was a phenomenally precocious painter whose first signed work, a fully realized still life, dates from her fourteenth year. She was born in Antwerp and worked in Amsterdam and The Hague. She did a great variety of still lifes—flowers, food stuffs, and precious objects. Peeters was especially interested in the fall of light and resulting reflections on metal. Harris and Nochlin say, "Her first works predate almost all known examples of Flemish still life painting of the type she made." Thus she would appear to be one of the originators of the genre. She married in 1639.

Benedict, Curt. "Osias Beert, un peintre oublié de natures mortes." *L'amour de l'art.* 19(1938):307–314.
 Harris and Nochlin suggest that Beert might have been Peeters' teacher, but note that since none of his paintings are dated their relationship will be hard to determine.

Bénézit. *Dictionnaire.* Vol. 8, p. 188.

Bryan. *Dictionary of Painters.* Vol. 4, p. 86.

Edwards. *Women: An Issue.*

Fine. *Women and Art.* Pp. 29–30.
 Describes her speciality as breakfast pieces.

Gerson, H., and E. H. Ter Kuile. *Art and Architecture in Belgium, 1600–1800.* Baltimore: Penguin Books, 1960. Pp. 161–162.
 The authors note that Peeters' breakfast pieces are almost impossible to distinguish from those of Floris van Schooten, a Haarlem painter.

Greer. *The Obstacle Race.* Pp. 236–237.

Greindl, E. *Les peintres flamands de nature morte au XVIIᵉ siècle.* Brussels, 1956.

Hairs, Marie Louise. *The Flemish Flower Painters in the Seventeenth Century.* Brussels: Le Febvre and Gillet, 1985. Pp. 349–353, 487–488.
 Hairs says that approximately fifty works by Peeters are known and that thirty-six are signed and several are dated. She describes a number of Peeters' works and includes an excellent color reproduction.

Harris and Nochlin. *Women Artists, 1550–1950*. Pp. 28, 32–34, 41–43, 72, 131–133, 342.
They believe Peeters' marriage at age forty-five was an indication of financial difficulties.

Heller. *Women Artists*. Pp. 38, 40.

Hill. *Women: A Historical Survey . . .* Catalog. P. ix.

Mitchell. *Great Flower Painters*. Pp. 196, 199.
Mitchell discusses the documents concerning Peeters' disputed dates, which he believes are 1589 to after 1657. He includes two black-and–white reproductions in his discussion of her style.

National Museum of Women in the Arts. Pp. 20–21.

Petersen and Wilson. *Women Artists*. Pp. 36–37.

Tufts. *Our Hidden Heritage*. Pp. xxviii, 72, 100.

Collections:

Amsterdam, Rijksmuseum.
Karlsruhe, Staatliche Kunsthalle.
Madrid, Prado.
Oxford, Ashmolean Museum.
Washington (D.C.), National Museum of Women in the Arts.

LUISA ROLDÁN. 1656–1704. Spanish.
Roldán, the daughter of a sculptor, was born in Seville and is the first woman sculptor recorded in Spain. She worked in the family workshop with two brothers and a sister. Another sister was trained as a sculpture painter. Roldán married a sculptor in 1671. Her first independent work was in 1687, a commission for Holy Week monument figures. In 1696 she moved to Madrid and the following year was appointed sculptor of the Royal Court of Charles II—without salary. After his death she continued as sculptor for Philip V. Her work consists mainly of wood and clay figures, frequently polychromed, and often approaching a trompe l'oeil realism.

Bénézit. *Dictionnaire*. Vol. 9, p. 55.

Ellet. *Woman Artists.* Pp. 87–88.

Flack, Audrey. "The Haunting Images of Luisa Roldan." *Helicon Nine.* 1(Spring–Summer 1979):70–79.

In this excellent biographical summary, Flack quotes from the petitions Roldán wrote repeatedly to her patrons, seeking remuneration for her work. Several black-and-white reproductions are included.

Hall-Van den Elsen, C. "Una Valoracion de dos obras en terracota de Luisa Roldán." *Goya.* 209(March–April 1989):291–295.

Harris and Nochlin. *Women Artists, 1550–1950.* Pp. 29, 163.

Martin, Domingo Sánches-Mesa. "Nuevas obras de Luisa Roldán y Jose Risueño en Londres y Granada." *Archivo español de arte.* 40(October 1967):325–331.

Munsterberg. *A History of Women Artists.* P. 86.

Nemser. *Art Talk.* Pp. 312–313, 321.

Audrey Flack's 1971 painting, *Macerena Esperanza,* is of a statue by Luisa Roldán. The statue, located in Seville, is life-size and of polychromed wood.

Petersen and Wilson. *Women Artists.* Pp. 31–32.

Proske, Beatrice Gilman. "Luisa Roldán at Madrid." *Connoisseur.* 155(February–April 1964):126–132, 199–203, 269–273.

This three-part article is an excellent survey of Roldán's life and work. It includes good color reproductions, as well as black-and-white. Part I summarizes her biography and details her financial difficulties. Parts II and III describe her work, especially her small terra cotta groups. Proske notes that Roldán's knowledge of color harmony was from Valdes Leal, who often collaborated with her father.

Thieme and Becker. *Allgemeines Lexikon.* Vol. 28, p. 523.

Lists Roldán's works.

Tufts. *Our Hidden Heritage.* Pp. xvi, 101.

Collections:

London, Victoria and Albert Museum.
New York, Hispanic Scoiety of America.

ANNA MARIA VAN SCHURMAN. 1607–1678. Dutch.

Van Schurman was born in Cologne to Dutch parents who had emigrated because of religious persecution. The family moved to Utrecht in 1615 and to Franeker around 1622. After the death of her father, her mother returned the family to Utrecht. Schurman was a precocious child, learning to read at age three. By the age of seven she was proficient in Latin. She became fluent in several other languages, developed expertise in math and science, and was skilled as a musician. She also drew, painted, carved in wood and ivory, modeled in wax, and made copper engravings. Later in her life, van Schurman became a follower of Johann de Labadie and gave up her artistic activities to devote herself to theological studies. She was also an advocate of women's rights. Many of the notable personalities of her age sought to become acquainted with her, and she carried on an extensive correspondence with major scholars. She was visited by William Penn in 1677 and was acquainted with Maria Sibylla Merian.

Bénézit. *Dictionnaire.* Vol. 9, p. 458.

Birch, Una. *Anna van Schurman: Artist, Scholar, Saint.* London: Longmans, Green and Company, 1909.
 The major biography on this artist. Describes her writings, her friendships and her extensive correspondence. Three black-and-white self-portraits are included.

Brodsky, Judith. "Some Notes on Women Printmakers." *College Art Journal.* 35(Summer 1976):375.

Bryan. *Dictionary of Painters.* Vol. 5, p. 52.

Clement. *Women in the Fine Arts.* Pp. 307–310.

Ellet. *Women Artists.* Pp. 99–103.

Fine. *Women and Art.* Pp. 30–31.

Greer. *The Obstacle Race.* P. 281.

Guhl. *Die Frauen . . .*

Krull. *Women in Art.* P. 76.

Munsterberg. *A History of Women Artists.* Pp. 29–29.

National Museum of Women in the Arts. Pp. 22–23.

New York. Grolier Club. *Catalogue of a Collection of Engravings, Etchings and Lithographs by Women.* 1901. P. 98.

Pelliot, Marianne. "Verres gravés au diamant." *Gazette des beaux-arts.* 3(1930):319.
 Describes two glasses, etched and signed by van Schurman, in the Rijksmuseum, Amsterdam.

Penn, William. *Journal of William Penn While Visiting Holland and Germany in 1677.* Philadelphia: Friends' Book Store, 1878. Pp. 116–126.
 Account of Penn's visit to Wieward, where the Labadist group was residing, and of his interview with van Schurman. She was sixty years old at the time, "an ancient maiden." She explained that she joined the group when she saw that her learning was vanity. She resolved to give up her former way of life and acquaintances and retire from the world.

Petersen and Wilson. *Women Artists.* P. 38.

Russell. "The Women Painters in Houbraken's Groote Schouburgh." Pp. 9–10.

Sparrow. *Women Painters of the World.* P. 285.

Thieme and Becker. *Allgemeines Lexikon.* Vol. 30, p. 343.

Collections:

Amsterdam, Rijksmuseum.
Franeker, Stedelijk Museum.
Utrecht, Universiteits Museum.
Washington (D.C.), National Museum of Women in the Arts.

ELISABETTA SIRANI. 1638–1665. Italian.
Sirani was born to a poor Bolognese family. Her father and teacher, Giovanni Andrea Sirani (1610–1670) was a minor painter. She was encouraged to paint by Malvasia, who eventually became her biographer. Sirani met with immediate success, executing her first commission at the age of seventeen. According to her own records she completed at least 190 works before her early death. She painted and engraved portraits, religious, allegorical and mythological works, and received public commissions. Her work is related to that of Guido Reni, and she has been dismissed as only a minor imitator. Harris and Nochlin point out the superficial nature of this evaluation and contend that her achievements have yet to be the object of serious scholarship. A servant was accused of poisoning her when Sirani died suddenly at the age of twenty-seven. An autopsy revealed holes in her stomach, which would probably be diagnosed today as ulcers. The pace at which she must have worked and the pressures on her to produce might well have resulted in such a condition.

Alf. "My Interest in Women Artists of the Past."

Bénézit. *Dictionnaire.* Vol. 9, p. 628.

Bryan. *Dictionary of Painters.* Vol. 5, p. 87.

Clements. *Women in the Fine Arts.* Pp. 317–319.

Edwards, Evelyn Foster. "Elisabetta Sirani." *Art in America.* 5(August 1929):242–246.
Noting that Sirani never left Bologna, Edwards describes her art as naive and without the sophistication that comes with a wider experience.

Ellet. *Women Artists.* Pp. 68–72.

Emiliani, Andrea. "Giovan Andrea ed Elisabetta Sirani." In *Maestri della pittura del seicento emiliano.* Pp. 139–145 and figs. 64–65. Catalog by F. Arcangeli et al. Bologna: Edizioni Alfa, 1959.
Provides a biographical summary.

Faxon, Alicia. "Elisabetta Sirani: Bolognese Jewel." *Boston Globe* (July 13, 1972).

Fine. *Women and Art.* Pp. 17–20.

Gabhart and Broun. "Old Mistresses."

Greer. *The Obstacle Race.* Pp. 215–222.
 Says Sirani opened her studio to other women wanting to learn to paint.

Guhl. *Die Frauen . . .*

Harris and Nochlin. *Women Artists, 1550-1950.* Pp. 25, 29, 41, 77, 147–150, 343–344.

Heller. *Women Artists.* Pp. 32–34.

Kurz, Otto. *Bolognese Drawings . . . at Windsor Castle.* London, 1955. Pp. 133–136.

Malvasia, Carlo Cesare. *Felsina pittrice.* Bologna, 1678. Vol. 2, pp. 453–563.
 Count Malvasia was a friend of the Sirani family and Elisabetta's biographer. The chapter devoted to her is illustrated by a portrait engraving and the design of the elaborate catafalque for her lavish funeral.

Manaresi, Antonio. *Elisabetta Sirani.* Bologna, 1898.

Munsterberg. *A History of Women Artists.* P. 105.

National Museum of Women in the Arts. Pp. 18–19, 231.

Parker and Pollock. *Old Mistresses.* Pp. 26–27.

Petersen and Wilson. *Women Artists.* Pp. 27–28.

Ragg. *Women Artists of Bologna.* Pp. 229–310.

Schwartz. "They Built Women a Bad Art History."

Sparrow. *Women Painters of the World.* Pp. 28–30.
 Sparrow attributes her death to a stomach disease.

Thieme and Becker. *Allgemeines Lexikon.* Vol. 31, pp. 99–100.
 Includes an extensive listing of her works and a lengthy bibliography.

Tufts. *Our Hidden Heritage.* Pp. 81–87.

"Women Artists" (review of Guhl).

Collections:

Baltimore, Walters Art Gallery.
Bologna, Pinacoteca Nazionale.
Cambridge, Harvard University, Fogg Art Museum.
New York, Metropolitan Museum of Art.
Washington (D.C.), National Museum of Women in the Arts.

ANNA WASER. 1676–1713. Swiss.
Waser (whose name is also spelled "Wasser"), was born in Zurich. Her father was an artist, and her artistic talent was noticed at an early age. She was also a precocious linguist. At age twelve she began a three-year period of study with Joseph Werner in Bern. She gained a wide reputation as a miniaturist and received numerous commissions from the courts of Europe. Her father, realizing her monetary value, rushed and overworked her, which eventually resulted in her failing health. In 1699 she accepted a position at the court of the count of Solms-Braunfels. There she was able to perfect her painting and her health improved. Her father summoned her home, however, and in the haste of her return she fell, suffering an injury that brought her death at age thirty-four. Waser excelled in pastoral and rural scenes, as well as portraiture.

Bénézit. *Dictionnaire.* Vol. 10, p. 643.
 Gives her dates as 1678–1714.

Bryan. *Dictionary of Painters.* Vol. 5, p. 336.

Clement. *Women in the Fine Arts.* Pp. 355–356.

Ellet. *Women Artists.* Pp. 129–131.

Foster. *Dictionary of Painters of Miniatures.* P. 320.

Greer. *The Obstacle Race.* P. 4.

Krull. *Women in Art.* P. 92.

Munsterberg. *A History of Women Artists.* Pp. 31, 33.

Munsterberg provides a reproduction in black-and-white of a self-portrait painted at age fifteen.

Thieme and Becker. *Allgemeines Lexikon.* Vol. 35, p. 170.

Collection:

Zurich, Kunsthaus.

EIGHTEENTH CENTURY

PAULINE AUZOU. 1775–1835. French.

Auzou was a history painter who actively participated in the glorification of the Napoleonic reign through her paintings. She was born in Paris and studied with Regnault. Her early subjects were taken from Greek history. Auzou exhibited at the Salon between 1793 and 1817. She married around 1794 and raised three children. In addition to history painting, she also did portraits and sentimental genre scenes. For twenty years Auzou maintained an atelier for female students in Paris.

Bénézit. *Dictionnaire.* Vol. 1, p. 329.

Bryan. *Dictionary of Painters.* Vol. 1, p. 329.

Cameron, Vivian. "Portrait of a Musician by Pauline Auzou." *Currier Gallery of Art Bulletin* (1974):1–17.

Champlin. *Cyclopedia of Painters and Painting.* Vol. 1, p. 83.

Greer. *The Obstacle Race.* Pp. 301–302.
Greer notes that in the late 1790's Auzou did a number of interior scenes of young women reading and playing musical instruments.

Harris and Nochlin. *Women Artists, 1550–1950.* Pp. 48–49, 211–212, 349.
These authors point out that Auzou shows the influence of Ingres after 1800.

Hein, Jean-François; Claire Beraud; and Philippe Heim. *Les salons de peinture de la Révolution français.* Paris: C.A.C.S.a.r.1. Edition 1989.
Lists her Salon works from 1793 to 1799.

Krull. *Women in Art.* Pp. 78–79.

Thieme and Becker. *Allgemeines Lexikon.* Vol. 2, pp. 266–267.

Collections:

Manchester (New Hampshire), Currier Gallery of Art.
Versailles, Musées de Versailles et des Trianons.

HESTER BATEMAN. Ca. 1740–1790. English.
Although Bateman was not the only woman silversmith of her time, she was certainly the most prolific. A considerable quantity of her work survives and includes virtually every kind of silver utensil. She was active in London from 1774, when she entered the Goldsmith's Hall, until 1789. Prior to 1778–1779 she produced small works, such as spoons and sugar tongs. She began making larger pieces after 1779. Her husband, John, was a chain maker and a jeweler. They had at least five children, who became her apprentices. Her sons Peter and Jonathan carried on the family business after her death.

Gillingham, Harrold E. "Concerning Hester Bateman." *Antiques.* 39(February 1941):76–77.
Summarizes the biographical facts and includes many illustrations of Bateman's work and her mark.

Jackson, Sir Charles. *English Goldsmiths and Their Marks.* London, 1921.
Lists close to fifty women silversmiths working during the eighteenth-century.

Keyes, Homer Eaton. "Hester Bateman, Silversmith." *Antiques.* 20(December 1931:367–368.
Keyes views the wide variety of Bateman's surviving work as evidence of her large patronage. He believes she had only four children.

Shure, David. *Hester Bateman: Queen of English Silversmiths.* Garden City, New York: Doubleday and Company, 1959.
Monograph of her work. Contains a short but comprehensive biographical summary, a helpful family tree, and numerous photographs of her work.

Walter, William. "New Light on Hester Bateman." *Antiques.* 63(January 1953):36–39.
Discusses her registration at Goldsmith's Hall, her will, and her husband's will. Describes the evolution of the family business and compares her work to that of her children.

Wenham, Edward. "Women Silversmiths." *Antiques.* 46(October 1944):200–200-202.

Collections:

Chicago Art Institute.
Springfield (Massachusetts), Museum of Fine Arts.

LADY DIANA BEAUCLERK. 1734–1808. English.

Lady Beauclerk was the eldest daughter of the third duke of Marlborough and was celebrated as an amateur painter and sculptor. In 1757 she married the second Lord Bolingbroke. She was named lady-in-waiting to Queen Charlotte in 1761. She divorced her husband in 1768 and two days later married Topham Beauclerk. During her youth she especially admired the work of Rubens and spent much time copying his work and that of other great masters. Her subjects were cupids, children, and the rustic genre—done in a rather Rococo style, often only lightly touched with color. Josiah Wedgwood commissioned designs from her, and she also did some interior decorating. Beauclerk was a friend of Horace Walpole and illustrated his *Mysterious Mother.* She also illustrated, in 1796, Burger's *Lenora* and Dryden's *Fables* in 1797.

Bénézit. *Dictionnaire.* Vol. 1, P. 547.

Ellet. *Women Artists in All Ages.* P. 187.

Erskine, Beatrice Caroline Strong [Mrs. Stuart]. *Lady Diana Beauclerk: Her Life and Work.* London: T. F. Unwin, 1903.
 Includes color plates.

———. "Lady Di's Scrapbook." *Connoisseur.* 7(1903):32–37.
 Discusses one of Beauclerk's sketchbooks. Includes several good black-and-white reproductions and a watercolor sketch in color.

Foster. *Dictionary of Painters of Miniatures.* P. 16.

Greer. *The Obstacle Race.* Pp. 288–290.
 Greer calls Beauclerk an expert in " 'soot-water' designs of delightful cupids."

Petersen and Wilson. *Women Artists.* Pp. 46–47.

Sparrow. *Women Painters of the World.* P. 58.

Thieme and Becker. *Allgemeines Lexikon.* Vol. 3, p. 115.

Walpole. *Anecdotes of Painting.* Vol. 1, p. xx.

Collections:

London, British Museum.
London, Victoria and Albert Museum.

MARIE-GUILLEMINE BENOIST. 1768–1826. French.
Benoist was born in Paris. Her artistic interests were encouraged by her family, and she began studying with Vigée-LeBrun by 1781 or 1782. David was also one of her teachers and highly influential on her style. Between 1784 and 1788 she exhibited at the Exposition de la Jeunesse. Two of her works were exhibited at the Salon of 1791. She married Pierre Vincent Benoist, a Royalist, in 1793. His antirevolutionary activities prevented her participation in the Salon of 1793. Benoist again exhibited in the Salons between 1793 and 1812, and she received a gold medal in the Salon of 1804. That year she also received her first official commission to paint Napoleon's portrait. She continued to contribute works to Napoleon's propaganda machine and received an annual stipend from the Napoleonic government. Although Benoist is noted for her portraits, she also painted history and genre works. She abandoned history painting in 1793, however, after receiving adverse criticism.

Ballot, Marie-Juliette. *La Comtesse Benoist, l'Émilie de Demoustier, 1768–1826.* Paris. 1914.

Bénézit. *Dictionnaire.* Vol. 1, p. 630.

Fine. *Women and Art.* Pp. 54–55.

Greer. *The Obstacle Race.* Pp. 298–300.
Notes that she founded an atelier in 1804.

Harris and Nochlin. *Women Artists, 1550–1950.* Pp. 48–50, 209–210, 349.

Heller. *Women Artists.* Pp. 63–64.
Says her studies with Vigée-LeBrun started in 1791.

Munsterberg. *A History of Women Artists.* Pp.48–49.

Collection:

Paris, Louvre.

ROSALBA CARRIERA. 1675–1757. Italian.
 Carriera was one of the originators of the Rococo style in Italy and France, and she is credited with introducing the pastel portrait into France. Her brilliant and innovative pastel technique influenced Maurice Quentin de la Tour. She also did oil portraits and miniatures. Carriera was the granddaughter of an artist, but probably first showed her artistic abilities in lace making, her mother's profession. She is said to have been the student of several Venetian artists including Antonio Lazari, Guiseppe Diamantini, Antonio Balestra, and Giovanni Antonio Pellegrini, her brother-in-law. Her work, however, resembles none of theirs. She was selling miniatures by 1700 and in 1705 was elected to the Academy of Rome. Carriera's international career was greater than any of the women who had preceded her. She visited Paris in 1720 and was inundated with commissions. She was elected to the Royal Academy that year and was ultimately admitted to the academies of Bologna and Florence. She received commissions from the courts of France and Austria. Carriera never married and throughout her life was assisted by her sister Giovanna. She was born and died in Venice. The last ten years of her life were spent in blindness.

Bénézit. *Dictionnaire.* Vol. 2, pp. 559–560.

Blashfield, Evangeline W. *Portraits and Backgrounds.* New York: Charles Scribner's Sons, 1971; reprint, Freeport, N.Y. Books for Libraries Press, 1971.
 Carriera is the subject of one of four biographical essays. Blashfield quotes from her letters.

Bryan. *Dictionary of Painters.* Vol. 1, pp. 260–261.
 Mentions several people with whom Carriera studied; includes list of 143 of her works in the Dresden Gallery.

Cessi, F. *Rosalba Carriera.* Milan: I Maestri de Colore, no. 97, 1967.

Clement. *Women in the Fine Arts.* Pp. 74–76.

Colding, Torben Holch. *Aspects of Miniature Painting: Its Origins and Development.* Copenhagen: Ejnar Munksgaard, 1953. Pp. 13–14, 125–142, 144–150.
 Colding says Carriera is the first artist known to have painted miniatures on ivory, and he provides an extensive discussion of this aspect of her work. Her influence on miniature painting and her clientele are also discussed. Several black-and-white reproductions are included.

Dobson, Austin. *Rosalba's Journal and Other Papers.* London: Chatto and Windus, 1915; reprint, Freeport, N.Y.: Books for Libraries Press, 1970.
 The essay on Carriera examines the journal she kept during her sojourn in Paris.

La donna ideale. Milano: Editore Rizzoli, 1966.

Edwards. *Women: An Issue.*

Ellet. *Women Artists in All Ages.* Pp. 226–232.

Fine. *Women and Art.* Pp. 20–22.
 Notes that both of her sisters, Angela and Giovanna, were her pupils.

Gatto, Gabrielle. ''Per la cronologia di Rosalba Carriera.'' *Arte veneta.* 25(1971):182–193.

Greer. *The Obstacle Race.* Pp. 258–259.

Guhl. *Die Frauen . . .*

Harris and Nochlin. *Women Artists, 1550–1950.* Pp. 17, 30, 36, 38–40, 161–164, 345.

Heller. *Women Artists.* Pp. 54–56.

Hoerschlemann, Emilie von. *Rosalba Carriera, Die Meisterin der Pastellmalerie, und Bilder aus der Kunst und Kulturgeschichte des 18 Jahrhunderts.* Leipzig, 1908.

Jeannerat. C. "Le origini del ritratto a miniatura in avario." *Dedalo*. 11 (1931): 767–780.

Krull. *Women in Art*. Pp. 115, 122–124.

Levey, Michael. *Painting in Eighteenth Century Venice*. London: Phaidon Press, 1959. Pp. 135–146.

Longhi, Roberto. *Viatice per cinque secoli di pittura venegiana*. Florence, 1946. P. 35.

Malamani, Vittorio. *Rosalba Carriera*. Bergamo: Instituto d'arti grafiche, 1910.
 This monograph includes the diary Carriera kept while in Paris. Harris and Nochlin cite an earlier version with fuller documentation published in *Le Gallerie Nazional i Italiane*. 4(1899):27–149.

Munsterberg. *History of Women Artists*. Pp. 35–37.

Nochlin. "Why Have There Been No Great Women Artists?" P. 31.
 Includes a beautiful full-page reproduction of Carriera's pastel portrait of Mme. Irene Crozat as "Spring."

Orlandi, P. A. *Abededario pittorrico* . . . Bologna, 1704.
 Harris and Nochlin cite a Venice edition of 1753, pp. 448–449.

Petersen and Wilson. *Women Artists*. Pp. 47–48.

Schwartz. "They Built Women a Bad Art History."

Schwarz, Michael. *The Age of the Rococo*. London: Pall Mall Press, 1971. Pp. 59–60, 179.
 Schwarz notes her "legendary facility for rejuvenating and idealizing her subjects." Frederick IV of Denmark was among her royal patrons.

Sensier, Alfred, trans. *Journal de Rosalba Carriera: pendant son séjour à Paris en 1720 et 1721*. Paris: J. Techeuer, 1865.
 This translation of Carriera's diary is followed by a biographical statement, a list of works done during this period, and a list of her works on display.

Sparrow. *Women Painters of the World*. Pp. 20, 37, 48, 51.

Tufts. *Our Hidden Heritage.* Pp. 107–115.

Watson, F. J. B. "Two Venetian Portraits of the Young Pretender: Rosalba Carriera and Francesco Guardi." *Burlington Magazine.* 111(June 1969): 333–337.
 Discusses Carriera's portrait of Prince Charles Edward Stuart and the sales history of the work.

Wilhelm, Jacques. "Le portrait de Watteau per Rosalba Carriera." *Gazette des beaux-arts.* 42(November 1953): 235–246, 271–274.
 Illustrates and traces the provenance of one of Carriera's drawings.

Zanetti, Antonio Maria. *Della pittura veneziana e della opere pibbliche de veneziana maestr.* 5 vols. Venice, 1771.

Collections:

 Boston Museum of Fine Art.
 Cleveland, Museum of Art.
 Dijon, Musée des Beaux-Arts.
 Florence, Uffizi.
 London, Victoria and Albert Museum.
 Venice, Accademia.
 Vienna, Kunsthistorisches Museum.
 Washington (D.C.), National Gallery of Art.

CONSTANCE-MARIE CHARPENTIER. 1767–1849. French.
 Charpentier did ambitious mythological and allegorical scenes, in addition to portraits and genre work. Her teachers were minor painters, and she was principally influenced by David and Gérard. Only three works are attributed to her today, the best known being her portrait of Charlotte du Val d'Ognes, in the Metropolitan Museum. It was long considered a David. She exhibited in the Salon between 1798 and 1819.

Art News. 69(January 1971): cover.
 The cover of this special women's issue is a reproduction of the famous portrait of Charlotte du Val d'Ognes.

Bellier-Auvray. *Dictionnaire général.* Vol. 1, pp. 233–234.

Bénézit. *Dictionnaire.* Vol. 2, p. 449.

Bryan. *Dictionary of Painters.* Vol. 1, p. 284.

Clement. *Women in the Fine Arts.* P. 78.
 Clement calls Charpentier the pupil of David and lists the titles of
several of her allegorical works, lost today.

Ellet. *Women Artists in All Ages.* P. 236.

Eva. "Women Artists . . . "

Fleisher. "Love or Art."

Gabhart and Broun. "Old Mistresses."

Harris and Nochlin. *Women Artists, 1550–1950.* Pp. 207–208, 348.

Hess and Baker, eds. *Art and Sexual Politics.* Pp. 44–45.

Munsterberg. *History of Women Artists.* P. 48.

Paris. Grand Palais. *French Painting, 1774–1830: The Age of the
 Revolution.* 1974–1975.
 See catalog entry no. 19 and pp. 345–347.

Parker and Pollock. *Old Mistresses.* P. 106.

Petersen and Wilson. *Women Artists.* Pp. 61–63.

Soby, James T. "A 'David' Reattributed." *Saturday Review of Litera-
 ture.* 34(March 3, 1951):42–43.

Sterling, Charles. "Fine David Reattributed: Portrait of Charlotte du Val
 d'Ognes by Mme. Charpentier?" *Metropolitan Museum of Art Bulle-
 tin.* 9(January 1951):121–132.
 An excellent article demonstrating art historical sleuthing at its best.
Good black-and-white reproductions are offered of the two other
works today given to Charpentier, an oil entitled *Melancholy,* and a
pencil portrait in profile. Sterling cites the biographical dictionaries of
Gabet and Bellier-Auvray as providing what little is known of her life.
The article is flawed only by Sterling's typical but wearisome sexism:
The portrait's "very evident charms, and its cleverly concealed
weaknesses, its ensemble made up from a thousand subtle artifices, all
seem to reveal the feminine spirit."

Collections:

Amiens, Musée de Picardie.
Dijon, Musée Magnin.
New York, Metropolitan Museum of Art.

JEANNE ELISABETH CHAUDET. 1767–1832. French.
Chaudet studied with Vigée-LeBrun. In 1793 she married Antoine-Denis Chaudet, a sculptor and painter with whom she also studied. He died in 1810. In 1812 she married an archivist, Pierre-Arsène-Denis Husson. When he died in 1843 he left most of Chaudet's works to the museum in Arras; unfortunately, the majority were destroyed in the Second World War. Chaudet exhibited at the Salon between 1798 and 1817. Her works were often sentimentalized paintings of children and animals, composed as antique bas-relief profiles.

Bénézit. *Dictionnaire.* Vol. 5, p. 681.
She is listed under "Husson."

Bryan. *Dictionary of Painters.* Vol. 1, p. 286.

Ellet. *Women Artists.* Pp.237–238.

Fine. *Women and Art.* P. 60.

Harris and Nochlin. *Women Artists, 1550–1950.* Pp. 46–47, 198.

Paris. Grand Palais. *French Painting, 1774–1830: The Age of Revolution.* Pp. 347–348.
This is the source of most of the above biographical material. A reproduction of her work is included.

Sparrow. *Women Painters of the World.* P. 202.

Thieme and Becker. *Allgemeines Lexikon.* Vol. 6, p. 435.

Collections:

Arras, Musée, d'Arras.
Paris, Musée Marmottan.
Rochefort, Musée de Beaux-Arts.
Versailles, Musées des Versailles et des Trianons.

MARIE-ANNE COLLOT. 1748–1821. French.

Collot entered the studio of the sculptor Etienne Falconet at age fifteen; before long he admitted that she was more skilled in creating portrait busts. Her earliest known busts date from 1765. When Falconet went to Russia in 1766 to work on his commission of a monument to Peter the Great, Collot went along as his assistant, doing the head of that equestrian sculpture. She remained in Russia until 1778, except for one visit to Paris in 1775–76. These were her most prolific years. She was appointed official portrait sculptor to Catherine II, from whom she received twenty-five commissions, and she obtained private commissions as well. In 1777 she married Falconet's son, Pierre-Etienne, a painter. When she returned to Paris in 1778 with her young daughter, a few months behind her husband, she encountered a hostile reception because of her marriage. In 1779 Collet took refuge with the elder Falconet in The Hague and did not return to Paris until 1780. In 1783 (the date of her last known sculpture) Etienne Falconet became ill. Collot devoted her full attention to him, totally neglecting her art, until his death in 1791. A few months later her husband also died. She then left Paris, purchased property in Lorraine, and lived there the remaining thirty years of her life.

Bénézit. *Dictionnaire.* Vol. 3, p. 118.

Cournault, Charles. "Etienne-Maurice Falconet et Marie-Anne Collot." *Gazette des beaux-arts.* Series 2 (1869):117–144.

Ellet. *Women Artists.* P. 201.

Hill. *Women: A Historical Survey . . .* Catalog. P. xi.

Kosareva, Nina. "Masterpieces of Eighteenth-Century French Sculpture." *Apollo.* 101(June 1975):446–447.
 A few of Collot's works are briefly discussed in this survey of the eighteenth-century French sculpture collection of the Hermitage.

Krull. *Women in Art.* Pp. 116, 141.

Levitine, George. *The Sculpture of Falconet.* Greenwich, Connecticut: New York Graphic Society, 1972. Pp. 18–21.
 Levitine believes Collot was Falconet's mistress before she was his daughter-in-law. He says her marriage ended in a "social scandal."

Opperman, H. N. "Marie-Collot in Russia: Two Portraits." *Burlington Magazine.* 107(August 1965):408–415.

Good summary of Collot's biography. Discusses two commissions from Lord Cathcart and compares her work with Falconet's. Falconet's abuse of Collot is also discussed. Includes good black-and-white reproductions.

Petersen and Wilson. *Women Artists.* P. 60.
Summarizes the relationship between Collot and Falconet and the resulting neglect of her art.

Raymond, A. G. "Le buste d'Etienne-Noel Damilaville par Marie-Anne Collot." *Revue du Louvre.* 23(1973):255–260.

Reau, Louis. "Les bustes de Marie-Anne Collot." *Renaissance.* 14(November 1931):306–312.

————"Une femme-sculpteur française au dix-huitième siècle, Marie-Anne Collot (Madame Falconet)." *L'art et les artistes* (February 1923):165–171.

Thieme and Becker. *Allgemeines Lexikon.* Vol. 11, p. 221.

Collections:

St. Petersburg, State Hermitage Museum.
Nancy, Musée des Beaux-Arts.
Paris, Louvre.

MARIA HADFIELD COSWAY. 1759–1838. English.
Cosway was born in Florence, Italy, the child of wealthy English parents. A devout Roman Catholic, she expressed an early interest in the religious life, but her parents disapproved. She was talented in art and linguistics and was an excellent musician. In Rome she studied with Batoni, Mengs, and Fuseli. Johann Zoffany became her tutor, and Joseph Wright of Derby provided additional criticism. In 1778 she became a member of the Florence Academy. At the urging of her friend Angelica Kauffman, she moved to England around 1778–79. She began exhibiting on a regular basis at the Royal Academy beginning in 1781. Between 1781 and 1801 she sent forty-two works to the Academy. She married the painter Richard Cosway in 1781, but it was not a happy union. Out of jealousy, her husband attempted to dissuade her from painting. Cosway was afflicted with bouts of depression throughout her life. Three months after the birth of her only child, a daughter, she left her husband and child

and began traveling. She returned to England briefly in 1794 and again in 1796 when her six-year-old daughter died. Around 1800 she was again living in London and showing at the Royal Academy. In 1801 she moved to Paris, where Jacques-Louis David became one of her many suitors. For a while she was head of a seminary for young ladies in Lyon, France. She fulfilled a longtime ambition in 1812 by founding a college in Lodi, Italy. Cosway died there at the age of seventy-nine. Much of her work consisted of miniatures, but she also engraved and painted large mythological canvases, adopting the pastoral mode of Gainsborough and Lawrence. Although she also did allegorical paintings and works based on literary subjects, Cosway was best known for her portraiture. She had a brief affair with Thomas Jefferson in 1786, meeting him through a mutual friend, the artist John Trumbull. They corresponded until 1824.

Bénézit. *Dictionnaire.* Vol. 3, p. 205.

Brodsky, Judith. ''Rediscovering Women Printmakers, 1550–1850.'' *Counterproof.* 1(Summer 1979):8.

Bryan. *Dictionary of Painters.* Vol. 1, pp. 337–388.
 Notes that although her marriage was difficult, Cosway did return to England to nurse her husband through his mental disorder and death.

Bullock, Helen Duprey. *My Head and My Heart: A Little History of Thomas Jefferson and Maria Cosway.* New York: G. P. Putnam's Sons, 1945.

Clayton. *English Female Artists.* Pp. 314–335.

Clement. *Women in the Fine Arts.* Pp. 89–91.

Cunningham, Allan. *The Lives of the Most Eminent British Painters.* 2nd edition, annotated and continued by Mrs. Charles Heaton. 3 vols. London: George Bell and Sons, 1880. Vol. 2, pp. 347–357.
 Includes many interesting anecdotes, including how Cosway was almost murdered as an infant by a trusted servant and her early desire to be a nun. Notes that many accounts, especially foreign ones, thought she possessed more talent than her husband.

Ellet. *Women Artists.* Pp. 191–198.

Fine. *Women and Art.* Pp. 77–79.

Foskett. *Dictionary of British Miniature Painters.* Vol. 1, p. 221.

Foster. *Dictionary of Painters of Miniatures.* Pp. 61–62.

Greer. *The Obstacle Race.* Pp. 41–42.

Guhl. *Die Frauen . . .*

Kimball, Marie. "Jefferson's Farewell to Romance." *Virginia Quarterly Review.* 4(July 1928):402–419.
 Summarizes his relationship with Cosway, reproducing several letters exchanged by the couple.

Krull. *Women in Art.* P. 54.

Long. *British Miniaturists.* Pp. 101–103.

New York, Grolier Club. *Catalogue of a Collection of Engravings, Etchings and Lithographs by Women.* 1901.

Nochlin. "Why Have There Been No Great Women Artists?" P. 27.
 A small reproduction of Cosway's painting, *Mrs. Fuller and Son.*

Petersen and Wilson. *Women Artists.* P. 46.

Redgrave and Redgrave. *A Century of Painters of the English School.* Pp. 155–156.
 The extreme eccentricities on the part of Cosway's husband, Richard, are described.

Scheerer, Constance. "Maria Cosway: Larger-than-Life Miniaturist." *Feminist Art Journal.* 5(Spring 1976):10–13.
 Interesting account of her life, but lacks bibliography and footnotes. Proposes that "miniaturism" was not her art form of choice, but the result of the times and circumstances.

Stephen and Lee. *Dictionary of National Biography.* Vol. 4, pp. 1203–1204.

Thieme and Becker. *Allgemeines Lexikon.* Vol. 7, pp. 544–546.

Thomas Jefferson: A Biography in His Own Words. Editors of Newsweek Books. New York: Newsweek, 1974. Pp. 172–176.
 Reproduces part of Jefferson's "Head and Heart" dialogue, a

seventeen-page letter to Cosway in which his emotional side (the "heart") converses with his rational side (the "head").

Van Pelt, Charles. "Thomas Jefferson and Maria Cosway." *American Heritage.* 22(August 1971):22–29, 102–103.
An account of their relationship and correspondence.

Walker, John. "Maria Cosway: An Undervalued Artist." *Apollo.* 123(May 1986):318–324.
Excellent description of Cosway's social world and of the contradictions of her personality. Identifies many of her lovers. Notes that she was one of the few, if not the only, eighteenth-century painter to produce advertisements.

Williamson, George C. *Richard Cosway. R.A., His Wife and Pupils.* London: George Bell and Sons, 1905.
Maria Cosway's dominance and popularity is evidenced by noting that four of the nine chapters in this work center on her. Williamson includes an interesting account of her early youth and art studies. He draws on information Cosway provided in a letter to Allan Cunningham, author of *The Lives of the Most Eminent British Painters.* Her founding of the college at Lodi is discussed in detail, and her will is quoted in its entirety.

"Women Artists" (review of Guhl).

Collections:

London, British Museum.
Washington (D.C.), National Gallery of Art.

ANNE SEYMOUR DAMER. 1748–1828. English.
Damer was born into an aristocratic family. Horace Walpole, a friend since her childhood, bequeathed his villa, Strawberry Hill, to her. Damer studied with John Bacon and Guiseppe Ceracchi. She was the only woman sculptor of note in England until the twentieth century, which undoubtedly contributed to the perception of her as being eccentric. Damer created Neoclassic marble sculpture, mainly portrait busts and small animal pieces. She exhibited at the Royal Academy from 1784 to 1818. She received several commissions from Napoleon. Although she had social distinctions and was acquainted with many of the European notables of her day, her life was marked by domestic

tragedy. She married John Damer in 1767. He gambled and drank to excess. Their brief marriage ended with his suicide in 1776. After his death, she traveled extensively, especially to Italy and Portugal. Damer took an active interest in political affairs.

Bénézit. *Dictionnaire.* Vol. 3, p. 338.

Clement. *Women in the Fine Arts.* Pp. 96–100.

Ellet. *Women Artists.* P. 170.

Fine. *Women and Art.* Pp. 76–77.

Guhl. *Die Frauen . . .*

Gunnis, Rupert. *Dictionary of British Sculptors, 1660–1851.* Cambridge, Massachusetts: Harvard University Press, 1954. Pp. 120–121.
 Gunnis, in an excellent biographical sketch, says Damer was "absurdly over-praised by Walpole." He notes that she often wore men's clothing and that she disdained the frivolous pursuits of women of high society. Gunnis also says that her detractors whispered that she was assisted by "ghosts" and professional sculptors.

Harris and Nochlin. *Women Artists, 1550–1950.* P. 29.

Jackson-Stops, Gervase, ed. *The Treasure House of Britain: Five Hundred Years of Private Patronage and Art Collecting.* New Haven: Yale University Press, 1985. P. 301.
 Illustrates and discusses her marble work, *Two Sleeping Dogs,* carved for the Duke of Richmond.

Leslie and Lee. *Dictionary of National Biography.* Vol. 5, pp. 450–451.
 These authors say Damer's work "must be appraised as that of an amateur fine lady."

Munsterberg. *A History of Women Artists.* Pp. 86, 88.

Noble, Percy. *Anne Seymour Damer: A Woman of Art and Fashion, 1748–1828.* London: Kegan Paul, Trench, Trubner and Company, 1908.
 An illustrated biography that draws on her memoirs and letters of her contemporaries.

Petersen and Wilson. *Women Artists.* Pp. 46–47.

Post, Chandler. *A History of European and American Sculpture.* New York: Cooper Square Publishers, 1969. Vol. 2, p. 57.
 The idea that women can be capable sculptors continues to elude even modern writers: "It has sometimes been supposed that her masters put the best touches in the works ascribed to her."

Pyke, E. J. *A Biographic Dictionary of Wax Modelers.* P. 36.

Thieme and Becker. *Allgemeines Lexikon.* Vol. 8, pp. 318–319.

Walpole. *Anecdotes of Painting in England.* Vol. 1, pp. xx–xxii.
 Lists her works.

Collections:

 London, British Museum.
 London, National Portrait Gallery.
 London, Victoria and Albert Museum.

FRANÇOISE DUPARC. 1726–1778. French.
 Duparc, born in Marseille, was the daughter of sculptor Antoine Duparc. Her early artistic education was probably from her father. Later she may have studied painting with Jean Baptiste van Loo. She painted half-length portraits of working-class people, unusual in that they are devoid of setting or narrative. Duparc's choice of subjects relates her to Chardin, but it has yet to be determined whether she knew his work. It is speculated that she was in London in the 1760's. Of the forty-one paintings listed as in her studio upon her death, only four are definitely known today.

Achard, C. F. *Les hommes illustrés de la Provence.* 1878. Pp. 174ff.

Auquier, Philippe. "An Eighteenth-Century Painter: Francoise Duparc." *Burlington Magazine.* 6(1905):477–478.

Bénézit. *Dictionnaire.* Vol. 4, p. 22.
 Notes that Duparc was also a history painter. Gives her birth date as ca. 1705.

Billioud, Joseph. "Un peintre des types populaires: Françoise de Marseille (1726–1778)." *Gazette des beaux-arts.* 20(1938):173–184.

Greer. *The Obstacle Race.* Pp. 259–260.
 Greer notes that Duparc moved to Paris after the death of her parents and that she was admitted to the Academy of Marseille in 1776.

Harris and Nochlin. *Women Artists, 1550–1950.* Pp. 171–173, 346.
 They describe Duparc's work as a blend of portraiture and genre. Most of the above biographic information is from this source.

Heller. *Women Artists.* Pp. 64–67.
 Heller says that Duparc's mother was Spanish and that she was born in Spain.

Petersen and Wilson. *Women Artists.* Pp. 49–50.

Thieme and Becker. *Allgemeines Lexikon.* Vol. 10, p. 152.
 Gives birth date of 1705.

Collections:

 Marseille, Musée des Beaux-Arts.
 Perpignan, Musée Hyacinthe Rigaud.
 Roanne, Musée Joseph Déchelette.

MARGUERITE GÉRARD. 1761–1837. French.
 Although Gérard is less acclaimed than Vigée-LeBrun or Labille-Guiard, she was the first French woman to succeed in genre paintings, considered at the time to be a notch above portraiture and still life. She did small, sentimental genre scenes based on Dutch prototypes (similar to those of Metsu and ter Borch) and successfully emulated their painstaking technique of multiple glazes. Gérard was Fragonard's sister-in-law and student. She exhibited in the Salon from 1799 to 1824 and was awarded a gold medal in 1804. The ugly assumption that Gérard was Fragonard's mistress and that he directly assisted her in painting is one that often persecutes women artists with a close association to a male master. There is no proof to substantiate this slander about Gérard, and much evidence that would deny it.

Algond, H. "Marguerite Gérard au Musée Fragonard de Grasse."

Ananoff, Alexandre. "Propos sur les peintures de Marguerite Gérard." *Gazette des beaux-arts.* 94(December 1979):211–218.

Ananoff analyzes the influence of Fragonard on Gérard. He says that Fragonard signed some etchings by Gérard to help sales, thus some prints by Fragonard between 1784 and 1806 should be reattributed to Gérard. Ananoff also notes similarities in compositional devices used by the two artists.

Bénézit. *Dictionnaire.* Vol. 4, pp. 679–680.

Bryan. *Dictionary of Painters.* Vol. 2, p. 231.

Doin, Geanne. "Marguerite Gérard (1761–1837)." *Gazette des beaux-arts.* 109(1912):429–452.

Ellet. *Women Artists.* P. 201.

Fine. *Women and Art.* Pp. 51–53.
Fine says that Gérard collaborated on two paintings with Fragonard.

Gabhart and Broun. "Old Mistresses."
These authors unfortunately repeat the old gossip about Gérard and Fragonard.

Goulinet. "Les femmes peintres au XVIIIe siècle."

Greer. *The Obstacle Race.* Pp. 101–102, 301.
Brief discussion of Gérard's relationship with Fragonard.

Harris and Nochlin. *Women Artists, 1550–1950.* Pp. 197–201, 348.

Heller. *Women Artists.* Pp. 66, 68.

Hill. *Women: A Historical Survey . . .* Catalog. Pp. xi, 10.
Includes a black-and-white reproduction of one of her literary paintings with a long caption that includes an exhibition record.

Levitine. G. "Marguerite Gérard and Her Stylistic Significance." *Baltimore Museum Annual.* 3(1968):21ff.

National Museum of Women in the Arts. Pp. 36–37.

Nochlin. "Why Have There Been No Great Women Artists?" P. 26.
Nochlin provides a small black-and-white reproduction.

Perate, A. "Les esquisses de Gérard." *L'art et les artistes* (1909):4–7.

Petersen and Wilson. *Women Artists.* P. 61.

Thieme and Becker. *Allgemeines Lexikon.* Vol. 13, p. 439.

Wells-Robertson, Sally. "Marguerite Gérard, 1761–1837." *Marsyas.* 19(1977–1978):73–74.
 Summary of Wells-Robertson's dissertation, an investigation of Gérard's career and oeuvre which included a catalogue raisonné. Her dissertation was undertaken at the Beaux-Arts Institute of Fine Arts, New York University.

Collections:

Baltimore Museum of Art.
Cambridge (Massachusetts), Harvard University, Fogg Art Museum.
St. Petersburg, State Hermitage Museum.
Paris, Musée Cognacq-Jay.
Paris, Louvre.
Washington (D.C.), National Museum of Women in the Arts.

HENRIETTA JOHNSTON. Active 1708–1725; died 1728–29. English.
 Johnston was an Englishwoman who lived in Charleston, South Carolina, from 1708 until her death in 1728–29. She did "primitive" portraits in pastel on tinted linen paper. Most of her subjects were prominent in the early history of the Carolina colony. She was born Henrietta Deering and married a clergyman, Gideon Johnston, in Dublin in 1705. In 1707, he was appointed rector of St. Philip's Church in Charleston, and they arrived in the colonial American city by 1708. Johnston returned to England briefly in 1711 because of ill health and because she was out of drawing materials. She returned to Charleston by 1713. After her husband's drowning death off the Carolina coast in 1716, Johnston probably supported herself by her art. Biographical information about her is sparse.

Bénézit. *Dictionnaire.* Vol. 6, p. 88.

Craven, Wayne. *Colonial American Portraiture.* Cambridge: Cambridge University Press, 1986. Pp. 247–249.
 Provides a brief account of her career in Charleston and two black-and-white reproductions.

Fine. *Women and Art.* Pp. 96–97.

Hill. *Women: A Historical Survey.* Catalogue. P. 3.
 A small black-and-white reproduction.

Keyes, Homer Eaton. "Coincidence and Henrietta Johnston." *Antiques.*
 16(December 1929):490–494.
 On the basis of pastels in English collections that are attributed to
Johnston, Keyes tentatively places her as an Englishwoman working
in Surrey under the influence of Edmund Ashfield or one of his pupils.
He thinks that Johnston probably left for South Carolina between
1700 and 1710. He notes that she visited New York City around 1725.
A color reproduction is included.

Middleton, Margaret Simons. *Henrietta Johnston of Charles Town,
 South Carolina: America's First Pastellist.* Columbia: University of
 South Carolina Press, 1966.
 The only major biography of this artist. It lists Johnston's known
works and attributions. Middleton points out that Johnston signed and
dated her works on the backing of the simple frames she furnished her
patrons. If the frame was changed, the signature was lost.

Rubinstein. *American Women Artists.* Pp. 21–23.

Rutledge, Anna Wells. "Who Was Henrietta Johnston?" *Antiques.*
 51(March 1947):183–185.
 Mentions early sources of information on Johnston. Rutledge
believes Johnston was Irish and that she was recently widowed when
she came to America.

Troop, Miriam. "Two Lady Artists and the Way for Success and Fame."
 Smithsonian. 8(February 1978):114–116, 118, 120–122, 124.
 Brief synopsis of Johnston's career. A color reproduction of one of
her works is included.

Willis, Eola. "The First Woman Painter in America." *International
 Studio.* 87(July 1927):13–20.
 Johnston is at least one of the earliest professional artists to be
documented in colonial America.

———. "Henrietta Johnston: South Carolina Pastellist." *Antiquarian.*
 11(September 1926):46–47.
 Willis thinks Johnston was English and the pupil of John Riley.
Mentions that she worked in New York and possibly North Carolina.
Includes good black-and-white reproductions.

Collections:

Charleston, Gibbes Art Gallery.
New Haven (Connecticut), Yale University Art Gallery.
Richmond, Virginia Museum of Fine Arts.
Winston-Salem (North Carolina), Museum of Early Southern Decorative Arts.

ANGELICA KAUFFMANN. 1741–1807. Swiss.
Kauffmann was a splendid practitioner of Neoclassical painting. She holds a special place in the history of women artists because she was the first to succeed at the hitherto all-male endeavor of history painting. Born in Switzerland, she was the daughter of an itinerant painter. Following the death of her mother, the teenage Kauffmann worked with her father in Italy. She was accomplished in music and fluent in many languages. She studied in Italy and France and settled in England in 1766 where she stayed until 1781. She was a friend of Sir Joshua Reynolds, Goethe, Mengs, and Winklemann. Although she had many suitors (Fuseli fell in love with her), she made an unfortunate marriage in 1767 to a Swedish "Count de Horn" who subsequently turned out to be a married commoner. In 1781 the Italian painter Antonio Zucchi became her husband and replaced her aging father in managing her business affairs. In addition to her history painting, Kauffmann was noted for her portraits. She also became involved in decorative arts, creating designs for Wedgwood and Meissen china, and decorations for ceilings and mantlepieces. She was a founding member of the English Royal Academy, and in 1765 she was elected to the Academy in Rome. She moved to Rome in 1782 and resided there until her death. The esteem in which she was held was reflected in her funeral. Organized by Antonio Canova, it was styled on Raphael's.

Bénézit. *Dictionnaire.* Vol. 6, pp. 172–173.

Bergenz. Vorarlberger Landesmuseum. *Angelika Kauffman und ihre Zeitgenossen.* 1968
 Exhibition organized by Dr. Oscar Sander.

Boase, T. S. R. "Macklin and Bowyer." *Warburg and Courtauld Institute Journal.* 26(1963):150, 165–66, 177.
 Discusses the work Kauffmann did for two English publishers, Thomas Macklin and Robert Bowyer.

Bryan. *Dictionary of Painters.* Vol. 3, p. 124.
 Lists her paintings and etchings.

Busiri Vici, Andrea. "Angelica Kauffman and the Bariatinskis." *Apollo.*
77(March 1963):201–208.
 Discusses a group portrait of Princess Catherine Bariatinski and her
family, painted in Rome in 1791. Includes several black-and-white
reproductions. Note the different spelling. "Kauffman" is often seen
in writing about her, but the spelling she always used was
"Kauffmann."

Clark, Anthony M. "Neo-classicism and the Roman Eighteenth Century
Portrait." *Apollo.* 78(November 1973):358–359.
 Black-and-white reproduction and brief description of her portrait
of Cardinal Rezzonico.

Clayton. *English Female Artists.* Pp. 233–294.

Clement. *Women in the Fine Arts.* Pp. 179–190.

Croft-Murray, Edward. *Decorative Painting in England, 1537–1837.*
London: Country Life Books, 1970. Vol. 2, pp. 227–229.
 Discussion of the Neoclassical decorative insets Kauffmann did for
domestic interiors.

Dekker, H. T. Douwes. "Angelica Kaufmann Imitatrice de Madame
Vigée-LeBrun." *Gazette des beaux-arts.* 104(November 1984):195.
 Notes a similarity between two compositions, one by each artist.

Eddy, Linda R. "An Antique Model for Kauffmann's *Venus Persuad-
ing.*" *Art Bulletin.* 58(December 1976):569–573.
 Venus Persuading was painted in Rome in 1790, toward the end of
Kauffmann's long career. Eddy discusses the antique prototypes of the
Homeric subject matter.

Edwards. *Women: An Issue.*

Ellet. *Women Artists.* Pp. 144–163.

Eva. "Women Artists . . . "

Fine. *Women and Art.* Pp. 72–75.
 Excellent chronology of Kauffmann's career and her acquaintance
with the luminaries of her century throughout England and Europe.

Fleisher. "Love and Art."

Gerard, Frances A. *Angelica Kauffman: A Biography.* London: Ward and Downey, 1893.
The appendix of this work has extensive listing of Kauffmann's works and a guide to houses decorated by her.

Goethe. *Italian Journey, 1786–1788.* Trans. W. H. Auden and Elizabeth Mayer. New York: Pantheon Books, 1962.

Greer. *The Obstacle Race.* Pp. 80–82, 90–95.

Guhl. *Die Frauen . . .*

Harris and Nochlin. *Women Artists, 1550–1950.* Pp. 81, 174–178, 346.

Hartcup, Adeline. *Angelica: The Portrait of an Eighteenth Century Artist.* London: W. Heinemann, 1954.
This biography is illustrated.

Hutchison, Sidney C. *The Homes of the Royal Academy.* London, 1956. Pp. 9ff., 16, 28.

Kamerick, Maureen. "The Woman Artist in the Eighteenth Century: Angelica Kauffman and Elizabeth Vigée-LeBrun." New Research on Women at the University of Michigan, 1974. Pp. 14–22.

Krull. *Women in the Arts.* Pp. 115–116, 127–129.

Maguinness, Irene. *British Painting.* London: Sidgwick and Jackson, 1920. P.76.
Maguinness says Kauffmann's work "is of no particular interest at this time and is best known through engravings."

Manners, Lady Victoria, and G. C. Williamson. *Angelica Kauffman, R.A., Her Life and Works.* London: John Lane, The Bodley Head, 1924; reprint, New York: Hacker Art Books, 1976.

Marks, Arthur S. "Angelica Kauffmann and Some Americans on the Grand Tour." *American Art Journal.* 12(Spring 1980):4–24.
Discussion of Kauffmann's Italian sojourn of 1760–1764 and some Americans of her acquaintance, including Benjamin West. Includes several black-and-white reproductions.

Mayer, Dorothy Moulton. *Angelica Kauffmann, R.A., 1741–1807.* London: Colin Smythe, 1972.
Many reproductions, several in color.

Moser, Joseph. *European Magazine.* 55(1809):259.
An obituary.

Munsterberg. *A History of Women Artists.* Pp. 40–45.

National Museum of Women in the Arts. Pp. 40–41.

Neilson. *Seven Women . . .* Pp. 9–29.

Petersen and Wilson. *Women Artists.* Pp. 43–46.

Poensgen, Georg. "Christoph Heinrich Knierp? Ein Kunstlerbildnis von Angelika Kauffmann." *Pantheon.* 31(July–September 1973):294–297.

Redgrave and Redgrave. *A Century of Painters of the English School.* Pp. 67–68.
Here Kauffmann's work is described as "weak and faulty in drawing." The authors elaborate by saying that her works "are of small value . . . If any progress were to be made in Art the British School did well to forget her."

"Richard Arkwright's Cabinet." *Connoisseur.* 136(January 1956): 356–357.
Excellent color reproduction of ornate cabinet with bow-fronted doors attributed to Kauffmann. Discusses briefly her work in interior decoration.

Ritchie, Mrs. Richmand. "Miss Angel." *Cornhill Magazine* (1875).
A fictionalized and popularized version of Kauffmann's life.

"A Roman Portrait by Angelica Kauffman." *Connoisseur.* 135(May 1955):190–191.
A discussion of Kauffmann's portrait of Mrs. Henry Benton, with a color illustration. Notes that after Kauffmann moved to Italy she had many commissions from the resident English colony in Rome.

Rossi, Giovanni Gherado de. *Vita de Angelica Kauffmann, pittrice.* Florence, 1810.
First published biography of the artist.

Roworth, Wendy Wassyng. "Angelica Kauffman's 'Memorandum of Paintings.' " *Burlington Magazine.* 126(October 1984):629–630.
Analysis of an Italian manuscript listing her works, which now belongs to the Royal Academy. An English translation had been included in the Manners and Williamson biography and attributed to Kauffmann. Roworth argues that much of it was written by Zucchi, her husband.

———. "The Gentle Art of Persuasion: Angelica Kauffman's *Praxitele and Phryne.*" *Art Bulletin.* 65(September 1983):488–492.

Schwartz. "If De Kooning . . . "

Schwarz, Michael. *The Age of the Rococo.* London: Pall Mall Press, 1971. P. 183.
Schwarz calls Kauffmann's pictures typical examples of the transition period between the Rococo and Neoclassicism.

Snyder-Ott, J. *Women and Creativity.* P. 69.
Brief summary of her career. Says Gainsborough felt threatened by her.

Sparrow, Walter Shaw. "Angelica Kauffman's Amazing Marriage." *Connoisseur.* 92(1933):242–248.
Sparrow at his most gossipy.

———. *Women Painters of the World.* Pp. 58–59.

Thieme and Becker. *Allgemeines Lexikon.* Vol. 20, pp. 1–5.

Tomory, Peter A. "Angelica Kauffman's *Costanza.*" *Burlington Magazine.* 129(October 1987):668–669.
Discussion of a work commissioned in Rome in 1783 and now in the collection of Australia's Queensland Art Gallery.

———. "Angelica Kauffman—*Sappho.*" *Burlington Magazine.* 113(May 1971):275–276.
Discusses the history of this painting. Mentions a possible romantic attachment between Kauffmann and the engraver William Ryland.

Tufts. *Our Hidden Heritage.* Pp. 117–125.

Vienna. Austrian Museum für Angewandte Kunst. *Angelika Kauffman und ihre Zeitgenossen.* 1969.

Exhibition catalog with several essays on her work. Excellent reproductions, some in color, of her work and that of her contemporaries are included.

Walch, Peter S. "An Early Neoclassical Sketchbook by Angelica Kauffmann." *Burlington Magazine.* 119(February 1977):98–111.
Discussion of a sketch book in the Victoria and Albert Museum. The drawings were executed between 1762 and 1766 when Kauffmann was traveling in Italy. Includes a biographical summary and black-and-white reproductions.

————. *Angelica Kauffman.* Ph.D. dissertation, Princeton University, 1969.

————. "Angelica Kauffman and Her Contemporaries." *Art Bulletin.* 51(March 1969):83–85.
Review of the exhibition listed above, held in Vienna and in Bregenz in 1968.

————. "Charles Rollin and Early Neo-classicism." *Art Bulletin.* 49(June 1967):124–125.
Discussion of the impact of the historian Rollin and the engraver Gravelot on Neoclassical art, with Kauffmann being one of the artists examined.

Wally, Leon de. *Angelica Kauffman.*1838.

Waterhouse, Ellis. "Reynolds, Angelica Kauffmann and Lord Borington." *Apollo.* 122(October 1985):270–274.
Discussion of Kauffmann's works in the collection of Saltram House.

"Women Artists" (review of Guhl).

Collections:

Berlin, Kupferstichkabinett.
Florence, Uffizi.
St. Petersburg, State Hermitage Museum.
London, Nation Portrait Gallery.
London, Victoria and Albert Museum.
London, Royal Academy of Arts.
Manchester, City of Manchester Art Gallery.

Naples, Museo e Gallerie Nazionali di Capodimonte.
New York, Metropolitan Museum of Art.
Philadelphia, Pennsylvania Academy of the Fine Arts.
Princeton (New Jersey), Princeton University Art Museum.
Richmond, Virginia Museum of Fine Arts.
Rome, Galleria dell'Accademia di San Luca.
Sarasota (Florida), John and Mable Ringling Museum of Fine Art.
Vienna, Osterreichische Galerie.
Washington (D.C.), National Museum of Women in the Arts.
Zurich, Kunsthaus.

ANNA BARBARA KRAFFT. 1764–1825. Austrian.
 Krafft was the daughter and student of Johann Steiner. She excelled in history and genre painting and portraiture. Krafft was a member of the Vienna Academy and was named Painter to the City of Bamberg. She and her apothecary husband lived in Prague, Salzburg, and Bamberg. Her son, Johann August Krafft, was also a painter.

Bénézit. *Dictionnaire.* Vol. 6, p. 303.

Bryan. *Dictionary of Painters.* Vol. 3, p. 150.

Clement. *Women in the Fine Arts.* P. 201.

Ellet. *Women Artists.* P. 241.

Greer. *The Obstacle Race.* P. 304.

Harris and Nochlin. *Women Artists, 1550–1950.* P. 50.

Thieme and Becker. *Allgemeines Lexikon.* Vol. 21, pp. 384–385.

ADÉLAÏDE LABILLE-GUIARD. 1749–1803. French.
 Labille-Guiard, a native of Paris, first learned the art of pastel painting from Maurice Quentin de La Tour between 1769 and 1774. She later became an incisive and virtuoso painter of oil portraits. Although she came from a nonartistic family (her father was a cloth merchant), she was probably encouraged in her career. In addition to her studies with La Tour, she also studied portrait miniature painting and oil painting with François Vincent. At the age of twenty she married Louis Guiard; they separated and were divorced ten years later. Her second husband was her

teacher, François Vincent. Labille-Guiard had no children. She and Vigée-LeBrun were admitted to the Royal Academy on the same day in 1783, shortly before it was dissolved by the Revolution. Although they were reportedly rivals, this may reflect journalism more than history. Labille-Guiard supported the aims of the Revolution, during which she agitated for women's rights. She remained in Paris and gradually won commissions to do portraits of the leading revolutionaries. When the Academy was reconstituted in 1795 as the Academy of Fine Arts, women were barred from membership; however, she continued to exhibit in the Salons between 1795 and 1800. Labille-Guiard was a particularly gifted teacher to a number of women students.

Bénézit. *Dictionnaire.* Vol. 6, pp. 351–352.
 Lists her Salon showings by year.

Callieux, Jean. "Royal Portraits of Mme. Vigée-LeBrun and Mme. Labille-Guiard." *Burlington Magazine.* 111(March 1969):iii–vi (advertisement supplement).
 Discusses the rivalry between the two artists.

Clement. *Women in the Fine Arts.* Pp. 202–203.

Edwards. *Women: An Issue.*

Fine. *Women and Art.* Pp. 45–48.
 Believes her husband, Vincent, was probably not her teacher. Notes she was the recipient of a royal pension in the mid-1780's.

Gabhart and Broun. "Old Mistresses."

Goulinat. "Les femmes peintres au XVIIIe siècle."

Greer. *The Obstacle Race.* Pp. 98–100, 262–268.

Harris and Nochlin. *Women Artists, 1550–1950.* Pp. 37, 40, 185–187, 347.
 Notes that she had few commissions in 1789 and 1790, and that she was ill for part of this time.

Hill. *Women: A Historical Survey . . .* Catalog. P. x.
 A good reproduction of *Portrait of the Artist with Two Pupils: Mlle. Marie-Gabrielle Capet and Mlle. Carreaux de Rosemond.* Capet was a particularly devoted student who cared for Labille-Guiard during her last illness.

Jallut, Marguerite. "Le portrait du prince de Bauffremont par Madame Labille-Guiard." *Revue du Louvre.* 12(1962):217–222.

Kagen, Andres. "A Fogg 'David' Reattributed to Mme. Adélaïde Labille-Guiard." *Acquisitions Report, 1969–1970, Fogg Art Museum.* Cambridge, Massachusetts, 1971. Pp. 31–40.

Munsterberg. *A History of Women Artists.* Pp. 38–40.

National Museum of Women in the Arts. Pp. 32–33.

Nochlin. "Why Have There Been No Great Women Artists?" P. 27. A small reproduction in black and white.

Paris. Grand Palais. *French Painting, 1774–1830: The Age of Revolution.* 1974–1975. P. 517.

Parker and Pollock. *Old Mistresses.* Pp. 28, 31–34.

Passez, Anne Marie. *Adélaïde Labille-Guiard: biographie et catalogue raisonné de son oeuvre.* Paris: Arts et métiers graphiques, 1973. Thorough account of Labille-Guiard's life and work. Discusses the rivalry with Vigée-LeBrun. Records and accepts 183 works; however, the locations of only 81 of these are known.

Petersen and Wilson. *Women Artists.* Pp. 54–58.

Portalis, Baron Roger. "Adélaïde Labille-Guiard." *Gazette des beaux-arts.* 26(1901):353–356, 477–494; 26(1902):100–118, 325–347. Until the catalog by Passez, this four-part article was the principal work on Labille-Guiard. Many black-and-white reproductions of fair quality are included.

————. *Adélaïde Labille-Guiard (1749–1803).* Paris, 1902.

Sparrow. *Women Painters of the World.* Pp. 175, 185, 188.

Thieme and Becker. *Allgemeines Lexikon.* Vol. 22, pp. 167–168.

Wilenski, R. H. *French Painting.* Boston: Charles T. Branford Company, 1931. Pp. 160–164.

Collections:

Boston, Harvard University, Fogg Art Museum.
New York, Metropolitan Museum of Art.
Paris, Louvre.
Phoenix Art Museum.
Versailles, Musées de Versailles et des Trianons.
Washington (D.C.), National Museum of Women in the Arts.

GIULIA LAMA. ca. 1685–after 1753. Italian.
 Lama's life is poorly documented. Her father was perhaps Agostino Lama, an obscure Venetian painter who died in 1714. She may have been the student of Giovanni Battista Piazzetta (1683–1754), to whom some of her oeuvre has been previously attributed. Lama did large-scale religious and narrative paintings. She was commissioned to do at least three Venetian altarpieces, of which two are extant. Currently some twenty-six paintings are given to her, in addition to many drawings. Of these drawings, some are of the male nude, unusual in women's art history considering the restrictions under which women received their education in art.

Goering, M. "Giulia Lama." *Jahrbuch der Königlich preussischen Kunstsammlungen.* 1935.

Greer. *The Obstacle Race.* Pp. 89–90, 145–146.

Harris and Nochlin. *Women Artists. 1550–1950.* Pp. 26, 29–30, 165–166, 345.
 These authors say that Lama is "one of the few women active before the nineteenth century whose figure paintings deserve serious study." Most of bibliography and biographical facts presented here are from this source.

Pallucchini, R. "Di una pittrice veneziana del settecento: Giulia Lama." *Rivista d'arte* (1933):400.

———. "Miscellanea piazzettesca." *Arte veneta* (1968):107–130.

———. "Per la conoscenza di Giulia Lama." *Arte veneta* (1970):161–172.
 This article reprints a letter from Abbot Luigi Conti to Mme. de Caylus, written in 1728, that reveals something of Lama's personality.

According to Harris and Nochlin, the letter shows Lama as a woman who studied mathematics, was persecuted by other painters, was interested in a machine for making lace, wrote poetry, and was witty if not pretty.

————. *Piazzetta.* Milan, 1956.

Ruggieri, Ugo. *Dipinti e disegni di Giulia Lama.* Bergamo: Monumenta Bergmensia XXXIV, 1973.

Thieme and Becker. *Allgemeines Lexikon.* Vol. 22, p. 247.

Collections:

Florence, Uffizi.
Lugano, Thyssen Collection.
Venice, Ca'Rezzonico, Museo del Settecento Veneziano.
Venice, Santa Maria Formosa.

JEANNE PHILIBERTE LEDOUX. 1767–1840. French.
Ledoux was born in Paris. She was the pupil of Greuze, and her style is derivative of his; thus their work has been confused. The lack of dates and signatures on her paintings, and the lack of a catalog of Greuze's work, contributes to the problem of identifying her oeuvre. Ledoux exhibited in the Salon from 1793 until 1819. The Salon records are the principal documentary source for her. Ledoux excelled in head and shoulder portraits of children and young women. She also painted genre works.

Bellier-Auvray. *Dictionnaire général.* Vol. 1, pp. 963.

Bénézit. *Dictionnaire.* Vol. 6, p. 526.
Describes her as being ''moderate in ambition.''

Ellet. *Women Artists in All Ages.* P. 236.

Fine. *Women and Art.* P. 60.

Gabhart and Broun. ''Old Mistresses.''

Harris and Nochlin. *Women Artists, 1550–1950.* Pp. 205–206, 348.

Hill. *Women: A Historical Survey . . . Pp. x, 10.*

Sparrow. *Women Painters of the World.* P. 176.

Thieme and Becker. *Allgemeines Lexikon.* Vol. 22, p. 538.

Collections:

Baltimore Museum of Art.
Budapest, Museum of Fine Arts.
Dijon, Musée des Beaux-Arts.
Dijon, Musée Magnin.
Paris, Louvre.
Vienna, Gemäldegalerie der Akademie der Bildenden Künste.

MARIE-VICTOIRE LEMOINE. 1754–1820. French.
 Little is presently known about this Paris-born painter. She studied
with Menageot (1744–1816). Though there is evidence to deny that
Lemoine was ever Vigée-LeBrun's student, her 1796 painting *Interior of
the Atelier of a Woman Painter* (New York, Metropolitan Museum of
Art) is an obvious and fascinating homage to Vigée-LeBrun. Lemoine
exhibited at the Salon de la Correspondence in 1778 and 1785 and at the
official Salons from 1796 to 1814. Her work consisted primarily of
miniatures and genre and portrait oils.

Bellier-Auvray. *Dictionnaire général.* Vol. 1, p. 998.

Bénézit. *Dictionnaire.* Vol. 6, p. 570.

Gabhart and Broun. "Old Mistresses."

Greer. *The Obstacle Race.* P. 271.

Harris and Nochlin. *Women Artists, 1550–1950.* Pp. 188–189, 347.

Hill. *Women: A Historical Survey . . .* Catalog. P. x, 8.

Ojalvo, David. "Musée des Beaux-Arts d'Orleans: peintures des XVIIe
et XVIIIe siècles." *Revue du Louvre.* 22(1972):333.
 Ojalvo believes the influence of Vigée-LeBrun is very distinct in
Lemoine's work. Includes a black-and-white reproduction of a self-
portrait.

Petersen and Wilson. *Women Artists.* P. 52.

Thieme and Becker. *Allgemeines Lexikon.* Vol. 23, p. 34.

Collections:

 New York, Metropolitan Museum of Art.
 Orleans, Musée des Beaux-Arts.

THÉRÈSE CONCORDIA MARON-MENGS. 1725–1808. German.
 Maron-Mengs was born in Aussig. She studied with her father, Ismael Mengs, and shared the art education of her brother, Anton Raphael Mengs. She was a miniaturist and a superb pastel portraitist. In 1741 she traveled to Rome where she met and married painter Anton Maron. She lived in Rome for the remainder of her life.

Bénézit. *Dictionnaire.* Vol. 7, p. 333.

Bryan. *Dictionary of Painters.* Vol. 3, p. 289.
 Bryan gives her birth date as 1733 and says she went to Rome with her brother in 1752.

Foster. *Dictionary of Painters of Miniatures.* P. 205.
 Foster notes that she also excelled in enamels and crayons.

Harris and Nochlin. *Women Artists, 1550-1950.* Pp. 39–40.

Krull. *Women in Art.* Pp. 35, 44.

Thieme and Becker. *Allgemeines Lexikon.* Vol. 24, p. 393.

Collections:

 Dresden, Gemaldegalerie.
 St. Petersburg, State Hermitage Museum.
 Rome, Galleria dell'Accademia di San Luca.
 Wurzburg, University of Wurzburg.

MARY MOSER. 1744–1819. English.
 Moser was the daughter of George Michael Moser, a Swiss artist residing in London. He was a prominent drawing instructor, enamel

painter, and official in the Royal Academy. Moser was a precocious artist, and after studying with her father, had her first showing at age fourteen. Along with Angelica Kauffmann, a close friend, she was elected to the Royal Academy. In Zoffany's 1772 painting of the Academy's life class, both Moser and Kauffmann are relegated to being depicted as portrait busts on the wall (a reproduction of that painting is available in Nochlin's "Why Have There Been No Great Women Artists?" P. 28). Moser was a regular exhibitor at the Royal Academy between 1769 and 1800, showing an occasional history painting, but mainly contributing flower pieces. She was reportedly in love with Fuseli, a passion that was not returned. In 1797 she married a military officer and painted only as an amateur thereafter.

Bénézit. *Dictionnaire.* Vol. 7, p. 562.
 Gives her marriage date as 1758.

Bryan. *Dictionary of Painters.* Vol. 3, p. 374.
 Notes that she received royal patronage to decorate a room at Frogmore.

Clayton. *English Female Artists.* Pp. 295–313.

Clement. *Women in the Fine Arts.* P. 244.

Ellet. *Women Artists in All Ages.* P. 181.

Eva. "Women Artists . . ."

Fine. *Women and Art.* Pp. 75–76.
 Describes her infatuation with Henry Fuseli. Fine comments that Moser's work is difficult to assess since so much of her oeuvre is in private collections or provincial museums.

Greer. *The Obstacle Race.* P. 248.

Harris and Nochlin. *Women Artists, 1550-1950.* Pp. 38, 174, 249.

Mitchell. *Great Flower Painters.* Pp. 182–183.

Redgrave and Redgrave. *A Century of Painters of the English School.* P. 153.
 These authors note that Moser's letters prove a desire to establish a "literary flirtation" with Fuseli.

Short, E. H. *The Painter in History.* P. 444.

Sparrow. *Women Painters of the World.* Pp. 60, 94.

Thieme and Becker. *Allgemeines Lexikon.* Vol. 25, p. 183.

Tufts. *Our Hidden Heritage.* P. 118.

Collections:

Cambridge, Fitzwilliam Museum.
London, British Museum.
London, Royal Academy of Arts.
London, Victoria and Albert Museum.

CATHERINE READ. 1723–1778. Scotch.
Born in Scotland, Read was one of thirteen children of a Scottish laird. By the late 1740's she was in Paris where she studied pastel portraiture with Quentin de la Tour. By 1751 she was in Rome where she studied oil painting with Louis Blanchet. She returned to England and in the late 1760's and early 1770's was that country's best-known portraitist. She also painted family scenes. In addition to oils, she also produced crayon works. Her work was reproduced in engravings. In the 1770's she traveled to India. Greer says she died there in 1777.

Bénézit. *Dictionnaire.* Vol. 8, p. 633.

Bryan. *Dictionary of Painters.* Vol. 4, p. 201.
Gives a death date of ca. 1786.

Ellet. *Woman Artists.* P. 190.

Fine. *Women and Art.* P. 71.

Foster. *Dictionary of Painters of Miniatures.* P. 247.

Greer. *The Obstacle Race.* Pp. 277–279.
Provides a good biographical summary.

Stephen and Lee. *Dictionary of National Biography.* Vol. 16, p. 793.
These authors say Read primarily painted portraits of the aristocracy.

Thieme and Becker. *Allgemeines Lexikon.* Vol. 28, p. 61.

RACHEL RUYSCH. 1664–1750. Dutch.

Rachel Ruysch was a fruit and flower painter of extraordinary quality. She was born in Amsterdam, the daughter of a botany professor, anatomist, and amateur painter. Her father's scientific influence is apparent in the wide range of flora and fauna she depicted and the concern for accuracy that her paintings demonstrate. At age fifteen she was apprenticed to Willem van Aelst, a flower painter. In 1693 she married portrait painter Juriaen Pool II (1666–1745). They had ten children. Unlike some other women painters, her production did not seem to decline with marriage. Her work was initially influenced by the work of Otto Marseus van Schriek but soon surpassed it in inventiveness. Ruysch's still lifes often include small dramas between the insects and other little creatures that usually inhabited the foreground. In 1701 she and her husband were admitted to the Hague Guild. From 1708 until 1716 they were patronized by the German court in Düsseldorf. She always signed her paintings with her birth name. Ruysch continued to paint until the age of eighty.

Bénézit. *Dictionnaire.* Vol. 9, p. 198.
 Gives lengthy listing of museum holdings of her work.

Bergstrom, Ingvar. *Dutch Still-Life Painting in the Seventeenth Century.* Trans. Christina Hedstrom and Gerald Taylor. London: Faber and Faber, 1956. P. 226.

Bernt, Walther. *The Netherlandish Painters of the Seventeenth Century.* 3 vols. London: Phaidon, 1970. Vol. 3, p. 100.

Bryan. *Dictionary of Painters.* Vol. 4, pp. 306–307.
 Lists museum holdings.

Champlin. *Cyclopedia of Painters and Paintings.* Vol. 4, pp. 92–93.

Clement. *Women in the Fine Arts.* Pp. 304–305.

Ellet. *Women Artists.* Pp. 106–109.

Fine. *Women and Art.* Pp. 35–36.

Grant, Maurice H. *Flower Painting Through Four Centuries: A Descriptive Catalogue of the Collection Formed by Major the Honorable Henry Rogers Broughton, Including a Dictionary of Flower Painters from the Sixteenth to the Nineteenth Century.* Leigh-on-Sea, Essex: F. Lewis, 1952.

————. *Rachel Ruysch, 1664–1750.* Leigh-on-Sea, Essex: F. Lewis, 1956.
 Harris describes this work as an uncritical catalog, compiling a list of 230 works, but with no discussion of the evidence.

Greer. *The Obstacle Race.* Pp. 241–243.

Guhl. *Die Frauen . . .*

Harris and Nochlin. *Women Artists, 1550–1950.* Pp. 29, 78, 158–160, 344–345.
 Harris notes that there are records of sixty signed and dated works and another thirty that are just signed. The locations of many of these are unknown today. She concludes that a critical catalogue raisonné is seriously needed.

Heller. *Women Artists.* P. 41.

Hill. *Women: A Historical Survey . . .* Catalog. Pp. 4, ix-x.
 A reproduction with exhibition and bibliographical information included in the caption.

Hofstede de Groot, Cornelis. *Beschreibendes und kritisches Verzeichnis der Werke der hervorragendsten holländischen Maler des XVII Jahrhunderts: nach dem muster John Smith's Catalogue raisonné zusammengestelt . . . Esslingen, 1907–1928; reprint edition, London, 1928.*

Lewis, Frank. *Dictionary of Dutch and Flemish Flower, Fruit and Still-Life Painters: Fifteenth to Nineteenth Century.* Leigh-on-Sea, Essex: F. Lewis Publishers, 1973. P. 62.
 Lewis notes that Ruysch was appointed court painter to the Kurfurst von der Pfalz in Düsseldorf in 1708.

Mitchell. *European Flower Painters.* Pp. 222–223.
 Discusses Ruysch's style and provides two reproductions. Summarizes the biographical facts.

Munsterberg. *History of Women Artists.* P. 26.

National Museum of Women in the Arts. Pp. 26–27, 228.

Nochlin. ''Why Have There Been No Great Women Artists?'' P. 30.

Petersen and Wilson. *Women Artists.* P. 41.

Renraw, R. "The Art of Rachel Ruysch." *Connoisseur.* 92(1933):397–399.
 Good discussion of the stylistic development of her work. Includes three good black-and-white reproductions.

Rosenberg, Jakob; Seymour Slive; and E. H. Ter Kuile. *Dutch Art and Architecture, 1600–1800.* Baltimore: Penguin Books, 1966. P. 216.

Schwarz, Michael. *The Age of the Rococo.* London: Pall Mall Press, 1971. Pp. 128, 137, 187.
 Calls Ruysch the most important of the early Dutch still-life painters.

Sip, Jaromir. "Notities bij het Stilleven van Rachel Ruysch." *Nederlands Kunsthistorisch Jaarboek.* 19(1966):157–170.
 Traces Ruysch's interest in botany and biology to her father and his collection of specimens and notes that her still lifes usually included biological specimens. Illustrated with engravings of her father's collection by Joseph Fulden and Cornelis Huyberts.

Sparrow. *Women Painters of the World.*

Sterling, Charles. *Still-Life Painting from Antiquity to the Present Time.* Paris, 1959. P. 48

Thieme and Becker. *Allgemeines Lexikon.* Vol. 29, pp. 243–244.

Timm, Werner. "Bemerkungen zu einem Stilleben von Rachel Ruysch." *Oud-Holland.* 77(1972):137–138.

Tremaine, George. "A Queen of Flower Painters: Rachel Ruysch." *Garden Design.* 22(1935):52–54.

Tufts. *Our Hidden Heritage.* Pp. 99–107.

Valentiner, W. R. "Allegorical Portrait of Rachel Ruysch." *North Carolina Museum of Art Bulletin.* 1(Summer 1957):7.
 This may be the same painting that faces the chapter on Ruysch in Tuft's book (*above*), by Constantin Netscher, *Rachel Ruysch in Her Studio.*

"Women Artists" (review of Guhl).

Collections:

Cambridge, Fitzwilliam Museum.
Florence, Palazzo Pitti.
Florence, Uffizi.
Glasgow Art Gallery and Museum.
Karlsruhe, Staatliche Kunsthalle Karlsruhe.
New York, Metropolitan Museum of Art.
Oxford, Ashmolean Museum.
Rotterdam, Museum Boymans-Van Beuningen.
Toledo Museum of Art.
Vienna, Gemäldegalerie der Akademie der bildenden Künste.
Washington (D.C.), National Museum of Women in the Arts.

ANNA DOROTHEA THERBUSCH-LISZEWSKA. 1721–1782.
German.

This artist was born in Berlin into a family of Polish artists and received her first training from her father. He birth name was Liszewska; Therbusch was her married name. She is occasionally listed as Liszewska-Therbusch. She may have been the student of Antoine Pesne (1683–1757) and have studied in Paris. Her earliest work is influenced by Watteau. Therbusch-Liszewska married an amateur painter and did not accept a major commission until 1761, when her children were grown. She worked for the courts of Stuttgart and Mannheim and for Frederick the Great. She painted portraits, genre, and some mythological and historical scenes, but her frank realism and lack of idealism were not appreciated. Therbusch-Liszewska was in Paris between 1766 and 1770, but her work was not well received in France, though she was admitted to the French Academy in 1768. She was also a member of the academies of Bologna, Berlin, and Vienna. Her younger sister, Anna Rosina Liszewska (1713–1783), was also an artist.

Bartoschek, Gerd. *Anna-Dorothea Therbusch, 1721–1782.* Potsdam-Sancouci: Kulturhaus Hans Marchwitza, 1971.
 A catalog.

Bénézit. *Dictionnaire.* Vol. 5, p. 602.

Bryan. *Dictionary of Painters.* Vol. 3, p. 234.

Champlin. *Cyclopedia of Painters and Paintings.* Vol. 3, p. 89.

Clement. *Women in the Fine Arts.* Pp. 213–214.

Diderot, Denis. *Diderot Salons (1759–1779).* Jean Adhemar and Jean Seznac, eds. Oxford, 1957–1967. Vol. 3, p. 250.
Diderot describes Therbusch-Liszewska as not lacking in talent but saw her lack of youth, beauty, and coquetry as working to her disadvantage.

Ellet. *Women Artists.* P. 143.
Lists her date of birth as 1722.

Greer. *The Obstacle Race.* Pp. 88–89.

Harris and Nochlin. *Women Artists, 1550–1950.* Pp. 36, 42, 79, 169–170, 345–346.

Hill. *Women: A Historical Survey . . .* Catalog. P. x.
Says she earned Diderot's praise for her depiction of a male nude.

Parker and Pollock. *Old Mistresses.* Pp. 92–93, 96.

Petersen and Wilson. *Women Artists.* P. 48.
Describes her as ambitious and obviously having the strong ego necessary to deal with the excessively masculine Prussian court.

Thieme and Becker. *Allgemeines Lexikon.* Vol. 22, pp. 282–283.
This entry is by C. Reidemeister, based on his unpublished 1924 dissertation.

Collections:

Berlin, Staatliche Museum.
Moscow, Pushkin State Museum.
Paris, Louvre.
Vienna, Gemäldegalerie der Akademie der bildenden Künste.

ANNE VALLAYER-COSTER. 1744–1818. French.
Vallayer-Coster was the daughter of a goldsmith. Her family moved to Paris when she was ten years old. Nothing is known of her training. The majority of her work consists of still lifes and flower paintings. She made some efforts at portraiture but these were not well received. She was one of three women admitted to the Royal Academy before the

Revolution of 1789, gaining the honor in 1770. Vallayer-Coster was given the title of Painter to the King and was given an apartment in the Louvre. In 1781 she married a lawyer. She exhibited regularly in the Salons from 1770 to 1789 and from 1795 to 1817.

Bénézit. *Dictionnaire.* Vol. 3, p. 204.

Bryan. *Dictionary of Painters.* Vol. 5, p. 230.

Fine. *Women and Art.* P. 45.
Notes that over four hundred paintings are attributed to her.

Foster. *Dictionary of Painters of Miniatures.* P. 61.

Goulinat. "Les femmes peintres au XVIII^e siècle."

Greer. *The Obstacle Race.* Pp. 244–246.

Harris and Nochlin. *Women Artists, 1550–1950.* Pp. 82, 179–184, 346–347.

Hill. *Women: A Historical Survey* . . . Catalog. Pp. 2, 7, 8.
Provides exhibition and bibliographic information and two reproductions.

Mirimonde, A. P. de. "Les oeuvres françaises à sujet de musique au Musée en Louvre. II: Natures mortes des XVIII^e et XIX^e siècles." *Revue du Louvre.* 15(1965):111–124.
Illustrates and briefly discusses her work, *The Attributes of Music.*

Mitchell. *Great Flower Painters.* P. 248.

Nochlin. "Why Have There Been No Great Women Artists?" P. 30.
Reproduces one of her works.

Paris. Grand Palais. *French Painting, 1774–1830: The Age of Revolution.* 1974–1975. Pp. 638–639.

Petersen and Wilson. *Women Artists.* Pp. 58–60.

Roland Michel, Marianne. "A propos d'un tableau retrouvré de Vallayer-Coster." *Bulletin de la Société de l'Histoire de l'Art Français.* 1965.

————. *Anne Vallayer-Coster, 1744–1818.* Paris: C.I.L., 1970.

————. "A Basket of Plums." *Cleveland Museum Bulletin.* 60(February 1973):52–59.
 Points out the diversity of Vallayer-Coster's work: still lifes, flower pieces, and portraits. Summarizes her choice of subject matter chronologically and discusses the motif of the plum basket in her work.

————. "Tapestries on Designs by Anne Vallayer-Coster." *Burlington Magazine.* 102(November 1960):Supp. i–ii.
 Before the Revolution the Gobelins tapestry factory employed designs by Vallayer-Coster and later reused the same designs. Includes three black-and-white illustrations.

Sterling, Charles. *Still Life Painting from Antiquity to the Present Time.* New York: Universe Books, 1959. P. 89.
 Calls Vallayer-Coster "after Chardin and Oudry, the best French still life painter of the eighteenth century."

Thieme and Becker. *Allgemeines Lexikon.* Vol. 35, p. 76.

Tufts. *Our Hidden Heritage.* P. 128.

Collections:

 Cleveland Museum of Art.
 Geneva, Musée d'Art et d'Histoire.
 New York, Metropolitan Museum of Art.
 Paris, Louvre.
 Toledo (Ohio), Museum of Art.

MARIA VARELST. 1680–1744. Austrian.
 Varelst was the daughter of the painter Herman Varelst and the student of her uncle, Simon Varelst. She was born in Vienna, but her family moved to London when she was three, and it was there that her artistic career came to fruition. Varelst painted portraits and small history paintings. She was also talented as a musician and a linguist.

Bénézit. *Dictionnaire.* Vol. 8, p. 519.

Clayton. *English Female Artists.* Pp. 71–77.

Clement. *Women in the Fine Arts.* Pp. 339–340.

Ellet. *Women Artists.* Pp. 165–166.
Ellet lists Antwerp as Varelst's birthplace.

Foskett. *A Dictionary of British Miniature Painters.* Vol. 1, p. 560.

Hill. *Women: A Historical Survey . . . P. ix.*

Long. *British Miniaturists.* P. 447.

Thieme and Becker. *Allgemeines Lexikon.* Vol. 34, p. 237.

MARIE LOUISE ELISABETH VIGÉE-LeBRUN. 1755–1842. French.
Elisabeth Vigée-LeBrun was the daughter of pastellist Louis Vigée. She was born and died in Paris. She exhibited artistic talent at an early age. Her earliest teachers, Gabriel Doyen and Davesne, were friends of her father. At the age of fourteen she took lessons in the Louvre with Gabriel Briard. In 1776 she made an unwise marriage to one of the most important art dealers of the period, Jean-Baptiste LeBrun. They had one daughter. Unfortunately LeBrun was a womanizer and a gambler. In 1779 Vigée-LeBrun was named official painter to Marie-Antoinette, who is supposed to have picked up the artist's dropped paint brushes when the artist was too far into pregnancy to stoop down. Vigée-LeBrun was elected to the French Academy in 1783 along with Adélaïde Labille-Guiard. During her career, she was also admitted to the academies of Berlin, Rome, Bologna, Florence, and St. Petersburg. Because of her close relationship with Marie-Antoinette, Vigée-LeBrun was forced to flee France at the outbreak of the Revolution in 1789. Her husband did not accompany her, and they divorced in 1794. Vigée-LeBrun spent twelve years traveling and painting portraits. She worked in Rome, for the Royal Court in Naples, in Vienna, Prague, and Berlin. She spent six years in Russia where she painted close to fifty portraits. Vigée-LeBrun met with an enthusiastic reception wherever she went, finding many commissions. In 1802 she returned to France briefly, then traveled to England where she worked for three years. A prolific painter, she produced more than eight hundred portraits during her career.

Adams, Brooks. "Privileged Portraits: Vigée-LeBrun." *Art in America.* 70(November 1982):74–81.
Review of first retrospective of her work, held in 1982 at the Kimbell Art Museum in Fort Worth, Texas.

Babin, G. "Mme. Vigée-LeBrun, portrait de Mme. Grand, plus tard princesse de Tallyrand." *L'illustration* (June 1912).

Baillio, Joseph. *Elisabeth Louise Vigée-LeBrun, 1755–1842*. Fort Worth: Kimbell Art Museum, 1982.
Exhibition catalog of retrospective show, held June 5–August 6, 1982. This is the first comprehensive monograph on the artist since 1919. It includes a chronology of her life and contains copious reproductions, both in color and in black and white.

————. *Elisabeth Louise Vigée-LeBrun (1775–1842)*. Ph. D. dissertation, University of Rochester, 1983.

————. "Identification de quelques portraits d'anonymes de Vigée-LeBrun aux Etats-Unis." *Gazette des beaux-arts*. 96(November 1980):157–168.
Baillio assigns identities to several portraits that have not been previously identified.

————. "Marie-Antoinette et ses enfants par Madame Vigée- LeBrun." *L'oeil*. 308(March 1981):34–41; 310(May 1981)52–61, 90–91.
This two-part article explores various portraits of Marie-Antoinette by Vigée-LeBrun and their political implications. Different symbols used by the artist are discussed as well as the reactions provoked by her presentation of the painting of Marie-Antoinette and her children at the Salon of 1787. Includes excellent color reproductions.

————. "Quelques peintures réattribuées à Vigée-LeBrun." *Gazette des beaux-arts*. 99(January 1982):2–26.
Baillio concedes that some works have been unduly assigned to Vigée-LeBrun. He then presents arguments for reattributing eight works to her that have been thought to be by her father, Duplessis, Perronneau, and others.

Bénézit. *Dictionnaire*. Vol. 10, pp. 500–502.
Long list of museums holding her work.

Bischoff, Ilse. "Vigée-LeBrun's Portraits of Men." *Antiques*. 93(January 1968):109–111.
Discusses the differences in her portrait treatment of men and women. Details her relationships with the sitters. Includes several black-and-white reproductions.

Blum, André. *Madame Vigée-LeBrun, peintre des grandes dames du XVIIIe siècle*. Paris, 1919.

Bordeaux, Jean-Luc. "Elisabeth Louise Vigée-LeBrun, 1755–1842." *Art International.* 26(July–August 1983):25–28, 64.
Review of exhibition of Vigée-LeBrun's works at the Kimbell Museum in Fort Worth, Texas, in 1982. Includes several color reproductions.

Bouchot, Henri. "Une artiste française pendant l'emigration, Madame Vigée-LeBrun." *Revue de l'art ancien et moderne.* 1(1898):219–230.

Bryan. *Dictionary of Painters.* Vol. 3, pp. 193–194.

Cailleux, Jean, ed. "Royal Portraits of Mme. Vigée-LeBrun and Mme. Labille-Guiard." *Burlington Magazine.* 111(March 1969):iii-vi.

Clement. *Women in the Fine Arts.* Pp. 340–350.

Constans, Claire. "Un portrait de Catherine Vassilievna Skavronskais par Madame Vigée-LeBrun." *Revue de Louvre.* 17(1967):265–272.

Duret-Robert, François. "Deux longueurs d'avance pour Madame Vigée-LeBrun." *Connaissance des arts.* 395(January 1985):92.
Discusses current prices of Vigée-LeBrun's work.

Ellet. *Women Artists.* Pp. 206–220.

Eva. "Women Artists . . ."

Faxon, Alicia. "Elisabeth LeBrun: A Queen's Favorite." *Boston Globe* (July 18, 1972).

Fine. *Women and Art.* Pp. 48–51.

Frankfurter, Aldred. "Museum Evaluations, 2: Toledo." *Art News.* 63(January 1965):26, 55–56.
Discusses her painting *Lady Folding a Letter* and speculates on the reason for inclusion of genre accessories in her portraits.

Gabhart and Broun. "Old Mistresses."

Gallet, Michel. "La maison de Madame Vigée-LeBrun Rue du Gros-Chenet." *Gazette des beaux-arts.* 56(November 1960):275–282.
Description of the house built in 1785 by her husband, J. P. LeBrun.

Golzio, Vincenzo. "Il soggiorno romano di Elisabeth Vigée-LeBrun." *Studio romani.* 4(1956):182–183.

Goulinat. "Les femmes peintres au XVIII^e siècle."

Greer. *The Obstacle Race.* Pp.95–98, 268–275.

Guhl. *Die Frauen . . .*

Harris and Nochlin. *Women Artists, 1550-1950.* Pp. 28–29, 37, 40–41, 46, 83, 185–194, 347–348.

Hautecour, Louis. *Mme. Vigée-LeBrun: étude critique.* Paris, [1917].

Heller. *Women Artists.* Pp. 58–60.

Helm, William Henry. *Vigée-LeBrun: Her Life, Works and Friendships.* Boston: Small, Maynard and Company, 1915; London, 1916.

Hill. *Women: A Historical Survey . . .* Catalog. Pp. x, 9.
 Vigée-LeBrun was also an important teacher. The work of one of her students, Marie-Victoire Lemoine (1754–1820), can be seen on page 8.

Kamerick, Maureen. "The Woman Artist in the Eighteenth Century: Angelica Kauffman and Elizabeth Vigée-LeBrun." *New Research on Women at the University of Michigan.* 1974. Pp. 14–22.

Krull. *Women in Art.* Pp. 141–142.

Kyle, Elizabeth [Agnes Dunlop]. *Portrait of Lisette.* New York: Thomas Nelson and Sons, 1963.
 A fictionalized account for juvenile readers.

LeBrun, Jean Baptiste Pierre. *Précis historique de la vie de la citoyenne LeBrun, peintre.* Paris, 1794.
 A petition by Vigée-LeBrun's husband for her to be allowed to return to France.

Levey, Michael. *Art and Architecture of the Eighteenth Century in France.* Harmondsworth, Middlesex: Penguin, 1972. Pp. 187–188.

Lucas, E. V. *Chardin and Vigée-LeBrun.* London, New York, n.d.
 Two unrelated essays.

MacColl, D. S. "Madame Vigée-LeBrun's *Boy in Red.*" *Burlington Magazine.* 42(April 1923):182–187.

Brief account of the iconography of this work and the reasons for its attribution to her.

Macfall, Haldane. *Vigée-LeBrun*. London, New York: Masterpieces in Colour Series, [ca. 1909].
Lightweight biography with inferior color reproductions.

Michel, Marianne Roland, and Catherine Binda. "Un portrait de Madame Du Barry." *Revue de l'art.* 46(1979):40–45.
Discussion of the history of this portrait by Vigée-LeBrun and the methods used to restore the painting.

Munhall, Edgar. "Vigée-LeBrun's *Marie Antoinette*." *Art News.* 82(January 1983):106–108.
Discusses the ties between the artist and her famous patron.

Munsterberg. *A History of Women Artists*. Pp. 37–38.

Muntz, E. "Lettres de Mme. Vigée-LeBrun relatives à son portrait de la galerie des offices (1791)." *Nouvelle archives de l'art français.* 1874-1875. Pp. 449–452.

Musick, James. "An Early Portrait by Vigée-LeBrun." *St. Louis Museum Bulletin.* 26(July 1941):53–55.

National Museum of Women in the Arts. Pp. 34–35.

Neilson. *Seven Women . . .* Pp. 31–45.

Nikolenko, Lada. "The Russian Portraits of Mme. Vigée-LeBrun." *Gazette des beaux-arts.* 70(July-August 1967):91–120.
Catalogs the portraits done during Vigée-LeBrun's six years in Russia (1795–1801) and discusses her style. Includes many reproductions.

Nochlin. "Why Have There Been No Great Women Artists?" P. 34.
A full-page color reproduction of a portrait of her daughter.

Nolhac, Pierre de. *Mme. Vigée-LeBrun, peintre de la reine Marie-Antoinette. 1755–1842.* Paris, 1908; reprint, Paris: Goupil et Cie, 1912.
The second edition was titled *Madame Vigée-LeBrun: Painter of Marie-Antoinette.*

Paris, Grand Palais. *French Painting, 1774–1830: The Age of Revolution.* 1974–1975. Pp. 664–668.

Petersen and Wilson. *Women Artists.* Pp. 49–54.

Pillet, Charles. *Madame Vigée-LeBrun.* Paris, 1890.

Rosenberg, Pierre. "A Drawing by Madame Vigée-LeBrun." *Burlington Magazine.* 123(December 1981):739–741.
 Discusses the obstacles to her admission to the French Academy.

"St. Louis Obtains Charming Vigée-LeBrun." *Art Digest.* 15(January 1, 1941):13.
 Portrait of her younger brother, painted when she was eighteen. Black-and-white illustration.

Schwarz, Michael. *The Age of Rococo.* London: Pall Mall Press, 1971. Pp. 64, 73, 188.

Shelley, Gerard, trans. *The Memoirs of Mme. Elisabeth Vigée-LeBrun.* New York: George H. Doran and Company, [1927].
 An abridged translation. *See also* Strachey for a somewhat less abridged translation.

Sizer, Theodore. "The John Trumbulls and Mme. Vigée-LeBrun." *Art Quarterly.* 15(Summer1952):170–178.
 Trumbull met Vigée-LeBrun in 1786 in Paris, where he participated in soirees at her studio. Discusses the similarities in their lives and their art, concluding that she had a lasting and beneficial effect on his style.

Sparrow. *Women Painters of the World.* Pp. 175–178.

Strachey, Lionel, trans. *Memoirs of Elisabeth Vigée-LeBrun.* New York: Doubleday, Page and Company, 1903.
 An abridged translation, but less so than Shelley's. Includes lengthy appendix listing her paintings.

Sutton, Denys. "Madame Vigée-LeBrun: A Survivor of the *Ancien Régime.*" *Apollo.* 116(July 1982):24–30.
 Good summary of her career. Includes several reproductions, in both color and black and white.

————. "Russian Francophiles of the Dix-huitième." *Apollo.* 101(June 1975):426.
Summarizes her six-year Russian sojourn.

Tripier-Le Franc, Justin. "Notice sur la vie et les ouvrages de Mme. LeBrun," extract from *Le journal dictionnaire de biographie moderne.* Paris, 1928. Pp. 177–192.

Tuetey, A. "L'emigration de Mme. Vigée-LeBrun." *Bulletin de la Société de l'Histoire de l'Art Français* (1911):169–182.

Tufts. *Our Hidden Heritage.* Pp. 127–137.

————. "Vigée-LeBrun." *Art Journal.* 42(Winter 1982):335.
Reviews the Kimbell Museum retrospective and its catalog.

Vigée-LeBrun, Marie Louise Elisabeth. *Souvenirs de Mme. Vigée-LeBrun.* 3 vols. Paris, 1835–1837.
Fascinating memoirs, two abridged English translations of which were listed above. Reveals her lack of comprehension that aristocratic society was doomed. She gives marvelous practical advice, such as how to do a man's portrait without letting him flirt with you.

"Women Artists." (review of Guhl).

Collections:

Baltimore Museum of Art.
Birmingham, Barber Institute of Fine Arts.
Boston Museum of Fine Arts.
Columbus (Ohio), Gallery of Fine Arts.
Florence, Uffizi.
Fort Worth, Kimbell Art Museum.
Geneva, Musée d'Art et d'Histoire.
Indianapolis Museum of Art.
London, Wallace Collection.
Montpellier, Musée Fabre.
New York, Metropolitan Museum of Art.
Paris, Louvre.
Pasadena, Norton Simon Museum of Art.
Raleigh, North Carolina Museum of Art.
St. Louis Art Museum.
Toledo (Ohio), Museum of Art.

Vienna, Kunsthistorisches Museum.
Washington (D.C.), National Gallery of Art.
Washington (D.C.), National Museum of Women in the Arts.

PATIENCE LOVELL WRIGHT. 1725–1786. American.
Wright was born in New Jersey to a family of Quakers. She ran away from this restrained life and settled in Philadelphia. At the age of twenty-three she married Joseph Wright, a farmer who died in 1769. Throughout the nineteen years of her marriage, as she raised three children, she modeled small figures in bread dough, and later in wax, as a hobby. After the death of her husband, Wright moved to New York City and supported herself and her family by selling her wax sculptures. She created a traveling exhibition of well-known waxwork likenesses, the first of its kind. Her life-size figures, with clothing and glass eyes, were placed in tableaux. In 1772 Wright took her art to London. While in England she modeled King George and Queen Charlotte. Her outgoing personality and her artistic skill made her quite popular in London. Because of her English connections she was rumored to have been a spy for the Americans during the Revolution. In 1781 she was in Paris where she was commissioned to do a bust of Benjamin Franklin.

Bénézit. *Dictionnaire.* Vol. 10, p. 806.

Craven. *Sculpture in America.* Pp. 27–28.
Craven describes Wright's bas-relief portraits and her numerous commissions. He mentions that her son Joseph studied painting with Benjamin West and her daughter married the English portrait painter John Hoppner.

Ellet. *Women Artists in All Ages.* Pp. 182–186.

Fine. *Women and Art.* Pp. 97–98.

Lesley, Parker. "Patience Lovell Wright: America's First Sculptor." *Art in America.* 24(October 1936):148–157.
Summarizes the early written source material about Wright.

National Cyclopaedia of American Biography. Vol. 8, p. 278.
Says she carried on a "patriotic" correspondence with Franklin.

Post. *History of European and American Sculpture.* P. 108.

Pyke. *Biographic Dictionary of Wax Modelers.* Pp. 158–159.

Rubinstein. *American Women Artists.* Pp. 23–26.
 Good summary of her career.

Sellers, Charles C. *Patience Wright: American Artist and Spy in George III's London.* Middleton, Connecticut: Wesleyan University Press, 1976.
 A very readable biography, compiled after years of research. Quotes from her thirty surviving letters.

————. "Wright, Patience." In *Notable American Women, 1607–1950.* Vol. 3, pp. 685–687.

Stephen and Lee, eds. *The Dictionary of National Biography.* Vol. 21, pp. 1036–1037.

Tinling. *Women Remembered.* P. 356.

Troop, Miriam. "Two Lady Artists and the Way for Success and Fame." *Smithsonian.* 8(February 1978):114–116, 118, 120–122, 124.
 Wright's career is briefly summarized. A color reproduction of one of her works is included.

Collections:

 Baltimore, Maryland Historical Society.
 London, Victoria and Albert Museum.
 London, Westminster Abbey.
 Newark (New Jersey) Museum.

NINETEENTH CENTURY

HELEN ALLINGHAM. 1848–1928. English.

Allingham was very popular during the Victorian era for her pictures of old-fashioned gardens, cottages, and children. More recently her work has been viewed as overly sentimental and sweet. She was born in Burton-on-Trent. She studied at the Birmingham School of Design and at the Royal Academy School. In 1868 she traveled in Italy on a short sketching tour. She married the Irish poet William Allingham. Allingham's first success was as a graphic artist. She illustrated the first serial magazine version of Thomas Hardy's *Far from the Madding Crowd.* Allingham was a member of the London Fine Art Society.

Beaumont, Mary Rose. "London Reviews." *Art and Artists.* 15(July 1980):34.

Notes that Ruskin admired her detailed drawings of snail shells and her studies of cliffs showing clearly their geological structure. Says Allingham illustrated two books, *Happy England* (1903), and *The Cottage Homes of England* (1909).

Bénézit. *Dictionnaire.* Vol. 1, pp. 126–127.

Darley, Gillian. "The Cottage Garden in Nineteenth-Century Painting." *Connoisseur.* 201 (June 1979):104–109.

Darley calls Allingham the "high-priestess" of the cottage garden painting movement and notes that she painted little else. Darley faults the "saccharine images" of her work, but finds that her paintings were extremely accurate records of gardens.

"From Manor to Cottage." *Art and Artists.* 225(June 1985):35–36.

An exhibition review with biographical summary. Says Allingham earned her living from 1868 to 1874 as a magazine and newspaper illustrator, although this was after her marriage.

Johnson and Greutzner. *Dictionary of British Artists, 1880–1940.* P. 24.

Nunn. *Victorian Women Artists.* P. 215.

Nunn notes that Allingham was frequently given one-woman exhibitions by the Fine Art Society in the 1880's and 1890's.

Sparrow. *Women Painters of the World.* P. 69.

Wood, Cristopher. *Paradise Lost: Paintings of English Country Life and Landscape, 1850-1914.* London: Barrie and Jenkins, 1988. Pp. 29, 129–131.

Collections:

Birmingham, City of Birmingham Museums and Art Gallery.
Sydney, Art Gallery of New South Wales.

LADY LAURA THERESA ALMA-TADEMA. 1852–1909. English.
This artist was born in London. Both of her parents were painters and encouraged her early interest in drawing. At the age of eighteen she became the pupil of Sir Lawrence Alma-Tadema. She married her teacher in 1871. Lady Alma-Tadema exhibited at the Royal Academy beginning in 1873, and in Berlin and Paris. The majority of her work consists of genre scenes, often depicting children, set in seventeenth-century Holland. She also did pastel portraits, also often of children. On her visits to Italy she painted landscapes. She signed her works "L. Alma-Tadema," causing them to be often confused with those of her husband. Although he is well known as an artist, she has been virtually forgotten.

Bénézit. *Dictionnaire.* Vol. 1, p. 130.

Clayton. *English Female Artists.* Vol. 2, p. 6.

Clement. *Women in the Fine Arts.* Pp. 9–10.

Greer. *The Obstacle Race.* P. 45.
Says her father was a Dutch cocoa merchant.

Meynell, Alice. "Laura Alma-Tadema." *Art Journal.* 22(November 1883):345–347.
This is the major source of information on the artist, written when Lady Alma-Tadema was only thirty-one. At this point in her career she had completed fifty-six paintings, "although like most women Mrs. Alma-Tadema works with interruptions." She evidently had

some influence on her husband's art: "Her teacher does her charming work the honor of consulting her studies now and then in aid of his own accessory landscapes." Four engravings of her work are reproduced.

Sparrow. *Women Painters of the World.* P. 70.

Thieme and Becker. *Allgemeines Lexikon.* Vol. 1, p. 325.

Collection:

London, Victoria and Albert Museum.

SOPHIE ANDERSON. 1823–after 1898. English.
Anderson was born in Paris. Her mother was English; her father was a French architect and engineer. The family lived in France until 1848, then moved to America for a period before settling in England. Anderson studied in Paris with Steuben but spent the majority of her artistic career in London where she was employed by the Louis Prang Lithograph Company. She married the English artist Walter Anderson. Because of her poor health they resided in Italy from 1871 to 1894. Anderson specialized in sentimental narrative scenes of domestic life and also did portraits and landscapes. She exhibited regularly at the Royal Academy from 1855 to 1896.

Bénézit. *Dictionnaire.* Vol. 1, p. 170.

Clayton. *English Female Artists.* Vol. 2, pp. 7–9.

Graves, Algernon. *The Royal Academy of Arts.* London, 1905. Vol. 1, p. 33.

Harris and Nochlin. *Women Artists. 1550–1950.* P. 53.

Heller. *Women Artists.* P. 76.

Hill. *Women: A Historical Survey . . .* Catalog. Pp. xi, 12.
Illustrates one of her works and provides bibliographical information.

Johnson and Greutzner. *Dictionary of British Artists.* P. 26.

Nochlin. "By a Woman Painted . . ." P. 70.
 A small, color reproduction with a short stylistic analysis.

Sparrow. *Women Painters of the World.* P. 105.

Thieme and Becker. *Allgemeines Lexikon.* Vol. 1, p. 438.

Wood. *Dictionary of Victorian Painters.* P. 23.

Collections:

 Leicester Museum and Art Gallery.
 Liverpool, Walker Art Gallery.

RUTH HENSHAW BASCOM. 1772–1848. United States.
 Bascom spent her life in New Hampshire and Massachusetts. She
married a Dartmouth professor in 1804. After his death she married the
Reverend Ezekiel Bascom in 1806. Bascom was a self-taught portraitist
who rarely charged for her work. She did full-size profiles in pastels,
usually tracing a projected shadow of the subject in pencil. Sometimes
the profiles were cut out and pasted onto a sheet of colored paper.
Occasionally she added bits of metal foil to simulate jewelry or
spectacles.

Dewhurst, C. Kurt; Betty MacDowell; and Marsha MacDowell. *Artists
 in Aprons: Folk Art by American Women.* Pp. 155–156.

Dods, Agnes. "Connecticut Valley Painters." *Antiques.* 46(October
 1944):207–209.

Ebert, John, and Katherine Ebert. *American Folk Painters.* New York:
 Charles Scribner's Sons, 1975. Pp. 48–50.
 A good account of Bascom's life and an excellent description of her
 stylistic characteristics.

Lipman, Jean, and Alice Winchester. *The Flowering of American Folk
 Art, 1776-1876.* New York: Viking Press, 1974. Pp. 25, 280.

———, eds. *Primitive Painters in America, 1750–1950.* New York:
 Dodd, Mead, 1950.
 Includes several illustrations of Bascom's work. The chapter on
 Bascom is by Agnes Dods. She notes that the diaries Bascom kept

most of her adult life are in the American Antiquarian Society, Worcester, Massachusetts.

Reutlinger, Dagmar E. "American Folk Art: Two groups of Family Portraits by Ruth Henshaw Bascom and Erasus Salisbury Field." *Worcester Art Museum Bulletin.* 5(May 1976):1–12.

Rubinstein. *American Women Artists.* Pp. 33–34.

Sears, Clara Endicott. *Some American Primitives.* Port Washington, New York: Kennikat Press, 1968. Pp. 118–125.
 Includes excerpts from Bascom's diaries.

Collections:

Concord (Massachusetts), Concord Antiquarian Society Museum.
Sturbridge (Massachusetts), Old Sturbridge Village.

MARIE BASHKIRTSEFF. 1860–1884. Russian, active in France.
 Bashkirtseff's parents separated during her childhood, and she and her brothers were taken from Russia to Europe by their mother. After residing in Nice for a period, they settled in Paris. Bashkirtseff was a gifted child, talented in linguistics and music. Her early ambition was to be a singer, but she finally settled on art in an attempt to keep from dissipating her efforts in too many directions. In 1877 she entered the Julien Academy, and in 1881 she made a trip to Spain. She painted portraits and realistic urban scenes of Paris. Bashkirtseff died of tuberculosis at the age of twenty-four.

Bashkirtseff, Marie. *Le journal de Marie Bashkirtseff.* André Theuriet, ed., 2 vols. Paris: Charpentier, 1888.
 There are several English translations of Bashkirtseff's journal, some of which are listed below.

Bénézit. *Dictionnaire.* Vol. 1, p. 492.

Borel, P. "L'idyll mélancolique: histoire de Marie Bashkirtseff et de Jules Bastien-Lepage." *Annales politiques et littéraires.* 78(1922): 535–536, 591–592, 617–618, 643–644.

Breakell, M. L. "Marie Bashkirtseff: The Reminiscences of a Fellow-Student." *Nineteenth Century and After.* 62(1907):110–125.

Bryan. *Dictionary of Painters.* Vol. 1, p. 93.

Cahuet, Alberic. *Moussia: ou, La vie et la mort de Marie Bashkirtseff.* Paris: E. Fasquelle, 1926.

Clement. *Women in the Fine Arts.* Pp. 26–33.

Creston, Dormer [Dorothy Baynes]. *Fountains of Youth: The Life of Marie Bashkirtseff.* London: T. Butterworth, 1936.

Cronin, Vincent. *The Romantic Way.* Boston: Houghton Mifflin Company, 1966.
This is a series of biographic essays focusing on the idea of romantic love in nineteenth-century France. Bashkirtseff is the subject of one of the essays. Cronin discusses her relationships with various men and includes some of her correspondence with Guy de Maupassant.

Ettinger, P. "Exposition Marie Bashkirtseff à Leningrad." *Beaux-arts.* 8(May 1930):12.

Gilder, Jeanette. Foreword. In *The Last Confessions of Marie Bashkirtseff and Her Correspondence with Guy de Maupassant.* New York: Frederick A. Stokes, 1901.

Harris and Nochlin. *Women Artists, 1550–1950.* Pp. 56, 255–257, 353.

Havice. "The Artist in Her Own Words." Pp. 107.

Lemlein, Rhonda F. "Influence of Tuberculosis on the Work of Visual Artists: Several Prominent Examples." *Leonardo.* 14(Spring 1981): 115.
Lemlein argues that one effect of tuberculosis can be feverish activity in an attempt at achievement before death. She believes that Bashkirtseff, pale and sickly as a child, probably had tuberculosis by the age of ten. Bashkirtseff began keeping a journal at the age of twelve and even at that early age had a premonition of early death.

Moore, Doris. *Marie and the Duke of H: The Day Dream Love Affair of Marie Bashkirtseff.* London: Cassell, 1966.
Moore presents an interesting discussion of Bashkirtseff's diaries and claims that the various published editions are abridged and occasionally even falsified. Her book, which covers a year in Bashkirtseff's life, from about the age of fourteen to fifteen, she says is

unique in being written from the original manuscript which has been located in the National Library of France since 1917. The year she covers includes the period of Bashkirtseff's infatuation with the English Duke of Hamilton.

Paris. Union des Femmes Peintres et Sculpteurs. *Catalogue des oeuvres de Mlle. Bashkirtseff.* 1885.

Parker, Rosie. "Portrait of the Artist as a Young Woman: Marie Bashkirtseff." *Spare Rib.* 30(April 1975):32–35.

Parker and Pollock. *Old Mistresses.* Pp. 106–110, 155.
 A discussion of the conflicts and obstacles (both inner and outer) Bashkirtseff faced as a young woman artist in the late nineteenth century.

Safford, Mary, trans. *The New Journal of Marie Bashkirtseff (from Childhood to Girlhood).* New York: Dodd, Mead and Company, 1912.

Serrano, Mary, trans. *Marie Bashkirtseff: The Journal of a Young Artist, 1860–1884.* New York: Cassell Publishing Company, 1889.

Sparrow. *Women Painters of the World.* P.182.

Theuriet, André. *Jules Bastien-Lepage and His Art: A Memoir.* London: T. Fisher Unwin, 1892.
 Bashkirtseff was a close friend of the artist Bastien-Lepage. A chapter by Mathilde Blind is included: "A Study of Marie Bashkirtseff." Lists her works, including sculpture. Engravings of her work are used as illustrations.

Yeldham. *Women Artists in Nineteenth-Century France and England.* Vol. 1, pp. 373–378.
 An excellent account of Bashkirtseff's life and career.

Collections:

Paris, Louvre.
Paris, Musée d'Orsay.

CECILIA BEAUX. 1855 (or1863?)–1942. United States.

Born in Philadelphia, Beaux was raised in the matriarchal environment of aunts and a grandmother, as her mother had died twelve days after her birth. Her first teacher was a relative, Catherine Anne Drinker. She later studied with William Sartain. Beaux was a student at the Pennsylvania Academy of Fine Arts from 1877 to 1879. She first exhibited at the Pennsylvania Academy in 1879 and at the Paris Salon in 1887. In 1888 she made her first trip to Europe, enrolling in the Julien Academy. She left there in 1889, traveling in Italy and England before returning to Philadelphia. In 1895 Beaux began teaching at the Pennsylvania Academy of Fine Arts and continued in that capacity until 1915. In 1899 she became the first woman to win the first prize in the Carnegie International. During her long career she won numerous other prizes and awards. She was primarily a portrait painter and her freely brushed style is similar to Sargent's.

Bailey, Elizabeth. "The Cecilia Beaux Papers." *Archives of the American Art Journal*. 13(1973):14–19.

Summarizes the 1500 items of personal correspondence, dating from 1863 and consisting of 12 notebooks and diaries and 65 manuscripts of speeches, essays, and poetry. The collection is preserved on microfilm and available at regional offices.

Beaux, Cecilia. *Background with Figures*. Boston and New York: Houghton Mifflin Company, 1930.

This is Beaux's autobiography, illustrated with black-and-white reproductions.

Bell, Mrs. Arthur. "The Work of Cecilia Beaux." *Studio*. 17(September 1899):215–222.

Bénézit. *Dictionnaire*. Vol. 1, p. 557.

Bowen, Catherine Drinker. *Family Portrait*. Boston: Little, Brown and Company, 1970.

Bowen is Beaux's niece. This family history presents a personal view of Beaux and her sometimes difficult personality. Unfortunately, it is not indexed.

Burrows, Carlyle. "The Portraits of Cecilia Beaux." *International Studio*. 85(October 1926):74–80.

"Cecilia Beaux." *Art Digest.* 17(October 1, 1942):20.
 Obituary.

Clement. *Women in the Fine Arts.* Pp. 35–38.

Drinker, Henry S. *The Paintings and Drawings of Cecilia Beaux.*
 Philadelphia: Pennsylvania Academy of Fine Arts, 1955.
 The foreword is by Royal Cortissoz.

Evans, Dorinda. "Cecilia Beaux, Portraitist." *American Art Review.*
 2(January–February 1975):92–102.
 Evans reviews the 1974–1975 retrospective exhibition of Beaux's
work. She believes Beaux's preoccupation with value contrasts and
sequence of value is an area neglected by the catalog. In her
comparison of Beaux's work with that of Cassatt, she concludes that
Cassatt was more versatile, more prolific, and a better colorist, but that
Beaux's work has an underlying deeper seriousness.

Fine. *Women and Art.* Pp. 114–118.

Gerdts, William. *American Impressionism.* Seattle: Henry Arts Center,
 University of Washington, 1980. P. 49.

Goodyear, Frank, and Elizabeth Bailey. *Cecilia Beaux: Portrait of an
 Artist.* Philadelphia: Pennsylvania Academy of Fine Arts, 1974–1975.
 Catalog of retrospective exhibition of Beaux's work. Excellent
color plates, good essay on her life and work, and a chronology.

Harris and Nochlin. *Women Artists, 1550–1950.* Pp. 56, 92, 252–254,
 352–353.

Havice. "The Artist in Her Own Words." Pp. 1–7.

Hill, F. D. "Cecilia Beaux, the Grand Dame of American Portraiture."
 Antiques. 105(January 1974):160–168.
 Includes bibliography and fourteen illustrations, some in color.

Hill. *Women: A Historical Survey . . .* Catalog. Pp. xii, 18–19.

Huber, Christine. *The Pennsylvania Academy and Its Women.* Philadel-
 phia: Pennsylvania Academy of Fine Arts, 1974.

Mechlin, Leila. "The Art of Cecilia Beaux." *International Studio.*
 41(July 1910):iii–x.

National Museum of Women in the Arts. Pp. 56–57.

Neilson. *Seven Women.* Pp. 97–124.

Neuhaus, Eugene. *History and Ideals of American Art.* Stanford, California: Stanford University Press, 1931. P. 225.
Neuhaus says Beaux often equalled Sargent, but couches his praise in sexist terms: "This is remarkable for a woman, since the strength of Sargent would not normally be expected in women painters."

New York. American Academy of Arts and Letters. *A Catalogue of an Exhibition of Paintings by Cecilia Beaux.* 1935.
Text by Royal Cortissoz.

Oakley, Thornton. *Cecilia Beaux.* Philadelphia: Howard Biddle Printing Company, 1943.

Peterson and Wilson. *Women Artists.* Pp. 88–89.

Philadelphia. Philadelphia Museum of Art. *Philadelphia: Three Centuries of American Art.* April 11–October 10, 1976. Pp. 426–427, 443–444.
Notes that in the 1880's and 1890's, Beaux did china painting to gain financial independence.

Rubinstein. *American Women Artists.* Pp. 124–128.

Sparrow. *Women Painters of the World.*

Stein, Judith. "Profile of Cecilia Beaux." *Feminist Art Journal.* 4(Winter 1975–1976):25–33.

Thieme and Becker. *Allgemeines Lexikon.* Vol. 3, pp. 126–127.

Walton, William. "Cecilia Beaux." *Scribner's Magazine.* 22(October 1897):477–485.
Describes Beaux's 1875 work with the United States Geological Reports, in which she did lithograph illustrations of fossils. Many quotes from contemporary critics provide insight into her status at the time. Several good black-and-white reproductions.

Whipple, B. "Eloquence of Cecilia Beaux." *American Artist.* 38(September 1974):44.

Collections:

Baltimore, Johns Hopkins University, Art Gallery.
Brooklyn Museum.
Chicago Art Institute.
Florence, Uffizi.
Memphis, Brooks Memorial Art Gallery.
New York, Metropolitan Museum of Art.
New York, National Academy of Design.
New York, Whitney Museum of American Art.
Philadelphia, Pennsylvania Academy of the Fine Arts.
Toledo (Ohio), Museum of Art.
Washington (D.C.), Corcoran Gallery of Art.
Washington (D.C.), National Collection of Fine Arts.
Washington (D.C.), National Museum of Women in the Arts.
Youngstown (Ohio), Butler Institute of American Art.

ROSA BONHEUR. 1822–1899. French.
 Both of Bonheur's parents were artists. Her father's disdain for
convention set the pattern for her life. He was a follower of the
Saint-Simonian movement, based on economic socialism and equality of
the sexes. He was her only teacher. Bonheur did vigorous animal
paintings and sculpture, a mode much appreciated in her day. She began
exhibiting in the Salons in 1841. In 1849 she received a Salon gold
medal, and one of her works was purchased by the government for
permanent exhibition in the Louvre. She also succeeded her father that
year as director of the state-run School of Design for Girls. Her most
famous work is the monumental *Horse Fair.* She received a gold medal
for this work in 1853, and it was exhibited at Buckingham Palace at the
request of Queen Victoria. In 1887 *Horse Fair* was donated to the
Metropolitan Museum by Cornelius Vanderbilt. Bonheur's behavior was
refreshingly unconventional: she wore men's clothing (for which she
had to obtain government permission), she was uninterested in marriage,
she smoked cigarettes, and she had her hair cut short. She claimed her
short hair and male attire were necessary in order to study animal
anatomy in the slaughterhouses. Her lifelong companion was Natalie
Micas, who attended to the details of daily living so Bonheur could
devote herself to her art. Bonheur has the distinction of being the first
woman to be made an Officer of the Legion of Honor.

Ashton, Dore. *Rosa Bonheur: A Life and a Legend.* New York: Viking
 Press, 1981.

A readable biography that unfortunately is not well documented and contains little description or critical analysis of Bonheur's work. It does include a helpful chronology and a bibliography along with many reproductions and photographs. The illustrations and captions are by Denise Browne Hare.

Bacon, Henry. "Rosa Bonheur." *Century.* 28(October 1884):833–840.

Bénézit. *Dictionnaire.* Vol. 2, pp. 149–150.

Benjamin. *Contemporary Art in Europe.* P. 91.
 Describes some of Bonheur's works. Notes that two of her brothers were also artists.

Boime, Albert. "The Case of Rosa Bonheur: Why Should a Woman Want to Be More Like a Man?" *Art History.* 4(December 1981): 384–409.
 Discusses the influence of feminism and the Saint-Simonian beliefs of her parents in Bonheur's androgynous development. Many illustrations are included.

Bois-Gallais, Lepelle de. *Memoir of Mademoiselle Rosa Bonheur.* Trans. James Perry. New York: William, Stevens, William and Co., 1857.

Bonheur, Rosa. "Fragments of My Autobiography." *Magazine of Art.* 26(1902):531–536.

Bryan. *Dictionary of Artists.* Vol. 1, pp. 165–166.

Clement. *Women in Fine Arts.* Pp. 48–54.

Crastro, Francis. *Rosa Bonheur.* Trans. Frederic T. Cooper. New York: F. A. Stokes Co., 1912.

Ellet. *Women Artists.* Pp. 261–284.
 Ellet's article was prepared with Bonheur's help.

Faxon, Alicia. "Rosa Bonheur: The Emperor Neglected." *Boston Globe* (July 1972).

Fine. *Women and Art.* Pp. 57–60.

Forbes-Robertson, John. "Rosa Bonheur." *Magazine of Art.* 5(1882): 45–50.
 Lists her works and summarizes her biography.

Greer. *The Obstacle Race.* Pp. 20, 57–60.
 Describes Bonheur's relationship with Natalie Micas.

Harris and Nochlin. *Women Artists, 1550–1950.* Pp. 53, 87, 223–225,
 249–250, 349–350.

Havice. "The Artist in Her Own Words." Pp. 1–7.

Hill. *Women: A Historical Survey . . .* Catalog. Pp. xi, 11.

Iskin. "Sexual Imagery in Art . . ."

Klumpke, Anna Elizabeth. *Memoirs of an Artist.* Ed. Lilian Whiting.
 Boston: Wright and Potter, 1940.
 Klumpke became Bonheur's companion after Micas' death. All
 three were buried together. Bonheur had Klumpke write the biography
 that Micas had originally intended to do.

———. *Rosa Bonheur: sa vie, son oeuvre.* Paris: E. Flammarion, 1909.
 A large format with illustrations.

Masters in Art: Rosa Bonheur. Boston, 1903.

Munsterberg. *A History of Women Artists.* Pp. 49–53.

National Museum of Women in the Arts. Pp. 62–63, 161.

Nochlin. "By a Woman Painted . . ." Pp. 69–70.

———. "Why Have There Been No Great Women Artists?" Pp. 36, 39,
 67–69.
 In addition to some reproductions, Nochlin offers some astute
 analysis into the problems of nineteenth-century women artists, with
 Bonheur as her chief example.

Petersen and Wilson. *Women Artists.* Pp. 74–78.

Roger-Miles, Leon. *Atelier Rosa Bonheur.* Paris: Georges Petit,
 1900.

Rorem. "Women: Artist or Artist-ess."

Shriver, Rosalia. *Rosa Bonheur.* Philadelphia: The Art Alliance Press,
 1982.

This work includes a checklist of Bonheur's work in U.S. collections and a good biographical summary. Several color and many black-and-white reproductions are included.

Smith, Christine. "Rosa Bonheur: How She Was Victimized by the (Male) Critics." *Women and Art* (Winter 1971):1, 4, 6, 20.

Sparrow. *Women Painters of the World.* Pp. 180–181.

Stanton, Theodore, ed. *Reminiscences of Rosa Bonheur.* New York: D. Appleton and Company, 1910; reprint, New York: Hacker Art Books, 1976.
Huge, chatty, anecdotal account that utilizes many quotes from letters. Includes many black-and-white illustrations of Bonheur and members of her family.

Sterling, Charles, and M. Salinger. *French Painting in the Collection of the Metropolitan Museum.* New York, 1966. Vol. 11, pp. 160–164.

Styles-McLeod, Catherine. "Historic Houses: Rosa Bonheur at Thomery." *Architectural Digest.* 43(February 1986):143–150, 164.
Description of Bonheur's country chateau, purchased in 1859. Includes excellent photographs of her studio.

Thieme and Becker. *Allgemeines Lexikon.* Vol. 4, pp. 289–291.

Tufts. *Our Hidden Heritage.* Pp. 147–157.

Yeldham. *Women Artists in Nineteenth-Century France and England.* Vol. 1, pp. 337–344.
Comprehensive account of Bonheur's life and art. Describes the progression of her career.

Collections:

Ann Arbor, University of Michigan, Museum of Art.
Baltimore, Walters Art Gallery.
Chicago Art Institute.
Cody (Wyoming), Buffalo Bill Historical Center.
Fontainebleau, Musée National du Château de Fontainebleau.
New Orleans Museum of Art.
New York, Metropolitan Museum of Art.
Paris, Louvre.

Stockton (California), Pioneer Museum and Haggin Galleries.
Toronto, Art Gallery of Ontario.
Washington (D.C.), National Museum of Women in the Arts.

MARIE QUIVERON BRACQUEMOND. 1841–1916. French.
 Bracquemond was admitted to Ingres's studio as a young woman
and quickly gained the reputation of being one of his most intelligent
students. In 1869 she married Félix Bracquemond, one of the foremost
engravers of the time. While she made important artistic contacts
through her husband's circle, the marriage had a stifling effect on her art.
She had a work accepted in the Salon of 1874. To her husband's dismay,
in the 1870's she became influenced by the work of Monet and Renoir.
As she became fully committed to the Impressionist aesthetic, her
husband remained firmly opposed to Impressionist methods, such as
plein air painting. Bracquemond exhibited in the Impressionist exhibi-
tions of 1879, 1880, and 1886. Finally, in 1890, the continual domestic
friction brought on by her husband's disapproval, his jealousy of her
talent, and his inability to accept her criticism, led her to abandon
painting.

Bénézit. *Dictionnaire.* Vol. 2, p. 264.
 Calls her a painter of genre and flowers.

Bouillon, Jean-Paul, and Elizabeth Kane. "Marie Bracquemond."
 Woman's Art Journal. 5(Fall 1984–Winter 1985):21–27.
 Interesting account of her life and domestic difficulties.

Bracquemond, Pierre. *La vie de Félix and Marie Bracquemond.*
 This unpublished manuscript by her son, one of her staunchest
 supporters, records the conflicts she suffered because of her needs as
 an artist and her responsibilities as a wife and mother. The manuscript
 is in a private collection in Paris. Pierre Bracquemond arranged a
 retrospective of his mother's work in 1919.

Broude, Norma. "Will the Real Impressionists Please Stand Up." *Art
 News.* 85(May 1986):87, 89.

Clement. *Women in the Fine Arts.* P. 60.

Garb. *Women Impressionists.* Pp. 9–12.
 The source for most of the above biography.

Kane, Elizabeth. "Marie Bracquemond: The Artist Time Forgot." *Apollo.* 117(February 1983):118–121.
　　Describes the impact her marriage had on her career. Notes that shortly after her marriage, her husband became artistic director of Haviland porcelain works and that she worked with him, designing highly popular faience pieces.

Lucie-Smith, Edward. *Impressionist Women.* P. 140.

Collections:

　　Geneva, Petit Palais.
　　Paris, Louvre.
　　Paris, Musée du Petit Palais.

MARIE LOUISE BRESLAU 1856–1928. Swiss.
　　Breslau was born in Munich, but when she was ten years old her family moved to Zurich where her father had accepted a university post. She studied in Zürich, and in 1878 she entered the Julien Academy in Paris, where she was a student of Robert-Fleury. At the Julien Academy one of her classmates was Bashkirtseff, who mentions her in her diaries. Bastien-Lepage and Degas were later teachers. Breslau was a painter, lithographer, and pastellist, doing mainly portraits of women and children, flower studies, and landscapes. She first exhibited at the Salon of 1879. A major retrospective of her work was sponsored by the Ecole des Beaux-Arts in Paris in 1928.

Bénézit. *Dictionnaire.* Vol. 2, p. 300.

Clement. *Women in the Fine Arts.* Pp. 61–63.

Edouard-Joseph, René. *Dictionnaire Biographique des artistes contemporains, 1910–1930.* 3 Vols. Paris: Art and Edition, 1930. Vol. 1, pp. 202–203.
　　This source gives Zurich as her birthplace and gives her death date as 1927.

Harris and Nochlin. *Women Artists, 1550–1950.* Pp. 57, 255.

Hovelaque, Emile. "Mlle. Louise Breslau." *Gazette des beaux-arts.* 34(1905):195–206.
　　Includes several black-and-white reproductions.

Sparrow. *Women Painters of the World.* Pp. 182, 289, 304, 314.
 Calls Breslau a ''painter's painter'' and credits her with a thorough
 knowledge of modern realism.

Thieme and Becker. *Allgemeines Lexikon.* Vol. 4, p. 586.

Yeldham. *Women Artists in Nineteenth-Century France and England.*
 Vol. 1, pp. 367–369.

Collections:

 Berne, Kunstmuseum.
 Paris, Musée du Luxembourg.

LADY ELIZABETH SOUTHERDEN THOMPSON BUTLER. 1850–
1933. English.
 Elizabeth Southerden Thompson was born in Lausanne, Switzer-
land, to English parents. She spent much of her youth in Italy. Her first
art studies were undertaken at the South Kensington School of Art. By
the age of twenty-two she was studying in Florence with Guiseppi
Bellucci. Lady Butler's specialty was military painting, and she was
highly praised for her ability to depict the movement of horses. In 1873
she exhibited for the first time at the Royal Academy, but her biggest
success came the following year when her entry, *Calling the Roll After
an Engagement,* was purchased by the queen. In 1877 she married
Colonel Sir William Butler, a well-known African explorer. Lady Butler
failed to become a member of the Academy by two votes, but her success
in the revival of military painting (a male-dominated field) eased the way
for the election of other women painters.

Ash, Russell. ''English Paintings of 1874.'' *Connoisseur.* 185(January
 1974):33–40.
 Ash gives a vivid account of Lady Butler's 1874 Academy success
 and discusses her obsessive attention to detail. Includes a black-and-
 white reproduction.

Bénézit. *Dictionnaire.* Vol. 10, pp. 159–160.

Benjamin. *Contemporary Art in Europe.* Pp. 37–39.
 Includes her portrait and a black-and-white reproduction.

Butler, Lady Elizabeth. *An Autobiography.* London: Constable and Company, 1923.
Includes sketches by the author. Bases her account of her life on diaries she kept from the age of twelve.

———. *From Sketch-book and Diary.* London: A. and C. Black, 1909.
Description of her travels in Africa, Ireland, and Italy. Includes twenty-eight color and twenty-one black-and-white illustrations by the author.

———. *Letters from the Holy Land.* London: A. and C. Black, 1903.
Account of her travels in Palestine with ten color illustrations.

Champlin. *Cyclopedia of Painters and Paintings.* Vol. 1, p. 224.

Clement. *Women in the Fine Arts.* Pp. 68–70.

Fine. *Women and Art.* Pp. 83–84.

Greer. *The Obstacle Race.* Pp. 82–84.
Praises her technical proficiency.

Harris and Nochlin. *Women Artists, 1550–1950.* Pp. 53–54, 91, 249–250, 352.

Johnson and Greutzner. *Dictionary of British Artists.* P. 89.
Gives her birth date as 1846.

"Lady Butler." *Connoisseur.* 92(November 1933):341.

Lulumia, Matthew. "Lady Elizabeth Thompson Butler in the 1870's." *Woman's Art Journal.* 4(Spring–Summer 1983):9–14.
Biographical summary that relates her work to the British Social Realism movement. Describes the *Roll Call* and two other works based on the Crimean War.

Meynell, W. (Alice). "The Life and Work of Lady Butler." *The Art Annuals.* 18(1898). London.
Meynell, the author of this account of the artistic career of Lady Butler, was her sister.

Nunn. *Canvassing.* Pp. 70–112.
Excerpts from Butler's *Autobiography* of 1922 and the 1909 *From Sketch-book and Diary* are provided.

Oldcastle, J. "Elizabeth Butler." *Magazine of Art.* 2(1879):257–262.

Stemp, R. "War Artists: Lady Butler." *Artist.* 102(September 1987): 35–37.

Underwood, Paul "Elizabeth Thompson Butler: The Consequences of Marriage." *Woman's Art Journal.* 9(Spring–Summer 1988):30–34.
　　At the time of her marriage in 1877, Elizabeth Thompson was Britain's leading woman artist. Usherwood's analysis is that marriage undermined her career. He notes that after 1881 reviews were generally unfavorable and that she seldom managed to sell her work. She faced increasing male competition, and extensive travel interrupted her work. Usherwood also sees reflected in some of her paintings her husband's critical view of the government's imperial policy.

————, and Jenny Spencer-Smith. *Lady Butler (1846–1933): Battle Painter.* London: National Army Museum and Allan Sutton, 1987.

Wood. *Dictionary of Victorian Painters.* P. 20.

Yeldham. *Women Painters in Nineteenth-Century France and England.* Vol. 1, pp. 318–328.
　　Comprehensive account of Butler's life and work. Yeldham notes that the artist felt the glory of war was not a worthy theme and instead chose to depict the "pathos" of conflict.

Collections:

Leeds, City Art Gallery.
London, Tate Gallery.
Melbourne, National Gallery of Victoria.
Sandhurst, Museum of the Military Academy.

JULIA MARGARET CAMERON. 1815–1879. English.
　　Cameron was born in Calcutta and educated in France and England. In 1838 she married Charles Hay Cameron, a retired member of the Supreme Court of India. They had six children and adopted several others. In 1848 they moved back to England and settled on the Isle of Wight, where they became the center of an artistic and literary circle, and she became active in social causes. In 1863, when Cameron was forty-eight, she received a camera from her daughter as a gift. She

devoted herself completely to mastering this new art form. She learned to do her own developing and printing, utilizing a coal house for a darkroom and converting a chicken house into a studio. She did many large portrait close-ups and immortalized, through her photographs, many of the famous personalities of the Victorian age. She also made allegorical and genre photographs. In 1874, at the request of her friend Tennyson, Cameron illustrated *Idylls of the King*. Cameron returned to Ceylon in 1875 where she spent the remainder of her life.

Beaton. *The Magic Image*. Pp. 62–67.
 Excellent description of Cameron's eccentric personality. Calls her the ugly duckling of seven sisters famous for their beauty. Includes good reproductions of her work.

Fagan-King, Julia. "J. M. Cameron, G. F. Watts, D. G. Rossetti: The Influence of Photography on Painting." *History of Photography*. 10(January–March 1986):19–29.
 Discussion of the "extensive but brief" influence of Cameron's photographs on the paintings of Rossetti and Watts.

Ford, Colin, comp. *The Cameron Collection: An Album of Photographs Presented to Sir John Herschel*. New York: Van Nostrand Reinhold, 1975.

Ford, Colin. "Julia Margaret Cameron." *Creative Camera*. 177(March 1979):90–97.
 A brief biological summary accompanied by seven full-page portraits by Cameron.

———. "Rediscovering Mrs. Cameron—and Her First Photography." *Camera*. 58(May 1979):4–35.
 This was originally broadcast on the BBC in 1979 on the hundredth anniversary of Cameron's death.

Fry, Roger, and Virginia Woolf. *Victorian Photographs of Famous Men and Fair Women, by Julia Margaret Cameron*. New York: Harcourt, 1928.
 A brief biographical essay is by Woolf. Cameron was Woolf's great aunt. Fry provides a discussion of Cameron's photographic work. Thirty-four photographs are reproduced.

Gernsheim, Helmut. *History of Photography*. Pp. 250–252, 304–306.
 Good discussion of her photographic technique.

————. *Julia Margaret Cameron: Her Life and Photographic Work.* New York: Transatlantic Arts, 1950.

————. *Masterpieces of Victorian Photography.* London: Phaidon Press, 1951. Pp. 98–99.
 Includes six reproductions of her portrait studies.

————. "Sun Artists: Victorian Photography." *Camera.* 47(December 1968):13–14.
 Describes her as having superior artistic conception, but too little regard for technical perfection. Discusses the influence of her chief artistic advisor, George Frederick Watts, who encouraged her to rival the compositions of the Renaissance and Pre-Raphaelite painters.

Hill, Brian. *Julia Margaret Cameron: A Victorian Family Portrait.* London: Peter Owen, 1973.
 A biographical treatment. Includes a family tree.

Hinson, Tom. "Photography: Recent Acquisitions." *Bulletin of the Cleveland Museum of Art.* 62(February 1965):36–46.
 Describes her portraits as interpretive studies rather than mere physical equivalents.

Hopkinson, Amanda. *Julia Margaret Cameron.* London: Virago Press, 1986.
 An excellent monograph that focuses on Cameron's innovations, her desire to be a professional photographer, and her efforts to elevate photography to high art.

Malibu. J. Paul Getty Museum. *Whisper of the Muse.* September 10–November 16, 1986.
 This exhibition was based on an album of photographs presented as a gift by Cameron to her friend, Lord Overstere. The photographs were taken during the first eighteen months of her photographic career. The introductory essay is by Mike Weaver.

Marsh and Nunn. *Women Artists and the Pre-Raphaelite Movement.* Pp. 92–97.
 In this biographical summary the authors note the parallel themes between much of Cameron's photography and Pre-Raphaelite painting.

Munsterberg. *A History of Women Artists.* Pp. 122–123.

New York. Museum of Modern Art. *Victorian Photographers.* 1968.

Newhall, Beaumont. *History of Photography.* Pp. 64–65.

————, and Nancy Newhall. *Masters of Photography.* New York: George Braziller, 1958. Pp. 46–53.

Ovenden, Graham, ed. *A Victorian Album: Julia Margaret Cameron and Her Circle.* New York: DaCapo Press, 1975.
　　Introductory essay by Lord David Cecil. Cameron's family tree is included.

Rochester. International Museum of Photography at the George Eastman House. *Cameron: Her Work and Career.* 1983.
　　The essay for this exhibition catalog is by Joanne Lukitsh.

Strasser, Alex. *Victorian Photography.* New York: Focal Press, 1942. Pp. 113–114.
　　Several good reproductions of her work are included.

Symmes. "Important Photographs by Women." Pp. 142–144.
　　Discusses her attempts, through staged images of idealized figures and literary subjects, to imitate Italian Renaissance and Pre-Raphaelite paintings.

Szarkowski, John. *Looking at Photographs: One Hundred Pictures from the Collection of the Museum of Modern Art.* New York: Museum of Modern Art, 1973.

Weaver, Mike. *Julia Margaret Cameron, 1815–1879.* Boston: New York Graphic Society, 1983.
　　A four-part essay that discusses her subject matter in the context of the times. Includes a chronology and bibliography.

Whelan. "Are Women Better Photographers Than Men?" Pp. 83–84.

Wilson, A. N. *Eminent Victorians.* London: BBC Books, 1989. Pp. 203–236.
　　A chapter in this book is devoted to the life and career of Cameron.

Wintersgill, Donald. "Mrs. Cameron's Hobby." *Art News.* 73(December 1974):88.

Collections:

Detroit Institute of Art.
New York, Metropolitan Museum of Art.
Wellesley (Massachusetts), Wellesley College Museum.

MARY CASSATT. 1844–1926. United States.
 Mary Cassatt has long been used as art history's token woman. She was the daughter of a well-to-do Pennsylvania family. During her childhood the family lived in Paris, Heidelberg, and Darmstadt. Cassatt entered the Pennsylvania Academy of Arts in 1861 and by 1866 was studying in Europe against her father's wishes. By 1874 she had returned to Paris to live and had a painting accepted in the Salon. A turning point in her development was an invitation from Degas to join the Impressionists. She first showed with the Impressionists in their fourth exhibition, in 1879. Breeskin believes her to have been Degas' respected colleague rather than his student or mistress as art history has hitherto assumed. While one of her favorite themes was mothers and children, it comprised only about one-third of her output. Cassatt was an innovative printmaker of color drypoints and aquatints. For many years she had heavy family responsibilities, caring for her parents and sister. She never married. A supporter of suffrage for women, she called herself a socialist. Her encouragement to U.S. collectors (such as Louisine Havemeyer and Mrs. Potter Palmer) was instrumental in the acquisition of many Impressionist and earlier European masterpieces by U.S. museums. In 1904 she was honored by the French government by being made a Chevalier of the Legion of Honor. Her long life ended in blindness. The following is a selected bibliography from the great quantity of literature available about her.

Alexandre, Arsène. "La collection Havemeyer et Miss Cassatt."*La renaissance de l'art.* 13(February 1939):51–56.

———. "Miss Mary Cassatt, aquafortiste." *La renaissance de l'art.* 7(March 1924):127–133.

Baltimore. Museum of Art. *Paintings, Drawings, Graphic Works by Manet, Degas, Morisot and Cassatt.* April 18–June 13, 1962.

Bénézit. *Dictionnaire.* Vol. 2, pp. 578–579.

Biddle, George. *An American Artist's Story.* Boston: Little, Brown and Company, 1939.

———. "Some Memories of Mary Cassatt." *Arts.* 10(August 1926): 107–112.

Breeskin, Adelyn D. *The Graphic Work of Mary Cassatt: Catalogue Raissoné.* New York: H. Bittner and Company, 1948.
This important work was reprinted in 1979 by the Smithsonian Institution under the title *Mary Cassatt: A Catalogue Raissoné of the Graphic Work.*

———. "The Line of Mary Cassatt." *Magazine of Art.* 35(January 1942):29–31.

———. *Mary Cassatt: A Catalogue Raisonné of the Oils, Pastels, Watercolors and Drawings.* Washington, D.C.: Smithsonian Institution Press, 1970.
Breeskin catalogs 941 works, almost all of which are illustrated with sharp black-and-white photographs. Information is extremely complete for each entry, including reproductions, literature, and often anecdotes in addition to the usual information.

Breuning, Margaret. *Mary Cassatt.* New York: Hyperion Press, 1944.
Reference is made to her important mural, *Modern Woman,* commissioned for the Woman's Building of the Chicago Columbian Exposition of 1893.

Brinton, Christian. "Concerning Miss Cassatt and Certain Etchings." *International Studio.* 27(February 1916):I–VI.

Buettner. "Images of Modern Motherhood."

Bullard, E. John. *Mary Cassatt: Oils and Pastels.* New York: Watson-Guptill, 1972.
This is a good introduction to Mary Cassatt the painter. It consists of thirty-two full-page color reproductions of oils and pastels, some of which are undeservedly lesser-known works. They are arranged chronologically and each is accompanied by a page-long discussion.

Carey, Elizabeth Luther. "The Art of Mary Cassatt." *Script.* 1(1905): 1–5.

Carson, Julia M. *Mary Cassatt.* New York: David McKay Company, 1966.
 This biography is adequate and correct but not especially scholarly.

Cassatt, Mary. *Correspondence Addressed to Mrs. H. O. Havemeyer, 1900–1920.*
 Typescripts of original letters on deposit at the National Gallery of Art, Washington, D.C.

Clement. *Women in the Fine Arts.* Pp. 76–78.

Cortissoz, Royal. *American Artists.* New York: Charles Scribner's Sons, 1923. Pp. 183–189.
 Summarizes the biographical facts obtained by Segard (q.v.) and emphasizes that Cassatt spoke freely with him.

Custer, A. "Archives of American Art." [Group of Mss. and Other Documents of Mary Cassatt Microfilmed.] *Art Quarterly.* 18, no. 4(1955):391.

Drexler, R. "Mary Cassatt in Washington: Retrospective Exhibition at the National Gallery." *Life.* 69(October 30, 1970):10.

Elliot. *Art and Handicraft in the Woman's Building.*
 Reference is made to Cassatt's important mural, *Modern Woman.*

Faxon, Alicia. "Painter and Patron: Collaboration of Mary Cassatt and Louisine Havemeyer." *Woman's Art Journal.* 3(Fall 1982–Winter 1983):15–20.
 Traces the relationship between the two women. Uses letters to document Havemeyer's artistic judgments and collecting interests.

Fine. *Women and Art.* Pp. 129–135.
 Identifies her teachers as Charles Chaplin in Paris and Carlo Raimondi in Rome. Believes her family responsibilities lessened her production, especially in the 1880's, when she first began working on her theme of mothers and children.

Fuller, Sue. "Mary Cassatt's Use of Soft-Ground Etching." *Magazine of Art.* 43(February 1950):54–57.

Garb. *Women Impressionists.* Pp. 12, 15.

Gardner. "A Century of Women."

Discusses the reaction to Cassatt's mural for the Columbian Exposition Woman's Building.

Geffroy, Gustave. "Femmes artistes—Un peintre de l'enfance: Mary Cassatt." *Les modes.* 4(February 1904):4–11.

Gerdts, William. *American Impressionism.* Seattle: Henry Art Center, University of Washington, 1980. Pp. 44–49.
Gerdts provides an excellent summary of Cassatt's artistic development.

Getlein, Frank. *Mary Cassatt: Paintings and Prints.* New York: Abbeville Press, 1980.
Numerous full-page color reproductions are provided.

Grafly, Dorothy. "In Retrospect—Mary Cassatt." *American Magazine of Art.* 18(June 1927):305–312.

Greer. *The Obstacle Race.* Pp. 112, 322–323.

Hale, Nancy. *Mary Cassatt: A Biography of the Great American Painter.* New York: Doubleday and Company, 1975.
A very readable biography that attempts a psychological analysis of the artist.

Harris and Nochlin. *Women Artists, 1550–1950.* Pp. 58, 66, 90, 237–243, 351–352.

Havemeyer, Louisine. "The Cassatt Exhibition." *Pennsylvania Museum Bulletin.* 22(May 1927):373–382.

———. *Sixteen to Sixty: Memoirs of a Collector.* New York: Metropolitan Museum of Art, 1961.
Havemeyer was Cassatt's closest woman friend for most of her life. Cassatt advised the Havemeyers in their collection of art, which today is in New York's Metropolitan Museum of Art.

Havice. "The Artist in Her Own Words." Pp. 1–7.

Heller. *Women Artists.* Pp. 94, 97–99.

Hyslop, Francis E., Jr. "Berthe Morisot and Mary Cassatt." *Art Journal.* 13(Spring 1954):179–184.

Iskin, Ruth. "Mary Cassatt's Mural of *Modern Woman.*" Abstract of a paper delivered before the College Art Association, January 1975.

————. Review of "Mary Cassatt, Oils and Pastels," by E. John Bullard. *Womanspace Journal.* 1(April–May 1973):13–14, 34.
 Iskin objects to Bullard's interpretation of *Modern Woman* as a mere genre scene, ignoring its political content.

Johnson, Una. "The Graphic Art of Mary Cassatt." *American Artist.* 9(November 1945):18–21.

King, Pauline. *American Mural Painting.* Boston: Noyes, Platt and Company, 1902.
 King has two chapters about the mural projects generated by the Chicago World's Columbian Exposition of 1893. She provides two black-and-white details plus considerable commentary about Cassatt's mural.

Kramer, Hilton. *The Age of the Avant-Garde.* New York: Farrar, Straus and Giroux, 1972. Pp. 76–79.

Kysela, John D., S.J. "Mary Cassatt's Mystery Mural and the World's Fair of 1893." *Art Quarterly.* 29, no. 2(1966):128–145.
 Kysela has done the definitive task of documenting the circumstances of the commission, the critical response to the mural and the data pertaining to its disappearance. He concerns himself less with the work's visual qualities and iconography. He offers excellent reproductions and bibliographic resources.

Lucie-Smith. *Impressionist Women.* Pp. 140–142.

McChesney, Clara. "Mary Cassatt and Her Work." *Arts and Decoration.* 3(June 1913):265–267.

McKown, Robin. *The World of Mary Cassatt.* New York: Dell Publishing Company, 1972.
 An examination of the life, times, and associates of Cassatt. A volume in a series of biographical works designed for young adults.

Mathews, Nancy Mowll, ed. *Cassatt and Her Circle: Selected Letters.* New York: Abbeville Press, 1984.
 Annotated letters arranged to reflect different stages of Cassatt's career. Sixty of the 208 letters were written by her friends and family.

————. *Mary Cassatt.* New York: Harry N. Abrams, in association with the National Museum of American Art, Smithsonian Institution, 1987.
An excellent monograph that discusses the major artistic episodes in Cassatt's life. A brief chronology and many excellent reproductions are included, several in color.

————. *Mary Cassatt and the "Modern Madonna" of the Nineteenth Century.* Ph.D. dissertation, New York University, Institute of Fine Arts, 1980.

Mauclair, Camille. "Un peintre de l'enfance: Mary Cassatt." *L'art decoratif.* 4(April 1902):177–185.

Mellerio, André. "Mary Cassatt." *L'art et les artistes.* 12(November 1910):69–75.

Mitchell. *Great Flower Painters.* Pp. 80–82.

Munro. *Originals: American Women Artists.* Pp. 59–74.
An excellent exploration of Cassatt's choice of subject matter. Discusses her close, sometimes confining, family relationships.

Munsterberg. *A History of Women Artists.* Pp. 53, 55, 56–59, 65, 104–105, 109–110, 146.

Myers, Elizabeth. *Mary Cassatt: A Portrait.* Chicago: Reilly and Lee, 1971.

National Museum of Women in the Arts. Pp. 48–49, 166–167.

Newman, Gemma. "Greatness of Mary Cassatt." *American Artist.* 30(February 1966):42–49.

New York. Coe Kerr Gallery. *Mary Cassatt: An American Observer.* 1984.

Omaha, Nebraska. Joslyn Art Museum. *Mary Cassatt Among the Impressionists.* April 10–June 1, 1969.
This catalog includes a short essay by Breeskin detailing the relationships between Cassatt and individual Impressionist artists.

Paris. Centre Culturel Americain. *Mary Cassatt: peintre et graveur.* November 25, 1959–January 10, 1960.
Exhibition catalog with black-and-white reproductions.

Parker and Pollock. *Old Mistresses.* Pp. 38–41.

Petersen and Wilson. *Women Artists.* Pp. 87–90.

Philadelphia. Philadelphia Museum of Art. *Mary Cassatt and Philadelphia.* February 17–April 14, 1985.
 Essay by Suzanne G. Lindsay discusses Cassatt's ties with Philadelphia: the exhibitions she held there, the collectors she advised, and her major patrons from the city.

Pica, Vittorio. "Artisti contemporanei—Berthe Morisot e Mary Cassatt." *Emporium.* 26(January 1907):11–16.

Pollock, Griselda. *Mary Cassatt.* London: Jupiter Books, 1980.
 Pollock provides a thoughtful analysis of Cassatt's subject matter and the influences on her art. She includes a brief chronology, thirty-two color plates, and over fifty black-and-white reproductions.

Richardson, E. P. "Sophisticates and Innocents Abroad: Sargent, Whistler and Mary Cassatt in Metropolitan Loan Show." *Art News.* 53(April 1954):20–23.

Roudebusch, Jay. *Mary Cassatt.* New York: Crown Publishers, 1979.
 This work is aimed at a general audience.

Rubinstein. *American Women Artists.* Pp. 130–138.
 A concise summary of Cassatt's life and career.

Russell, John. "Mary Cassatt: Decor and Decorum." *Art in America.* 66(November–December 1978):96–99.
 Review of the Boston Museum of Fine Arts exhibition of decorative objects and pieces of furniture shown together with the paintings by Cassatt in which they are depicted.

Segard, Achille. *Une peintre des enfants et des mères—Mary Cassatt.* Paris: Librairie Paul Ollendorf, 1913; reprint edition, New York: Burt Franklin.
 This work is important because Cassatt designated Segard to be her biographer, and he draws on interviews with her. However, it includes numerous errors.

Shapiro, Barbara Stern. *Mary Cassatt at Home.* Boston: Museum of Fine Arts, 1978.

Catalog of exhibition that combined paintings by Cassatt with objects from her home and studio that are depicted in the paintings.

Smith. "Observations on a Few Celebrated Women Artists." P. 80.
Smith strongly objects to the theory that Cassatt's spinsterhood was the reason for her preoccupation with the mother/child theme. He suggests it is the male ego that prefers to sentimentalize the woman as imprisoned by her offspring.

Sparrow. *Women Painters of the World.* Pp. 157, 327.

Sweet, Frederick A. *Mary Cassatt, 1844-1926: Retrospective Exhibit.* Chicago: International Galleries, November–December, 1965.

———. *Miss Mary Cassatt, Impressionist from Pennsylvania.* Norman: University of Oklahoma Press, 1966.
Much of this biography of Cassatt consists of translated letters augmented with footnotes, allowing the reader to draw his or her own conclusions.

———. *Sargent, Whistler and Mary Cassatt.* Chicago: Art Institute. January 14–February 25, 1954.

Tate, Penelope. *The Influence of the Japanese Woodcut on the Prints and Paintings of James A. McNeill Whistler and Mary Cassatt.* M.A. thesis, Florida State University, 1969.

Teal, Gardner. "Mother and Child—The Theme as Developed in the Art of Mary Cassatt." *Good Housekeeping.* 50(February 1910):141–146.

Thieme and Becker. *Allgemeines Lexikon.* Vol. 6, p. 126.

Valerie, Edith. *Mary Cassatt.* Paris: Cres et cie, 1930.

Walter, William. "Miss Mary Cassatt." *Scribner's Magazine.* 19(March 1896):353–361.

Washington, D.C. Museum of Graphic Art and Smithsonian Institution Press. *The Graphic Art of Mary Cassatt.* 1967.
This volume catalogs and presents high-quality black-and-white reproductions of eighty-two of Cassatt's prints. The introduction is by Breeskin, easily the foremost Cassatt scholar.

Washington, D.C. National Gallery of Art. *Mary Cassatt, 1844–1926.*
September 27–November 8, 1970.
Introduction by Breeskin.

Watson, Forbes. *Mary Cassatt.* New York: Whitney Museum of American Art, 1932.

———. "Philadelphia Pays Tribute to Mary Cassatt." *Arts.* 11(June 1927):289–297.

Webster, Sally. "Mary Cassatt's Allegory of Modern Woman." *Helicon Nine.* 1(Fall–Winter 1979):38–47.
Excellent description and analysis of Cassatt's mural for the Woman's Building at the 1893 World's Columbian Exposition.

Weimann. *The Fair Women.* Pp. 194–214, 322–323, 592.
This is a detailed account of Cassatt's mural work for the Columbian Exposition.

Weitenkampf, Frank. "The Drypoints of Mary Cassatt." *Print Collector's Quarterly.* 6(December 1916):397–409.

———. "Some Women Etchers." *Scribner's Magazine.* 46(December 1909):731–739.

Wilson, Ellen. *An American Painter in Paris: A Life of Mary Cassatt.* New York: Farrar, Straus, and Giroux, 1971.

Yeh, Susan Fillin. "Mary Cassatt's Images of Women." *Art Journal.* 35(Summer 1976):359–363.
Instead of stressing the sentimentality of Cassatt's works, especially her mother and child depictions, Yeh emphasizes Cassatt's view of women as independent beings, pursuing individual interests, and often enjoying the company of other women.

Yeldham. *Women Artists in Nineteenth-Century France and England.* Vol. 1, pp. 357–364.
A concise account of Cassatt's life and career.

Young, Mahonri Sharp. *American Realists.* New York: Watson-Guptill Publications, 1977. Pp. 52–61.
A brief biographical statement is accompanied by nine black-and-white reproductions of Cassatt's work.

Collections:

Andover (Massachusetts), Phillips Academy, Addison Gallery of American Art.
Baltimore Museum of Art.
Boston Museum of Fine Arts.
Brooklyn Museum.
Chicago Art Institute.
Cincinnati Art Museum.
Cleveland Museum of Art.
Detroit Institute of Art.
Hartford (Connecticut), Wadsworth Atheneum.
Kansas City, Nelson-Atkins Museum of Art.
Los Angeles County Museum of Art.
Minneapolis, Walker Art Center.
New York, Metropolitan Museum of Art.
Newark (New Jersey) Museum.
Philadelphia Museum of Art.
Pittsburgh, Museum of Art, Carnegie Institute.
Richmond, Virginia Museum of Fine Art.
San Diego Fine Arts Gallery.
Washington (D.C.), Corcoran Gallery of Art.
Washington (D.C.), National Collection of Fine Arts.
Washington (D.C.), National Gallery of Art.
Washington (D.C.), National Museum of Women in the Arts.
Worcester (Massachusetts), Art Museum.

MARIE-ELIZABETH CAVÉ. 1809–after 1875. French.
The information that survives about Cavé is concerned only with her relationship to Delacroix—a brief affair that evolved into an enduring friendship. Artistically, she is considered his follower. When Cavé first met Delacroix in 1833, at the age of eighteen, she was already married to the painter Clement Boulanger. Her romantic involvement with Delacroix occurred in 1834. In 1842 Cavé's husband died, and two years later she married François Cavé, a Beaux-Arts administrator. She was a member of the Amsterdam Academy of Fine Arts.

Angrand, Pierre. *Marie-Elizabeth Cavé, disciple de Delacroix.* Lausanne: La Bibliothèque des Arts, 1966.

Bénézit. *Dictionnaire.* Vol. 2, p. 224.

Cavé, Marie Elizabeth. *L'aquarelle sans maître.*Paris: N. Chaix, 1851.

————. *Le dessin sans maître.* Paris: Suisse frères, 1850; reprint, *Drawing Without a Master.* New York: G. P. Putnam and Son, 1868.

Both of Cavé's how-to books were extremely popular and may have incorporated views of Delacroix. This book confined itself to the accepted ideas of the woman's sphere through its format. It was written in the form of letters to a friend concerning the art education of her daughter. The first edition was eighty-two pages. The several later editions were each longer than the previous one. The English version of the book contains a translation of Delacroix's review and a report on her method, submitted to the Minister of the Interior.

————. *La femme aujourd'hui, la femme d'autrefois.* Paris, 1863.

Champlin. *Cyclopedia of Painters and Paintings.* Vol. 1, pp. 190–191.

Gives her birth date as 1810 and identifies her first husband as Louis Boulanger.

Clement. *Women in the Fine Arts.* P. 57.

Delacroix. Eugène. *Revue des deux-mondes.* (September 15, 1850).

Review of Cavé's *Le dessin sans maître.* Delacroix's opening sentence is, "Here is the first method of drawing that teaches anything."

Johnson, Lee. "Recent Delacroix Literature." *Burlington Magazine.* 110(February 1968):105.

Most scholarly interest on Cavé seems to rest on the hope of her supplying information on Delacroix, rather than on her own work. Johnson considers her worthy of serious study because her ideas on teaching possibly would reflect Delacroix's ideas.

Joubin, A. "Deux amies de Delacroix: Mme. Elizabeth Boulanger-Cavé et Mme. Rang-Babut." *Revue de l'art ancien et moderne.* 52(January 1930):57–94.

Levitine, George. Review of "Marie-Elizabeth Cavé, Disciple of Delacroix," by Angrand. *Art Bulletin.* 52(December 1970):465

Levitine calls Cavé a "moderately gifted painter." Notes that no illustrations of her work are included in Angrand's biography.

Prideux, Tom. *The World of Delacroix, 1798–1863.* New York: Time-Life Books, 1966. Pp. 124, 134–135.

A small reproduction of an Ingres pencil portrait of her is included.

Thieme and Becker. *Allgemeines Lexikon.* Vol. 4, p. 447.

Trapp. Frank. "A Mistress and a Master: Mme. Cavé and Delacroix."
Art Journal. 27(Fall 1967):40–47, 59–60.
 Summarizes Cavé's two books, using liberal quotations. Recounts
the biographical data.

Collection:

 Rouen, Musée des Beaux-Arts et de la Ceramique.

VICTORIA DUBOURG. 1840–1926. French.
 Dubourg was born in Paris and married the artist Henri Fantin-
Latour. She was highly influenced by her husband and always signed her
works with her maiden name so that they would not be thought to be
fraudulent Fantins. Her subject matter, like his, was still life. Her works
were exhibited regularly in the Salons beginning in 1868. Most of her
career was spent in perpetuating the reputation and fame of her hus-
band. After his death in 1904 she devoted her time to cataloging his
work.

Apollo. 93(April 1971):Cover.
 A reproduction of Dubourg's painting, *Nasturtiums.*

Bénézit. *Dictionnaire.* Vol. 4, p. 269.

Clement. *Women in the Fine Arts.* P. 111.

"Denver's Twenty-four Acquisitions of Paintings Since Jan.1 Show
Verve." *Art Digest.* 10(October 15, 1935):15.
 Most of the biographic information was obtained from this short
article.

Edouard-Joseph, René. *Dictionnaire Biographique des Artistes Contem-
porains.* 3 vols. Paris: Art and Edition, 1930. Vol. 1, p. 430.

Collections:

 Denver Art Museum.
 Paris, Museum of Modern Art.

SUSAN HANNAH MACDOWELL EAKINS. 1851–1938. U.S.

Eakins was the daughter of engraver William Macdowell. She studied at the Pennsylvania Academy of fine Arts in 1876 with Christian Schussele and from 1880 to 1882 with Thomas Eakins. When she married Eakins in 1884, at age thirty-two, she was a professional painter, having regularly exhibited at the Academy during the period from 1876 to 1882. The impact of the marriage on her artistic career is a matter of dispute. Some scholars believe she subordinated her life to her husband and his art. Others say she had the time and freedom to paint during her thirty-year marriage and that her husband was supportive of her work. There was, in any case, a marked increase in her artistic activity following his death in 1916, as though she were busy making up for lost time. Susan Eakins did portraits, genre works, still lifes, and landscapes in a lovely brushed style.

"The Artist's Wife." *Apollo.* 98(July 1973):60.

A review of an exhibition of her work in 1973 at the Pennsylvania Academy of Fine Arts. Includes a black-and-white reproduction.

Brownell, William C. "The Art Schools of Philadelphia." *Scribner's Monthly Illustrated Magazine.* 17(September 1879):745, 749.

Castera, Susan P. *Susan Macdowell Eakins. 1851–1938.* Philadelphia: Pennsylvania Academy of Fine Arts, May 4–June 10, 1973.

Catalog for Eakins' first one-woman show, held thirty-five years after her death. The introduction is by Seymour Adelman. Includes excellent illustrations and a bibliography.

Domit, Moussa M. *The Sculpture of Thomas Eakins.* Washington, D.C.: Corcoran Gallery of Art, 1969. P. 7.

Fine. *Women and Art.* Pp. 113–114.

Goodrich, Lloyd. *Thomas Eakins: His Life and Work.* New York: Whitney Museum of American Art, 1933.

Hill. *Women: A Historical Survey . . .* Catalog. Pp. xii, 17.

Homer, William Innes. "Who Took Eakins' Photographs?" *Art News.* 82(May 1983):112–114.

Provides a good argument that not all photographs attributed to Thomas Eakins were actually taken by him. Susan Eakins was also a serious amateur photographer. She exhibited at the first annual Philadelphia Photographic Salon in 1898.

McHenry, Margaret. *Thomas Eakins Who Painted.* Oredale, Pennsylvania: privately printed, 1946.

Pach, Walter. *Queer Things, Paintings: Forty Years in the World of Art.* New York: Harper and Brothers, 1938. Pp. 64–65.
 Pach, in a brief reminiscence, describes Eakins as continuing to paint after the death of her husband and notes her "intensive observation of people and things."

Roanoke, Virginia. North Cross School Living Gallery. *Thomas Eakins: Susan Macdowell Eakins: Elizabeth Macdowell Kenton.* September 18–October 2, 1977.
 This exhibition consisted of paintings, photographs, and artifacts pertaining to all three artists, loaned by family members. Elizabeth Kenton was Susan Eakins' sister and had also studied with Thomas Eakins. The catalog is illustrated with small black-and-white reproductions and photographs. An essay by David Sellin is included, "Eakins and the Macdowells and the Academy."

Rubinstein. *American Women Artists.* Pp. 143–144.

Sherril, Sarah. "Susan Macdowell Eakins." *Antiques.* 103(May 1973):834.

"Susan Eakins Dies." *Art Digest.* 13(January 15, 1939):26.
 This obituary includes a short tribute by Charles Bregler, a longtime friend of the Eakins family.

FELICIE DE FAUVEAU. 1799–1887. French.
 This artist was born in Florence to exiled French parents, but grew up in Paris, Bayonne, and other French cities. Although she received no formal artistic training, she made her Salon debut in 1827 and won a medal in the exhibition of 1830. Because of her support of the Bourbon king, Charles X, Fauveau had to flee Paris during the Revolution of 1830. Her active participation in the efforts to oust Louis Philippe from the French throne resulted in a seven-month prison term. When she was later sentenced to life imprisonment, she managed to escape to Belgium. In 1834 Fauveau settled in Florence where exiled Bourbons provided her with commissions. Her adventurous life has diverted attention from her artistic career. Fauveau was primarily a sculptor, working in a variety of materials. She was fascinated with the medieval period, and this interest was reflected in her Neogothic style. Religion and royalty were her main themes. Fauveau designed weapons, jewelry, and decorative objects. She

exhibited at the Paris World Exhibition of 1855. In a rare alteration of roles, she gave her brother, Hippolyte, lessons in art.

Barbotte, Juliette. ''La dague de Felicie de Fauveau.'' *Revue de Louvre.* 33, no. 2(1983):122–125.
Description of a small dagger or letter opener embellished with scenes from *Romeo and Juliet.* Her brother, Hippolyte, collaborated with Fauveau on the work.

Bénézit. *Dictionnaire.* Vol. 4. pp. 289–290.
Says she studied with Hersent. Gives a comprehensive discussion of her political difficulties.

Clement. *Women in the Fine Arts.* P. 123.

Ellet. *Women Artists.* Pp. 247–261.
Lengthy, but unclear, account of her life.

Fine. *Women and Art.* Pp. 56–57

Munsterberg. *A History of Women Artists.* Pp. 88–89.
Includes a full-page reproduction of the tomb she created for Louise Favreau.

Schiff, Gert. ''The Sculpture of the 'Style Troubadour.' '' *Arts Magazine.* 58(Summer 1984):104–107.
Fascinating description of Fauveau's activities with the Bourbon resistance. Says her vast but little-known oeuvre is scattered over Europe.

Thieme and Becker. *Allgemeines Lexikon.* Vol. 11, pp. 304–305.

Yeldham. *Women Artists in Nineteenth-Century France and England.* Vol. 1, pp. 329–336.
Comprehensive account of Fauveau's life and art.

Collections:

Florence, Church of Santa Croce.
Louviers, Musée Municipal.
Paris, Louvre.
Toulouse, Musée du Vieux.

MARGARET FOLEY ca. 1820/1827–1877. United States.

Foley grew up in Vergennes, Vermont and taught there. After a brief stint of working in a textile mill in Lowell, Massachusetts, she moved to Boston in 1848. Foley became proficient in the art of cutting cameo portraits. She also taught drawing and painting at the New England School of Design. In 1860 she went to Rome where she quickly became known for her portrait busts and large marble relief medallions. She lived in Rome for seventeen years. Her best-known work was a fountain for the Philadelphia Centennial Exhibition of 1876. She died while on vacation in the Tyrolean Alps and is buried in Merano, Italy.

Bénézit. *Dictionnaire.* Vol. 4, p. 417.

Says she worked in London and exhibited at the Royal Academy from 1870 to 1877.

Clement. *Women in the Fine Arts.* P. 127.

Craven. *Sculpture in America.* Pp. 330–332.

Ellet. *Women Artists.* P. 287

Fine. *Women and Art.* P. 113.

Gerdts. *American Neo-Classic Sculpture.* Pp. 49, 64, 66.

Munsterberg. *A History of Women Artists.* P. 90.

Payne. ''The Work of Some American Women in Plastic Art.'' P. 313.

Rubinstein. *American Women Artists.* Pp. 87–88.

Taft. *The History of American Sculpture.* Pp. 211–212.

Thorp. *The Literary Sculptors.* Pp. 91–93.

Notes that Foley's fountain at the Philadelphia Centennial Exhibition was set up among the flowers in the Horticultural Hall rather than the Statuary Hall and thus went unnoted by the critics.

————. ''The White, Marmorean Flock.'' *New England Quarterly.* 32(June 1959):161–162.

Tinling. *Women Remembered.* P. 442.

Tuckerman. *Book of the Artists.* P. 603.

Tufts, Eleanor. ''Margaret Foley's Metamorphosis: A Merrimack 'Female Operative' in Neo-Classical Rome.'' *Arts.* 56(January 1982):88–95.

The most complete description of Foley's career with numerous black-and-white illustrations. Notes that by 1855 she had opened a studio in Lowell, Massachusetts, where she taught drawing and painting.

Collections:

Amherst (Massachusetts), Mead Art Building, Amherst College.
Cambridge (Massachusetts), Harvard University.
Vergennes (Vermont), Bixby Memorial Library.
Wellesley (Massachusetts), Wellesley College Museum.
Westford (Massachusetts), J. V. Fletcher Library.

MARY HALLOCK FOOTE. 1847–1938. United States.

Foote was a well-known illustrator and author of short stories and novels about life in the American west. A native of Milton, New York, in 1864 she began three years of artistic studies at the Cooper Union Institute of Design for Women. Her talent led to employment with the publishing firm of Field, Osgood and Company, where she produced wood engravings to illustrate books. She also worked for Scribner and Company, and her illustrations were published in popular periodicals of the day, such as *Century* and *St. Nicholas.* In 1876 she married a mining engineer, Arthur De Wint Foote, and traveled throughout the west with him. They lived in mining districts in Colorado, California, and Idaho. She continued to work as an illustrator and novelist while raising three children. Between 1880 and 1925 she published four volumes of short stories and twelve novels. Around 1882 she decided to decline outside commissions for illustrations and to illustrate chiefly her own writings. She exhibited in the 1913 Armory Show.

Armstrong, Regina. ''Representative American Women Illustrators.'' *Critic.* 37(August 1900):131–141.

Clement. *Women in the Fine Arts.* Pp. 130–131.

Foote, Mary Hallock. *The Cup of Trembling and Other Stories.* 1895; reprint, Freeport, New York: books for Libraries Press, 1970.

————. *In Exile and Other Stories.* 1894; reprint, New York: Garrett Press, 1969.

————. *The Led-Horse Claim: A Romance of a Mining Camp.* 1883; reprint, Ridgewood, New Jersey: Gregg Press, 1968.
Illustrations are by the author.

————. *A Touch of Sun and Other Stories.* 1903; reprint, New York: Garrett Press, 1969.

Gragg, Barbara. "Mary Hallock Foote's Images of the Old West." *Landscape.* 24, no. 3(1980):42–47.
Gragg shows that through her use of realistic, commonplace images, Foote depicted the west as a setting for homes and families. Several reproductions of her work are included.

Johnson, Lee Anne. *Mary Hallock Foote.* Boston: Twayne Publishers, 1980.
This monograph includes a biographical summary and a discussion of Foote's artistic career. William Rimmer and William J. Linton are named as her teachers. A few reproductions of her illustrations are included.

Maguire, James H. *Mary Hallock Foote.* Boise, Idaho: Boise State College, 1972.
This work summarizes Foote's life and career and provides a brief analysis and description of her writings.

Paul, Rodman W., ed. *A Victorian Gentlewoman in the Far West: The Reminiscences of Mary Hallock Foote.* San Marino, California: The Huntington Library, 1972.
Foote wrote the story of her life during the early 1920's, but it was never published. Rodman, using her draft, presents a biography of Foote, supplemented with a large selection of her magazine illustrations, a family tree, and a number of photographs of Foote, her family, and friends.

Rubinstein. *American Women Artists.* Pp. 72–74.

Stegner, Wallace. *Angle of Repose.* New York: Doubleday, 1971.
This is a thinly disguised story of Foote's life, distorted for dramatic purposes. The author drew heavily on her memoirs for source material. The Pulitzer Prize-winning novel was adapted into an opera in 1976.

Taft, Robert. *Artists and Illustrators of the Old West, 1850–1900.* New York: Charles Scribner's Sons. Pp. 172–175.

Willard and Livermore. *American Women.* Vol. 1, p. 295.

Collection.

Chicago Art Institute.

EVA GONZALÈS. 1849–1883. French.
Gonzalès was born in Paris. Her father, a novelist, was of Spanish descent. She grew up in a circle of literary and artistic personalities. While still in her teens she began studying with Charles Chaplin and showed an aptitude for pastel work. Manet was attracted by her beauty and wanted to paint her. In 1869, against the protests of her parents, she went to his studio for the dual purpose of posing for him and receiving his criticism of her work. Manet did two portraits of her and she became his only real student. Although she never exhibited with the Impressionists, her work shares their interest in technique and themes of contemporary life. Gonzalès began exhibiting at the Salon in 1870. She worked with less regularity after her marriage in 1877 to the engraver Henri Guerard. She died at age thirty-four from complications of childbirth, but had accomplished a substantial body of work during her short life. Eighty-five works were shown at a retrospective in 1885.

Bayle, Paul. "Eva Gonzalès." *La renaissance* (June 1932).

Bénézit. *Dictionnaire.* Vol. 5, p. 106.
Provides list of her works.

Fine. *Women and Art.* Pp. 135–136.

Garb. *Women Impressionists.* P. 12.

Harris and Nochlin. *Women Artists, 1550–1950.* Pp. 246–248, 260, 352.

Hill. *Women: A Historical Survey* . . . Catalogue. Pp. xii, 17.

Lucie-Smith. *Impressionist Women.* P. 146.

Mathey. *Six femmes peintres.* P. 8.

Monaco. *Eva Gonzalès exposition.* 1952.
Catalog by Claude Roger-Marx.

Moreau-Nelaton, E. *Manet raconti par lui-même.* Paris, 1926.

Nochlin. "Why Have There Been No Great Women Artists?" P. 32.

Paris. Galerie Bernheim-Jeune. *Eva Gonzalès.* 1914.

Paris. Galerie Daber. *Eva Gonzalès.* May 28–June 18, 1959.
Exhibition catalog with six black-and-white illustrations. The introduction is by Claude Roger-Marx. The catalog was compiled by Alfred Daber.

Paris. Galerie Marcel Bernheim. *Eva Gonzalès, exposition rétrospective.* 1932.
Catalog by Paul Bayle.

Paris. Salons de la Vie Moderne. *Catalogue des peintres et pastels de Eva Gonzalès.* 1885.
Preface by Philippe Burty, essay by Théodore de Banville.

Petersen and Wilson. *Women Artists.* Pp. 91–92, 97.

Roger-Marx, Claude. *Eva Gonzalès.* St.-Germain-en-Laye: Les Editions de Neuilly, 1950.
Notes that the Morisot sisters were annoyed by Manet's praise of Gonzalès. Lists her Salon presentations and includes many black-and-white reproductions.

Sparrow. *Women Painters of the World.* Pp. 181, 223, 231.

Sweet, Frederick. "Eva Gonzalès." *Chicago Art Institute Bulletin.* 34(September–October 1940):74–75.

Yeldham. *Women Artists in Nineteenth-Century France and England.* Vol. 1, pp. 365–366.
Provides a concise summary of Gonzalès's life and career.

Collections:

Bremen, Kunsthalle.
Chicago Art Institute.

Paris, Louvre.
Waltham (Massachusetts), Rose Art Museum, Brandeis University.

SARAH GOODRIDGE. 1788–1853. United States.
Goodridge was born in Templeton, Massachusetts. She was self-taught as an artist. Her early interest was sculpture, but a scarcity of materials caused her to abandon this. Her career began around 1812 when she started doing portraits in watercolor and colored crayons. In 1820, after a period of teaching in village schools, she moved to Boston to live with her sister. In Boston Goodridge opened a studio and met Gilbert Stuart, who gave her some instruction. Her work in watercolor miniatures on ivory is characterized by almost photographic detail. Her name is alternately spelled "Goodrich."

Bénézit. *Dictionnaire.* Vol. 5, p. 113.

Comstock, Helen. "Miniature of Isaiah Thomas by Sarah Goodrich." *Connoisseur.* 119(March 1947):40.

Dods, Agnes. "Sarah Goodridge." *Antiques.* 51(May 1947):328–329.
Lists forty known works and includes several black-and-white reproductions.

Dresser, Louisa. "Portraits Owned by the American Antiquarian Society." *Antiques.* 96(November 1969):725–726.

Fine. *Women and Art.* Pp. 99–100.
Says she painted about two miniatures a week.

Morgan, John Hill. *Gilbert Stuart and His Pupils.* New York: New York Historical Society, 1939.

Petersen and Wilson. *Women Artists.* Pp. 67–68.

Rubinstein. *American Women Artists.* Pp. 45–46.

Wehle. *American Miniatures, 1730–1850.* Pp. 64, 88.
Recounts an episode when Goodridge was working in Gilbert Stuart's studio, painting a miniature after one of his portraits. Stuart lost patience after watching her "groping methods" and demonstrated how a "miniature should be painted."

Collections:

Boston Museum of Fine Arts.
New York, Metropolitan Museum of Art.
Templeton (Massachusetts), Narragansett Historical Society.

KATE GREENAWAY. 1846–1901. English.

Greenaway, the daughter of the wood engraver John Greenaway, was one of the most prolific illustrators of her day. She studied in South Kensington and at the Slade School. Her first exhibition was in 1868. In 1889 she became a member of the Royal Institute of Painters in Watercolors. Her career as an illustrator began with the *Illustrated London News,* the paper for which her father had worked. She also did illustrations for the *Ladies Home Journal.* Her work consisted primarily of color wood engravings and was wide in its scope. She designed Christmas and Valentine cards, published almanacs, and drew for *Punch.* She wrote rhymes and did illustrations for children's books. Greenaway also invented a process to reproduce photographically her drawings. Among her intimate friends were Violet Dickinson and John Ruskin. For seventeen years she carried on a voluminous correspondence with Ruskin, beginning in 1879, although they did not meet until 1882. Only a few of her illustrated works are included in the bibliography below.

"Art in the Nursery." *Magazine of Art.* 6(1883):127–132.
Discussion of several illustrators for children, including Greenaway.

Bénézit. *Dictionnaire.* Vol. 5, p. 187.

Browning, Robert. *The Pied Piper of Hamelin.* London: Frederick Warne, 1909.
The illustrations are by Greenaway.

Bryan. *A Dictionary of Painters.* Vol. 2, pp. 275–276.
Extensive chronology of her work. Lists books she published in partnership with Edmund Evans.

Clement. *Women in the Fine Arts.* Pp. 150–151.

Dobson, Austin. *De Libris: Prose and Verse.* London: Macmillan Company, 1908. Pp. 91–107.
Discusses Greenaway's art.

Engen, Rodney K. *Kate Greenaway.* London: Academy Editions, 1976.
 A book of reproductions that illustrates the many facets of Greena-
way's oeuvre, accompanied by a brief essay providing a context for
her art. Engen describes Greenaway as "a shrewd escapist who
created a universal, sugar-coated world of sexless, middle-class
children, dressed in derivative costumes, romping blissfully in idyllic
pastel-coloured landscapes." Includes over fifty black-and-white
reproductions and lists works illustrated by her.

————. *Kate Greenaway.* New York: Schocken Books, 1981.
 A biography that details her life and work. Discusses the correspon-
dence she carried on with John Ruskin. Includes many black-and-
white reproductions and lists works illustrated by her.

Ernest, Edward, ed. *The Kate Greenaway Treasury: An Anthology of the
 Illustrations and Writings of Kate Greenaway.* Cleveland: World
 Publishing Company, 1967.

Foster, Myles B. *A Day in a Child's Life.* London: G. Routledge, 1881.
 A collection of children's songs with music by Myles Foster and
illustrations by Greenaway.

Greenaway, Kate. *A Apple Pie.* London: Routledge and Sons, 1886.
 Twenty-two color illustrations.

————. *Marigold Garden: Pictures and Rhymes.* London: G. Routledge
and Sons, n.d.

Holme, Bryan. *The Kate Greenaway Book.* New York: Viking Press,
 1976.
 Excellent biographical treatment and discussion of her many publi-
cations. Profusely illustrated, primarily with black-and-white repro-
ductions. Includes a list of books illustrated by Greenaway.

Kate Greenaway. New York: Rizzoli. 1977.
 Fifty color reproductions of her work.

Kiger, Robert, ed. *Kate Greenaway.* Pittsburgh: Carnegie-Mellon Uni-
 versity, 1980.
 Catalog for an exhibition of materials from the Frances Hooper
Collection at the Hunt Institute for Botanical Documentation, Carnegie-
Mellon University. Includes an essay by Hooper, the collector of the
materials, a biographical summary by Rodney Engen, and a brief as-
sessment of Greenaway's art by John Brindle. Numerous reproductions.

Mavor, William Fordyce. *The English Spelling Book.* London: G. Routledge and Sons, 1885.
 Illustrations by Greenaway.

Moore, Anne Carroll. *A Century of Kate Greenaway.* London: Frederick Warne and Company, 1946.
 Brief account of Greenaway's illustrated stories for children.

Munsterberg. *A History of Women Artists.* Pp. 105, 109.

Paul, Frances. "A Collection of Children's Books Illustrated by Walter Crane, Kate Greenaway, and Randolph Caldecott." *Apollo.* 43(January–June 1946):141–143.

Sparrow. *Women Painters of the World.* Pp. 65–66.

Spielmann, Marion H., and G. S. Layard. *Kate Greenaway.* London: Adam and Charles Black, 1905.
 Major biography that contains photographs of Greenaway and many reproductions of her works. Traces the role of Ruskin as a critic of her work who wanted her to make more serious use of her talent. Also discusses her antisuffrage views, such as the belief that "men have more ability."

Taylor, Jane, and Ann Taylor. *Little Ann and Other Poems.* London: G. Routledge, 1883.
 Illustrations by Greenaway.

Thompson, Susan Ruth, comp. *Kate Greenaway: A Catalogue of the Kate Greenaway Collection, Rare Book Room, Detroit Public Library.* Detroit: Wayne State University Press, for the Friends of the Detroit Public Library, 1977.

Collections:

 Detroit Public Library.
 Pittsburgh, Carnegie-Mellon University, Hunt Institute for Botanical Documentation.

ANTOINETTE-CECILE-HORTENSE HAUDEBOURT-LESCOT. 1784–1845. French.
 This artist began art studies with Guillaume Lethière at age seven. He also introduced her into society, where she acquired a reputation as a

graceful dancer. A scandal ensued when she followed Lethière to Rome when he was named director of the French Academy there. She became one of the first women to study there. She was in Rome from 1807 to 1816, and it was there that she met and married the architect Haudebourt. They returned to France in 1816. Haudebourt-Lescot specialized in Italian landscapes and in Italian genre scenes totally devoid of her teacher's influence. She exhibited regularly at the Salon from 1810 to 1840, presenting over 110 paintings. She was also a superb portraitist and after 1828 exhibited only portraits. In 1830 she was one of the artists commissioned to paint the great personalities of French history for Versailles. Haudebourt-Lescot was also a teacher.

Bénézit. *Dictionnaire.* Vol. 5, p. 430.

Bryan. *Dictionary of Painters.* Vol. 3, p. 20.

Fine. *Women and Art.* Pp. 55–56.

Greer. *The Obstacle Race.* P. 303.
 Notes that her fame spread to the United States, for a painting by Jane Peale is a copy of one of Hardebourt-Lescot's works.

Harris and Nochlin. *Women Artists, 1550–1950.* Pp. 48, 86, 218–219, 349.

Hauatecoeur, L. *Bulletin des musées* (1925):324–325 (68–69).

National Museum of Women in the Arts. Pp. 38–39.

Paris. Grand Palais. *French Painting, 1774–1830: The Age of Revolution.* 1974–1975. Pp. 486–487.
 Exhibition catalog with entry on Haudebourt-Lescot by Isabella Julia and Sally Wells-Robertson.

Sparrow. *Women Painters of the World.* Pp. 179–180.

Thieme and Becker. *Allgemeines Lexikon.* Vol. 16, pp. 125–126.

Valabrèque, A. "Mme. Haudebourt-Lescot." *Les lettres et les arts.* 1(1887):102–109.

Wells-Robertson, Sally. "A. C. H. Haudebourt-Lescot, 1784–1845." New York University, Institute of the Fine Arts, 1973.
 An unpublished paper.

Collections:

> Paris, Louvre.
> Versailles, Musée National du Château Versailles et des Trianons.
> Washington (D.C.), National Museum of Women in the Arts.

EDITH HAYLLAR. 1860–1948. English.
and
JESSICA HAYLLAR. 1858–1940. English.

James Hayllar, an English painter, was the father and teacher of four artist daughters. In the late 1880's and 1890's he and his daughters yearly exhibited at least one picture each in the Royal Academy. The daughters received no other artistic training and used one another as models. Thus, many of their works depict family scenes in their riverfront home, Castle Priory.

Jessica specialized in domestic scenes. She exhibited at the Royal Academy from 1880 to about 1915. In 1900 she was crippled in an accident, but continued to paint from her wheelchair, doing mainly flower studies. She stopped painting around 1915.

Edith exhibited at the Royal Academy from 1882 to 1897. Her style and subject matter were similar to Jessica's, and in addition she was interested in depicting sporting events. She married the Reverend Bruce Mackay and gave up painting around 1900.

The other two sisters, Kate and Mary, were not so talented and had briefer careers. Kate exhibited at the Academy from 1885 to 1898, doing mainly still lifes. Around 1900 she gave up painting to become a nurse. Mary, who also did still lifes, exhibited at the Academy from 1880 to 1885. She married Henry Wells and ceased painting around 1887. She began painting miniatures of children after she bore several children.

Bénézit. *Dictionnaire.* Vol. 5, p. 442.
> Mentions all four sisters.

Forbes, Christopher. *The Royal Academy (1837–1901) Revisited: Victorian Painting from the Forbes Magazine Collection.* New York: Forbes Magazine, 1975.

Harris and Nochlin. *Women Artists, 1550–1950.* Pp. 55, 93, 258–259, 353.

Hill. *Women: A Historical Survey . . .* Catalog. P. xi.
> Mentions Edith Hayllar.

Thieme and Becker. *Allgemeines Lexikon.* Vol. 16, p. 179.
 Has entry on Jessica Hayllar.

Wood, Christopher. "The Artistic Family Hayllar. Part I. James."
 Connoisseur. 186(April 1974):266–273.

―――. "The Artistic Family Hayllar. Part II. Jessica, Edith, Mary,
 Kate." *Connoisseur.* 186(May 1974):2–10.
 These two articles provided the majority of the above biographical
 information. They document the family history and provide numerous
 black-and-white reproductions.

Collection:

 New York, Forbes Magazine Collection.

CLAUDE RAQUET HIRST. 1855–1942. United States.
 Hirst was born in Cincinnati, where she studied at the Art Academy
with Nobel. She also studied in New York. Her husband, William Fitler,
was a landscape painter. Hirst's work was first exhibited by the National
Academy of Design in 1884. Prior to 1890 she usually painted fruit and
flower still lifes. William Harnett was a friend and had a studio next door
to hers. His influence is seen in Hirst's work after 1890, when she began
doing similar realistic still lifes of books, pipes, and tobacco jars. She
usually worked in watercolor. Hirst was a member of the National
Academy of Women Painters and Sculptors and of the New York
Watercolor Club. She died in poverty.

Ball, Charlotte, ed. *Who's Who in American Art, 1940–41.* Washington,
 D.C.:American Federation of Arts, 1940. Vol. 3, p. 303.

"Claude R. Hirst." *New York Times* (May 4, 1942):19.
 Obituary.

Frankenstein, Alfred. *After the Hunt: William Harnett and Other
 American Still Life Painters, 1870–1900.* Berkeley: University of
 California Press, 1953. Pp. 153–154.
 Traces Hirst's relationship to Harnett. Includes a black- and-white
 reproduction.

―――. *The Reality of Appearance.* New York: New York Graphic
 Society, 1970. Pp. 142–143.

Gabhart and Broun. "Old Mistresses."

Gerdts, William H., and Russell Burke. *American Still-Life Painting.* New York: Praeger Publishers, 1971. P. 145.

Rubinstein. *American Women Artists.* Pp. 144–145.

Collection:

Youngstown (Ohio), Butler Institute of American Art.

HARRIET G. HOSMER. 1830–1908. United States.

Hosmer was born in Watertown, Massachusetts. After having lost his wife and three children to tuberculosis, her physician-father encouraged her to pursue a physically active, outdoor life. Thus she grew up confident and independent, traits that continued to mark her personality. She became interested in sculpture and studied first in Boston. After she was refused admittance to anatomy classes at the Boston Medical School, she studied anatomy at the Medical College of St. Louis, through connections with a school friend. Hosmer subsequently traveled unattended in the Midwest—shocking behavior for her day. Under the sponsorship of the actress Charlotte Cushman, she went to Rome in 1852 and entered the studio of John Gibson. Hosmer rapidly attained success and became widely known in artistic and literary circles. Among her many friends were the Robert Brownings, the actress Fanny Kemble, the Nathaniel Hawthornes, and Sir Frederic Leighton. Interest in her unique personality and social life has probably been equal to the interest in her artistic efforts. When she returned to the United States in 1860 for a brief visit, she was described as having had her hair cut and wearing the clothes of a boy. She boasted of not having worn a bonnet in five years. Hosmer continued to work abroad until 1900, when she returned to the States for the last years of her life. She never married, being convinced of the impossibility of combining art and marriage. Working in a Neoclassical style, she drew frequently on literary and mythological subject matter, although she was increasingly involved in portraiture after 1860.

Armstrong. *Two Hundred Years of American Sculpture.* Pp. 280–281.
Good summary of biographical data.

Art Journal. 35(Summer 1976):Cover.
The cover of this issue is embellished with a sepia-toned photograph of Hosmer surrounded by twenty-four male assistants, circa 1860.

"The Beatrice Cenci." *Crayon.* 4, pt. 12(December 1857):379.

Bénézit. *Dictionnaire.* Vol. 5, p. 625.

Bidwell, W. H. "Harriet G. Hosmer." *Eclectic Magazine.* 77, n.s. 14(August 1871):245–246.

Bradford, Ruth A. "The Life and Works of Harriet Hosmer." *New England Magazine.* 45(October 1911):265–269.

Carr, Cornelia, ed. *Harriet Hosmer: Letters and Memories.* New York: Moffat, Yard and Company, 1912.
 The editor of this work was Hosmer's school friend and the daughter of Dr. Wayman Crow, who gave Hosmer an early commission and remained a consistent patron.

Child, L. Maria. "Miss Harriet Hosmer." *Littell's Living Age.* 56(March 13, 1858):697–698.

Clement. *Women in the Fine Arts.* Pp. 164–165.

Craven. *Sculpture in America.* Pp. 325–330.

Ellet. *Women Artists.* Pp. 349–369.

Faxon, Alicia. "Harriet Hosmer: From Watertown to World Fame." *Boston Globe* (August 10, 1972).

————. "Images of Women in the Sculpture of Harriett Hosmer." *Woman's Art Journal.* 2(Spring–Summer 1981):25–29.
 The Schlesinger Library at Radcliffe College has a Harriet Hosmer collection.

Fine. *Women and Art.* Pp. 108–111.

Gerdts. *American Neo-Classic Sculpture.* Pp. 19, 47–48, 62–63, 122–123, 136–137, 155.

————. "The *Medusa* of Harriet Hosmer." *Bulletin of the Detroit Institute of Arts.* 56, no.2(1978):96–107.
 Gerdts discusses Gibson's influence on her work. He also traces the inspiration for her *Medusa,* which he identifies as her first commissioned work. He also notes that her artistic energies lessened in the late 1860's and early 1870's as her social life expanded.

————. *The White Marmorean Flock.*

Groseclose, Barbara S. "Harriet Hosmer's Tomb to Judith Falconnet: Death and the Maiden." *America Art Journal.* 12(Spring 1980):78–89.
Comprehensive discussion of this only known tomb by Hosmer.

Hanaford. *Daughters of America.* Pp. 300–303.

"Harriet Hosmer." *Cosmopolitan Art Journal.* 3, no. 5(December 1859):214–217.

Hart. *Some Lessons of Encouragement.*

Heller. *Women Artists.* Pp. 85–86.

Hosmer, Harriet. "The Process of Sculpture." *Atlantic Monthly.* 14(December 1864):734–737.

LaBarre, Margaret Wendell. *Harriet Hosmer: Her Era and Art.* Master's thesis, University of Illinois, 1966.

Leach, Joseph. "Harriet Hosmer: Feminist in Bronze and Marble." *Feminist Art Journal.* 35(Summer 1976):9–13, 44–45.
Summarizes her work and discusses the influence of Charlotte Cushman.

Logan, Mary. *The Part Taken by Women in America History.* Wilmington, Delaware: Perry-Nalle Publishing Company, 1912. Pp. 761–762.

Lynes, Russell. *Art Makers of the Nineteenth Century.* New York: Atheneum, 1978. Pp. 129–132, 136.
Says Hosmer studied in Boston with Paul Stephenson and that she invested substantial sums trying to devise a perpetual-motion machine.

"Miss Hosmer's Statue of Zenobia." *The New Path.* 2(April 1865):49–53.

Munsterberg. *A History of Women Artists.* P. 90.

Osgood, Dr. Samuel. "American Artists in Italy." *Harper's.* 41(August 1870):423.
Briefly mentions Hosmer and notes that "men must have some-

thing more than their sex to boast of if they would keep the track of honor and wealth to themselves.''

Payne. ''The Work of Some American Women in Plastic Art.'' Pp. 311–313.
Comments that Hosmer had a preference for the draped figure and minute detail.

Petersen and Wilson. *Women Artists.* Pp. 80–82, 84.

Proske. ''American Women Sculptors.''
Notes that Hosmer sued for libel when it was printed that her *Zenobia* was actually by John Gibson.

''Puck.'' *Art Journal.* 14(1875):312.
Puck was the title of one of Hosmer's most popular works. This article describes Hosmer's work as having ''a robust, masculine character.''

Roos, Jane Mayo. ''Another Look at Henry James and the 'White, Marmorean Flock.' '' *Woman's Art Journal.* 4(Spring–Summer 1983):29–34.
The phrase ''white, marmorean flock,'' coined by James, was intended in a disparaging sense. James belittled Hosmer's accomplishments.

Ross, John F. ''The Object at Hand.'' *Smithsonian.* 22, no. 11(February 1992):22–26.

Rubinstein. *American Women Artists.* Pp. 75–79.

Taft. *History of American Sculpture.* Pp. 203–211.

Thieme and Becker. *Allgemeines Lexikon.* Vol. 17, pp. 546–547.

Thorp, Margaret Farrand. *The Literary Sculptors.* Pp. 79–88.

———. ''The White, Marmorean Flock.'' *New England Quarterly.* 32(June 1959):147–169.
Good summary of Hosmer's life and work. Includes descriptions of some of Hosmer's mechanical experiments.

Thurston. *Eminent Women of the Age.* Pp. 566–598.

Tinling. *Women Remembered.* Pp. 72, 201.

Tuckerman. *Book of the Artists.* Pp. 601–602.

Van Rensselaer, Susan. "Harriet Hosmer." *Antiques.* 84(October 1963):424–428.
 Excellent summary of Hosmer's life, with many quotes from her famous friends. Between 1870 and 1889 she apparently closed her studio in Rome and lived with Lady Ashburton in England, where she did original work on the study of perpetual motion and on technical processes. Includes several good reproductions of her work.

Waller, Susan "The Artist, the Writer, and the Queen: Hosmer, Jameson, and *Zenobia.*" *Woman's Art Journal.* 4(Spring–Summer 1983):21–28.
 Relates the genesis and development of *Zenobia* to Hosmer's meeting the art critic Anna Jameson shortly before undertaking the work. Believes Jameson's advice and encouragement was influential in the creation of the sculpture.

Whiting, Lilian. *Women Who Have Ennobled Life.* Philadelphia: Union Press, 1915.
 A chapter on Hosmer is included.

Withers. "Artistic Women and Women Artists." Pp. 334–335.

Collections:

 Detroit Institute of Arts.
 Hartford (Connecticut), Wadsworth Atheneum.
 St. Louis, Washington University Gallery of Art.
 Wellesley (Massachusetts), Wellesley College Library.

VINNIE REAM HOXIE. 1847–1914. United States.
 Vinnie Ream was born in an Indian village near Madison, Wisconsin, where her father was doing survey work. She entered Christian College in Columbia, Missouri, at the age of fourteen. The following year the family move to Washington, D.C. Her interest in sculpture, which began during her year of college, was fueled by her new surroundings. At the remarkable age of eighteen, after one year of study in the studio of Clark Mills, she received a commission from Congress for a statue of Lincoln. After completing the plaster model, she traveled

to Europe in 1869 to complete the sculpture in marble. She studied in Paris with Bonnat and in Rome with Luigi Majoli. The completed statue of Lincoln is on display in the Capitol rotunda. In 1878 she married Lieutenant Richard Hoxie. After the birth of a son, she gave up sculpture, but returned to her work later in her life.

Ames, Mary Clemmer. *Independent.* New York City (February 18, 1871).

Baker, Isadore. "The Ream Statue of Farragut." *Carter's Monthly.* 15(May 1899):405–410.

———. "Vinnie Ream Hoxie: Her Statue of Lincoln and Other Works." *Midland Monthly.* 8(November 1897):405ff.

Becker, Carolyn Berry. "Vinnie Ream: Portrait of a Young Sculptor." *Feminist Art Journal.* 5(Fall 1976):29–31.
 Excellent account of Hoxie's life and work. Includes photographs of the artist and a bibliography.

Bénézit. *Dictionnaire.* Vol. 8, p. 634.

Brandes, George Morris Cohen. *Recollections of My Childhood and Youth.* 1906.

Clement. *Women in the Fine Arts.* Pp. 165–166.

Fine. *Women and Art.* P. 113.

Gerdts. *America Neo-Classic Sculpture.* Pp. 64, 87, 157–158.

———. *The White Marmorean Flock.*

Griffin, Maude E. "Vinnie Ream: Portrait of a Sculptor." *Missouri Historical Review.* 56(April 1962):230–243.
 Excellent discussion of Hoxie's early life and of the connections and circumstances that led to her Lincoln commission. Also details her inadvertent involvement in the efforts to impeach President Andrew Johnson, which resulted in the loss of her Washington studio.

Haefner, Marie. "From Plastic Clay." *Palimpsest.* 11(November 1930):473–482.

Hall, Gordon Langley. *Vinnie Ream: The Story of the Girl Who Sculptured Lincoln.* New York: Holt, Rinehart and Winston, 1963.

Hanaford. *Daughters of America.* P. 300.

Holzer, Harold, and Lloyd Ostendort. "Sculptures of Abraham Lincoln from Life." *Antiques.* 113(February 1978):386–387.
The authors provide illustrations of a bas-relief and two busts of Lincoln completed by Ream before she received her congressional commission for the full-length Lincoln statue. They note that Mrs. Lincoln campaigned to deny her the commission.

Hoxie, Richard L. *Vinnie Ream.* Washington, D.C., 1908.

Hoxie, Vinnie Ream. "Lincoln and Farragut." *The Congress of Women, Held in the Woman's Building, World's Columbian Exposition, Chicago, U.S.A., 1894.*
This work was edited by Mary Cavanaugh Oldham Eagle in 1894.

Hudson, Ralph M. "Art in Arkansas." *Arkansas Historical Quarterly.* 3(Winter 1944):324.

Lemp, Joan A. "Vinnie Ream and *Abraham Lincoln.*" *Woman's Art Journal.* 6(Fall 1985–Winter 1986):24–29.
The Vinnie Ream Hoxie papers are in the collection of the manuscript division of the Library of Congress.

Payne. "The Work of Some American Women in Plastic Art." P. 313.
Payne describes her work as immature but interesting for the novelty of her youth.

Petersen and Wilson. *Women Artists.* P. 83.

Rubinstein. *American Women Artists.* Pp. 83–85.

Stathis, Stephen W., and Lee Roderick. "Mallet, Chisel, and Curls." *American Heritage.* 27(February1976):44–47, 94–96.
Details the political intrigue during the period she was working on the statue of Lincoln.

Taft. *The History of American Sculpture.* Pp. 212–213.

Thorp. *The Literary Sculptors.* Pp. 96–98.

Tinling. *Women Remembered.* Pp. 331–332, 507.

Weimann. *The Fair Women.* Pp. 285–289.

Documents the exhibition of three works by Hoxie at the 1893 Chicago World's Columbian Exposition.

Wilkins, Thurman. "Ream, Vinnie." *In Notable American Women, 1607–1950.* Vol. 3, pp. 122–123.

Collection:

Brooklyn, City Hall.

EDMONIA LEWIS. 1845–ca. 1901. United States.

Lewis was born near Albany, New York, to a black father and a Chippewa mother. She was orphaned at an early age and raised by her mother's tribe. Her only brother helped support her education in Albany, New York, and for a brief period at Ohio's Oberlin College. She left there in 1862, at the age of fifteen, after being accused of poisoning two of her white classmates. John Mercer Langston defended her, and she was acquitted of the charge. Lewis moved to Boston where she briefly studied with the sculptor Edward Brackett. She exhibited for the first time in Boston in 1865. With the support of the William Story family she went to Rome in 1867, where she reportedly studied with both Harriet Hosmer and John Gibson. Lewis's work was characteristic of the popular Neoclassical style. She made a visit to the United States in 1873 to exhibit and sell her work. Although she was still active in Rome in 1885, information about the remaining years of her life has not been uncovered.

The Aldine. 11, no. 8(August 1869):76.

Bénézit. *Dictionnaire.* Vol. 6, p. 635.

Blodgett, Geoffrey. "John Mercer Langston and the Case of Edmonia Lewis: Oberlin 1862." *Journal of Negro History.* 53(July 1968):201–218.
 Discussion of Langston's defense of Lewis.

Bontemps, Arna. *One Hundred Years of Negro Freedom.* New York: Dodd, Mead, 1962. P. 121

Brown, William Wells. *The Rising Sun.* 1874. Pp. 465–468.

Bullard, Laura C. "Edmonia Lewis." *Revolution.* 7, no. 16(April 20, 1871):8.
Describes works seen on a visit to Lewis's studio.

Cederholm. *Afro-American Artists.* Pp. 176–178.

Clement. *Women in the Fine Arts.* Pp. 210–211.

Craven. *Sculpture in America.* Pp. 333–335.

Dannett, Sylvia G. *Profiles of American Negro Womanhood.* Yonkers, New York: Negro Heritage Library, 1964. Vol. 1, pp. 118–123.
The chapter on Lewis is entitled "Mary Edmonia Lewis, 1846–1890: The First American Negro to Achieve Recognition in the Field of Sculpture."

Darcy, Cornelius P. "Edmonia Lewis Arrives in Rome." *Negro History Bulletin.* 40(March–April 1977):688.

Dover, Cedric. *American Negro Art.* Greenwich, Connecticut: New York Graphic Society, 1960. Pp. 19, 26–28, 82.

Fax, Elton C. *Seventeen Black Artists.* New York: Dodd, Mead and Company, 1971. Pp. 4–5.
Lists several of Lewis's works. Notes that she modeled a medallion of John Brown and bust of Col. Robert Gould Shaw.

Fine. *Women and Art.* Pp. 111–113.

Freedman's Record. 11, no. 4(1866):67.

Freeman, Murray. *Emancipation and the Freed in American Sculpture.* 1916.

Gerdts. *America Neo-classic Sculpture.* Pp. 48–49, 80–81, 156.

———. *Ten Afro-American Artists of the Nineteenth Century.* Howard University, The Gallery of Art, February 3–March 30, 1967.

———. *The White Marmorean Flock.*

H.W. "A Negro Sculptress." *Athenaeum.* No. 2001(March 3, 1866):302.

Hanaford. *Daughters of America.* Pp. 286–288.

Langston, John M. *From the Virginia Plantation to the National Capitol.* Hartford, Connecticut, 1894. Pp. 171–180.
 In his autobiography Langston includes his account of Lewis's trial at Oberlin.

Lewis, Samella. *Art: Africa American.* New York: Harcourt, Brace, Jovanovich, 1978, Pp. 39–43.
 Lewis provides a good account of the sculptor's difficulties at Oberlin College. Gives her date of birth as 1843.

Locke, Alain. *Negro Art Past and Present.* 1936.

Los Angeles. Los Angeles County Museum of Art. *Two Centuries of Black American Art.* September 30–November 21, 1976. Pp. 48–49, 131.
 The text of this catalog is by David Driskell.

Lynes, Russell. *The Art-Makers of Nineteenth-Century America.* New York: Atheneum, 1970. Pp. 134–136.

Majors, Monroe. *Noted Negro Women and Their Triumphs.* Chicago, 1893. P. 27.

Montesane, Philip M. "The Mystery of the San Jose Statues." *Urban West.* 1(March–April 1968):25–27.

Munsterberg. *A History of Women Artists.* P. 90.

National Cyclopaedia of America Biography. Vol. 5, p. 173.
 Gives birth date of 1845.

New National Era. 11(May 4, 1871):1.

New York. City University of New York. *The Evolution of Afro-American Artists: 1800–1950.* October 16–November 5, 1967.

Nickerson, Cynthia D. "Artistic Interpretations of Henry Wadsworth Longfellow's *The Song of Hiawatha,* 1855–1900." *American Art Journal.* 16(Summer 1984):59–64.
 Among the interpretations discussed are those of Lewis. Nickerson sees Lewis's interest in this theme as a reflection of her heritage and a reference to the Civil War.

Petersen and Wilson. *Women Artists.* Pp. 81–82.

Porter, Dorothy B. "Edmonia Lewis." *Dictionary of America Negro Biography.* Ed. Rayford Logan and Michael Winston. New York: W. W. Norton and Company, 1982. Pp. 393–395.
 Good discussion of Lewis's life and career. Says that she married a Dr. Peck of Philadelphia in 1869. Notes that she benefited from the criticism of Anne Whitney, a Boston sculptor. Gives 1865 as the date of her departure for Europe.

Porter, James A. "Lewis, Edmonia." In *Notable American Women 1607–1950.* Vol. 2, pp. 397–399.

―――. *Modern Negro Art.* 1943; reprint, New York: Arno Press, 1969. Pp. 57–63.
 The reprint contains a new preface by the author.

―――. "Versatile Interest of Early Negro Artists: A Neglected Chapter in America Art History." *Art in America.* 24(January 1936):16–27.

Progressive American Colored Weekly (September 28, 1876).

Proske. "American Women Sculptors."

Rubinstein. *American Women Artists.* Pp. 79–82.

Taft. *The History of American Sculpture.* P. 212.

Thorp. *The Literary Sculptors.* Pp. 93–95.

―――. "The White, Marmorean Flock." *New England Quarterly.* 32(June 1959):163–164.

Tuckerman. *Book of the Artists.* Pp. 603–604.
 Enthusiastic evaluation of Lewis's work.

Tufts, Eleanor. "Edmonia Lewis, Afro-American Neo-Classicist." *Art in America.* 62(July 1974):71–72.
 Excellent summary of Lewis's artistic career. Tufts notes that Lewis originally intended to pursue a musical career in Boston. Her introduction to Edward Brackett was through the abolitionist William Lloyd Garrison.

―――. *Our Hidden Heritage.* Pp. 159–167, 245.

Wyman, Lillian Buffum, and Arthur C. Wyman. *Elizabeth Buffum Chase, 1806–1899: Her Life and Its Environment.* Boston: W. B. Clarke, 1914.

Collections:

San Jose (California), San Jose Public Library.
Tuskegee (Alabama), Tuskegee Institute.
Washington (D.C.), Howard University Gallery of Art.
Washington (D.C.), Museum of African Art.

MARCELLO (ADELE d'AFFRY). 1836–1879. Swiss.
Adele d'Affry was born near Fribourg, Switzerland. At the age of eighteen she began her study of sculpture in Rome with the Swiss sculptor Heinrich Imhof. In addition to sculpture, she also did painting and printmaking. She married the duke of Castiglione-Colonna in 1856, but he died six months later of typhoid fever. After 1859 she lived in Paris and became a conspicuous figure in the court of Napoleon III. Beginning in 1863 she exhibited on a regular basis in the Salon under the masculine pseudonym Marcello. Before her early death of tuberculosis, she enjoyed a quasi-amorous friendship with the writer Mérimée. She was also friends with Delacroix, Courbet, Carpeaux, Liszt, and Gounod.

Alcantara, Comtesse d'. *Marcello: Adele d'Affry, duchesse Castiglione-Colonna, 1836–1879.* Geneva, 1961.

Bessis, Henriette. "Duo avec Carpeaux." *Connaissance des arts.* 277(March 1975):84–91.
 Bessis discusses Marcello's friendship with J. B. Carpeaux, whom she met in Rome in 1861. Quotes from their correspondence.

———. "Porquoi une telle résonance de la *Bianca Capello* de Marcello dans les dernières années du XIXe siècle?" *Gazette des beaux-arts.* 100(November 1982):183–186.
 Discusses the history and critical responses to Marcello's bust of Bianca Capello, which she exhibited in the Salon of 1863.

Gerdts, William. "The *Medusa* of Harriet Hosmer." *Bulletin of the Detroit Institute of Art.* 56, no. 2(1978):104–105.
 Says Marcello retired to the city of Fribourg after Napoleon III's downfall.

ILLUSTRATIONS

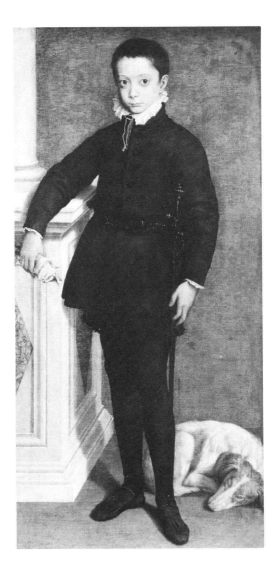

[1.] Sofonisba Anguissola. *Portrait of a Boy with Sword, Gloves and Dog.*
Oil. Walters Art Gallery, Baltimore, Maryland.

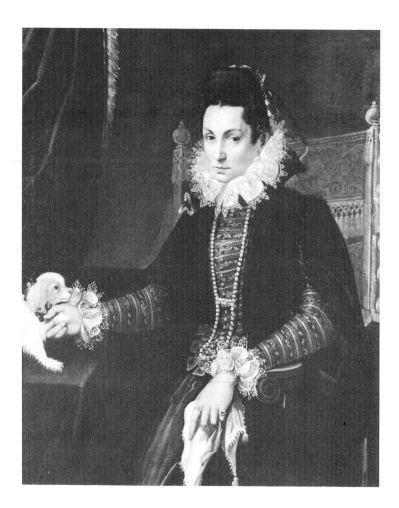

[2.] Lavinia Fontana. *Portrait of a Noble Woman with a Lap Dog.* Oil. Walters Art Gallery, Baltimore, Maryland.

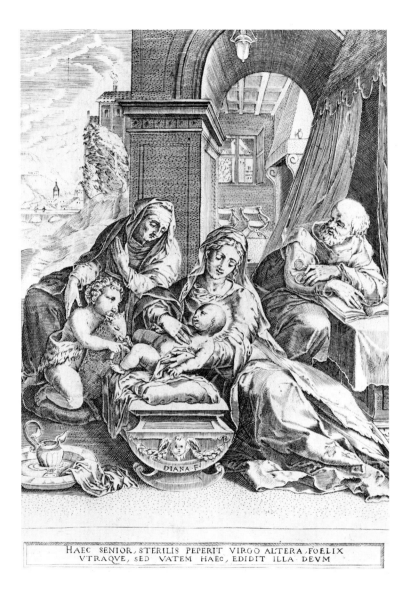

Inside the engraving, within the cartouche: DIANA F.

Text within the tablet at the base of the engraving:

HAEC SENIOR, STERILIS PEPERIT VIRGO ALTERA, FOELIX
VTRAQVE, SED VATEM HAEC, EDIDIT ILLA DEVM

[3.] Diana Ghisi Scultori. *The Holy Family.* Engraving; 268 x 192 mm. Fogg Art Museum, Harvard University, Cambridge, Massachusetts. Gift of Belinda L. Randall from the collection of John Witt Randall.

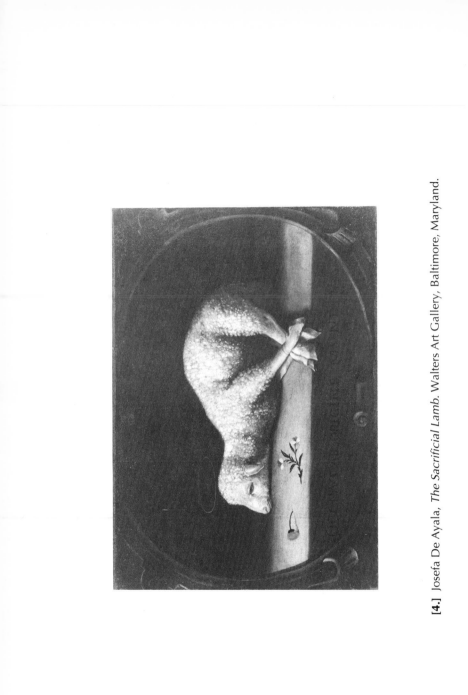

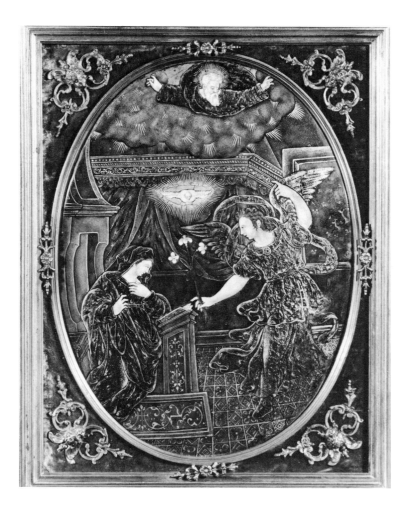

[5.] Suzanne de Court. *The Annunciation.* ca. 1600. Limoges enamel plaque. 7-7/16″ x 5-5/8″. Walters Art Gallery, Baltimore, Maryland.

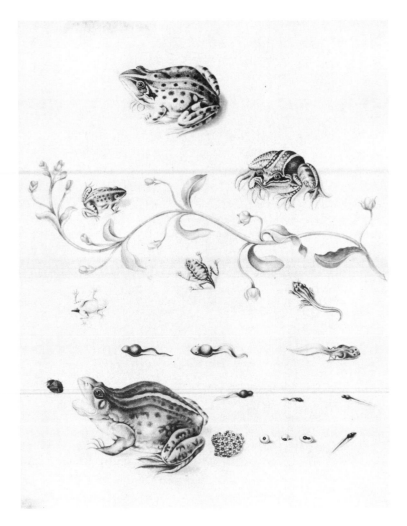

[6.] Maria Sibylla Merian. *Metamorphosis of a Frog.* Watercolor. 15-5/16"
x 11-3/8". The Minneapolis Institute of Arts, the Minnich Collection.

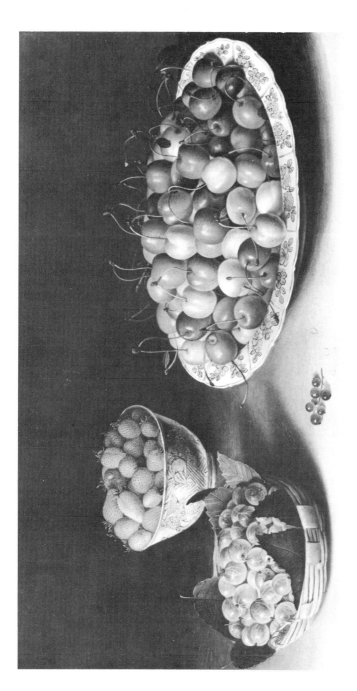

[7.] Louise Moillon. *Still Life with Cherries, Strawberries and Goose-berries.* 1630. Oil on panel; 18-1/4″ x 25-1/2″. The Norton Simon Foundation, Pasadena, California.

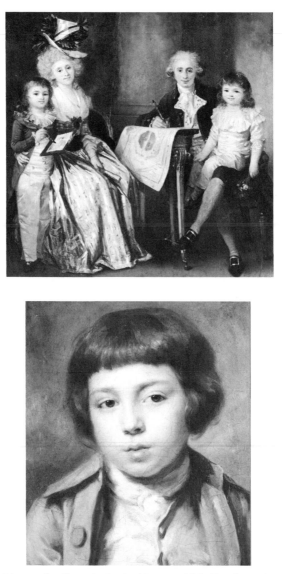

[8.] Top: Marguerite Gerard. *An Architect and His Family.* c. 1787-1837. Oil on wood; 12″ x 9-1/2″. The Baltimore Museum of Art, the Mary Frick Jacobs Collection. BMA 1938.232.

Bottom: Jeanne Philibert Ledoux. *Portrait of a Boy.* c. 1800. Oil on canvas; 16″ x 12-1/2″. The Baltimore Museum of Art, bequest of Leonce Rabillon. BMA 1929.3.9

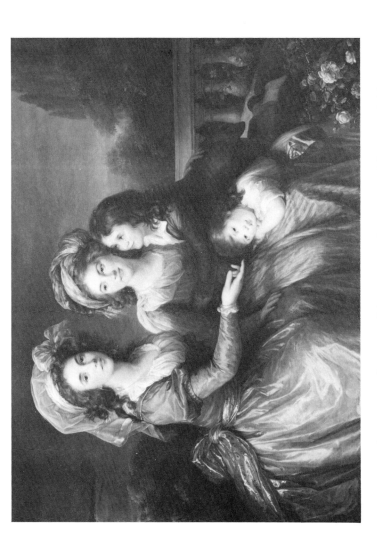

[9.] Elisabeth Vigee-LeBrun. *The Marquise de Peze and the Marquise de Rouget with her Two Children.* 1964.11.1. 1787; Canvas; 48-5/8" x 61-3/8". National Gallery of Art, Washington, D.C. Gift of the Bay Foundation in memory of Josephine Bay Paul and Ambassador Charles Ulrick Paul.

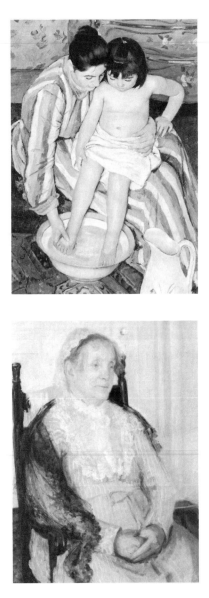

[10.] Top: Mary Cassatt. *The Bath.* ca. 1891. Oil on canvas. 39″ x 26″. The Art Institute of Chicago, Robert A. Waller Fund.

Bottom: Mary Hallock Foote. *Old Lady.* Oil on canvas, before 1913. 91.5 cm x 63.6 cm, Friends of American Art, 1913.520, © 1990 The Art Institute of Chicago, all rights reserved.

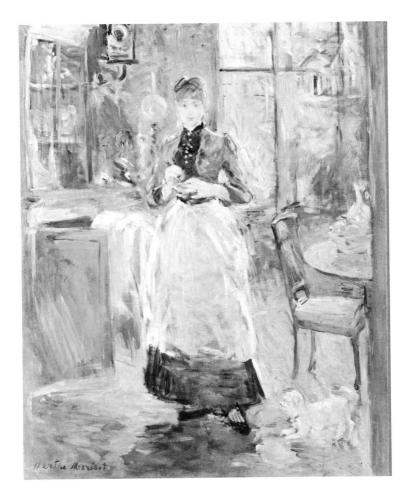

[11.] Berthe Morisot. *In the Dining Room.* 1963.10.185. Canvas; 24-1/8″ x 19-3/4″. National Gallery of Art, Washington, D.C., Chester Dale Collection.

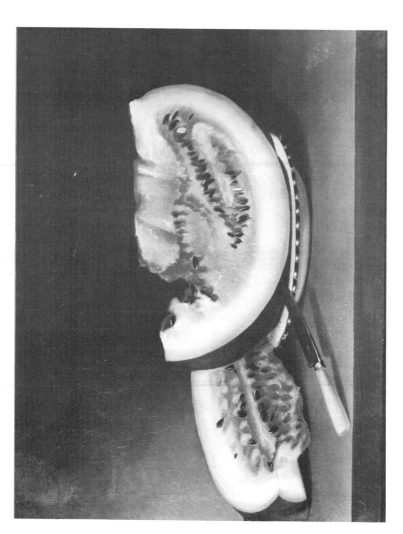

[12.] Sarah Miriam Peale. *Slice of Watermelon.* 1825. Oil on canvas; 17″ x 21-13/16″. Wadsworth Atheneum, Hartford, Connecticut. Ella Gallup Sumner and Mary Catlin Sumner Collection.

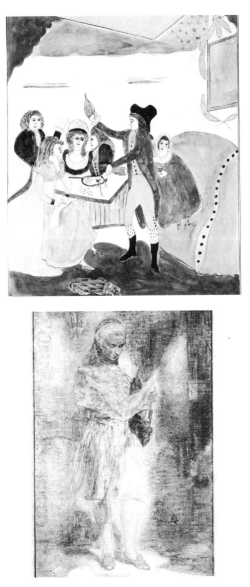

[13.] Top: Mary Ann Willson. *The Prodigal Son Wasted His Substance with Riotous Living.* ca. 1815. B-25138. Watercolor. National Gallery of Art, Washington, D.C., gift of Edgar William and Bernice Chrysler Garbisch.

Bottom: Isabel Bishop. *Girl Reading Newspaper.* Oil on pressed wood. 62.9 cm x 38.4 cm. Nelson-Atkins Museum of Art, Kansas City, Missouri. Bequest of Marie P. McCune, 68-8/2.

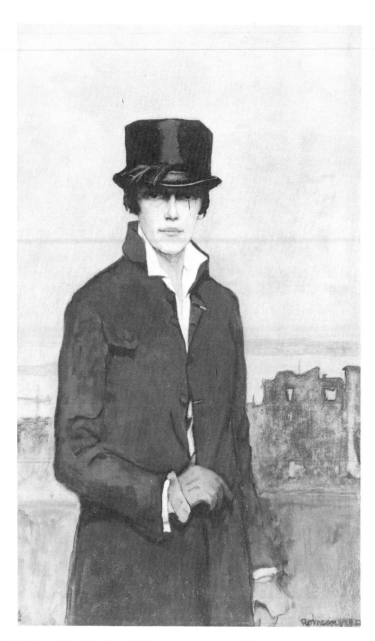

[14.] Romaine Brooks. *Self Portrait.* 1923. Oil on canvas; 46-3/4″ x 26-7/8″. National Museum of American Art, Smithsonian Institution, Washington, D.C. Gift of the artist. 1966.49.1

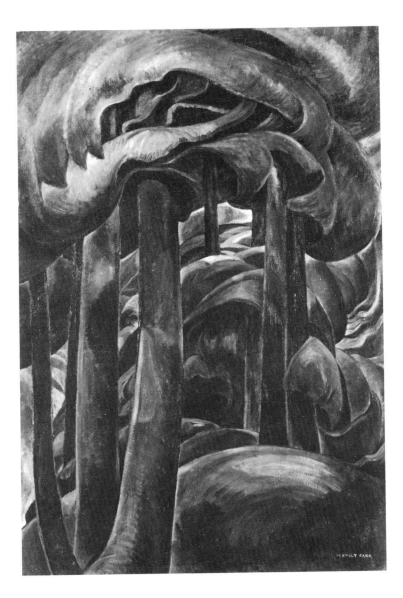

[15.] Emily Carr. *Western Forest.* ca. 1931. Oil on canvas; 128.3 cm x 91.8 cm. Art Gallery of Ontario, Toronto, Canada.

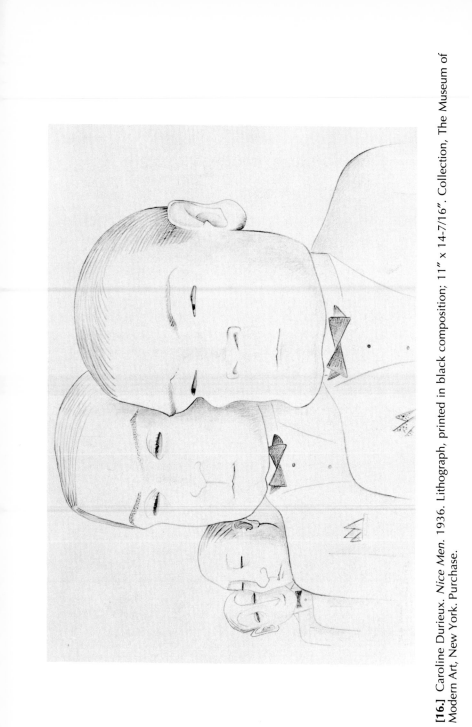

[16.] Caroline Durieux. *Nice Men.* 1936. Lithograph, printed in black composition; 11″ x 14-7/16″. Collection, The Museum of Modern Art, New York. Purchase.

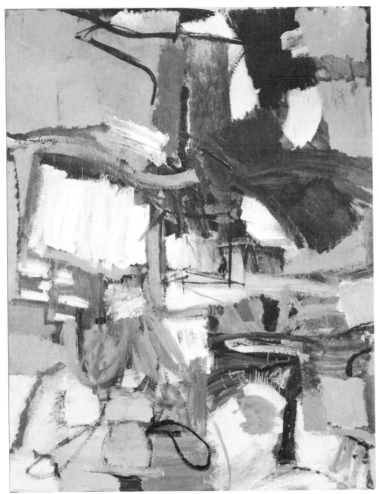

[17.] Grace Hartigan. *Broadway Restaurant.* 1957. Oil on canvas. 79″ x 62-3/4″. Nelson-Atkins Museum of Art, Kansas City, Missouri, gift of Mr. William T. Kemper.

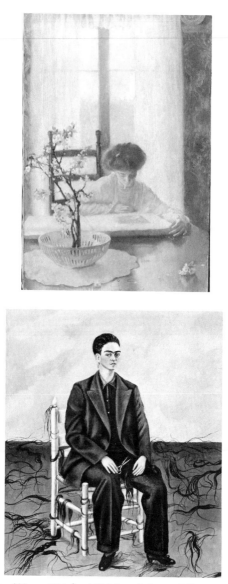

[18.] Top: Lilian Wescott Hale. *L'Edition de Luxe.* Oil on canvas; 23-1/4" x 15". Gift of Miss Mary C. Wheelwright; courtesy, Museum of Fine Arts, Boston.

Bottom: Frida Kahlo. *Self Portrait with Cropped Hair.* 1940. Oil on canvas; 15-3/4" x 11". Collection, The Museum of Modern Art, New York. Gift of Edgar Kaufmann, Jr.

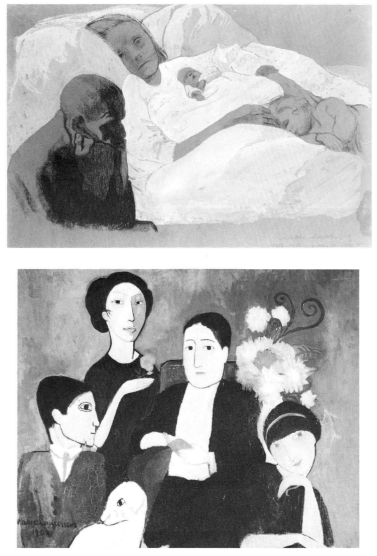

[19.] Top: Käthe Kollwitz. *Unemployment.* 1909. Charcoal and opaque wash on paper. National Gallery of Art, Washington, D.C., Rosenwald Collection.

Bottom: Marie Laurencin. *Group of Artists.* 1908. Oil on canvas; 24-3/4" x 31-1/8". Baltimore Museum of Art, Cone Collection, formed by Dr. Claribel Cone and Miss Etta Cone of Baltimore, Maryland. BMA 1950.215.

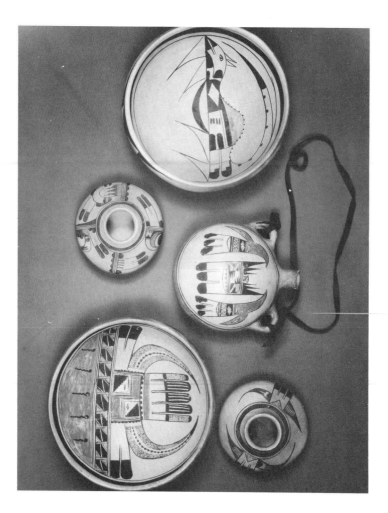

[20.] Nampeyo, pottery. Milwaukee Public Museum of Milwaukee County, Milwaukee, Wisconsin.

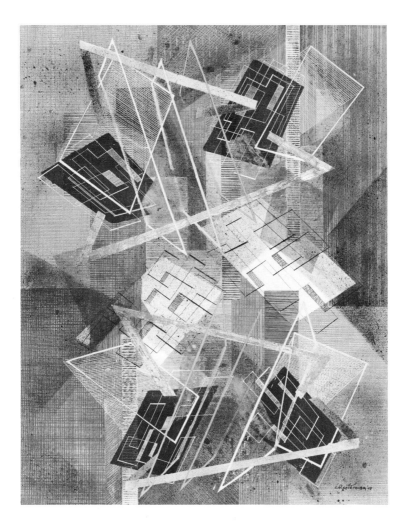

[21.] I. Rice Pereira. *Oblique Progression.* 1948. Oil on canvas; 50" x 40". Collection of Whitney Museum of American Art, New York. Purchase. 48.22.

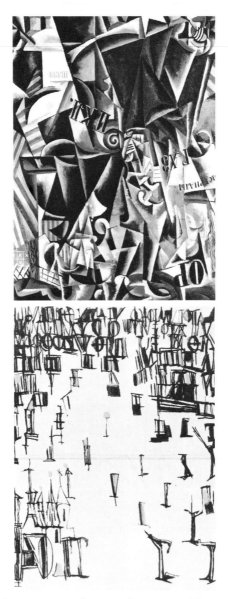

[22.] Top: Luibov Popova, *The Traveller*. 1915. Oil on canvas; 56" x 41-1/2". The Norton Simon Art Foundation, Pasadena, California.

Bottom: Vieira da Silva, *Les Pietons de Noel*. 1978. Color lithograph; 9" x 7-1/8"; P.79.1. The Minneapolis Institute of Arts, Minneapolis, Minnesota. Gift of Samuel Sachs II, 1979.

Janson, H. W. *Nineteenth-Century Sculpture.* New York: Harry N. Abrams, 1985. Pp. 148–151.
 Janson calls Marcello the "finest woman sculptor of the century."

———. "Rodin Was Not the Only One." *Portfolio.* (September–October 1980):42.

Laurent, Monique. "Marcello (1836–1879)." *Revue du Louvre.* 3, no. 4(1980):284–285.
 A biographical summary.

Marcello, sculpteur. Musée d'Art et d'Histoire, Fribourg, 1980.
 Exhibition catalog.

Paris, Musée Rodin. *Catalogue Exposition Marcello.* October 22, 1980–January 5, 1981.

Preston, Stuart. "Preserving the Patrimony." *Apollo.* 113(January 1981):51–52.
 In this review of an exhibit of Marcello's work at the Musée Rodin in 1980–1981, Preston says she has been "unfairly neglected as an artist."

Collections:

 Paris, Musée de l'Opéra.
 Philadelphia Museum of Art.
 Fribourg, Musée d'Art et d'Histoire.

MARIA MARTIN. 1796–1863. United States.
 Martin was a native of Charleston, South Carolina, and the daughter of a Lutheran minister. Her sister married the Reverend John Bachman, a naturalist. She met John James Audubon in November 1831, when he visited Charleston and stayed at her brother-in-law's home. A letter from Bachman to Audubon's wife relates that Audubon "taught my sister, Maria, to draw birds; and she has now such a passion for it, that whilst I am writing, she is drawing a Bittern, put up for her at daylight by Mr. Audubon." Bachman's wife died in 1846, and in 1849 he married Martin. Martin became one of Audubon's three principal assistants and the only woman of the group. She contributed primarily backgrounds to his watercolor bird studies and was skilled in creating branches, insects, flowers, and butterflies. Audubon named a species of woodpecker in her

honor. Martin also contributed a number of drawings to *North American Herpetology* by John E. Holbrook, published between 1836 and 1842.

Bodine, Idella. *South Carolina Women.* Lexington, South Carolina: Sandlapper Store, 1978. Pp. 62–64.
 This book, for juvenile readers, contains a brief account of Martin.

Fielding. *Dictionary of American Painters, Sculptors, Engravers.* P. 587.
 Good summary of her life and career.

Herrick, Francis Hobart. *Audubon the Naturalist.* New York: D. Appleton and Company, 1917. 3 vols. Vol 2, pp. 6, 61, 281.
 Herrick provides documentation of Martin's work for Audubon. A letter of 1833, written by Audubon to his son says "Miss Martin, with her superior talents, assists us greatly in the way of drawing; the insects she has drawn are, perhaps, the best I've seen."

Hollingsworth, Buckner. *Her Garden Was Her Delight.* New York: Macmillan, 1962. Pp. 54–55.
 Hollingsworth provides a basic biography and notes that Audubon stayed in the Bachman house during visits to Charleston in both 1831 and the winter of 1833–34. He implies that Martin fell in love with Audubon.

Williams, Margot, and Paul Elliott. "Maria Martin: The Brush Behind Audubon's Birds." *Ms.* 5(April 1977):14–15, 17–18.
 These authors call Martin America's first woman naturalist-artist. They note that in 1827 she traveled through eastern Canada with Bachman while he collected plants.

Collections:

 Charleston (South Carolina), Charleston Museum.
 New York, New York Historical Society.

MARIE FRANÇOISE CONSTANCE MAYER. 1775–1821. French.
 Mayer studied with Suvée, Greuze, and with Prud'hon, who became her lover. She probably met Prud'hon around 1802. They both had studios in the Sorbonne from 1809 to 1821, and they seem to have painted several pictures in collaboration. Prud'hon also painted several portraits of Mayer. It is generally believed that several works attributed

to either Greuze or Prud'hon are actually by Mayer. She exhibited in the Salon from 1796 until her death. Mayer committed suicide in 1821 after Prud'hon refused to marry her. In 1822 he organized a retrospective of her work.

Bellier-Auvray. *Dictionnaire général. . . . s.v.* Vol. 2, pp. 61–62.

Bénézit. *Dictionnaire.* Vol. 7, p. 286.
This source describes Mayer as an artist of genre, portraits, pastels, and miniatures.

Bryan. *A Dictionary of Painters.* Vol. 3, p. 308.
Lists several of her works and gives a birth date of 1778.

Clement. *Women in the Fine Arts.* Pp. 384–385.

Doin, Jean. "Constance Mayer." *Le revue de l'art ancien et modern* (January 1911):49–60; (February 1911):139–150.

Ellet. *Women Artists.* P. 236.

Goulinat. "Les femmes peintres." Pp. 290, 292.
Includes a reproduction of one of her paintings.

Greer. *The Obstacle Race.* Pp. 36–39.
Greer provides an excellent account of Mayer's obsessive relationship with Prud'hon.

Gueullette, Charles. "Mademoiselle Constance Mayer of Prud'hon." *Gazette des beaux-arts* (May, October, December 1879).

Guiffre, Jean. *L'oeuvre de Pierre-Paul Prud'hon.* Musée National du Louvre (Documents d'Art), 1924.

Harris and Nochlin. *Women Artists, 1550–1950.* Pp. 46, 207, 212–214, 239.

Munsterberg. *A History of Women Artists.* P. 49.

Muther, Richard. *History of Modern Art.* London, 1894. Vol. 1, pp. 310–313.

Collections:

St. Petersburg, State Hermitage Museum.
Paris, Louvre.

ANNE FOLDSTONE MEE. ca. 1770/1775–1851. English.
Anne was the oldest child of a London painter, John Foldstone.
When he died, the duty of supporting the large family fell to her. She had
learned the rudiments of painting from her father and was encouraged by
Romney. She became a successful miniaturist and was patronized by
Horace Walpole and King George IV. She exhibited at the Royal
Academy from 1804 to 1837. In 1793 she married Joseph Mee, who
"pretended to family and fortune, and had neither." They had six
children.

Bénézit. *Dictionnaire.* Vol. 7, p. 302.

Bryan. *A Dictionary of Painters.* Vol. 3, p. 313.

Clayton. *English Female Artists.* P. 391.

Foskett. *A Dictionary of British Miniature Painters.* Vol. 1, pp. 402–403.
Foskett describes Mee's work as "uneven and not always well
drawn." Notes she was also talented as a musician and poet.

Long, Basil S. "Mrs. Mee, Miniature Painter." *Connoisseur.* 95(April
1935):218–221.
Major source of biographic material. Includes several black-and-
white illustrations.

Sparrow. *Women Painters of the World.* Pp. 60, 93.

Stephen and Lee. *The Dictionary of National Biography.* Vol. 13, p. 209.
Says her later miniatures were of poor quality.

Thieme and Becker. *Allgemeines Lexikon.* Vol. 25, p. 331.

Collection:

London, Victoria and Albert Museum.

PAULA MODERSOHN-BECKER. 1876–1907. German.

Modersohn-Becker's works, mainly figurative, were precursors of the German Expressionist movement. Her principal influences were Cézanne, Gaugin, and Van Gogh. During her short career of ten years she managed to produce four hundred paintings and over one thousand drawings and prints. Paula Becker was born in Dresden and moved to Bremen at the age of twelve. When she was sixteen she went to London to study art while living with relatives. She later attended the Women's School of the Berlin Academy. She graduated from a schoolteachers' seminary in Bremen. In 1898 she became a part of the Worpswede artists' colony and there met the painter Otto Modersohn, whom she married in 1901. In 1900 she was studying in Paris. Modersohn-Becker became close friends with Rainer Maria Rilke, who wrote the poem "Requiem for a Friend" about her. She was virtually unencouraged during her career and sold only two works during her lifetime. She died at the age of thirty-one of a heart attack shortly after giving birth to a daughter. Her work consists of landscapes, still lifes, and many self-portraits, painted in an intensely personal style.

Bass, Ruth. "Self-Portrait with Bitter Lemon." *Art News.* 83(May 1984):101–104.
Includes several reproductions.

Behr. *Women Expressionists.* Pp. 10, 18–19, 22–25.

Bénézit. *Dictionnaire.* Vol. 7, p. 445.

Bremen, Kunsthalle. *Paula Modersohn-Becker: zum hundertsten Geburtstag.* 1976.
Essays by Gunter Busch and museum staff.

Buettner. "Images of Modern Motherhood." P. 17.

Busch, Gunter. *Paula Modersohn-Becker: Malerin, Zeichnerin.* Frankfurt: S. Fischer, 1981.
Basic monograph on her life and career.

———, and Liselotte von Reinken, eds. *Paula Modersohn-Becker: The Letters and Journals.* ed. and trans. Arthur Wensinger and Carole Clew Hoey. New York: Taplinger Publishing Company, 1984.
An expanded translation of the 1979 German edition, it is thoroughly annotated.

Butler, Eliza Marian. *Ranier Maria Rilke.* Cambridge, England, 1961. P. 100.

Davidson, Martha. "Paula Modersohn-Becker: Struggle Between Life and Art." *Feminist Art Journal.* 11(Winter 1973–1974):1, 3–5.
　　Chronicles her friendships with Rilke and with the sculptor Clara Westhoff. Describes the influence of Cézanne on her works. Discusses the conflict between her position as an artist and as a married woman.

Edwards. *Women: An Issue.*

Fine. *Women and Art.* Pp. 155–158.

Fleisher. "Love or Art."

Greer. *The Obstacle Race.* Pp. 49–51.

Haftmann, Werner. *Painting in the Twentieth Century.* New York: Frederick Praeger, 1965. Vol. 1, pp. 82–83.

Hamburg. Kunstverein. *Paula Modersohn-Becker: Zeichnungen, Pastelle, Bildentwurfe.* September 25–November 21, 1976.
　　Much of the text for this exhibition catalog is by Uwe M. Schneede. It includes numerous black-and-white reproductions, photographs, and a biographical summary.

Harris and Nochlin. *Women Artists, 1550–1950.* Pp. 58–59, 65–67, 273–280, 355.

Hetsch, Rolf. *Paula Modersohn-Becker: Ein Buch der Freundschaft.* Berlin: Rembrandt, 1932.
　　Reminiscences of various friends and acquaintances.

Modersohn-Becker, Paula. *Briefe und Tagebuchblätter.* Berlin: Kurt Wolff Verlag, 1920.
　　Publication of her notebooks and letters.

Munsterberg. *A History of Women Artists.* Pp. 68–69.

Murken-Altrogge, Christa. *Paula Modersohn-Becker: Leben und Werk.* Cologne: DuMont Buchverlag, 1980.

National Museum of Women in the Arts. Pp. 128–129, 218.

New York. Galerie St. Etienne. *Paula Modersohn-Becker.* November 15, 1983–January 7, 1984.
　　Exhibition catalog with essay by Jane Kallir. It includes twenty-two black-and-white reproductions and a few color plates.

Oppler, Ellen. "Paula Modersohn-Becker: Some Facts and Legends." *Art Journal*. 35(Summer 1976):364–369.

> An important reevaluation of this "innovator of modern painting." Oppler discusses the reasons study of Modersohn-Becker's work has been neglected. Reviews what has been written about her.

Pauli, Gustav. *Paula Modersohn-Becker*. Leipzig, 1919; 3rd edition, Berlin: Kurt Wolff, 1934.

> Complete catalog. The reproductions are poor, but this is balanced by a good introductory essay.

Perry, Gillian. *Paula Modersohn-Becker: Her Life and Work*. New York: Harper and Row, 1979.

> Excellent biographical presentation, drawing heavily on Modersohn-Becker's letters and diaries. Unfortunately, it has no index. Discusses subject areas explored by the artist and includes many reproductions, several in color.

Petersen and Wilson. *Women Artists*. Pp. 108–111.

Petzet, Heinrich W. *Das Bildnis Des Dichters: Rainer Maria Rilke, Paula Becker-Modersohn, Eine Begegnung*. Frankfurt am Main: Insel, 1976.

Radycki, Diane. *The Letters and Journals of Paula Modersohn-Becker*. Metuchen, New Jersey: Scarecrow Press, 1980.

———. "The Life of Lady Art Students." Pp. 10–11.

Rilke, Rainer Maria. *Worpswede*. Leipzig: Velhagen and Klasing Bielefeld, 1903.

> An illustrated monograph on Worpswede. Despite his friendship with Modersohn-Becker, Rilke discusses only the five male Worpswede artists.

Selz, Peter. *German Expressionist Painting*. Berkeley: University of California Press, 1957.

Stelzer, Otto. *Paula Modersohn-Becker*. Berlin: Rembrandt, 1958.

Tickner, Lisa. "Pankhurst, Modersohn-Becker and the Obstacle Race." *Block*. No. 2(Spring 1980):24–39.

Tufts. *Our Hidden Heritage*. Pp. 189–193.

Werner, Alfred. "Paula Modersohn-Becker." *Art and Artists.* 10(March 1976):18–21.
 Excellent summary of her life and art, accompanied by good black-and-white reproductions.

————. "Paula Modersohn-Becker: A Short, Creative Life." *American Artist.* 37(June 1973):16–23, 68–70.
 Says she studied with Fritz Mackensen. Includes many reproductions.

Collections:

 Basel, Kuntshalle.
 Basel, Öffentliche Kunstsammlung-Kunstmuseum.
 Bremen, Becker-Modersohn Haus.
 Bremen Kunsthalle.
 Detroit Institute of Arts.
 Dortmund, Museum am Ostwall.
 Essen, Museum Folkwang.
 Hamburg Kuntshalle.
 Kiel, Gemaldegalerie und Graphische Sammlung Kuntshalle.
 Washington (D.C.), National Museum of Women in the Arts.
 Wuppertal, von der Heydt-Museum.

MARY NIMMO MORAN. 1842–1899. United States.
 Although born in Scotland, Mary Nimmo came to the United States as a child. She married the artist Thomas Moran in 1862 and they settled in Philadelphia. Moran acquired her interest in art from her husband, becoming his student after their marriage. The Morans traveled to Europe in 1866–67 to study and work. In 1872 they moved to Newark, New Jersey, in order to be close to the office of *Scribner's Monthly* and the illustration work it could provide. The couple made a trip to the far west in 1874. Mary Moran worked principally in watercolor until 1879. Then, with her husband's encouragement, she tried etching and rapidly excelled in this medium and became the foremost woman etcher in the country during the 1880's. Moran exhibited seventeen works when the Philadelphia Society of Etchers held its first exhibition in 1882. She participated in an exhibition of women etchers at the Boston Museum of Fine Arts in 1887. She became a member of the London Society of Painter-Etchers, and the New York Etching Club. Although Moran exhibited sporadically at the Pennsylvania Academy from 1869 to 1879, her responsibilities as a wife and mother undoubtedly diminished her

creative output. She was her husband's most trusted critic and his manager, taking charge of practical matters in order to free him for his work. She died in 1899 of typhoid fever. Moran's only one-woman show has been an exhibition of her etchings, held in 1950 at the Smithsonian Institution.

Bénézit. *Dictionnaire.* Vol. 7, p. 519.

Benson, Frances M. "The Moran Family." *Quarterly Illustrator.* 1(April–June 1893):67–84.

Brodsky. "Some Notes on Women Printmakers." P. 375.

Earle. *Biographical Sketches of American Artists.* Pp. 219–220.

Everett, Morris T. "The Etchings of Mary Nimmo Moran." *Brush and Pencil.* 8(April 1901):3–16.

Foster, Kathleen A. "American Prints and Drawings in the Pennsylvania Academy." *Antiques.* 121(March 1982):717.
A work by Moran is illustrated in this article.

Francis, Marilyn G. "Mary Nimmo Moran: Painter-Etcher." *Woman's Art Journal.* 4(Fall 1983–Winter 1984):14–19.
Francis says she became Thomas Moran's student two years before their marriage. She provides details of the couple's various travels.

Koehler, S. R. "The Works of the American Etchers: Mrs. Mary Nimmo Moran." *American Art Review.* 2(1881):183.

The National Cyclopedia of American Biography. Vol. 22, p. 25.
Includes a photograph of the artist and lists several of her works.

New York. Klackner Gallery. *A Catalogue of the Complete Etched Works of Thomas Moran, N.A., and M. Nimmo Moran, S.P.E.* 1889.

"Two American Etchers: The Work of Mr. and Mrs. Moran." *New York Daily Tribune.* March 11, 1889. P. 7.

Weitenkampf, Frank. "Some Women Etchers." *Scribner's Magazine.* 46(December 1909):731–739.
Some discussion of her technical methods and a reproduction of one of her works.

Wilkins, Thurman. "Moran, Mary Nimmo." In *Notable American Women, 1607–1950.* Vol. 2, pp. 576–577.
 Good biographical summary. Includes a listing of locations of her work.

————. *Thomas Moran: Artist of the Mountains.* Norman: University of Oklahoma Press, 1966.
 This biography of her husband also contains biographical facts of her life.

Collections:

 London, British Museum.
 Newark (New Jersey) Museum.
 New York, Metropolitan Museum of Art.
 Philadelphia, Pennsylvania Academy of the Fine Arts.
 St. Louis, Jefferson National Expansion Memorial.
 Tulsa, Thomas Gilcrease Institute of America History and Art.

BERTHE MORISOT. 1841–1895. French.
 Berthe Morisot and her sister Edma were encouraged in their artistic pursuits by their mother, whose grandfather was Fragonard. Berthe Morisot studied with Guichard, Corot, Oudinot, Daubigny, and Daumier. The sisters met Manet around 1867. Shortly after this, Edma married and gave up painting. Berthe married Manet's brother, Eugène, five years later. Manet used her as a model, and it was she who led him to take up plein air painting. Morisot exhibited two landscape paintings at the Salon of 1864. The only exhibit of the Independents in which she did not participate was the one which occurred the year her daughter was born. She remained true to Impressionism throughout her career.

Adler, Kathleen. "The Suburban, the Modern and 'Une Dame de Passy.' " *Oxford Art Journal.* 12, no.1(1989):3–13.
 Adler suggests that the suburb Passy played a determining role in Morisot's art. She lived there from the 1850's until her death. Scenes from the suburb are common in her work. Morisot also shows a distinction between the city — the realm of men, and the suburb — the place of women.

Adler, Kathleen, and Tamar Garb. *Berthe Morisot.* Oxford: Phaidon, 1987.
 Designed for the general reader, this work attempts to recreate the

social and cultural milieu in which Morisot worked. The biographical facts of Morisot's life are incorporated in to the thematic arrangement of the text. Excellent reproductions are included, many in color.

―――, eds. *The Correspondence of Berthe Morisot.* London: Camden Press, 1986.
An English translation of Rouart's work (q.v.).

Angoulvent, Monique. *Berthe Morisot.* Paris: Morance, 1933.
A monograph of 164 pages and 15 plates. It includes a preface by Robert Rey, an essay on her life and work, an excellent catalog of 665 works, and an extensive bibliography.

Bailly-Herzberg, Janine. "Les estampes de Berthe Morisot." *Gazette des beaux-arts.* 93(May–June 1979):215–227.
Good discussion of Morisot's work in the print medium. Includes a catalog of her prints and several reproductions.

Baltimore. Museum of Art. *Paintings, Drawings, Graphic Works by Manet, Degas, Morisot and Cassatt.* April 18–June 3, 1962.

Bataille, M. L., and G. Wildenstein. *Berthe Morisot—catalogue des peintres, pastels et aquarelles.* Paris, 1961.
A catalog with 815 reproductions, 83 of which are full page, arranged in chronological order. Three pages of bibliography are included. This work was prepared in collaboration with the artist's daughter, Mme. Julie Rouart.

Bénézit. *Dictionnaire.* Vol. 7, pp. 545–546.

Bernier, Rosamond. "Dans la lumière impressionniste." *L'oeil.* 5(May 1959):38–47.
Discussion of Morisot and her circle of artistic friends. Includes several photographs of her and her home.

Boston. Museum of Fine Arts. *Berthe Morisot: Drawings, Pastels, Watercolors, Painting.* New York: Shorewood Publishing Company, 1960.
This catalog accompanied an exhibition of Morisot's work in Boston from October 10 to November 8, 1960, and later showings in Minneapolis, New York, and San Francisco. The introduction by Elizabeth Morgan is a biographical summary. An essay by Denis Rouart discusses her drawings. Also included are a chronology, a bibliography, and several reproductions, primarily black and white.

Bryan. *Dictionary of Artists.* Vol. 3, pp. 368–369.

Buettner. "Images of Modern Motherhood." Pp. 14–21.

Clairet, Alain. " 'Le Cerisier' de Mezy." *L'oeil.* 358(May 1985):48–51.
Excellent color reproductions and black-and-white studies accompany discussion of this work by Morisot.

Clement. *Women in the Fine Arts.* Pp. 388–389.

Cortissoz, Royal. *American Artists.* New York: Charles Scribner's Sons, 1923. Pp. 190–192.
Summarizes her biography.

Duret, Theodore. *Manet and the French Impressionists.* Philadelphia, 1910.
Includes a brief chapter on Morisot.

Fine. *Women and Art.* Pp. 124–129.
Quotes from letters exchanged by Berthe and her sister Edma. Discusses her relationship with Manet and its reciprocal benefits. Credits Geoffroy Alphonse Chocarne with being her first teacher.

Fourreau, Armand. *Berthe Morisot.* Trans. H. Wellington. Paris: Maîtres de l'art moderne, 1925; New York: Dodd, Mead and Company, 1925.
Includes a biographical summary and forty black-and-white plates.

Garb. *Women Impressionists.* P. 12.
Describes the relationship between Morisot and Manet as reciprocal, with her urging him to work *en plein air.*

Greer. *The Obstacle Race.* Pp. 111–112.

Harris and Nochlin. *Women Artists, 1550–1950.* Pp. 89, 231–236, 350–351.

Havice. "The Artist in Her Own Words." pp. 1–7.

Hill. *Women: A Historical Survey . . .* Catalog. Pp. 21–22.

Huisman, Philippe. *Morisot: Enchantment.* New York: French and European Publications, 1963.
Biographical account drawing heavily on excerpts from Morisot's diaries. Includes many color reproductions.

Hyslop, Francis E., Jr. "Berthe Morisot and Mary Cassatt." *College Art Journal.* 13(Spring 1954):179–184.

Lucie-Smith. *Women Impressionists.* Pp. 148–149.

Mathey. *Six femmes peintres.*

Mellquist, Jerome. "Berthe Morisot." *Apollo.* 70(December 1959):158–160.
 Good analysis of Morisot's art historical status. Includes color reproductions.

Mitchell. *Great Flower Painters.* Pp. 181–182.

Montalant, Delphine. "Julie Manet." *L'oeil.* 374(September 1986):52–57.
 Discussion of Morisot's daughter, born in 1878, who also painted. Compares her paintings with those of her mother.

———. "Une longue amitié: Berthe Morisot et Pierre-Auguste Renoir." *L'oeil.* 358(May 1985)42–47.
 Traces the friendship between the two artists. Includes several reproductions, some in color.

Moreau-Nelaton, E. *Manet raconté par lui-même.* Paris, 1926, Vol. 1.

Muehsam, Gerd. *French Painters.*

Munsterberg. *A History of Women Artists.* Pp. 53–56.

Neilson. *Seven Women . . .* Pp. 47–67.

New York. Wildenstein and Company. *Berthe Morisot: Loan Exhibition of Paintings.* 1960.

Newton, Eric. "French Painters VII — Edouard Manet (With a Reference Also to Berthe Morisot)." *Apollo.* 57(February 1953):51–52.

Paris. *Berthe Morisot and Her Circle.* 1952.
 Introduction by Denis Rouart.

Paris. Musée National du Louvre. *Peintures, école française, XIXe siècle.* 1960.

Petersen and Wilson. *Women Artists.* Pp. 90–94.

Rewald, John. *The History of Impressionism.* New York, 1946.
 A chronology of Impressionists in relation to world events. Bibliography included.

Rey, Jean-Dominique. *Berthe Morisot.* Trans. Shirley Jennings. Bergamo: Bonfini, 1982.
 Rey provides a brief summary of Morisot's life and career. The book is copiously illustrated with many color plates.

Rouart, Denis. *Berthe Morisot.* Paris, 1948.
 This volume is from the series, "Les maîtres." There are forty-eight plates and a brief essay in French, English, and German.

———. *Berthe Morisot.* Paris, 1941.
 From the series, "Editions d'histoire et d'art."

———, ed. *Correspondance de Berthe Morisot avec sa famille et ses amis Manet, Purvis de Chavannes, Degas, Monet, Renoir et Mallarmé.* Paris, 1950; *The Correspondence of Berthe Morisot . . .* London: Lund Humphries, 1957.
 The text is by Morisot's grandson, Denis Rouart. The book includes many reproductions of Morisot's work and that of her circle. Extensive quotations from letters are incorporated with a discussion of her life and work. This book was reissued in 1986 by London's Camden Press with a new introduction and notes by Kathleen Adler and Tamar Garb.

Scott, William P. "Berthe Morisot's Experimental Techniques and Impressionist Style." *American Artist.* 51(December 1987):42–47.
 Discussion of technical aspects of Morisot's work.

———. "Berthe Morisot: Paintings from a Private Place." *American Artist.* 41(November 1977):66–70, 95–108.
 A good biographical summary.

Seize aquarelles. Paris, 1946.
 Essays on Morisot by Mallarmé (untitled, published originally in Durand-Ruel's 1896 catalog), and by Valéry (published elsewhere as "Au sujet de Berthe Morisot" and as "Berthe Morisot").

Sparrow. *Women Painters of the World.* Pp. 182, 211, 213.

Sterling, Charles, and M. Salinger. *French Paintings in the Collection of the Metropolitan Museum.* New York, 2, 1966; 3, 1967. Pp. 163–164.

Thieme and Becker. *Allgemeines Lexikon.* Vol. 25, pp. 156–157.

Tufts. *Our Hidden Heritage.* Pp. xvi, 169, 172.

Valéry, Paul. *Degas/Manet/Morisot.* New York, 1960.
This is volume twelve of Bollingen Series 45, *The Collected Works of Paul Valéry,* translated by David Paul. It includes two essays on Morisot, "Tante Berthe" and "Berthe Morisot."

Vevey, Switzerland. Musée Jenisch. *Berthe Morisot.* June 24–September 3, 1961.
Illustrated with drawings only.

Washington, D.C. National Gallery of Art. *Berthe Morisot, Impressionist.* September 6–November 29, 1987.
Essays in this catalog are by Charles F. Stackney, William P. Scott, and Suzanne G. Lindsay. Includes a chronological survey of Morisot's work, an analysis of her materials and working methods, and many color plates.

Werner, Alfred. "Berthe Morisot, Major Impressionist." *Arts.* 32(March 1958):40–45.
Includes several color and black-and-white reproductions.

Wilding, Faith. "Women Artists and Female Imagery." *Everywoman.* (May 7, 1971).

Wyzewa, Teodore de. *Peintres de jadis et d'aujourd'hui.* Paris, 1903.
This includes a short essay on Morisot.

Yeldham. *Women Artists in Nineteenth Century France and England.* Vol. 1, pp. 351–356.
Summarizes Morisot's career and provides an excellent description of her style.

Collections:

Boston Museum of Fine Arts.
Brooklyn Museum.
Buffalo, Albright-Knox Art Gallery.

Chicago Art Institute.
Cleveland Museum of Art.
London, Tate Gallery.
New York, Metropolitan Museum of Art.
Paris, Louvre.
Paris, Musée Marmottan.
Rome, Galleria Doria Pamphili.
Toledo (Ohio) Museum of Art.
Washington (D.C.), National Gallery of Art.
Washington (D.C.), Phillips Gallery.

ELISABET NEY. 1833–1907. German-American.
 Ney was born in Prussia. Her father was a tombstone carver, and she
first studied sculpture with him. Ney was the first female admitted to the
sculpture department of the Munich Academy of Art. In 1854 she moved
to Berlin to study with Christian Rauch. She was named court sculptor to
Ludwig II of Bavaria, who gave her a studio in one of his palaces. In
1863 she married a Scotch physician and philosopher. Ney was already
famous in Europe when she emigrated to the United States with her
husband in 1870, searching for freedom of thought not found under the
repressive reign of Otto von Bismarck. They settled first in a utopian
commune in Madeira, Georgia, before moving to Texas in 1873. For the
next twenty years she devoted her energies to running a plantation and
did not resume her sculptural career until the 1890's. Working in a
Neoclassical style, she received commissions for figurative works for the
state capitol in Austin and for the Chicago and St. Louis World Fairs.
Ney's studio in Austin, Texas, designed in 1892, is now open to the
public as a museum.

Bénézit. *Dictionnaire.* Vol. 7, p. 702.

Clement. *Women in the Fine Arts.* P. 390.

Comini, Alessandra. "In Praise of Creative Misinterpretation, or 'How a
 Little Bit of Schopenhauer Changed My Life.' " *Arts.* 53(February
 1979): 118–123.
 Discussion of various personalities and their interactions with
Schopenhauer, who was a friend of Ney's. Includes a detailed
description of Ney's 1859 bust of Schopenhauer.

Cutrer, Emily Fourmy. *The Art of the Woman: The Life and Work of
 Elisabet Ney.* Lincoln: University of Nebraska Press, 1988.

Fine. *Women and Art.* P. 108.
Sources vary in regard to Ney's marriage to Edmund Montgomery. Fine says they were secretly married, other sources say the union was never legalized, or was legalized only years later.

Fortune, Jan, and Jean Burton. *Elisabet Ney.* New York: A. A. Knopf, 1943.
A very readable biography, but unfortunately it lacks footnotes and sources. It does include an extensive bibliography and several black-and-white reproductions of only fair quality.

Goar, Marjory. *Marble Dust: The Life of Elisabet Ney — An Interpretation.* Austin: Eakins Press, 1984.

Kachelmeier, Glenda. "Elisabet Ney." *Texas Highways* (March 1983).

Levy, Sandra. "Texas Project." *Archives of the American Art Journal.* 25, no. 1/2(1985):60–61.
A report on filming the archives of the Ney Museum in Austin. It includes a concise biographical summary and two photographs of the artist.

Logan, Mary. *The Part Taken by Women in American History.* Wilmington, Delaware: Perry-Nalle Publishing Company, 1912. P. 763.

Loggins, Vernon. "Ney, Elisabet." in *Notable American Women, 1607–1950.* Vol. 2, pp. 623–625.
Loggins describes Ney's feminism, clears up confusion about her marriage, and discusses the difficulties she had in raising her son.

———. *Two Romantics and Their Ideal Life.* New York: Odyssey Press, 1946.
Biography of Ney and her husband, Edmund Montgomery. An appendix provides sources for each chapter. A few poor-quality black-and-white reproductions and photographs are included.

Muller-Munster, Eugen. *Elizabeth Ney.* Leipzig: Koehler and Amelang, 1931.

The National Cyclopaedia of American Biography. Vol. 13, p. 371.
Anecdotal account of Ney's life.

Payne. "The Work of Some American Women in Plastic Art." P. 313.

Proske. "Part I. American Women Sculptors." Pp. 3–15.

Rubinstein. *American Women Artists.* Pp. 106–108.

Scharfe, Alice K. "Studio on the Frontier." *Americana.* 11(March–April 1983):48–51.
 Notes Ney's efforts at promoting art education in the state of Texas, where she served as president of the Association of the Texas Academy of Liberal Arts.

Taft, Lorado. *The History of American Sculpture.* New York: Macmillan Company, 1930. Pp. 214–215.

Taylor, Bride Neill. *Elisabet Ney, Sculptor.* New York: Devin-Adair Company, 1916.

Thieme and Becker. *Allgemeines Lexikon.* Vol. 25, p. 428.

Tinling. *Women Remembered.* Pp. 264–265.

Collections:

 Austin (Texas), Elisabet Ney Museum.
 Berlin, Nationalgalerie.
 Washington (D.C.), National Museum of America Art.

EMILY MARY OSBORN. 1834–ca. 1885. English.
 Osborn was born in London, the daughter of a clergyman and the oldest of nine children. She studied with Mr. Mogford at Mr. Dickinson's Academy and extensively with James M. Leigh. Her first Academy showing was in 1851. By 1855 Osborn was successful enough to be able to add a studio to her residence. She visited Germany frequently. Osborn was primarily a genre painter, but she also did some history paintings and portraits. She was a member of the Society of Lady Artists.

Bénézit. *Dictionnaire.* Vol. 8, p. 43.

Clement. *Women in the Fine Arts.*

Dafforne, James. "British Artists: Their Style and Character. No. LXXV. Emily Mary Osborn." *Art Journal.* 3(1864):261–263.
 This is a good account of her life and the source of the above

biographical material. Dafforne describes several of her paintings and includes three black-and-white engravings of her work.

Maas, Jeremy. *Victorian Painters.* New York: Putnam, 1969. P. 121.

Nochlin. "By a Woman Painted . . . " P. 74.
Nochlin discusses Osborn's *Nameless and Friendless,* which she believes is autobiographical. The painting is of poor orphaned young woman artist attempting to sell a work to a crafty-looking dealer. Nochlin poses the question, Why has the extremely complex symbolism of nineteenth-century narrative painting been ignored by scholars while the iconography of fifteenth- and sixteenth-century religious painting has been taken so seriously? Includes an unfortunately small black-and-white reproduction of the work.

————. "Some Women Realists." *Arts.* 48(February 1975):46–51.
Nochlin cites Osborn as the foremother of such current women Realists as Sylvia Mangold, Yvonne Jacquette, and Janet Fish. Mentions several of her paintings and points out how her work deals specifically with problems related to women, such as issues of social oppression and poverty.

————. "Why Have There Been No Great Women Artists?" P. 33.
Includes reproduction of *Nameless and Friendless.*

"Selected Pictures." *Art Journal.* 7(August 1868):148–149.
Describes and reproduces her work, *God's Acre.*

Thieme and Becker. *Allgemeines Lexikon.* Vol. 26, p. 69.

Wood. *Dictionary of Victorian Painters.* P. 207.

Yeldham. *Women Artists in Nineteenth-Century France and England.* Vol. 1, pp. 309–311.
An excellent biographical summary.

Collection:

Cardiff, National Museum of Wales.

FRANCES FLORA BOND PALMER. 1812–1876. United States.
Frances (Fanny) Flora Bond Palmer was one of Currier and Ives' most prolific artists. She was born in England, where she began her

professional career. She married in 1832 and immigrated to the United States with her husband, Edmund Palmer, around 1844. They began a lithographic business in New York. After the business failed she began working for the immensely successful Currier and Ives Lithograph Company. During the 1860's she was the artist for almost all of their fruit and flower prints. Palmer is also believed to have been the artist for several anonymous fruit and flower prints and was especially noted for the atmospheric quality of her landscapes. Her prints date between 1862 and 1867. Palmer shouldered the financial responsibility of supporting her husband and children. She died of tuberculosis.

Cowdrey, Mary B. ''Palmer, Frances Flora Bond.'' In *Notable American Women 1607–1950.* Vol 3, pp. 10–11.

————. *Prints: Thirteen Illustrated Essays on the Art of the Print.* New York: Carl Zigrosser, 1962.
 Includes an essay on Palmer.

Fielding. *Dictionary of American Painters, Sculptors and Engravers.* P. 692.

Gerdts, William H., and Russell Burke. *American Still-Life Painting.* New York: Praeger Publishers, 1971. Pp. 55, 68.

King, Roy, and Burke Davis. *The World of Currier and Ives.* New York: Random House, 1968. P. 13.
 These authors date Palmer's involvement with Currier and Ives to 1849 and note that in less than twenty years she produced at least two hundred lithographs. They see her primary weakness in the drawing of the human body.

Mitchell. *Great Flower Painters.* P. 193.

Peters, Harry T. *Currier and Ives, Printmakers to the American People.* Garden City, New York: Doubleday, Doran and Company, 1942. Pp. 26–29.
 In this concise biographical summary, Peters notes that Palmer signed her sketches inconsistently. She also worked closely with Charles Currier in the development and manufacture of lithographic crayons.

Rubinstein. *American Women Artists.* Pp. 68–70.
 A good summary of Palmer's career.

————. "The Early Career of Frances Flora Bond Palmer." *American Art Journal.* 17(Autumn 1985):71+.

Rubinstein documents Palmer's life and career before her immigration to the United States and the early years in this country before she began working for Currier and Ives. Numerous black-and-white reproductions are included.

Collections:

Boston Museum of Fine Arts.
New York, New York Historical Society.
New York, Museum of the City of New York.
Washington (D.C.), Library of Congress.
Worcester (Massachusetts), American Antiquarian Society.

THE PEALE WOMEN. United States.

The famous Peale family of artists of Philadelphia included a number of talented women:

ANNA CLAYPOOLE PEALE. 1791–1878.
MARGARETTA ANGELICA PEALE. 1795–1882.
SARAH MIRIAM PEALE. 1800–1885.
ROSALBA CARRIERA PEALE. 1799–1874.
HARRIET PEALE. Ca. 1800–1869.
MARY JANE SIMES. 1807–1872.
MARY JANE PEALE. 1827–1902.

Anna Claypoole Peale.

Anna Peale was the daughter of James Peale, who gave her lessons in watercolor on ivory and oil on canvas. She exhibited for the first time in 1811. In 1824 she was elected to the Pennsylvania Academy of Art. Her most active period was from 1820 to 1840, when she gained a reputation as a miniature painter, working in Baltimore, New York, Boston, Washington, and Philadelphia. Her work is noted for its brilliant color and detail. She married twice but had no children.

Margaretta Angelica Peale.

Margaretta Peale was also the daughter of James Peale. She began painting about 1810 and specialized in still life. She exhibited in Philadelphia from 1828 to 1837. She never married.

Sarah Miriam Peale.

Sarah was the third daughter of James Peale. She is often recognized as the first professional woman artist in the United States because she supported herself by her art work (although that claim is also made for Henrietta Johnson). Sarah Peale was strongly influenced by her cousin Rembrandt Peale during visits to Baltimore in 1818 and 1820 — there she developed her sense of detail and her skill in the superimposition of delicate glazes. Although she was primarily a portrait painter, late in her life she did still lifes. Sarah Peale was elected to membership in the Pennsylvania Academy of Art in 1824. She lived and worked in St. Louis from 1847 to 1875 where she became that city's leading portraitist. In 1878 she returned to Philadelphia where she lived the remainder of her life. She never married.

Rosalba Carriera Peale.

Rosalba Peale was the daughter and student of Rembrandt Peale. She was a lithographer. She married in 1860.

Harriet Peale.

Harriet Peale was the student and second wife of Rembrandt Peale. Most of her works seem to be copies of those of other artists.

Mary Jane Simes.

This artist was the niece of Anna, Margaretta, and Sarah and the granddaughter of James Peale. She was a miniaturist who exhibited in Philadelphia and Baltimore between 1825 and 1835. Simes halted her career when she married.

Mary Jane Peale.

Mary Jane Peale was the daughter of Rubens Peale. She studied with her uncle, Rembrandt Peale, and with Thomas Sulley. Her best-known works are still lifes. She never married.

Baltimore. Maryland Historical Society. *Four Generations of Commissions: The Peale Collection of the Maryland Historical Society.* March 3, 1975–June 29, 1975.

Born, Wolfgang. "The Female Peales: Their Art and Its Tradition." *American Collector*. 15(August 1946):12–14.

Cincinnati. Cincinnati Art Museum. *Paintings by the Peale Family*. October 1–October 31, 1954.
Sarah Miriam Peale and Anna Claypoole Peale are briefly mentioned in this catalog.

Clement. *Women in the Fine Arts*. P. 268

Edwards. *Women: An Issue*.

Elam, Charles H., ed. *The Peale Family: Three Generations of American Artists*. Detroit: Detroit Institute of the Arts and Wayne State University Press, 1967.
This publication includes a helpful family tree, a chart characterizing the Peale family still lifes, and many black-and-white reproductions.

Ellet. *Women Artists*. Pp. 290–294.

Fine. *Women and Art*. Pp. 100–103.

Gerdts, William. "The Peale Family at Detroit and Utica." *Burlington Magazine*. 109(April 1967):258, 260–262.
Brief summary of the quality and diversity of the Peale artistic dynasty.

————, and Russell Burke. *American Still-Life Painting*. New York: Praeger Publishers, 1971. Pp. 37–40.

Greer. *The Obstacle Race*. Pp. 24–26.

Hanaford. *Daughters of America*. P. 273.

Harris and Nochlin. *Women Artists, 1550–1950*. Pp. 221–222, 349.

Hill. *Women: A Historical Survey . . .* Catalog. P. 13.
Includes a black-and-white reproduction of a work by Mary Jane Peale.

Hirshorn, Anne Sue. "Legacy of Ivory: Anna Claypoole Peale's Portrait Miniatures." *Bulletin of the Detroit Institute of Arts*. 64, no. 4(1989):16–27.

Excellent discussion of the life and career of this member of the
Peale family. A family tree is provided.

Hunter, Wilbur H. *The Peale Family and Peale's Baltimore Museum,
1814–1850.* Baltimore: The Peale Museum, 1965.

————, and John Mahey. *Miss Sarah Miriam Peal, 1800–1855: Por-
traits and Still Lifes.* Baltimore: The Peale Museum, 1967.
An excellent monograph with astute stylistic analysis. The authors
appreciate how exceptional was Sarah Peale's vocation for a woman
in the nineteenth century. Accompanied by many good black-and-
white reproductions.

Jensen, Oliver. "The Peales." *American Heritage.* 6(April 1955):40–51,
97–101.
Primarily discusses Charles Wilson Peale, but includes an interest-
ing illustrated genealogical chart.

Munsterberg. *A History of Women Artists.* Pp. 59–60.
Discusses Sarah Miriam Peale.

National Museum of Women in the Arts. Pp. 42–43.

Nochlin. "By a Woman Painted . . . " Pp. 72–73.
Includes two color reproductions of still lifes by Sarah Miriam and
Margaretta Peale with a brief stylistic analysis.

————. "Why Have There Been No Great Women Artists?" P. 30.
Includes a black-and-white reproduction of a still life by Anna
Peale.

Petersen and Wilson. *Women Artists.* Pp. 70–71, 74.
Discusses Sarah Miriam Peale.

Philadelphia. Philadelphia Museum of Art. *Philadelphia: Three Centu-
ries of American Art.* April 11–October 10, 1976. Pp. 254–255, 281.
Discusses Anna Claypoole Peale.

Rubinstein. *American Women Artists.* Pp. 46–50, 64.

Schwartz. "If De Kooning . . . "

Sellers, Charles Coleman. *The Peale Heritage.* Hagerstown, Maryland:
Washington County Museum of Fine Arts, 1963.

————. "Peale, Anna Claypoole, Margaretta Angelica and Sarah Miriam." In *Notable American Women, 1607–1950.* Vol. 3, pp. 38–40.

Tufts. *Our Hidden Heritage.* Pp. 139–145.
 Tufts' chapter is devoted to Sarah Peale. She tells of Charles Wilson Peale's giving artists' names to his numerous children (his sons were named Raphaelle, Rembrandt, Rubens, Titian; his daughters were named Angelica Kauffman, Sofonisba Anguissola, Rosalba Carriera, and Sybilla Meriam). He thus demonstrated a "remarkable knowledge, not generally paralleled today . . . of women artists of the past."

Wehle. *American Miniatures, 1730–1850.* Pp. 95, 103.
 Brief discussion of miniature work by Anna Claypoole Peale and Mary Jane Simes.

Collections:

 Baltimore, Maryland Historical Society.
 Baltimore, Peale Museum.
 Boston Museum of Fine Arts.
 Hartford (Connecticut), Wadsworth Atheneum.
 Richmond, Virginia Museum of Fine Arts.
 St. Louis, Missouri Historical Society.
 Washington (D.C.), National Museum of Women in the Arts.

LILLA CABOT PERRY. 1848–1933. United States.
 Lilla Cabot was born to a socially prominent Boston family. Described as a strong-minded woman, she married Thomas Sergent Perry, a writer and teacher, in 1874. She was almost forty when she began her art studies in the 1880's at Boston's Cowles School. Robert Vonnoh and Dennis Bunker were her teachers. She later studied in Paris, at the Julien and Colarossi academies, and in Munich. In addition to her artistic endeavors, she was also a poet, publishing four volumes of poetry between 1886 and 1923. Beginning in 1889, Perry spent ten summers in France where she lived next door to Monet. Her art was strongly influenced by him, and she in turn was an important figure in introducing Impressionism to Americans. She brought the first Monet to Boston, she lectured and wrote about Impressionism, and she encouraged her wealthy Boston friends to purchase works by Monet. From 1893 to 1901 she lived in Tokyo, where her husband had taken a teaching position. While much of Perry's work is portraiture, she also produced landscapes,

especially while living in Japan. She was a founding member of the Guild of Boston Artists.

Apollo. 91(February 1970):159.
Review of an exhibition of Perry's work.

Bénézit. *Dictionnaire.* Vol. 8, p 239.

Clement. *Women in the Fine Arts.* Pp. 271–272.

Fielding. *Dictionary of American Painters, Sculptors, and Engravers.* P. 717.

Gammell, R. H. Ives. *The Boston Painters, 1900–1930.* Orleans, Massachusetts: Parnassus Imprints, 1986. Pp. 145–147, 193.
Lists Alfred Stevens as also being one of Perry's teachers.

Gerdts, William. *American Impressionism.* Seattle: Henry Arts Center, University of Washington, 1980. P. 97.

Harris and Nochlin. *Women Artists, 1550–1950.* Pp. 244–245, 352.
Lists her many awards and exhibitions.

Hill. *Women: A Historical Survey . . .* Catalog. P. xii.

Hilman, Carolyn, and Jean Nutting Oliver. "Lilla Cabot Perry—Painter and Poet." *American Magazine of Art.* 14(November 1923):600–604.
A general discussion of Perry's work. Quotations from her poetry are included.

National Museum of Women in the Arts. Pp. 50–51, 222.

New York. Hirschl and Adler Galleries. *Lilla Cabot Perry: A Retrospective Exhibition.* 1969.
Essay by Stuart P. Feld.

Perry, Lilla Cabot. *The Jar of Dreams.* New York: Houghton Mifflin Company, 1923.
A volume of her poetry.

———. "Reminiscences of Claude Monet from 1889 to 1909." *American Magazine of Art.* 18(March 1927):119–125.

Rubinstein. *American Women Artists.* Pp. 138–139.

Collections:

Boston Museum of Fine Art.
Washington (D.C.), National Museum of Women in the Arts.

EUNICE PINNEY. 1770–1849. United States.
Pinney, born in Connecticut, was the well-educated daughter of a wealthy family. She was married twice and had five children. After her second marriage in 1798 she indulged in her hobby of painting. Most of her works date from between 1809 and 1826. This "primitive" artist had no formal training. Over fifty watercolors have survived, with a wide range of subject matter including several based on literary sources.

Black, Mary. "Pinney, Eunice." In *Notable American Women, 1607–1950.* Vol. 3, pp. 72–73.

Ebert, John, and Katherine Ebert. *American Folk Painters.* New York: Charles Scribner's Sons, 1975.

Fine. *Women and Art.* Pp. 98–99.

Lipman, Jean. "Early Connecticut Water-Colorist." *Art Quarterly.* 6(1943):213–221.
Includes reproductions of her work.

Lipman, Jean, and Alice Winchester. *Primitive Painters in America, 1750–1950.* New York: Dodd Mead and Co., 1950. Pp. 22–30.

Munsterberg. *A History of Women Artists.* Pp. 61–63.

Rubinstein. *American Women Artists.* P. 32.

Collections:

Cooperstown, New York State Historical Association.
Williamsburg (Virginia), Abby Aldrich Rockefeller Folk Art Collection.

ELIZABETH ELEANOR SIDDAL. 1834–1862. English.
Siddal's father was a Sheffield cutler. When the family moved to London she became an assistant in a bonnet shop. There she was

discovered by the Pre-Raphaelites and began modeling for several of them, including Dante Rossetti, Hunt, and Morris. Rossetti fell in love with her, and after a long engagement and living together for nine years, they married in 1860. He is credited with discovering her aptitude for art and gave her lessons in painting and drawing. Siddal's work shows the influence of her husband. John Ruskin was impressed by her art, offering to purchase all her drawings. In 1857 she was included in the Pre-Raphaelite Exhibition and in an exhibition of British art held in New York. Siddal showed the first indications of tuberculosis in 1853 and began her long struggle with the disease. In 1861, following the birth of a stillborn infant, she developed depression. A physician advised frequent does of laudanum, which contains opium. In February of 1862 she died of an overdose of the drug. In addition to her painting, Siddal also wrote poetry.

Bénézit. *Dictionnaire.* Vol. 9, p. 102.

Brown, David. "Pre-Raphaelite Drawing in the Bryson Bequest to the Ashmolean Museum." *Master Drawings.* 16(August 1978):289 and plates 40–41.

Doughty, Oswald. *A Victorian Romantic: Dante Gabriel Rossetti.* London: F. Muller, 1949.

Edwards, Marion R. "Elizabeth Eleanor Siddal—The Age Problem." *Burlington Magazine.* 119(February 1977):112.
 Edwards documents Siddal's birthday, confirming that she was born on July 15, 1829.

Fredeman, William. *Pre-Raphaelitism: A Bibliocritical Study.* Cambridge, Massachusetts: Harvard University Press, 1965. Section 59, pp. 209–211.
 Contains an annotated bibliography.

Harris and Nochlin. *Women Artists, 1550–1950.* Pp. 229–231, 350.

John. "The Woman Artist."

Kitchen, Paddy. *The Golden Veil.* London: H. Hamilton, 1981.
 A novel based on Siddal's life.

Lemlein, Rhoda. "Influence of Tuberculosis on the Work of Visual Artists: Several Prominent Examples." *Leonardo.* 14(Spring 1981):115.

Mander, Rosalie. "Rossetti's Models." *Apollo.* 78(July 1963):18–32.
Brief discussion of Siddal's role as a model.

Marsh, Jan. *The Legend of Elizabeth Siddal.* London: Quartet Books,
1987.
A quest for the real Siddal, who has been obscured behind
legendary accounts. Marsh concludes with an appraisal of the infor-
mation now available.

————. *The Pre-Raphaelite Sisterhood.* New York: St. Martin's Press,
1983. Pp. 15–36.
Biographic account that discusses Siddal's modeling period and her
influence on Rossetti. Marsh says she was drawing by 1852.

Marsh and Nunn. *Women Artists and the Pre-Raphaelite Movement.* Pp.
65–73.
These authors provide an excellent summary of Siddal's artistic
career.

Nochlin. "By a Woman Painted . . . " Pp. 73–74.
This contains a good color reproduction of her small watercolor,
Clerk Sanders.

Procter, Ida. "Elizabeth Siddal: The Ghost of an Idea." *Cornhill
Magazine* (Winter 1951–52):368–386.

Reynolds, Graham. "The Pre-Raphaelites and Their Circle." *Apollo.*
93(June 1971):494–501.
This article reproduces a pen and wash drawing by Siddal, dated
1854, entitled *Pippa Passes.*

Rose, Andrea. *The Pre-Raphaelites.* Oxford: Phaidon Press, 1977.
Includes a reproduction of a self-portrait.

Rossetti, William M. "Dante Rossetti and Elizabeth Siddal." *Burlington
Magazine.* 1(May 1903):273–295.
A brief monograph of Siddal's life with a listing of her works and a
description of her encounters with Ruskin. Includes five drawings of
her by Rossetti and a listing of the works for which she posed.

Shefer, Elaine. "Elizabeth Siddal's *Lady of Shalott.*" *Woman's Art
Journal.* 9(Spring–Summer 1988):21–29.
This excellent article relates Siddal's painting to the Victorian
attitude toward women and its effect on their creativity. Shefer

provides a good summary of the mythology that surrounds Siddal's association with Ruskin and Rossetti. She interprets this work as a self-portrait.

————. "Deverell, Rossetti, Siddal, and 'The Bird in the Cage.' " *Art Bulletin.* 67(September 1985):437–448.
Describes the symbolism in the works in which Siddal is the model.

Thieme and Becker. *Allgemeines Lexikon.* Vol. 29, p. 48.

Troyen, Aimee B. "The Life and Art of Elizabeth Eleanor Siddal." Senior essay, History of Art Department, Yale University, 1975.

Vitale, Zaira. "Eleanor Siddal Rossetti." *Emporium.* 19(June 1904):430–447.

Waugh, Evelyn. *Rossetti: His Life and Works.* London: Duckworth, 1928. Pp. 54–58, 70–75, 87–92, 107–111.
Describes Siddal's personality and her relationship with Rossetti.

Wood, Esther. *Dante Rossetti and the Pre-Raphaelite Movement.* London: Simpson Low, Marston and Company, 1895. Pp. 99–103, 159–161.

Collections:

Cambridge, Fitzwilliam Museum.
London, Tate Gallery.
Oxford, Ashmolean Museum.

LILLY MARTIN SPENCER. 1822–1902. United States.
Spencer was a self-taught but acclaimed narrative and genre painter. Her work became quite popular in her own day through prints, which were frequently reproduced by Currier and Ives. She was born in England to French parents. They immigrated to the United States in 1830, and she grew up in Marietta, Ohio. Spencer was a precocious artist and had her first show at age seventeen. She turned down a chance to study in Europe. After her marriage in 1844, her husband devoted himself to helping her with both professional and domestic tasks. Although Spencer considered herself an amateur, she was the breadwinner for the family. She had thirteen children, seven of whom lived to maturity. Around 1847 Spencer studied at the National Academy of

Design. In 1858 the family moved to Newark, New Jersey, but were plagued by continuous financial difficulties, despite the popularity of prints of Spencer's work. To supplement her income, she did illustrations for *Godey's Lady's Book.* Although Spencer had an output of some five hundred paintings and was a credible portraitist, her lack of training (especially in anatomy and life drawing) severely limited her scope. She painted until the day of her death, at age seventy-nine.

Bénézit. *Dictionnaire.* Vol. 9, p. 741.
 Mentions only her portrait painting.

Bolton-Smith, Robin. "The Sentimental Paintings of Lilly Martin Spencer." *Antiques.* 104(July 1973):108–115.
 Includes good color and black-and-white reproductions.

————, and William H. Truettner. *Lilly Martin Spencer, 1822–1902: The Joys of Sentiment.* Washington, D.C.: The National Collection of Fine Arts, June 15–September 13, 1973.
 The first extensive retrospective of Spencer's work. The National Collection had two of her paintings on permanent display: *Peeling Onions,* circa 1852, and *We Both Must Fade (Mrs. Fithian),* dated 1869. Spencer's command over textures helps one get past her shortcomings.

Cowdrey, Bartlet. "Lilly Martin Spencer, 1822–1902, Painter of the American Sentimental Scene." *American Collector* (August 1944):6–7, 14, 19.
 This article provides some clear black-and-white reproductions.

Dwight, Edward. "Art in Early Cincinnati." *Cincinnati Art Museum Bulletin.* 3(August 1953):4–10.

Ellet. *Women Artists.* Pp. 317–326.

Fine. *Women and Art.* Pp. 105–108.

Freivogel, Elsie. "Lilly Martin Spencer: Feminist Without Politics." *Archives of American Art Journal.* 12(1972):9–14.

Gabhart and Broun. "Old Mistresses."
 We Both Must Fade was included in the Walters Art Gallery show in Baltimore. The authors note that in some of Spencer's finest works "her stunning colors and painterly expression transcend the awkward rendering of her figures."

Gardner, Albert Ten Eyck. "A Century of Women." *Metropolitan Museum Bulletin.* 7(December 1948):110–118.

Hadery, Henrietta. "Mrs. Lilly M. Spencer." *Sartain's Magazine.* 9(August 1851):152–157.

Hanaford. *Daughters of America.*

Harris and Nochlin. *Women Artists, 1550–1950.* Pp. 226–227, 350.

Heller. *Women Artists.* Pp. 78–79.

Hill. *Women: A Historical Survey . . .* Catalog. Pp. xii, 12.
 Includes a reproduction of an insipid pencil drawing titled *Young Lovers.*

Hitchcock, Henry R. "Romantic Nineteenth-Century American Painting: Reading the Legend." *Smith College Bulletin.* 35–36(1954–1955):22–23.

Munsterberg. *A History of Women Artists.* Pp. 60–61.

National Museum of Women in the Arts. Pp. 44–45.

Petersen and Wilson. *Women Artists.* Pp. 84–87.

Roberson, S. A., and William H. Gerdts. "Greek Slave." *Museum* (Newark). 17(Winter–Spring 1965):10–11.

Rubinstein. *American Women Artists.* Pp. 50–53.

Rylance, Mecca. "Truth Unveiling Falsehood." *Off Our Backs.* (July–August 1972).
 This is the title of one of Spencer's most celebrated paintings, now lost.

Schumer, Ann Byrd. "Spencer, Lilly Martin." In *Notable American Women 1607–1950.* Vol. 3, pp. 334–336.

Schwartz. "If De Kooning . . . "
 Schwartz cites Spencer's work as demonstrating the fading convictions of women artists in their own powers.

Withers. "Artist Women and Women Artists." Pp. 332–334.

Collections:

Brooklyn Museum.
Columbus (Ohio), Ohio Historical Center.
Newark (New Jersey) Museum
Washington (D.C.), National Collection of Fine Arts.
Washington (D.C.), National Museum of Women in the Arts.

EMMA STEBBINS. 1815–1882. United States.
Stebbins was a native of New York City. She began her art career as an amateur, doing drawings and paintings for her own amusement, after taking instruction from Henry Inman. She eventually committed herself to her art and at the age of forty-two moved to Rome to study sculpture with Paul Akers. Her sculpture was executed in the prevailing Neoclassical style. In Rome Stebbins met and became the constant companion of actress Charlotte Cushman. They returned to the United States in 1870 and lived together in Newport, Rhode Island, until Cushman's death in 1876. A scrapbook compiled by Stebbins' sister is in the collection of the Archives of American Art.

Clement. *Women in the Fine Arts.* Pp. 323–324.

Craven. *Sculpture in America.* P. 333.

Ellet. *Women Artists.* Pp. 346–349.

Fine. *Women and Art.* P. 113.

Gerdts. *American Neo-Classic Sculpture.*

———. ''Stebbins, Emma.'' In *Notable American Women, 1607–1950.* Vol. 3, pp. 354–355.

———. *The White Marmorean Flock.* Catalog.

Hanaford. *Daughters of America.*

Heller. *Women Artists.* Pp. 86–87.

Payne, Frank. ''The Work of Some American Women in Plastic Art.'' P. 313.

Proske, Beatrice. "Part I: American Women Sculptors."

Rubinstein. *American Women Artists*. Pp. 85–86.

Stebbins, Emma, ed. *Charlotte Cushman: Her Letters and Memories of Her Life*. New York, 1879.
Cushman was an American actress who took an interest in and befriended many of the American women sculptors working in Rome.

Taft, Lorado. *The History of American Sculpture*. P. 211.

Thorp. *The Literary Sculptors*. P. 91.

———. "The White, Marmorean Flock." *New England Quarterly*. 32(June 1959):160.

Tinling. *Women Remembered*. P. 408.
Calls the Bethesda Fountain in New York's Central Park Stebbins' masterpiece.

Tuckerman. *Book of the Artists*. Pp. 602–603.
Summarizes the work Stebbins did in Rome.

Tufts. *Our Hidden Heritage*. Pp. xvi, 160, 162.

Collections:

Huntington (New York), Heckscher Museum.

ALICE BARBER STEPHENS. 1858–1932. United States.
A native of New Jersey, Stephens began her study of wood engraving at the Philadelphia School of Design for Women while still attending secondary school. She also attended the Pennsylvania Academy from 1876 to 1877 and from 1879 to 1889 and studied with Eakins. She became good friends with Eakins and his wife, Susan, and she engraved some of Thomas Eakins' work for reproduction. Stephens was primarily an illustrator, with her works published regularly in most major magazines and in over fifty books. Her work began to appear steadily in *Harper's Weekly, Scribner's Monthly, Cosmopolitan,* and *McClure's Magazine* by 1884. Her subject matter usually portrayed everyday home life, children, and rural scenes. She also did portraits. Stephens went to London in 1886 and then to Paris to study at the Julien

Academy. She exhibited an engraving in the 1887 Paris Salon. From 1888 to 1893 she taught classes at the Philadelphia School of Design for Women. She married in 1890 and had one son. Her works were exhibited at the Philadelphia Academy between 1881 and 1890. Stephens was one of the founders of the Plastic Club, a club for Philadelphia women artists.

"Alice Barber Stephens." *Art Digest.* 6(August 1932):6.
 This obituary recounts the basic biographical facts.

American Art Annual. 29(1932):431.
 Obituary.

Bénézit. *Dictionnaire.* Vol. 9, p. 820.

Clement. *Women in the Fine Arts.* P. 324.

Earle. *Biographical Sketches of American Artists.* P. 296.

Gilchrist, Agnes Addison. "Stephens, Alice Barber." In *Notable American Women, 1607–1950.* Vol. 3, pp. 359–360.

Goodman, Helen. "Alice Barber Stephens, Illustrator." *Arts.* 58(January 1984):126–129.
 A good description of Stephens' stylistic evolution and of her working methods. Includes several black-and-white reproductions.

———. "Women Illustrators of the Golden Age of American Illustration." Pp. 15–16.
 Describes Stephens' work as having a wider range of subject matter than that of her contemporaries. Notes that after the mid-1890's her work showed Impressionist qualities.

Harris and Nochlin. *Women Artists, 1550–1950.* Pp. 52, 221.

Mahony, Bertha, and Elinor Whitney. *Contemporary Illustrators of Children's Books.* Boston: Women's Educational and Industrial Union, 1930. P. 70.

Philadelphia. Philadelphia Museum of Art. *Three Centuries of American Art.* April 11–October 10, 1976. Pp. 446–448.

Rubinstein. *American Women Artists.* Pp. 145–146.

Collection:

Philadelphia, Pennsylvania Academy of the Fine Arts.

JANE STUART. 1812–1886. United States.

Jane Stuart was the youngest child of the noted painter Gilbert Stuart. Although he refused to be her teacher, he did allow her to assist him in his studio, grinding his colors and filling in his backgrounds. In this unacknowledged way, she learned his style and methods. In fact, her work has often been attributed to him. Stuart's talent was not fully developed until after her father's death, when she opened a studio in Boston. For sixty years she supported herself and the other women in her family through her art. Much of her career was spent copying her father's portraits. She also did some narrative works in her own distinct style. Unfortunately, much of her work was destroyed in a fire in her studio in the 1850's. After this she worked almost exclusively in Newport, Rhode Island.

Bénézit. *Dictionnaire.* Vol. 9, p. 878.
 Gives her birth date as 1816.

Catalog. Women Salem. P. xii.

Ellet. *Women Artists.* P. 315.
 Notes that her later years were spent in Newport, Rhode Island.

Fine. *Women and Art.* Pp. 103–105.

Flexner, James Thomas. *Gilbert Stuart.* New York: Alfred Knopf, 1955.
 Pp. 185–187.
 Flexner describes Jane Stuart as ''a reincarnation of her father, although hampered by being a woman and possessed of little talent.'' He also describes her physical appearance as ''ugly.''

Mastai, M. L. D'Otrange. ''Portrait of Jefferson.'' *Connoisseur.* 155(April 1964):274.
 Here Stuart is described as a mediocre painter who watered down her father's work. Includes a black-and-white illustration.

Morgan, John Hill. *Gilbert Stuart and His Pupils.* New York: New York Historical Society, 1939.

Munsterberg. *A History of Women Artists.* P. 59.

Powel, Mary E. "Miss Jane Stuart, 1812–1888." *Bulletin of the Newport Historical Society.* 31(January 1920):1–16.
The author's mother and grandmother were friends of Stuart during her many years of residence in Newport, Rhode Island.

Rubinstein. *American Women Artists.* Pp. 43–45.
Notes that she also painted miniatures.

Stuart, Jane. "Anecdotes of Gilbert Stuart by His Daughter." *Scribner's Monthly.* 14(July 1877):376–382.

———. "The Stuart Portraits of Washington." *Scribner's Monthly.* 12(July 1876):367–374.

MARIE-CLEMENTINE ("SUZANNE") VALADON. 1865–1938. French.
Valadon, a Postimpressionist painter, was the illegitimate daughter of Madeleine Valadon, a laundress. She started drawing as a child and worked at menial jobs from the age of nine. At age sixteen she was a circus trapeze artist, but an injury halted that career. During the 1880's and 1890's Valadon was a favorite model for many artists working in Paris, including Renoir, Puvis de Chavannes, and Toulouse-Lautrec. Valadon also began producing art herself, although she had never had the benefit of formal lessons. Degas encouraged her and interested some galleries in showing her drawings. Her first etchings, produced under the direction of Degas, were exhibited in 1895 by the dealer Vollard. Toulouse-Lautrec persuaded her to change her name from her baptismal name, Marie-Clementine, to the more colorful Suzanne. In 1883 Valadon gave birth to a son, Maurice. Eight years later Miguel Utrillo signed a legal document giving Maurice his surname. As a young man, Maurice Utrillo became an alcoholic, a disease from which he suffered throughout his short life. While recuperating from a "cure," he was taught to paint by his mother, a change from the usual pattern in which it is a father who teaches his son or daughter to be an artist. Valadon's vitality is attested to by her affair and eventual marriage to André Utter, twenty-one years her junior. Her first one-woman show was held in 1915. After the First World War, Valadon's and Utrillo's paintings began to sell for prices high enough to make possible the purchase of a chateau. Valadon continued painting throughout her life. Her oeuvre includes still lifes, landscapes, and some portraiture, but her most consistent theme was the

unidealized female nude, vigorously and lyrically outlined and juxta-posed against the patterned surfaces of an interior.

Beachboard, Robert. *La trinité maudite*. Paris, 1952.
The "wicked" or "damned" three refers to Valadon, her son Utrillo, and her husband Utter.

Bénézit. *Dictionnaire*. Vol. 10, pp. 365–366.

Bouret, Jean. *Suzanne Valadon*. Paris: Editions O. Petrides, 1947.
Catalog for an exhibition held at the Galerie Petrides.

Brumer, Miriam. "Words, the Critical Hangup." *Women and Art* (Winter 1971).

Colombier, Pierre de. "Suzanne Valadon." *L'amour d l'art*. 7(September 1926):303–306.

Coughlan, Robert. "Dark Wine of Genius." *Life*. 28(January 16, 1950):88–102.
Excellent summary of the careers of Valadon and Utrillo. Includes many reproductions.

Dorival, Bernard. *The School of Paris in the Musée d'Art Moderne*. Pp. 23–25, 29, 90–92, 262, 265–267, 299.
Page 91 is an excellent color plate; the rest are small black-and-white reproductions.

———. *Twentieth-Century Painters*.

Edwards. *Women: An Issue*.

Fels, Florent. *Maurice Utrillo*. Paris: Librairie de France, 1930.

Fine. *Women and Art*. Pp. 136–140.

Greer. *The Obstacle Race*. Pp.64–67.
Discusses Valadon's troubled relationship with her son.

Guilleminault, Gilbert. *Les maudits de Cezanne à Utrillo*. Paris, 1959.
An essay about Valadon by Anne Manson, "Suzanne Valadon la frénétique," is included on pages 249–311.

Harris and Nochlin. *Women Artists, 1550–1950*. Pp. 259–261, 354.

Heller. *Women Artists*. Pp. 114–115.

Iskin. "Sexual Imagery in Art . . . "

Jacometti, Nesto. *Suzanne Valadon*. Geneva: Pierre Cailler, 1947.
 A biographical summary with many reproductions, mainly black-and-white.

"Maria of Montmartre." *Time*. 67(May 28, 1956):84, 87.

Mathey. *Six femmes peintres*.

Mermillon, Marius. *Suzanne Valadon, 1867–1938*. Paris: Braun, 1950.

Munsterberg. *A History of Women Artists*. P. 65.

National Museum of Women in the Arts. Pp. 68–69, 238.

Paris. Musée National d'Art Moderne. *Suzanne Valadon*. 1967.
 Catalog by Bernard Dorival.

Petersen and Wilson. *Women Artists*. Pp. 95–97.

Pétridès, Paul. *Catalogue raisonné de l'oeuvre de Suzanne Valadon et avant propos*. Paris: Compagnie Français des Arts Graphiques, 1971.

Ray, Robert. *Suzanne Valadon*. Paris: Editions de la "Nouvelle Revue Français," 1922.

Raynal. *Modern French Painters*. Pp. 160–162.

Storm, John. *The Valadon Drama: The Life of Suzanne Valadon*. New York: Dutton and Company, 1958.
 A somewhat speculative, but extremely readable, biography of Valadon and her circle. As an uneducated woman, Valadon left few literary remains, and Storm was thus forced to depend upon the verbal testimony of the friends who survived her to reconstruct her life.

"Suzanne Valadon." *Art Digest*. 12(April 15, 1938):15.
 Obituary.

Tabarant, André. "Suzanne Valadon et ses souvenirs de modèle." *Le bulletin de la vie artistique* (December 15, 1921):626–629.

Thieme and Becker. *Allgemeines Lexikon.* Vol. 34, pp. 46–47.

Tufts. *Our Hidden Heritage.* Pp. 169–177.
The biographical information and most of the bibliography here are derived from Tufts.

Utter, André. "Maurice Utrillo and Suzanne Valadon" (trans. G. Rees). *Royal Society of Arts Journal.* 86(October 7, 1938):1125–1127.

Valadon, Suzanne, and Germain Bazin. "Suzanne Valadon par elle-même." *Promethée* (March 1939).

Warnod, Jeanine. *Suzanne Valadon.* New York: Crown Publishers, 1981.
This biographical treatment incorporates brief descriptions of many of Valadon's works. Includes a chronology and many excellent reproductions, most in color.

Werner, Alfred. "The Harsh Beauty of Suzanne Valadon's Work." *American Artist.* 42(December 1978):58–65.
Includes several reproductions of her work.

————. "The Unknown Valadon." *Arts.* 30(May 1956):169–177.
An excellent and well-illustrated article. "Degas emphasized a woman's ugliness, Renoir her charm, Lautrec her depravity, Gaugin her sexuality; if for Rousseau she was a fantastic doll, for Cézanne a pictorial pretext, and for his antipode, Bouguereau, an object for lecherous bankers, Valadon's women were sound proletarian types as nobody had painted before. Her nude was neither a Venus nor an Amazon, neither courtesan nor odalisque, nor a bourgeoise surprised in an intimate moment. The women she painted were just the opposite of Marie Laurencin's sickly ladies . . . Hers were ungroomed working women who never went to hairdressers or wore make-up. But unlike those of Kollwitz, they were not symbols of suffering humanity or victims of capitalism."

Collections:

Detroit Institute of Art.
Geneva, Petit Palais.
Grenoble, Musée de Peinture et de Sculpture.
Nantes, Musée des Beaux-Arts.

New York, Metropolitan Museum of Art.
Paris, Musée National d'Art Moderne.
Washington (D.C.), National Museum of Women in the Arts.

JOANNA MARY BOYCE WELLS. 1831–1861. English.
Wells began her art studies at age eighteen in the studio of a Mr. Carey. She later studied with James M. Leigh. In 1855 she joined the ladies class at Couture's atelier in Paris, but after a few weeks she became ill and had to resign. Between 1853 and 1857 she exhibited at the Royal Academy. Her work was influenced by the Pre-Raphaelites, and she was mentioned in Ford Maddox Brown's diary. She traveled in Italy in 1857 and became acquainted with one of the members of the traveling group, Henry T. Wells, a miniature and portrait painter. They married in Rome in December 1857. They returned to England in March 1858. Wells died at age thirty of fever following the birth of her second child.

Bénézit. *Dictionnaire.* Vol. 10, p. 685.
Describes briefly her portraits, landscapes, and genre works.

Bryan. *Dictionary of Painters.* Vol. 5, p. 354.
Says she did portraits, genre, and occasional landscapes.

London. Tate Gallery. *An Exhibition of Painting by Joanna Mary Boyce.* June 14–July 27, 1935.
Catalog of a retrospective exhibition that reproduces several of her works in black and white and provides much biographical information.

Marsh and Nunn. *Women Artists and the Pre-Raphaelite Movement.* Pp. 47–52.

"Mrs. Wells." *Art Journal.* 23(1861):273.

Nunn. *Victorian Women Artists.* Pp. 146–158.
Biographical account of her life and art.

Thieme and Becker. *Allgemeines Lexikon.* Vol. 35, p. 359.

Yeldham. *Women Artists in Nineteenth-Century France and England.* Vol. 1, pp. 302–304.
Excellent biographical summary.

Collection:

London, Tate Gallery.

ANNE WHITNEY. 1821–1915. United States.

Whitney was born in Watertown, Massachusetts, to a liberal Unitarian family that encouraged all her interests. Her first artistic mode was poetry, and she published a volume of her work in 1859. She turned to sculpture when she was thirty-four. Whitney studied in New York and Philadelphia and in 1862 was studying anatomy in Boston with William Rimmer. She made three trips to Europe between 1867 and 1876. Whitney was an abolitionist and a suffragist, and as subject matter she often chose champions of intellectual freedom or those oppressed by the lack of it. She was hesitant to have any of her works exhibited at the Woman's Building of the 1893 World's Columbian Exposition, for she felt women's work should not be segregated from men's. Whitney won anonymously the only competition she ever entered; however, the commission was refused her when the judges discovered she was a woman. She lived in Boston with painter Adeline Manning, who devoted her life to her. Whitney was an instructor in art at Wellesley College for many years, and her papers are in the Wellesley College collection.

Armstrong. *Two Hundred Years of American Sculpture.* P. 320

Bénézit. *Dictionnaire.* Vol. 10, p. 719.

Clement. *Women in the Fine Arts.* P. 362.

Craven. *Sculpture in America.* Pp. 228–232.
 Discusses the influence of French sculpture on Whitney's work of the 1870's.

Fine. *Women and Art.* P. 113.

Gerdts. *American Neo-Classic Sculpture.* Pp. 49, 66.

Heller. *Women Artists.* Pp. 84–95.

Payne, Elizabeth Rogers. "Whitney, Anne." In *Notable American Women, 1607–1950.* Vol. 3, pp. 600–601.

———. "Anne Whitney, Art and Social Justice." *Massachusetts Review.* 12(Spring 1971):245–260.

———. "Anne Whitney, Sculptor." *Art Quarterly*. 25(Autumn 1962): 244–261.
 Excellent biographical summary. Lists her sculpture.

Payne, Frank. "The Work of Some American Women in Plastic Art." P. 313.

Petersen and Wilson. *Women Artists*. Pp. 82–84.

Proske. "Part I. American Women Sculptors." Pp. 3–15.

Rubinstein. *American Women Artists*. Pp. 82–83.

Taft. *The History of American Sculpture*. Pp. 213–214.

Thorp. *The Literary Sculptors*. Pp. 89–90.
 Describes many of Whitney's works as "touched with propaganda."

———. "The White Marmorean Flock." *New England Quarterly*. 32(June 1959):147–169.

Tinling. *Women Remembered*. Pp. 44–45.

Tuckerman. *Book of the Artists*. P. 605

Weimann. *The Fair Women*. Pp. 258, 284–285.

Whitney, Anne. *Poems*. New York: D. Appleton, 1859.

Collections:

 Northampton (Massachusetts), Smith College.
 Wellesley (Massachusetts), Wellesley College.

MARY ANN WILLSON. 1810–ca. 1840. United States.
 Willson was a self-taught primitive artist. She resided on a farm near Greenville, New York, with a Miss Brundage, with whom she had a romantic attachment. Brundage farmed while Willson painted watercolors which she sold to local farmers. Her work was not rediscovered until the 1940's. At that time a portfolio of her work surfaced, accompanied by a letter written around 1850, recording what little is known of her life

and work. Her pigments were prepared from brick dust, berry juices, and vegetable dyes. She worked with a wide range of subject matter, using greatly distorted scale and perspective and a stylization of natural elements that borders on abstraction.

Black, Mary. "American Primitive Watercolors." *Art in America.* 51(August 1963):64–82.
Includes several color reproductions of Willson's work.

DeLisser, R. Lionel. *Picturesque Catskills, Greene County.* Northampton, Massachusetts, ca. 1894.
DeLisser recorded local recollections and legends about Willson that lingered in Greene County ca. 1894. This was reissued in 1967 by Charles E. Dornbusch.

Ebert. *American Folk Painters.* P. 214.

Karlins, N. F. "Mary Ann Willson." *Antiques.* 110(November 1976):1040–1045.
Includes several reproductions and lists her known watercolors.

Lipman, Jean. "Miss Willson's Watercolors." *American Collector.* 13(February 1944):8–9, 20.
Describes twenty of Willson's works.

————, and Alice Winchester. *Primitive Painters in America, 1750–1950: An Anthology.* New York: Dodd, Mead, 1950. Pp. 50–56.

Miller, Isabel [pseud.]. *Patience and Sarah.* New York: McGraw-Hill, 1972.
A historical novel that reconstructs the relationship between Willson and Brundage.

Petersen and Wilson. *Women Artists.* Pp. 68–69.

Rubinstein. *American Women Artists.* Pp. 32–33.

Collections:

Boston Museum of Fine Arts.
Cooperstown (New York), New York State Historical Association.
Washington (D.C.), National Gallery of Art.

TWENTIETH CENTURY

BERENICE ABBOTT. 1898– . United States.
 Abbott, born in Ohio, was first a sculptor. She studied in Berlin and in 1921 went to Paris where she studied with Bourdelle and Brancusi. Her career shifted when in 1923 she became a photographic assistant to Man Ray. From 1926 to 1929 she operated her own studio in Paris, taking portraits of many of the famous personalities of the period. Abbott's first exhibition was held in Paris in 1929. She became interested in the photographic work of Eugene Atget and was instrumental in saving his work. In 1929 she returned to New York and became fascinated with the city. She decided to photograph New York, as Atget had photographed Paris. Abbott's work from 1936 to 1939 was funded by the Federal Art Project. In the 1940's and 1950's she devoted herself to scientific and experimental photography. Abbott taught at the New School of Social Research for over twenty years, beginning in 1938.

Abbott, Berenice. *Changing New York.* Text by Elizabeth McCausland. New York: E. P. Dutton and Co., 1939.
 This work was sponsored by the Federal Art Project.

———. "Eugene Atget." *Creative Art.* 5(September 1929):651–656.
 Abbott briefly summarizes Atget's biography and style of photography.

———. *Greenwich Village Today and Yesterday.* Text by Henry W. Lanier. New York: Harper and Brothers, 1949.

———. *A Guide to Better Photography.* New York: Crown Publishers, 1942.

———. "The Image of Science." *Art in America.* 47(Winter 1959):76–79.
 Discusses briefly the photographic image as an educational tool in science.

———. *A Portrait of Maine.* Text by Chenoweth Hall. New York: Macmillan, 1968.

————. *The View Camera Made Simple.* Chicago: Ziff-Davis Publishing Co., 1948.

————. "What the Camera and I See." *Art News.* 50(September 1951):36–37, 52.
 Brief statement presenting her views of photography as an art form.

————. *The World of Atget.* New York: Horizon Press, 1964.

Beaton. *The Magic Image.* P. 149.

Cleveland, Ohio. The New Gallery of Contemporary Art. *Berenice Abbott: Documentary Photographs of the 1930's.* November 7–December 6, 1980.
 The introductory essay is by Michael G. Sundell.

Lyons, Nathan, editor. *Photographers on Photography.* Englewood Cliffs, New Jersey: Prentice-Hall, 1966.
 Reprints two essays written by Abbott, "It Has to Walk Alone" (from *Infinity* 7[1951]:6–7, 14) and "Photography at the Crossroads" (from the 1951 *Universal Photo Almanac,* pp. 42–47).

McCausland, E. "Berenice Abbott . . . Realist." *Photo Arts* (Spring 1948):46–50+.

Munsterberg. *A History of Women Artists.* Pp. 135–137.

National Museum of Women in the Arts. Pp. 76–77, 148–149.

Newhall. *History of Photography.* Pp. 149–150.

Rukeyser, Muriel, and David Vestal. *Berenice Abbott.* New York: Horizon Press, 1970.

Steinbach, Alice. "Berenice Abbott's Point of View." *Art in America.* 64(November–December 1976):76–81.
 An interesting interview that recaps the major events and personalities Abbott encountered in her fifty-year career.

Symmes, Marilyn. "Important Photographs by Women." Pp. 149–151.

Whelan. "Are Women Better Photographers than Men?" Pp. 80–82.

Collections:

Detroit Institute of Arts.
New York, Museum of Modern Art.
Washington (D.C.), National Museum of Women in the Arts.

ANNI ALBERS. 1899– . German.

This artist was born in Berlin and studied in Berlin and Hamburg before entering the Bauhaus in 1922. There she met her husband, Josef Albers. She began her career as a painter and credits Klee with influencing her work. Her later work was primarily in design and textiles. Fleeing from Hitler's regime, she became a U.S. citizen. From 1933 to 1949 she and her husband taught at Black Mountain College in North Carolina, where she set up the weaving workshop. Albers has worked as a textile designer for industry and has written extensively. Her first one-woman show, held in 1949 at the Museum of Modern Art, was also the only solo exhibition the museum has ever given by a weaver. Her contribution to abstract art has not been fully appreciated, even though she was working through the same design problems in cloth that her more famous husband was exploring in painting.

Albers, Anni. "Anni Albers on the Beginnings of Weaving." *American Fabrics.* 69(Fall 1965):89–92.
 An excerpt from her book, *On Weaving,* which discusses the historical evolution of thread interlacing.

————. "Design: Anonymous and Timeless." *Magazine of Art.* 40(February 1947):51–53.
 Albers sees the designer as having lost the direct experience of a medium as the result of craft being broken down into areas of specialization. Information is then substituted for experience.

————. "Fabric: The Pliable Plane." *Craft Horizons.* 18(July–August 1958):15–17.
 Discusses the possible uses of fabric in the overall conception of an architectural plan, rather than as an afterthought.

————. *On Designing.* New Haven, Connecticut: Pellango Press, 1960.
 Ten essays with photographic accompaniment, seeking to relate permanent values of craft to the values of our time. Comments on the problems of designing for industry.

————. "On the Designing of Textiles and the Handweavers Place in Industry." *American Fabrics.* 50(Summer 1960):98–99.

Excerpt from her book, *On Designing.* Good black-and-white reproductions of her work.

————. *On Weaving.* Middletown, Connecticut: Wesleyan University Press, 1965.

Albers discusses design fundamentals related to the visual and structural aspects of weaving. Includes sixteen plates of her work, some in color.

————. "Work with Material." *College Art Journal.* 3(January 1944):51–54.

Discusses the relationship between crafts and industrialization and the resulting estrangement of man from materials in their original form.

Baro, Gene. *Anni Albers.* New York: Brooklyn Museum, 1977.

A catalog of prints and drawings by Albers. It includes an interview with the artist and a brief essay by Nicholas Fox Weber.

Bénézit. *Dictionnaire.* Vol. 1, p. 81.

Fine. *Women and Art.* Pp. 198–200.

Harris and Nochlin. *Women Artists, 1550–1950.* P. 59.

Hartford, Connecticut. Wadsworth Athenaeum. *Josef and Anni Albers: Paintings, Tapestries and Woven Textiles.* July 8–August 2, 1953.

Hill. *Women: A Historical Survey . . .* Catalog. P. 54.

Rubinstein. *American Women Artists.* Pp. 246–247.

"Weavings." *Artforum.* 25(April 1987):88–91.

An edited version of a talk Albers gave to a woman's club in Black Mountain, North Carolina, four years after her arrival there. Includes excellent color reproductions of her work.

Weber, Nicholas Fox. "Anni Albers and the Printerly Image." *Art in America.* 63(July 1975):89.

Albers began printmaking in 1974 at the urging of June Wayne. The similarities between her weaving and her print imagery are discussed.

————. *The Woven and Graphic Art of Anni Albers.* Washington, D.C.: Smithsonian Institution Press, 1985.

Published in conjunction with a retrospective exhibition of her weavings and prints at the Renwick Gallery, June 12, 1985, to January 5, 1986.

Welliver, Neil. "A Conversation with Anni Albers." *Craft Horizon.* 25(July–August 1965):17–21, 40–45.

Albers discusses weaving from a historical standpoint, her experiences at the Bauhaus, and her role as a teacher. Several reproductions are included.

Collections:

Cambridge (Massachusetts), Harvard University, Busch-Reisinger Museum.
New York, Museum of Modern Art.

DIANE ARBUS. 1923–1971. United States.

Arbus was married at age eighteen and became the mother of two daughters. Both Arbus and her husband worked as fashion photographers for her father, the owner of a prominent women's fashion store. They expanded their careers, working for *Glamour, Vogue,* and various advertising agencies. Around 1956 Arbus stopped working with her husband and pursued an independent career. They divorced in 1969. In 1959 Arbus began studying with photographer Lisette Model. Arbus was the recipient of two Guggenheim fellowships. From 1965 to 1966 she taught at the Parsons School of Design, and from 1968 to 1969 at the Cooper Union. The last ten years of her life she devoted to recording her unique and unsettling subject matter—ritual oddities of America and images of malformed people, marred by birth or psychological aberrations.

Arbus, Doon. "Diane Arbus." *Camera.* 51(November 1972):22, 41–42.

Personal reminiscences by Arbus's daughter, reprinted from *Ms.* (October 1972).

————, and Marvin Israel, eds. *Diane Arbus.* Millerton, New York: Aperture Books, 1972.

Text edited from a series of classes Arbus gave in 1971, some interviews, and some of her writings.

―――. *Diane Arbus: Magazine Work.* Millerton, New York: Aperture Books, (ca. 1984).
Collections of photographs and small essays by Arbus, representing her enormous body of work published mainly in *Esquire, Harper's Bazaar,* and London's *Sunday Times Magazine.* Includes an essay by Thomas Southall.

Beaton and Nicholson. *The Magic Image.* P. 244.
Summary of biographical data.

Bosworth, Patricia. *Diane Arbus.* New York: Alfred A. Knopf, 1984.
Well-documented biography. It explores Arbus's artistic impulses, working methods, and the fears and depressions that eventually led her to commit suicide. Includes numerous photographs.

"Five Photos by Diane Arbus." *Artforum.* 9(May 1971):64–69.
Introduced by a brief quote from Arbus.

Goldin, Amy. "Diane Arbus: Playing with Conventions." *Art in America.* 61(March–April 1973):72–75.
A critical look at the relationship between Arbus's subject matter and the viewer.

Goldman, Judith. "Diane Arbus: The Gap Between Intention and Effect." *Art Journal.* 34(Fall 1974):30–35.
An in-depth discussion of Arbus's unique and often disturbing subject matter.

Jeffrey, Ian. "Diane Arbus and American Freaks." *Studio International.* 187(March 1974):133–134.

Kozloff, Max. "The Uncanny Portrait: Sander, Arbus, Samaras." *Artforum.* 11(June 1973):58–66.
Comparison of the portrait styles of these three photographers.

Kramer, Hilton. *The Age of the Avant-Garde.* New York: Farrar, Straus and Giroux, 1973. Pp. 491–495.

Kuspit, Donald. "Diane Arbus at Helios." *Art in America.* 95(July–August 1977):95.

Levy, Alan. "Working with Diane Arbus: A Many-splendored Experience." *Art News.* 72(Summer 1973):80–81.
A personal reminiscence by the author, who briefly worked with Arbus.

Munsterberg. *A History of Women Artists.* Pp. 141–143.
The source for most of the above biographical material.

Nemser, Cindy. "The Disturbing Vision of Diane Arbus." *Feminist Art Journal.* 2(Winter 1973):3–4.
Nemser disputes the view that Arbus extended empathy to her subjects and sees her work as evidence of her feelings of isolated detachment.

Porter, Allan. "Diane Arbus." *Camera.* 51(November 1972):4–21.
Introduces a portfolio of sixteen of Arbus's works with personal recollections.

Rice, Shelly. "Essential Differences." *Artforum.* 18(May 1980):66–71.
Rice compares the portrait photography of Arbus and Lisette Model.

Whelan. "Are Women Better Photographers than Men?" Pp. 80–82.

Collections:

Lawrence (Kansas), University of Kansas, Spencer Art Museum.
New York, Museum of Modern Art.

VANESSA BELL. 1879–1961. English.
Bell was the older sister of Virginia Woolf. She studied at the Slade School. Widely traveled, she was in Italy and Paris in 1904, Greece in 1906 and Constantinople in 1911. She married the art critic Clive Bell in 1906. They had two sons. The marriage broke up between 1911 and 1914 as the result of her interest in Roger Fry. By 1915 she was living with Duncan Grant and had a daughter by him. Between 1913 and 1919 she worked with Roger Fry in his Omega Workshops, and from 1914 to 1916 she collaborated with Duncan Grant on interior decoration. In 1916 she settled in rural seclusion, near Brighton, with Clive Bell and Duncan Grant. Together they became known as the "Bloomsbury Group." Bell's painting style has been described as English Postimpressionism, with subject matter consisting of figure studies and still lifes. She also designed pottery, carpets, stage sets, and book jackets. She painted prolifically until her death.

Bell, Quentin. "Charleston." *Architectural Review.* 166(December 1979): 394–396.

A brief remembrance of the Sussex farmhouse where Vanessa Bell lived and worked. Includes good color photographs of the interior.

————. *Charleston: Past and Present.* London: Hogarth Press, 1987.

————. *Virginia Woolf: A Biography.* 2 vols. London: Hogarth Press, 1973.

This biography by Vanessa Bell's son details her close relationship with her sister, Virginia Woolf. Her uninhibited views on sex are discussed, but the actual progression of her affairs is unclear. She evidently continued a close relationship with Clive Bell, her husband, after an affair with Roger Fry.

————, and Stephen Chaplin. "The Ideal Home Rumpus." *Apollo.* 80(October 1964):284–291.

The Omega workshop, of which Bell was a part, became involved in a dispute with Wyndham Lewis over the commission to design a room for an "Ideal Home Exhibition." Letters between Bell and Roger Fry discussing the dispute are included as well as photographs of Bell.

Clutton-Brock, A. "Vanessa Bell and Her Circle." *Listener.* 65(May 4, 1961):790.

Dictionary of Twentieth-Century Art. New York: Phaidon, 1973. P. 29.
Basic biographical facts.

Garnett, Angelica. *Deceived with Kindness: A Bloomsbury Childhood.* New York: Harcourt, Brace, Jovanovich, 1985.
Garnett is the daughter of Vanessa Bell and Duncan Grant.

Gillespie, Diane Filby. *The Sisters' Arts: The Writing and Painting of Virginia Woolf and Vanessa Bell.* Syracuse, New York: Syracuse University Press, 1988.

A discussion of the relationship between Woolf's writing and the visual arts. Gillespie wants to shift the focus from the influence of Roger Fry on Woolf and to explore the role Vanessa Bell had. Since this is primarily a work of literary criticism, evaluations of Bell's paintings are not undertaken. The professional relationship of the sisters is thoroughly explored.

Harris and Nochlin. *Women Artists, 1550–1950.* Pp. 60–61, 63, 283–285, 356.

Heller. *Women Artists*. Pp. 144–145.

Lipke, William. "The Omega Workshops and Vorticism." *Apollo*. 91(March 1970):224–231.

Roger Fry started the Omega workshops in 1913 to create a new movement in decorative art, translating the avant-garde into applied art that drew on the contribution of the Vorticists. Bell was one of the participants. A reproduction of a screen by Bell is included.

London. Anthony d'Offay Gallery. *Vanessa Bell: Paintings and Drawings*. 1973.

Introduction by R. Morphet.

London. Art Council Gallery. *Vanessa Bell: A Memorial Exhibition of Paintings*. 1964.

Introduction by R. Pickvance.

London. Lefevre Galleries. *Catalogue of Recent Paintings by Vanessa Bell*. 1934.

Introduction by Virginia Woolf.

London. London Artist's Association, the Cooling Galleries. *Recent Paintings by Vanessa Bell*. 1930.

Introduction by Virginia Woolf.

"Lord Benbow's Apartments. The *Architectural Review* Competition." *Architectural Review*. 68(December 1930):242.

Bell won third prize in this competition based primarily on her color scheme and largeness of conception. However, she was faulted with treating the plan of the room as a "comparative irrelevancy." Color reproductions of her room and rug designs are included.

Morphet, Richard. "The Significance of Charleston." *Apollo*. 86(November 1967):342–345.

A well-illustrated look at an important era in the decorative history of England. Charleston, a farmhouse, was leased by Bell and her group (including Duncan Grant, Quentin Bell, and others) so they could continue their work during the First World War. Design work by Bell included radiator screens, wall decorations, and cushions.

Petersen and Wilson. *Women Artists*. P. 106.

Rienaecker, Victor. "An Interesting Experiment." *Apollo*. 43(February 1946):34–35, 38.

Description of a decor designed by Bell and Duncan Grant for the duchess of Wellington.

Rosenbaum, S. P., ed. *The Bloomsbury Group: A Collection of Memoirs, Commentary and Criticism.* Toronto, 1975. Pp. 169–177.

Shone, Richard. *Bloomsbury Portraits: Vanessa Bell and Duncan Grant and Their Circle.* New York: E. P. Dutton, 1976.

Sickert, Walter. "Vanessa Bell." *Burlington Magazine.* 41(July 1922):33–34.
Includes three black-and-white reproductions.

Wallis, Nevile. "Vanessa Bell and Bloomsbury." *Connoisseur.* 156(August 1964):247.

Waters, Grant. *Dictionary of British Artists Working 1900–1950.* Eastbourne, Sussex: Eastbourne Fine Art, 1975.
Waters says Bell studied with Sir Arthur Cope and at the Royal Academy schools.

Williams. *Women Photographers.* Pp. 77–88.
This history of women photographers in Great Britain includes an interesting discussion of the uses and purposes of Vanessa Bell's snapshots taken at Charleston. Several are reproduced.

Collection:

London, Tate Gallery.

CHARLOTTE BEREND-CORINTH. 1880–1967. German.
Berend-Corinth was born in Berlin. She studied with Eva Short and Max Schafer. In 1903 she married the painter Lovis Corinth. Her first exhibition was in Berlin in 1906. She did mainly portraits and genre works, influenced by Expressionist sources. Much of her early work was destroyed in the Second World War. Rather than promoting her own work, which has been virtually unnoted, she devoted much of her time to cataloging her husband's work following his death in 1925. After his death, she lived in Berlin and in Ascona, Switzerland. She died in New York City.

Bénézit. *Dictionnaire.* Vol. 2, p. 631.

Berend-Corinth, Charlotte. *Die Gemälde von Lovis Corinth: Werk Katalog.* Munich: F. Bruckmann, 1958.

"Mrs. Lovis Corinth, 86; Widow of German Painter." *New York Times* (January 11, 1967):25.
Obituary.

Schultzman, Monty. *Die Malerin Charlotte Berend-Corinth.* Munich: F. Bruckmann, 1968.
Includes forty black-and-white reproductions.

Thieme and Becker. *Allgemeines Lexikon.* Vol. 7, p. 413.

Who's Who in American Art. Washington, D.C.: American Federation of Arts, Vol. 3, 1940–1941, p. 62.

ISABEL BISHOP. 1902–1988. United States.
 Born in Cincinnati, Bishop spent her youth in Detroit and in 1918 moved to New York where she settled in the Union Square neighborhood. She entered the New York School of Applied Design for Women to study illustration. This was followed by study at the Art Students League with Kenneth Hayes Miller. After traveling in Europe Bishop returned to the Art Students League as an instructor, the only full-time teacher at the time. In 1934 Bishop married a prominent neurologist. Although they made their home in Riverdale, New York, she continued to work at her Union Square studio until 1984. The Union Square atmosphere supplied her subject material—nudes, working women, and street scenes crowded with people. A confessed perfectionist, Bishop worked slowly. A painting was usually preceded by numerous pen-and-ink sketches and an etching. The resulting work, which often expresses her interest in body movement, has been described as having a "hazy luminosity." The Whitney Museum of American Art gave Bishop a major retrospective in 1975.

Alloway, Lawrence. "Isabel Bishop, the Grand Manner and the Working Girl." *Art in America.* 63(September 1975):61–67.
 A discussion of Bishop's style and subject matter, with attention to her marked responsiveness to specifically feminine situations. Includes three good color illustrations.

Archives of American Art. Smithsonian Institution. "Isabel Bishop's Papers."

Bishop, Isabel. "Concerning Edges." *Magazine of Art.* 38(May 1945):168–173.
 Historical examination of linear and painterly styles. Bishop argues for not mixing the two.

————. "Isabel Bishop Discusses 'Genre' Drawings." *American Artist.* 17(June 1953):46.
 Brief historical summary of drawing styles.

————. "Kenneth Hayes Miller." *Magazine of Art.* 45(April 1952):169.
 Personal reminiscences of her former teacher.

Burnett, Catherine. "A Woman of Substance." *Arts and Antiques* (December 1988):64–71.

Canaday, John. "A Certain Dignity for the Figure." *New York Times* (May 11, 1975):31.

Denz, Sarah. "Isabel Bishop." *Womansphere.* 1(September 1975):12–13.
 Brief synopsis of Bishop's subject matter.

"The Drawings of Isabel Bishop." *Magazine of Art.* 13(June 1949):49–51.
 Good illustrations.

Fine. *Women and Art.* Pp. 205–208.

Galligan, Gregory. "Isabel Bishop: Early Drawings." *Arts.* 61(April 1987):42–43.

Glueck, Grace. "New Honors for Painter of Union Square." *New York Times* (April 11, 1975):18.

Harmes, Ernest. "Light Is the Beginning—The Art of Isabel Bishop." *American Artist.* 25(February 1961):28–33, 60–62.
 An in-depth analysis of Bishop's style. Discusses her lengthy creative process from pencil sketch to etching to painting.

Harris and Nochlin. *Women Artists, 1550–1950.* Pp. 64, 325–326, 360–361.

Heller. *Women Artists.* Pp. 150–153.

Hill. *Women: A Historical Survey . . .* Catalog. Plate 59.

Johnson, Una, and Jo Miller. *Isabel Bishop: Prints and Drawings, 1925–1964.* New York: The Brooklyn Museum, 1964.
 A monograph in the "American Graphic Artists of the Twentieth Century" series. It consists of a very short biographical summary, a chronology, and several reproductions.

Lunde, Karl. *Isabel Bishop.* New York: Harry Abrams, 1975.
 A careful analysis of Bishop's technique and subject matter. Includes many excellent color and black-and-white reproductions.

Munro. *Originals: American Women Artists.* Pp. 145–153.

National Museum of Women in the Arts. Pp. 90–91.

Nemser, Cindy. "Conversation with Isabel Bishop." *Feminist Art Journal.* 5(Spring 1976):14–20.
 Discusses Bishop's Union Square subject material, her education as an artist, and her work.

Newsom, Patricia Paull. "Isabel Bishop." *American Artist.* 49(September 1985):42–45, 90.

Pagano, Grace. *Contemporary American Painting.* New York: Duell, Sloan and Pearce, 1945. Pp. 5–6.
 Notes Bishop's commission by the Treasury Department to do post office murals.

Petersen and Wilson. *Women Artists.* Pp. 3–4.

"Poet in the Square." *Time.* 76(May 16, 1960):80, 82.

Reich, Sheldon. "Isabel Bishop: The 'Ballet' of Everyday Life." *Art News.* 74(September 1975):92–93.
 Describes Bishop as the primary portrayer of the American working woman.

Rubinstein. *American Women Artists.* Pp. 227–231.

Russell, John. "A Novelist's Eye in Isabel Bishop's Art." *New York Times* (April 12, 1975):25.

St. John, Bruce. *Isabel Bishop: The Affectionate Eye.* Los Angeles: Laband Art Gallery, Loyola Marymount University, 1985.

Sayre, Ann. "Substantial Technique in Isabel Bishop's Work." *Art News*. 34(February 22, 1936):8.

Seckler, Dorothy. "Bishop Paints a Picture." *Art News*. 50(November 1951):38–41, 63–64.
 Photo essay and discussion of Bishop's working methods and use of models.

Teller, Susan Pirpiris. *Isabel Bishop: Etchings and Aquatints*. New York: Associated American Artists, 1985.

Trenton, New Jersey. New Jersey State Museum. *Painting by Isabel Bishop: Sculpture by Dorothea Greenbaum*. May 2–July 5, 1970.
 Exhibition catalog.

Tucson. University of Arizona Museum of Art. *Isabel Bishop*. 1974.
 This is the catalog of the first retrospective exhibition of Bishop's work held in the United States. The introduction is by Sheldon Reich. Includes many black-and-white illustrations.

Yglesias, Helen. *Isabel Bishop*. New York: Rizzoli, 1989.
 An excellent monograph. Copiously illustrated chapters are devoted to Bishop's various themes. Includes lists of her works in public collections, exhibitions, honors and awards, and a selected bibliography.

Young, Mahonri Sharp. "The Fourteenth Street School." *Apollo*. 113(March 1981):165–170.
 Discusses Bishop's subject matter and technique. Includes seven excellent black-and-white reproductions.

Watson, Forbes. "Isabel Bishop." *Magazine of Art*. 32(January 1939):53–54.
 Brief review of an exhibition.

Collections:

Des Moines Art Center.
Kansas City, Nelson-Atkins Museum of Art.
New York, Metropolitan Museum of Art.
New York, Whitney Museum of American Art.
Newark (New Jersey) Museum.
Philadelphia, Pennsylvania Academy of the Fine Arts.

Springfield (Massachusetts), Museum of Fine Arts.
Washington (D.C.), National Museum of Women in the Arts.
Wichita Art Museum.
Wilmington, Delaware Art Museum.

MARIA BLANCHARD. 1881–1932. Spanish.
Blanchard was a painter working in the Cubist idiom. She was born in Spain, and her first art studies were in Madrid. Blanchard was hunchbacked and dwarfed from birth and lived in continuous pain. She often painted from her wheelchair, but still managed to support her sister and her three children financially. Blanchard's father was Spanish and her mother was half-French and half-Polish. She changed her name from Gutierez to Blanchard when she moved to Paris in 1906. In Paris she studied at the Academie Vitii with Van Dongen and Anglade. She returned to Spain in 1913 to accept a teaching position in Salamanque. She went back to Paris in 1916. Picasso and Gris were her friends, and her work is often compared to that of Gris. Her work was little known by the public. All of her Cubist works between 1916 and 1919 were purchased by Leonce Rosenberg. After 1919 her painting became more realistic. Many of her works are scenes of family life and childhood. She exhibited in the Salon des Independants from 1920 to 1922.

Bénézit. *Dictionnaire.* Vol. 2, p. 68.

Casson. J. "La jeune peintre espagnole." *Renaissance.* 16(July 1913): 160–161.

Charmet. R. "Les individualistes du cubisme au Petit Palais de Genève." *Galerie.* 125(March 1973):51–54.
 Brief discussion of the work of several Cubists, including Blanchard.

Dorival. *The School of Paris in the Musée d'Art Moderne.*
 Includes a reproduction of one of Blanchard's paintings.

———. *Twentieth Century Painters.*

Fernandez-Quintanilla, Paloma. "Marie Blanchard, un Espiritu en Lucha." *Goya.* 164–165(September–December 1981):100–105.
 Includes several black-and-white reproductions.

Hill. *Women: A Historical Survey* . . . Catalog. P. xiii.

Mathey. *Six femmes peintres.*

Petersen and Wilson. *Women Artists.* Pp. 97–98.

Phaidon Dictionary of Twentieth Century Art. New York: Phaidon, 1973. P. 38.

Raynal. *Modern French Painters.* Pp. 43–45.

Sumner, Maud. "Recollections of Paris." *Apollo.* 102(October 1975):289–291.
 Sumner lived in Blanchard's home around 1929 and recalls the artist briefly.

Tello, Francisco. "Exposiciones en Madrid." *Goya.* 161–162(March–June 1981):377–378.
 Review of exhibition of Blanchard's work at Galleria Gavar. Includes four black-and-white reproductions.

Collections:

 Paris, Musée National d'Art Moderne.
 Grenoble, Musée de Peinture et de Sculpture.
 Nantes, Musée des Beaux-Arts.

LOUISE BOURGEOIS. 1911– . French-American.
 Bourgeois was born in Aubusson, France. She began her artistic career there as a child, assisting in the family craft of restoring old tapestries. Her formal art education was obtained from Ecole du Louvre, Ecole des Beaux-Arts (1936–1938), Académie du Louvre, Académie de la Grand Chaumière, and in Fernand Leger's studio in Paris. In 1938 Bourgeois married Robert Goldwater, an American art historian and moved to New York City. She then studied at the Art Students League. She exhibited at the Whitney's Painting Annuals between 1948 and 1958 as an abstract painter. Her first all-sculpture show was in 1949. Bourgeois has taught sculpture at several colleges. She works in a variety of sculptural forms, using brass, plastic, marble, and latex. Much of her recent work has an anatomical basis, making reference to breasts, penises, and other body parts.

Andersen, Wayne. *American Sculpture in Process, 1930–1970.* Boston: New York Graphic Society, 1975. Pp. 92–95.

Armstrong. *Two Hundred Years of American Sculpture.* Pp. 261–262.

Baldwin, Carl. "Louise Bourgeois: An Iconography of Abstraction." *Art in America.* 63(March–April 1975):82–83.
A chronological discussion of her style. He sees a recurring theme of the problem of helplessness and the difficulty of self-reliance in the biomorphic abstraction of her work.

Bloch, Susi. "An Interview with Louise Bourgeois." *Art Journal.* 35(Summer 1976):370–373.

Bourgeois, Louise. "The Fabric of Construction." *Craft Horizon.* 29(March–April 1969):30–35.
Reviews a Museum of Modern Art exhibition of wall hangings. Contrasts fabric work with sculpture.

Heller. *Women Artists.* Pp. 138–139.

Kiril, Alain. "The Passion for Sculpture." *Arts.* 63(March 1989):68–75.
A conversation between Bourgeois and the author, who is also a sculptor. They discuss the sexual imagery in her works.

Krasne, Belle. "Ten Artists in the Margin." *Design Quarterly.* 30(1954):18.
Includes a brief description by Bourgeois of her own work.

Kuspit, Donald. "Louise Bourgeois: Where Angels Fear to Tread." *Artforum.* 25(March 1987):115–120.
Analysis of the artist's imagery. Includes excellent reproductions in both color and black and white.

Lippard, Lucy. *"The Blind Leading the Blind."* Bulletin of the Detroit Institute of Arts. 59(Spring 1981):24–29.
Discussion of a work by Bourgeois in the collection.

———. "Louise Bourgeois: From the Inside Out." *Artforum.* 13(March 1975):26–33.
Excellent summary of Bourgeois' life and an analysis of her work. Lippard notes the wide variety of materials and techniques used by the artist. Good reproductions are included.

Marandel, J. Patrice. "Louise Bourgeois." *Art International.* 15(December 1971):46–47, 73.

Miller and Swenson. *Lives and Works.* Pp. 2–14.
 An interview with Bourgeois. Includes a listing of exhibitions and
awards.

Munro. *Originals: American Women Artists.* Pp. 154–169.
 Good account of her youth and formative influences on her art. Says
she studied with Otto Frieze.

New York. Museum of Modern Art. *Louise Bourgeois.* November 3,
 1982–February 8, 1983.
 This catalog includes a chronology, exhibition record, bibliogra-
phy, and numerous photographs and reproductions. The essay by
Deborah Wye chronologically explores Bourgeois' life and career.
The introduction is by William Rubin.

Robbins, Daniel. "Sculpture by Louise Bourgeois." *Art International.*
 8(October 1964):29–31.

Rubin, William. "Some Reflections Prompted by the Recent Work of
 Louise Bourgeois." *Art International.* 13(April 1969):17–20.
 Compares her sculpture to the painting being produced in the
1940's and 1950's. Sees the sexuality of her work as not being
conducive to "aesthetic contemplation."

Semmel, Joan, and April Kingsley. "Sexual Imagery in Women's Art."
 Woman's Art Journal. 1(Spring–Summer 1980):1–6.
 Until recently Bourgeois experienced almost total critical and
public neglect because of the sexual imagery in her art.

Storr, Robert. "Louise Bourgeois: Gender and Possession." *Art in
 America.* 71(April 1983):128–137.
 Excellent reproductions reveal the diversity of Bourgeois' work.

Watson-Jones. *Contemporary American Women Sculptors.* Pp. 62–63.

Collections:

 Detroit Institute of Arts.
 New Orleans Museum of Art.
 New York, Museum of Modern Art.
 New York, Metropolitan Museum of Art.
 New York, Whitney Museum of American Art.
 Portland (Maine), Museum of Art.

MARGARET BOURKE-WHITE. 1904 or 1905–1971. United States.

Bourke-White was one of the outstanding women photographers of the twentieth century. Her interest in photography began during her college days at Cornell University. She later studied with Clarence White at Columbia. When her early marriage ended in divorce, she began her career as a free-lance photographer. In 1927 she moved to Cleveland and began photographing architecture and steel mills. Soon her work was appearing in national magazines, such as *Architectural Record*. She moved to New York, becoming the main photographer and an associate editor of *Fortune*. In 1936 Bourke-White was hired as one of the first photographers for *Life* magazine. Her career with *Life* took her around the world and resulted in numerous awards. In the 1930's she was the first professional U.S. photographer allowed access to Russia, where she documented the progress of the first five-year plan. In the Second World War she was the first woman photographer to be accredited by the United States Armed Forces. She was the only Western photographer to cover the first German bombardment of Moscow. After the war Bourke-White covered such events as religious conflict in India, African gold mining, and the Korean War. She married Erskine Caldwell in 1939, and they were divorced in 1942. In the early 1950's she developed Parkinson's disease and spent the last years of her life in a heroic struggle against her illness. She retired from the staff of *Life* in 1969.

Beaton. *The Magic Image*. P. 182.

Bourke-White, Margaret. "How the Pictures Were Made." *Popular Photography*. 2(March 1939):15–16, 94–95.
Describes the technical aspects (equipment, lighting, film) involved in the preparation of *You Have Seen Their Faces*.

———. *Portrait of Myself*. New York: Simon and Schuster, 1963.
Autobiography.

———. *Shooting the Russian War*. New York: Simon and Schuster, 1942.
This is a travelogue, illustrated with her photographs, of a trip she and Erskine Caldwell made to Russia in 1942. An appendix gives technical information on the exposure data, cameras, and lenses used.

———. *They Called It "Purple Heart Valley."* New York: Simon and Schuster, 1944.
Her personalized account of the Second World War in Italy.

————, and Erskine Caldwell. *Say, Is This the U.S.A.?* New York: Duell, Sloan and Pearce. 1941.

————. *You Have Seen Their Faces.* New York: Modern Age Books, 1937.
A study of rural poverty in the South.

"Bourke-White's Twenty-five Years." *Life.* 38(May 16, 1955):16–18.
A photo-essay of Bourke-White at work.

Brown, Theodore. *Margaret Bourke-White: Photojournalist.* Ithaca, New York: Cornell University, Andrew Dickson White Museum of Art, 1972.
Lavishly illustrated exhibition catalog, documenting Bourke-White's extensive travels. Comprehensive bibliography and list of published photographs is included.

Caldwell, Erskine. *North of the Danube.* New York: Viking Press, 1939.
This description of Czechoslovakia is accompanied by photographs taken by Bourke-White.

Callahan, Sean, ed. *The Photographs of Margaret Bourke-White.* Boston: New York Graphic Society, 1972.
Includes chronology and bibliography.

Goldberg, Vicki. *Margaret Bourke-White: A Biography.* New York: Harper and Row, 1986.
This is an excellent, very readable biography. Many of Bourke-White's photographs illustrate the text.

Kelley, Etna M. "Margaret Bourke-White." *Photography.* 31(August 1952):34–43, 85.
Traces her career with *Life.*

Munsterberg. *A History of Women Artists.* Pp. 139–141.

Newhall. *History of Photography.* Pp. 149, 158.

Silverman, Jonathan. *For the World to See: The Life of Margaret Bourke-White.* New York: Viking Press, 1983.
Many reproductions of her work are included in this biography.

Tucker. *The Woman's Eye.*

Washington, D.C. National Museum of Women in the Arts. *Bourke-White: A Retrospective.* June 27–August 27, 1989.

Collections:

Brooklyn Museum.
Cleveland Museum of Art.
New York, Museum of Modern Art.
Washington (D.C.), Library of Congress.

ROMAINE BROOKS. 1874–1970. United States (French resident).

Brooks was born in Rome, the daughter of a wealthy and eccentric mother. Her younger brother was emotionally disturbed. Brooks' father deserted the family before she was born. Her mother traveled perpetually, subjecting Brooks to a bizarre childhood, changing schools frequently during her youth. She studied professional singing briefly before choosing a career in art. She studied in Paris and in Rome at the Scuola Nazionale and the Circolo Artistico. Not until both her mother and brother had died and she had inherited the family fortune was she free to pursue her own life. She was born with the name Goddard, but took John Brooks' name after a brief marriage of convenience. She was a lesbian and lived in a relationship with Natalie Clifford Barney for fifty years. Many of Brooks' paintings were of unusual female nudes and portraits of personal friends, all done in a somber palette of neutral gray tones. Her first solo exhibition was in Paris in 1910. She painted very little after 1935.

Bénézit. *Dictionnaire.* Vol. 2, p. 331.

Blume, Mary. "Romaine Brooks." *Réalités.* 205(December 1967):96–99.
Discusses her close relationship with Gabriele d'Annunzio.

Breeskin, Adelyn D. "Brooks, Romaine." In *Notable American Women: The Modern Period.* Vol. 4, pp. 110–111.

———. *Romaine Brooks, "Thief of Souls."* Washington, D.C.: National Collection of Fine Arts, Smithsonian Institution Press, March 1971.
Breeskin's essay in this catalogue of a retrospective exhibition provides a visual analysis of Brooks' work. The preface of the catalog was written by Joshua Taylor.

————. "The Rare, Subtle Talent of Romaine Brooks." *Art News.* 79(October 1980):156–159.
A good biographical summary. Notes that in addition to her drawings, approximately thirty-five of Brooks' paintings survive.

Brooks, Romaine. *No Pleasant Memories.* Unpublished manuscript of her autobiography, ca. 1930.
This manuscript is discussed in *Life and Letters Today,* vol. 18, pp. 38–44, vol. 19, pp. 14–32.

Butler, J. T. "Romaine Brooks, Whitney Museum, N.Y. Exhibit." *Connoisseur.* 178(October 1971):136–137.

Fine. *Women and Art.* Pp. 189–191.

Gabhart and Broun. "Old Mistresses."

Greer. *The Obstacle Race.* Pp. 60–61.

Harris and Nochlin. *Women Artists, 1550–1950.* Pp. 268–271, 354–355.

Hill. *Women: A Historical Survey . . .* Catalog. P. 22.
Brooks' painting of Ida Rubenstein is reproduced.

Kahn, Gustave. "Romaine Brooks." *L'art et les artistes.* 37(May 1923):307–314.
Fourteen reproductions of her work are included.

Kramer, Hilton. "Revival of Romaine Brooks." *New York Times* (April 25, 1971).

————. "Romaine Brooks: Revelation in Art." *New York Times* (April 14, 1971).

London. The Fine Art Society. *Romaine Brooks Centenary, 1876–1976.* January 19–February 14, 1976.
A brief catalog reprinted from Breeskin's 1971 catalog for the National Collection of Fine Arts in Washington, D.C.

Petersen and Wilson. *Women Artists.* Pp. 100–101.

Raven, Arlene. "Romaine Brooks." *Womanspace Journal.* 1, no. 2(April–May 1973):508.

Romaine Brooks. Paris: Braun and Cie, 1952.
This small volume contains an introduction by Elisabeth de Gramont, a reprint of the biography by John Usher that originally appeared in the February 1926 *International Studio,* excerpts from critical reviews of 1910–1952, and black-and-white reproductions of several paintings and drawings.

Rubinstein. *American Women Artists.* Pp. 196–200.

Secrest, Meryle. *Between Me and Life.* New York: Doubleday and Company, 1974.
An in-depth biography of Brooks. It contains reproductions of her paintings and unusual drawings and photographs of her circle. It is indexed and contains an exhaustive bibliography, some of which has been utilized here. Secrest uses an ingenious format to deal with some of the contradictory primary sources about Brooks, in particular her childhood. For example, she writes one chapter from the point of view of Brooks' mother, Ella Goddard, as preserved in her letters. Rather than presuming to resolve the enigma, Secrest presents both sides of the evidence.

Usher, John, "A True Painter of Personality." *International Studio* (February 1926).

Wicks, George. *The Amazon of Letters: The Life and Loves of Natalie Barney.* New York: G. P. Putnam, 1976.

Young, M. S. "Thief of Souls." *Apollo.* 93(May 1971):425–427.
The sobriquet "thief of souls" refers to her often eerie portraits.

Collections:

Paris, Musée du Petit Palais.
Washington (D.C.), National Collection of Fine Arts.

DORIS CAESAR. 1892–1971. United States.
Caesar was born in Brooklyn. Her artistic ambitions were encouraged by her father. In 1909 she studied at the Art Students League in New York. She married in 1913 and stopped her art work while raising her children. In 1925 she studied with Archipenko. Around 1953 she began to concentrate almost exclusively on sculptural interpretations of the female figure, simplified, elongated, and slightly distorted. Most

were created in bronze. Her works were regularly exhibited in New York
galleries beginning in 1931. Caesar also published poetry. She moved to
Litchfield, Connecticut, in 1957. Syracuse University has her papers and
the largest single collection of her work.

Bénézit. *Dictionnaire.* Vol. 2, p. 442.

Bush, Martin. *Doris Caesar.* Syracuse: Syracuse University Press, 1970.
 Monograph that includes numerous reproductions, a chronology,
extensive bibliography, exhibition list, and list of collections contain-
ing her work.

Caesar, Doris. *Certain Paths.* New York: G. P. Putnam's Sons, 1937.

————. *Phantom Thought.* New York: G. P. Putnam's Sons, 1934.
 Both of these are volumes of poetry.

Fielding. *Dictionary of American Painters, Sculptors and Engravers.*
 P. 125.

Goodrich, Lloyd, and John Baur. *Four American Expressionists.* New
 York: Frederick Praeger for the Whitney Museum, 1959. Pp. 22–36.
 The chapter on Caesar is by Baur and contains many good
black-and-white reproductions.

Opitz, Glenn, ed. *Dictionary of American Sculptors.* P. 57.

Rubinstein. *American Women Artists.* P. 260.

Collections:

> Newark (New Jersey) Museum of Art.
> New York, Whitney Museum of American Art.
> Philadelphia Museum of Art.

EMILY CARR. 1871–1945. Canadian.
 Carr was born into a large family in Victoria, British Columbia. Her
parents died when she was young, and she was raised by her sisters. She
attended the Mark Hopkins School of Art in San Francisco from 1889 to
1894. She then returned to Victoria, set up a studio, and began to teach
children's art classes. Her first voyage to Ucluelet, an isolated Indian
village on Vancouver Island, was made in 1898. The Indians gave her the

name *Klee Wyck,* meaning "laughing one." This began her interest in documenting Native American life and legend. In 1899 she enrolled in London's Westminster School of Art. After almost two years of study she became ill and was confined to a sanatorium for two years with pernicious anemia. Carr returned to Victoria in 1904. From 1904 to 1910 she lived in Vancouver and worked as an instructor for the Vancouver Ladies' Art Club. From 1910 to 1911 she studied at the Academie Colarossi in Paris, where she acquired her heavy brushwork and violent color. Two of her works were exhibited in the Salon d'Automne of 1911. Recognition of her work, however, was discouragingly slow. After her return from France she virtually gave up painting and struggled to support herself by opening a boardinghouse, making and selling pottery and hooked rugs, and raising puppies for sale. The turning point in her career came in 1927 when she met a group of painters called the Group of Seven. They, especially Lawren Harris, had an understanding of her art and brought her work to the attention of the director of the National Gallery in Ottawa. Carr's best work was done in the 1950's as she continued to document Native American life and the Canadian landscape. She was also a writer, producing autobiographical material, novels, and numerous stories.

Art Gallery of Ontario: The Canadian Collection. Toronto: McGraw-Hill Company of Canada, 1970. Pp. 60–63.
 Brief biographical summary and three black-and-white reproductions.

Bénézit. *Dictionnaire.* Vol. 2, p. 547.

Blanchard, Paula. *The Life of Emily Carr.* Toronto/Vancouver: Douglas and McIntryre, 1987.

Buchanan, Donald W. "Emily Carr: Canadian Painter." *Studio.* 126(August 1943):60.

Carr, Emily. *The Book of Small.* 1942; reprint, Toronto: Clarke, Irwin, 1951.
 Recollections of her childhood.

———. *Fresh Seeing.* Toronto: Clarke, Irwin and Company, 1972.
 Reprints of the only two public talks Carr gave, both dealing with her aesthetic views. The preface is by Doris Shadbolt, and an introduction to the 1930 speech is by Ira Dilworth.

———. *Growing Pains.* Toronto: Oxford University Press, 1946.

This autobiography was edited after her death by Ira Dilworth, her literary executor.

————. *The House of All Sorts.* 1944; reprint, Toronto: Clarke, Irwin, 1967.

————. *Hundreds and Thousands: The Journals of Emily Carr.* Toronto: Clarke, Irwin, 1968.

————. *Klee Wyck.* Toronto: Oxford University Press, 1941.
Autobiographical work encompassing Carr's interpretation of Native American legends and the lives and fears of the tribes. The work received the Governor-General's Award for nonfiction.

————. *Pause: A Sketch Book.* Toronto: Clarke, Irwin, 1953.
A posthumous publication of her sketches, correspondences, and reminiscences.

Dilworth, Ira, ed. *The Heart of a Peacock.* Toronto: Oxford University Press, 1953.
Collection of Carr's unpublished writings and stories illustrated with her line drawings of animals and birds.

Heller, *Women Artists.* Pp. 118–120.

Hembroff-Schleicher, Edythe. *Emily Carr: The Untold Story.* Saanichton, British Columbia: Hancock House, 1978.

————. *M.E.: A Portrait of Emily Carr.* Toronto: Clarke, Irwin, 1969.

Hirsch, Gilah Yelin. "Emily Carr." *Feminist Art Journal.* 5(Summer 1976):28–31.
Comprehensive survey of Carr's life and work. Unfortunately, a bibliography is not included, but Hirsch generously offers to share her material with anyone interested.

"The Laughing One." *Time.* 64(November 22, 1954):82.
Includes a color illustration.

"Memories of Emily Carr in a Tobey Exhibition." *Canadian Art.* 16(Autumn 1959):274.

Mark Tobey stayed briefly in Carr's boardinghouse and gave her some instruction while there. Illustrated with his 1928 painting of her studio.

Shadbolt, Doris. *The Art of Emily Carr.* Seattle: University of Washington Press, 1979.

A comprehensive study of Carr's artistic development combined with a chronologic survey of her life. Includes over two hundred reproductions, many in color.

————. "Emily Carr: Legend and Reality." *Artscanada.* 28(June–July 1971):17–21.

An excellent analysis of Carr's personality and its relationship to her work. Contrasts her sense of "otherness" to the isolation of the Indians with whom she closely identified. Includes photographs of Carr and reproductions of her work.

Tippett, Maria. *Emily Carr: A Biography.* Toronto: Oxford University Press, 1979.

A well-documented, detailed biography. It presents a good picture of Carr's difficult personality. Included are many photographs and several color reproductions of Carr's work.

"The Ucluelet Wharf." *Apollo.* 94(October 1971):314.

Review of the 1971 centennial retrospective at the Vancouver Art Gallery.

Vancouver. Vancouver Art Gallery. *Emily Carr.* May 18–August 29, 1971.

This centennial exhibition catalog includes a chronology, a bibliography, an essay by Doris Shadbolt, and several excellent color reproductions.

Wallace, W. Stewart, ed. *The Macmillan Dictionary of Canadian Biography.* Toronto: Macmillan of Canada, 1978. P. 133.

Collections:

Ottawa, National Gallery of Canada.
Toronto, Art Gallery of Ontario.
Vancouver Art Gallery.

LEONORA CARRINGTON. 1917– . English.
 Carrington was born in England where her father was a wealthy
textile manufacturer. She made paintings and drawings without any
formal training until she was nineteen. In 1937 she entered the Ozenfant
Academy in London and in the same year met Max Ernst. She
participated in the International Surrealist Exhibition in 1938 in Paris.
From 1937 to 1940 she lived with Ernst. At the outbreak of the Second
World War Ernst immigrated to the United States while Carrington fled
to Spain, where she was hospitalized with a nervous breakdown. After
recovering she came to New York and in 1942 moved to Mexico, where
she still resides. Carrington's Surrealist work often satirizes her English,
upper-middle-class social background and frequently includes mythical
creatures, magic animals, and female symbols. She has also produced
sculpture, designed tapestry, and has written and illustrated stories.
Carrington was one of the originators and leaders of the women's
liberation movement in Mexico in the early 1970's.

Alexandrian, Sarane. *Surrealist Art.* New York: Praeger Publishers,
 1970.

Bénézit. *Dictionnaire.* Vol. 2, p. 562.

Carrington, Leonora. *Down Below.* Chicago: The Black Swan Press,
 1972; reprinted by the Surrealist Group of *Radical America.*
 This is a reissue of Carrington's account of her bout with nervous
depression. It was first published in 1944 with the title *En bas.* An
English translation first appeared in *VVV* 4(February 1944).

———. *The Hearing Trumpet.* New York: St. Martin's Press, 1976.

———. *The House of Fear: Notes from Down Below.* New York: E. P.
Dutton, 1988.
 This is a compilation of four of Carrington's literary works (*House
of Fear, The Oval Lady, Little Frances,* and *Down Below.* The
introduction is by Marina Warner. The black-and-white illustrations
are by Carrington and photographs of the artists are also provided.

———. *El mundo magico de los Mayas.* Mexico City, 1964.

———. *The Oval Lady.* Trans. Rochelle Holt. Santa Barbara, California:
Capra Press, 1975.
 A collection of six surreal stories and illustrations.

————. *The Seventh Horse and Other Stories.* London: Virago Press, 1989.
 The introduction to these stories is provided by Marina Warner.

Chadwick, Whitney. "Leonora Carrington: Evolution of a Feminist Consciousness." *Woman's Art Journal.* 7(Spring–Summer 1986):37–42.
 Discussion of Carrington's imagery. Chadwick believes the origins of her feminist vision lie in the paintings and writings produced between 1938 and 1947.

————. "The Muse as Artist: Women in the Surrealist Movement." P. 122.

————. *Women Artists and the Surrealist Movement.* Pp. 67–69, 74–80, 195–201, 206–215, 240.

Fauchereau, Serge. "Surrealism in Mexico." *Artforum.* 25(September 1986): 88–91.
 Briefly mentions Carrington in this synopsis of Mexican Surrealism.

Fine. *Women and Art.* Pp. 178–180.

Gablik, Suzi. "Leonora Carrington at Iolas and the Center for Inter-American Relations." *Art in America.* 64(March 1976):111.
 Exhibition review.

Helland, Janice. "Daughter of the Minotaur: Lenora Carrington and the Surrealist Image." M.A. thesis, University of Victoria, British Columbia, 1984.

Heller. *Women Artists.* Pp. 156–158.

Hill. *Women: A Historical Survey . . .* Catalog. P. iii.

Jean, Marcel. *The History of Surrealist Painting.* Trans. Simon W. Taylor. New York: Grove Press, 1959.
 Gives an account of her emotional breakdown. Includes her own description of her painting, *The Temptation of Saint Anthony.* Also includes one of her Surrealist cooking recipes.

Maron, Monika. "Wo War Leonora Carrington?" *Du.* 10(October 1988):109.

National Museum of Women in the Arts. Pp. 120–121.

New York. Center for Inter-American Relations. *Lenora Carrington: A Retrospective Exhibition.* 1976.

Orenstein, Gloria. "Leonora Carrington—Another Reality." *Ms.* (August 1974).

————. "Leonora Carrington's Visionary Art for the New Age." *Chrysalis.* No. 3(1978):65–77.
 Comprehensive discussion of Carrington's imagery, revealing the invisible world of the female psyche as personified by goddesses, female sorcerers, alchemists, and shamans. Describes her imagery as a "matriarchal interpretation of a transformed reality." Includes several black-and-white reproductions.

————. *The Theatre of the Marvelous: Surrealism and the Contemporary Stage.* New York: New York University Press, 1975. Pp. 122–144.
 Excellent analysis of Carrington's art. Includes a discussion of plays written by the artist.

————. "Women of Surrealism." *Feminist Art Journal.* 2(Spring 1973):1, 15–21.

Petersen and Wilson. *Women Artists.* Pp. 131–132.

Ponce, Juan Garcia, and Leonora Carrington. *Leonora Carrington.* Mexico: Ediciones Era, 1974.

Collection:

Washington (D.C.), National Museum of Women in the Arts.

IMOGEN CUNNINGHAM. 1883–1976. United States.
 Cunningham was born in Portland, Oregon, and studied chemistry at the University of Washington. After college she worked in the Seattle studio of Edward S. Curtis. In 1909 she won a scholarship to study photographic chemistry in Dresden. Upon her return in 1910, she opened a portrait studio in Seattle. Cunningham married in 1915, moved to San Francisco, and had three sons. While her first interest was portraits, she turned to the study of flowers while raising her family. Following her

divorce, she returned to portraits. In the early 1930's she became one of the founding members, along with Edward Weston and Ansel Adams, of the F/64 group, instrumental in creating an interest in sharply realistic photographs instead of the previously favored soft-focus, painterly photographs. Between 1931 and 1936 Cunningham occasionally did assignments for *Vanity Fair*. In 1947 she opened a portrait studio in San Francisco. She also taught at the San Francisco Art Institute.

Beaton. *The Magic Image*. P. 756.
A good analysis of the stylistic changes in Cunningham's work.

Conrad, Barnaby, III. "An Interview with Imogen Cunningham." *Art in America*. 65(May 1977):42–47.
Cunningham's feisty personality shines through in this last interview before her death.

Craven, George. "Imogen Cunningham." *Aperture*. 11, no. 4(1964).
The entire issue is devoted to Cunningham and includes a chronology of her life, list of major exhibitions, and many reproductions. The major portion of the text is by Craven.

Cunningham, Imogen. *After Ninety*. Seattle: University of Washington Press, 1977.
Cunningham worked on this book of photographs of the elderly just before her death. The introduction is by Margaretta Mitchell.

———. *Photographs*. Seattle: University of Washington Press, 1970.
This is a collection of photographs taken by Cunningham between 1901 and 1970. The introduction is by Margery Mann.

Imogen Cunningham: A Portrait. Boston: New York Graphic Society, 1979.

Mann, Margery. *Imogen! Imogen Cunningham Photographs, 1910–1973*. Seattle: University of Washington Press, 1974.
Survey of over sixty years of Cunningham's career. The short essay by Mann is followed by 105 photographs presented in roughly chronological order.

Munsterberg. *A History of Women Artists*. Pp. 126, 131.

Stanford University Art Gallery. *Imogen Cunningham: A Celebration*. January 1977.

———. *Imogen Cunningham: Photographs, 1921–1967.* March 31–
April 23, 1967.
The introduction is by Beaumont Newhall.

Symmes. ''Important Photographs by Women.''
Symmes says Cunningham decided to pursue photography when
she saw reproductions of Kasebier's work in 1901. She originally
studied through a correspondence course.

Collections:

Detroit Institute of Arts.
New York, Museum of Modern Art.
Oakland Museum.
Washington (D.C.), Library of Congress.

SONIA DELAUNAY. 1885–1979. Russian/French.
This artist was born in the Ukraine and grew up in St. Petersburg. At
age eighteen she began two years of study in Karlsruhe, Germany, with
Ludwig Schmidt-Reuter. In 1905 she enrolled in the Académie de la
Palette in Paris. She married the German art dealer and critic Wilhelm
Uhde in 1909—mainly to prevent her family from insisting on her return
to Russia. The marriage was brief, for the following year she married
Robert Delaunay. They had one son. From 1914 to 1920 they lived in
Spain and Portugal. They worked together on a mural for the 1937 Paris
Exposition Internationale. Both were involved in the development of
Orphic Cubism. Robert Delaunay died in 1941, and Sonia spent the
remaining war years in southern France, returning to Paris in 1944 or
1945. Delaunay spent considerable time promoting her husband's work
after his death—organizing exhibitions and cataloging his works. It has
often been assumed that her work replicates and documents her hus-
band's achievements; actually, they collaborated closely and the exact
nature of their influence on each other is difficult to analyze. Her work
was wide-ranging in its scope and included bookbinding, tapestry work,
fabric design, interior decorations, clothing design, designs for film sets
and theater costumes, and she even worked out the design for painting a
car. In 1964 she became the first living woman artist to have an
exhibition of her work at the Louvre. Delaunay continued to work until
her death at the age of ninety-four.

Baber, Alice. ''Sonia Terk Delaunay.'' *Craft Horizons.* 33(December
1973):32–39.

An excellent summary of Delaunay's life with a good assortment of reproductions of her work in various media.

Bénézit. *Dictionnaire.* Vol. 3, p. 462.

Buffalo. Albright-Knox Art Gallery. *Sonia Delaunay: A Retrospective.* February 2–March 16, 1980.
Essays in this exhibition catalog are by Sherry A. Buckberrough. All facets of Delaunay's career are presented and illustrated. In addition to a biographical sketch, a list of exhibitions is provided. An excellent chronology by Susan Krane incorporates Delaunay's writings.

Clay, Jean. "The Golden Years of Visual Jazz: Sonia Delaunay's Life and Times." *Réalités.* [English language edition]. 1965. Pp. 42–47.

Cohen, Arthur, ed. *The New Art of Color: The Writings of Robert and Sonia Delaunay.* Trans. David Shapiro and Arthur Cohen. New York: Viking Press, 1978.

———. *Sonia Delaunay.* New York: Harry N. Abrahms, 1975.
Definitive work with many reproductions, photographs, and an extensive bibliography. Cohen compares the work of Robert and Sonia Delaunay. He also discusses how her work as a designer is related to her work as a painter.

———. "Sonia Delaunay: Memories of an Optimist." *Art News.* 79(March 1980):127.
Brief reminiscence of a friend of twenty years that captures the spirit and personality of the artist.

Craven, Arthur. "L'Exposition des Indépendants." *Maintenant.* Special issue (March–April 1914).

Damase, Jacques. *Sonia Delaunay.* Paris: Galerie de Varenne, 1971.
Biographical notes are by Edouard Mustelier.

———. *Sonia Delaunay: Rhythms and Colours.* Greenwich, Connecticut: New York Graphic Society, 1972.
The preface is by Michel Hoog.

———. "Sonia Delaunay: Un demi-siècle d'avant garde." *Connaissance d'art.* 308(October 1977):80+.
Includes excellent color illustrations.

Delaunay, Sonia. *Alphabet and robes-poemes.* Paris, 1969.
The text is by Jacques Damase.

―――. *Sonia Delaunay, ses peintres, ses objets, ses modes.* Paris: Librarie des Arts Decoratifs, 1925.

Desanti, Dominique. *Sonia Delaunay: magique magicienne.* Paris: Editions Ramsay, 1988.

Dorival, Bernard. "La donation Delaunay au Musée National d'Art Moderne." *La revue du Louvre.* Paris, 1963.

―――. "Les oeuvres récentes de Sonia Delaunay." *XXe siècle.* 36(June 1971):42–50.

―――. *Retrospective Sonia Delaunay.* Paris: National Museum of Modern Art, 1965.

―――. *The School of Paris in the Musée d'Art Moderne.*

―――. *Twentieth Century Painters.* New York: Universe Books, 1958.

Ferreira, Paulo. *Correspondance de quatre artistes portugais avec Robert et Sonia Delaunay.* Paris, 1972.

Fine. *Women and Art.* Pp. 169–171.
Fine says that Delaunay's work with fashion and fabric design diminished her reputation as an artist. This reflects the idea of craft as a secondary facet of art and as "woman's work."

Geneva. Galerie du Perron. *Sonia Delaunay.* 1969.
Exhibition catalog.

Gilioli, E. "Les tapis de Sonja Delaunay." *XXe siècle.* 34(June 1970):145–149.

Harris and Nochlin. *Women Artists, 1550–1950.* Pp. 60–61, 63, 65, 97, 291–294, 357.

Heller. *Women Artists.* Pp. 122–123.

Hill. *Women: A Historical Survey . . .* Catalog. P. 28.

Hoog, Michel. *R. et S. Delaunay: Inventaire des collections publique françaises.*

Lansner, Fay. "Arthur Cohen on Sonia Delaunay." *Feminist Art Journal.* 5(Winter 1976–1977):5–10.
Excellent summary of her life and work.

Madsen, Alex. *Sonia Delaunay: Artist of the Lost Generation.* New York: McGraw-Hill Publishing Company, 1989.
A well-documented and interesting biography. Contains a bibliography and photographs of the artist, her family, and friends.

Marter, Joan. "Three Women Artists Married to Early Modernists: Sonia Delaunay-Terk, Sophie Tauber-Arp and Marguerite Thompson Zorach." *Arts.* 54(September 1979):89–95.
Marter explores the parallels in the artistic development of these three women artists.

Molinari, Danielle. *Robert Delaunay, Sonia Delaunay.* Paris: Nouvelle Editions Français, 1987.

Mulhouse. Musée de l'Impression sur Etoffes. *Sonia Delaunay: Etoffes imprimées de années folles.* 1971.

Munsterberg. *A History of Women Artists.* Pp. 67–68.

National Museum of Women in the Arts. Pp. 138–139.

Nemser. *Art Talk.* Pp. 35–51, 360.
An interview accompanied by good black-and-white reproductions. Nemser explores the belated recognition of Delaunay's contribution to the development of Orphism.

Nochlin. "Why Have There Been No Great Women Artists?" P. 39.
Nochlin cites Delaunay as a major figure in the liberation of color. Includes a beautiful color reproduction of her tondo painting, *Rythme Couleur, Opus 1541,* of 1967.

Ornellas, B. "L'Hommage de Lisbonne à Robert et à Sonia Delaunay. *XXe siècle.* 100(December 1972):100–112.

Ottawa. The National Gallery of Canada. *Robert and Sonia Delaunay.* 1965.

The text, printed in French and English, was written by Michel Hoog. Bernard Dorival contributed the preface.

Paris. Bibliothèque Nationale. *Sonia and Robert Delaunay.* 1977.
This catalog contains excellent photographs of the artist throughout her career. A chronology is also included.

Paris. Galerie Denis René. *Sonia Delaunay.* 1968.
Exhibition catalog.

Paris. Musée National d'Art Moderne. *Retrospective Sonia Delaunay.* 1967.

Peppiatt, Michael. "Sonia Delaunay: A Life in Color." *Art News.* 74(March 1975):88, 91.

Petersen and Wilson. *Women Artists.* Pp. 104, 107, 111–113.

Rendell, Clare. "Sonia Delaunay and the Expanding Definition of Art." *Woman's Art Journal.* 4(Spring–Summer 1983):35–38.
Discussion of the wide range of Delaunay's artistic interests.

Rickey, Carrie. "Sonia Delaunay: Theater of Color." *Art in America.* 68(May 1980):90–101.
Excellent synopsis of Delaunay's life and work with numerous color reproductions.

Sonia Delaunay: Art into Fashion. New York: George Braziller, 1983.
Numerous illustrations accompany an introduction by Elizabeth Morano and a foreword by Diana Vreeland.

Vriesen, Gustav, and Max Imdahl. *Robert Delaunay.* New York: Harry N. Abrams, 1967.

Wallen, Burr. "Sonia Delaunay and Pochoir." *Arts.* 54(September 1979):96–101.
Wallen discusses Delaunay's use of the printmaking technique known as pochoir, which he describes as especially suited to her joyous spirit. Several reproductions accompany the article.

Collections:

Buffalo, Albright-Knox Gallery.
Los Angeles County Museum.

New York, Museum of Modern Art.
Paris, Musée National d'Art Moderne.

CAROLINE DURIEUX. 1896– . United States.
Durieux was a well-known lithographer and social satirist during the 1930's and 1940's. She grew up in the New Orleans Creole community and in 1913 began attending New Orlean's Sophia Newcomb College. In 1917 she began a brief period of study at the Pennsylvania Academy of Fine Arts. She married a New Orleans exporter in 1919, and by 1920 the couple was living in Cuba. From 1926 to 1936 they lived in Mexico City, where she became acquainted with Diego Rivera. On returning to New Orleans, she taught art at Newcomb College and from 1938 to 1943 Durieux served as director of the Federal Art Project for Louisiana. She joined the faculty of Louisiana State University in Baton Rouge in 1942. Working with nuclear scientists at the university, she developed the technology of the electron print. Durieux also revived the cliché verre technique of printmaking on glass. After 1950 her art became increasingly abstract.

Cox, Richard. *Caroline Durieux: Lithographs of the Thirties and Forties.* Baton Rouge: Louisiana State University Press, 1977.
Excellent biography describing her art and the influence of Mexico on her work. Describes many of her lithographs and includes fifty-eight reproductions.

———. "Southern Works on Paper, 1900–1950." *American Artist.* 45(October 1981):96.

Durieux, Caroline. *An Inquiry into the Nature of Satire.* M.A. thesis, Louisiana State University, Baton Rouge, 1949.

Rubinstein. *American Women Artists.* Pp. 225–226.
Excellent summary of her career and the source for much of the above biography.

"She Is 'Politely Cruel, Charmingly Venomous.' " *Art Digest.* 10(1 December 1935):14.
A review of a New York exhibition of Durieux's satirical paintings. Refers to her "feminine" sense of color.

Wickiser, Ralph; Caroline Durieux; and John McCrady. *Mardi Gras Day.* New York: Henry Holt and Co., 1948.
Description of New Orlean's Mardi Gras, illustrated with reproductions of prints by the authors.

Zigrosser, Carl. *The Artist in America.* New York: Alfred A. Knopf, 1942. Pp. 125–131.

Collections:

 Baton Rouge, Louisiana State Library.
 Baton Rouge, Louisiana State University.
 New York, Museum of Modern Art.
 New York Public Library.
 Philadelphia Museum of Art.
 Washington (D.C.), Library of Congress.

MABEL DWIGHT. 1876–1955. United States.

Dwight was born in Cincinnati, but spent her childhood in New Orleans and California. She studied painting in San Francisco at the Hopkins School of Art. Dwight traveled extensively in Europe and the Orient. She was best known for her work in lithography, first working in this medium in Paris in 1927. She also did watercolors and drawings. Between 1935 and 1939 Dwight painted watercolors for the Federal Art Project. Her scenes of urban dwellers have been described as satire and caricatures of the foibles of society.

Cox, Richard. "Southern Works on Paper, 1900–1950." *American Artist.* 45(October 1981):96.

Davidson, Martha. "Graphic Art of Exceptional Quality: Mabel Dwight." *Art News.* 36(January 8, 1938):14.

Kistler, Aline. "Prints of the Moment." *Prints.* 6(October 1935):47–48.

"Mabel Dwight, 79, an Artist, Is Dead." *New York Times* (September 5, 1955):11.

 Mentions that by 1929 Dwight had turned out more than one hundred prints of New York personalities.

Rubinstein. *American Women Artists.* Pp. 224–225.

"Satire in the Spirit of 'Aren't We All.' " *Art Digest.* 12(January 15, 1938):25.

 Brief review of Dwight's subject matter.

"Scenes from the Cinema by Mabel Dwight." *Vanity Fair.* 32(March 1929):54.
Includes two reproductions.

Zigrosser, Carl. *The Artist in America.* New York: Alfred A. Knopf, 1942. Pp. 145–151.

———. "Mabel Dwight, Master of Comédie Humaine." *American Artist.* 13(June 1949):42–45.
Reviews biographical facts, discusses subject content, and mentions an unpublished autobiography. Includes several reproductions.

Collection:

Philadelphia Museum of Art.

ABASTENIA SAINT LEGER EBERLE. 1878–1942. United States.
Eberle was born in Iowa, but grew up in Ohio and Puerto Rico. She was an accomplished musician, but abandoned that art form for sculpture. She moved to New York in 1899 to study at the Art Students League. Among her teachers were George Gray Barnard, Gutzon Borglum, and Kenyon Cox. In New York, in 1904 and 1905, she shared a studio and collaborated on sculpture with Anna Hyatt Huntington. Eberle did the figures, while Huntington contributed the animals. One of their collaborations won a prize at the 1904 St. Louis Exposition. Eberle traveled abroad twice—to Italy in 1907 and 1908 and to Paris in 1913. She exhibited four genre pieces at the National Academy of Design show in 1908, and she exhibited in the 1913 Armory Show. Eberle was influenced by the writings of Jane Addams, and her work became increasingly rich in social comment, often reflecting themes of labor and the life of working people. To immerse herself in these themes, she opened a studio in 1914 in the crowded tenement section of Manhattan's Lower East Side. She equipped her studio with a playroom, so visiting children could become her unconscious models. Eberle was elected to membership in the National Sculpture Society in 1906. She was an active supporter of women's rights. In 1919 she became seriously ill and was forced to give up her sculpture career. Her work has been described as Impressionistic, with socially conscious genre themes and with an interest in depicting motion.

"Abastenia Eberle, Long a Sculptor." *New York Times* (February 28, 1942):17.

Armstrong. *Two Hundred Years of American Sculpture.* P. 270.
 The source for much of the biographical information. Includes a
photograph of her.

Bénézit. *Dictionnaire.* Vol. 3, p. 479.

Casteras, Susan P. "Abastenia St. Leger Eberle's *White Slave.*"
 Woman's Art Journal. 7(Spring–Summer 1986):32–36.
 Discussion of a controversial work which Eberle exhibited in the
Armory Show of 1913.

Craven, Wayne. "Saint Leger Eberle, Abastenia.' In *Notable American
 Women, 1607–1950.* Vol. 1, pp. 548–549.

Des Moines Art Center. *Abastenia St. Leger Eberle, Sculptor (1878–
 1942).* July 15–August 17, 1980.
 The catalog essay is by Louise R. Noun.

Earl. *Biographical Sketches of American Artists.* P. 105.

Heller. *Women Artists.* P. 150.

Hill. *Women: A Historical Survey . . .* Catalog. P. xiii.

Payne, Frank. "The Tribute of American Sculpture to Labor." *Art and
 Archaeology.* 6(1917):87–91.
 Discusses her subject matter and includes a reproduction of *The
 Windy Doorstep.*

———. "The Work of Some American Women in Plastic Art." Pp.
 321–322.

Proske, Beatrice. "American Women Sculptors. Part I." Pp. 3–15.

———. *Brookgreen Gardens Sculpture.* Pp. 152–154.

Rubinstein. *American Women Artists.* Pp. 170–172.
 Relates her work to the Ashcan movement.

"Sculptor of Children Dies." *Art Digest.* 16(March 15, 1942):15.
 Obituary.

Tinling. *Women Remembered.* P. 509.

"Without Prejudice." *International Studio.* 73(March 1921):iii–v.
Review of an exhibition of her work. Includes black-and-white
reproductions.

Collections:

Chicago Art Institute.
New York, Metropolitan Museum of Art.
New York, Whitney Museum of American Art.
Webster City (Iowa), Kendell Young Library.

ALEXANDRA EXTER. 1882–1949. Russian.
Exter was a Russian avant-garde artist with an interest in theatrical
design. She was born near Kiev and died in Paris. In 1907 she studied art
in Kiev and took part in several Kiev exhibitions. Although she had a
home and a husband in Russia, she spent a large part of each year from
1907 to 1914 in Paris where she had a studio. Exter exhibited at Milan's
"Free Futurist Exhibition" in 1914. She designed her first theatrical
production in Moscow in 1916. In 1918 she opened her own studio in
Kiev and had several students. Exter moved to Paris in 1924 and
continued her interest in stage design while teaching at Leger's Aca-
démie d'Art Moderne until the early 1930's. She painted and created
collages in a Cubist style. She also designed some rather Cubist
marionettes and worked in textile design. Exter is credited with introduc-
ing French Cubism to Russia and Russian art to Paris. She died in
poverty.

Bénézit. *Dictionnaire.* Vol. 4, p. 224.

Betz, Margaret. "Alexandra Exter, Marionettes." *Art News.* 75(January
 1976):128.

Bowlt, John. "Russian Exhibitions, 1904–1922." *Form* (September
 1968).

———. "When Life was a Cabaret." *Art News.* 83(December
 1984):122–127.
 Discussion of the Russian avant-garde artists whose scenic theater
designs drew on Russian folk traditions, such as the circus and
cabaret. Bowlt notes that in 1924 Exter did designs for a cinematic
space fantasy *Aelita.* She also created "epidermic" costumes, or
costumes which were painted on the actors' bodies.

Cohen, Ronny H. "Alexandra Exter and Western Europe: An Inquiry into Russian-Western Relations in Art, Theater and Design in the Early Twentieth Century." Ph.D. dissertation, Institute of Fine Arts, New York University, 1979–80.

————. "Alexandra Exter's Designs for the Theater." *Artforum.* 19(Summer 1981):46–49.
Cohen discusses Exter's sources and influences. Her early work for Moscow's Kamernyi Theater is described.

————. "The Russian Revolution in Art—3." *Artforum.* 19(March 1981):83–84.
Review of an exhibition of works by Russian avant-garde artists. Cohen believes Exter's three-dimensional figure-costume constructions, the "knock-out of the show," could have been models for courses she taught in stage and costume design in Russia and in Paris. Exter is credited with being the first to create and to teach a "truly modernist style of constructed theater design." Includes several reproductions.

Cologne. Galerie Gmurzynska. *From Surface to Surface: Russia, 1916–24.* September 18–November 1974. P. 88.
Exhibition catalog with translation and introduction by John Bowlt. He notes that Exter was a supporter of Suprematism.

Compton, Susan. "Alexandra Exter and the Dynamic Stage." *Art in America.* 62(September 1974):100–102.
Good review of Exter's stage and film art. Discusses the influence of the director Alexander Tairov on her work. Excellent reproductions are included.

Elderfield, John. "On Constructivism." *Artforum.* 9(May 1971):61–62.
Two reproductions of Exter's work are provided.

Exter, Alexandra. *Décors de théâtre.* Paris, 1930.
Preface by Alexander Tairov.

Fine. *Women and Art.* Pp. 165–166.

Gray, Camilla. *The Russian Experiment in Art, 1863–1922.* New York, 1972.

Greer. *The Obstacle Race.* P. 9.

Harris and Nochlin. *Women Artists, 1550–1950.* Pp. 60–63, 288–290, 357.
 Give Exter's birth name as Grigorovich.

Heller. *Women Artists.* Pp. 125–126.

Hilton, Alison. "When the Renaissance Came to Russia." *Art News.* 70(December 1971):36–39.
 Good color reproductions of Exter's work.

Kramer, Hilton. "Bringing Cubism to the Stage." *New York Times* (May 5, 1974):21.

Lozowick, Louis. "Alexandra Exter's Marionettes." *Theatre Arts Monthly.* 12(July 1928):514–519.

Marcadé, Jean-Claude. "Femmes d'avant-garde sur fond Russe." *L'oeil.* 334(May 1983):38–45.
 Good discussion of Exter's involvement in theatrical design.

National Museum of Women in the Arts. Pp. 136–137.

New York. Leonard Hutton Galleries. *Alexandra Exter: Marionettes Created in 1926.* 1975.

————. *Russian Avant-Garde, 1908–1922.* 1971.

New York. Public Library at Lincoln Center, Vincent Astor Gallery. *Artist of the Theatre: Alexandra Exter.* Spring–Summer 1974.
 Exhibition catalog. Several short essays summarize Exter's life. A list of her theatrical projects is included.

Paris. Galerie Jean Chauvelin. *Alexandra Exter.* 1972.
 Catalog by Andrei B. Nakov.

Petersen and Wilson. *Women Artists.* Pp. 113, 115.

Sutton, Denys. "Love at First Sight." *Apollo.* 107(March 1978):206.
 Brief description of marionettes designed by Exter in 1926 in Paris for a film by Peter Gad. The film was never produced.

Tairov, Alexander. *Notes of a Director.* Trans. William Kuhlke. Miami: University of Miami Press, 1969.
 Tairov is the director for whom Exter did stage designs.

Tugendhold, Yakov A. *Alexandra Exter.* Berlin, 1922.

Collection:

Washington (D.C.), National Museum of Women in the Arts.

LEONOR FINI. 1918– . Italian.
 Fini was born in Buenos Aires to Italian parents and raised in Trieste. Essentially a self-taught artist, she settled in Paris in 1935. Though she never attended Surrealist meetings and did not accept the appellation, preferring to maintain her autonomy, she participated in their group shows and is considered a Surrealist painter. Fini has also been involved in theater design and book illustration. Her work frankly explores matriarchy, lesbianism, and androgyny. She often works in egg tempera and is noted for her use of brilliant color. Her use of glazes is especially noteworthy. A major retrospective of her work was held in Japan in 1972.

Bénézit. *Dictionnaire.* Vol. 4. p. 371.

Brion, Marcel. *Leonor Fini et son oeuvre.* Paris: Jean-Jacques Pauvert, 1955.
 An illustrated monograph.

Carrieri, Raffaele. *Leonor Fini.* Collona di monografie d'arte italiana moderna, 7. 1951.

———. *Leonor Fini.* Milan: Galleria, 1951.

Chadwick. "The Muse as Artist: Women in the Surrealist Movement."

———. *Women Artists and the Surrealist Movement.* Pp. 80–82, 86–87, 110–113, 187–189, 241.

Clement, Virginia. "Leonor, un souterrain nommé désir." *Aesculape.* 36(March 1954):67.

Fini, Leonor, and José Alvarez. *Le livre de Leonor Fini: peintures, dessins, écrits, notes de Leonor Fini.* Paris: Clairefontaine-Vilo, 1975.

Gaggi, Silvio. "Leonor Fini: A Mythology of the Feminine." *Art International.* 23(September 1979):34–39, 49.
Detailed discussion of Fini's imagery. Notes that she is known in France as much for her theatrical designs as for her paintings. Gaggi classifies Fini as a fantasy artist.

Gauthier, Xavière. *Leonor Fini.* Paris: Le Musée de Poche, 1973.

Genet, Jean. *Lettre à Leonor Fini.* Paris: Loyau, 1950.

Guibbert, Jean Paul. *Leonor Fini graphique.* Lusanne: Editions Clairefontaine, 1971.

Harris and Nochlin. *Women Artists, 1550–1950.* Pp. 329–331, 361.

Heller. *Women Artists.* P. 159.

Jean, M. *History of Surrealist Paintings.* 1959.

Jelenski, Constantin. *Leonor Fini.* New York: Olympia Press, 1968.
A beautiful book augmented by numerous tipped-in color plates, black-and-white reproductions, and photographs. The extensive bibliography has supplied many of the references offered here. The book is severely flawed, however, by a text which is obscure to the point of being ridiculous. In spite of this, the reproductions make it invaluable.

Joloux, Edmond; Paul Eluard; Alberto Moravia; George Hugnet; Charles Henri Ford; Mario Praz; and Alberto Savio. *Leonor Fini.* Rome: Sansoni, 1945.
An illustrated monograph.

Jouffrey, Alain. "Portrait d'un artiste (iv): Leonor Fini." *Arts.* 541(November 9–15, 1955):9.

Lanoux, Armand. "Instants d'une psychanalyse critique: Leonor Fini." *La table ronde.* 108(December 1956):184.

Lauter, Estella. "Leonor Fini: Preparing to Meet the Strangers of the New World." *Women's Art Journal.* 1(Spring–Summer 1980):44–49.
Good biographical summary, including a brief mention of Fini's periods of communal living. Traces chronologically the development of her imagery.

————. *Women as Mythmakers.* Pp. 114–128.
Discusses the goddess images in Fini's work.

Mandiargues, André Peyré de. *Les masques de Leonor Fini.* Paris: André Bonne, 1951.

Monegal, Emir R. "La pintura como exorcismo." *Mundo nuevo.* 16(October 1967):5–21.

Munsterberg. *A History of Women Artists.* Pp. 80–81.

Orenstein. "Women of Surrealism." Pp. 15–21.

Parker and Pollock. *Old Mistresses.* Pp. 137–143.

Petersen and Wilson. *Women Artists.* Pp. 132–133.

Styles-McLeod, Catherine. "Architectural Digest Visits Leonor Fini." *Architectural Digest.* 43(March 1986):156–163, 210.
Photographs of Fini's apartment in Paris and her country home on the Loire River are combined with a brief psychological portrait of the artist.

Webb, Peter. "Leonor Fini Retrospective." *Burlington Magazine.* 128(September 1986):699–700.
Report of retrospective held at the Musée du Luxembourg in Paris, which included over 100 watercolors and drawings, 80 theater and costume designs, 5 masks, 70 paintings, and 14 books with original illustrations.

Wilding, Faith. "Women Artists and Female Imagery." *Everywoman.* (May 7, 1971).

HELEN FRANKENTHALER. 1928– . United States.
Frankenthaler was born into a privileged and supportive family. Her father was a New York State Supreme Court justice. She attended private schools and her art teacher during her high school years at the Dalton School was Rufino Tamayo. Frankenthaler traveled in Europe in 1948 and the following year graduated from Bennington College. She then spent a semester as a graduate student in art history at Columbia University before devoting herself to a painting career. Her first one-woman show was in 1951. She married the painter Robert Motherwell in 1958; they divorced in 1971. Frankenthaler works on very large

canvases of cotton duck (providing a bright white rather than the tan of linen) without priming. Colors are then "stained" on in brilliant washes which are evocative of landscapes. Morris Louis and Kenneth Noland, both color-field painters, have publicly acknowledged their debt to her. Frankenthaler won first prize at Venice Biennale in 1959, and the Whitney Museum of American Art held a retrospective of her work in 1969.

Baro, Gene. "The Achievement of Helen Frankenthaler." *Art International.* 11(September 20, 1967):33–38.

Belz, Carl. "Helen Frankenthaler's 'Eden.' " *Art News.* 80(May 1981):156–157.
 Belz advocates a new appreciation for Frankenthaler's work of the 1950's.

Carmean, E. A. *Helen Frankenthaler: A Paintings Retrospective.* New York: Abrams, 1989.
 Catalog of a traveling exhibition.

———. "On Five Paintings by Helen Frankenthaler." *Art International.* 22(April–May 1978):28–32.
 Carmean discusses the development of Frankenthaler's style by examining a series of her paintings.

Champa, Kermit. "New Work of Helen Frankenthaler." *Artforum.* 10(January 1972):55–59.
 Good stylistic analysis. Includes a color reproduction.

Elderfield, John. *Frankenthaler.* New York: Harry N. Abrams, 1989.
 Full-length historical and critical study of Frankenthaler's work, in a large-format publication with 260 beautiful color reproductions. In this well-documented study, Elderfield places her art in the context of that of her contemporaries. A detailed chronology, list of exhibitions, bibliography, and 138 additional black-and-white reproductions are included.

———. "Specific Incidents." *Art in America.* 70(February 1982):100–106.
 Elderfield discusses Frankenthaler's turpentine-thinned images of the 1950's. Color reproductions are included.

Faxon, Alicia. "Helen Frankenthaler: Radical Technique, Created Color School." *Boston Globe* (August 16, 1972).

Fine. *Women and Art.* Pp. 216–219.

Forge, Andrew. "Frankenthaler: The Small Paintings." *Art International.* 22(April–May 1978):21–25, 33.

Friedman, B. H. "Towards the Total Color Image." *Art News.* 65(Summer 1966):31–33, 67–68.

Galligan, Gregory. "An Interview with Helen Frankenthaler: 'There Are Many More Risks to Take.' " *Art International.* 7(Summer 1989):45–52.
 Frankenthaler discusses her recent work and her interest in sculpture. Several excellent color reproductions are included.

Geldzahler, Henry. "An Interview with Helen Frankenthaler." *Artforum.* 4(October 1965):36–38.
 Discussion of early influences on her work and of her use of acrylic.

Goldman, Judith. "Painting in Another Language." *Art News.* 74(September 1975):cover photo, 28–31.

Goossen, Eugene C. *Helen Frankenthaler.* New York: Whitney Museum of American Art and Praeger, 1969.
 Catalog from the 1969 Whitney Museum exhibition of her work. Discusses the chronological progression of her paintings; includes an extensive bibliography and many reproductions, some in color.

Helen Frankenthaler Prints, 1961–1979. New York: Harper and Row, in association with the Williams College Artist-in-Residence Program, 1980.

Heller. *Women Artists.* Pp. 169, 171.

Hill. *Women: A Historical Survey . . .* Catalog. P. 51.

Hoving, Thomas. "The Next Link in the Chain." *Connoisseur.* 214(March 1984):15.
 Praises her work of 1983 as paintings that "entice grand reflections on the development of all modern art; paintings that are virtually certain to make history."

Judd, Donald. "Helen Frankenthaler." *Arts.* 37(April 1963):54.
 Brief exhibit review.

Kramer, Hilton. *The Age of the Avant-Garde.* New York: Farrar, Straus, and Giroux, 1973. Pp. 392–394.

Mackie, Alwynne. "Helen Frankenthaler: Sculpture as Painting." *Art International.* 22(April–May 1978):26–27, 33.
Discussion of Frankenthaler's clay sculpture, produced in the previous two years. Good reproductions are included.

Munro. *Originals: American Women Artists.* Pp. 207–224.

Munsterberg. *A History of Women Artists.* Pp. 77–78.

National Museum of Women in the Arts. Pp. 102–103.

Nemser, Cindy. "Interview with Helen Frankenthaler." *Arts.* 46(November 1971):51–55.
Brief discussion of Frankenthaler's recent work, accompanied by one color and several black-and-white reproductions.

Rose, Barbara. *Frankenthaler.* New York: Harry N. Abrams, 1972.
A lavish monograph with many color reproductions. Includes a biographical outline, bibliography, and lists of reviews and exhibitions.

———. "Painting Within the Tradition: The Career of Helen Frankenthaler." *Artforum.* 7(April 1969):28–33.
Discusses the influence of Jackson Pollock on Frankenthaler's method of painting and her contributions in color-field work.

Rubinstein. *American Women Artists.* Pp. 326–330.
Good description of Frankenthaler's working methods.

Shaw-Eagle, Joanna. "A Conversation with Helen Frankenthaler." *Architectural Digest.* 38(June 1981):172–182.
Discusses Frankenthaler's work in the print medium.

Schuyler, James. "Helen Frankenthaler Exhibition." *Art News.* 58(May 1960):13.

Washington, D.C. Corcoran Gallery of Art. *Helen Frankenthaler Paintings, 1969–1974.* April 20–June 1, 1975.
Exhibition catalog. The introduction is by Gene Baro.

Wilkin, Karen. *Frankenthaler: Works on Paper, 1949–1984.* New York:
G. Braziller, in association with the International Exhibitions Founda-
tion, 1984.
 Excellent chronological analysis of the stylistic evolution of Frank-
enthaler's work. Includes many excellent color reproductions.

Collections:

 Brooklyn Museum.
 Washington (D.C.), National Museum of Women in the Arts.

META VAUX WARRICK FULLER. 1877–1968. United States.
 Fuller was a prolific sculptor and influential teacher whose career
was hindered by financial difficulties and racial discrimination. Her
color was a barrier to both sales and exhibitions of her work. She was
born in Philadelphia where she won a three-year scholarship to study at
the Pennsylvania Museum and School of Industrial Art. In 1899 she
went to Paris for further study at the Colarossi Academy. During her
second year in Paris, she received encouragement from Rodin. As would
be expected, her early works were quite romantic. On her return from
abroad in 1904 Fuller opened a studio in Philadelphia. Her first major
commission came in 1907 when she was asked to create a tableau of 150
figures for the Jamestown Tercentennial Exposition to illustrate the
progress of blacks in the United States, for which she won a gold medal.
In 1909 she married Solomon Fuller, a noted physician, and moved to
Framingham, Massachusetts. A tragic fire in 1910 destroyed her tools
and all the work she had created in Paris. She then turned her attention to
raising her three sons. In the 1950's Fuller's production diminished as
she cared for her dying husband and was herself confined for two years
in a sanatorium for the treatment of tuberculosis. She actively returned to
work in the 1960's. Most of her sculpture is figurative.

Butcher, Margaret Just. *The Negro in American Culture.* New York:
 Alfred A. Knopf, 1973. Pp. 220–221.

Cederholm. *Afro-American Artists.* Pp. 98–99.

Driskell, David. "The Flowering of the Harlem Renaissance: The Art of
 Aaron Douglas, Meta Warrick Fuller, Palmer Hayden, and William H.
 Johnson." In *Harlem Renaissance: Art of Black America.* New York:

Studio Museum in Harlem and Harry N. Abrams, 1987. Pp. 107–109, 113–118.

Driskell discusses Fuller's art as symbolic of the style and spirit of the Harlem renaissance. He describes her approach to art as "pan-Africanist." He also notes the strong influence of Rodin on her work. Nine excellent color reproductions of her work are included.

Fax, Elton C. *Seventeen Black Artists.* New York: Dodd, Mead and Co., 1971. Pp. 5–6.

Hoover, Velma J. "Meta Vaux Warrick Fuller: Her Life and Art." *Negro History Bulletin.* 40(March–April 1977):678–681.
A reminiscence and biographical summary by a family friend.

Kellner, Bruce, ed. *The Harlem Renaissance: A Historical Dictionary for the Era.* Westport, Connecticut: Greenwood Pres, 1984. Pp. 131–132.
An excellent biographical summary and the source for most of the information presented here.

Lewis, Samella. *Art: African American.* New York: Harcourt, Brace, Jovanovich, 1978. Pp. 53–55.

Logan, Rayford. "Fuller, Meta Vaux Warrick." In *Notable American Women: Modern Period.* Vol. 4, pp. 255–256.

Porter. *Modern Negro Art.* Pp. 86–87.

Rubinstein. *American Women Artists.* Pp. 207–209.

Tinling. *Women Remembered.* P. 55.

Collections:

Atlanta, Y.M.C.A.
Boston Museum of Afro-American History.
Cleveland Museum of Art.
New York Public Library, Schomburg Collection.
San Francisco, Palace of the Legion of Honor.
Washington (D.C.), Howard University, Gallery of Art.

LAURA GILPIN. 1891–1979. United States.

Gilpin was the foremost photographer of the landscape of the Southwest and of its native people. She studied photography at the Clarence White School in New York City in 1916 and 1917 while sharing an apartment with Brenda Putnam and two other women artists. She then returned to her native Colorado Springs to begin her career as a professional photographer. Her early works were soft-focus, romantic views. Later works became sharply focused. In 1922 she traveled to Europe with Putnam. During the Second World War Gilpin did commercial photography for the Boeing Company in Wichita, Kansas. After the war she moved to Santa Fe. Gilpin published four major books that established her as an important commentator on the culture and geography of the Southwest.

"An Enduring Grace." *Americana.* 13(January–February 1986):20–22.

Gilpin bequeathed all of her 20,000 negatives and 27,000 prints, correspondence, and photographic books to the Amon Carter Museum in Fort Worth, Texas. The museum held a major retrospective of her work in January 1986.

Gilpin, Laura. *The Enduring Navaho.* Austin: University of Texas Press, 1968.

———. *The Pueblos: A Camera Chronicle.* New York: Hastings House, 1941.

Includes seventy-five of her photographs.

———. *The Rio Grande: River of Destiny.* New York: Duell, Sloan and Pearce, 1949.

———. *Temples in Yucatan: A Camera Chronicle of Chichen Itza.* New York: Hastings House, 1948.

Norwood, Vera. "The Photographer and the Naturalist: Laura Gilpin and Mary Austin in the Southwest." *Journal of American Culture.* 5(Summer 1982):1–28.

Norwood explores the relationships between the nature writing of Austin and Gilpin's photographs. She concludes that each was involved in building a base for a support system for women's lives in the wilderness. Several of Gilpin's photographs are reproduced.

Sandweiss, Martha. *Laura Gilpin: An Enduring Grace.* Fort Worth: Amon Carter Museum, 1986.

This is the first book devoted to the life and work of Gilpin.

Sandweiss, the curator of photographs at the Amon Carter Museum, includes a list of Gilpin's exhibitions, a bibliography, and a list of published photographs. Forty of Gilpin's photographs illustrate the book.

————. *Laura Gilpin (1891–1979): Photographer of the American Southwest.* Ph.D. dissertation, Yale University, 1985.

Whelan. "Are Women Better Photographers than Men?" Pp. 80–82.

Collections:

Detroit Institute of Arts.
Fort Worth, Amon Carter Museum of Western Art.

ANNE GOLDTHWAITE. 1869–1944. United States.
Called an American regionalist, painter Goldthwaite came from a sheltered, conservative background. She was born in Montgomery, Alabama. Her father was a former Confederate officer. She studied painting with Walter Shirlaw and etching with Charles Mielatz at the National Academy of Design in New York. She also studied at the Académie Moderne in Paris. Goldthwaite exhibited at the Armory Show of 1913. For over twenty-three years she taught at the New York Art Students League. From 1937 to 1938 she was president of the New York Society of Women Artists. Goldthwaite's art was diverse. She was commissioned to do murals for post offices in Alabama, produced over two hundred prints, painted, and made fired clay sculpture. Her subject matter often drew on Southern scenes and included portraits, still lifes, and landscapes.

"Anne Goldthwaite." *Art Digest.* 18(February 15, 1944):23.

Bénézit. *Dictionnaire.* Vol. 5, p. 94.

Breeskin, Adelyn. "Impressionist from the South: Remembering Anne Goldthwaite." *Art News.* 43(October 15, 1944):24.

Breuning, Margaret. "League Honors Anne Goldthwaite." *Art Digest.* 20(November 15, 1945):25.
Brief review of an exhibition of her work.

Cox, Richard. "Southern Works on Paper, 1900–1950." *American Artist*. 45(October 1981):96.

Hill. *Women: A Historical Survey* . . . Catalog. Plate 32.

Montgomery, Alabama. Montgomery Museum of Fine Arts. *Anne Goldthwaite: 1896–1944*. March 22–May 1, 1977.
 The brief introductory essay, which summarizes Goldthwaite's life and career, is by Adelyn Breeskin. A list of her exhibitions is included, along with several black-and-white reproductions of her work.

Rubinstein. *American Women Artists*. Pp. 178–179.
 Rubinstein says Goldthwaite moved to New York after a suitor was killed in a duel. She also notes that Katherine Dreier was a lifelong friend.

Tinling. *Women Remembered*. Pp. 115–116.

Collections:

> Boston Museum of Fine Art.
> New York, Metropolitan Museum of Art.
> New York, Whitney Museum of American Art.
> Providence, Rhode Island School of Design, Museum of Art.
> Seattle Art Museum.
> Washington (D.C.), National Collection of Fine Arts.

NATALIA GONCHAROVA. 1881–1962. Russian.
 Goncharova and her husband, Mikhail Larionov, were the founders of the Rayonist movement, a Russian offshoot of Cubism that was also related to Futurism. She was born near Tula, Russia, and her father was an architect. Gocharova studied at the Moscow Institute of Painting, Sculpture, and Architecture where, in 1900, she met Larionov. They lived and worked together the rest of their lives, but did not marry until 1955. She began exhibiting in 1900. Gocharova was greatly influenced by traditional Russian folk art and was partly responsible for creating an interest in primitive art and a renewed appreciation of icons. She worked closely with Malevich from 1906 to 1912. In 1912 she exhibited in the second Blaue Reiter exhibition and in Roger Fry's Postimpressionist exhibition in London. She and Larionov moved to Paris in 1914. Goncharova was also actively involved in costume and stage design.

Apollinaire, Guillaume. "La vie anecdotique—Madame de Gontcharova et Monsieur Larionov." *Mercure de France.* 422(January 16, 1916):373.

Basel. Galerie Beyeler. *Gontcharova et Larionov.* July–September 1961. Exhibition catalog with several color reproductions.

Betz, Margaret. "The Icon and Russian Modernism." *Artforum.* 15(Summer 1977):38–45.
Discusses briefly Goncharova's religious paintings, 1909–1911, that adopted the mood and subject matter of traditional icons.

Bowlt, John. "Natalia Goncharova and Futurist Theater." *Art Journal.* 49(Spring 1990):44–51.
Bowlt says theater was the principal area in which Goncharova excelled. Includes several black-and-white reproductions of her designs for theatrical productions.

———. "Neo-Primitivism and Russian Painting." *Burlington Magazine.* 116(March 1974):133–140.

Brussels. Musée d'Ixelles. *Retrospective: Larionov, Gontcharova.* April 29–June 6, 1976.
Excellent color reproductions and a chronology are provided.

Chamot, Mary. "The Early Work of Goncharova and Larionov." *Burlington Magazine.* 97(1955):170–174.

———. *Goncharova: Stage Designs and Paintings.* London: Oresko Books, 1979.
Excellent essay summarizes her career. Includes many excellent reproductions of her paintings and theatrical designs, several in color.

———. *Gontcharova.* Paris: La Bibliothèque des Arts, 1972.
This book contains color reproductions.

———. "Russian Avant-Garde Graphics." *Apollo.* 98(December 1973):494.
Discussion of her graphic work with color reproductions.

———, and Camilla Gray. *A Retrospective Exhibition of Paintings and Designs for the Theater: Larionov and Goncharova.* London: London Arts Council, 1961.
Exhibition catalog.

Dabrowski, Magdalena. "The Formation and Development of Rayonism." *Art Journal.* 34(Spring 1975):200–207.
Discusses Goncharova's role in the Rayonist movement.

Davies, Ivor. "Primitivism in the First Wave of the Twentieth-Century
Avant-Garde in Russia." *Studio International.* 186(September
1973):80–84.
Discusses the seventeenth-century icons, toys, and popular woodcuts that Goncharova and Larionov utilized in their development of
neoprimitive art.

Denvir, Bernard. "The Lost Generation." *Art International.* 17(December 1973):15–17.
General discussion of Russian art from 1900 to 1920.

Eganbiuri, Eli. [I. Zdanevich]. "Goncharova i Larionov." *Zharptitsa
(Jar-Ptiza).* 7(1922):39–40.

———. *Nataliia Goncharova, Mikhail Larionov.* Moscow, 1913.

Fine. *Women and Art.* Pp. 162–165.
Notes that Goncharova and Larionov did not marry until 1955,
when both were seventy-four years old.

Goncharova, Natalia. *Les Ballet Russes.* Paris: L'Imprimerie Union,
1955.

———. "Predislovie K Katalogu vystavki. 1913g" (preface to exhibition catalog, 1913). Reprinted in *Maestera iskusstva ob iskusstve.* Ed.
A. Fedorov-Davydov and G. Nedoshivin. Moscow, 1970. Vol. 7, pp.
497+.

Gray, Camilla. "The Russian Contribution to Modern Painting."
Burlington Magazine. 102(1960):205–211.

———. *The Russian Experiment in Art, 1863–1922.* New York: Harry
N. Abrams, 1962.
Includes discussion of the work of Goncharova and other women
artists. Accompanied by color reproductions.

Greer. *The Obstacle Race.* P. 9.

Harris and Nochlin. *Women Artists, 1550–1950.* Pp. 60–64, 96, 283,
286–288, 356.

Heller. *Women Artists.* Pp. 123–124.

Hill. *Women: A Historical Survey . . .* Catalog. P. xiii.

Hilton, Alison. "When the Renaissance Came to Russia." *Art News.*
70(December 1971):34–39, 56–62.

Khardzhiev, N. "Pamiati Natalii Goncharovy (1881–1962) i Mikhail a
Larionova (1881–1964)." *Iskusstvo knigi.* 5(1968):306–318.

Loguine, Tatiana, ed. *Gontcharova et Larionov: 50 ans à St. Germain
des Prés.* Paris: Editions Klincksieck, 1971.
 Illustrated work.

"The Metamorphoses of the Ballet 'Les Noches.' " *Leonardo.*
12(Spring 1979):137–143.
 This is a translation by Mary Chamot of a French version of part of
an article originally published in 1932 in *Russkiy Arkhiv.* The original
was written by Goncharova and consists of her recollections of a
seven-year period. Discusses the sources of her images for costumes,
curtains, and decorations for the Stravinsky work. Includes several
black-and-white reproductions.

National Museum of Women in the Arts. Pp. 134–135.

Orenstein, Gloria. "Natalia Goncharova: Profile of the Artist—Futurist
Style." *Feminist Art Journal.* 3(Summer 1974):3–6, 19.
 Excellent summary of her life and artistic development. Includes
several black-and-white reproductions.

Parnak, V. *Gontcharova et Larionov: L'art décoratif théâtral moderne.*
Paris: Editions la Cible, 1920.

Parton, Anthony. "Russian 'Rayism'—The Work and Theory of
Mikhail Larionov and Natalya Goncharova, 1912–1914: Ouspensky's
Four-Dimensional Super Race?" *Leonardo.* 16(Autumn 1983):298–
305.
 Believes the works of Larionov and Goncharova gave visual
expression to the theories of the fourth dimension of space, popular-
ized by Ouspensky's writings, published in St. Petersburg from 1909
to 1913.

Petersen and Wilson. *Women Artists.* Pp. 104, 112–116.

Sarab'ianov, D. "Neskol'ko slov o Natalii Goncharovoi" (Some words
on Natalia Goncharova). *Prometei.* 7(1969):201–203.

Tsvetaeva, M. "Natal'ia Goncharova." *Prometei.* 7(1969):144–201.
Written in 1929.

Tufts. *Our Hidden Heritage.* Pp. 210–221.

TugendKol'd, Ya. "Vystavka Kartin Natalii Goncharovoi (Pis'mo iz
Moskvy)" (Exhibition of paintings by Natalia Goncharova—Letter
from Moscow). *Apollon* (1913):71–73.

Collections:

Hartford (Connecticut), Wadsworth Atheneum.
London, Tate Gallery.
New York, Solomon R. Guggenheim Museum.
New York, Museum of Modern Art.
Paris, Musée National d'Art Moderne.
Washington (D.C.), National Museum of Women in the Arts.

ELIZABETH SHIPPEN GREEN. 1871–1954. United States.
Green studied at the Pennsylvania Academy with Thomas Anshutz,
Thomas Eakins, and Robert Vonnoh. In 1896, when she began studying
with Howard Pyle, she had already sold illustrations to several well-
known magazines. Green began her career as an illustrator by doing
advertisements and later did drawings for children's poems and stories.
She had the responsibility of being the sole financial support of her
parents. For fourteen years she shared studio space and a home with
Violet Oakley and Jessie Willcox Smith. This trio of artists held a joint
exhibition in 1902. After the death of her parents in 1911, she married
the architect Huger Elliott and moved with him to Rhode Island.
Following his death in 1951 she returned to live with her Philadelphia
friends. Green was named the first woman staff artist for *Harper's*
magazine and remained under contract with them until 1924. She
especially liked to illustrate historical books and short stories. Her work
has been described as having strong formal qualities and a subtle color
sense.

Earl. *Biographical Sketches of American Artists.* P. 135.
Earl says that Green studied abroad for six years.

Goodman. "Women Illustrators of the Golden Age of American Illustration." Pp. 17–18.

Likos, Patt. "The Ladies of the Red Rose." *Feminist Art Journal.* 5(Fall 1976):11–15, 43.

Excellent review tracing the relationship of Green, Oakley, and Smith. Includes a photograph of Green and a reproduction of her work. Likos also participated in the 1977 Annual Meeting of the College Art Association, discussing the relationship of the three women in a program on Women and Communal Art.

Morris, Harrison. "Elizabeth Shippen Green." *Book Buyer.* 24(March 1902):111–115.

Mentions the numerous magazines for which Green did illustrations. Includes several good reproductions of her work.

Rubinstein. *American Women Artists.* P. 162.

Stryker, Catherine C. *The Studios at Cogslea.* Wilmington: Delaware Art Museum, 1976.

LILIAN WESCOTT HALE. 1881–1963. United States.

Lilian Wescott was born in New England. Her first art teacher was William Merritt Chase. Later, she studied at the Boston Museum School with Edmund C. Tarbell and Philip Hale. At the age of nineteen she married Philip Hale. They had one daughter. Hale made several trips to Paris between 1881 and 1885 and in 1885 exhibited in the Paris Salon. Many of her works consist of carefully arranged figures, often mothers and children, with still-life elements. In addition to painting, Hale was also an active printmaker.

Berry, Rose V. S. "Lilian Wescott Hale—Her Art." *American Magazine of Art.* 18(February 1927):59–70.

Berry is effusive in her praise of Hale's art, but offers little in the way of biography. Includes several black-and-white reproductions.

Gammell, R. H. Ives. *The Boston Painters, 1900–1930.* Orleans, Massachusetts: Parnassus Imprints, 1986. Pp. 123–125.

Gammell attempts to explain Hale's success as the result of her husband's influence, while at the same time admitting the superiority of her paintings.

Hale, Nancy. *The Life in the Studio.* Boston: Little, Brown and Company, 1969.

Beautifully written biography by Hale's daughter. It illustrates how life in the studio was integrated into the totality of the artist's life and family.

Leader, Bernice K. "Antifeminism in the Paintings of the Boston School." *Arts.* 56(January 1982):117–118.
A discussion of the tendency of male Boston painters of the period from 1890 to 1918 to portray women as idealized dreamers in domestic interiors rather than as the energetic, publicly active reformers that they often were. Hale's husband, Philip, is included in the discussion, which notes that he was probably threatened by her success as an artist.

National Museum of Women in the Arts. Pp. 54–55.
Includes William Rimmer and William Morris Hunt among her teachers. Notes that she moved to Washington, D.C., in 1902.

Rubinstein. *American Women Artists.* P. 164.

Collections:

Boston Museum of Fine Arts.
Washington (D.C.), National Museum of Women in the Arts.

GRACE HARTIGAN. 1922– . United States.
Hartigan was born in New Jersey. Immediately after high school she married and had a child. Her husband encouraged her to take art classes at night. She studied painting with Isaac Lane Muse from 1942 to 1947 and then moved to New York City. Hartigan worked with the first-generation Abstract Expressionists and was particularly influenced by De Kooning, Kline, and Pollock. Her first one-woman show was in 1951. In 1960 Hartigan married her second husband and moved to Baltimore. She has taught at Baltimore's Maryland Institute College of Art since 1967. In 1977 she was honored for her teaching by the College Art Association.

"Artists on Tape." *New York Times* (April 26, 1968).

Barber, Alan. "Making Some Marks." *Arts.* 48(June 1974):49–51.
An interview with Hartigan.

Campbell, Lawrence. "To See the World Mainly Through Art: Grace

Hartigan's *Great Queens and Empresses* (1983).'' *Arts.* 58(January 1984):87.
Discusses her series of queens and empresses and describes her painting technique.

Friedman, B. H., ed. *School of New York: Some Young Artists.* New York: Grove Press, 1959.
This includes a good chapter on Hartigan by Emily Dennis.

Hakanson, Jay. ''Robust Paintings at Hartigan Show.'' *Sunday News Detroit* (April 28, 1974).

Hartigan, Grace. ''An Artist Speaks.'' *Arrow* (December 9, 1960).

Hill. *Women: A Historical Survey . . .* Catalog. Plate 76.

Hunter, Sam. *Art Since 1954.* New York: Harry N. Abrams, 1959.

Ketner, Joseph D., II. ''The Continuing Search of Grace Hartigan.'' *Art News.* 80(February 1981):128–129.
Summarizes her artistic evolution. Notes her emergence after a dearth of exhibitions between 1964 and 1974.

Mattison, Robert S. ''Grace Hartigan: Painting Her Own History.'' *Arts.* 59(January 1985):66–72.
Good biographical and stylistic summary. Includes several black-and-white reproductions.

Nemser. *Art Talk.* Pp. 148–177, 363.
An excellent interview touching upon Hartigan's personal history, choices, and her work.

Petersen and Wilson. *Women Artists.* P. 128.

''The 'Rawness,' and the Vast.'' *Newsweek.* 53(May 11, 1959):113–114.

Russo. *Profiles on Women Artists.* Pp. 87–107.

Schoenfeld, Ann. ''Grace Hartigan in the Early 1950's: Some Sources, Influences and the Avant-Garde.'' *Arts.* 60(September 1985):84–88.
Lists the group exhibitions in which Hartigan participated between 1950 and 1959. Discusses the influence of the poet Frank O'Hara on her work.

Schwartz, D. M. "Hartigan at Tibor de Nagy." *Apollo.* 70(September 1959):62–63.

Soby, James Thrall. "Interview with Grace Hartigan." *Saturday Review.* 40(October 5, 1957):27.

―――. "Non-Abstract Authorities." *Saturday Review.* 38(April 23, 1955).

Twelve Americans. New York: The Museum of Modern Art, 1956.

Westfall, Stephen. "Then and Now: Six of the New York School Look Back." *Art in America.* 73(June 1985):118–120.
 Includes an interview with Hartigan.

Collections:

 Baltimore Museum of Art.
 Boston Museum of Fine Art.
 Chicago Art Institute.
 Kansas City, Nelson-Atkins Museum of Art.
 New York City, Metropolitan Museum of Art.
 New York City, Museum of Modern Art.
 New York City, Whitney Museum of American Art.
 Raleigh, North Carolina Museum of Art.
 St. Louis Art Museum.

BARBARA HEPWORTH. 1903–1975. English.
 Hepworth's sculpture is abstract in form, yet based on nature. She studied at Leeds School of Art and London's Royal College of Art. She was later awarded a scholarship enabling her to travel in Italy for two years. Hepworth's first one-woman was in 1928. In the 1950's she began receiving commissions for large public works. Hepworth also designed sets and costumes for theatrical productions. She was married twice; first to sculptor John Skeaping, with whom she had one child, and then in 1931 to painter Ben Nicholson. She and Nicholson were the parents of triplets. That marriage was dissolved in 1951. Hepworth died tragically in a fire in her studio.

Barbara Hepworth: A Guide to the Tate Gallery Collection at London and St. Ives, Cornwall. London: Tate Gallery, 1982.

Barbara Hepworth: Sculpture and Lithographs. London: Arts Council, 1970.
This is a catalog for a traveling exhibition.

Bowness, Alan. *The Complete Sculpture of Barbara Hepworth,* 1960–1969. London: Lund Humphries, 1971.
Mainly a visual resource, but an introductory transcript of Hepworth discussing her work with Bowness is included.

Fine. *Women and Art.* Pp. 180–183.
Good summary of the various forms Hepworth's work has taken.

Hammacher, A. M. *Barbara Hepworth.* London: Modern Sculpture Series, A. Zwemmer, 1958.

———. *Barbara Hepworth.* London: World of Art Series, Thames and Hudson, 1968.
Discussion of the development of her work. A biographical summary, illustrations, and extensive bibliography are included.

Heller. *Women Artists.* Pp. 134–137.

Hepworth, Barbara. *Barbara Hepworth—A Pictorial Autobiography.* Bath: Adams and Dart, 1970.

———. *Barbara Hepworth, Carvings and Drawings.* London: Lund Humphries, 1952.
The text is by the artist. An introduction by Herbert Read discusses the influences on her development. Many excellent black-and-white reproductions of Hepworth's work are included.

———. *Drawings from a Sculptor's Landscape.* Bath: Cory, Adams and Mackay, 1966.
Hepworth describes her early interest in art and her interest in relating the human figure to the landscape. An introduction by Alan Bowness relates her drawings to her sculpture. Numerous reproductions are included, some in color.

Hill. *Women: A Historical Survey . . .* Catalog. Plates 60, 61.

Hodin, J. P. *Barbara Hepworth: Life and Work.* London: Lund Humphries, 1961.

Kramer, Hilton. *The Age of the Avant-Garde.* New York: Farrar, Straus and Giroux, 1973. Pp. 166–168.

Discusses her commission to execute the Dag Hammarskjold Memorial at the United Nations.

London. Marlborough Gallery. *Barbara Hepworth: The Family of Man—Nine Bronzes and Recent Carvings.* 1972.
Excellent color reproductions of her work from 1970 to 1972.

London. Tate Gallery. *Barbara Hepworth.* 1968.
Exhibition catalog with reproductions and an important discussion of her artistic development.

Munsterberg. *A History of Women Artists.* Pp. 90–95.

National Museum of Women in the Arts. Pp. 118–119.

Nemser. *Art Talk.* Pp. 12–33, 359–360; originally published as "Conversation with Barbara Hepworth," *Feminist Art Journal.* 11(Spring 1973):3–6, 22.
Nemser's essay supplied much of the bibliography presented here.

New York. Marlborough Gallery. *Barbara Hepworth: Carvings and Bronzes.* May 5–June 29, 1979.
Exhibition of work done between 1959 and 1974. A short essay by Nicolas Wadley is illustrated with photographs of the artist and her studio.

———. *Barbara Hepworth "Conversations."* March–April 1974.
Excellent color reproductions. The introduction is by Dore Ashton.

Petersen and Wilson. *Women Artists.* Pp. 120–121, 123–124.

Shepherd, Michael. *Barbara Hepworth.* London: Methuen, 1963.
Includes a small statement by the artist discussing her technique.

Collections:

Baltimore Museum of Art.
Detroit Institute of Arts.
London, Tate Gallery.
New York, Museum of Modern Art.
New York, United Nations Building.
Raleigh, North Carolina Museum of Art.
St. Louis, Washington University.

Washington (D.C.), Hirshborn Museum and Sculpture Garden.
Washington (D.C.), National Museum of Women in the Arts.

HANNAH HÖCH. 1889–1978. German.
Höch enrolled in the Berlin School of Decorative Art in 1912. By 1915 she was studying with Emil Orlik and working in an Impressionist style. She then turned to abstraction. From 1918 to 1922 Höch was one of the principal members of the Berlin Dada movement. Her most important works were collages and photomontages, often with a strong political commentary. Experimentation was a consistent characteristic during her long career.

Bénézit. *Dictionnaire.* Vol. 5, pp. 561–562.

Berlin. Akademie der Künst. *Hannah Höch, Collagen aus den Jahren 1916–71.* 1971.

"Die Malerin Hannah Höch." *Kunstwerk.* 31(June 1978):92.
 Obituary notice.

Dieterich, Barbara. "Hannah Höch y el Dadaismo en Berlin." *Goya.* 146(September 1978):82–85.
 Includes several black-and-white reproductions of her work.

Gebhardt, Heiko, and Stefan Moses. "Ein Leban lang im Gartenhaus." *Stern.* (April 22, 1976):96, 99, 101, 103.

Harris and Nochlin. *Women Artists, 1550–1950.* Pp. 307–309, 359.
 These authors credit Höch, along with Raoul Hausmann, with being one of the inventors of the photomontage.

London. Marlborough Fine Art. *Hannah Höch.* 1966.
 Catalog by Will Grohman, translated by Michael Ivory.

Mehring, Walter. *Berling Dada: Ein Chronik.* Zurich, 1959.

Munsterberg. *A History of Women Artists.* Pp. 131–132.

New York. German Cultural Institute, Goethe House. *Berlin Now: Contemporary Art, 1977.* March 18–April 19, 1977.
 Höch is one of four women among fifty men represented in this show.

New York. The Museum of Modern Art. *Extraordinary Women—Drawings.* July 22–September 29, 1977.

Ohff, Heinz. *Hannah Höch.* Berlin, 1968.

————. "Hannah Höch." *Künstwerk.* 17(May 1964):41.
Includes a reproduction.

Paris. Musée d'Art Moderne; Berlin. Nationalgalerie. *Hannah Höch: collages, peintures, aquarelles, gouaches, dessins.* 1976.
Includes "Interview with Hannah Höch," by Suzanne Page; "Hannah Höch, ihr Werk und Dada," by Peter Krieger; and "Hannah Höch, Künstlerin im Berliner Dadaismus," by Hanna Bergius.

Petersen and Wilson. *Women Artists.* P. 115.

Picard, Lil. "Hannah Höch in *Berlin Now.*" *Women Artists Newsletter.* 3(May 1977):7.

Roditi, Edouart. "Interview with Hannah Höch." *Arts.* 34(December 1959):24–29.
Although little biographical information on Höch is included, Roditi does recall her associations with the Berlin Dada group.

————. "Surrealism: Jubilee or Jamboree?" *Apollo.* 79(May 1964):430.
Includes a black-and-white reproduction of a work by Höch.

Winter, Peter. "Hannah Höch: Fotomontagen, Gemalde, Aquarelle von 1907 bis 1970." *Kunstwerk.* 33, no. 5(1980):87–89.
Review of an exhibition of her work.

Zurich. Kunstgewerbemuseum. *Collagen.* 1968.
Edited by Mark Buchmann and Erika Billeter.

MALVINA HOFFMAN. 1887–1966. United States.
Hoffman, a native New Yorker, was the daughter of a musician and grew up in a family that encouraged her artistic ambitions. She studied in New York at the Women's School of Applied Design and at the Art Students League. She first studied painting, then her interests turned to sculpture. She also studied in Paris at the Académie Colarossi as a studio apprentice with Janet Scudder. From 1910 to 1914 Hoffman studied with Rodin. She included anatomy among her educational pursuits, studying

at Columbia University's College of Physicians and Surgeons. Her interests in human movement and in ethnic types are well represented in her work. In 1929 she received a commission from Chicago's Field Museum of Natural History to model racial types for a "Hall of Man" project. In preparation, she traveled worldwide for two years with her husband sculpting natives in their natural environments. She had married Samuel Grimson, a musician, in 1924. They were divorced in 1936. Anna Pavlova was a close friend, and Hoffman became the sculptural interpreter of the great dancer. Hoffman was the recipient of many prizes and medals for her work.

Armstrong. *Two Hundred Years of American Sculpture.* P. 280.

Bénézit. *Dictionnaire.* Vol. 5, p. 575.

Bouve, Pauline C. "The Two Foremost Women Sculptors in America: Anna Vaughn Hyatt and Malvina Hoffman." *Art and Archaeology.* 26(September 1925):77–82.

Craven. *Sculpture in America.* Pp. 560–563.
 Craven assesses Hoffman's "Hall of Man" figures as "more an ambitious anthropological exercise than great art." However, he does praise her portrait busts of the 1920's and 1930's as truly fine and creative.

Decoteau, Pamela Hibbs. "Malvina Hoffman and the 'Races of Man.' " *Woman's Art Journal.* 10(Fall 1989–Winter 1990):7–12.
 Decoteau presents the context of Hoffman's "Hall of Man" project, relating the sculpture to anthropology and the concept of racial types. She details how Hoffman influenced and changed the original commission. The critical response to the work is also discussed. She notes that the assemblage of the 104 "Hall of Man" sculptures was dismantled after Hoffman's death in 1966 and never reinstalled.

Dodd. *Golden Moments in American Sculpture.* Pp. 52–56.

Earl. *Biographical Sketches of American Artists.* Pp. 152–153.

Eden, Myrna. "Hoffman, Malvina Cornell." In *Notable American Women: Modern Period.* Vol. 4, pp. 343–345.

Field, Henry. *The Races of Mankind.* Chicago: Field Museum of Natural History, 1942.

Field traces the history and purpose of the "Hall of Man" project. He also discusses the study of race biology and presents a description of various racial types. A complete list of the works by Hoffman is included along with several reproductions.

Heller. *Women Artists*. Pp. 108–111.

Hill. *Women: A Historical Survey . . .* Catalog. Plate 43.

Hoffman, Malvina. *Heads and Tales*. New York: Charles Scribner's Sons, 1936.
A detailed account of her "Hall of Man" project and of her career up to that point, including her studies with Rodin. Copiously illustrated.

———. *Sculpture Inside and Out*. New York: W. W. Norton, 1939.
A textbook of sculpture techniques.

———. *Yesterday Is Tomorrow: A Personal History*. New York: Crown Publishers, 1965.
This interesting autobiography includes a chronological list of her sculpture.

National Museum of Women in the Arts. Pp. 60–61.

Nochlin, Linda. "Malvina Hoffman: A Life in Sculpture." *Arts*. 59(November 1984):106–110.
Nochlin presents an excellent summary of Hoffman's career and a critical analysis of her work. She discusses Hoffman's lack of insight into her position as a woman. Nochlin discusses the "Hall of Man" figures and their current condition. She sees them as having an anomalous status between science and art and describes them as exhibiting "relentless naturalism and staggering technical proficiency." Most importantly, Nochlin discusses the problem of the "Hall of Man" project as projecting a racist and colonial ideology that the races can be "scientifically" cataloged.

Petersen and Wilson. *Women Artists*. P. 84.

Proske, Beatrice. "Part I. American Women Sculptors." Pp. 3–15.

———. *Brookgreen Gardens Sculpture*. Pp. 208–213.

Rubinstein. *American Women Artists*. Pp. 205–207.

Thieme and Becker. *Allgemeines Lexikon.* Vol. 17, pp. 275–276.

Tinling. *Women Remembered.* P. 465.

Whiting, F. A., Jr. "Malvina Hoffman." *Magazine of Art.* 14(April 1937):246–247.

Collections:

> Brooklyn Museum.
> Chicago, Field Museum of Natural History.
> New York, Metropolitan Museum of Art.
> Washington (D.C.), National Museum of Women in the Arts.

ANNA HYATT HUNTINGTON. 1876–1973. United States.

Huntington grew up in Cambridge, Massachusetts, where her father was a professor of zoology at Harvard. She was trained as a concert violinist, but began modeling in clay while recuperating from an illness. She studied in Boston with Henry Kitson and then in New York at the Art Students League with Hermon P. MacNeil and Gutzon Borglum. MacNeil advised her against going to Europe for further study. Her first show, at the Boston Arts Club when she was twenty-four years old, was of forty sculptured animal pieces. She continued to specialize in animal sculpture, an interest probably related to her father's profession. She shared a studio and collaborated for two years with Abastenia Saint Leger. In 1907 and 1908 Huntington traveled and worked in Europe. She married the philanthropist Archer Milton Huntington in 1923. They established and endowed the Brookgreen Sculpture Garden near Georgetown, South Carolina, in 1931. She was one of the first U.S. sculptors to cast her work in aluminum. Huntington received many awards.

Armstrong. *Two Hundred Years of American Sculpture.* P. 281.

Bénézit. *Dictionnaire.* Vol. 5, p. 689.

Bouve. Pauline. "The Two Foremost Women Sculptors in America: Ann Vaughn Hyatt and Malvina Hoffman." *Art and Archaeology.* 26(September 1925):74–77.

Cook, Doris. E. *Woman Sculptor: Anna Hyatt Huntington (1876–1973).* Hartford, Connecticut: Privately printed, 1976.

This biographical sketch of Huntington includes lists of her works,

arranged by subject matter. Her exhibitions, awards, and honors are also included. Includes a few photographs of her work.

Craven. *Sculpture in America.* Pp. 545–547.

Dodd, Loring Holmes. *Golden Moments in American Sculpture.* Pp. 57–62.

Eden, Myrna Garvey. *Anna Hyatt Huntington, Sculptor, and Mrs. H. H. A. Beach, Pianist and Composer: A Comparative Study of Two Women Representatives of the American Cultivated Tradition in the Arts.* Ph.D. dissertation, Syracuse University, 1977.

———. "Huntington, Anna Vaughn Hyatt." In *Notable American Women: Modern Period.* Vol. 4, pp. 358–359.

Evans, Cerinda. *Anna Hyatt Huntington.* Newport News, Virginia: The Mariners Museum, 1965.

Heller. *Women Artists.* P. 111.

Hill. *Women: A Historical Survey . . .* Catalog. Plate 38.

Ladd, Anna Coleman. "Anna V. Hyatt—Animal Sculptor." *Art and Progress.* 4(1912):773–776.

MacAgy, Jermayne. "Exhibition of Aluminum Sculpture by Anna Hyatt Huntington." *Bulletin of the California Palace of the Legion of Honor Museum.* 2(July 1944):24–29.

National Museum of Women in the Arts. P. 60.

National Sculpture Society. *Anna Hyatt Huntington.* New York: W. W. Norton and Company, 1947.
 Foreword by Eleanor Mellon.

New York. American Academy of Arts and Letters. *Catalogue of an Exhibition of Sculpture by Anna Hyatt Huntington.* 1936.

New York. Hispanic Society of America. *Sculpture by Anna Hyatt Huntington.* October 15, 1956–March 5, 1958.
 Introductory essay by Beatrice Proske.

Nickerson, Ruth. "A Vanguard of American Women Sculptors." *Sculpture Review.* 35(Winter 1986–87):16–24, 29, 31.

Payne. "The Work of Some American Women in Plastic Art." Pp. 319–321.

Petersen and Wilson. *Women Artists.* P. 84.

Proske. "American Women Sculptors."

———. *Brookgreen Gardens Sculpture.* Pp. 168–180.
Describes many of Huntington's works exhibited at Brookgreen Gardens.

———. "Huntington: Art Patron *Extraordinaire.*" *Sculpture Review.* 33(Fall 1984):26–27.

Royère, Jean. *Le musicisme sculptural: Madame Archer Milton Huntington.* Paris: Messein, 1933.

Rubinstein. *American Women Artists.* Pp. 202–204.

Schaub-Koch, Emile. *A obra animalista e monumental de Anna Hyatt Huntington.* Braga, Portugal: Academia nacional de Belas Artes, 1955.
Includes a section of black-and-white reproductions.

———. *L'oeuvre d'Anna Hyatt-Huntington.* Paris: Editions Messein, 1949.
Many illustrations.

———. *Madame Anna Hyatt Huntington et la statuaire moderne.* New York: Hispanic Society of America, 1936.

———. *Vie et modelage.* Lisbon: Tipografia Gaspar, 1957.
A fairly detailed discussion of Huntington's work, with a short biographical note. Includes many illustrations, not only of her animal sculpture but of her earlier portrait busts and monuments.

Smith, Bertha. "Two Women Who Collaborate in Sculpture." *The Craftsman.* 9(June–September 1905):623–633.

Tinling. *Women Remembered.* Pp. 389–390, 618–619.
Notes that Archer Milton Huntington was the founder of the

Hispanic Society of America, located in New York City, and that many of his wife's sculptures grace its outer court.

Collections:

New York, The Hispanic Society of America.
New York, Metropolitan Museum of Art.
San Francisco, The California Palace of the Legion of Honor.
Tulsa, Philbrook Art Center.
Washington (D.C.), National Museum of Women in the Arts.

GWENDOLYN JOHN. 1876–1939. English.

Gwendolyn John was born in Wales. Her mother, an amateur artist, encouraged her children's interest in art. John's brother was Augustus John, who was an enormously successful artist and president of the Royal Academy. In contrast, she worked and lived in extreme obscurity. She studied at the Slade School of Art in 1895 and in 1898 entered Whistler's Académie Carmen in Paris. She remained in France the rest of her life except for brief visits to England. John earned part of her living as a model. In 1903 she posed for Rodin and an intimate friendship developed between them. That same year she was in what was purportedly a two-person show with her brother; however, the exhibition consisted of forty-five works by him and only three by her. One of her works was in the 1913 Armory Show. The only major exhibition of her work during her lifetime was in 1936, when she was sixty. The majority of her works are of female figures with introspective gazes. After her conversion to Catholicism in 1913, nuns and schoolchildren were added to her subject matter. She did not paint during the last seven years of her life. John never married and became increasingly reclusive. She died in poverty.

Chitty, Susan. *Gwen John, 1876–1939.* New York, 1987.
 A full-length, illustrated biography.

Daniels, J. "Exhibition in London." *Apollo.* 91(June 1970):43.

Edwards. *Women: An Issue.*

Fine. *Women and Art.* Pp. 84–87.

Gablick, Suzi. "Gwendolyn John." *Studio International.* 191(May–June 1976):301–302.
 Good discussion of John's use of color.

Goodman, Helen. "Gwen John." *Arts.* 61(September 1986):114.
A brief biographical sketch of John.

Greer. *Obstacle Race.* P. 64.

Hall, D. "Acquisitions of Modern Art by Museums: Edinburgh." *Burlington Magazine.* 114(April 1972):269.

Harris and Nochlin. *Women Artists, 1550–1950.* Pp. 52, 59–60, 270–272, 355.

Heller. *Women Artists.* Pp. 141, 143–145.

Hill. *Women: A Historical Survey . . .* Catalog. P. 23.

Holroyd, M. *Augustus John: The Years of Innocence.* London, 1974.

―――. *Augustus John: The Years of Experience.* London, 1975.

John, Augustus. *Chiaroscuro.* London: Cape, 1954; reprint, London: Grey Arrow, 1962.
Her brother's autobiography.

―――. *Gwen John, 1876–1939.* London: Arts Council, 1946.

―――. "Gwendolyn John." *Burlington Magazine.* 81(1942):237–238.
Caustic reminiscences about his sister's dark studios, her concern for her many cats, and her poverty, yet he calls her "the greatest woman artist of her age."

Langdale, Cecily. *Gwen John.* New Haven: Yale University Press, 1987.
Comprehensive discussion of John's life and artistic production. Includes a catalogue raisonné and a selection of drawings. Langdale has studied the relationship of the paintings to one another in her assessment of John's artistic achievement. The critical responses to John's work are also considered.

McEwen, John. "A Room of Her Own." *Art in America.* 74(June 1986):110–115.
Provides a good summary of John's style and includes several good color reproductions. McEwen says John created canvases whose "superficial calm masks an almost painful depth of feeling."

Maritain, Jacques. *Carnet de notes (Annexe au chapitre VI: A propos de Gwendoline et Augustus John).* Paris: Desclee de Brouwer, 1965.

Melville, Robert. "Kinds of Loving." *New Statesman* (February 2, 1968):150.
"It is her almost desperate response to women that is inextricably involved in her devotion to painting."

National Museum of Women in the Arts. Pp. 116–117.

New York. Davis and Long Company. *Gwen John: A Retrospective Exhibition.* 1975.

Petersen and Wilson. *Women Artists.* Pp. 99–100, 103–104.

Phaidon Dictionary of Twentieth Century Art. New York: Phaidon, 1973. Pp. 180–181.

Rothenstein, John. *Modern English Painters—Sickert to Smith.* London: Eyre and Spottiswoode, 1952. P. 161.

Sackerlotzky, Rotraud. "Gwen John: *Interior: The Brown Teapot.*" *Cleveland Museum of Art Bulletin.* 75(April 1988):98–111.
A discussion of the iconography and style of a work in the collection by John, done ca. 1915–1916.

Shone, Richard. "Gwendolyn John at Anthony d'Offay." *Burlington Magazine.* 118(March 1976):175–176.
Exhibition review. Notes that Rilke was a close friend.

Stanford, California. Stanford University Museum of Art. *Gwen John: Paintings and Drawings from the Collection of John Quinn and Others.* April 27–June 27, 1982.
Only a fraction of her 200 paintings were exhibited during John's lifetime. This exhibition included 13 oils and 30 watercolors and drawings from U.S. collections. The catalog includes essays by Betsy Fryberger and Cecily Langdale.

Taubman, Mary. *Gwen John.* London: The Arts Council, 1968.
A catalog of a retrospective exhibition. It contains an abridged version of the above short article by Augustus John. Good black-and-white reproductions with a full color frontispiece.

———. *Gwen John: The Artist and Her Work.* Ithaca, New York: Cornell University Press, 1985.

Taylor, Hilary. " 'If a Young Painter Be Not Fierce and Arrogant, God

. . . Help Him': Some Women Art Students at the Slade, c. 1895–
1889.'' *Art History.* 9(June 1986):232–244.

In the 1890's the Slade was one of the most influential art schools in
Great Britain. Taylor says that during this period, Gwen John was the
only woman student to have achieved some recognition.

Tufts. *Our Hidden Heritage.* Pp. 198–209.

Vaizey, Marina. ''Portrait of the Artist as a Romantic Recluse.'' *Art
News.* 75(Mary 1976):103.
　　Exhibition review.

Watson, Forbes. Foreword. In *John Quinn, 1870–1925: Collection of
Paintings, Watercolors, Drawings and Sculpture.* Huntington, New
York, ca. 1926. P. 149.
　　Quinn, a wealthy American, provided John with an annual stipend
from 1910 until his death in 1924.

Collections:

　　Cleveland Museum of Art.
　　London, National Portrait Gallery.
　　London, Tate Gallery.
　　Manchester, City Art Gallery.
　　New York, Museum of Modern Art.
　　Sheffield, City Art Galleries.
　　Southhampton Art Gallery.
　　Washington (D.C.), National Museum of Women in the Arts.
　　Washington (D.C.), Hirshhorn Museum and Sculpture Garden.

FRANCES BENJAMIN JOHNSTON. 1864–1952. United States.
　　Johnston was born in Grafton, West Virginia. She traveled to Paris
in 1883 for two years to study drawing and painting at the Julien
Academy. On her return to the United States, she studied at the Art
Students League in Washington, D.C. Her first job was as a correspon-
dent for a magazine, and through this she developed an interest in
photography. Her first photographs were published in 1889–90 in
Demorest's Family Magazine. In 1890 Johnston opened a portrait studio
in Washington, D.C. In 1899 she was commissioned to photograph the
school system of Washington, D.C., and the Hampton Institute in
Virginia. By the turn of the century she was one of the first news
photographers in Washington. Johnston used her art in her involvement

in the women's rights and civil rights movements. She was one of the few women delegates to the International Photographic Congress in Paris, where she delivered a lecture on U.S. women photographers. She also wrote a series of articles on the same subject for the *Ladies Home Journal.* In 1933 she began photographing architecture, concentrating on the Southern states. She considered this work to be the achievement and culmination of her career. She was a member of the New York Camera Club and in 1945 was made an honorary member of the American Institute of Architects in recognition of her documentary photographs of early architecture.

Beaton. *The Magic Image.* Pp. 84–85.
 Good biographic summary.

Brock, Henry Irving. *Colonial Churches in Virginia.* Richmond: Dale Press, 1930.
 Johnston contributed the photographs.

Daniel, Peter, and Raymond Smock. *A Talent for Detail: The Photographs of Miss Frances Benjamin Johnston.* New York: Harmony Books, 1974.

Doumato, Lamia. *Frances Benjamin Johnston, Architectural Photographer: A Bibliography.* Monticello, Illinois: Vance Bibliographies, 1990.

"Frances Benjamin Johnston: Her Photographs of Our Old Buildings." *Magazine of Art.* 30(September 1937):548–555.
 Includes several good reproductions of her work.

"Houses of the Old South." *American Architect.* 147(September 1935):57–64.
 Photographic portfolio of her documentation of the historic architecture of Virginia.

Johnston, Frances Benjamin. *The Hampton Album: Forty-four Photographs from an Album of the Hampton Institute.* New York: Museum of Modern Art, 1966.
 Introduction and note on the photographer by Lincoln Kirstein.

————. *Mammoth Cave by Flash-Light.* Washington, D.C.: Gibson Brothers, 1893.
 Twenty-five photographs by Johnston.

————. *The White House.* Washington, D.C.: Gibson Brothers, 1893.
Thirty-six illustrations by Johnston.

Long Beach. California State University. *Frances Benjamin Johnston: Women of Class and Station.* February 12–March 11, 1979.
An exhibition of Johnston's photographs of noted women. The catalog introduction is by Anne Peterson.

Munsterberg. *A History of Women Artists.* P. 126.

Nichols, Frederick D. *The Early Architecture of Georgia.* Chapel Hill: University of North Carolina Press, 1957.
Photographs by Johnston.

Peterson, Anne E. "Frances B. Johnston: The Crusader with a Camera." *Historic Preservation.* 32(January–February 1980):17–20.

Vanderbilt, Paul. "Frances Benjamin Johnston, 1864–1952." *Journal of American Institute of Architects.* 18(November 1952):224–228.
In-depth discussion of Johnston's architectural photography from 1933 to 1940. Dates her first architectural commission from 1909, and notes that she continued for many years to photograph the homes of millionaires.

Waterman, Thomas T. *The Early Architecture of North Carolina.* Chapel Hill: University of North Carolina Press, 1941.
Photographs by Johnston.

Whelan. "Are Women Better Photographers Than Men?" P. 86.

Collections:

New York, Museum of Modern Art.
Washington (D.C.), Library of Congress.

FRIDA KAHLO. 1910–1954. Mexican.
In 1925 the teen-age Kahlo was injured in a bus accident in Mexico City. The accident halted her premedical studies and left her permanently disabled. She underwent numerous major operations on her back. Her spine injury and broken pelvis made it impossible for her to bear the children she wanted and condemned her to a series of miscarriages, hemorrhages, and unsuccessful cesarean sections. Kahlo's physical

suffering is graphically depicted in her powerful paintings, in which self-portraits with anatomical motifs predominate. In 1929 she married Diego Rivera, whose influence upon her was political rather than artistic. They lived in New York for several months in 1933 while he was working on the Radio City murals. The marriage was stormy—both had love affairs. They agreed to divorce in 1939, but remarried the following year. Rivera honored her by depicting her several times in his murals and by founding the Museo Frida Kahlo in the home they shared in Coyoacan, a Mexico City suburb. Eventually Kahlo was confined to a wheelchair, and after the amputation of her leg, to bed. She did her last paintings lying down. She died at the age of forty-four, having produced fewer than two hundred works, most of which are autobiographical.

Breslow, Nancy D. "Frida Kahlo's *The Square Is Theirs:* Spoofing Giorgio De Chirico." *Arts.* 56(January 1982):120–123.
 Discusses Kahlo's parody of De Chirico's metaphysical painting. Points out Kahlo's knowledge and use of Surrealism while maintaining her loyalty to traditional Mexican art.

Breton, André. "Frida Kahlo de Rivera." 1938.
 A brochure for the Frida Kahlo Exhibition at the Julien Levy Gallery.

———. *Surrealism and Painting.* New York: Harper and Row, 1972.
 Contains the essay "Frida Kahlo de Rivera," reprinted from above. Breton describes Kahlo as a surrealist without the theoretical background.

Chadwick. *Women Artists and the Surrealist Movement.* Pp. 87–02, 134–135, 160–161, 177–180, 241.

Conde, Teresa del. "La Pintora Frida Kahlo." *Artes Visuales.* 4(October–December 1974):1–5.

Crommie, Karen, and David Crommie, producers and editors. *The Life and Death of Frida Kahlo.* 16mm film, 40 min. 1966.

Flores Guerrero, Raul. *Cinco Pintores Mexicanos: Frida Kahlo, Guillermo Meza, Juan O'Gorman, Julio Castellanos, Jesus Reyes Ferreira.* Mexico City: Universidad Nacional Autonoma de Mexico, 1957. Pp. 15–23.
 Includes sixteen reproductions of Kahlo's work.

The Frida Kahlo Museum. Mexico City, 1968.
A catalog with brief notes by Diego Rivera, Lola Olmedo de Olvera, and Juan O'Gorman.

Greer. *The Obstacle Race.* P. 52.

Grimberg, Solomon. *Frida Kahlo.* Dallas, 1989.
Catalog of an exhibition at the Meadows Museum in Dallas. Includes eighteen color plates of her work.

Harris and Nochlin. *Women Artists, 1550–1950.* Pp. 59, 61, 335–337, 361–362.

Heller. *Women Artists.* Pp. 147–148.

Helm, McKinley. *Modern Mexican Painters.* New York: Harper and Row, 1941. Pp. 166–171.

Herrera, Hayden. *Frida: A Biography of Frida Kahlo.* New York: Harper and Row, 1983.
This well-documented biography draws on letters, diaries, and interviews.

————. "Frida Kahlo, Her Life and Art." *Artforum.* 14(May 1976):38–44.
Excellent summary of Kahlo's life and career, accompanied by good color reproductions of her work.

————. "Frida Kahlo: The Palette, the Pain, and the Painter." *Artforum.* 21(March 1983):60–67.
Graphic account of Kahlo's medical problems and their reflection in her art. Includes several reproductions, some in color.

————. "A Painter's Passion." *Art in America.* 71(April 1983):160–162.
This description of the Museo Frida Kahlo includes many excellent color photographs of the museum and reproductions of Kahlo's work.

————. "Portrait of Frida Kahlo as a Tehuana." *Heresies* (Winter 1977–1978):57–58.

————. "Portraits of a Marriage." *Connoisseur.* 209(March 1982):124–128.

Discussion of the Riveras' marriage and Diego's notorious woman-izing and how Kahlo chronicled this in her art. Includes several reproductions.

Kozloff, Joyce. "Frida Kahlo at the Neuberger Museum." *Art in America.* 67(May 1979):148–149.
Review of Kahlo's first U.S. retrospective.

London. Whitechapel Art Gallery. *Frida Kahlo and Tina Modotti.* March 26–May 2, 1982.
Excellent essay by Laura Mulvey and Peter Wollen which traces the threads connecting these two artists and the feminist aspects of their art. Includes numerous illustrations, many in color.

O'Gorman, Juan. *Frida Kahlo.* Mexico: Editions Miguel Galas, 1970.
This is the catalog of the Frida Kahlo Museum. In addition to a large number of her paintings, her diary is also on display there. This catalog also contains an essay by Rivera, "Frida Kahlo and Mexican Art."

Orenstein, Gloria. "Frida Kahlo: Painting for Miracles." *Feminist Art Journal.* 2(Fall 1973):7–9.
Includes several black-and-white reproductions. Good biographical summary of Kahlo's life.

Petersen and Wilson. *Women Artists.* Pp. 4, 133–135.

Prampolini, Ida Rodrigues. *El surrealismo y el arte fantastico de Mexico.* Universidad Nacional Autonoma de Mexico, 1969.

Rivera, Diego (with Gladys March). *My Art, My Life.* New York, 1960.

Sullivan, Edward J. "Frida Kahlo in New York." *Arts.* 57(March 1983):90–92.

Tibol, Raquel. *Frida Kahlo: cronica, testimonios, y aproximaciones.* Mexico City: Ediciones de cultura popular, 1977.

Wolfe, Bertram D. *The Fabulous Life of Diego Rivera.* New York: Stein and Day, 1963.

Collections:

> Austin, University of Texas Collection.
> Buffalo, Albright-Knox Art Gallery.
> Mexico City, Museo Frida Kahlo.
> New York, Museum of Modern Art.

GERTRUDE KASEBIER. 1852–1934. United States.

Kasebier was born in Iowa and during her childhood traveled by covered wagon to Colorado, where her father operated a gold mine. She married in 1874 and until 1888 was occupied with raising her three children. For the next six years she studied portrait painting at the Pratt Institute in Brooklyn. It was not until 1893, during a trip to Paris to study painting, that Kasebier began to use a camera seriously. She opened a studio in Paris in 1894. In 1897 she went to Germany, where she studied the technical aspects of photography. Kasebier then returned to New York and opened a portrait studio, doing most of her own printing. Although she did many portraits and studies of artists, writers, and Native Americans, her most noted works were soft-focus studies of mothers and children. The effects she achieved have been compared to Impressionist paintings. Kasebier was one of the founders of the Photo-Secessionist movement in 1902. The entire first issue of *Camera Work,* in January 1903, was devoted to her photography.

Beaton. *The Magic Image.* P. 102.
> Good biographical summary.

Bunnell, Peter C. "Gertrude Stanton Kasebier." In *Notable American Women, 1607–1950.* Vol. 2, pp. 308–309.

"Camera Pioneer." *Art Digest.* 9(December 1, 1934):10.

Johnston, Francis B. "Photographic Work of Gertrude Kasebier." *Ladies Home Journal.* 18(May 1901):1.

Munsterberg. *A History of Women Artists.* Pp. 123–126.

National Museum of Women in the Arts. Pp. 72–73.

O'Mara, Jane Cleland. "Gertrude Kasebier: The First Professional Woman Photographer, 1852–1934." *Feminist Art Journal.* 3(Winter 1974–1975):18–20.

Symmes, Marilyn. "Important Photographs by Women." Pp. 145–146. Says that Kasebier attended Moravian College for Women in Bethlehem, Pennsylvania.

Tighe, Mary Ann. "Gertrude Kasebier, Lost and Found." *Art in America.* 65(March–April 1977):94–98.

"Trade Notes and News." *American Photography* (December 1934): 786.
 Obituary.

Whelan. "Are Women Better Photographers Than Men?" Pp. 86–87.

Wilmington. Delaware Art Museum. *A Pictorial Heritage: The Photographs of Gertrude Kasebier.* March 2–April 22, 1979.
 Catalog for a full-scale retrospective exhibition. The excellent biographical essay is by William Innes Homer. Black-and-white reproductions of her work are included.

Collections:

 Detroit Institute of Arts.
 New York, Museum of Modern Art.
 Washington (D.C.), Library of Congress.
 Washington (D.C.), National Museum of Women in the Arts.

KÄTHE KOLLWITZ. 1867–1945. German.
 Kollwitz was a graphic artist who, along with Goya, was one of the few ever to combine successfully social and political protest with art of a universal stature. She was an ardent socialist, pacifist, and feminist. From 1885 to 1886 Kollwitz studied at the Women's School of the Berlin Academy. In 1891 she married a physician, which gave her moderate economic security but exposed her to the suffering of the poor, especially women and children. Kollwitz's small studio was next to her husband's office for many years. In 1904 she studied in Paris, and in 1907, in Italy. She also taught for a couple of years. Kollwitz did her first woodcuts in 1919. The loss of one of her two sons in the First World War intensified her hatred of war, a theme which is greatly reflected in her

work. Though the exposure of various social evils in her art had often drawn official criticism (beginning with Kaiser Wilhelm II), this trend culminated during the Nazi regime when she was purged from the faculty of the Prussian Academy of Art and her work was removed from public view throughout Germany. Kollwitz also produced sculpture.

"Anger, Sorrow, Pain and Beauty: The Work of Kollwitz." *Berkeley Book Review* (Spring 1972).
A review of the Kleins' biography of Kollwitz (*see below*).

"Artists and the War." *Freedom News* (June 1970).

Avenarius, Ferdinand. *Käthe Kollwitz Mappe.* Munich: G.D.W. Callwey, 1927.

Behr. *Women Expressionists.* Pp. 10, 16–17.

Berlin. Paul Cassirer Gallery. *Sonder-Ausstellung Käthe Kollwitz zu ihrem 50. Geburtstag.* 1917.

Bittner, Herbert. *Käthe Kollwitz, Drawings.* New York: Thomas Yoseloff, 1959.
The bibliography (pages 17–18) includes several sources that have not been used here, in particular, contemporary German material. The catalog contains 147 reproductions.

Bonus, Arthur. *Das Käthe Kollwitz-Werk.* Dresden: Carl Reissner, 1930.
Includes many excellent black-and-white reproductions.

Bonus-Jeep, Beate. *Sechzig Jahre Freundschaft mit Käthe Kollwitz.* Boppard, Germany: Karl Rauch Verlag, 1948; reprint, Bremen, 1963.
An account of the author's sixty-year friendship with Kollwitz.

Buettner. "Images of Modern Motherhood." Pp. 14–21.

Comini, Alessandra. "For Whom the Bell Tolls: Private Versus Universal Grief in the Work of Edvard Munch and Käthe Kollwitz." *Arts.* 51(March 1977):142.

Devree, Howard. "Käthe Kollwitz." *Magazine of Art.* 32(September 1939):512–517.

Dittman, P. "Das Nachwirken Theophile Alexandre Steinlens am Beispiel von Ernst Barlach und Käthe Kollwitz." *Wallraf-Richartz-Jahrbuch.* 45(1984):173–201.

Dobard, Raymond. *Subject Matter in the Work of Käthe Kollwitz: An Investigation of Death Motifs in Relation to Traditional Iconographic Patterns.* Ph.D. dissertation, Johns Hopkins University, 1975.

The Drawings of Kaethe Kollwitz. Alhambra, California: Borden Publishing Company, 1967.
 Introduction by Stephen Longstreet.

Fanning, Robert Joseph. *Kaethe Kollwitz.* Karlsruhe, Germany, and New York: George Wittenborn, 1956.

Faxon, Alicia. "Käthe Kollwitz: Voice of the Sacrificed." *Boston Globe* (July 21, 1972).

Fecht, Tom, ed. *Käthe Kollwitz: Works in Color.* Trans. A. S. Wensinge and R. H. Wood. New York: Schocken Books, 1988.

Fine. *Women and Art.* Pp. 150–155.

Harris and Nochlin. *Women Artists, 1550–1950.* Pp. 65–67, 262–265, 275, 354.

Havice, Christine. "The Artist in Her Own Words." *Woman's Art Journal.* 2(Fall–Winter 1982):107.
 Examination of the published letters of several women artists, including Kollwitz.

Heit, Janet. "Käthe Kollwitz." *Arts.* 54(May 1980):12.

Heller. *Women Artists.* Pp. 139–141.

Hill. *Women: A Historical Survey . . .* Catalog. P. 20.

Hinz, Renate. "Käthe Kollwitz: Her Talent Was a Responsibility." *Art News.* 80(December 1981):84–87.

Kearns, Martha Mary. "Book Review: *Käthe Kollwitz, Life in Art.*" *Feminist Art Journal.* 11(Winter 1973):9 & 16.
 Kearns reviews the Kleins' biography (*see below*). She applauds it generally, but is disappointed in the lack of emphasis upon the limitations imposed upon Kollwitz as a young woman art student.

———. *Käthe Kollwitz: Woman and Artist.* Old Westbury, New York: The Feminist Press, 1976.

Account of Kollwitz's life from a "contemporary feminist perspective." Includes an excellent annotated bibliography.

Klein, Mina C., and H. Arthur Klein. *Käthe Kollwitz: Life in Art.* New York: Holt, Rinehart and Winston, 1972.
The first in-depth biography on Kollwitz in English. Includes a good selected bibliography and excellent reproductions and photographs.

Klipstein, August. *Käthe Kollwitz: Verzeichnis des graphischen Werks.* Bern: Klipstein and Company; New York: Galerie St. Etienne, 1955.
A catalogue raisonné of all of Kollwitz's known etchings, lithographs, and woodcuts.

Kollwitz, Hans, ed. *Briefe der Frendschaft.* Munich: List Verlag, 1966.
Hans Kollwitz is her son.

———, ed. *The Diary and Letters of Kaethe Kollwitz.* Trans. Richard Winston and Clara Winston. Chicago: Henry Regnery, 1955.

———. *Ich sah die Welt mit liebevollen Blicken.* Hannover: Fackelträger-Verlag, 1968.
A collection of photographs of sculpture by Kollwitz.

———. *Käthe Kollwitz: Das plastiche Werk.* Hamburg: Wegner, 1967.

———, ed. *Käthe Kollwitz Tagebucherblätter und Briefe.* Berlin, 1949.

Kollwitz, Käthe. *Aus meinem Leben.* Munich: List Verlag, 1958.
This short memoir of her early years was written for her sons and published after her death.

———. *Twenty-one Late Drawings.* Boston: Boston Book and Art, 1970.

Krull. *Women in Art.* Pp. 144–145.

Lauter. *Women as Mythmakers.* Pp. 47–61.
This chapter, "Käthe Kollwitz: The Power of the Mother," was written with Dominique Rozenberg. It discusses the significance of postures used by Kollwitz in her depiction of mothers.

McCauseland, Elizabeth. *Frau Käthe (Schmidt) Kollwitz: Ten Lithographs.* New York: Henry C. Kleeman, Curt Valentine, 1941.

McKay, Pauline, and Roan Barris. "Kaethe Kollwitz: Her Life and Art, 1867–1945." *Herself* (September 1972).

Melville, Robert. "Good Grief." *New Statesman* (December 8, 1967).

Munich. *Käthe Kollwitz, Handzeichnungen und graphische Seltenheiten, eine Ausstellung zum 100.* Geburtstag, 1967.
Catalog by A. vonder Beche.

Munich. Museum Villa Stuck. *Käthe Kollwitz: Zeichnung, Graphik, Plastik.* May 12–August 7, 1977.
This catalog includes a short essay by Hella Robels, many excellent reproductions, and a brief chronology.

Munsterberg. *A History of Women Artists.* Pp. 109–115.

Nagel, Otto. *Die Selbstbildnisse der Käthe Kollwitz.* Berlin: Henschelverlag, 1965.
"The complete cycle of the artist's self-portraits from 1885 to 1943."

———. *Käthe Kollwitz.* Trans. Stella Humphries. Greenwich, Connecticut: New York Graphic Society, 1971.

———. *Käthe Kollwitz: Die Handzeichnungen.* Berlin, 1972.

National Museum of Women in the Arts. Pp. 126–127, 207.

New York. Marlborough Galleries. *Ernst Barlach, Käthe Kollwitz.* November–December, 1967.
Exhibition catalog with introduction by Wolfgang Fischer. Many black-and-white reproductions of sculpture, drawings, and prints.

New York. St. Etienne Gallery. *Memorial Exhibition: Käthe Kollwitz.* 1945.

Northampton, Massachusetts. Smith College. *Käthe Kollwitz.* 1958.

Nundel, Harri. *Käthe Kollwitz.* Leipzig: Bibliographisches Institut, 1964.

Petersen and Wilson. *Women Artists.* Pp. 116–119.

Radycki. "The Life of Lady Art Students." Pp. 11–13.

Riverside. University Art Galleries, University of California. *Käthe Kollwitz, 1867–1945: Prints, Drawings, Sculpture.* April 2–May 5, 1978.
Includes many excellent black-and-white reproductions.

St. Paul. Minnesota Museum of Art. *Exhibit of Graphic Work by Käthe Kollwitz from the Permanent Collection.* September 26–November 10, 1973.
Beautifully designed catalog with excellent reproductions.

Sayers, Valerie. "Darkness and Light: the Abiding Power of Käthe Kollwitz." *Arts and Antiques.* 6(February 1989):78–83, 90.
Excellent biographical summary and description of the visual themes in Kollwitz's art.

Schmalenbach, Fritz, ed. *Käthe Kollwitz.* Konigstein im Taunus, Germany: K. R. Langewiesche, 1965.

Shikes, Ralph E. *The Indignant Eye: The Artist as Social Critic in Prints and Drawings.* Boston: Beacon Press, 1969.

Sievers, Johannes. *Die Radierungen und Steindrucke von Käthe Kollwitz innerhalf der Jahre 1890 bis 1912.* Dresden, 1913.

Storrs. University of Connecticut Museum of Art. *Käthe Kollwitz Prints and Drawings: The Landauer Collection.* 1968.

Thieme and Becker. *Allgemeines Lexikon.* Vol. 21, pp. 245–247.

Tufts. *Our Hidden Heritage.* Pp. 178–187.

Weltenkampf, Frank. "Some Women Etchers." *Scribner's Magazine.* 46(December 1909):731–739.

Zigrosser, Carl, ed. *Käthe Kollwitz.* New York: Bittner, 1946.

———, ed. *Prints and Drawings of Käthe Kollwitz.* New York: Dover Publishing, 1951.

Collections:

Berlin, Staatliche Museum.
Cambridge, Massachusetts, Harvard University, Fogg Art Museum.

Los Angeles County Museum of Art.
Stanford (California), Stanford University Art Museum and Art
 Gallery.
Washington (D.C.), National Gallery of Art.
Washington (D.C.), National Museum of Women in the Arts.

LEE KRASNER. 1908–1984. United States.
 Krasner grew up in Brooklyn, in a family of Russian immigrants. In
1926 she enrolled at the Copper Union and later at the National Academy
of Design. From 1938 to 1940 she studied with Hans Hoffman. Between
1934 and 1943 she worked with the Federal Art Project, part of that time
as an assistant to muralist Max Spivak. For many years Krasner was
arbitrarily dismissed as only a follower of her famous husband, Jackson
Pollock, whom she had married in 1945. Although he was certainly a
major influence upon her development, she too was a pioneer of the
"action painting" of the New York School in the 1940's. As Mrs.
Pollock she paid an enormous price—her work was not shown until
1951; she was asked to leave the Parsons Gallery when Pollock left it;
and she generally had to contend with being considered a wife rather
than a serious artist. Fortunately her career is being reassesed and her
work is now being given the serious study it deserves. Especially
important are her "little images," a series of paintings that began to
evolve in 1945, after an unproductive period of three years.

Campbell, Lawrence. "Of Lilith and Lettuce." *Art News.* 67(March
 1968):42–43, 61–64.
 This chronologic analysis of her work emphasizes the influence she
 had on Pollock. Good color reproductions are included.

Cannell, Michael. "An Interview with Lee Krasner." *Arts.* 59(Septem-
 ber 1984):87–89.
 Krasner discusses her WPA work, her studies with Hans Hoffman,
 and the resistance toward women artists.

Fine. *Women and Art.* Pp. 208–210.

Friedman, B. H. "Manhattan Mosaic." *Craft Horizon.* 19(January–
 February 1959):26–29.
 Discusses a mosaic created by Krasner and Ronald Stein.

Harris and Nochlin. *Women Artists, 1550–1950.* Pp. 64, 331–333, 361.

Hill. *Women: A Historical Survey . . .* Catalog. P. 44.

London. Whitechapel Art Gallery. *Lee Krasner: Drawings and Collages.* 1965.
The catalog includes an essay by B. H. Friedman.

Munro. *Originals: American Women Artists.* Pp. 100–119.
In an interview, Krasner talks about her childhood, her work with the WPA, and her life with Pollock.

National Museum of Women in the Arts. Pp. 92–93.

Nemser, Cindy. *Art Talk.* Pp. 80–111, 361–362.
Much of the biographic information above is from Nemser's excellent interview. Nemser praises the continuity of Krasner's artistic development and its rich variety.

———. "A Conversation with Lee Krasner." *Arts.* 47(April 1973):48.

———. "The Indomitable Lee Krasner." *Feminist Art Journal.* 4(Spring 1975):4–9.

———. "Lee Krasner's Paintings, 1946–49." *Artforum.* 12(December 1973):61–65.
Discussion of the group of paintings Krasner called her "little images." Nemser analyzes these works stylistically and assesses their relation to the contemporary works of Pollock, Tobey, and Gottlieb.

New York. Grey Art Gallery, New York University. *Krasner/Pollock: A Working Relationship.* November 3–December 12, 1981.
The essay by Barbara Rose discusses the influence each artist had on the other. A comparative chronology is included.

New York. Marlborough Gallery. *Lee Krasner: Recent Paintings.* 1973.
Exhibition catalog.

New York. Marlborough-Gerson Gallery. *Lee Krasner.* 1968.
Exhibition catalog.

New York. Museum of Modern Art. *Extraordinary Women—Drawings.* July 22–September 29, 1977.

New York. Robert Miller Gallery. *Lee Krasner: Paintings from the Late Fifties.* October 26–November 20, 1982.
This catalog includes numerous color reproductions, lists of awards and exhibitions, and a chronology.

New York. Whitney Museum of American Art. *Lee Krasner: Large Paintings.* 1973.
 The text of this catalog is by Marcia Tucker.

Petersen and Wilson. *Women Artists.* P. 128.

Robertson, Bryan. "The Nature of Lee Krasner." *Art in America.* 61(November–December 1973):83–87.

Rose, Barbara. "American Great: Lee Krasner." *Vogue.* 159(June 1972):118–121, 154.

————. *Lee Krasner: A Retrospective.* New York: Museum of Modern Art, 1983.
 An excellent monograph which includes a biographical summary, a thoughtful sytlistic analysis, a chronology, bibliography, and numerous reproductions, some in color.

Rubinstein. *American Women Artists.* Pp. 270–275.
 An excellent summary of Krasner's career.

Washington, D.C. Corcoran Gallery of Art. *Lee Krasner: Collages and Works on Paper, 1933–1974.* 1975.
 The catalog essay is by Gene Baro.

Wasserman, Emily. "Lee Krasner in Mid-Career." *Artforum.* 6(March 1968):38–43.

Collections:

New York, Whitney Museum of American Art.
Washington (D.C.), National Museum of Women in the Arts.

DOROTHEA LANGE. 1895–1965. United States.
 Lange was born in Hoboken, New Jersey. In 1917 she enrolled in a photography course taught at Columbia by Clarence White. Her early work was also influenced by Arnold Genthe, who acted as her critic. In 1919 Lange opened a portrait studio in San Francisco and the following year married painter Maynard Dixon. They had two children before divorcing in 1935. She then married Paul Taylor, a University of

California economist. During the 1930's Lange was a photographer for the California State Emergency Relief Administration and the Farm Security Administration. The uncompromising realism of her photographs of the poor and of migrant workers was responsible for bringing their plight to public attention. Her interest in documentary photography continued. She photographed Japanese-American relocation camps for the War Relocation Authority during the 1940's. In the 1950's she contributed several photo-essays to *Life* magazine.

Arrow, Jan. *Dorothea Lange.* London: Macdonald and Company, 1985.
A biographical summary, accompanied by Lange's photographs of the rural United States of the 1930's.

Beaton. *The Magic Image.* Pp. 168–169.

Curtis, James C. "Dorothea Lange, Migrant Mother, and the Culture of the Great Depression." *Winterthur Portfolio.* 21(Spring 1986):1–20.
Detailed account of how Lange achieved the composition of her most famous work, *Migrant Mother.* He discusses this photograph as a vital reflection of the times.

Dixon, Daniel, and Dorothea Lange. "Photographing the Familiar." *Aperture.* 1(1952):4–15, 68–72.

Dorothea Lange: Photographs of a Lifetime. Millerton, New York: Aperture, 1982.
The text accompanying each photograph is from Lange's writings and interviews. An essay by Robert Coles explores her working methods. A chronology and selected bibliography are included.

Fort Worth. Amon Carter Museum. *Dorothea Lange Looks at the American Country Woman.* 1967.
A photographic essay with works dating from the 1930's to the 1950's. The commentary is by Beaumont Newhall.

Grover, Jan Zita. "Dorothea Lange: A Case Study for Biography." *Afterimage.* 9(Summer 1981):14–17.
Reviews several publications about Lange and her photography.

Heyman, Therese Thau. *Celebrating a Collection: The Work of Dorothea Lange.* Oakland, California: The Oakland Museum, 1978.

Paul Taylor, Lange's husband, donated her negatives and memorabilia to the Oakland Museum. This catalog describes the collection of over 35,000 negatives, prints, letters, and artifacts. A large group of previously unpublished photographs are included in the catalog.

Lange, Dorothea, and Pirkle Jones. "Death of a Valley." *Aperture.* 8(1960).
The entire issue is devoted to a photo-essay on the change of a farm valley into a reservoir.

————, and Paul Taylor. *An American Exodus: A Record of Human Erosion.* New York: Reynal and Hitchcock, 1939.
These photographs were taken for the Farm Security Administration.

Meltzer, Milton. *Dorothea Lange: A Photographer's Life.* New York: Farrar, Straus and Giroux, 1978.
A well-documented biography.

Munsterberg. *A History of Women Artists.* Pp. 133–135.

Newhall. *History of Photography.* Pp. 146, 148, 150.

New York. Museum of Modern Art. *Dorothea Lange.* 1966.
This exhibition catalog contains an extensive bibliography and a detailed chronology. The introductory essay is by George Elliott.

Ohrn, Karin Becker. *Dorothea Lange and the Documentary Tradition.* Baton Rouge: Louisiana State University Press, 1980.
Ohrn discusses Lange's contributions to the developments in the documentary approach in photography.

Van Dyck, W. "The Photographs of Dorothea Lange: A Critical Analysis." Camera Craft. 41(October 1934):461–467.

Collections:

Detroit Institute of Arts.
Oakland Museum.
Washington (D.C.), Library of Congress.

MARIE LAURENCIN. 1883–1956. French.

Laurencin, a native of Paris, studied at the Ecole de Sèvres, the Lycée Lamartine, and the Académie Humbert. She exhibited for the first time in the Salon des Indépendants in 1906. She was a friend of Apollinaire and was introduced by him into Cubist circles. Her brief marriage to a German artist in 1914 forced her to wait out the war in Spain. She divorced in 1920 and returned to Paris. Laurencin's work consists of distinctive and unusual paintings that depict a dreamy private fantasy world of women, animals, and birds. She was also involved in theater design, book illustration, fabric design, and printmaking. In addition, she published poetry under the name Louise Lalanne.

Allard, Roger. *Marie Lauarencin.* Paris: Editions de la N.R.F., 1921.

Apollinaire, Guillaume. *Apollinaire on Art: Essays and Reviews, 1902–1918.* New York: Viking Press, 1972. Pp. 44, 67, 151, 206–207, 210, 215, 219–220, 229–230, 284, 291–292, 325, 332.
 Edited by LeRoy C. Breunig and translated by Susan Suleiman. In his reviews Apollinaire frequently referred to works by Laurencin.

Bénézit. *Dictionnaire.* Vol. 6, pp. 427–428.

Birmingham, Alabama. Birmingham Museum of Art. *Marie Laurencin: Artist and Muse.* March 18–April 30, 1989.
 The catalog essay is by Heather McPherson.

Day, George [pseud.]. *Marie Laurencin.* Paris: Editions du Dauphin, 1947.

Dorival. *The School of Paris in the Musée d'Art Moderne.*
 Includes reproductions of her work.

————. *Twentieth Century Painters.*

Fabre-Favier, Louise. *Souvenirs sur Guillaume Apollinaire.* Paris, 1945.

Fagan-King, Julia. ''United on the Threshold of the Twentieth-Century Mystical Ideal: Marie Laurencin's Integral Involvement with Guillaume Apollinaire and the Inmates of the *Bateau Lavoir.''Art History.* 11(March 1988): 88–114.
 Fagan-King explores the ideas connecting poets and painters, the sources of Laurencin's images, and the influence of Apollinaire on her work.

Fine. *Women and Art*. Pp. 171–173.
Brief discussion of Laurencin's book illustrations.

Gere, Charlotte. *Marie Laurencin*. London: Academy Editions, 1977.

Gray, C. "Marie Laurencin and Her Friends." *Baltimore Museum of Art News*. 21(February 1958):6–15.

Harris and Nochlin. *Women Artists, 1550–1950*. Pp. 58, 260, 295–296, 357–358.

Laboureru, Jean-Emile. "Les estampes de Marie Laurencin." *L'art d'aujourd'hui*. 1(Autumn–Winter 1924):17–21.

Laurencin, Marie. *Le carnet des nuits*. Geneva, 1956.

Lethève, Jacques; Françoise Gardey; and Jean Adhémar. "Marie Laurencin." *Bibliothèque Nationale du fonds français après 1800*. Paris, 1965.

Marchesseau, Daniel. *Marie Laurencin*. Tokyo: Curieux-Do, 1980.
The text is in Japanese and French. The preface is by Yoshio Abe. Over a hundred excellent color reproductions and a family tree are included.

Marie Laurencin. Paris, 1928.
Preface by Marcel Jouhandeau.

Mathey. *Six femme peintres*.

Munsterberg. *A History of Women Artists*. Pp. 65–67.

National Museum of Women in the Arts. Pp. 70–71.

Neilson. *Seven Women*. Pp. 125–143.
Much of the bibliography and biography supplied here are from this source.

"A Noseless Convention." *Connoisseur*. 7(January 1925):47.
Description of an exhibit of Laurencin's work in England. Notes the complete absence of noses in many of her works, or its replacement by the faintest smudges of pigment.

"Obituary." *Arts*. 30(July 1956):34.

"Obituary." *New York Times* (June 9, 1956).

Petersen and Wilson. *Women Artists*. Pp. 97, 104, 106–107.

Phaidon Dictionary of Twentieth Century Art. New York: Phaidon, 1973. P. 211.

Raynal. *Modern French Painters*. Pp. 109–111.

Sandell, Renee. "Marie Laurencin: Cubist Muse or More?" *Woman's Art Journal*. 1(Spring–Summer 1980):23–27.
Sandell argues that Laurencin should be given more credit than as simply the "muse" who inspired the poet and Cubist critic, Guillaume Appollinaire. Several black-and-white reproductions of her work accompany the article.

Sanouillet, Michel. *Francis Picabia et "391."* 2 vols. Paris, 1928.

Steegmuller, Francis. *Apollinaire: Poet Among Painters*. New York: Farrar, Straus, 1963.

Strasbourg. Ancienne Douane. *Les Ballets Russes de Serge Diaghilev, 1909–1929.* 1969. Pp. 204–207.

Thierry, Solange. "Le Musée Marie Laurencin." *L'oeil*. 378–379(January–February 1987):32–39.
Description of a new museum in the Japanese city of Tateshina, devoted to the works of Laurencin. Color reproductions are included.

Tokyo. Isetan Gallery. *Marie Laurencin*. 1971.

Wedderkop, H. von. *Marie Laurencin*. Leipzig: Klinkhardt and Bierman, 1921.

Collections:

Baltimore Museum of Art.
Boston Museum of Fine Arts.
Kansas City, Nelson-Atkins Museum of Art.
London, Tate Gallery.
New York, Museum of Modern Art.
Philadelphia Museum of Art.
Washington (D.C.), National Gallery of Art.
Washington (D.C.), National Museum of Women in the Arts.

MARISOL. 1930– . Venezuelan-American.

Marisol dropped her last name, Escobar, early in her career. She was born in Paris to wealthy Venezuelan parents. In 1948 she enrolled at the Ecole des Beaux-Arts in Paris. She came to New York in 1950 and began studying at the Art Students League. From 1951 to 1954 she studied painting with Hans Hoffman. Marisol then switched to her own unique sculptural style, which she has exhibited regularly in New York since the early 1960's. She utilizes various media—wood, terra cotta, and welded metal—to create her figurative sculptures. Her figures are usually in frontal poses and are often assembled in a tableau. She frequently uses castings or tracings of various parts of her own body in her work. Marisol's work is usually described as a form of pop art, with satirical, mysterious overtones. She co-starred in Andy Warhol's film *The Kiss.*

Berman, Avis. "A Bold and Incisive Way of Portraying Movers and Shakers." *Smithsonian.* 14(February 1984):54–63.

Bernstein, Roberta. "Marisol as Portraitist: Artists and Artistes." *Arts.* 55(May 1981):112–115.

Discussion of Marisol's carved portraits of other artists, executed between 1977 and 1981. Includes both color and black-and-white reproductions.

———. "Marisol's Self-Portraits: The Dream and the Dreamer." *Arts.* 59(March 1985):86–89.

A feminist analysis of the autobiographical content in Marisol's work, of how she uses her own image to reveal her vision of reality, and of her use of the theme of family. Black-and-white reproductions are included.

Campbell, Lawrence. "Marisol's Magic Mixtures." *Art News.* 63(March 1964):38–41.

Stylistic analysis and discussion of Marisol's techniques. Includes color reproductions.

Craven. *Sculpture in America.* Pp. 660–661.

Craven says Marisol has "an astute insight into contemporary life."

"The Dollmaker." *Time.* 85(May 28, 1965):80–81.

Includes color reproductions.

Fine. *Women and Art.* Pp. 219–221.

Glueck, Grace. "It's Not Pop, It's Not Op—It's Marisol." *New York Times Magazine* (March 7, 1965):34–35, 45–46, 48, 50.

Heller. *Women Artists.* Pp. 173–174.

Hill. *Women: A Historical Survey . . .* Catalog. Plate 81.

Loring, John. *Marisol: Prints, 1961–1973.* New York: New York Cultural Center, 1973.

———. "Marisol's Diptych Impressions, Tracings, Hatchings." *Arts.* 47(April 1973):69–70.
 Discusses her sculpture and her printmaking.

Medina, José Ramón. *Marisol.* Caracas: Ediciones Armitano, 1968.
 This work, in Spanish, consists largely of full-page reproductions of Marisol's work, many in color.

Munsterberg. *A History of Women Artists.* Pp. 97, 101.

Nemser, Cindy. *Art Talk.* Pp. 179–199, 363–364.

———. "A Conversation with Marisol." *Feminist Art Journal.* 2(Fall 1973):1, 3–6.

New York. Sidney Janis Gallery. *Marisol.* May 3–31, 1973.
 Exhibition catalog with several black-and-white reproductions.

———. *New Drawings and Wall Sculpture by Marisol.* March 5–29, 1975.

O'Doherty, Brian. "Marisol: The Enigma of the Self-Image." *New York Times* (June 21, 1973).

Rubinstein. *American Women Artists.* Pp. 347–350.

Schjeldahl, Peter. "Marisol: A Humorist in Three Dimensions." *New York Times* (June 21, 1973).

Simon, Joan. "Chers Maîtres." *Art in America.* 69(October 1981): 120–121.
 Discussion of Marisol's sculpture tableaux of twentieth-century artists.

Watson-Jones. *Contemporary American Women Sculptors.* Pp. 386–387.

Worcester, Massachusetts. Worcester Art Museum. *Marisol.* September 23–November 14, 1971.
 An exhibition of works executed in the 1960's. The brief essay is by Leon Shulman.

Collections:

 Chicago Art Institute.
 Chicago, Museum of Contemporary Art.
 Hakone (Japan), Open-Air Museum.
 New York, Museum of Modern Art.
 New York, Whitney Museum of American Art.
 Memphis, Brooks Memorial Art Gallery.

AGNES MARTIN. 1912– . United States.
 Martin, a forerunner of the minimal art movement, is a native of Canada. She came to the United States in 1932 and obtained citizenship in 1940. A graduate of Columbia University, she has lived and worked periodically in New York City. In the late 1940's she taught at the University of New Mexico. She has also done some writing, and her unpublished manuscripts are at the Institute of Contemporary Art of the University of Pennsylvania. Martin's first one-woman show was in 1958. Shortly after that she began doing grid works—square canvases with overall grids penciled on monochrome oil or acrylic backgrounds. In 1967 Martin abruptly left New York for New Mexico and ceased painting.

Alloway, Lawrence. "Agnes Martin." *Artforum.* 11(April 1973):32–37.
 Discusses the developmental changes within the uniform fields set up by her grids. Includes one color reproduction.

————. *Agnes Martin.* Philadelphia: Institute of Contemporary Art, University of Pennsylvania, January 22–March 1, 1973.
 The catalog essay is by Alloway. Written statements by Martin are included.

————. "Formlessness Breaking Down Form: The Paintings of Agnes Martin." *Studio International.* 185(February 1973):61–63.
 Discussion of Martin's grid works. Points out the importance of her titles to our perceptions of the work.

Barron, Stephanie. "Giving Art History the Slip." *Art in America.* 62(March 1974):80–84.

Summary of the art produced at Coenties Slip, a Manhattan warehouse district that was home to a group of artists (including Martin) between 1954 and 1964. Discusses the interrelationships of the artists. Between 1959 and 1961 Martin produced some sculptural assemblages, one of which is illustrated.

Borden, Lizzie. "Early Works." *Artforum.* 11(April 1973):39–44.

Recounts Martin's early life and discusses the abstract, biomorphic form her art took before the grid works.

Elderfield, John. "Grids." *Artforum.* 10(Mary 1972):52–59.

Discussion of several artists utilizing the grid approach with a brief mention of Martin. Includes a good color reproduction of her *Night Sea.*

Linville, Kasha. "Agnes Martin: An Appreciation." *Artforum.* 9(June 1971):72–73.

Discusses stylistic changes in Martin's work.

McEvilley, Thomas. " 'Grey Geese Descending': The Art of Agnes Martin." *Artforum.* 25(Summer 1987):94–99.

Discusses the characteristics of Martin's art and relates it to her interest in Taoist thought. Includes good reproductions.

Martin, Agnes. "Reflections." *Artforum.* 11(April 1973):38.

Brief personal statement concerning her view of art and its role in life.

———. "The Untroubled Mind." *Studio International.* 185(February 1973):64–65.

Collection of statements by the artist.

Michelson, Annette. "Agnes Martin: Recent Paintings." *Artforum.* 5(January 1967):46–47.

Description of her grid paintings.

Petersen and Wilson. *Women Artists.* P. 27.

Poirier, Maurice, and Jane Necol. "The Sixties in Abstract: Thirteen Statements and an Essay." *Art in America.* 71(October 1983):132.

Interviews by Poirier and Necol with artists reminiscing about what it was like to be an abstract painter in the 1960's. Martin states that she

left New York because of ''an overdeveloped sense of responsibil-
ity.''

Ratcliff, Carter. ''Agnes Martin and the Artificial Infinite.'' *Art News.*
72(May 1973):26–27.
 Summary of the biographical facts.

Rubinstein. *American Women Artists.* Pp. 331–333.

Who's Who in American Art, 1976. New York: R. R. Bowker Company,
1976. P. 367.

Wilson, Ann. ''Agnes Martin—The Essential Form: The Committed
Life.'' *Art International.* 18(December 1974):50–52.
 Poetic analysis of Martin's art, drawing on the New Mexico
atmosphere for background. Illustrated with drawings by Martin.

———. ''Linear Webs.'' *Art and Artists.* 1(October 1966):48.
 Discusses Martin's use of the fabric of the canvas. Includes quotes
from the artist.

Collection:

Poughkeepsie (New York), Vassar College Art Gallery.

MARIA MARTINEZ. 1887–1980. Native American.
 Martinez, a Pueblo Indian, was born in San Ildefonso, New Mexico.
Part of her girlhood was spent at St. Catherine's Indian School in Santa
Fe. She became economically secure through mastery of the Pueblo craft
of pottery. Her husband, Julian, worked closely with her: Maria shaped
and polished the pieces, and he painted them. Between 1908 and 1912
they worked on a small scale. She was also employed at the Museum of
New Mexico as a pottery demonstrator. Encouraged by anthropologists
and archaeologists in the Santa Fe area, around 1919 they developed
their famous matte-black decoration. The popularity of their ware led
them to a type of mass production, with the employment of several
relatives. Julian was plagued at times with a drinking problem and died
in 1943. Maria Martinez continued making pottery until 1972.

Bahti, Tom. *An Introduction to Southwestern Indian Arts and Crafts.*
Flagstaff, Arizona: K. C. Publications, 1964.

Ball, Charlotte, ed. *Who's Who in American Art*. Vol. 3, *1940–1941*. Washington, D.C.: American Federation of the Arts, 1940. P. 423.
Martinez exhibited at the 1934 Chicago Century of Progress Exhibition and taught pottery to girls in her village.

Bergé, Carol. "Dark Radiance." *Arts and Antiques* (September 1988):104–107, 134.

"Best—Stone and Clay." *Newsweek*. 43(April 26, 1954):95.
Martinez won the American Institute of Architects fine arts medal in craftsmanship.

Covarrubias, Miguel. *The Eagle, the Jaguar, and the Serpent: Indian Art of the Americas*. New York: Alfred A. Knopf, 1954. Pp. 229–230.

Grothe, Carl. *Pueblo Pottery Making: A Study at the Village of San Ildefonso*. New Haven: Yale University Press, 1925.

Highwater, Jamake. *Arts of the Indian Americas: Leaves From the Sacred Tree*. New York: Harper and Row, 1983. P. 94.

"Maria Martinez." *Ceramic Review*. 68(March–April 1981):7–9.
This brief article points out the growth and development of Martinez's art, now carried on by other family members.

Marriott, Alice. *Maria: The Potter of San Ildefonso*. Norman: University of Oklahoma Press, 1948.
Popularized biography that contains a good chronology, but unfortunately has no photographs.

Munsterberg. *A History of Women Artists*. Pp. 5–6.

National Museum of Women in the Arts. P. 114.

Peterson, Susan. *The Living Tradition of Maria Martinez*. Tokyo: Kodansha International; New York: Harper and Row, 1982.
Biography with numerous color reproductions.

———. "Matriarchs of Pueblo Pottery."

Rubinstein. *American Women Artists*. Pp. 10–11.

Spivey, Richard. *Maria*. Flagstaff, Arizona: Northland Press, 1979.

Trimble, Stephen. *Talking with the Clay: The Art of Pueblo Pottery.* Santa Fe, New Mexico: School of American Research Press, 1987. Pp. 38–41, 44.

Wade, Edwin, ed. *The Arts of the North American Indian.* New York: Hudson Hill Press, 1986. Pp. 184–187, 250–254.
 Excellent discussion of the economic impact of Martinez's success on San Ildefonso society.

Whitman, William. *The Pueblo Indians of San Ildefonso.* New York: Columbia University Press, 1947.

Collections:

New York, Museum of the American Indian, Heye Foundation.
Taos (New Mexico), Millicent Rogers Museum.
Washington (D.C.), National Museum of Women in the Arts.

JOAN MITCHELL. 1926– . United States.
 Mitchell was born in Chicago to a socially prominent family. She was educated at Smith College and the Chicago Art Institute. In 1948 Mitchell moved to New York and then on to Paris. She spent two years working in Europe as a Fulbright Fellow. Mitchell's first one-woman exhibition was in 1952. She lived in New York from 1950 to 1955. She has lived in France with the Canadian artist Jean-Paul Riopelle since 1968. Mitchell is a second-generation Abstract Expressionist, utilizing a primary palette.

Berkson, Bill. "In Living Chaos: Joan Mitchell." *Artforum.* 27(September 1988):96–99.

Bernstock, Judith. *Joan Mitchell.* New York: Hudson Hill Press, in association with the Herbert E. Johnson Museum of Art, Cornell University, 1988.
 An excellent monograph that provides a thoughtful discussion of the relationship between poetry and Mitchell's paintings. A bibliography, list of exhibitions, a brief chronology, and many excellent color plates are also provided.

Fine. *Women and Art.* Pp. 214–216.

Harithas, James. "Weather Paint." *Art News.* 71(May 1972):40–43, 63.

Johnson, Ellen. "Is Beauty Dead?" *Oberlin College Bulletin.* 20(Winter 1963):57–59
 Review of an exhibition "Three Young Americans," which included Mitchell.

Munro. *Originals: American Women Artists.* Pp. 233–247.

Munsterberg. *A History of Women Artists.* P. 77.

National Museum of Women in the Arts. Pp. 98–99.

Nemser, Cindy. "An Afternoon with Joan Mitchell." *Feminist Art Journal.* 3(Spring 1974):5–6, 24.
 More of an analysis of Mitchell's personality than an evaluation of her work.

Petersen and Wilson. *Women Artists.* P. 129.

Rubinstein. *American Women Artists.* Pp. 282–283.
 Says that Mitchell produces only about twenty paintings a year and destroys many of those.

Sandler, Irving. "Mitchell Paints a Picture." *Art News.* 56(October 1957):44–47, 69–70.
 Examination of Mitchell's technique of painting.

Sawin, Martica. "A Stretch of the Seine: Joan Mitchell's Paintings." *Arts.* 62(March 1988):29–31.

Schneider, Pierre. "From Confession to Landscape." *Art News.* 67(April 1968):42–43, 72–73.
 Convoluted analysis of Mitchell's work, noting that "nothing discloses that it was painted by a woman." Includes good color reproductions.

Tucker, M. *Joan Mitchell.* New York: Whitney Museum, 1974.

Westfall, Stephen. "Then and Now: Six of the New York School Look Back." *Art in America.* 73(June 1985):113–114.
 An interview with Mitchell.

Collections:

New York, Whitney Museum of American Art.
Washington (D.C.), Hirshhorn Museum and Sculpture Garden.
Washington (D.C.), National Museum of Women in the Arts.

TINA MODOTTI. 1896–1942. Italian.

Modotti, an Italian by birth, immigrated to California with her family in 1913. She had a brief career as a Hollywood actress before meeting the photographer Edward Weston in 1921. Her role as his model escalated to a love affair that lasted a number of years and a friendship that continued throughout her life. Modotti's husband, an artist, died during a visit to Mexico in 1922. The following year she returned to Mexico with Weston and they lived there from 1923 to 1926. During that time he taught her photography. They exhibited and published their work jointly; however, her work was strongly influenced by Weston's. In 1926 Weston returned to his family and Modotti remained in Mexico. She became very involved in revolutionary Mexican politics and was deported from the country in 1930. She then traveled around Europe, abandoning photography in order to dedicate all her efforts to working for the Communist party. She returned to Mexico in 1938, where she later died under mysterious circumstances.

Constantine, Mildred. *Tina Modotti: A Fragile Life.* New York: Paddington Press, 1975.

This illustrated biography details her political interests and activities. Constantine draws on letters and interviews.

Hellman, Robert, and Marvin Hoshino. ''Tina Modotti.'' *Arts.* 51(April 1977):23.

Exhibition review that recounts basic biographical facts. ''There's no way to account for her early consistent mastery except to conclude that the master was looking over her shoulder.''

London. Whitechapel Art Gallery. *Frida Kahlo and Tina Modotti.* March 26–May 2, 1982.

An excellent essay by Laura Mulvey and Peter Wollen weaves the story of the art of Kahlo and Modotti and their relationship. Includes numerous reproductions of Modotti's work.

Munsterberg. *A History of Women Artists.* Pp. 137–139.

Says her best work consists of studies of the common people of Mexico.

Newhall, Nancy, ed. *The Daybooks of Edward Weston.* 2 vols. Millerton, New York: Aperture, 1973.

Excepts from Weston's journals. Numerous references to Modotti are included as well as portions of letters written by Modotti in which she refers to some of her own photographic work.

Newman, Michael. "The Ribbon Around the Bomb." *Art in America.* 71(April 1983):160–169.

Newman notes an explicit political content in Modotti's work. He discusses the personal and artistic connections between Kahlo and Modotti.

Rice, Shelley. "Tina Modotti at the Museum of Modern Art." *Art in America.* 65(July 1977):96.

Review of an exhibition of forty of Modotti's prints. Rice believes Modotti's most significant photographic work was done between 1923 and 1930. She notes that no more than a hundred pictures survive from these years. For Rice, the strongest photographs are those which join Modotti's social conscience with Weston's principles of formalism.

Rochfort, Desmond. "Tina Modotti and Frida Kahlo at the Whitechapel Gallery." *Creative Camera.* 210(June 1982):550–553.

Review of exhibition. Includes reproduction of her work.

Symmes, Marilyn F. "Important Photographs by Women." *Bulletin of the Detroit Institute of Arts.* 56, no. 2(1978):148–149.

Collection:

Detroit Institute of Arts.

BARBARA MORGAN. 1900– . United States.

Morgan was born in Kansas but grew up in southern California. She began her artistic career as an abstract painter after majoring in art at UCLA between 1919 and 1923. She married a photographer, Willard Morgan, in 1925 and began working with photography the following year. Her most important work consists of photomontages of movement based on her interest in dance photography.

Beaton. *Magic Image.* P. 173.

Hering, Doris. "Barbara Morgan." *Dance Magazine.* 45(July 1977):43–56.
 An excellent analysis of Morgan's dance photography from 1935 to 1945, with many reproductions of her work.

Morgan, Barbara. *Aperture.* 11, no. 1(1964):1–44.
 The entire issue was designed and written by Morgan—a monograph on herself.

———. *Barbara Morgan.* Fort Worth: Amon Carter Museum, 1972.
 Lists her exhibitions.

———. *Barbara Morgan.* Dobbs Ferry, New York: Morgan and Morgan, 1972.
 A monograph.

———. "In Focus: Photography, the Youngest Visual Art." *Magazine of Art.* 35(November 1942):248–255.
 Discussion of the aesthetics of photography.

———. *Martha Graham: Sixteen Dances in Photographs.* New York: Duell, Sloan, and Pearce, 1941.

———. *Photomontage.* Dobbs Ferry, New York: Morgan and Morgan, 1980.

———. *Summer's Children.* Scarsdale, New York: Morgan and Morgan, 1951.
 A photographic cycle of life at summer camp.

Newhall. *History of Photography.* Pp. 158–159.

Collections:

 Detroit Institute of Arts.
 New York, Metropolitan Museum of Art.
 New York, Museum of Modern Art.
 St. Petersburg (Florida), Museum of Fine Art.

ANNA MARY ROBERTSON (GRANDMA) MOSES. 1860–1961.
United States.
 This artist was born in Greenwich, New York. She showed an interest in art as a child, but this interest was submerged until late in her

life. She married when she was twenty-seven years old and had ten children, five of whom died in infancy. She and her husband farmed in the Shenandoah Valley of Virginia. A self-taught artist, her work was "discovered" by Louis Caldor, a New York collector, in 1938 when Moses was seventy-eight. Her work was first shown in 1939 at the Museum of Modern Art's exhibition of "Unknown Contemporary American Painters." She had her first one-woman show that same year at the Otto Kallir Gallery. Her "primitive" works were done from memory and usually consisted of rural scenes and landscapes.

Armstrong, William. *Barefoot in the Grass: The Story of Grandma Moses.* Garden City, New York: Doubleday and Company, 1970.

Ebert. *American Folk Painters.* P. 211.

Humez, Jean McMahon. "The Life and Art of Anna Mary Robertson Moses." *Woman's Art Journal.* 1(Fall 1980–Winter 1981):7–12.
 Using Moses' autobiography, Humez offers a new perspective. Instead of the quaint "Grandma," Moses is shown as a professional artist who used her talent to support herself and maintain her independence after her husband died. Humez reveals the conflict between Moses' art and her role as a traditional rural homemaker. Many of her works are described.

Kallir, Otto. *Grandma Moses.* New York: Harry N. Abrams, 1973.
 A biography and catalogue raisonné.

————. *Grandma Moses: American Primitive.* Garden City, New York: Doubleday and Company, 1946.
 Includes forty reproductions with commentaries by the artist. The introduction is by Louis Bromfield.

Moses, Anna Mary. *My Life's History.* Ed. Otto Kallir. New York: Harper and Brothers, 1952.
 This autobiography was written when Moses was almost ninety.

New York. Galerie St. Etienne. *Grandma Moses.* 1957.
 A New York showing of works that were exhibited in Europe from 1955 to 1957. Includes a selection of reviews by the European press.

————. *Grandma Moses: The Artist Behind the Myth.* November 16, 1982–January 8, 1983.
 An extensive essay by Jean Kallir, granddaughter of Otto Kallir, examines the artist's creative process and stylistic development. Kallir

explores Moses' sources and discusses the cultural milieu of her time. Includes numerous reproductions.

————. *My Life's History.* 1960.
An exhibition assembled on the occasion of the artist's one hundredth birthday. Black-and-white reproductions are accompanied by quotes from her autobiography.

Rubinstein. *American Women Artists.* Pp. 36–38.

Seckler, Dorothy. "The Success of Mrs. Moses." *Art News.* 50(May 1951):28–29, 64–65.
Attributes her success partially to an American nostalgia for the rural past.

Tinling. *Women Remembered.* Pp. 94–95.
Notes that Moses painted on Masonite panels with house paint. Her artistic skills developed as she worked to fill the demand for her paintings. The government issued a postage stamp in her honor in 1969.

Washington, D.C. National Gallery of Art. *Grandma Moses: Anna Mary Robertson Moses (1860–1961).* February 11–April 1, 1979.
Exhibition catalog that contains a biographical sketch.

Yglesias, Helen. "Moses, Anna Mary Robertson (Grandma)." In *Notable American Women: Modern Period.* Vol. 4, pp. 501–503.

Collections:

Dearborn (Michigan), Greenfield Village and Henry Ford Museum.
New York, Metropolitan Museum of Art.
Shelburne (Vermont), Shelburne Museum.
Washington (D.C.), Phillips Collection.

GABRIELE MÜNTER. 1877–1962. German.
Münter was born in Berlin. She studied art briefly at the Women's Art School in Düsseldorf before embarking in 1898 on two years of travel in the United States. On her return to Germany, Münter resumed art studies in Munich. In 1902 she began studying painting at the Phalanx School in Munich where her teacher was Wassily Kandinsky. She and Kandinsky lived together for eleven years, from 1903 to 1914. Münter's work

appeared in the first two Blue Rider shows. After her relationship with Kandinsky ended, Münter's work seemed to falter for several years. In 1927 she met Johannes Eichner, an art historian, and lived with him in Murnau during the last twenty-five years of her life. In 1937 her work was declared "degenerate" and was removed from an exhibition of the Munich Art Association. She painted secretly throughout the balance of the Second World War and continued painting up until her death.

Bachrach, Susan P. "A Comparison of the Early Landscapes of Münter and Kandinsky, 1902–1910." *Women's Art Journal*. 2(Spring–Summer 1981):21–24.
 Chronicles the couple's travels to the Munich countryside, Holland, North Africa, and Paris. Contends that despite their close relationship, Kandinsky did not cause her to change her style and that she was never his imitator.

Behr. *Women Expressionists*. Pp. 10–13, 32–33, 38–39, 42–43, 46–49, 68–69.

Bénézit. *Dictionnaire*. Vol. 7, pp. 612–613.

Buchheim, Lothar-Günther. *Der blaue Reiter und die "Neue Kunstlrtvereinigung Munchen."* Feldafing: Buchheim Verlag, 1959.

Comini, Alessandra. "State of the Field, 1980: The Women Artists of German Expressionism." *Arts*. 55(November 1980):147–153.
 Includes an extensive discussion of Münter and her relationship with Kandinsky. Notes that Münter is now taking her rightful place in U.S. museum exhibition history.

Eddy, Arthur Jerome. *Cubists and Post Impressionists*. Chicago, 1914.
 Eddy describes Münter as having a "vision of things quite her own, a sense of humor and of life that penetrates beneath the surface, and that manifests itself in a technique that is, one might almost say, nonchalant."

Eichner, Johannes. *Kandinsky und Gabriele Münter vom Ursprungen moderner Kunst*. Munich, 1957.
 A detailed biography of the two artists and a critical analysis of their work.

Erlanger, Liselotte. "Gabriele Münter: A Lesser Life?" *Feminist Art Journal*. 3(Winter 1974–1975):11–13, 23.
 Much of the bibliography supplied here comes from this source.

Fine. *Women and Art*. Pp. 160–162.

Fleisher. "Love and Art."

Gollek, R. *Der Blaue Reiter im Lenbachhaus Munchen*. Munich, 1974. Pp. 220–246.

Greer. *The Obstacle Race*. Pp. 42–43.

Gregg, Sara H. "Gabriele Münter in Sweden: Interlude and Separation." *Arts*. 55(May 1981):116–119.
Relates the period Münter spent in Sweden in 1916 to her relationship with Kandinsky.

Grohman, Will. *Wassily Kandinsky*. Cologne, 1958.

Handler, Von Holten. *German Painting in Our Time*. Berlin, 1956.

Harris and Nochlin. *Women Artists, 1550–1950*. Pp. 58–59, 95, 281–283, 355–356.

Heller. *Women Artists*. Pp. 116–119.

Hill. *Women: A Historical Survey* . . . Catalog. P. 25.

Lahnstein, Peter. *Münter*. Ettal, 1971.
The magnificent color plates make this a good introduction to Münter's work. The text is in German.

Lindsay, Kenneth. "Gabriele Münter and Wassily Kandinsky: What They Meant to Each Other." *Arts*. 56(December 1981):56–62.
Details their long relationship and its reflections in each of their oeuvres.

London. Marlborough Fine Art. *Gabriele Münter: Oil Paintings, 1903–1937*. 1940.

Mochon, Anne. *Gabriele Münter: Between Munich and Murnau*. Cambridge, Massachusetts: Publications Dept., Harvard University, Fogg Art Museum, 1980.
Describes Münter's investigations into printmaking in 1906. Provides many good reproductions.

Munich. Städtische Galerie im Lenbachhaus. *Der Blaue Reiter.* 1966.
An enormous exhibit catalog with many color reproductions of
Münter's paintings.

Munich. Städtische Galerie im Lenbachhaus. *Gabriele Münter, 1877–
1962.* 1962.

Munsterberg. *A History of Women Artists.* Pp. 69–70, 118.

National Museum of Women in the Arts. Pp. 130–131, 219.

Neigemont, Olga. *German Expressionists: The Blue Rider School.* New
York: Crown Publishing Company, n.d.
One of the ten color plates is Münter's.

New York. Leonard Hutton Galleries. *Der Blaue Beiter.* February
19–March 30, 1963.
This catalog includes two women in the Blue Rider: Münter and
Marianna von Werefkin.

New York. Leonard Hutton Galleries. *Gabriele Münter (1877 to 1962):
Fifty Years of Her Art, Paintings, 1906–1956.* March–April, 1966.
The introduction is by Hans Konrad Roethel.

Petersen and Wilson. *Women Artists.* Pp. 104, 107–108.

Roditi, Edouard. "Interview with Gabriele Münter." *Arts.* 34(January
1960):36–41.

Roethel, Hans Konrad. *Gabriele Münter.* Munich, 1957; English edition,
New York, 1971.

Selz, Peter. *German Expressionistic Painting.* Berkeley: University of
California Press, 1957. Pp. 180, 182–183, 195, 197, 209, 270.
Selz discusses and describes several of Münter's works as he places
Münter in the context of her contemporaries.

Werner, Alfred. "Gabriele Münter: Native Genius." *American Artist.*
39(January 1975):54–59, 82–83.
Excellent summary of Münter's life and work. Good color repro-
ductions.

Wingler, Hans Maria. *Der Blaue Reiter.* Feldafing, 1954.

Collections:

Milwaukee Art Center.
Munich, Lenbachhaus.

NAMPEYO (Priscilla Namingha). 1856–1942. Native American.
Nampeyo, a woman of the Hopi pueblo of Hano, learned pottery making as a child. She is credited with helping to revive Hopi pottery making in the early twentieth century. She and her husband, Lesou, worked as a creative team. In the late 1880's, the long-abandoned Hopi pueblo ruins at Sikyatki were being explored by archaeologists. Nampeyo began using rediscovered Sikyatki shapes and designs on her white-slip pottery between 1885 and 1890. She later adopted the yellow clay used in Sikyatki pottery. The Fred Harvey Company employed her in 1905 and in 1907 to demonstrate her art at the Grand Canyon Hopi House. In the Hopi tradition, she taught her art to her female relatives.

Collins, John. *Nampeyo, Hopi Potter: Her Artistry and Her Legacy.* Flagstaff, Arizona: Northland Press, 1974.

Highwater, Jamake. *Arts of the Indian Americas.* New York: Harper and Row, 1983. P. 193.

Kramer, Barbara. "Nampeyo, Hopi House, and the Chicago Land Show." *American Indian Art.* 14(Winter 1988):46–53.
Carefully researched article that details Nampeyo's employment by the Fred Harvey Company and her participation in 1910 in their railway exhibit for the United States Land and Irrigation Exhibition, held in Chicago. Kramer says that Nampeyo's work became known as the Sikyatki Revival style. Kramer also notes that the potter was photographed many times between 1900 and 1919 by Edward S. Curtis.

Peterson. "Matriarchs of Pueblo Pottery."

Rubinstein. *American Women Artists.* Pp. 11–12.

Trimble, Stephen. *Talking with the Clay: The Art of Pueblo Pottery.* Santa Fe, New Mexico: School of American Research Press, 1987. Pp. 91–92.

Wade, Edwin L., ed. *The Arts of the North American Indian*. New York: Hudson Hills Press, 1986. Pp. 182–185.
 Good biographical summary.

Collections:

 Mesa Verde National Park Museum, Arizona.
 Milwaukee Public Museum.

ALICE NEEL. 1900–1984. United States.
 Neel, a Pennsylvania native, was primarily a portrait painter. Hers is a direct Expressionistic mode involving both the linear and the painterly. Her harsh and penetrating vision resulted in portraits that were often amazingly perceptive. Neel's choice of subjects was occasionally innovative, such as her paintings of pregnant women or naked men. In 1921 she began her formal art eduction at the Philadelphia School of Design for Women (now Moore College of Art). She married a Cuban student in 1925 and moved with him to Havana to bear their first child and to have her first exhibit. Upon their return to New York in 1924 their daughter died of diphtheria. Neel and a second daughter, born in 1928, were separated for several years when the child was left in Cuba by her father while he went to Europe. By 1930 Neel had suffered a nervous breakdown which kept her from working for a year. Next followed a succession of lovers and the birth of two sons. Throughout those years, the 1930's, Neel worked for the WPA to support herself and her children. She continued her "collection of souls," as she termed her paintings, even though for most of her career she worked in relative obscurity. She did not receive any critical acclaim until the 1960's. The Whitney gave her a one-woman show in 1974.

Alloway, Lawrence. "Art." *The Nation*. 218(March 9, 1974).

Berliner, David C. "Women Artists Today." *Cosmopolitan* (October 1973):218.

Berrigan, Ted. "The Portrait and Its Double." *Art News*. 64(January 1966):30–33, 63–64.

Bonosky, Phillip. "Alice Neel Exhibits Her Portraits of the Spirit." *Daily World* (Fall 1973):8.

Castle, Ted. "Alice Neel." *Artforum.* 22(October 1983):36–41.
An interview with Neel in which she talks about people she has known and her reaction to fame, and discusses some of her paintings.

Cochrane, Diane. "Alice Neel: Collector of Souls." *American Artist.* 37(September 1973):32–37, 63–64.

Crehan, Hubert. "A Different Breed of Portraitist." *San Francisco Sunday Examiner and Chronicle* (March 7, 1971):"This World" section.

————. "Introducing the Portraits of Alice Neel." *Art News.* 61(October 1962):44–47, 68.

Elgon, John. "Painting People Finally Won Her Acclaim." *East African Standard* (June 21, 1972).
This is a Nairobi, Kenya, newspaper.

Fine. *Women and Art.* Pp. 203–205.

Gruen, John. *Close Up.* New York: Viking Press, 1968. Pp. 144–146.
A brief description of the artist.

Halasz, Piri. "Alice Neel: 'I Have This Obsession with Life.' " *Art News.* 73(January 1974):47–49.

Harris and Nochlin. *Women Artists, 1550–1950.* Pp. 323–324, 360.

Heller. *Women Artists.* Pp. 148–149.

Higgins, Judith. "Alice Neel and the Human Comedy." *Art News.* 83(October 1984):70–79.
Excellent biographical summary with many good photographs and reproductions.

Hill. *Women: A Historical Survey . . .* Catalog. P. 55.

Hills, Patricia. *Alice Neel.* New York: Harry Abrams, 1983.
Transcribed tape-recorded interviews with the artist. Hills includes a list of exhibitions, a chronology, and many excellent reproductions, 103 in color.

Hope, Henry R. "Alice Neel: Portraits of an Era." *Art Journal.* 38(Summer 1979):273–281.

Johnson, Ellen H. "Alice Neel's Fifty Years of Portrait Painting." *Studio International.* 193(May–June 1977):174–179.
Biographical summary with emphasis on her political activism.

Kramer, Hilton. "Alice Neel Retrospective." *New York Times* (October 24, 1970):25.
Kramer was Neel's chief detractor.

Krebs, Patricia. "Portrait Painter Tracks Down Her Sisters." *Greensboro Daily News* (October 28, 1973):B12.

Kroll, Jack. "Curator of Souls." *Newsweek* (January 31, 1966):82.

Leslie, Alfred. *The Hasty Papers: A One-Shot Review.* New York, 1960.

Loercher, Diana. "Alice Neel, American Portraitist." *Christian Scientist Monitor* (March 4, 1974):F6.

————. "One-Man Shows Liven N.Y. Galleries." *Christian Scientist Monitor* (October 11, 1973):16.

Mainardi, Patricia. "Alice Neel at the Whitney Museum." *Art in America.* 62(1974):107–108.

————, ed. "Talking About Portraits." *Feminist Art Journal.* 3(Summer 1974):13–16, 19.
A group interview of Marcia Marcus, Patricia Mainardi, and Alice Neel conducted by Judith Vivell.

Miller and Swenson. *Lives and Works.* Pp. 121–129.
An interview with the artist.

Mitchell, Anita Velez. "A Visit with Alice Neel." *Helicon Nine.* 1(Spring–Summer 1979):21–25.
Several reproductions are included.

Munro. *Originals: American Women Artists.* Pp. 120–130.

National Museum of Women in the Arts. Pp. 88–89.

Nemser, Cindy. *Alice Neel: The Woman and Her Work.* Athens: Museum of Art, University of Georgia, September 7–October 19, 1975.
This catalog unfortunately only has black-and-white reproductions.

The preface is by William D. Paul, Jr. Nemser's essay is titled "Alice Neel—Teller of Truth." Her comments are enlivened by her description of Neel persuading her and her husband, Chuck, to pose for their portraits nude. Statements by Raphael Soyer, Dorothy Pearlstein, and Neel herself are included. The catalog has a selected chronology and bibliography.

————. *Art Talk.* Pp. 112–147, 362.
Nemser's in-depth interview supplied most of the specifics in the above biographical paragraph.

————. "Portraits of Four Decades." *Ms.* 2(October 1973):48–53.

Nochlin, Linda. "Some Women Realists." *Arts.* 48(May 1974):30.

Perreault, John. "Art: Alice Neel Show." *Village Voice* (February 21, 1974).

————. "Reading Between the Face's Lines." *Village Voice* (September 27, 1973):27.

Petersen and Wilson. *Women Artists.* P. 136.

Peterson, Valerie. "U.S. Figure Painting: Continuity and Cliché." *Art News.* 61(Summer 1962):38.
Describes Neel as an artist who involves the portrait directly with subject as a personality.

Rubinstein. *American Women Artists.* Pp. 381–385.

Russo. *Profiles on Women Artists.* Pp. 195–208.

Schmitt, Marilyn. "Alice Neel." *Arts.* 52(May 1978):9.
Review of two south Florida exhibitions of Neel's work.

Solomon, Elke Morger. *Alice Neel.* New York: Whitney Museum of American Art, February–March 1974.
The modest catalog of her small retrospective exhibit.

Time. (August 31, 1970): cover.
Neel's cover portrait of Kate Millett.

Collections:

Baltimore Museum of Art.
New York, Metropolitan Museum of Art.
New York, Museum of Modern Art.
New York, Whitney Museum of American Art.
Washington (D.C.) National Museum of Women in the Arts.

LOUISE NEVELSON. 1899–1988. United States.
Nevelson, a major twentieth-century sculptor, was born in Kiev, Russia, and immigrated with her family to the United States in 1905. She was raised in Maine. At the age of twenty-one she married Charles Nevelson and they had a son. She studied both performing and visual arts during her marriage, which ended in divorce in 1931. From 1929 to 1930 she was a student at the Art Students League. She studied with Hans Hoffman in Munich in 1931 and in 1932 at the Art Students League. In 1933 she worked as one of Diego Rivera's assistants. Nevelson worked in poverty and isolation throughout the 1930's and 1940's; most of her early work is lost because she could not afford storage. Her first one-woman show was held in 1941 at the Nierendort Gallery in New York. Her early work was in a Cubist vein and gradually developed into her emphasis upon environment, frontality, and a compellingly asserted surface. While her all-white, gold, or black wooden assemblages are most familiar, she also utilized Plexiglas, aluminum, and steel. Nevelson was elected president of the New York Artists Equity in 1957 and of the national group in 1963. The Whitney Museum of American Art gave her a major retrospective in 1967.

Armstrong. *Two Hundred Years of American Sculpture.* Pp. 295–296.

Baro, Gene. *Nevelson: The Prints.* New York: Pace Editions, 1974.
 Discussion of Nevelson's activity as a printmaker.

Bongartz, Roy. " 'I Don't Want to Waste Time,' Says Louise Nevelson at 70." *New York Times Magazine* (January 24, 1971): Section 6.

Fine. *Women and Art.* Pp. 200–203.

Friedman, Martin. *Nevelson Wood Sculptures.* New York: E. P. Dutton, 1973.
 Catalog for an exhibition held at the Walker Art Center, Minneapolis, November–December 1973.

Glimcher, Arnold B. *Louise Nevelson.* New York: Praeger Publishers, 1972.
Excellent coverage of Nevelson's early years and her struggles to become an artist. Includes many photographs.

Gordon, John. *Louise Nevelson.* New York: Whitney Museum of American Art, 1967.
This work includes many black-and-white reproductions of Nevelson's art, an abbreviated chronology, a list of exhibitions, and a selected bibliography.

Heller. *Women Artists.* Pp. 133–134.

Henning, Edward. "Sky Cathedral—Moon Garden Wall by Louise Nevelson." *Cleveland Museum Bulletin.* 64(September 1977):242–251.
A description of one of Nevelson's wall assemblages, done between 1956 and 1959.

Hill. *Women: A Historical Survey . . .* Catalog. Plate 57.

Hobbs, Robert. "Louise Nevelson: A Place That Is an Essence." *Woman's Art Journal.* 1(Spring-Summer 1980):39–43.
A contextual investigation of Nevelson's *Sky Cathedrals,* placing the work in its historical context.

Johnson, Una E. *Louise Nevelson.* New York: Shorewood Publishers, 1967.

―――. *Louise Nevelson: Prints and Drawings, 1953–1966.* New York: Brooklyn Museum, 1967.
Discusses three phases of printmaking, starting with her 1953 intaglio prints.

Kramer, Hilton. *The Age of the Avant-Garde.* New York: Farrar, Straus, and Giroux, 1973. Pp. 365–368.
Discusses her work in Plexiglas.

―――. "The Sculpture of Louise Nevelson." *Arts.* 32(June 1958): 26–29.
Good reproductions of her work.

Lipman, Jean. *Nevelson's World.* New York: Hudson Hills Press, 1983.
Chronological biography.

Lisle, Laurie. *Louise Nevelson: A Passionate Life.* New York: Summit Books, 1990.

Lurie, James Harrison. "Every Scrap of Wood." *Arts and Antiques.* 6 (April 1989):76–81, 108–110.
 This article is based on the author's experiences as Nevelson's assistant in 1982 and 1983.

MacKown, Diana, and Louise Nevelson. *Dawns and Dusks.* New York: Scribner's, 1976.
 A description of Nevelson's struggles and motivations, written by her assistant, MacKown, from tape transcripts of conversations.

Mogelon, Alex, and Norman Laliberté. *Art in Boxes.* New York: Van Nostrand Reinhold Company, 1974. Pp. 117–123.
 Includes several black-and-white reproductions of her work.

Munro. *Originals: American Women Artists.* Pp. 131–144.
 Excellent investigation into the impulses for Nevelson's work.

Munsterberg. *A History of Women Artists.* Pp. 95–97, 118.

Naples. Villa Pignatelli. *Louise Nevelson: Grafica.* May 9–May 30, 1976.

Nemser. *Art Talk.* Pp. 52–79, 360–361.
 This interview with Nevelson was originally printed in the *Feminist Art Journal.* 1(Fall 1972):1, 14–19.

Nevelson, Louise. *Louise Nevelson: Atmospheres and Environments.* New York: Clarkson N. Potter, 1980.
 An examination of seven environmental/thematic exhibitions held by Nevelson between 1955 and 1961. The introduction by Edward Albee includes a biographical summary. Commentaries on the exhibitions are by Laurie Wilson. Also includes a chronology and an annotated bibliography.

New York. Martha Jackson Gallery. *Nevelson.* 1961.
 The foreword is by Kenneth Sawyer; the commentary is by George Mathieu.

New York. Pace Gallery. *Nevelson: Recent Wood Sculpture.* 1969.

———. *Nevelson: Sky Gates and Collages.* May 4–June 8, 1974.

Otterlo, Netherlands. Rijksmuseum Kroller-Muller. *Louise Nevelson Sculptures, 1959–1969.* 1969.
The introduction is by R. Oxenaar.

Petersen and Wilson. *Women Artists.* Pp. 123–124.

Purchase. Neuberger Museum, State University of New York. *Nevelson at Purchase: The Metal Sculptures.* August 8–September 11, 1977.

Robert, Collette. *Nevelson.* Paris: The Pocket Museum, Editions Georges Fall, 1964.

Rubinstein. *American Women Artists.* Pp. 305–310.

Seckler, Dorothy Gees. "The Artist Speaks: Louise Nevelson." *Art in America.* 55(January–February 1967):32–43.

Watson-Jones. *Contemporary American Women Sculptors.* Pp. 434–435.

Wilson, Laurie. "Bride of the Black Moon: An Iconographic Study of the Work of Louise Nevelson." *Arts.* 54(May 1980):140–148.
An interesting discussion of the autobiographical content in Nevelson's work and of three principal motifs she uses: royalty, marriage, and death. Accompanied by many small black-and-white reproductions.

―――. *Louise Nevelson: Iconography and Sources.* New York: Garland Publishing, 1981.
Wilson's Ph.D. dissertation for the City University of New York, in Garland's series, "Outstanding Dissertations in the Fine Arts."

Women's History Research Center. *Female Artists Past and Present.*
Additional bibliographic material is available on page 93.

Collections:

Atlanta, High Museum of Art.
Birmingham (Alabama), Birmingham Museum of Art.
Brooklyn Museum.
Cleveland Museum of Art.
Kansas City, Nelson-Atkins Museum of Art.
Los Angeles County Museum of Art.

New York, Museum of Modern Art.
New York, Whitney Museum of American Art.
Washington (D.C.), Hirshhorn Museum and Sculpture Garden.

VIOLET OAKLEY. 1874–1961. United States.
Violet Oakly studied with Carroll Beckwith at the Art Students League in New York from 1893 to 1894. This was followed by a period of study abroad. In Paris she studied at the Académie Montparnasse and in England with Charles Lazar. She then returned to Philadelphia to study illustration with Howard Pyle at the Drexel Institute. Oakley shared a home and studio space with Jessie Willcox Smith and Elizabeth Shippen Green. Her career was quite diversified. In 1897 she collaborated with Jessie Willcox Smith on illustrations for *Evangeline,* published by Houghton Mifflin and Company. Oakley was also a successful stained glass designer, creating windows for churches in Boston and New York. One of her most important commissions was for the historic murals for the capitol at Harrisburg, Pennsylvania. She finished the forty-three murals in 1927. The Architectural League of New York awarded her a medal of honor for her workmanship and for her success in the decorative treatment of historical subjects. She also wrote, lettered and illuminated several books, and briefly taught mural design at the Pennsylvania Academy of Fine Arts. For three years, during assemblies of the League of Nations in Geneva, she drew portraits of the delegates and received a commission to do the same at the United Nations. An advocate of world peace, she was a devout Christian Scientist and a follower of the Quaker philosophy. All these beliefs were incorporated into her work. Edith Emerson, a former student, was her lifelong companion.

Bénézit. *Dictionnaire.* Vol. 7, p. 772.

Clement. *Women in the Fine Arts.* Pp. 254–255.
Mentions that she also did mosaics and was a student of Ceclia Beaux.

Earl. *Biographical Sketches of American Artists.* Pp. 232–234.
Lists some of her work.

Fielding. *Dictionary of American Painters, Sculptors and Engravers.* P. 675.
Joseph De Camp and Ceclia Beaux are cited as her teachers at the Pennsylvania Academy of Fine Arts.

Goodman, Helen. "Violet Oakley." *Arts.* 54(October 1979):7.
Goodman reviews a retrospective of Oakley's work held in 1979 at the Philadelphia Museum of Art. One color reproduction accompanies the review.

————. "Women Illustrators of the Golden Age of American Illustration." Pp. 19–20.

Krull. *Women in Art.* P. 109.

Likos, Patricia. "The Ladies of the Red Rose."
Excellent summary of her life and work, stressing her relationship with Green and Smith.

————. "Violet Oakly." *Philadelphia Museum of Art Bulletin.* 75(June 1979):1–32.
The entire issue is devoted to Oakley. It includes an extensive discussion of her work by Likos, a checklist of the exhibition of Oakley's work presented in the summer of 1979, and numerous black-and-white reproductions of her work.

Mason, Clara. "Violet Oakley's Latest Work." *American Magazine of Art.* 21(March 1930):130–138.
Discusses in detail her Geneva portraits and a mural for the Graphic-Sketch Club in Philadelphia. Good black-and-white illustrations.

Morris, Harrison. "Violet Oakley." *Book Buyer.* 24(May 1903):292–299.
Summarizes her work and discusses her stained glass designs. Includes a photograph of the Red Rose Inn, the home she shared with her artist friends.

Philadelphia. Philadelphia Museum of Art. *Three Centuries of American Art.* April 11–October 10, 1976, pp. 511–514.

Rubinstein. *American Women Artists.* Pp. 159–161.
Notes that both of Oakley's grandfathers were members of the National Academy of Design.

Tinling. *Women Remembered.* P. 435.

Collections:

Philadelphia, Pennsylvania Academy of the Fine Arts.
Philadelphia Museum of Art.
Wilmington, Delaware Art Museum.

GEORGIA O'KEEFFE. 1887–1986. United States.
This unique U.S. painter was born in Wisconsin. In 1905, while still a teenager, she began studies at the Chicago Art Institute. She moved to New York in 1907 and studied at the Art Students League with William Merritt Chase. By 1912 she was studying with Arthur Wesley Dow at Columbia University. A few years later O'Keeffe supervised art instruction in Amarillo, Texas, where she stayed four years. An important turning point in her career occurred when a friend showed O'Keeffe's drawings to Alfred Stieglitz, an important gallery owner and photographer. He was impressed and decided to exhibit them. A year later, in 1917, O'Keeffe returned to New York for the second exhibit Stieglitz gave her. They married in 1924, the same year she started painting her close-ups of flowers. Each year between 1923 and 1946 Georgia O'Keeffe had a one-woman show at Stieglitz's gallery. Beginning in 1929 she spent her summers in New Mexico; following Stieglitz's death in 1946, she moved to the New Mexico desert permanently. The Museum of Modern Art in New York exhibited a retrospective of her work in 1946. O'Keeffe's paintings are well known for their stark and economical compositions, defined by lyrical contours. Her subject matter excluded people and consisted primarily of western mountains, architecture, flowers, plants, and bones. Critics have often noted sexual allusions in her work, but O'Keeffe persistently denied this, saying, "Well I made you take time to look at what I saw and when you took time to really notice my flower you hung all your own associations with flowers on my flower and you write about my flowers as if I see what you think and see of the flower—and I don't."

Amarillo, Texas. Amarillo Art Center. *Georgia O'Keeffe and Her Contemporaries.* September, 7–December 1, 1985.

Baker, Kenneth. "The World in a Drop of Water." *Artforum.* 24 (December 1985):56–59.
 A discussion of O'Keeffe's watercolor paintings, accompanied by several good color reproductions.

————. "What Went Wrong? A Reappraisal of Georgia O'Keeffe."
Connoisseur. 217 (November 1987):170–175.
Baker questions whether O'Keeffe's mythic status has distorted
critical perceptions of her art. He deplores what he describes as her
tendency to settle for an emblematic approach to image making and
says that in the second half of her life O'Keeffe became a regional
artist. Good color reproductions are included.

Bry, Doris, and Nicholas Callaway, eds. *Georgia O'Keeffe: In the West.*
New York: Alfred A. Knopf, in association with Callaway Editions,
1989.
Coffee-table book with excellent color reproductions. A short essay
by Bry is included.

Callaway, Nicholas, ed. *Georgia O'Keeffe: One Hundred Flowers.* New
York: Alfred A. Knopf, in association with Callaway Editions, 1987.
Coffee-table publication of color reproductions of O'Keeffe's
flower paintings. A short essay by Callaway is included.

Castro, Jan Garden. *The Art and Life of Georgia O'Keeffe.* New York:
Crown Publishers, 1985.
An excellent monograph. Includes many color plates and a selected
bibliography.

Coke, Van Deren. "Why Artists Came to New Mexico: Nature Presents
a New Face Each Moment." *Art News* 73(January 1974):22–24.

Dallas. Gerald Peters Gallery. *Georgia O'Keeffe: Selected Paintings and
Works on Paper.* June 14–July 14, 1986.
Exhibition catalog with many good color reproductions.

Drohojowska, Hunter. "The Unknown O'Keeffe." *Art and Antiques.* 6
(September 1989):76–91.
Includes a number of excellent color reproductions.

Eldredge, Charles Child, III. *Georgia O'Keeffe: The Development of an
American Modern.* Ph.D. dissertation, University of Minnesota, 1971.

Fine. *Women and Art.* Pp. 191–194.

Fort Worth. Amon Carter Museum. *Georgia O'Keeffe.* March 17–May
8, 1966.
An exhibition of O'Keeffe's work from the period of 1915 to 1966.
A selection of critical commentary from those years is edited by
Mitchell A. Wilder.

Goetzmann, William H., and William N. Goetzmann. *The West of the Imagination.* New York: W. W. Norton and Company, 1986. Chapter 3, pp. 422–434, is devoted to O'Keeffe.

Goodrich, Lloyd, and Doris Bry. *Georgia O'Keeffe.* New York: Praeger, for the Whitney Museum of American Art, 1970.
The exhibition catalog for the retrospective which took place from October 8 to November 20, 1970, and traveled to the Chicago Art Institute and to San Francisco early in 1971. The large catalog includes bibliography, chronology, and full-page reproductions, some of which are in color.

Goosen, E. C. "O'Keeffe." *Vogue.* 149(March 1, 1967):174–179, 221–224.

Greenough, Sarah. "The Letters of Georgia O'Keeffe." *Antiques.* 132 (November 1987):1110–1117.
This article is accompanied by excellent color reproductions.

Hapgood, Hutchins. *A Victorian in the Modern World.* New York: Harcourt, Brace and Company, 1939.
This book focuses on O'Keeffe's husband, Alfred Stieglitz.

Harris and Nochlin. *Women Artists, 1550–1950.* Pp. 59, 65, 67, 300–306, 358–359.

Heller, *Women Artists.* Pp. 126–128.

Hill. *Women: A Historical Survey . . .* Catalog. Pl. 48.

Hoffman, Katherine. *An Enduring Spirit: The Art of Georgia O'Keeffe.* Metuchen, New Jersey: Scarecrow Press, 1984.
A biographical summary that emphasizes the forces that influenced O'Keeffe's art. It includes a discussion of the critical literature concerning her art. An extensive bibliography is provided.

Kuh, Katherine. *The Artist's Voice: Talks with Seventeen Artists.* New York: Harper and Row, 1962.
An interview with O'Keeffe is included.

Lawson, Karol Ann. "Vitality in American Still-life: the Flowers of Martin Johnson Heade and Georgia O'Keeffe." *Athanor.* 3(1983): 41–49.
A comparison of the formal and philosophic affinities of these two artists as seen in their flower paintings.

Lerman, Ora. "From Close-Up to Infinity: Reentering Georgia O'Keeffe's World." *Arts.* 60(May 1986):80–83.
An account of a visit to the O'Keeffe's home in 1963.

Lisle, Laurie. *Portrait of an Artist.* New York: Seaview Books, 1980.
A biography of O'Keeffe. Includes photographs, a genealogy tree, and a selected bibliography.

Lynes, Barbara Buhler. *O'Keeffe, Stieglitz and the Critics, 1916–1929.* Ann Arbor: UMI Research Press, 1989.
Comprehensive examination of the complex critical reaction to O'Keeffe's art. Lynes clearly shows that the critics praised her work, but were baffled by her imagery. She also shows how O'Keeffe tried to direct the critical thinking about her work. An appendix of critical writings about O'Keeffe from 1916 to 1929 is included.

Messinger, Lisa Mintz. *Georgia O'Keeffe.* New York: Thames and Hudson and the Metropolitan Museum of Art, 1989.
This general discussion of O'Keeffe's life and art is based on an examination of the collection of her work in the Metropolitan Museum of Art, which spans the years from 1915 to the 1950's. This largest public collection of her work represents most of the themes explored by O'Keeffe. A number of color plates and a chronology are included.

Minneapolis. Walker Art Center. *The Precisionist View in American Art.* 1960.
Catalog by Martin L. Friedman.

Mitchell. *Great Flower Painters.* P. 190.

Moss, Irene. "Georgia O'Keeffe and 'These People.' " *Feminist Art Journal.* 11(Spring 1973):14.

Munro. *Originals: American Women Artists.* Pp. 75–92.

Munsterberg. *A History of Women Artists.* Pp. 71–72.

National Museum of Women in the Arts. Pp. 80–81.

Neilson. *Seven Women, Great Painters.* Pp. 144–164.

New York. Whitney Museum of American Art. *Georgia O'Keeffe.* July 8–October 4, 1981.

An exhibition of works from the Whitney's permanent collection. The catalog essay is by Patterson Sims. A biographical summary and a chronology are included.

O'Keeffe, Georgia. *Georgia O'Keeffe*. New York: Viking Press, 1976. The artist writes about her life and work. A large number of reproductions are included.

Petersen and Wilson. *Women Artists*. Pp. 121–124.

Plagens, Peter. "A Georgia O'Keeffe Retrospective in Texas." *Artforum*. 4(May 1966):27–31. Chronological analysis of O'Keeffe's work. Includes good color reproductions.

Pollack, Duncan. "Artists of Taos and Santa Fe, from Zane Grey to the Tide of Modernism." *Art News*. 83(January 1974):13–21.

Pollitzer, Anita. "That's Georgia." *Saturday Review*. 33(November 4, 1950):41–43. Pollitzer was one of O'Keeffe's best friends and the one who first introduced O'Keeffe's drawings to Stieglitz.

————. *A Woman on Paper: Georgia O'Keeffe*. New York: Simon and Schuster, 1988. This biography was based on letters between O'Keeffe and Pollitzer, a friend from her student days. O'Keeffe initially encouraged Pollitzer when she was working on the manuscript in the 1950's, but later refused to grant permission for its publication. She felt Pollitzer had romanticized her and had written a "dream picture." The manuscript was finally published after both their deaths (Pollitzer died in 1971). The end result is a rather dry, chronologic presentation of letters that fails to capture the passion and controversies of O'Keeffe's life.

Rich, Daniel Catton. *Georgia O'Keeffe: Forty Years of Her Art*. Worcester, Massachusetts: Worcester Art Museum, October 4, 1960. Exhibition catalog.

————. *Bulletin of the Art Institute of Chicago* (February 1943). An article about O'Keeffe.

Robinson, Roxana. *Georgia O'Keeffe: A Life*. New York: Harper and Row, 1989.

This captivating biography is well written and well documented. It includes a selected bibliography.

Rose, Barbara. "Georgia O'Keeffe: The Paintings of the Sixties." *Artforum.* 9(November 1970):42–46.

Rubinstein. *American Women Artists.* Pp. 181–185.

Santa Fe. Museum of Fine Art, Museum of New Mexico. *Georgia O'Keeffe: Works on Paper.* September 14–November 17, 1985. This catalog includes an essay by Barbara Haskell.

Stieglitz, Alfred. *Georgia O'Keeffe: A Portrait.* New York: Metropolitan Museum of Art, 1978. Reproduces the photographs of O'Keeffe taken by Stieglitz between 1917 and 1924. In the introduction, O'Keeffe recalls sitting for the photographs and her relationship with Stieglitz.

Tompkins, Calvin. "Profiles: The Rose in the Eye Looked Pretty Fine." *New Yorker.* 50(March 4, 1974):40–66.

Toyko. Seibu Museum. *Georgia O'Keeffe.* August 12–August 30, 1988. The text of this catalog is printed in English and Japanese.

Washington, D.C. National Gallery of Art. *Georgia O'Keeffe: Art and Letters.* November 1, 1987–February 21, 1988. This catalog consists of color plates of all the exhibited works and also includes 120 previously unpublished letters from O'Keeffe to friends, artists, and critics. The letters are annotated and introduced by Sarah Greenough. The catalog also contains essay by Jack Coward and Juan Hamilton and a chronology.

Weisman, Celia. "O'Keeffe's Art: Sacred Symbols and Spiritual Quest." *Woman's Art Journal.* 3(Fall 1982–Winter 1983):10–14. An interesting analysis of O'Keeffe's imagery as archetypal spiritual symbols. Weisman traces this mystical element in her work to one of her teachers, Arthur Wesley Dow.

Women's History Research Center. *Female Artists, Past and Present.* P. 52. Includes much of the preceding bibliography plus additional citations.

The Work of Georgia O'Keeffe: A Portfolio of Twelve Paintings. New York: Dial Press, 1939.

These reproductions are accompanied by an introduction by James W. Lane and an appreciation written by Leo Katz.

Yeh, Susan F. "Innovative Moderns: Arthur G. Dove and Georgia O'Keeffe." *Arts.* 56(June 1982):68–72.
Comparison of the work and influences on the two artists, stressing their interest in the Arts and Crafts movement.

Collections:

Andover (Massachusetts), Phillips Academy, Addison Gallery of American Art.
Brooklyn Museum.
Chicago Art Institute.
Fort Worth, Amon Carter Museum of Western Art.
Milwaukee Art Center.
Minneapolis, University of Minnesota, University Gallery.
Minneapolis, Walker Art Center.
New York, Metropolitan Museum of Art.
New York, Museum of Modern Art.
New York, Whitney Museum of American Art.
Philadelphia Museum of Art.
Washington (D.C.), Corcoran Gallery of Art.
Washington (D.C.), National Museum of Women in the Arts.
Washington (D.C.), Phillips Collection.

MERET OPPENHEIM. 1913–1985. Swiss-German.
Oppenheim was born in Germany to a German father and Swiss mother. The family moved to Switzerland with the outbreak of the First World War. She studied in Basel and in Germany before moving to Paris and enrolling in the Académie de la Grande Chaumière in 1932. Oppenheim's work was brought to the attention of André Breton by Arp and Giacometti. She exhibited with the Surrealists from 1933 to 1937. In 1936 she created the famous *Fur-Lined Teacup and Saucer* and held her first one-woman show in Basel. Unfortunately, her reputation has rested on this one work. She returned to Switzerland in 1937. In addition to her sculpture, Oppenheim also designed fantastic furniture and clothing accessories. Her production declined from 1944 to 1956 as she went through a period of depression. In 1956 she began exhibiting again. She organized the inaugural feast at the International Exposition of Surrealism in Paris in December 1959 and exhibited *Woman as Banquet.* A

major retrospective of Oppenheim's work was presented by the Moderna Museet in Stockholm in 1967.

Alexandrian, Sarane. "Sculpture de la surréaliste." *Connaissance des arts.* 245(July 1972):56.
Excellent summary of Oppenheim's life.

Bénézit. *Dictionnaire.* Vol. 8, p. 24.

Calas, Nicolas. "Meret Oppenheim: Confrontations." *Artforum.* 16 (Summer 1978):24–25.

Casciani, Stefano. "Westostlicher Divan." *Domus.* 645(December 1983):42–50.
Description of one of Oppenheim's residences and photographs of some of the art and furniture she created for it.

Chadwick. *Women Artists and the Surrealist Movement.* Pp. 12, 46–47, 122–123, 142, 146, 242.

Curiger, Bice. *Meret Oppenheim.* Zurich: ABC, 1982.

Fine. *Women and Art.* Pp. 177–178.
Notes that although Oppenheim wrote about the problems of being a woman, she refused to exhibit at sexually segregated exhibitions.

Heller. *Women Artists.* Pp. 160–161.

"Meret Oppenheim." *Art in America.* 74(January 1986):168.
Obituary.

Monteil, Annemarie. "Meret Oppenheim: Die Idee Mit den Brunnen." *Du.* 10(1980):68–69.

Orenstein, Gloria. "Women of Surrealism." *Feminist Art Journal.* 11 (Spring 1973):18–19.
Orenstein's article has supplied much of the above biographical information.

Petersen and Wilson. *Women Artists.* Pp. 131, 134.

Phaidon Dictionary of Twentieth Century Art. New York: Phaidon, 1973. P. 287.

Tillman, L. M. "Don't Cry . . . Work." *Art and Artists.* 8(October 1973):22–27.
 An interview with Oppenheim.

Withers, Josephine. "The Famous Fur-Lined Teacup and the Anonymous Meret Oppenheim." *Arts.* 52 (November 1977):88–93.
 Withers attempts to remedy the "truly stunning absence of critical curiosity about Meret Oppenheim." Includes a biographical summary and several black-and-white reproductions.

Collections:

New York, Museum of Modern Art.
Stockholm, Moderna Museet.

I. RICE PEREIRA. 1907–1971. United States.
 This nonobjective painter was born Irene Rice in Boston. At fifteen she became the sole support of a sick mother and three younger brothers and sisters. To accomplish this, she completed a three-year commercial course in six months to become a stenographer. While working she attended high school at night and in 1927 enrolled in the Art Students League evening sessions. She studied at the Art Students League until 1932. In 1929 she married the first of her three husbands, Humberto Pereira, also an artist. Pereira visited Europe and North Africa in 1931. The experience of the Sahara Desert challenged her thereafter to attempt to convey infinite space and light. There have been at least fifty one-woman shows of her art since 1932. She arrived at geometric and nonobjective abstraction in 1937. Pereira pioneered the use of new materials in paintings. In 1939 she began her first transparent paintings on layers of corrugated glass to portray a shifting three-dimensional space. She taught design courses at the Pratt Institute from 1939 to 1940. Pereira participated in the Whitney Annuals from 1944 to 1970. In 1953 the Whitney Museum presented a retrospective of her work. In the 1950's Pereira privately published several works which explore mysticism and science. She spent her last years painting on the Spanish Costa Del Sol.

Baur, John I. H. *Loren MacIver, I. Rice Pereira.* New York: Whitney Museum of American Art, 1953.

Bénézit. *Dictionnaire.* Vol. 8, p. 216.

Heller. *Women Artists.* Pp. 130–131.

Hill. *Women: A Historical Survey . . .* Catalog. Plates 64, 65.

Marxer, Donna. "I. Rice Pereira: An Eclipse of the Sun." *Women Artists Newsletter.* Pt. 2, 2(May 1976):1, 4.

Miller, Donald. "The Timeless Landscapes of I. Rice Pereira." *Arts.* 53 (October 1978):132–133.
Miller laments the lack of attention paid to Pereira. He notes that Pereira founded the Design Laboratory in New York as part of the WPA Federal Art Project.

Munsterberg. *A History of Women Artists.* Pp. 72–73.

New York. Amel Gallery. *I. Rice Pereira.* 1962.

New York. Galerie Internationale. *I. Rice Pereira.* 1964.

New York. Museum of Modern Art. *Fourteen Americans.* 1946.
A statement by Pereira is on p. 46.

Pereira, I. Rice. *The Crystal of the Rose.* New York, 1959.

———. *The Finite Versus the Infinite.* New York, 1962.

———. *The Lapis.* New York, 1957.
Her theory of imagery. Illustrated.

———. Letter to the Editor. *Art Voices.* 4, no. 2(1965):80.

———. *Light and the New Reality.* New York, 1951.

———. *The Nature of Space: A Metaphysical and Aesthetic Inquiry.* Washington, D.C.: Corcoran Gallery, 1968.
This was privately published in 1956.

———. Rolls D222 and D223, Archives of American Art, New York.

———. *The Simultaneous Ever Coming "To Be."* New York, 1961.

———. *The Transcendental Formal Logic of the Infinite: The Evolutions of Cultural Forms.* New York, 1966.

————. *The Transformations of "Nothing" and the Paradox of Space.* New York, 1953.

Petersen and Wilson. *Women Artists.* P. 127.

Phaidon Dictionary of Twentieth Century Art. New York: Phaidon, 1973. P. 294.

Pousette-Dart, Nathaniel, ed. *American Painting Today.* New York, 1962. P. 42.

Rubinstein. *American Women Artists.* Pp. 247–250.

Schwartz, Therese. "Demystifying Pereira." *Art in America.* 67(October 1979):114–119.
Schwartz urges an assessment of Pereira's work, which she believes exists independently of her "opaque mystical texts." She sees her writing as a bid for intellectual recognition at a time when Abstract Expressionism was rising in popularity and as a way to compensate for her own lack of formal education.

Tufts. *Our Hidden Heritage.* Pp. 232–242.

Van Wagner, Judith K. "I. Rice Pereira: Vision Superceding Style." *Woman's Art Journal.* 1(Spring–Summer 1980):33–38.
Van Wagner questions Pereira's exclusion from exhibitions and lack of public attention her art has received after 1970. She concludes that Pereira's omission is related to her independent, uncompromising attitude toward the art world, the difficulty of categorizing her art, and her disregard of artistic trends. An excellent biographical summary and a brief discussion of her writings are included.

Washington, D.C. National Museum of Women in the Arts. *Irene Rice Pereira's Library: A Metaphysical Journey.* October 18, 1988–January 9, 1989.

Collections:

Dallas Museum of Fine Arts.
Hartford (Connecticut), Wadsworth Atheneum.
New York, Solomon R. Guggenheim Museum.
New York, Metropolitan Museum of Art.
New York, Museum of Modern Art.
New York, Whitney Museum of American Art.

Utica (New York), Munson-Williams-Proctor Institute.
Washington (D.C.), National Collection of Fine Arts.

LIUBOV POPOVA. 1889–1924. Russian.
Usually classified as a Constructivist, Popova was a member of the Russian avant-garde of the early twentieth century. She studied in Moscow from 1907 to 1908. Following a year's study she toured Italy. By 1912 she was in Paris, working in the studio of Cubist painter Jean Metzinger. Popova was a participant in the mass action in the streets of Moscow that occurred between 1918 and 1921. These performances were loosely dramatized reenactments of revolutionary events and were intended to bring to life specific historical moments. Popova was also involved in textile designs, in creating stage and costume designs, and in designing revolutionary posters.

Bénézit. *Dictionnaire.* Vol. 8, p. 430.

Bowlt, John. "When Life Was a Cabaret." *Art News.* 83(December 1984):127.
Popova is included in a discussion of Russian avant-garde artists whose scenic designs were part of a new kind of theater.

Cologne. Galerie Gmurzynska. *From Surface to Space: Russia, 1916–1924.* September 18–November 1974. P. 116.

Fine. *Women and Art.* Pp. 168–169.
Fine says Popova enrolled at the Stroganov School of Applied Art in Moscow in 1909.

Greer. *The Obstacle Race.* P. 9.

Harris and Nochlin. *Women Artists, 1550–1950.* Pp. 58, 60–63, 298, 310, 359.

Marcade, Jean-Claude. "Femmes d'avant-gard sur fond Russe." *L'oeil.* 334(May 1983):38–45.
Good discussion of Popova's involvement in theatrical design.

Collections:

St. Petersburg, State Russian Museum.
New York, Museum of Modern Art.
Pasadena (California), Norton Simon Museum.

BEATRIX POTTER. 1866–1943. English.

Potter, born in London, showed an interest in animals, nature, and drawing as a child. She was given private lessons in art from the age of twelve to the age of seventeen. Her artistic career began in 1890 when she sold some of her drawings for use on Christmas cards. In 1901 she privately printed the first of her series of children's books, *The Tale of Peter Rabbit*. The Frederick Warne Publishing Company published it the following year, starting a long and fruitful association with Potter. She took advantage of the popularity of her creations to engage in creative marketing. In 1903 she made and patented a Peter Rabbit doll. Potter became engaged to Norman Warne in the summer of 1905, but he died before they could marry. She continued to write and illustrate books and with the money earned from these endeavors she began purchasing property in the Lake District. After moving to her farm, she became increasingly interested in raising Herdwick sheep and less interested in creating new children's stories. However her farm property did serve as the setting for some of her later childrens' stories. In 1913 Potter married William Heelis, a lawyer who had assisted her in acquiring her farm properties. Potter deeded fifteen farms and over 4,000 acres in the Lake District to the National Trust. Her home, Hill Top, was opened to the public in 1946.

Beatrix Potter: The V and A Collection. London: Victoria and Albert Museum and Frederick Warne, 1985.

This is a catalog of the Leslie Linder bequest of Potter material, including watercolors, drawings, and manuscripts, books, photographs, and memorabilia. Anne Stevenson Hobbs and Joyce Irene Whalley compiled the catalog.

Bénézit. *Dictionnaire.* Vol. 8, p. 448.

Godden, Rumer. *The Tale of the Tales: The Beatrix Potter Ballet.* London: F. Warne, 1971.

Golden, Catherine. "Beatrix Potter, Naturalist Artist." *Woman's Art Journal.* 11(Spring–Summer 1990):16–20.

Discussion of Potter's accomplishments as a naturalist artist and a conservationist.

Lane, Margaret. *The Magic Years of Beatrix Potter.* London: Frederick Warne, 1978.

Chronological biography focusing on the thirteen-year period of Potter's greatest creativity (1900–1913). Profusely illustrated with many color reproductions.

————. *The Tale of Beatrix Potter.* New York, London: F. Warne, 1968.
This biography contains many photographs of the artist.

The Linder Collection of the Works and Drawings of Beatrix Potter.
Chatham, Kent: National Book League and the Trustees of the Linder
Collection, 1971.
A catalog of the collection of Leslie Linder which contains 280
original drawings and paintings and many first editions of Potter's
books. Several black-and-white reproductions are included.

Linder, Enid, and Leslie Linder. *The Art of Beatrix Potter.* New York,
London: F. Warne and Company, 1955; revised, 1972.
This revised edition omits a discussion of Potter's picture letters,
miniature letters, and manuscripts. It provides a synopsis of her life
and career. Discusses her art by examining the wide range of her
subject matter. An excellent description of her books is included and it
is profusely illustrated.

Linder, Leslie. *A History of the Writings of Beatrix Potter.* London: F.
Warne and Company, 1971.

————, transcriber. *The Journal of Beatrix Potter, from 1881 to 1897.*
New York, London: Frederick Warne.
Transcription of Potter's journal, which had been written in code.

MacDonald, Ruth K. *Beatrix Potter.* Boston: Twayne Publishers, 1986.
An excellent critical study of the written and visual form of the
Peter Rabbit series. A bibliography is included.

Moore, Anne Carroll. *The Art of Beatrix Potter.* London, 1955.

————. "The Art of Beatrix Potter." *Print.* 10(September 1955):
57–59.

Potter, Beatrix. *Appley Dapply's Nursery Rhymes.* New York, London:
F. Warne, 1917.

————. *The Derwentwater Sketchbook, 1903.* London: Frederick
Warne, 1985.
A facsimile reproduction of one of Potter's sketchbooks, with
additional commentary by Joyce I. Whalley and Wynne E. Bartlett.

————. *The Pie and the Patty-Pan.* New York: F. Warne, ca. 1905.

―――. *The Story of a Fierce Bad Rabbit.* London, New York: F. Warne, 1906.

Quinby, Jane. *Beatrix Potter: A Bibliographical Check List.* New York, 1954.

Taylor, Judy. *Beatrix Potter.* London: Frederick Warne, 1986.
An excellent biography of Potter that draws on interviews and Potter's letters. It is copiously illustrated with Potter's drawings and with photographs.

―――. *That Naughty Rabbit: Beatrix Potter and Peter Rabbit.* London: F. Warne and Company, 1987.
Many photographs and color reproductions illustrate this account of Potter's most famous character. It includes a description of the various efforts at merchandising Peter Rabbit.

Collections:

London, British Museum.
London, Tate Gallery.
London, Victoria and Albert Museum.

JEANNE REYNAL. 1903– . United States.
Reynal was born in White Plains, New York. By 1928 she was working in London as an apprentice to the mosaicist Boris Anrep. From 1930 to 1938 she continued to work with him in Paris and assisted on some of his largest commissions. Reynal returned to the United States in 1936, settling in California. In 1946 she moved to New York City and in 1953 married the painter Thomas Sills. She credits Seurat and the Neo-Impressionists with influencing her mosaic works.

Ashton, Dore; Lawrence Campbell; Elaine De Kooning; et al. *The Mosaics of Jeanne Reynal.* New York: George Wittenborn, 1964.
Reynal provides a historic and technical analysis of the mosaic medium, followed by an evaluation of her work by five authors.

Campbell, Lawrence. "Jeanne Reynal: The Mosaic as Architecture." *Craft Horizon.* 22(January–February 1962):16–19, 48–49.
Discusses the stylistic evolution and technical aspects of Reynal's work. Relates her work to the historical development of mosaic art. Discusses the use of mosaics in modern architecture and Reynal's

attempts to develop a form of mosaic which can function independently of the wall or with it.

De Kooning, Elaine. "Reynal Makes a Mosaic." *Art News*. 52(December 1953):34–36, 51–53.
Photographic study of Reynal at work. Includes a good description of the technical aspects of her art.

Falkenberg, Paul, editor and producer. *Mosaics: The Work of Jeanne Reynal*. Film, 1968.

Hare, David. "Between Stones Is." *Craft Horizon*. 39(April 1979): 60–61.
Discussion of recent mosaic work by Reynal. Includes color and black-and-white reproductions.

Kafka, Barbara P. "Art and Architecture: Four Recent Commissions." *Craft Horizon*. 28(January 1968): 23.
Briefly discusses a freestanding mosaic wall Reynal did for a New York church.

Munro. *Originals: American Women Artists*. Pp. 178–188.
Good summary of Reynal's career and of the influence of Anrep on her life and work.

Press. *Who's Who in American Art*. 17th edition, 1986. P. 840.

Collections:

Minneapolis, Walker Art Center.
New York, Museum of Modern Art.
New York, Whitney Museum of American Art.

GERMAINE RICHIER. 1904–1959. French.
Richier sculpted metamorphosed insects and human figures in lead and bronze. As a child she was deeply affected by nature, particularly insects, and knew from an early age that she would be a sculptor. She enrolled in the Ecole des Beaux-Arts in Montpellier at the age of eighteen, against her parents' wishes. In 1925 Richier entered the Paris atelier of Antoine Bourdelle. She married a fellow sculptor, Otto Banninger, in 1929. They fled to his native Switzerland at the outbreak of the Second World War. She taught in Switzerland and as a successful

woman sculptor inspired many women students. She and Banninger eventually divorced. Her best-known sculpture is from the early 1950's. She collaborated on some work with Maria Vieria da Silva. In 1955 Richier married René Solier, a writer. She died of cancer just before her fifty-fifth birthday.

Burr, James. "Toad, Bat, Spider or Man?" *Apollo.* 98(July 1973): 53–54.
　　Discussion of the nightmarish quality of her animal shapes.

Cassou, Jean. *Germaine Richier.* New York: Universe Books, 1961.

Fine. *Women and Art.* Pp. 174–176.

"Germaine Richier." *Werk.* 50(1963):n.p.

Guth, Paul. "Encounter with Germaine Richier." *Yale French Studies.* 19–20(Spring 1957–Winter 1958):78–84.

Heller. *Women Artists.* P. 137.

Hill. *Women: A Historical Survey . . .* Catalog. Plate 63.

Jacometti, Nesto. "Germaine Richier." *Vie, Art, Cité.* 3(1946):28.

Liberman, Alexander. *The Artist in His Studio.* New York: Viking Press, 1960. P. 71 and figs. 137–138.
　　Liberman comments briefly on Richier and his photographs of her studio.

London. Hannover Gallery. *Germaine Richier.* 1955.
　　Introduction by David Sylvester.

Munsterberg. *A History of Women Artists.* Pp. 94–95.

New York. Martha Jackson Gallery. *Germaine Richier.* 1957.
　　Introduction by René de Solier.

New York. Museum of Modern Art. *The New Decade: Twenty-two European Painters and Sculptors.* May 10–August 7, 1955. Pp. 35–38.
　　This catalog consists of statements by the artists and black-and-white reproductions of their work. It was edited by Andrew C. Ritchie.

Paris. Galerie Creuzebault. *Germaine Richier, 1904–1959.* 1966.

Paris. Musée National d'Art Moderne. *Germaine Richier.* October 10–December 9, 1956.

Petersen and Wilson. *Women Artists.* Pp. 2–3.

Phaidon Dictionary of Twentieth Century Art. New York: Phaidon, 1973. P. 318.

Restany, Pierre. "Germain Richier: le grand art de la statuaire." *L'oeil.* 279(October 1978):56–63.
A summary of Richier's life and work, accompanied by excellent photographs of her sculpture, some in color.

Collections:

Hartford (Connecticut), Wadsworth Atheneum.
London, Tate Gallery.
Minneapolis, Walker Art Center.
New York, Museum of Modern Art.
Paris, Musée National d'Art Moderne.
Stockholm, Moderna Museet.

OLGA ROZANOVA. 1886–1918. Russian.
Rozanova was born in a Russian village. By 1904 she had moved to Moscow where she studied at the Bolshakov Art College and the Stroganov School of Applied Art. In 1912 she married a Futurist painter and poet, Alex Kruchenikh. Rozanova was active in Futurist circles in Russia, and beginning in 1912 she illustrated Futurist booklets. She also wrote poetry and did a series of fashion and embroidery designs. After the Russian revolution, Rozanova headed the Industrial Art faculty of the IZO Art College.

Betz, Margaret. "Graphics of the Russian Vanguard." *Art News.* 75 (March 1976):52–54.
Betz argues that the shift to abstraction occurred in Rozanova's prints before her paintings.

Cologne. Galerie Gmurzynska. *From Surface to Space: Russia, 1916–1924.* September 18–November 1974. P. 126.
Rozanova is only briefly mentioned. The introduction to this exhibition catalog is by John Bowlt.

Fine. *Women and Art.* P. 168.
A concise synopsis of Rozanova's life.

Greer. *The Obstacle Race.* P. 9.
Greer classifies Rozanova as a Constructivist.

Harris and Nochlin. *Women Artists, 1550–1950.* Pp. 61–63, 298–299, 358.

Marcadé, Jean-Claude. "Femmes d'avant-gard sur fond Russe." *L'oeil.* 334(May 1983):38–45.

ANNE RYAN. 1889–1954. United States.
Ryan, a native of Hoboken, New Jersey, left college and married in 1911. The marriage ended in divorce around 1931. Ryan then lived for two years on the island of Mallorca. When she returned to New York, Hans Hoffman encouraged her in painting, but she did not commence her art career until 1938, after raising her children. Until then she channeled her creative energy into the writing of poetry and short stories. She studied printmaking with Stanley William Hayter. Ryan held her first one-woman show in 1941. She exhibited widely in the 1940's and early 1950's and continued to write. Her painting has been described as semiabstract, biomorphic, and influenced by Surrealism. She is best known for her collage work, which she began after seeing a Kurt Schwitters exhibition in 1948. Her collages are done in a Cubist style, utilizing cloth remnants, colored paper, and photomontage, often in an oval shape. Ryan also designed stage sets and ballet costumes. Her papers are in the Archives of American Art in Washington, D.C.

Ashbery, John. "A Place for Everything." *Art News.* 69(March 1970): 32–33, 73–75.
Describes and critiques Ryan's collage work. Includes several reproductions, one in color, and a photograph of the artist.

Brooklyn Museum. *Anne Ryan Collages.* March 13–April 21, 1974.
Contains a chronology of Ryan's career. The introduction, written by Sarah Faunce, is the major source of information on Ryan's career.

Cotter, Holland. "Material Witness." *Art in America.* 77(November 1989):176–183, 215.
Good discussion of the influences on Ryan's art, accompanied by several excellent color reproductions.

Faunce, Sarah. "Ryan, Anne." In *Notable American Women: The Modern Period.* Pp. 611–613.

Frank, Peter. "Anne Ryan at the National Collection of Fine Arts." *Art in America.* 62(September–October 1974):118.
Compares her work with Schwitters' and presents a brief chronological analysis of her collages.

Munsterberg. *A History of Women Artists.* Pp. 72–73.

Rubinstein. *American Women Artists.* Pp. 301–302.

Solomon, Doborah. "The Hidden Legacy of Anne Ryan." *New Criterion.* 7(January 1989):53–58.
Solomon summarizes Ryan's career and reviews the 1989 exhibition at the New York Metropolitan Museum of Art, "Anne Ryan: Prints and Collages."

Collections:

Brooklyn Museum.
Newark (New Jersey) Museum.
New York, Museum of Modern Art.
New York, Whitney Museum of American Art.

KAY SAGE. 1898–1963. United States.
Sage was born in New York, but lived in Italy and France during her childhood. She returned to the States for her schooling. In 1919 she enrolled in drawing classes at the Corcoran Art School in Washington, D.C. In 1924 she studied briefly at the Scuola Liberale dell belle Arti in Milan. She married Prince Ranieri di San Faustino in 1925. The marriage ended ten years later. Sage was exhibiting abstract paintings in Milan by 1936. The following year she moved to Paris, and in 1938 exhibited at the Salon des Independants. Shortly after this she began living with Yves Tanguy. They moved to the United States in 1939 and were married the following year. The Surrealist paintings done by Sage feature infinite perspectives, architectural elements, and draped amorphous objects. She also wrote poetry in English, Italian, and French. In her later years, Sage developed cataracts. This prompted her to work in three dimensional constructions, but she was plagued by depression and attempted suicide in 1959. She then turned her attention to creating collages and to cataloging Tanguy's work. Four years later she ended her life with a bullet.

Bénézit. *Dictionnaire.* Vol. 9, p. 226.

Breuning, M. "A Kay Sage Retrospective." *Arts.* 34(May 1960):54.

Buckley, C. E. "Yves Tanguy and Kay Sage." *Wadsworth Atheneum Bulletin.* 49(May–September 1954):4.
Compares the superficial similarities of the two artists' work and notes the marked individuality of Sage's creations.

Chadwick, Whitney. "The Muse as Artist: Women in the Surrealist Movement." Pp. 120–129.

———. *Women Artists and the Surrealist Movement.* Pp. 56–58, 62–63, 242.
Chadwick credits Sage with aiding many Surrealists fleeing Europe during the Second World War.

Cornell University. Johnson Museum. *Kay Sage, Retrospective.* January 26–March 13, 1977.

Fine. *Women and Art.* Pp. 197–198.

Greer. *The Obstacle Race.* P. 43.

Harris and Nochlin. *Women Artists, 1550–1950.* Pp. 319–320, 338, 360.

Heller. *Women Artists.* Pp. 152–153.

Hill. *Women: A Historical Survey . . .* Catalog. P. xiii.

Jean. *History of Surrealist Painting.* 1959.

Krieger, Regine. *Kay Sage (1898–1963).* Ithaca, New York: Cornell University Press, 1977.

Miller, Stephen R. "The Surrealist Imagery of Kay Sage." *Art International.* 26(September–October 1983):32–47.
Good biographical summary. Notes her debt to both Tanguy and De Chirico. Includes numerous black-and-white reproductions.

Pearson. *The Modern Renaissance in American Art.* Pp. 284–286.

Petersen and Wilson. *Women Artists.* P. 134.

Rubinstein. *American Women Artists.* Pp. 290–293.

Sage, Kay. *China Eggs.* 1955. Unpublished autobiography.
The manuscript is in the Archives of American Art, Washington, D.C.

—————. *Demain Monsieur Bilber.* Paris: Seghers, 1957.

—————. *Faut dire c'qui est.* Paris: DeBreese, 1959.

—————. *The More I Wonder.* New York: Bookman Associates, 1957.

San Faustino, K. di. *Piove in Giardino.* Italy, ca. 1936.
Written by Sage, using her married name. She also illustrated this children's book.

Soby, James Thrall. "A Tribute to Kay Sage." *Art in America.* 58 (October 1965):83.

Tessier, Regine. "Sage, Kay." In *Notable American Women: Modern Period.* Pp. 618–619.

University of Maryland. Art Department Gallery. *Kay Sage, 1898–1963.* April 1977.

Waterbury, Connecticut. Mattatuck Museum of the Mattatuck Historical Society. *A Tribute to Kay Sage.* 1965.

Collections:

Hartford (Connecticut), Wadsworth Atheneum.
New York, Metropolitan Museum of Art.
New York, Museum of Modern Art.
New York, Whitney Museum of American Art.
Poughkeepsie (New York), Vassar College Art Gallery.
Williamstown (Massachusetts), Williams College Museum of Art.

MIRIAM SCHAPIRO. 1923– . United States.
Schapiro was born in Toronto, Canada. She studied at the University of Iowa, where she met and married painter Paul Brach. The couple moved to New York. The Museum of Modern Art included Schapiro in their 1957 show of new talent. Her early work displayed an interest in

Cubism and Abstract Expressionism. In 1964 she received a grant from the Ford Foundation to work at the Tamarind Graphics Center. She moved to southern California in 1967, where she was co-founder of the Feminist Art Program at the California Institute of Arts. By the mid-1970's Schapiro was teaching at Bryn Mawr. Schapiro has incorporated the use of cloth (doilies, lace, ribbon, etc.) into many of her works, a collage technique that she refers to as "femmage."

Berman, Avis. "A Decade of Progress." P. 74.

Broude, Norma. "Miriam Schapiro and 'Femmage.' " *Arts.* 54(February 1980):83–87.
 Broude discusses Schapiro's work as a reflection of the conflict between decoration and abstraction in twentieth-century art.

Campbell, Lawrence. "A Crash of Symbols." *Art News.* 68(March 1969):42–43, 64–65.

Garver, Thomas. *Paul Brach and Miriam Schapiro.* Balboa, California: Newport Harbor Art Museum, 1969.
 Exhibition of work by Schapiro and her husband, Paul Brach. the essay chronologically covers the changing style of her work. Several illustrations, two in color, are included.

Gouma-Peterson, Thalia, ed. *Miriam Schapiro: A Retrospective, 1953–1980.* Wooster, Ohio: College of Wooster, 1980.

Heller. *Women Artists.* Pp. 198–199.

Marmer, Nancy. "Miriam Schapiro at Comsky." *Art in America.* 62 (September–October 1974):116–117.
 Reviews an exhibition in light of Schapiro's feminist ideology, concluding, "nor is this the first time that imperfect theory has made good art."

Munro. *Originals: American Women Artists.* Pp. 272–281.
 Good discussion of Schapiro's feminist development and the emergence of "vaginal" imagery in her art. Includes a description of the *Womanhouse* project.

Nochlin, Linda. "Miriam Schapiro: Recent Work." *Arts.* 48(November 1973):38–41.
 Raises the issue of the role of feminism in abstract art. Discusses Schapiro's collage technique of introducing patterned fabric into large-scale works.

Rubinstein. *American Women Artists.* Pp. 404–407.

Ruddick, Sara, and Pamela Daniels. *Working It Out.* New York:
Pantheon Books, 1977. Pp. 283–305.
A collection of autobiographic accounts of women and their work.
Schapiro's essay is entitled ''Notes from a Conversation on Art,
Feminism, and Work.'' She discusses the difficulties in balancing the
roles of wife, mother, artist, and teacher. Schapiro also details her
introduction to feminism and its influence on her art.

JANET SCUDDER. 1869–1940. United States.
Scudder was born in Terre Haute, Indiana. She studied drawing and
wood carving at the Cincinnati Art Academy and then moved to Chicago
in 1891 to study at the Art Institute of Chicago with Lorado Taft. Her
first professional work was some figures for buildings at the 1893
Chicago World's Columbian Exposition. In 1893 Scudder went to Paris
to study with Frederic MacMonnies. She also studied drawing at the
Colarossi Academy. Most of her work was undertaken in Paris, although
she did make visits back to the United States occasionally. She returned
to the United States to establish a studio in 1939. Although she painted
and ventured into architecture once, her work consisted mainly of garden
fountains and figures of children. She refused commissions for eques-
trian and portrait statues, stating, ''I won't add to this obsession of male
egotism that is ruining every city in the United States with rows of
hideous statues of men—men—men.'' Scudder was active in the
women's suffrage movement, was a member of the National Sculpture
Society, and was a Chevalier of the French Legion of Honor.

Bénézit. *Dictionnaire.* Vol. 9, p. 487.

Clement. *Women in the Fine Arts.* Pp. 311–312.

Dodd. *Golden Moments in American Sculpture.* Pp. 114–117.
A brief account of her ''lean'' years.

Earle. *Biographical Sketches of American Artists.* Pp. 282–283.

''Janet Scudder.'' *Art Digest.* 74(July 1, 1940):24.
Obituary.

National Cyclopaedia of American Biography. Vol. 15, pp. 346–347.

Paris, William F. *The Hall of American Artists.* New York: New York
University, 1954. Vol. 9, pp. 77–88.

Payne, Frank. "The Work of Some American Women in Plastic Art." Pp. 311, 313.

Proske. "Part I. American Women Sculptors." Pp. 3–15.

————. *Brookgreen Gardens Sculpture.* Pp. 104–108.

Rubinstein. *American Women Artists.* Pp. 94–97.

Scudder, Janet. *Modeling My Life.* New York: Harcourt, Brace and Company, 1925. Autobiography.

Williams, Lewis W., II. "Scudder, Janet." In *Notable American Women, 1607–1950.* Vol. 3, pp. 252–253.

Collections:

Brooklyn Museum.
New York, Metropolitan Museum of Art.
Paris, Musée du Luxembourg.
Paris, Musée Nationale d'Art Moderne.

SÉRAPHINE DE SENLIS. 1864–1942. French.
This artist, also known as Séraphine Louis, painted fantastic plant forms. She was self-taught, but has been described as a visionary rather than a primitive artist. De Senlis was a shepherdess as a youth and was working as a domestic servant when she was discovered by collector Wilhelm Uhde in 1912. Her first exhibition was held in 1927 at the Galerie des Quatre Chemins. Uhde bought all of her paintings until 1930 when he began to fear the economic consequences of the Depression. In 1934 de Senlis was confined to an insane asylum. Uhde claimed she died in 1934, but she actually lingered on in a desperate and friendless situation until 1942.

Bénézit. *Dictionnaire.* Vol. 9, pp. 526–528.
Corrects her death date to 1942 from the widely published date of 1934.

Bihalji-Merin, Oto. *Masters of Naive Art: A Historical and World Survey.* Trans. Russell Stockman. New York: McGraw-Hill, 1971. Pp. 71–72, 84, 270.

Dorival. *The School of Paris in the Musée d'Art Moderne*. Pp. 190–191.
Includes an excellent color reproduction of her painting, *The Tree of Paradise*, dated 1929.

————. *Twentieth Century Painters*. Pp. 16–17, 171.

Masters of Modern Painting. New York: Museum of Modern Art, 1938.

Mathey. *Six femmes peintres*.

Petersen and Wilson. *Women Artists*. Pp. 103–104.

Uhde, Wilhelm. "Painters of the Inner Light: Séraphine." *Formes*. 17 (September 1931):115–117.

————. *Five Primitive Masters*. Trans. Ralph Thompson. New York: Quadrangle Press, 1949.
This includes what is basically a repeat of the *Formes* article. Uhde describes meeting de Senlis in 1912 when she was an "old woman."

Collections:

Grenoble, Musée de Peinture et de Sculpture.
Hamburg, Kunsthalle.
Paris, Musée National de l'Art Moderne.

AMITRA SHER-GILL. 1913–1941. Indian.
Sher-Gill was born in Budapest to a Hungarian mother and an aristocratic Indian father. She lived in Budapest until 1921, when the family returned to India. From 1929 to 1934 she lived in Paris and studied art with Pierre Vaillant and Lucien Simon. She was also exposed to the art of Gauguin and Cézanne, whose influence can be seen in her works. Sher-Gill's family was distressed at the bohemian, promiscuous, and bisexual pattern of her life in Paris. She returned to India in 1934. In 1938 she went to Hungary and married her cousin, Dr. Victor Egan. They returned to India the following year and her career ended with her unexpected death at the age of twenty-eight. Her paintings are usually figurative, often of women or Indian village scenes.

Bénézit. *Dictionnaire*. Vol. 9, p. 570.

"Contemporary Paintings." *Marg.* 25(September 1972):70–71.
Color reproduction and discussion of her 1935 painting, *Hillmen.*

Goetz, H. "Amitra Sher-Gill." *Studio.* 150(August 1955):50–51.

Kapur, Geeta. "The Evolution of Content in Amitra Sher-Gill's Painting." *Marg.* 25(March 1972):39–53.
This whole issue is devoted to the work of Sher-Gill. Excellent color reproductions and a chronology are included.

Munsterberg. *A History of Women Artists.* P. 82.

Raman, A. S. "Present Art of India." *Studio.* 142(October 1951): 99–101.

Sheikh, Gulam. "Amitra Sher-Gill: Dialectics of Academicism and Pictorial Situation of Traditional Indian Art." *Marg.* 24(March 1972):55–62.

Subramanyan, K. G. "Amitra Sher-Gill and the East-West Dilemma." *Marg.* 25(March 1972):63–72.

Sundaram, Vivan. "Amitra Sher-Gill: Life and Work." *Marg.* 25 (March 1972):4–38.

Collection:

New Delhi, National Gallery of Modern Art.

JESSIE WILLCOX SMITH. 1863–1935. United States.
Smith, a Philadelphia native, studied at the Philadelphia School of Design for Women and at the Pennsylvania Academy after a short career as a kindergarten teacher. She studied briefly with Thomas Eakins and Anschutz, then in 1894 became a student of Howard Pyle at the Drexel Institute. Pyle had the strongest influence on her style. She began her artistic career in the advertising department of the *Ladies Home Journal.* Smith shared a studio with Violet Oakley and Elizabeth Shippen Green, with whom she collaborated on a number of books and calendars. She became wealthy as an illustrator, working for many magazines and illustrating many of the classics of children's literature, including Robert Louis Stevenson's *Children's Garden of Verses* (1914) and Charles

Kingsley's *Water Babies* (1916). In her later years she did many portraits of children. Smith was the recipient of numerous awards and prizes.

Bénézit. *Dictionnaire.* Vol. 9, p. 62.

Earle. *Biographical Sketches of American Artists.* P. 293.

"A Child's Artist." *Art Digest.* 9(May 15, 1935):12.

Clement. *Women in the Fine Arts.* Pp. 319–320.

Foster, Kathleen A. "American Prints and Drawings in the Pennsylvania Academy." *Antiques.* 121(March 1982):721.

Goodman, "Women Illustrators of the Golden Age of American Illustration." Pp. 16–17.
 Goodman describes Smith's work as influenced by Japanese prints.

Likos. "The Ladies of the Red Rose."

Mahony, Bertha, and Elinor Whitney. *Contemporary Illustrators of Children's Books.* Boston: Women's Educational and Industrial Union, 1930. Pp. 68–69.

Morris, Harrison. "Jessie Willcox Smith." *Book Buyer.* 24(April 1902): 201–205.
 Lists several of her prizes. Good black-and-white reproductions.

Nudelman, Edward D. *Jessie Willcox Smith: A Bibliography.* Gretna, Louisiana: Pelican Publishing Company, 1990.
 Nudelman provides a comprehensive catalog of Smith's illustration work, carefully listing not only books illustrated by her, but calendars, magazines, posters, and advertisements. An introductory essay discusses the themes in her work and the critical responses it evoked. Many beautiful color illustrations are included.

Philadelphia. Philadelphia Museum of Art. *Three Centuries of American Art.* April 11–October 10, 1976. Pp. 304–306.

Rubinstein. *American Woman Artists.* Pp. 161–162.
 Notes that Smith did over two hundred covers for *Good Housekeeping,* beginning in 1917.

Schnessel, S. Michael. *Jessie Willcox Smith.* New York: Crowell, 1977.
Smith's life and career are detailed in this definitive biography.

Stryker, Catherine C. *The Studios at Cogslea.* Wilmington: Delaware
Art Museum, 1976.
Stryker provides a summary of Smith's life and career. Black-and-
white reproductions of her work are included.

FLORINE STETTHEIMER. 1871–1944. United States.
Stettheimer was born in Rochester, New York. Although she is
often classified as a "primitive" or naive painter, she spent eight years in
Europe receiving academic training in art. She studied in Munich,
Berlin, and Stuttgart in the 1890's and at the Art Students League.
Stettheimer was one of four sisters who presided over an intellectual and
artistic salon in New York City. She died virtually unrecognized by the
art world, due to her own indifference. Her only one-woman show
occurred in 1916, before her work reached its maturity. No works were
sold. This negative response was so devastating that she never again
attempted to achieve public acceptance. Economically secure, she priced
her works out of selling range and gave them away to friends. However,
between 1917 and 1926 she exhibited her work at the annual group
shows of the Society of Independent Artists. Stettheimer's work, encom-
passing satire and symbolism, is noted for its characterization of U.S. life
in the 1920's. Friends and family members are often included in the
playful works. She also designed the sets, costumes, and lighting for
Gertrude Stein's play, *Four Saints in Three Acts.* The Museum of
Modern Art held a retrospective of her work in 1946.

Boston. Institute of Contemporary Art. *Florine Stettheimer: Still Lifes,
Portraits and Pageants, 1910 to 1943.* March 4–April 27, 1980.
The catalog essay is by Elisabeth Sussman. A chronology, bibliog-
raphy, and exhibition list are included.

Bower, Anthony. "Florine Stettheimer." *Art in America.* 52(April
1964):88–93.
Several color and black-and-white reproductions are included.
Offers a good analysis of Stettheimer's life-style and attitudes.

Columbia University. *Florine Stettheimer: An Exhibition of Paintings,
Watercolors, Drawings.* New York: Columbia University Press,
1973.

David, Howard. *Florine Stettheimer.* New York: Columbia University Press, 1973.

Fine. *Women and Art.* Pp. 186–189.

"Florine." *New Yorker.* 22(October 5, 1946):26–27.
 Humorous description of Stettheimer's home and family. Notes that she painted from memory, not from models.

Florine Stettheimer: Still Lifes, Portraits and Pageants, 1910 to 1942. *See above* Boston: Institute of Contemporary Art.
 Exhibition catalog.

Graves, Donna. " 'In Spite of Alien Temperature and Alien Insistence': Emily Dickinson and Florine Stettheimer." *Woman's Art Journal.* 3 (Fall 1982–Winter 1983):21–27.
 Exploration of how both women felt the constraints of an essentially Victorian conception of womanhood. Both sought refuge from criticism by playing the role of amateur. Compares the similarities in their personal iconographies and shows how their recurrent symbols provide clues to their conceptions of themselves as women artists.

Harris and Nochlin. *Women Artists, 1550–1950.* Pp. 58, 64, 94, 266–267, 354.

Hartley, Marsden. "The Paintings of Florine Stettheimer." *Creative Art.* 9(July 1931):18–23.
 Hartley discusses Stettheimer's portrait style and describes her art as full of delicate satire and wit. Good black-and-white reproductions.

Heller. *Women Artists.* Pp. 141–142.

McBride, Henry. *Florine Stettheimer.* New York: Museum of Modern Art, 1946.
 Exhibition catalog which discusses the technical aspects of Stettheimer's art. It includes photographs of her stage and costume designs. This essay has been reprinted in *Three Romantic Painters: Burchfield. Stettheimer, Watkins* (New York: Arno Press, for the Museum of Modern Art, reprint edition, 1969).

Nochlin, Linda. "Florine Stettheimer: Rococo Subversive." *Art in America.* 68(September 1980):64–83.
 Profusely illustrated article that carefully analyzes Stettheimer's art, the forces that influenced it, and the social concerns that are

reflected. Draws on her diary, which is in the Beinecke Rare Book and Manuscript Library at Yale University.

Petersen and Wilson. *Women Artists.* Pp. 99, 101–104.

Rosenfeld, Paul. "The World of Florine Stettheimer." *Nation.* 132(May 4, 1932):522–523.

Rubinstein. *American Women Artists.* Pp. 193–196.

Stettheimer, Florine. *Crystal Flowers.* New York, 1949.
Poetry by Stettheimer, never intended for publication, published after her death by her sister Ettie. The introduction is also by Ettie Stettheimer.

Tyler, Parker. *Florine Stettheimer: A Life in Art.* New York: Farrar, Straus and Company, 1963.
In-depth biography with many reproductions and photographs. Unfortunately, a bibliography is not included.

―――. "Stettheimer, Florine." In *Notable American Women.* Vol. 3, pp. 366–368.

Zucker, Barbara. "An 'Autobiography of Visual Poems.' " *Art News.* 76 (February 1977):68–73.
Describes Stettheimer's one-woman show of 1916 and discusses many of her works.

Collections:

Boston, Museum of Fine Arts.
Brooklyn Museum.
Cleveland Museum of Art.
Hartford (Connecticut), Wadsworth Atheneum.
Kansas City, Nelson-Atkins Museum of Art.
Nashville, Fisk University.
New Haven, Yale University Art Gallery.
New York, Metropolitan Museum of Art.
New York, Museum of Modern Art.
Philadelphia Museum of Art.
Poughkeepsie (New York), Vassar College Art Gallery.
West Point (New York), United States Military Academy.

DOROTHEA TANNING. 1912– . United States.

Tanning was born in Galesburg, Illinois. Her parents were Swedish immigrants. She briefly studied at the Chicago Art Institute before moving to New York City in 1936. Tanning was in Paris prior to the outbreak of the Second World War. She met Max Ernst in the early 1940's while organizing a show of women painters. She and Ernst became inseparable, living first in Long Island, then moving to Sedona, Arizona. They married in 1948 and returned to France in 1952. Her Surrealist paintings have been described as obsessions of adolescent and sexual fantasies. Tanning has also designed sets and costumes for a number of ballets. In the late 1960's she began creating some soft sculpture. A major retrospective of her work was held in 1974 at the Centre National d'Art Contemporain in Paris. She presently lives and works in New York.

Alexandrian, Sarane. *Surrealism.* New York: Praeger Publishers, 1970. Pp. 164–65, 242.

Bénézit. *Dictionnaire.* Vol. 10, pp. 71–72.
Lists a number of ballets for which Tanning did the decoration.

Bosquet, Alain. *Dorothea Tanning.* Paris: Jean-Jacques Pauvert, 1966.

Chadwick, Whitney. "The Muse as Artist." Pp. 120–129.

———. *Women Artists and the Surrealist Movement.* Pp. 92–95, 135, 138–140, 243.

Fine. *Women and Art.* Pp. 210–212.
Good summary of her career.

Gibson, Ann. "Dorothea Tanning: The Impassioned Double Entendre." *Arts.* 58(September 1983):102–103.
Discusses the multiple and contrary meanings than can be read into Tanning's work.

Harris and Nochlin. *Women Artists, 1550–1950.* Pp. 100, 338, 362.

Jouffroy, Alain. "La Révolution est femme." XXe siècle. 42(June 1974):116.
Includes color reproductions at Tanning's work.

Lumbard, Paula. "Dorothea Tanning: On the Threshold to a Darker Place." *Women's Art Journal.* 2 (Spring–Summer 1981):49–52.

Recounts Tanning's biography and discusses her imagery which explores female nature. Tanning denies any autobiographical significance to her imagery.

National Museum of Women in the Arts. Pp. 94–95.

Orenstein. "Women of Surrealism." Pp. 1, 15–21.

Paris. Centre National d'Art Contemporain. *Dorothea Tanning.* 1974.
This catalog of a major retrospective of Tanning's work includes an interview with Alain Jouffroy.

Plazy, Gilles. *Dorothea Tanning.* New York: U.E.M., 1979.
Reproduces many of her paintings, lithographs, and sculpture, some in color.

Rubinstein. *American Women Artists.* Pp. 293–295.
Brief summary of the biographical facts.

Russell, John. "Dorothea Tanning at Gimpel and Weitzenhoffer." *Art in America.* 68(February 1980):129–130.
Review of first exhibition of Tanning's work in fourteen years. Discusses her evolution from tight, linear, representational painting to more loosely painted abstract works with freer use of color, done after the 1950's.

Tanning, Dorothea. *Birthday.* San Francisco: Lapis Press, 1986.
The artist's memoir. Discusses her life with and without Ernst.

Collections:

Chicago Art Institute.
New Orleans Museum of Art.
New York, Museum of Modern Art.
Washington (D.C.), National Museum of Women in the Arts.

SOPHIE TAEUBER-ARP. 1889–1943. Swiss.
Sophie Taeuber was born in Switzerland. Between 1909 and 1912 she studied art in St. Gall, Munich, and Hamburg. She was active in the Zurich Dada group activities between 1916 and 1919. From 1916 to 1929 she was a professor of design and textile arts at the School of Applied Arts in Zurich. She married the sculptor Jean Arp in 1921, but

their artistic collaboration had begun in 1915. They lived in Paris from 1928 until 1942, when they returned to Zurich. Taeuber-Arp was killed in an accident the following year. She worked in various media—textiles, marionettes, stage designs, collage, household furnishings, and stained glass—incorporating the Dada style or geometric abstraction. She was also founder and editor of the magazine *Plastique,* a journal devoted to abstract art.

Arp-Taeuber, Sophie, and Blanche Gauchat. *Dessin et arts textiles.* Zurich, 1927.

Austin, Carole. "In the Shadow of Fame: Sophie Taeuber-Arp and Sonia Delaunay." *Fiberarts.* 12 (September–October 1985):50.

Bénézit. *Dictionnaire.* Vol. 10, p. 53.

Bern. Kunstmuseum. *Sophie Taeuber-Arp.* 1954.

Brzekowski, Jan. "Les quatre noms." *Cahiers d'art.* 9(1934):197–200.
Illustrated review of an exhibition of Taeuber-Arp's work.

Fine. *Women and Art.* Pp. 173–174.
Describes the attitude that viewed Taeuber-Arp's art as craft or "applied art" and, therefore, less valued. Fine believes her most inspired work may be a series of wood polychrome reliefs executed between 1935 and 1938.

Greer. *The Obstacle Race.* P. 43.

Harris and Nochlin. *Women Artists, 1550–1950.* Pp. 60–61, 291, 311–313, 321, 359.

Heller. *Woman Artists.* Pp. 132–133.

Hill. *Women: A Historical Survey . . .* Catalog. P. viii.

"Kelly, Collage and Color." *Art News.* 70(December 1971):44–46.
Briefly discusses Taeuber-Arp's influence on the work of Elsworth Kelly.

Krasner, Belle. "Arp and Arp." *Art Digest.* 24(February 15, 1950):15.
Brief review of an exhibition.

Marter, Joan M. "Three Women Artists Married to Early Modernists:

Sonia Delaunay-Terk, Sophie Tauber-Arp and Marguerite Thompson Zorach.'' *Arts.* 54(September 1979):89–95.

Marter explores the parallels in the lives and artistic development of the three artists, noting that each was involved in European modernism before marrying their more-famous husbands.

Munsterberg. *A History of Women Artists.* Pp. 70–71.

National Museum of Women in the Arts. Pp. 144–145.

New York. Museum of Modern Art. *Extraordinary Women—Drawings.* July 22–September 29, 1977.

New York. Museum of Modern Art. *Sophie Taeuber-Arp.* September 16–November 29, 1981.

The catalog essay is by Carolyn Lancher, who notes that Taeuber-Arp was also involved in dancing during her Dada years in Zurich. The catalog includes an excellent chronology.

Paris. Musée National d'Art Moderne. *Sophie Taeuber-Arp.* 1964.

Schmidt, Georg. *Sophie Taeuber-Arp.* Basel: Holbein Verlag, 1948.

Includes a catalogue raisonné by Hugo Weber. Taeuber-Arp did not sign or date her work until the last two years of her life. Dates of her work were established by Weber after her death at the request of Jean Arp.

Strasbourg. Musée d'Art Moderne. *Sophie Taeuber-Arp.* March 26–June 12, 1977.

Stuber, Margit. *Sophie Taeuber-Arp.* Lausanne: Editions Rencontre, 1970.

Collections:

Basel, Kunsthalle.
New Haven (Connecticut), Yale University Art Gallery.
New York, Museum of Modern Art.
Washington (D.C.), National Museum of Women in the Arts.
Zurich, Kunstgewerbemuseum und Museum Bellerive.
Zurich, Kunsthaus.

REMEDIOS VARO. 1913–1963. Spanish.
Varo's father was an engineer, and she learned the techniques of mechanical drawing from him. As a child she traveled with her family throughout Spain and North Africa. She married her first husband while attending the Academia de San Fernando in Madrid. Varo became involved with the Surrealist movement in Paris, where she met her second husband, the French Surrealist poet Benjamin Peret. They relocated to Mexico in 1942 where she spent the remainder of her life and where the entire body of her mature work was produced. In the 1950's she divorced Peret and married Walter Gruen. Her first one-woman show was in 1956 at the Galeria Diana in Mexico City. The Museo de Arte Moderno in Mexico City held a retrospective showing of her work in 1971. All of her works are reportedly in private collections.

Chadwick, "The Artist as Muse." Pp. 120–129.

———. *Women Artists and the Surrealist Movement.* Pp. 191–195, 201–205, 215–218, 243.
Discusses her close friendship with Leonora Carrington.

Heller. *Women Artists.* Pp. 155–156.
Heller notes that Varo often used imagery related to her father's engineering profession.

Jaguer, Edouard. *Remedios Varo.* Paris, 1980.

Kaplan, Janet. "Remedios Varo: Voyages and Visions." *Woman's Art Journal.* 1(Fall 1980–Winter 1981):13–18.
Kaplan provides a good summary of Varo's life, career, and iconography. She describes her as superstitious with a "mystical belief in the forces of nature."

———. *Unexpected Journey: The Art and Life of Remedios Varo.* New York: Abbeville Press, 1988.

Lauter. *Women as Mythmakers.* Pp. 79–97.
Lauter presents an excellent iconographic analysis of several of Varo's works. A number of her paintings feature a female protagonist involved in a psychological and spiritual quest. Four black-and-white reproductions are provided.

Orenstein. "Women of Surrealism." P. 15.

Paz. Octavio; Roger Caillois; and Juliana Gonzalez. *Remedios Varo.*
Mexico City: ERA Ediciones, 1966.
This monograph was based on the retrospective exhibitions of
Varo's work held in 1963 and 1964.

MARIA VIEIRA DA SILVA. 1908– . Portuguese/French.
Vieira da Silva was born in Lisbon to Brazilian parents. She is
identified with the School of Paris abstract painting movement although
her images are based on reality and contain both Cubist and Surrealist
elements. Vieira da Silva moved to Paris in 1928 where she studied
sculpture with Bourdelle and Despiau at the Académie de la Grand
Chaumière and painting with Leger, Othon Friesz, and Stanley William
Hayter. She married Hungarian painter Arpad Szenes in 1930. During
the Second World War she and her husband lived in Portugal and Brazil.
They returned to Paris in 1947. In 1950 she became a French citizen and
continues to live in Paris. Vieira da Silva was awarded the Grand Prix
National des Arts in 1966 and in 1969 was honored with a thirty-five-
year retrospective at the Museum of Modern Art in Paris.

Bénézit. *Dictionnaire.* Vol. 10, pp. 496–497.
Lists her many prizes and awards. Notes her involvement in
painting, printmaking, illustration, and tapestry design.

Dorival. *Twentieth Century Painters.* Pp. 132, 174.

Fine. *Women and Art.* Pp. 176–177.
Describes Vieira da Silva's work as "a fusion of Renaissance space
and the Cubist grid."

Heller. *Women Artists.* Pp. 131–132.

Lassaigne, Jacques, and Guy Weelen. *Vieira da Silva.* Trans. John
Shepley. New York: Rizzolli, 1979.
Presents a chronicle of the evolution of Vieira da Silva's stylistic
language. A bibliography and chronology are included along with
numerous reproductions, many in color.

Munsterberg. *A History of Women Artists.* Pp. 78, 80.

National Museum of Women in the Arts. Pp. 132–133.

New York. Museum of Modern Art. *The New Decade: Twenty-two
European Painters and Sculptors.* May 10–August 7, 1955. Pp.
102–105.

This catalog consists of statements by the artists and black-and-white reproductions of their work. It was edited by Andrew C. Ritchie.

Rewald, John. *Vierira da Silva.* New York: Knoedler Gallery, 1971.
An exhibition catalog.

Russell, John. "An Artist in the Family—Vieira da Silva." *Art News.* 54 (March–April 1966):60–63.
Includes good color reproductions.

Vallier, Dora. *Vieira da Silva.* Paris: Editions Weber, 1971.
Includes a chronology and numerous photographs. Many of the excellent reproductions are in color.

Watt, Alexander. "Visages d'artistes: Vieira da Silva." *Studio.* 161(May 1961):170–172.
A brief description of Vieira da Silva's art and her working methods.

Collections:

Cologne, Wallraf-Richartz Museum.
London, Tate Gallery.
Minneapolis, Walker Art Center.
New York, Solomon R. Guggenheim Museum.
Paris, Musée National d'Art Moderne.
St. Louis, Washington University Gallery of Art.
Washington (D.C.), National Museum of Women in the Arts.
Washington (D.C.), Phillips Collection.
Zurich, Kunsthaus.

BESSIE POTTER VONNOH. 1872–1955. United States.
Bessie Potter, a native of St. Louis, studied with Lorado Taft at the Chicago Art Institute. Her reputation as a sculptor was established by the work she did with Taft for the 1893 Columbian Exposition. In 1895 she traveled to Paris. She married the painter Robert Vonnoh in 1899 and they settled in New York City. Her early work consisted of small genre pieces, usually of women and children in everyday activities. Many of her groups of children form the central themes for fountains. In the 1920's and 1930's she began doing life-size figures. She also did portrait busts. Vonnoh won numerous prizes and became a member of the National Sculpture Society. She ceased working as a sculptor in the 1930's.

Armstrong. *Two Hundred Years of American Sculpture.* Pp. 316–317.
This is a good summary of her life.

Bénézit. *Dictionnaire.* Vol. 8, p. 448.

Clement. *Women in the Fine Arts.* P. 352.

Craven. *Sculpture in America.* Pp. 501–502.

Earle. *Biographical Sketches of American Artists.* Pp. 321–322.
Calls her a specialist in modeling "diminutive portraits." Notes
that in 1906 Vonnoh was elected an associate member of the National
Academy of Design.

Hill. *Women: A Historical Survey . . .* Catalog. Pp. xii, 21.

Hoeber, Arthur. "A New Note in American Sculpture: Statuettes by
Bessie Potter." *Century Magazine.* 32(May–October 1897):732–735.

Kohlman, Rena Tucker. "America's Women Sculptors." *International
Studio.* 76(December 1922):227.

"Miss Bessie Potter's Figurines." *Scribner's Magazine.* 19(January
1896):126–127.

National Museum of Women in the Arts. P. 59.

Payne. "The Work of Some American Women in Plastic Art." Pp.
314–316.

Proske. "American Women Sculptors."

———. *Brookgreen Gardens Sculpture.* Pp. 81–83.

Rubinstein. *American Women Artists.* Pp. 98–100.
Notes that Vonnoh's first one-woman show was at the Brooklyn
Museum in 1913.

"A Sculptor of Statuettes." *Current Literature.* 34(June 1903):699–
702.

Taft. *The History of American Sculpture.* Pp. 449–450.
Identifies her portraits of children as her most valuable work.

Tinling. *Women Remembered.* Pp. 383, 441.
 List some of Vonnoh's work, including the fountain in New York's
 Central Park Conservatory Gardens (1937).

Collections:

 Chicago Art Institute.
 New York, Metropolitan Museum of Art.
 Washington (D.C.), Corcoran Gallery of Art.
 Washington (D.C.), National Museum of Women in the Arts.

ENID YANDELL. 1870–1934. United States.
 Yandell was born in Louisville, Kentucky, where her father was a
prominent physician. After attending the Cincinnati Art Academy she
studied in New York City with Philip Martiny and in Paris with
Frederick MacMonnies and Rodin. She designed the caryatids which
supported the main entrance to the Woman's Building at the Columbian
Exposition held in Chicago in 1893 and won a designer's medal for her
efforts. By 1895 she was exhibiting on a regular basis in the Paris Salon.
One of her works was exhibited in the 1913 Armory Show. Yandell
eventually moved to Edgartown, Massachusetts, where she continued to
work and to teach. Many of her works are portrait busts and monuments.
She also produced the monumental figure of Athena which graces
Nashville's reproduction of the Parthenon. Yandell was active in several
professional art organizations and was one of the first women to be
admitted to the National Sculpture Society.

Bénézit. *Dictionnaire.* Vol. 10, p. 841.

"Enid Yandell." *Art News.* 32(July 14, 1934):8.
 Obituary.

"Enid Yandell Is Dead." *Art Digest.* 8(August 1934):23.
 Brief obituary.

Logan, Mary. *The Part Taken by Women in American History.* Wilming-
ton, Delaware: Perry-Nalle Publishing Co., 1912. Pp. 763–764.

Opitz. *Fielding's Dictionary.* P. 1065.

Rubinstein. *American Women Artists.* Pp. 100–101.

Simms, L. Moody, Jr. "Enid Yandell—One of the First Women Members of the National Sculpture Society." *National Sculpture Review.* 20(Summer 1971):26–27.
Mentions many of her works without critical commentary.

Taft. *History of American Sculpture.* P. 451.

Tinling. *Women Remembered.* Pp. 92, 166–167.

Weimann. *The Fair Women.* Pp. 158–167.
Extensive account of Yandell's work at the Columbian Exposition. Several photographs of her work are included.

Collections:

Providence, Rhode Island School of Design, Museum of Art.
St. Louis Art Museum.

MARGUERITE THOMPSON ZORACH. 1887–1968. United States.
This artist was born in Santa Rosa, California, and grew up in Fresno. She was granted admission to Stanford University, but an aunt offered to provide her the means to study in Europe and she accepted the offer. In 1908 she went to Paris to study at La Palette. There she met the artist William Zorach, whom she married in 1912. Between 1908 and 1915 she was the author of over a hundred articles printed in the *Fresno Morning Republican* describing her experiences as an art student in Paris and detailing her travels in Europe and the Orient. Zorach was instrumental in introducing Fauvism and Cubism to the United States between 1910 and 1920. Her works were exhibited at the 1911 Salon d'Automme and in the Armory Show of 1913. Until about 1916 she and her husband were considered to be artists of equal merit. In the ensuing decades, however, his career began to overshadow hers, even though they had a noncompetitive relationship. This was largely because of a change in medium on her part from painting to needlework, which was seen as a "craft" rather than art. After the birth of her children in 1915 and 1917, she turned to needlework when she found it difficult to concentrate on painting. She worked with stitchery and embroidered tapestries until the 1930's. Her embroideries were first exhibited in 1917. Zorach did not return to painting until the last twenty years of her life when failing eyesight prevented her from continuing with her needlework. In 1925 she founded and was the first president of the New York Society of Women Artists.

Bénézit. *Dictionnaire*. Vol. 10, p. 918.

Benson, E. M. ''Embroidery Paintings by Marguerite Zorach at the Brummer Gallery.'' *American Magazine of Art*. 28(December 1935): 742–744.
 An exhibition review. While Benson describes her works as easel paintings embroidered on linen bases in dyed wool, instead of referring to Zorach as an artist he calls her the ''foremost craftswoman of her kind.'' Although recognizing Zorach's sense of formal construction in color and design, Benson saw an incompatibility between the materials and the desired effect.

Harris and Nochlin. *Women Artists, 1550–1950*. P. 60.

Heller, *Women Artists*. Pp. 119–120.

Marter, Joan M. ''Three Women Artists Married to Early Modernists: Sonia Delaunay-Terk, Sophie Tauber-Arp, and Marguerite Thompson Zorach.'' *Arts*. 54(September 1979):89–95.

National Museum of Women in the Arts. Pp. 78–79.
 Identifies Zorach's most productive years as from 1908 to 1920 when she was experimenting with the theories of Fauvism and Cubism.

Rockland, Maine. William A. Farnsworth Library and Art Museum. *William and Marguerite Zorach: The Maine Years*. July 11– September 28, 1980.
 The text of this exhibition catalog was written by Roberta K. Tarbell.

Rubinstein. *American Women Artists*. Pp. 172–176.

Tarbell, Roberta K. *Marguerite Zorach: The Early Years, 1908–1920*. Washington, D.C.: Smithsonian Institution Press, 1973.
 A look at a long-neglected aspect of her art, her early years while she was still painting simplified, natural landscape forms in a Fauvist-influenced style.

Zorach, Marguerite. ''Embroidery as Art.'' *Art in America*. 44(Fall 1956):48–51, 66–67.
 While admitting that her embroidered work is not so popular as it was when she first exhibited it in 1917, Zorach offers an eloquent defense of its artistic qualities. She describes her work as ''the art

expression of a developed artist, aware of and using the abstract qualities and new freedoms of this modern age in art.'' Includes several black-and-white reproductions.

Collection:

Washington (D.C.), National Museum of Women in the Arts.

SECTION III

NEEDLEWORK

The following is a short, selected bibliography. Books and periodicals are grouped together alphabetically.

Bath, Virginia C. *Needlework in America.* London: Mills and Boon, 1979.
A survey of various techniques, including embroidery, lace, rug hooking, and patchwork. A chapter on the needlework of the Native Americans is included.

Bertrand, Simone. *La tapisserie de Bayeux.* Paris: Zodiaque, 1966.

Bishop, Robert, and Elizabeth Safanda. *America's Quilt's and Coverlets.* New York: E. P. Dutton, 1976.

————. *A Gallery of Amish Quilts: Design Diversity from a Plain People.* New York: E. P. Dutton, 1976.
Many reproductions accompany a discussion of materials and techniques.

Blum, Clara. *Old World Lace.* New York: E. P. Dutton, ca. 1920.

Bolton, Ethel S., and Eva J. Coe. *American Samplers.* Boston: Massachusetts Society of the Colonial Dames of America, 1921.

Bullard, Lacy F., and Betty Jo Shiell. *Chintz Quilts: Unfading Glory.* Tallahassee, Florida: Serendipity Publishers, 1983.

Caulfield, S. F. A., and Blanche Saward, eds. *Directory of Needlework.* London: L. Upcott Gill, 1882; reprint, Detroit: Singing Tree Press, 1971.
Encyclopedia of artistic, plain, and fancy needlework.

Christie, A. G. I. *English Medieval Embroidery.* Oxford, 1938.

Colby, Aberil. *Samplers.* Newton Centre, Massachusetts: C. T. Branford Company, 1964.

Cooper, Patricia, and Norma Buferd. *The Quilters.* Garden City, New York: Doubleday, 1977.

Davis, Mildred J. *Early American Embroidery Designs.* New York: Crown, 1969.

Dedera, Don. *Navajo Rugs.* Flagstaff, Arizona: Northland Press, 1975.

Digby, G. W. *The Bayeaux Tapestry.* London, 1956; reprint, 1967. Edited by F. Stenton.

Dommelen, David van. *Decorative Wall Hangings: Art with Fabric.* New York: Funk and Wagnalls Company, 1962.

Ebet, John, and Katherine Ebet. *American Folk Painters.* New York: Charles Scribner's Sons, 1975. P. 37.
 A good summary of the importance of needlework as a skill for eighteenth-century women. Includes several reproductions.

Finley, Ruth, E. *Old Patchwork Quilts and the Women Who Made Them.* Philadelphia: J. B. Lippincott, 1929; reprint, Newton Centre, Massachusetts: Charles T. Branford.
 Patchwork quilts have recently begun to be appreciated for their significance to American aesthetic expression. Includes 96 illustrations and 100 diagrams.

Fratto, Toni Flores. "Samplers: One of the Lesser American Arts." *Feminist Art Journal.* 5(Winter 1976–1977):11–15.

Fry, Gladys W. *Embroidery and Needlework.* London: Pitman and Sons, 1935.
 Textbook on design and technique; illustrated.

Giffen, Jane. "Susanna Rowson and Her Academy." *Antiques.* 98(September 1970):436–440.
 Describes a Boston school of the late eighteenth century that included courses in needlework. Good reproductions.

Haders, Phyllis. *Sunshine and Shadow: The Amish and Their Quilts.* New York: Universe Books, 1976.
Discusses the development of patterns and designs.

Hafter, Darly M. "Towards a Social History of Needlework Artists." *Woman's Art Journal.* 2(Fall 1981–Winter 1982):25–29.
Hafter describes the study of quilts as a "window" into customs, human relationships, and individual awareness that accompanied events from our past.

Hall, Carrie, and Rose Kretsinger, eds. *Romance of the Patchwork Quilt in America.* Caldwell, Ohio: Caxton Printers, 1936.

Hines, Millie. *American Heirloom Bargello: Designs from Patchwork Quilts, Woven Colonial Coverlets, and Navajo Rugs.* New York: Crown Publishers, 1976.

Holstein, Jonathan. *American Pieced Quilts.* Washington, D.C.: Smithsonian Institution, 1972.

Hughes, Therle. *English Domestic Needlework, 1660–1860.* London: Abbey Fine Arts, n.d.

Huish, Marcus. *Samplers and Tapestry Embroideries.* London: Longmans, Green and Company, 1913.
Includes 24 color plates.

James, George W. *Indian Blankets and Their Makers.* New York: Dover Publications, 1974.

Kahlenberg and Berlant. *The Navajo Blanket.* Los Angeles: Los Angeles County Museum, 1972.

Kelly, Mary B. "Goddess Embroideries of Russia and the Ukraine." *Woman's Art Journal.* 4(Fall 1983–Winter 1984):10–13.
Describes depictions of the goddess Berehinia on clothing, felt to protect or ensure fertility. Includes black-and-white reproductions.

Koehler, S. R. "American Embroideries." *Magazine of Art.* 9(1886):209.
Mentions several women designers of tapestry. Includes three good black-and-white reproductions.

Kopp, Joel, and Kate Kopp. *American Hooked and Sewn Rugs: Folk Art Underfoot.* New York: Dutton, 1975.

Krevitsky, Nik. *Stitchery: Art and Craft.* New York: Reinhold Publishing Corporation, 1966.

Lane, Rose Wilder. *The Woman's Day Book of American Needlework.* New York: Simon and Schuster, 1936.

Lithgow, Marilyn. *Quiltmaking and Quiltmakers.* New York: Funk and Wagnalls, 1974.

London. Arts Council of Great Britain. *Opus Anglicanum: English Medieval Embroidery.* 1963.
Catalog of an exhibit held at the Victoria and Albert Museum.

Lowes, Emily Leigh. *Chats on Old Lace and Needlework.* London: T. Fisher Unwin, 1908.
A detailed chronological history; well illustrated.

Mainardi, Patricia. "Quilts: The Great American Art." *Feminist Art Journal.* 2(Winter 1973):1, 18–23.
A comprehensive overview of quilt art, its myths and importance in the history of women in art. An extensive bibliography is included.

Maines, Rachel. "Fancywork: The Archaeology of Lives." *Feminist Art Journal.* 3(Winter 1974–1975):1, 3.
An analysis of needlework as a means by which feminist art history may be traced without the usual heavy influence of male cultural definitions and influence. It provided the beginning source for this section of the bibliography.

Makowski, Colleen Lahan. *Quilting 1915–1983: An Annotated Bibliography.* Metuchen, New Jersey: Scarecrow Press, 1985.

Norbury, James. *Counted-Thread Embroidery on Linens and Canvas.* New York: Studio Publications, 1956.

Orlofsky, Patsy, and Myron Orlofsky. *Quilts in America.* New York: McGraw-Hill, 1974.

Parker, Rosie. "The Word for Embroidery Was Work." *Spare Rib.* No. 37(July 1975):41–45.
Spare Rib is a London feminist publication.

Richert, Shirley K. "From Women's Work to Art Objects." *Feminist Art Journal.* 2(Winter 1973):17–21.

A good historical overview of quilt making. Includes several black-and-white reproductions and a good bibliography.

Ring, Betty. "Memorial Embroideries by American Schoolgirls." *Antiques.* 100(October 1971):570–575.
Good reproductions of an art form that reached its zenith about 1815.

————. *Needlework: An Historical Survey.* New York: Universe Books, 1976.

Robinson, Charlotte, ed. *The Artist and the Quilt.* New York: Alfred A. Knopf, 1983.
Describes twenty quilts created as a collaboration between an artist who generally works in a nonfiber medium and a quilt maker who executes the design. Also includes general historical background on quilt making.

Roth, Henry Ling. *Studies in Primitive Looms.* New York: Burt Franklin, Publisher, 1976.

Safford, Carleton, and Robert Bishop. *America's Quilts and Coverlets.* New York: Dutton, 1972.

Schutte, Marie, and Sigrid Muller-Christensen. *The Art of Embroidery.* London: Thames and Hudson, 1964.

Sestay, Catherine. *Needlework: A Selected Bibliography with Special Reference to Embroidery and Needlepoint.* Methuchen, New Jersey: Scarecrow Press, 1982.

Siegler, Susan. *Needlework Patterns from the Metropolitan Museum of Art.* New York: New York Graphic Society, 1976.

Swan, Susan Burrows. *Plain and Fancy: American Women and Their Needlework, 1700–1850.* New York: Holt, Rinehart and Winston, 1977.

Symonds, M., and L. Preece. *Needlework Through the Ages.* London, 1928.

Vanderpoel, Emily Noyes. *American Lace and Lacemakers.* New Haven: Yale University Press, 1924.

Weiss, Rita, ed. *Victorian Alphabets, Monograms, and Names for Needlework from Godey's Lady's Book and Peterson's Magazine.* New York: Dover Publications, 1974.

Weissman, Judith R., and Wendy Lavitt. *Labors of Love: America's Textiles and Needlework, 1650–1930.* New York: Alfred A. Knopf, 1987.
This excellent historical survey includes discussion of quilts, Native American textile work, white work, Berlin work, rugs, and needlework tools and accessories. Lavish color reproductions accompany the fifteen chapters. An extensive bibliography is also included.

A Winterthur Guide to American Needlework. New York: Crown, 1976.

ABOUT THE AUTHOR

Sherry Piland is a graduate of Drury College in Springfield, Missouri. She earned her M.A. in Art History at the University of Missouri-Kansas City and is currently completing a Ph.D. program in Art History at Florida State University. Ms. Piland is an architectural historian for Florida's Division of Historical Resources. She previously held similar positions with the Kansas City Landmarks Commission and the South Carolina Department of Archives and History. She has taught art history and humanities at several colleges and universities. Ms. Piland is the co-author, with Ellen Uguccioni, of *Fountains of Kansas City: A History and A Love Affair* (1985) and has published articles in professional journals.